DEGAS
Portraits

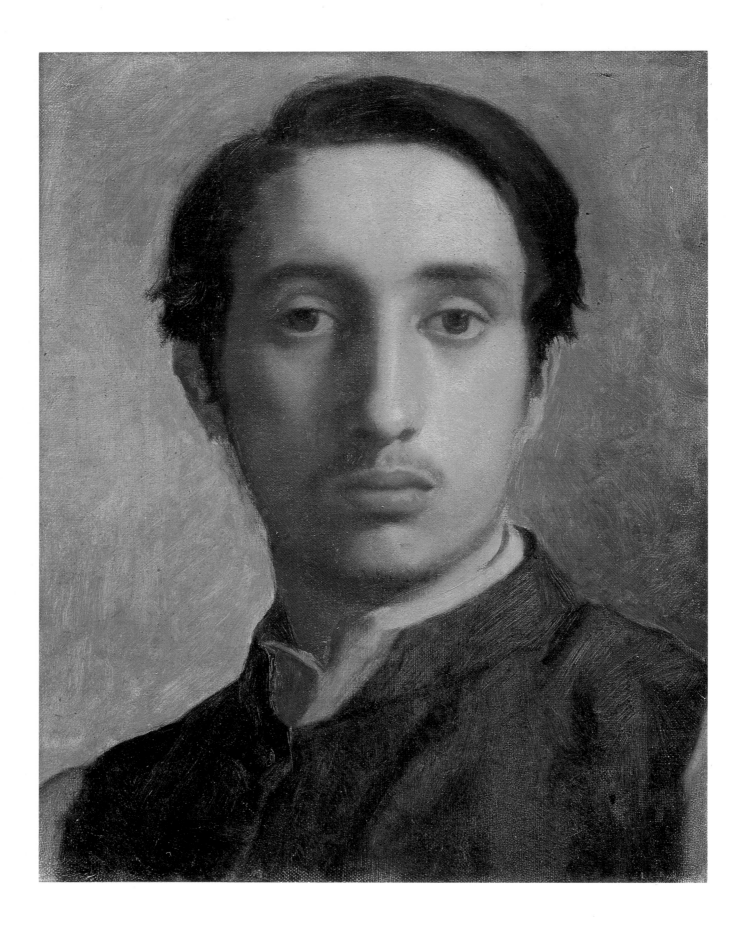

DEGAS
Portraits

EDITED BY

FELIX BAUMANN AND MARIANNE KARABELNIK

CONTRIBUTORS

JEAN SUTHERLAND BOGGS

FELIX BAUMANN TOBIA BEZZOLA ELISABETH BRONFEN
EMIL MAURER MARIANNE KARABELNIK LUZIUS KELLER
BARBARA STERN SHAPIRO ANTOINE TERRASSE
PIERRE VAISSE

MERRELL HOLBERTON
PUBLISHERS LONDON

The catalogue accompanies the exhibition held at the
Kunsthaus, Zurich, 2 December 1994 – 5 March 1995
and at the
Kunsthalle, Tübingen, 18 March 1995 – 18 June 1995

Exhibition curators at Zurich
Felix Baumann
Marianne Karabelnik

Exhibition curator at Tübingen
Götz Adriani

Advisors to the exhibition
Jean Sutherland Boggs
Walter Feilchenfeldt

Catalogue editorial
Tobia Bezzola, Paul Holberton,
Marianne Karabelnik, Daniela Tobler

Exhibition administration
Daniela Tobler

Transport
Gerda Kram

Publicity
Regina Meili
Marianne Fili

Accounts
Ilona Koller

First published in 1994
by Merrell Holberton Publishers Ltd
Axe & Bottle Court, 70 Newcomen Street, London SE1 1YT
ISBN 1 8594 014 1 [hardback]
ISBN 1 85894 015 X [paperback]

Produced by Merrell Holberton Publishers in association with
the Kunsthaus Zurich
Designed by Roger Davies
Translations from German and French by Judith Hayward
Typeset by August Filmsetting, St Helens
Colour reproduction by Columbia Offset, London
Printed and bound by Amilcare Pizzi, Milan

Front cover illustration
Elena Primicile Carafa (detail), 1875 (cat. 120)
Back cover illustration
The cotton office (detail), 1873 (cat. 114)
Frontispiece
Self-portrait ('*Degas en gilet vert*'), 1855–56 (cat. 9)

Contents

Acknowledgements

Organizing this exhibition in its present form would not have been possible but for the generous support of our friends and colleagues working in public museums and collections. We would like to express our heartfelt appreciation both to them and to those working with them.

Amsterdam, Rijksmuseum, Rijksprentenkabinet, Dr J.P. Filedt Kok, Director of Collections; Peter Schatborn, Keeper of Prints & Drawings

Birmingham, Museums and Art Gallery, Michael Diamond, Director

Boston, Museum of Fine Arts, Peter C. Sutton, Curator of European Paintings; Mrs Russell W. Baker, former Curator; Robert J. Boardingham, Assistant Curator of European Paintings; Barbara Stern Shapiro, Associate Curator Prints, Drawings and Photographs

Buenos Aires, Museo Nacional de Bellas Artes, Arq. Rafael E.J. Iglesia, Director

Buffalo, Albright-Knox Art Gallery, Douglas G. Schultz, Director

Cambridge/GB, The Fitzwilliam Museum, Simon Jervis, Director; David Scrase, Keeper, Department of Paintings, Drawings & Prints

Cambridge, MA, Harvard University Art Museums, Fogg Art Museum, James Cuno, Director; Dr Ivan Gaskell, Curator of Paintings; Ada Bortoluzzi, Coordinator of Loans

Chicago, The Art Institute of Chicago, James N. Wood, Director and President; Dr Douglas Druick, Searle Curator of European Painting/Prince Trust Curator of Prints and Drawings; Larry J. Feinberg, Associate Curator of European Painting; Suzanne Folds McCullagh, Curator of Earlier Prints and Drawings

Cleveland, The Cleveland Museum of Art, Robert P. Bergman, Director

Copenhagen-Charlottenlund, Ordrupgaardsamlingen, Hanne Finsen, Director; Mikael Wivel, Curator

Copenhagen, Statens Museum for Kunst, Den Kongelige Kobberstiksamling, Dr. Chris Fischer, Chief Curator; Dr. Jan Würtz Frandsen, Curator

Detroit, The Detroit Institute of Arts, Samuel Sachs II, Director; Iva Lisikewycz, Acting Curator, European Paintings

Edinburgh, National Gallery of Scotland, Michael Clarke, Keeper

Frankfurt, Städelsches Kunstinstitut, Graphische Sammlung, Dr Margret Stuffmann

Gérardmer, Ville de Gérardmer, C. Boulay, Maire

Hamburg, Hamburger Kunsthalle, Prof. Dr. Uwe Schneede, Direktor; Dr. Helmut R. Leppien

Hamilton, McMaster Art Gallery, Kim G. Ness, Director and Curator

Hartford, Wadsworth Atheneum, Patrick McCaughey, Director

Karlsruhe, Staatliche Kunsthalle, Prof. Dr. Horst Vey, Direktor; Dr. Annemarie Winther, Leiterin des Kupferstichkabinetts

Lausanne, Musée cantonal des Beaux-Arts, Dr. Jörg Zutter, Direktor

London, University of London, Courtauld Institute Galleries, Dr. Dennis Farr, former Director; John Murdoch, Director; Helen Braham, Curator

London, The National Gallery, Dr Nicholas Penny, Clore Curator of Renaissance Art and Acting Chief Curator; John Leighton, Curator of Nineteenth-Century Paintings

London, Tate Gallery, Nicholas Serota, Director

Los Angeles, The Armand Hammer Museum of Art and Cultural Center, Henry Hopkins, Director; Anne Bennett, Registrar

Los Angeles, Los Angeles County Museum, J. Patrice Marandel, Curator Department of European Painting and Sculpture; Stephanie Barron, Coordinator of Curatorial Affairs

Lyons, Musée des Beaux-Arts, Philippe Durey, Conservateur en Chef

Madrid, Fundación Colección Thyssen-Bornemisza, Tomás Llorens, Chief Curator; Eugenia Alonso, Rights & Reproductions Department

Manchester, The Whitworth Art Gallery, University of Manchester, Alistair Smith, Director

München, Bayerische Staatsgemäldesammlungen, Neue Pinakothek, Dr. Johann Georg Prinz von Hohenzollern, Generaldirektor; Dr. Christian Lenz, Hauptkonservator

New York, The Brooklyn Museum, Robert T. Buck, Director; Sarah Faunce, Curator, European Painting & Sculpture; Elizabeth Easton

New York, The Metropolitan Museum of Art, Philippe de Montebello, Director; Everett Fahy, Curator European Paintings; George Goldner, Drue Heinz Chairman Department of Drawings and Prints; Gary Tinterow, Chief Curator of European Paintings; Helen B. Mules, Associate Curator Drawings and Prints

New York, Pierpont Morgan Library, Charles E. Pierce Jr., Director; Cara Denison, Curator Drawings and Prints

Northampton, Smith College Museum of Art, Suzannah J. Fabing, Director; Linda Muehlig, Associate Curator

Ottawa, National Gallery of Canada, Dr Shirley L. Thomson, Director

Paris, Bibliothèque d'Art et d'Archéologie (Fondation Jacques Doucet), Jean-Luc Gautier-Gentès, Directeur; D. Nobecourt, Conservateur

Paris, Bibliothèque Nationale, Jean Favier, Administrateur Général; Bernard Marbot, Département des Estampes et de la Photographie

Paris, Direction des Musées de France, Françoise Cachin, Directeur

Paris, Musée du Louvre, Françoise Viatte, Conservateur Général chargé du Département des Arts Graphiques

Paris, Musée d'Orsay, Henri Loyrette, Directeur; Caroline Mathieu, Conservateur en Chef

Pau, Musée des Beaux-Arts, Philippe Comte, Conservateur en Chef; André Labarrere, Maire de la Ville de Pau

Philadelphia, The Philadelphia Museum of Art, Anne d'Harnoncourt, The George D. Widener Director; Joseph J. Rishel, Curator of European Painting and Sculpture; Innis Shoemaker, Prints, Drawings and Photographs

Providence, Rhode Island, Museum of Art, Rhode Island School of Design, Daniel Rosenfeld, Curator Painting and Sculpture

Richmond, Virginia Museum of Fine Arts, Katharine C. Lee, Director; Malcolm Cormack, Curator

Rotterdam, Museum Boymans-van Beuningen, Dr. J.R. ter Molen, Director a.i.

Saint Louis, The Saint Louis Art Museum, James D. Burke, Director; Sidney M. Goldstein, Associate Director

San Francisco, Fine Arts Museums of San Francisco, Harry S. Parker III, Director; Steven A. Nash, Associate Director/Chief Curator; Marion C. Stewart, Associate Curator European Art

Stockholm, Nationalmuseum, Olle Granath, Director; Görel Cavalli-Björkman, Chief Curator

Stuttgart, Staatsgalerie, Dr. Ulrike Gauss, Leiterin der Graphischen Sammlung

Tokyo, The Bridgestone Museum, Yasuo Kamon, Director; Katsumi Miyazaki, Curator; Mikako Tsukada, Associate Registrar

Vulaines, Musée Départemental Stéphane Mallarmé, Marie-Anne Sarda, Conservateur

Washington, National Gallery of Art, Earl A. Powell III, Director; Philip Conisbee, Curator of French Paintings

Washington, National Portrait Gallery, Smithsonian Institution, Alan M. Fern, Director; Claire Kelly, Assistant Curator

Washington, The Phillips Collection, Charles S. Moffett, Director; Elizabeth Hutton Turner, Curator

Williamstown, Sterling and Francine Clark Art Institute, David S. Brooke, Director

Zurich, Stiftung Sammlung E.G. Bührle, Hortense Anda-Bührle, Präsidentin

Our sincere thanks are also due to all those private collectors who have lent us works and co-operated with us in this project:
Mrs Isabella Brandt Johansen, New York
Mr Jean-Luc Baroni, Colnaghi Drawings, London
Mr and Mrs Walter and Maria Feilchenfeldt, Zurich
Sammlung Josefowitz
Mr and Mrs Jan and Marie-Anne Krugier-Poniatowski, Galerie Jan Krugier, Geneva
Mr and Mrs David Little
Mr and Mrs Barbara and Peter Nathan, Zurich
Mr Louis-Antoine Prat, Paris
Fondation Rau pour le Tiers-Monde, Dr. G. Rau; Dr. Robert Clémentz
Mr and Mrs Carol and Richard Selle
Messrs Robert and Manuel Schmit, Galerie Schmit, Paris
Mr Antoine Terrasse, Fontainebleau
Mr and Mrs Eugene V. Thaw
Wildenstein & Co., Inc., Mrs Ay-Whang Hsia, New York
as well as to others who have lent works but prefer to remain anonymous.

Our special thanks are also given to everyone who has assisted us in any way, helping to procure loans or advancing the project with their knowledge and advice:

Marie-Claude Antonini, Muzzano; Princesse de Beauvau, Sotheby's, Paris; Marc Blondeau, Paris; Philippe Brame, Brame & Lorenceau, Paris; Warren and Grace Brandt, New York; Léonard Gianadda, Martigny; Thomas Gibson, London; Robert F. Johnson, San Francisco; Eberhard W. Kornfeld, Bern; Henri Loyrette, Paris; Theodore Reff, New York; Michel Strauss, Sotheby's, London; Margit and Rolf Weinberg, Zurich.

Professor Jean Sutherland Boggs wrote what is still the standard reference work on Degas's portraiture more than thirty years ago, so we are particularly pleased that she is also the author of the main contribution to this catalogue. We are also especially grateful that she has unstintingly and patiently made her deep knowledge available to us and been a superb colleague and collaborator.

A special note of thanks is due to Mr Walter Feilchenfeldt. Without his active support it would have been virtually impossible to have brought this project to fruition in its present scope. He has provided friendly support and placed his knowledge and experience at our disposal from the beginning.

We would also like to thank the other contributors who have shared our enthusiasm for providing a new perspective on Degas and collaborated with us superbly: Dr. Tobia Bezzola, Professor Elisabeth Bronfen, Marianne Karabelnik, Professor Luzius Keller, Professor Emil Maurer, Barbara Stern Shapiro, Antonie Terrasse and Professor Pierre Vaisse.

Dr Paul Holberton and Hugh Merrell of Merrell Holberton Publishers have done everything to make our task easier, being considerate and painstaking in meeting our wishes.

Without the financial support of the 'Credit Suisse – Committed to Culture' an exhibition of this nature could never have taken place.

A project of this nature requires the involvement and collaboration of a large number of employees at the participating museums. Here we would like to draw attention to their contribution and express our sincere thanks to them.

Felix Baumann
Director Kunsthaus Zurich

Götz Adriani
Director Kunsthalle Tübingen

Introduction

FELIX BAUMANN
AND MARIANNE KARABELNIK

When Ludovic Halévy died Degas paid the family a visit to express his condolences and asked if he might see his old friend one more time in "full light". "That is Halévy as we knew him," he is said to have exclaimed, "and with a greatness that only death can give. I want to remember this."[1] That is also Degas as we know him: the keen observer who pitilessly demands "full light",[2] the greatness that he as a human being attributes to another human being, and the painter who wants to store up his impressions. But that is not all: we can speak of Degas as an outstanding portraitist only because he can convey such an indefinable element as 'greatness' by means of his art.

Between 1855 and the mid-1870s the portrait was the most important genre in Degas's creative work. It occupied less of his time in the following two decades, but then, again, in the late pictures of the Rouart family achieved surprising and original heights. Within those first twenty years the artist, still a young man, had gone through all the possibilities that this traditional genre could offer as regards both technique (oils, pastel, drawing, printmaking, sculpture, photography) and format. He experimented with the relationship of the figure to space, or he had concentrated entirely on the subtlety of a facial expression, or used details such as a bunch of flowers, a book or a picture frame to make sophisticated, significant points of emphasis. He had been beguiled by some gesture or trick of deportment of the sitter, or he composed a group portrait of fourteen people with each going individually about his own business. By the time Degas fell in with the group later known as the Impressionists, in the second half of the 1860s, he had by and large come up with an answer to all the questions a classically trained artist who was also open to innovation could have asked in this field. So it is definitely no accident that Duranty, in the pamphlet (*La Nouvelle Peinture*) he wrote to accompany the second Impressionist Exhibition at the Galerie Durand-Ruel in 1876, saw that 'new painting' required the individual to be portrayed as his own entity in his own context, not idealised, or jacketted according to the traditional or official formulas; and no accident that Duranty saw this requirement fulfilled authoritatively by Degas.

9

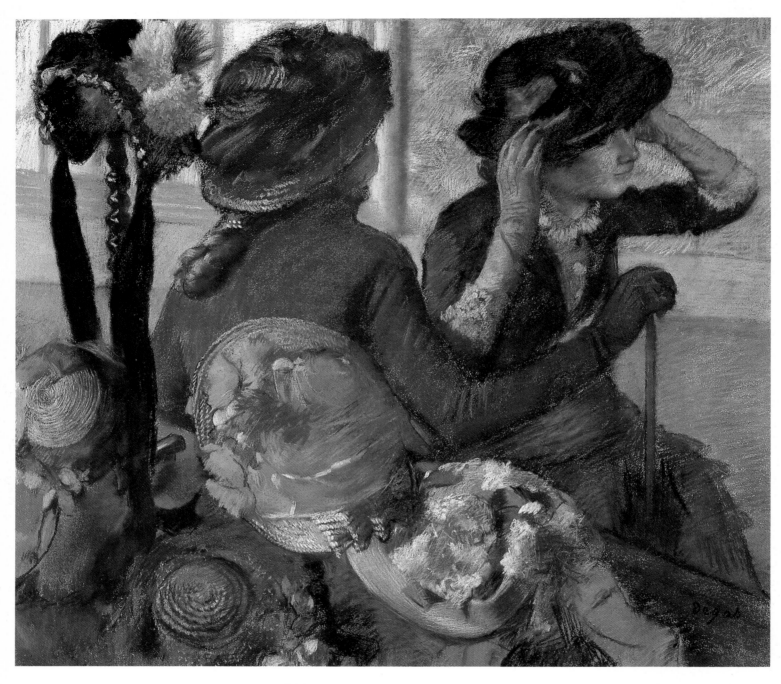

166
At the milliner's (*'Chez la modiste'*), ca. 1883, pastel, 75.9 × 84.4 cm, Madrid, Fundación Colección
Thyssen-Bornemisza (L 729)

166 (detail)

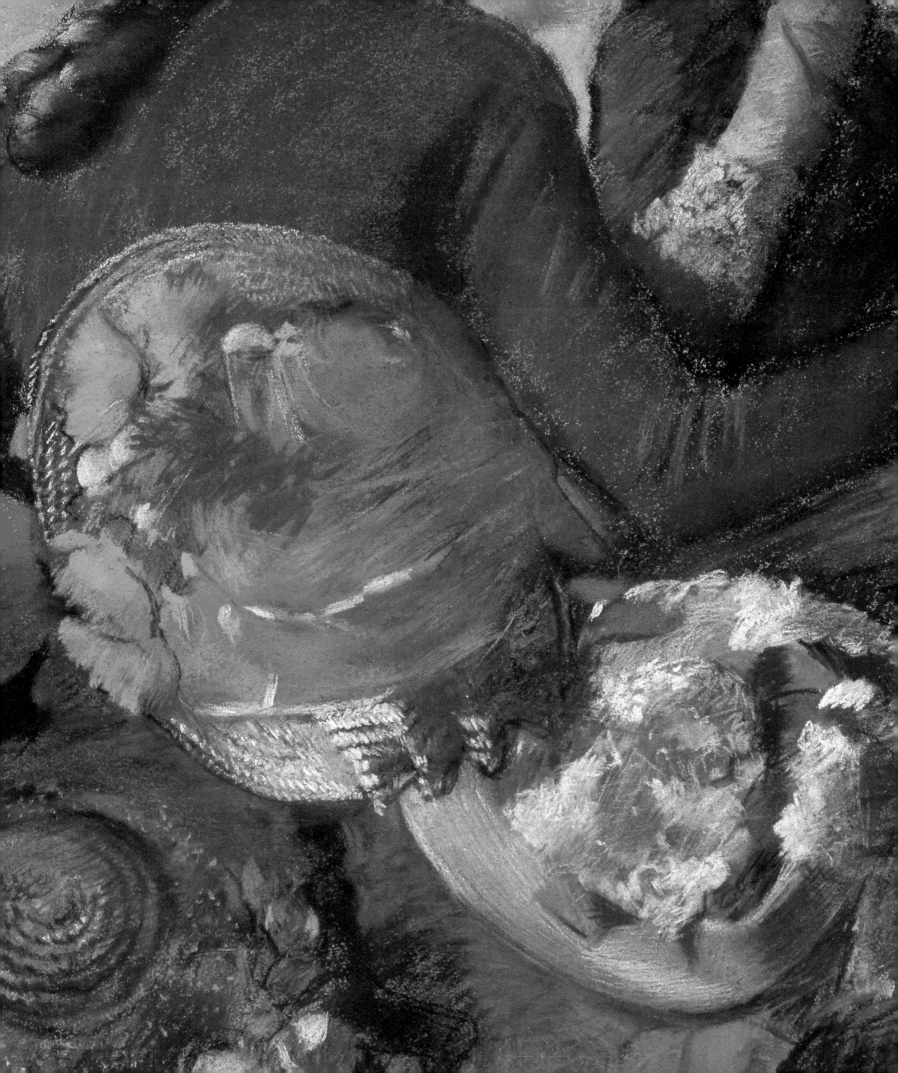

At the beginning of his career as a portraitist Degas was a classicist. On his return from Italy he brought back mainly portrait sketches and a few portraits, some of sitters, some copied after Old Masters. The portraits were conscientiously executed: the lines were beautifully drawn, the colouring carefully done, everything seemed to be turning out to his father's satisfaction. In 1858 Degas's father had written to him in Italy to say that two of his portraits had elicited compliments on all sides,[3] but that he would have preferred not to show three others to anyone. In fact Degas soon did not scruple to enliven his hitherto severe use of colour in Ingres's manner, and to loosen the stiff, staged, deliberately monumental pose of the sitter in favour of a more natural attitude; no doubt he was made bolder by the financial independence he enjoyed in his early years, so that he was not obliged to undertake commissioned portraits. His 1859 notebook establishes that he was already striving for compositions that would worthily represent his own time,[4] and his endeavours were also directed towards achieving harmony between the sitter's expression and body position. This approach corresponded to a new vision in which he attempted to convey the attitude of the person portrayed as naturally as possible, and at the same time from new, unusual viewing angles. However, Degas's increasing liking for the surprising pose and unusual viewing angle could go totally into reverse, or he could pursue the 'realism' promulgated by Duranty to bizarre extremes.[5] Degas may have been less than systematic in his theory, but he was always prepared to embark on artistic adventures. In the 1870s, for example, his researches extended into the realm of scientific physiognomy, leading to studies such as the *Criminal physiognomies* (cat. 161, illus. p. 291); again, he showed an almost malicious irony and pitiless perspicuity in observing women. He put a real tutu on his *Little fourteen-year-old dancer* (cat. 158, illus. p. 288), and in depicting a brothel in *La Famille Cardinal* he created a practical, clinical world devoid of feelings.[6] Manet had developed this search for naturalism to the point of rejecting the aspirations of an artist like Moreau: "He is leading us back to the unintelligible, whereas *we want everything to be understood.*"[7]

In line with the Impressionists' depiction of 'modern life' was Degas's liking for portraying people in their natural, everyday aspect. From the very beginning of his career he had been highly arbitrary in deciding whom he wished to portray. The only discernible constant is his impulsiveness in choosing his models. Initially he made portraits of members of his family and extended family, then of friends and acquaintances and, more rarely, paid models (see cat. 100, illus. p. 233) – though obviously they, too, were perfectly familiar to him;[8] but even here there was no rule – chance evidently played a large part in his choice. Accordingly we can view the development of his portraiture as progressing from his intimate circle, with portraits of his family and of himself, towards the 'outside', the artist gradually adding to the portraits which had originally been exclusively for the private sphere others intended for more public consumption. This is the basis for the way the Album in this publication is structured. Degas did not wish to abandon qualities particular to the portrait when he was depicting a group of figures, and would consistently pick out the isolated individual from the larger crowd and characterize him or her accordingly. As a result, he produced genre scenes in which the protagonists can be clearly identified (see Jean Sutherland Boggs's essay in this book).

Extending the concept of the portrait in this way continually led to an intermingling of genres in Degas's work. This makes it more difficult to categorize his production, and constantly calls for a revised concept of Degas's portraiture. To give one example, in *Place de la Concorde, Vicomte Lepic with his daughters* (illus. p. 43), which must be Degas's most famous portrait, it is open to question whether Degas was painting a portrait of Lepic and his daughters (as in the case of cat. 110, illus. p. 219, where the answer is unequivocal); perhaps we are looking at a townscape with Lepic and his daughters crossing the Place de la Concorde quite by chance – whether to enliven the scene or to allow Degas to make a pictorial joke. Or it could even be a 'society' portrait: Lepic and his aristocratic family, together with their correspondingly pedigree dog, would then be portrayed in sharp contrast to the ordinary, wondering citizens appearing at the edge

of the picture.

We must assume that such ambiguity was deliberate on Degas's part, but it may also be indicative of another phenomenon, namely that Degas was always suspended between accepting a realistic way of seeing and rejecting it. Many portraits – and this means a large part of his figure painting overall – present a real person in unreal surroundings. They are often contrived and are ultimately a blend of the real and the theatrical, so we quite often find ourselves in a real world which is at the same time invented.

The strangely hybrid aspect of Degas's work is expressed particularly in his portraiture: the beauty of a hand in conjunction with the ugliness of a face, the precise detail and the sketchy essentials, the depiction of a person so that only the silhouette is perceptible, and so on. The principle of spontaneity crops up in Degas's work again and again and is totally at odds with his attempts to produce works in series. So much is already evident in the portrait cycles of the Valpinçons, the Rouarts or the pictures of artists,[9] but it is more obvious in his pictures of the ballet, his nudes and his *café-concert* scenes. This corresponds to the rôle Degas played in the group of artists who met in the café Guerbois in the second half of the 1860s: while others debated the optical effect of the projection of shadows in the open air (a topic that did not interest Degas all that much), Degas was described as the "inventor of social *chiaroscuro*".[10] Degas was not to be deflected from pursuing his own ideas.

For the student of his work this produces some difficulties. The problem of dating the many undated works is linked with that of identifying the people depicted (see the Chronology, pp. 86–98). In the 1890s, moreover, Degas 'organized' his portfolios, noting the dates when his works had been produced with varying accuracy.[11] Then he picked out works he had produced earlier to rework them; this again results in difficulties when it comes to assessing style and texture, making it even harder to place the people depicted according to age. On occasion Degas would even ask for a picture to be returned to him so that he could work on it again. Judged by traditional criteria a large proportion of his pictures would have to be described as 'unfin-

ished'. Often the canvas on which he was working is in places covered with only rudimentary layers of colour or shows the grounding. Whatever Degas's motivation for this may have been, it produces an effect of lack of inhibition in confronting the sitter. Moreover, the unspectacular parts can heighten the effect of those painted in full. Even if at a first glance we may miss Manet's painterly brilliance, the quality of the picture lies in its very refusal of any form of show. A fruitful tension arises from Degas's undoubted ambition to achieve artistic perfection and his simultaneous refusal to make a virtuoso painterly gesture. In portraiture Degas – unlike Renoir – was never drawn by the glow of the lovely sitter and he never chose the pleasing way even if it provided him with a solution. He seldom embellished the women he painted, although he was completely captivated by their liveliness[12] ("that touch of ugliness without which there can be no salvation").[13]

Degas's *non finito* was therefore quite intentional. It might indicate something important or something unimportant; it might emphasize a gesture or a hand to such an extent that it came to signify the essential, making anything extra unnecessary. Or it might serve quite simply to enliven the picture, to give the pictorial qualities of the painting primacy over the portrait, to beguile or to baffle the viewer. But it also signified Degas's constant search for the 'craft' of the Old Masters.[14]

Degas's remarkable position as an outsider in his own time was also in keeping with his principle that nothing was impossible. Amid artists committed to the 'impression' he was the one who did not rely solely on the optical sense and in whom a later generation of artists would recognise a genius for composition.[15] This may be discerned in his portraits in particular; by their very nature they fulfilled a specific task that went beyond the 'fetishism of the palette'. Yet in the final analysis Degas, too, was endeavouring to achieve pure painting and always had to employ the figure in some form or other for this, given that he was not a *plein-air* painter, a landscape painter, a still-life painter or a painter of rural genre. Thus in his last great portraits dating from his middle period the insignificant is emphasized, achieving a life of its own. The sofa and the writing

implements in the portrait of Martelli (cat. 146, detail illus. p. 14, whole p. 269) for example, or the milliner's hats strewn on the floor (cat. 166, illus. pp. 10, 11), illustrate the other side of this complex artist who was described emblematically by a contemporary as being "in love with logic and art".[16]

146
Diego Martelli (detail; whole picture illus. p. 269)

NOTES

1 Quoted from Daniel Halévy 1960, p. 135

2 Degas's poor sight, by which he was afflicted relatively early, has always given rise to the supposition that he used his blindness as a pretext so as to avoid unpleasantness.

3 Letter from his father to Degas, private collection, quoted here from Loyrette, 1989, p. 18: "It is made by a master's hand and if you succeed in establishing your talent there and go on to perfect it still further, you are on your way. But I am not satisfied with the three other portraits of M., Mme and M. and Mme Ducros, so I have only shown the one of the little girls."

4 "trouver une composition qui peigne notre temps", in Reff 16, BN 27, p. 6.

5 Duranty himself in his novel about the fictional painter Louis Martin characterized Degas as a highly intelligent painter, whose ideas, however, were for the most part not understood by his contemporaries.

6 See the essay by Douglas W. Druick and Peter Zegers, 'Scientific Realism: 1873–1881', in 1988–89 Paris/Ottawa/New York, pp. 197–211.

7 Quoted from Pool 1963, p. 255f.

8 For example, Degas addressed to Emma Dobigny (see cat. 100) some extremely familiar and affectionate words, evidently after she was no longer coming to pose for him. The letter is in Reff 1968, pp. 87–94.

9 See Loyrette 1989, p. 20.

10 Duranty's words, quoted by John Rewald, *The History of Impressionism*, New York 1946 (German translation, Zurich and Stuttgart 1957, p. 143).

11 See Loyrette 1989.

12 Sickert 1917, p. 185: "He [Degas] said that painters too much made of women formal portraits, whereas their hundred and one gestures, their chatteries etc. should inspire an infinite variety of designs . . .".

13 Letter to Henri Rouart from New Orleans, 5 December 1872, in *Lettres* 1945, p. 28.

14 For Degas's technique see Rouart 1945.

15 Mirbeau 1884 about Degas, quoted from Loyrette 1991, p. 467.

Essays

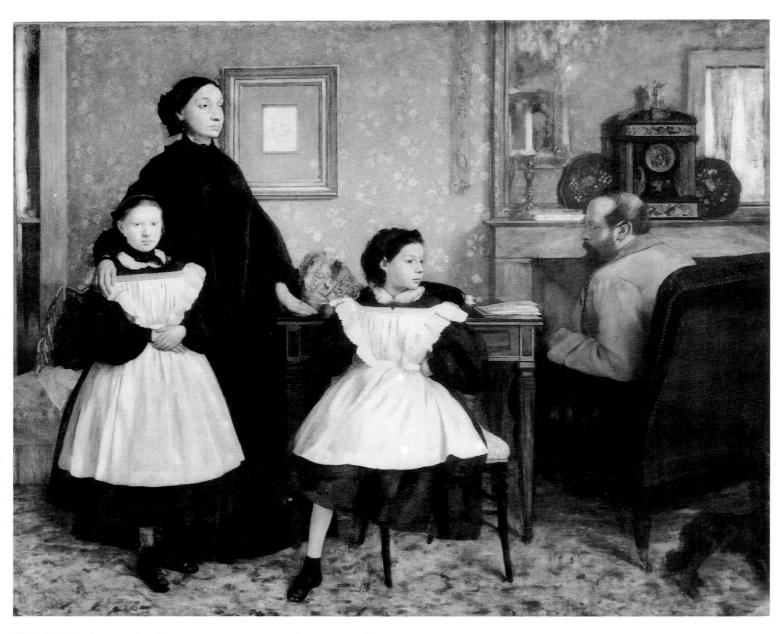

The Bellelli family, 1858–67, oil on canvas, 200 × 250 cm, Paris, Musée d'Orsay (L79)

Degas as a Portraitist

JEAN SUTHERLAND BOGGS

I. On the Way to Impressionism

After Edgar Degas's death on 27 September 1917, during the depths of the First World War, his heirs – his brother René and the children of his sister Marguerite Fevre – proceeded with remarkable dispatch.[1] They managed to collaborate with his dealers Durand-Ruel and Ambroise Vollard so that the first of the three sales of his collection was held six months later, on 26–27 March 1918, and the first of the five sales of most of his own work remaining in his studio two months after that.[2] This was particularly remarkable in war-time Paris, as described by the director of the National Gallery, London, C. J. Holmes, when he went over to buy works at the first sale of the painter's collection – two of them portraits by Ingres and Delacroix. Before he returned, the Germans were only nine miles from Amiens. The sale itself was interrupted by the "booms" of 'Big Bertha', which reduced the number of rival bidders. In May 1918 the first of the sales of Degas's own works was held – 113 oils, 196 pastels and 27 drawings. The National Gallery was not so successful this time because "Prices were rather high; the pictures we most fancied were fancied also by the Louvre". But to the interested public, who when they thought of Degas thought of ballerinas and bathers, the works to be seen in "the hot, crowded auction rooms", as Holmes describes them,[3] were a revelation. In his preface written in 1931 for the first exhibition of Degas's portraits, Paul Jamot noted, "His contemporaries had failed to recognise the gifts that establish Degas among the great portraitists of all time, from Holbein to Ingres".[4] Among the portraits in the first sale were twelve in this exhibition, including those of Mme Burtey (cat. 88, illus. p. 231), Diego Martelli (cat. 144, illus. p. 267) and Henri and Alexis Rouart (cat. 177, illus. p. 225).[5] But the painting which was most unexpected and would have aroused interest under any circumstances if only for its size and because the French State had, most controversially, bought it before the sale for the very large sum of 500,000 francs, was *The Bellelli family* (illus.). As Jamot described it in 1918, "The admirable *Family portrait* [as it was then called], which dates from 1860, was for a long time rolled in a corner ... The artist had to die, not only before it was admired, given its place by historians and critics, but even before it

was known to exist."[6] This large, masterful and provocative canvas, painted some fifty-eight years before, which had never previously been reproduced and probably never exhibited, inevitably provoked curiosity about this artist who had claimed to the young Alexis Rouart that he wanted to be "illustrious but unknown".[7]

Degas would never have considered himself a professional portrait painter, even if about twenty per cent of his work is portraiture and on 11 November 1858 his father had written to him in Florence from Paris, while he was contemplating painting *The Bellelli family,* "You tell me of the boredom you feel when making portraits; it would be better for you if you can overcome it, because they will be the finest jewel in your crown."*[8] It is very difficult to know whether Degas ever finished a commission for a portrait, and it has been impossible to discover whether he was ever paid. He seems to have agreed to paint Mme Dietz-Monnin,[9] perhaps to repay a loan from her son-in-law, his friend Hermann de Clermont (cat. 150, illus. p. 218), but wrote her an undated and often quoted letter to bring the matter to an end:

Dear Mrs Dietz-Monnin,
Let us forget the portrait, please. I was so surprised by your letter, proposing to reduce it to a boa and a hat, that I will not be able to reply to it ... Should I say that I regret having started something of mine only to see it transformed into something of yours? That would be rude, and yet ... Leaving aside my wretched art, please accept my compliments.*[10]

Apparently the unfinished painting (L534, Chicago, Art Institute, illus. p. 106) was returned to the painter and neither of the two pastels he made of Mme Dietz-Monnin (L535, Washington, National Gallery, and L536, Pasadena, Norton Simon Museum) went to her or to her family.

There are cases where inscriptions indicate that Degas had given portraits to certain sitters or their families. Among these are the gouache of Pellegrini (cat. 131, illus. p. 259), the painting of Linet, Lainé and Jeantaud, presented to Jeantaud (cat. 109, illus. p. 215), the small painting of Paul Lafond and Alphonse Cherfils (L647, Cleveland Museum of Art) dedicated "Degas à ses chers amis" and given to Cherfils, and a pastel (L870, Cologne, Kunsthaus

Lempertz), which he gave to Alexis Rouart who attached to its back this note: "Ce dessin, qui m'a été donné par Degas en mai 1903, est une étude faite pour le portrait de ma nièce Hélène Rouart." There were other gifts. They include the works owned by Désiré Dihau and his sister Marie (L172, New York, Metropolitan Museum; L186, Paris, Orsay; L263, Orsay),[11] perhaps even the portrait of their friend from Lille, Mme Olivier Villette (cat. 112, illus. p. 238), but not the study of Dihau (San Francisco, Museums of Fine Art) for the *Orchestra of the Opéra.* It is likely that Degas left some paintings of his Neapolitan relatives in Italy – such as the portrait of his grandfather Hilaire Degas (cat. 20, illus. p. 187), that of Henri Degas and his niece Lucie (cat. 127, illus. p. 199), and four of the paintings of the Primicile Carafa (cat. 97, 98, 120, 128; illus. pp. 196, 197, 198);[12] an exception is the double portrait of Elena and Camilla Primicile Carafa (cat. 77, illus. p. 195), which ended up with his niece Jeanne Fevre in France. The Valpinçons could easily have commissioned the portraits of their daughter Hortense (L206, Minneapolis, Institute of Arts, illus. p. 111) or of their son Henri (cat. 106, illus. p. 207), or Degas might simply have given them the works in return for their continuing hospitality at Ménil-Hubert in Normandy. The same applies to his portraits of the family of Henri Rouart although, apart from drawings, only the portrait of Henri Rouart in front of his factory (L373, Pittsburgh, Carnegie Museum), the painting of Henri with his daughter Hélène as a child on his knee (illus. p. 44), the pastel of Mme Rouart (cat. 180, illus. p. 224) and a pastel study of Henri Rouart (illus. p. 77) seem to have been part of this friend's distinguished collection.

Degas probably gave paintings to artists and their families,[13] as we know he did in the cases of Manet (illus. p. 25) and Miss Cassatt (cat. 168, illus. p. 276),[14] or to men who possessed talents related to his own such as Michel Manzi, the multitalented Neapolitan who reproduced his drawings (L995, Paris, Orsay).[15] We also know that Degas bought back his gift to Evariste de Valernes in 1893 when Valernes was in financial difficulties (L177, Paris, Orsay).[16] Although there were also undoubtedly gifts to members of his family, including self-portraits, we need to be careful because works

owned after his death in 1917 by his only heirs, René de Gas and the children of Marguerite Fevre, could have come to them as a result of the division of the contents of the artist's studio that took place before the sales held in 1918 and 1919. The only reasonably firm evidence for a commission concerns the small painting of General Mellinet and Rabbi Astruc (cat. 108, illus. p. 214), which the general and the rabbi are supposed to have asked Degas to paint.[17] Degas seems to have made most of his portraits for his own enjoyment, free from the demands imposed by his patrons on the professional portrait painter.

Degas still owned many of his portraits when he died: *Mlle Fiocre in the ballet* La Source (illus. p. 51), *M. and Mme Edouard Manet* (illus. p. 25), *Mme Fantin-Latour* (L137, Toledo, Museum of Art), *Mme Camus at the piano* (cat. 104, illus. p. 213), *Mme Camus in red* (L271, Washington, National Gallery, illus. p. 90); two portraits from New Orleans, probably of Mathilde Musson Bell (L313, Washington, National Gallery, and L318, Ordrupgaard); the dazzling portraits of 1879 of Diego Martelli (cat. 144, 146, illus. pp. 265, 267) and Edmond Duranty (L517, Glasgow, Burrell Collection, illus. p. 47); Rose Caron (cat. 175, illus. p. 285); and the Rouart portraits, *Hélène Rouart* from 1886 (L869, London, National Gallery, illus. p. 73), *Henri Rouart and his son Alexis* (cat. 177, illus. p. 225), *Louis Rouart* and *Mme Rouart* of 1904 (L1440, 1444, private collections) and *Mme Alexis Rouart and her children* of 1905 (L1450, Paris, Petit Palais, illus. p. 82). But the greatest surprise in the contents of his studio after his death aged eighty-three was undoubtably the monumental early work of *The Bellelli family*.[18]

Early work

While he was preparing for *The Bellelli family* – making some sketches of his Bellelli aunt and cousins after arriving in Italy in 1856, then making studies in Florence during the winter of 1858–59, followed by further studies on the short return trip he made there in 1860 and finally work on the canvas itself in Paris, presumably between 1859 and 1862 – Degas was still educating himself as a painter. He explored the world he knew, or that he could only imagine, in drawings in his notebooks or *carnets*.[19] He was inspired by the theatre, fiction,

works of art, and photographs. From one *carnet* in the Bibliothèque Nationale, no. 1, the largest, produced between 1858 and 1864,[20] we can see how varied (and pleasurable) his investigations were. He roamed from antiquity (of various civilizations) to contemporary landscape and society. The people he drew came from different races, ages and what then would have been described as different stations in life. The very richness and the keenness (and often levity) of his observations in these notebook drawings prepared the way for his work in both portraiture and genre.

In general at this time – and even before he left Paris for Italy in 1856 and after he returned in 1859 – Degas's portraits followed the conventions of composition and demeanour in contemporary painting and photography, with some suggestions of Renaissance art and of his admiration for painters such as Rembrandt and Van Dyck. In a portrait such as that of his ten-year-old brother René in 1855 (cat. 7, illus. p. 174), he gave hints of two directions in which he might move, consequently blurring the distinctions between portraiture and genre. One is some suggestion through inanimate objects – here a still life of an ink pot, pen and paper on a ledge and the casual student's smock with the cheerful red tie – of the boy dedicated, perhaps not completely willingly, to a social institution, school. The other is that, although the position of the body as a whole is so still that it is hardly revealing, René's gestures give something away. While his stocky right hand assumes an adult position as it holds a book bag against the arm of the chair, his left finds its way comfortingly into his pocket in a gesture which undoubtedly was as much a flaunting of parental control in 1855 as it would be today. We see an individual (a portrait) surrounded by the trappings of society (genre).

These clues of still life and gesture survive into the mid-1860s. Still life and dress, as we find them in his portrait of his grandfather, *Hilaire Degas* (cat. 20, illus. p. 187), in the so called *Woman with chrysanthemums* ('*La femme aux chrysanthèmes*', L125, New York, Metropolitan Museum; illus. p. 88), in *Mme Fantin-Latour* (L137, Toledo, Museum of Art) and in his pastel of *Thérèse Morbilli* (L255, private collection), may be more important as genre than as

aspects of a likeness, since they depict the social circumstances of the sitter. Alternatively, gesture indicates so much about an individual's self-possession (or lack of it) that it makes a major contribution to portraiture. Mme Burtey plucks gingerly at the threads of her shawl (cat. 90, illus. p. 230), Mme Gaujelin's fingers interweave tightly, delicate but strong (L165, Boston, Isabella Stewart Gardner Museum; illus. p. 88), Degas himself places his left hand horizontally across his chin as if his fingers were forming a protective barrier (cat. 82, illus. p. 172). Gesture can also suggest relationships with other people, as Mme Fantin-Latour's straightforward, folded hands do in the picture in Toledo. When more than one person is represented in a portrait or genre subject, gestures can reveal associations important both to portraiture and to the depiction of a situation.

The Bellelli family, 1858–62

The first major work in which Degas used portraiture as genre, as a representation not simply of a person but of the situation and circumstances of a social group, is *The Bellelli family* (illus. p. 16), painted on a scale that indicates an intention to submit it to the Salon.[21] The sitters were members of his extended family. The baroness was his aunt Laura, his father's sister, who had been pampered and adored, rejecting many eager suitors while she grew up in Naples.[22] Eventually in 1842 at the age of twenty-eight she married a forty-two-year-old Neapolitan lawyer, publicist and politician, Baron Gennaro Bellelli (see cat. 55, illus. p. 192), who would be exiled from Naples for his participation in the Revolution of 1848. Today we have access to a great deal of documented information about the Bellelli.[23] We know that they spent their exile in Florence in what the baron sadly described as "furnished apartments",[24] that the baroness was unhappy with her husband, which her relatives and, in particular, the painter understood, and that the couple were somewhat liberated by the establishment of the Kingdom of Italy in 1860: the baron was made a senator and they were able to return to Naples. The elder daughter, Giovanna (see cat. 42, 43, 47, 48, illus. pp. 89, 191, 192), was born in Naples in December 1848, when the father was already in exile. Degas described Giovanna to his friend the painter Gustave Moreau in 1858, when she was ten, as "réellement une petite beauté", but there is a slight reservation here compared with his description of her sister, seven-year-old Giulia (or Julie) (see cat. 44, 45, illus. p. 189, 192), about whom Degas wrote to Moreau, "the young one has the mind of a demon and the goodness of a little angel".[25] Serenely appearing a saint, in contrast to her "demon" sister Julie, Giovanna was actually difficult, which may account for her mother's protective stance. Degas clearly loved and admired his aunt – but not her husband. When the painter went back to Florence in 1860, principally to make drawings of the baron, he must have done so with some apprehension. Two years before, he had found living alone with this uncle in the Bellelli apartment in Florence for four months, as they waited for the return from Naples of the baroness and her daughters, something of a tribulation.

Newly discovered information has enriched and reinforced earlier interpretations of *The Bellelli family*. Reff, for example, gave the drawing behind the head of the baroness a particular significance when he proved it to be by Degas of his grandfather, Hilaire Degas (cat. 20, illus. p. 185),[26] for whose approaching death in Naples in 1858 the three Bellelli women had waited. Nevertheless the painting is so clearly worked out that the dignity of the baroness, her protectiveness towards Giovanna, the independence of little Giulia as the focus of family feelings, the gap between the proud wife and her morose husband have always been explicit.[27] The only unresolved question is the apparent pregnancy of the baroness, with the basinette behind her: she would have been forty-five in 1859, and to Degas a pregnancy at that age could have seemed a violation of the aunt he adored.[28]

It is a shock to learn from Daniel Schulman that this formal composition with the telling wedge of space between husband and wife may have been projected by Degas before he left Florence in March 1859, having originally been provoked by, or more certainly revised and strengthened in seeing, a lithograph by Daumier called '*Un propriétaire*' (a man of property), published in *Le Charivari* of 26 May 1837 (illus. p. 21).[29] If the dates were reversed we might

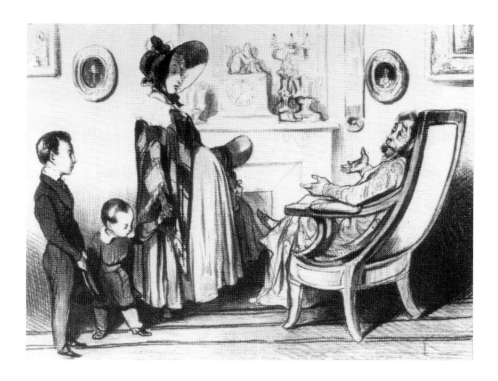

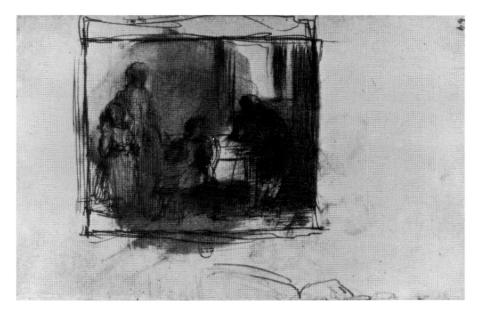

Honoré Daumier, *A man of property*, lithograph, published in *Le Charivari*, 26 May 1837

Sketch for the final composition of *The Bellelli family, carnet* 18 (Reff 12), 1860, Paris, Bibliothèque Nationale

naturally suspect that the Daumier is a caricature of the Degas – the family tableau with an even more pregnant mother, two children, two oval family portraits instead of the one drawing on the wall, a mantelpiece with a more elaborate chandelier instead of the single, chaste candle, a clock crowned by a slumping, naked Father Time instead of a triumphant Minerva, a more conspicuous bell-pull to summon a servant, and the father more relaxed in his position with his back towards us as he objects haplessly to his wife's extravagant shopping, as we know from the caption. But the Daumier came first.

From the time of his arrival in Naples in 1856 for his longest stay in Italy – three years – Degas was drawn to his small Bellelli cousins and painted Giovanna then (L10, Paris, Orsay).[30] He went to Florence in the summer of 1858 with the intention of making a Bellelli family portrait, which he must have conceived originally as a vertical painting with a pyramidal grouping of the baroness and her two daughters (cat. 46, 49, illus. p. 190). Before he left Florence, however, in the following March, he had already included the baron in what was now a horizontal composition. In one notebook that Reff dates 1858–59 (illus.), Degas had worked out much of the total composition, except that the baron is closer to the others with his elbow on the table and turns towards us frontally, cast in shadow against the bright light of a window behind. By 1860–62, a date Reff assigns to another notebook and therefore after the return to Paris, Degas drew the composition much as it is in the final painting, with his uncle in an armchair with his back towards us, placed against the mantelpiece.[31] It was because of the selection of this position, which places the baron's head in profile, that Degas had to make drawings of him on that return trip to Florence in the spring of 1860 (cat. 55, illus. p. 192). It may have been there that he did the pastel now at Ordrupgaard (cat. 40, illus. p. 188) of the whole composition, in which the baron's head is so developed that this work must postdate the drawings Degas had made of him in 1860.

Where does the Daumier fit in? Degas may have had a vague memory of it, which could have inspired the original idea for the painting of his aunt's family. He may have seen it for the first time – or again – on his return to Paris between March

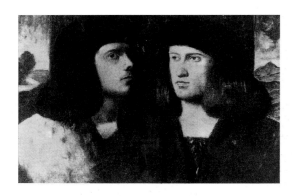

Copy after Giovanni
Cariani, Double portrait
Oil on canvas
43 × 63 cm
Whereabouts unknown
(L59)

1859 and April 1860. The most obvious link between the two is the uncle's chair, which Degas developed in Florence in 1860. Degas, who was well aware that *The Bellelli family* resonates with influences from other artists such as Ingres, Holbein, Bronzino and Van Dyck, might have been amused by the link of his very large painting, with its obvious ambitions for the Salon (even if it was never submitted), and a newspaper caricature. He did admire Daumier and was later to base other compositions upon his lithographs.[32] *The Bellelli family*, where the influence may be trivial if not coincidental, would have been the first.

The comparison of the painting with the print is nevertheless instructive in the consideration of genre in Degas's portraiture. The Daumier is undoubtedly genre; there is no suggestion of portraiture beyond social caricature. It has a subject popular in nineteenth-century fiction, caricature and illustration, the adjustments of the family of a self-made man to its new wealth. On the whole the accessories are appropriate, the boys neatly dressed, the father's bathrobe generous, and the pictures, mantelpiece and chair respectable. On the other hand the mother may be somewhat blowsy and is certainly immodestly pregnant, the clock and the candelabrum are vulgar, and the father too expressive to be dignified. It is Balzacian genre, not unsympathetic to the people it represents. By comparison the Degas is obviously more inhibited, the aunt and Giovanna proudly respecting the proprieties of the middle class or minor aristocracy.[33] Giulia (or Julie) departs from their conventions as she twists on her chair, but can be forgiven because she is only seven (in 1858), and she retains considerable self-possession. The accessories in the work are con-

sistently modest and restrained, while the uncle is acceptably confined in his own limbo. Within a formal convention Degas has produced a group portrait that is also a genre painting showing the strains within a 'gentle' family in reduced circumstances in exile during the 1850s. The late Roy McMullen in his biography of Degas suggests that the *Bellelli family* is "a brilliantly concise kind of history painting",[34] for genre can in time become a form of history. This was undoubtedly part of its fascination when it was discovered in the first sale after Degas's death.

After *The Bellelli family*, 1860–65

The precise dating of Degas's work between 1860 and 1865 is anything but clear, but it does seem certain that, instead of bringing his portraits closer to genre, he retreated into the conventions of traditional portraiture, considering his sitters either individually or, upon occasion, in pairs. He had been attracted in the Louvre by a Venetian Renaissance painting, then given to Gentile Bellini and now to Cariani, and had made a reasonably faithful copy of it (illus.) for which there is a study in this exhibition (cat. 15, illus. p. 152). In this enigmatic canvas, two youths, one dark and one red-headed, are close to each other but do not acknowledge one another, their differing temperaments probably symbolized by the landscapes on either side. Degas realised that contemporary photographers were using a similar motive when in a notebook he inscribed a sketch of two young women, "Disdéri photog." – a reference to the photographer André Adolphe Disdéri, whose speciality was *cartes de visite*.[35] Whatever the source or motivation was, Degas compared Giovanna and Giulia Bellelli with each other (cat. 78, illus. p. 194) as he had thought of doing in 1858 (L65, private collection). He juxtaposed another pair of cousins in his painting of his sister Thérèse with her husband (cat. 73, illus. p. 185); she had married a first cousin of theirs, Edmondo Morbilli, son of their impoverished aunt Rosa (Degas) Morbilli, Duchess of Sant'Angelo a Frosolone. Degas had first planned a more informal portrait of the couple, with a fuller indication of the rooms in which he painted them, but he scraped off paint, particularly on her skirt, and did not finish it

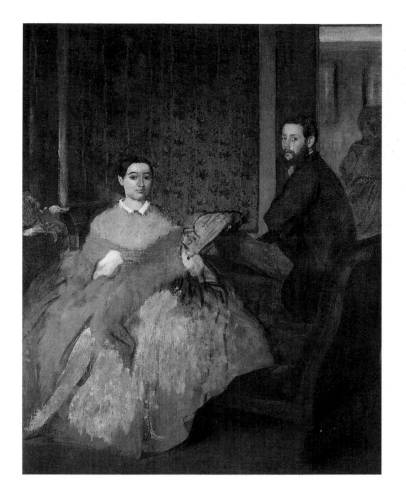

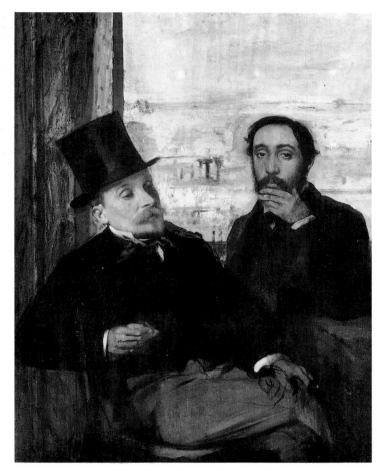

*M. and Mme Edmondo
Morbilli*
1863–64
Oil on canvas
117 × 89 cm
Washington D.C.,
National Gallery of Art,
Chester Dale Collection
(L131)

*Portrait of the artist with
Evariste de Valernes*
ca. 1865
Oil on canvas
116 × 89 cm
Paris, Musée d'Orsay
(L116)

(illus.), probably because Thérèse had lost the child with whom she had been so contentedly pregnant in the early stages of the work, as one can still see from her rounded face. Instead, Degas turned in his second painting of the couple to a more formal arrangement of them sitting side by side, Edmondo dominating in scale, but both dignified in their sense of loss. Degas even painted himself in a double portrait (illus.), in which he placed himself, with a frontality comparable to Edmondo Morbilli's, with his old painter friend from Carpentras, Evariste de Valernes; their background is Rome, which both had romanticised.

Degas never completely forgot the usefulness of the juxtaposition of one human being against another in making his portraits of both more revealing. And he was to employ it in 1870 at the end of the Franco-Prussian War in the unexpectedly exquisite small painting of the 'bellicose' Rabbi Astruc and the 'saintly' General Mellinet (cat. 108, illus. p.

214). Another pair of Italian cousins, Elena (born 1855) and Camilla (born 1857) Primicile Carafa, daughters of his Aunt Stefanina (Degas) Primicile Carafa, Marchioness of Cicerale and Duchess of Montejasi, inspired another double portrait (cat. 77, illus. p. 195), probably painted in the early 1870s, perhaps on a visit to Paris.

Into the mid-1860s the double or even family portrait seems to have provided the support that Degas's vulnerable sitters needed. Whether painted or drawn in isolation or with others, they appear to suffer from a vague melancholy and an absence of will, which arouses our sympathy and curiosity, but leaves them completely exposed. Mme Burtey (cat. 88–90, illus. pp. 230–31) illustrates this alienation from society exquisitely.

The Salon, the Morisot circle and Manet, 1865–72

It was some five years after Degas had settled back

into Paris after his return from Italy that he submitted a work to the Salon, in 1865. The first portraits he exhibited there were two "*portraits de famille*" in 1867; one was probably *Giovanna and Giulia Bellelli* (cat. 78, illus. p. 192); the other is uncertain. In 1868 he submitted a "*Portrait de Mlle E.F.* [Fiocre]*; à propos du ballet de la Source*" (illus. p. 51), arguably more genre than portraiture. In 1869 he showed "*Portrait de Mme G* . . . [Gaujelin]" (illus. p. 88) and in 1870 (his last appearance at the Salon) the pastel of Mme Gobillard (L214, New York, Metropolitan Museum) and *Mme Camus in red* (L271, Washington, National Gallery; illus. p. 90), although his other portrait of Mme Camus (cat. 101, illus. p. 213) was rejected. The activities around the submissions to the Salon and, indeed, around Degas's painting, pastel and drawings of Berthe Morisot's sister, Yves Gobillard (L213, 214 and two drawings, all in New York, Metropolitan Museum), are spiritedly chronicled in the correspondence of the Morisot family.[36] With a group of new friends, which included Puvis de Chavannes, Fantin-Latour, Fantin's future wife, Victoria Dubourg, Mme Lisle and Mme Loubens (of whom he made a double portrait, cat. 79, illus. p. 234), Degas and the Morisots met in each other's living-rooms for evenings that were sometimes musical and always devoted to gossip. It is not an exaggeration to say that this world, which mixed artists with government officials, had at its vortex the painter Edouard Manet and his wife Suzanne; his brother Eugène Manet (cat. 115, 125, illus. pp. 262, 263) would even marry Berthe Morisot.

We are not quite certain of the year in which Manet and Degas met, although we do know it was in the Louvre, where the older painter, Manet, expressed astonishment on finding Degas etching directly on a copper plate as he copied the *Infanta Marguerita* then given to Velázquez himself (cat. 61, illus. p. 157).[37] We can only regret that we do not know whether Degas marvelled at Manet's *Déjeuner sur l'herbe* in the Salon des Refusés of 1863 or his *Olympia* in the Salon of 1865, where it caused a sensation while Degas's *Medieval battle scene* ('*Scène de guerre en moyen-âge*'; L124, Paris, Orsay) was ignored. (Degas later owned a drawing for the *Olympia* and contributed to the acquisition of the painting in 1890 by the State through public subscription.) If the meeting of Degas and Manet did take place in 1861 or 1862, as has been believed, they do not seem to have become friends until later in the 1860s, probably after the sensation surrounding the older artist's exhibition of *Olympia* had subsided. Degas would have been uneasy with such notoriety. In fact the Manet-Morisot-Fantin-Puvis axis could only have taken form in the later 1860s. It was in 1867 that Fantin introduced Manet to Berthe Morisot and 1868 before Puvis met her.[38] Our first evidence that Degas and Manet knew each other comes in letters Manet wrote from Boulogne-sur-Mer in 1868. In the first, of 29 July, Manet asks Degas to accompany him to London and sends his regards to Fantin and the Naturalist authors Edmond Duranty and Emile Zola, some indication of a certain familiarity.[39] It now seems likely that Degas's portraits of Manet were drawn, etched and painted between 1867 and 1870.

In the 1860s when Degas painted an artist he usually removed his sitter from the act of painting itself: James Tissot was visiting another artist's studio when he debonairly threw his overcoat and top hat on a table (illus. p. 107); Gustave Moreau twists in a straight chair in an anonymous space, having dropped his top hat and gloves on the floor (illus. p. 142). We do assume some connection between the anonymous subject of the Brooklyn portrait of a man (cat. 85, illus. p. 250) and the paintings of meat in the background, the platter with sausages on a table behind him, and the large cut of beef for a roast on the floor at his feet – obviously a still-life painter – but it is the intense and awkward man who dominates his trade. In any case no physical evidence that he was a painter affects Manet's appearance in Degas's portraits of him. Instead he is the gentleman, the dandy, sometimes even the *flâneur* – very much the man of the world.

When Degas made drawings of Manet seated (cat. 62, illus. p. 254), intended presumably as studies for etchings, and then the etchings themselves (cat. 63–67, illus. p. 255–57), he had no need to provide any setting apart from the slender chair on which Manet sits. Manet carries his background with him in his independence, his restless, impatient energy and in the vagueness in his eyes, which hints

*M. and Mme Edouard
Manet*
ca. 1868–69
Oil on canvas
65 × 71 cm
Kitakyushu, Municipal
Museum of Art (L127)

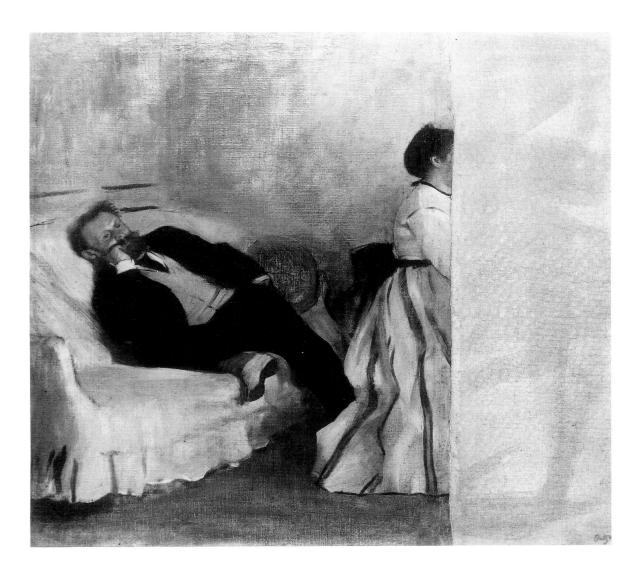

at a preoccupation with a space beyond the one he occupies. In the second set of etchings (with the artist turned towards the right, cat. 65–67, illus. pp. 256, 257), if not in the related drawing, Manet is given a background of the backs of large stretched canvases, arranged to form an impersonal screen. When Degas drew Manet at the races (cat. 83, 84, illus. p. 258), however, he showed him standing, even more cockily self-assured, with an impertinent thumb jutting out of the pocket his left hand otherwise occupies. He clearly looks beyond himself – at a very faintly drawn woman with a lorgnette, which Degas developed as an independent figure in one drawing and three small paintings and also introduced (and later painted over) in a race-track scene.[40] More than any other of Degas's sitters of

the 1860s, Manet maintains, in spite of his casual positions, a superb equilibrium, a balance as sure as a dancer's.

During this process Degas painted a natty Manet with light vest and spats, informally sprawled on a comfortable white sofa, restless as he listens to his wife playing the piano (illus.). Manet's impatience cannot be forgotten as we look at the painting, from which Manet cut off the profile of his wife and the piano that had offended him. Offended in his turn, Degas demanded that the painting be returned and eventually about 1895 had another piece of canvas added; but in the end he seems to have become reconciled to Manet's editing. A photograph exists of the truncated painting in Degas's apartment, ironically hanging beside Manet's *Ham*.[41] In the

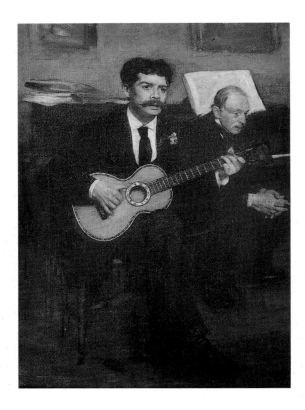

*Lorenzo Pagans and Auguste
De Gas*
ca. 1871–82
Oil on canvas
54 × 40 cm
Paris, Musée d'Orsay
(L256)

portrait as we know it, there is so little information about the room that we concentrate upon the husband and wife. Although Manet's body is at a diagonal, apparently strongly opposing his wife's, their clothes do touch and the composition seems to be without stress. Manet even appears to listen as he props up his head with his right hand, while the other finds its accustomed pocket. The gentle light of the almost unfurnished corner of the room focusses romantically on his head, giving him the sexual allure that so attracted women like Berthe Morisot. It is a small painting, and unpretentious, but a superbly simple representation of both Manet and the world he inhabited, in other words both portraiture and genre.

There are a few other precious paintings that record these evenings in the Manet-Morisot circle. One is a small canvas from Detroit (cat. 111, illus. p. 284), usually classified as genre because the sitters have not been identified. There is reason, however, to think that the young woman is Degas's younger sister, Marguerite Fevre, who was remembered by her friends and family as a musician.[42] The violinist, however, is still unexplained. Another is a painting

(illus.) that Degas particularly prized and kept in his bedroom, a portrait of his aging father Auguste De Gas listening to their friend, the tenor and guitarist Lorenzo Pagans, who often sung at their gatherings. Here the passion for music gives their painting greater warmth than the portrait of the Manets or the Detroit painting, exquisite as both are.

The interior: "mon tableau de genre", 1867–68

About the same time that Degas presumably painted the portrait of the Manets he produced his most theatrical genre composition, *Interior* (illus.), which has been known as *The rape* and which we are told Degas called "mon tableau de genre".[43] Although it presents a man and a woman in an interior – and Degas much later, when he wanted to sell it, jokingly said he would provide a wedding certificate to make it more acceptable – it is the antithesis of the painting of the Manets. Instead of detached and good-humoured observation, here we have an emotionally charged work in which there is a clear hostility between the man and the woman. As Susan Sidlauskas in her perceptive article on this painting describes, they are placed as if they are "stranded on either side of an abyss".[44] Instead of a minimal, tenderly lit corner, we have a meaningfully furnished room, with the evocative lights and shadows and the various objects[45] – from the opened sewing-box to the discarded corset – declaring that this is a scene of frustrated passions. It is an effectively provocative work, genuinely mysterious, that has invited many different solutions over the years.

Many sources have been suggested for the subject matter of *Interior*; the most generally accepted has been Reff's that it is a scene from Zola's *Thérèse Raquin* in which the newly wed couple return to their room to find themselves haunted by the ghost of the corpse of the woman's husband, whom together they have murdered.[46] *Thérèse Raquin* was published in 1867. Degas used a piece of paper printed with the date of 25 December 1867 in making what we presume to be the first drawing for the composition.[47] We know from Manet's letter to Degas of 1868, asking him to pass on his regards to Zola, Manet's great defender, that Zola's and Degas's paths had already crossed. In spite of the

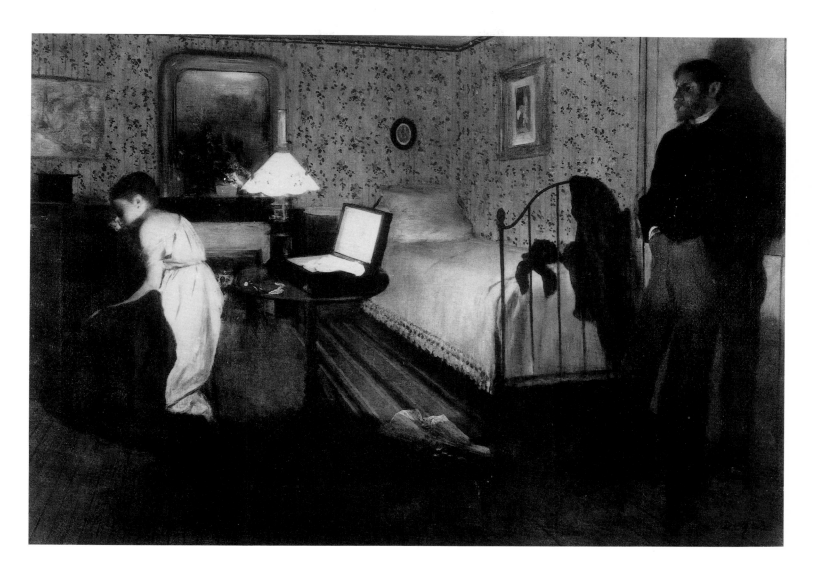

*Dans *Thérèse Raquin*, j'ai voulu étudier des tempéraments et non des caractères. Là est le livre entier. J'ai choisi des personnages souverainement dominés par leurs nerfs et leur sang, dépourvus de libre arbitre, entraînés à chaque acte de leur vie par les fatalités de leur chair. Thérèse et Laurent sont des brutes humaines, rien de plus.

nicety of these chronological correspondences, doubts have now been expressed, in particular by Armstrong and Sidlauskas,[48] about Zola's novel as the source, and indeed about Zola or about any novel as the foundation for Degas's genre painting.

One problem is that there are too many discrepancies, carefully documented by Reff himself, between the painting and Zola's description of the return of Thérèse and Laurent to his mother's house after their wedding.[49] Even more significant is that Zola's justification of his novel in the preface to its second edition in 1868 would have been unsympathetic to Degas. Zola wrote:

In *Thérèse Raquin*, my aim has been to study temperaments and not characters. That is the whole point of the book. I have chosen people completely dominated by

Interior (The rape)
ca. 1868–69
Oil on canvas
81 × 116 cm
Philadelphia Museum of Art (L348)

their nerves and blood, without free will, drawn into each section of their lives by the inexorable laws of their physical nature. Thérèse and Laurent are human animals, nothing more.*[50]

While it might seem that Degas had been ready to follow the writer's justification (rather than example) in using details as intimate as the corset or as overtly dramatic as the man's shadow on the door, overwhelming and belittling him while alarming us, the two characters in *The interior* are more complex than mere animals. The man is both assured and afraid, the woman submissive but still tenderly desirable. In both there is a moral sense – his defiance, her shame – and a conception of will – both have a sense of individual guilt but also a sense of self that creates the chasm between them. They are much more difficult to know and to explain than Zola's Thérèse and Laurent.

But the third reason advanced by both Armstrong and Sidlauskas for rejecting *Thérèse Raquin* as the source – and perhaps the most convincing – is that *The interior* is not, as a novel is, a narrative work. We could speculate but would probably not agree about the past the woman and the man might have shared. We are even uncertain about what has just happened to explain their positions now. And we do not have an inkling about the future. As Sidlauskas puts it, "*Interior* is singular in its period for simultaneously inviting and deflecting the expectation that a narrative solution is forthcoming. In terms of the kind of reception it inspires, the painting could be said to be 'anti-narrative', for the work does not simply depart from narrative expectations, it defies them. In *Interior*, Degas repeatedly referred to the strategies he refused. Out of this oppositional mode he produced a new series of subversive, yet systematic, conventions which acted to suppress anecdote, intensify ambiguity, and stimulate response."[51] And yet *Interior*, with the same mysterious compulsion, seems like an introduction to characters when the curtains are drawn on the stage. We are attracted partly because the outcome is unknown.

Invalids, 1870–74

In painting the infinitely mysterious *Interior* Degas may have developed a sense of compassion for the young woman that he carried over into a small group of works showing women in discomfort or pain. None is dated, not even by some remote external evidence, but they have usually been considered to be from the period of the visit Degas was to make to New Orleans in the winter of 1872–73. One reason for this may have been the realisation that by 1865 both Degas's sisters had married and left home and that he either lived alone or shared a bachelor apartment with his father and visiting brothers (two) and unmarried uncles (four). On the other hand, in New Orleans, he was to live in a house with his uncle and three daughters, two of them married with husbands and children; there were more opportunities to see the physical frailty of women strained by childbirth, child rearing and the fears of infidelity. It should be pointed out that, in addition to the experience in New Orleans, he did go to his sister Marguerite's house in Paris. There he made, for example, a drawing of one of her eventual seven children, Célestine Fevre, which he inscribed, "Ecoutant l'histoire de la bonne Mimi dans son bain/24 dec. 67".[52] Ironically this innocent study was drawn the day before the date on the paper on which Degas made his first study for *Interior*. And he did, of course, have models pose for him, usually at this time for his studies of the dance; and he encouraged them to behave naturally in his studio.

Of these genre paintings of invalids or nurses the most expressive in colour is the work called *Reflection* by the Phillips Gallery in Washington and '*La mélancolie*' in Lemoisne's catalogue raisonné of Degas's work (cat. 92, illus. p. 242); it is painted in reds as romantically evocative as those Degas used in *Mme Camus in red* (L271, Washington, National Gallery). The position of the young woman with her body twisted on a chaise, her fragile shoulders hunched, her arms crossed under her stomach, is neither reflective nor a meditative melancholy but a protection against intense (and presumably periodic) pain. Her body seems frail in relation to her magnificent head, emphasized by the white V of her collar. Contained within the oval cranium with its long, sloping nose and exploratory chin are the strong and sensitively mobile features of an actress – the expressive brows, the subtle eyes, the sensually opened mouth. Anonymous (and probably never a

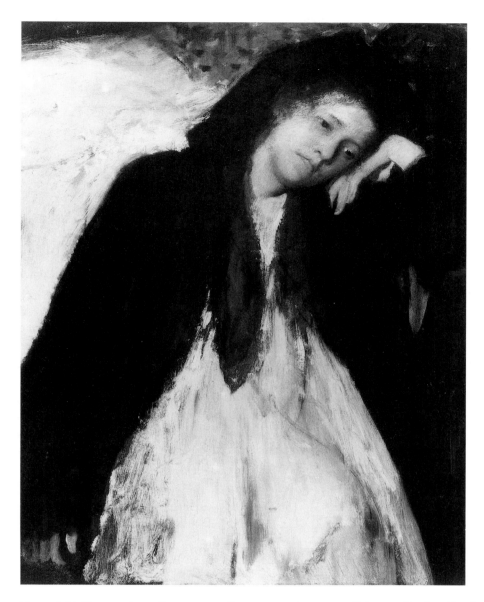

'*La malade*' ('*La convalescente*'), 1872–73, oil on canvas, 65 × 47 cm, Private collection (L316)

* ... faire des portraits des
gens dans des attitudes
familières et typiques ...
surtout donner à leur figure
les mêmes choix
d'expression qu'on donne à
leur corps.

portrait), she is still an individual woman, vulnerable and exposed.

In a *carnet* with notes made between 1869 and 1872 Degas wrote, "make portraits of people in typical, familiar poses, being sure above all to give their faces the same kind of expression as their bodies".*[53] In the process of becoming arguably the supreme painter of the human body in motion – at least of the hardships of learning the dance as a craft rather than of the liberation Matisse's dancers would enjoy – Degas had been less comfortable with his own command of the expressive possibilities of the head. In the painting that is known as '*La malade*' (illus.), under the bravura of Degas's handling of paint, the woman's body, including the hand on which her head is propped, is as limp as a rag doll's, drained by illness and fever. The face – pale, dim and, in spite of the dark eyes, almost inert – does follow his own advice to give the same expression to the head as to the body. The distinctions between features are blurred, the eyebrows tentative, the mouth opened so that the teeth are revealed. Looking back at Degas's watercolour of the three Musson women at Bourg-en-Bresse in 1865 (cat. 80, illus. p. 200) it is hard (but not impossible) to believe that Désirée Musson, who stands to the right of the early watercolour, could with illness some five or six years later become this figure who invites our compassion. The cataloguer of Degas's paintings, P.A. Lemoisne, sees this New Orleans cousin as the possible model for two more of these paintings devoted to illness.

One can agree more definitely with Lemoisne that in New Orleans Degas might have painted Désirée with a bandage under her chin, reclining sleepily on a garden chaise, in *Woman seated in a garden* (L315, private collection). There are three others with bandages around their heads (for toothache, earache or to protect the eyes? – the reasons vary). Improbable as Désirée seems as a model for the *Washerwoman with toothache* (L278, Paris, Orsay), she could have posed as the maiden aunt waiting through the night in '*La garde malade*' (L314, private collection), with her invitingly soft bed in the foreground of the painting. Less probably Désirée is the subject of the tiny, sunlit canvas, *Woman with a bandage* (L275, Detroit, Institute of Arts), of the profile

of the rather jaunty young woman with both a glass and cup behind her. Alternatively this could be the painter's sister, Marguerite De Gas Fevre.[54] There is another red-eyed young woman holding a handkerchief to her mouth (cat. 123, illus. p. 243); we do not know whether she was ill or merely sad. The range in discomfort and in Degas's sympathy for these women, if only on this domestic scale, can be described as generic but also seems to describe particular women, even if we do not know their names.

Portraits dans un bureau (Nouvelle-Orléans), 1873

Among the works by Degas in which it is difficult to separate portraiture from genre, *The cotton office* ('*Portraits dans un bureau (Nouvelle-Orléans)*'; cat. 114, illus. pp. 202–05), painted and dated in New Orleans in 1873, is the composition in which these two approaches seem most inextricably joined.[55] Degas also, uncharacteristically, recorded his conviction of the importance of the work to him. He wrote from New Orleans to James Tissot in London describing the painting as he was working on it.[56] He showed it in the second Impressionist exhibition in 1876 as "*Portraits dans un bureau (Nouvelle-Orléans)*" and he called it familiarly his "*coton*" when he was attempting to sell it as a solution to the financial disaster that faced his family after his father's death in 1874.[57] Cynically he may have played with the other meanings of *coton* in French which could apply to his life in the 1870s – 'difficult' (which '*c'est mon coton*' would suggest) or 'with his business affairs compromised' (*filer un mauvais coton*). Even some of the figures in the painting – his two brothers and his uncle – were not uninvolved in his own embarrassments. On the other hand he was genuinely pleased and honoured, as he wrote both to the mayor of Pau and to the curator of the museum in Pau when in 1878 the museum bought his "*coton*",[58] paying 2000 francs, five per cent of the sum he and his brother-in-law Henri Fevre, and possibly Achille De Gas,[59] had assumed to cover his father's debts to the Banque d'Anvers. At the end of 1899 he wrote begging a close friend, Paul Lafond, who had just been named curator of the Pau museum, not to lend the "*Cotonniers*" to the art exhibition at the Exposition Universelle in Paris

*De Gas Brothers sont considérés ici et je suis assez flatté de le voir. Ils feront une bonne fortune.

in 1900.[60] (It was nevertheless sent.)

This painting must have been so important to Degas because it is the most resolved of the works he produced during this one expedition to New Orleans (he was the only European Impressionist to touch the North American continent). His visit of five months was made in order to see the city where his American mother had been born, to pay his respects to her brother Michel Musson (who sits in the foreground of the painting), to meet other members of the New Orleans family beyond the four who had spent two years at Bourg-en-Bresse from 1863 to 1865 – Mme Michel Musson (now dead), Estelle Musson Balfour, her daughter by Joe Balfour (now married to René De Gas), and Désirée Musson (see cat. 80, illus. p. 200) – and, above all, to see how his two younger brothers René and Achille were doing in business there. As he wrote to his friend Henri Rouart on 5 December 1872, " 'De Gas Brothers' are respected here and I am quite tickled to see it. They will make their fortune."*[61] In fact the younger brother René, who had married their blind cousin Estelle Musson Balfour despite the objections of his uncle Michel Musson, had already borrowed more from his father's firm in Paris than he was ever able to repay.[62] Although Marilyn Brown has proved through photographs and architectural reconstructions that the painting is set in the office of Musson, Prestidge and Co.,[63] the two brothers are obviously visitors in their uncle's firm. Unconsciously the painter could not have found it reassuring to paint René reading the daily newspaper and their brother Achille at the left leaning idly against the partition into the next room. Achille was to return to Paris with Degas and in 1875 would shoot (but not kill) the husband of his former mistress in front of the Bourse, receiving a prison sentence which was finally reduced to one month.[64] In 1878, the year in which Degas would sell his "*coton*", René would desert his blind wife and five children in New Orleans and elope with a neighbour, both of them marrying bigamously in Cleveland, Ohio.[65] Later they would receive an official divorce in New York, legalising their position, and move to France. Even as Degas was working on the painting in 1873, Michel Musson announced in the New Orleans newspaper, the *Daily Picayune*, of 1 Febru-

ary that his firm, Musson, Livaudois and Prestidge, Cotton Factors and Commission Merchants, founded in 1870, had been dissolved.[66]

The *Portraits dans un bureau* also represented something else to Degas. In one sense it was a confident moment, in which he was probably successfully suppressing his suspicions that his father's business was over-extended, that his brothers would never make a fortune in business, that his late, rich Neapolitan grandfather Hilaire Degas had been right in believing New Orleans to be a financial quicksand,[67] and even that René was probably incapable of sustaining the marital responsibilities he had assumed. Edgar was perhaps particularly reluctant to see this in René since the painter had been the one member of the family to encourage him to move to New Orleans and in 1869 to marry their cousin, Estelle Musson, about whom he wrote to his friend the bassoonist Désiré Dihau, "My poor Estelle, René's wife, is blind as you know. She bears it in an incomparable manner; she needs scarcely any help about the house."*[68]

In addition to Joe Balfour, the daughter of Estelle's first marriage, René and Estelle had two children when Degas was visiting them and were expecting a third, Jeanne, for whom the painter was to be the godfather. But more than as a man achieving a relative serenity by avoiding or suppressing the truth of his family's problems, Degas as an artist was positively happy at a critical moment in his career. As he wrote to Tissot, "Mais je suis d'une vanité d'américain" – But my vanity is positively American.[69] He had exhibited at the Salon between 1865 and 1870 with modest but increasing success. He was finding a few discriminating collectors who were beginning to buy his work; among them were the Opéra tenor Jean-Baptiste Faure, his own friend Henri Rouart, another artist, Edouard Brandon, and the collector Gustave Mühlbacher.[70] He had prepared himself psychologically to break with the Salon and to join new friends – Monet, Renoir, Morisot, Cézanne and, initially he hoped, Manet – to form a group in the following December that would sponsor what has become known as the first Impressionist exhibition in the spring of 1874. Degas was confident at least about the direction in which his work was moving.

In undertaking *Portraits dans un bureau*, Edgar Degas was attempting a *tour de force*. He was to paint a portrait of fourteen figures in this all-male establishment.[71] Even the boy in the background, behind the small man with the light coat, black bow-tie and tilted hat, or the white-sleeved youth bending over to their right, has his own individuality, as does the pale clerk watching the moustached accountant (actually Musson's partner John Livaudais) at work at the right, or the two hatted figures at the left behind the partition. The individuality is a matter of distinctive features, personal dress, bodies moving, standing or sitting in different fashions, and the fact that each occupies his own discrete space – not lined up like *The Bellelli family*. In fact, although they are involved in what must be, at least to some degree, a social activity, there is surprisingly little social interaction. Michel Musson in the foreground concentrates on the cotton he is feeling with his fingers, looking over his spectacles as the painter had described him doing when he met the train that brought René and Edgar from New York to New Orleans. Achille is the typical *flâneur* transplanted to an office in New Orleans. René reads the newspaper, somewhat prophetically because eventually he will return to Paris and work for one. Only William Bell, the husband of their cousin Mathilde Musson, seems slightly aggressive as he holds out cotton to the bearded man across the table. Michel Musson's English partner, James Prestidge, perches behind René on a high stool, his hat not on his head but propped on his knee as he communes quietly with the bearded man with a notebook beside him. Each is believable. There is no conflict. But each has the potential of playing a rôle, as if he were on the stage or in a film. In this respect it resembles the *Interior*. It is curious that for this work, by contrast to the almost contemporary and equally complex ballet classes or rehearsals, so few preparatory studies are known.[72]

Certain historians and critics in our time have raised questions about the legitimacy of *Portraits dans un bureau* as a record of a social activity. Carol Armstrong points to the fundamental alienation of all the members of the De Gas and Musson families from the abstractions of commerce and money: as she writes, "throughout the image, commercial

*Tout le monde est gai, tout le monde travaille ; et ces gens n'ont pas non plus la servilité du marchand en boutique ... C'est une société ravissante.

*Sur la boulangerie, *le Pain* – Série sur les mitrons, vus dans la cave même, ou à travers les soupiraux de la rue – Dos couleur de farine rose – belles courbes de pâte – Natures mortes sur les différents pains, gros, ovales, flutes, ronds etc. – Essais en couleur sur les jaunes, roses, gris, blancs des pains. Perspectives des rangées de pains, distributions ravissantes de boulangeries. Gateaux – le blè – les moulins – la farine, les sacs – les forts de la Halle.

*J'ai pris ici le goût de l'argent, et une fois de retour j'en saurai gagner, je vous le jure.

*Il dessine ses tableaux comme ses *Portraits dans un bureau (Nouvelles-Orléans)*, qui se situent entre une marine et une gravure dans un journal illustré.

*Le malheur est qu'il gâte tout par ses embellissements. Ses meilleures choses sont des esquisses.

*J'en prepare un autre moins compliqué et plus imprévu, d'un meilleur art, ou les gens sont en costume d'été, murs blancs, mer de coton sur tables.

work is turned into a kind of private, domestic labor: writing, reading, doing accounts, the close work of inspection and scrutinization – which, in the figure of Père Musson, becomes something like the activities of handicraft and connoisseurship."[73] She recognises that these were the interests of the artist who, of course, worked with his hands and respected the work of others – dancers, singers, musicians, laundresses, milliners – whose work demanded physical skill, and was based, as Armstrong points out, on repetition. After all, Degas told Daniel Halévy that he had a particular admiration for the craftsmen of the Marais: "Everybody is lively; everybody is working. And these people have none of the servility of a merchant in his shop. Their society is delightful."*[74] We do not know what Degas thought of his great-grandfather and his other forebears (who were bakers),[75] or even if he knew about them, but it does seem relevant that in a notebook used between 1877 and 1883 he proposed as subjects: "On bakery, *Bread* – Series on baker's boys, seen in the cellar itself, or through the basement windows from the street – backs the colour of pink flour – beautiful curves of dough – still lifes of different breads, large, oval, long, round, etc. Studies in colour of the yellows, pinks, greys, whites of bread. Perspectives of rows of bread, delightful arrangements of bakeries – cakes – the corn – the mills – the flour, the bags, the strong men of the market."*[76] Although he seems never to have carried out this project, it is clear that he identified with the baker as he did with his uncle Michel Musson (whose forebears may have been clockmakers),[77] seen testing the cotton with his fingers, like a connoisseur, as Armstrong describes it.[78] It is only too probable that, with the exception of his paternal grandfather, Hilaire Degas, the members of the Musson and De Gas families were too much attracted by concrete things to have been successful capitalists.

What makes *Portraits dans un bureau* genre? It is a scene from contemporary life and anecdotal rather than tragic. Just as the figures are convincingly dressed and assume the most natural and informal of poses, the room provides an appropriate shell for their activities. Its orange floor, pale green walls and great height suggest a cool oasis in a tropical place.

The sashes of the windows in the partitions are at different heights, providing a believable informality. This is increased by the small window that projects in the upper left corner. Although Degas only painted two still lifes to our knowledge (L9 and L58, whereabouts unknown), he was a master of painting inanimate objects to build up the character of a room – the sea of cotton on the table, the rolls of it piled up casually on the shelves in the background, the untidy parcel of it on the chair beside M. Musson, and the crease and fold in René's newspaper, the *Daily Picayune*. The ledgers and papers are convincing on the table at the right, although not as animated as those in the wastepaper basket at the accountant's feet (illus. p. 205). This indeed is genre – a banal scene from ordinary life, not remarkable in itself in the period but refreshing in its freedom from sentiment, cant, and particularly the flirtatiousness of so many contemporary genre works. It is also a masterpiece. In 1920 Meier-Graefe would write of it, "The prose of an office scene is concentrated into rhymeless lyrics, in which hats and sleeves, the crackling of linen, and every conceivable form of motion – in a word everything portrayed – becomes the bearer of a new rhythm."[79]

In arriving at this fusion of portraiture and genre, Degas was not without models – including the work of such friends as Alfred Stevens, James Tissot, James Whistler and Henri Fantin-Latour. One incentive for it may have been the hope of his works being sold or published in England. When writing to James Tissot, with whom he was franker about financial matters than with his other friends, Degas indicated he was preoccupied with money, even before his father's death in 1874. On 30 September 1871 he wrote to Tissot, "Give me some idea how I too could gain some profit from England."[80] By 19 November 1872, writing from New Orleans, he promised, "Here I have acquired the taste for money, and once back, I shall know how to earn some I promise you."*[81] As Ronald Pickvance demonstrated in 1963 this awareness of a need for money was combined with a hope that Agnew in London might become his dealer and with an interest in the English illustrated press.[82] After he returned to Paris Degas told Tissot that in New Orleans he had seen an illustration of Tissot's

in an English paper[83] – *The Thames* in the *Graphic* of 8 February 1873. This, to Degas, seemed an appropriate market for his own talents.

The completed, and now famous, version of *Portraits dans un bureau (Nouvelle-Orléans)* was certainly designed with the tastes of the English for narrative painting in mind. In the well known letter Degas wrote about this painting to Tissot on 18 February 1873, he emphasized its intricacy by counting its figures, "*une quinzaine*" (about fifteen). Pickvance also points out that there is evidence that somewhat later Degas actually submitted the equally complex composition of one of his three ballet rehearsal pictures ('*Répétitions d'un ballet sur la scène*'; L340, Paris, Orsay; L400 and L499, both New York, Metropolitan Museum) to the *Illustrated London News*. A future owner of one of the versions (L400), the English painter Walter Sickert, in 1932 confirmed George Moore's story that it was rejected because the paper felt it might offend the sensibilities of the families of clergymen who were prominent among its subscribers.[84] It may have been rejected also because, as Armstrong and Brown argue,[85] Degas was reluctant to develop a story or a moral in his work.

Attracted as Degas was by the English market, he was beginning to have doubts about narrative paintings, doubts which may have been based on the realisation of his own deficiencies. To the Danish painter Lorentz Frölich, who was also a friend of Manet, Degas wrote from New Orleans about the choices he faced working in New Orleans, this time referring to a French illustrated paper, "It is not good to do Parisian art and Louisiana art indiscriminately, it is liable to turn into the *Monde Illustré*."[86] But it was to Tissot that he poured out the depth of his unease and his growing realisation that another approach to art was more appropriate for a French artist of his generation who was also a friend of Manet and Edmond Duranty and an acquaintance of Zola.

Relevant to the predicament he faced in New Orleans that winter is the fact that Zola, when Degas exhibited the *Portraits dans un bureau* in the second Impressionist exhibition in 1876, wrote of it in a review for a Russian newspaper: "He designs his pictures, like his *Portraits dans un bureau*

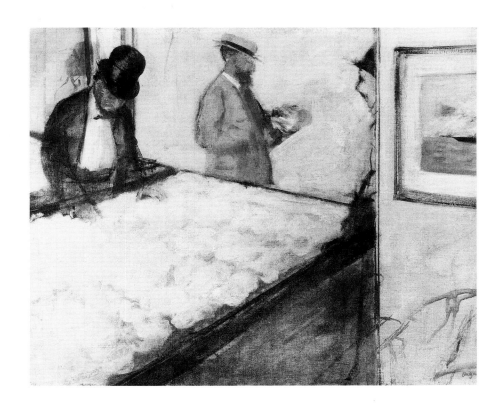

(Nouvelle-Orléans), as if they were something between a seascape and an engraving for an illustrated newspaper".*[87]

Zola scented the attractions that the *Graphic*, the *Illustrated London News* and possibly even *Le Monde Illustré* held for Degas, but ambivalently also realised the seductions of a freer painting style, "a seascape". In criticizing Degas with regard to this work, Zola wrote: "Unfortunately he spoils everything with his embellishments. His best things are his sketches".*[88]

Degas was perhaps fortunately unaware in New Orleans of what Zola would write some three years later. Nevertheless, in the letter of 18 February 1873 to Tissot, Degas did describe another painting on the same subject, treated differently: "I am preparing another less complicated and more spontaneous, it's better art, where the people are in summer dress, white walls, a sea of cotton on the tables."*[88] This is the *Cotton traders at New Orleans* ('*Marchands de coton à la Nouvelle Orléans*'; illus.) Later in the letter to Tissot Degas went on:

Remember the art of Le Nain and all medieval France. Our nation has something simple and bold to offer. The naturalist movement will draw in a manner worthy of the

Cotton traders at New Orleans
1873
Oil on canvas
60 × 73 cm
Cambridge (Mass.), Fogg Art Museum (L321)

*Rappelez-vous l'art des Lenain et tout le moyen âge français. Notre race donnera quelque chose de simple et d'hardi. – Le mouvement naturaliste dessinera comme les grandes écoles, et on reconnaîtra alors sa force. – Il y a bien souvent comme l'exploitation d'un truc dans cet art anglais qui nous plait tant. – On peut mieux faire qu'eux et aussi fermement.

great schools and then its strength will be recognised. This English art that appeals so much to us often seems to be exploiting some trick. We can do better than them and be just as strong.*

The *Cotton traders* was probably never finished and may not perfectly epitomize the direction in which Degas decided in New Orleans to move – but it does represent his desire for greater simplicity and spontaneity. The room in the earlier picture has been limited here to one marine print and the table of cotton, and the sitters reduced from fourteen to three men (with the possibility of the shadow of another behind the top-hatted gentleman). The three figures are sketched with a greater brevity even than paintings by Daumier. Although the top-hatted man has been identified as Degas's uncle Michel Musson, the features have almost been erased by the strokes of paint across his face. Another of Degas's paintings in New Orleans was handled with a similar economy, *Courtyard of a house, New Orleans* (L309, Ordrupgaard). When he exhibited it in the same Impressionist exhibition in which he exhibited *Portraits dans un bureau* – the second of 1876 – Degas added "*esquisse*" to the title. Like the *Cotton traders*, this painting appears tentative and unrealised, but consequently very appealing to us at the end of the twentieth century. It is, however, more monochromatic and more traditional in its spatial organization than the *Cotton traders*. The *Cotton traders* may also be an *esquisse* but there is a more positive pleasure in hues like the yellow of the straw hat and the blue behind the top hat and in the print's sky. The space is unconventionally flattened, like a Japanese print – as has often been observed. The word "seascape" which Zola would apply to the more finished version is certainly appropriate to this, partly because of the print on the wall but above all because of what Degas himself described as a "*mer de coton*".[89] There is so little suggestion either of portraiture or of genre that we can welcome Zola's classification.

One figure who looms in the background of Degas's visit to New Orleans is Manet. Their friendship was never untroubled, as the incident of Manet's vandalising Degas's portrait of M. and Mme Manet attests. Manet could be cruel about Degas, for instance when in 1869 he told Berthe Morisot, "As for your friend Degas, I certainly do not find his personality attractive; he has wit, but nothing more. He lacks spontaneity, he isn't capable of loving a woman, much less of telling her that he does or of doing anything about it."*[90] Degas could be angry with Manet as he was when, after his return from New Orleans, he wrote to Tissot: "I believe him, definitely, to be much more vain than intelligent".*[91] Although Degas admired and collected the other artist's work, attempting himself, for example, to find and reunite the parts of Manet's *Execution of Emperor Maximilien*, he could be ambivalent, as when he wrote to his friend Henri Rouart about Manet's *Bar at the Folies-Bergère* in the Salon of 1881, "foolish and fine, a playing card without depth, Spanish illusions, a painter".*[92] But in New Orleans Degas missed Manet, sent him his regards, complained that they did not write to each other, and believed, as he wrote to Henri Rouart, "Manet would see lovely things here – more than me".[93] Among those things would have been the "black world" about which Degas wrote to Tissot:

The black world, I have not the time to explore it; there are some real treasures as regards drawing and colour in these forests of ebony. I shall be very surprised to live among white people only in Paris. And then I love silhouettes so much and these silhouettes walk.[94]

It is not difficult to believe that Degas would have imagined Manet painting this world ravishingly. Degas was at a point when he was ready to follow Manet into a freer and more sensual style and yet, when he returned to Paris, although this influence did not cease, their paths essentially separated, Manet refusing to exhibit with the Impressionists and remaining with the Salon.

NOTES

1 My colleagues, co-organizers and co-authors of the catalogue of the retrospective exhibition *Degas* held in Paris, Ottawa and New York in 1988–89 (abbreviated here as 1988–89 Paris/Ottawa/New York), namely Henri Loyrette, Michael Pantazzi and Gary Tinterow, have contributed much to the work I have done on Degas since that time, including this essay. Because the 1988–89 catalogue is indexed, as is Loyrette's subsequent indispensable biography of Degas (Loyrette 1991), I am assuming it to be understood that I have used both as sources throughout, and have consequently made specific references to one or other only when there is a matter of disagreement or for a particularly significant contribution that might otherwise be missed.

2 The first sale of the collection was at Galeries Georges Petit, the second (prints) and third at Drouot, 6–7 and 15–16 November 1918. For the first four sales of his work, beginning 8 May 1918, see Abbreviations in the Bibliography. A fifth sale of his prints was held at Galerie Mansi-Joyant, 22–23 November 1918.

3 C.J. Holmes, *Self and Partners (Mostly Self)*, London 1916, pp. 335–41.

4 1931 Paris, p. 15.

5 In addition to the three mentioned they are L126, L128, L145, L207, L274, L366, L442, L992 and L1418.

6 Jamot 1918, p. 128.

7 Lemoisne I, p. 1.

8 Lemoisne I, p. 30.

9 On Mme Dietz-Monnin see Richard R. Brettell in 1984 Chicago, nos. 47 and 48, pp. 105–10. His information is based on "written communication" (p. 107) from family members.

10 *Lettres* 1945, XXVIII [no date], pp. 56–57.

11 Loyrette 1991, p. 217, believes that the Dihau portraits were commissioned. On the other hand Lemoisne writes of L186 that Degas "donne le tableau à Désiré Dihau".

12 The provenances of the Neapolitan pictures are not perfectly clear. Two – the portraits of René-Hilaire Degas (cat. 20) and of Henri and Lucie Degas (cat. 127) – come from the collection of the painter's cousin Lucie Degas Guerrero de Balde, who died in 1909, through her eldest daughter Anna, Signora Marco Bozzi; the first was bought directly from the family in 1932, the second by Wildenstein in 1926. Two others were sold through Vincent Imberti, Bordeaux: the portrait of Elena Primicile Carafa (cat. 120), bought in 1926 by the Courtauld Trust from the French Gallery, London, which had bought it from Paul Rosenberg who had bought it from Imberti; and the painting of Stefanina (Degas) Primicile Carafa, Marchioness of Cicerale and Duchess of Montejasi, with her daughters Elena and Camilla (cat. 128), bought by David-Weill in 1923. Two others of the duchess (cat. 97, 98) were bought by Wildenstein by 1949 "from the Italian family in Naples".

13 The artists who owned portraits of themselves (or of members of their families) by Degas were: Léon Bonnat (L111, Bayonne), who also owned a portrait of his brother-in-law, Albert Mélida (L112, Bayonne); Bellet du Poisat (cat. 70); Gustave Moreau (L178, Musée Moreau); Ludovic Lepic (cat. 110) and (L368, *Place de la Concorde*, currently held in a Russian Museum); Giuseppe De Nittis of his wife (L302, Portland Oregon); Eugène Manet, brother of Manet and husband of Berthe Morisot (cat. 125); Alfred Niaudet (L439, Richmond (Va.), Virginia Museum); J.-E. Blanche (L824, *Six friends at Dieppe*, Providence, R.I., which includes Blanche); and Zacharie Zacharian (L831, private collection).

14 Neither Manet nor Cassatt liked their portraits, which were the result of courtesy exchanges between artists rather than outright gifts. Manet cut off his wife's profile and piano and Degas demanded the return of the canvas, sending back the other artist's "plums"; Cassatt sold hers (cat. 168), as soon as she decently could, to Vollard in April 1913.

15 *Degas, vingt dessins, 1867–96*, Goupil & Co. and Boussod, Manzi, Joyant & Co., Paris 1896–98.

16 1924 Paris, no. 27.

17 *Ibid.*, no. 35: "Ils [i.e. Mellinet and Astruc] avaient demandé à Degas de les peindre ensemble."

18 Henri Loyrette, in 1988–89 Paris/Ottawa/New York, no. 20, and in Loyrette 1991, pp. 207–08, states his conviction that *The Bellelli family* was exhibited as one of Degas's two submissions, both called "portrait de famille", in the Salon of 1867; but no mention of it in any review has been found. This explains the excitement the discovery of the painting engendered after the artist's death.

19 See Reff 1976. Degas's first nineteen notebooks take us from 1853 through this period.

20 Reff 18, BN 1, 1859–1864, beautifully reproduced, much of it in colour, with a commentary by Reff, in 1984–85 Paris, pp. 219–372.

21 A convenient and attractive summary of scholarship, with the relevant illustrations, is in 1983 Copenhagen.

22 Her father was more permissive than has been assumed in recent criticism. See Raimondi 1958 and Boggs 1963, pp. 273–74.

23 New material is to be found in Raimondi 1958 (the author was a lawyer married to a niece of Edmondo Morbilli); Reff 1969, pp. 281–86; and in "unpublished letters" in Loyrette 1991 between pp. 129 and 150 and notes 258 and 372.

24 Letter 8 February 1860, in Raimondi 1958, p. 246.

25 27 November 1858, in Reff 1969, p. 283.

26 Reff 1976, pp. 96–97.

27 Almost forty years ago without knowledge of Raimondi, Reff or Loyrette, I wrote, in 'Edgar Degas and the Bellellis' (Boggs 1955, p. 133): "It is in the expression of the intricate web of tensions within the Bellelli family that this painting achieves its particular poignancy and its greatness."

28 See also Linda Nochlin, A House is not a Home: Degas and the Subversion of the Family, in Kendall/Pollock 1992, p. 45.

29 As recorded in 1988–89 Paris/Ottawa/New York, p. 82 and p. 81, fig. 37.

30 Inscribed "*Nini Bellelli/1856/Degas*".

31 Reff 12, BN 18, p. 64; Reff 19, BN 19, p. 97.

32 For example *L'Orchestre de l'Opéra* (L186, Paris, Orsay) on *L'orchestre pendant qu'on joue une tragédie*, in *Croquis Musicaux*, no. 17, *Le Charivari*, 5 April 1852, or *Portraits à la Bourse* (L499, Paris, Orsay) on *Robert Macaire Boursier*, in *Le Charivari*, 26 February 1837. See Reff 1976, pp. 70–86.

33 McMullen 1984, p. 92, explains the social background of the Bellelli (which would also apply to the other Italian members of the Degas family): "the family is sandwiched socially between the upper middle class, specifically the Neapolitan *galantuomini*, and the lower Italian aristocracy, specifically the one invented during the Bonaparte occupation".

34 *Ibid.*

35 Reff 18, BN 1, p. 31.

36 *Correspondance de Berthe Morisot avec sa famille et ses amis*, ed. Denis Rouart, Paris 1950.

37 See Loyrette 1991, p. 185: "il n'y a aucune raison de suspecter cette version des faits".

38 Information from chronologies in the following: Douglas Druick and Michel Hoog, *Fantin-Latour*, exhibition catalogue, Paris 1982–83, p. 14; Louise d'Argencourt and Jacques Foucart, *Puvis de Chavannes*, exhibition catalogue, Ottawa, National Gallery of Canada, 1977, p. 255.

39 Loyrette 1991, p. 222.

40 The other representations of a young woman with field glasses or lorgnettes are L179, London, British Museum; L268, Glasgow; L269, private collection, Switzerland; and L431, Dresden, Kunstgemäldesammlungen. The painting at the races with the same figure is L184, Weil Enterprises, Montgomery, Alabama.

41 Photograph reproduced in 1988–89 Paris/Ottawa/New York, p. 140, fig. 75.

42 Marguerite De Gas Fevre, the painter's sister, is seldom identified in Degas's work. Two paintings (cat. 36 and L61, Orsay) and two preparatory drawings for them (cat. 38, 39) were bought by the Louvre from Marguerite's daughter Jeanne Fevre. A third study (cat. 37) also came from Jeanne Fevre's estate. There is an etching of Marguerite (cat. 56). In her book on her uncle (Fevre 1949), Jeanne Fevre reproduces three drawings as of her mother, one, opposite p. 33, as a young girl (cat. 5), one, opposite p. 65, as a young woman sewing (cat. 37), a third, opposite p. 80, inscribed by Degas, "Portrait de ma sœur Marguerite coiffée en poudre pour un bal costumé, un ou deux ans avant son mariage [1865]. D." (whereabouts unknown). There is a reticent oil portrait of her head (in a bonnet) and shoulders, generally dated about 1868, which may be a decade too early (cat. 96). Of a drawing (Vente III: 404(2), Paris, Orsay), which is a study for a painting, *La répétition de chant* (L331, Washington, Dumbarton Oaks), Daniel Halévy, whose mother was a close friend of Marguerite, wrote (Halévy 1960, p. 24): "Les amateurs de son art la connaissent par ce beau dessin qui la montre debout, tenant en main la page écrite, bouche ouverte pour le chant." In addition to earlier drawings (Williamstown, Clark Art Institute; Detroit Institute of Arts) these identifications give reason to speculate that Marguerite may have been used by Degas as a model for 'Femme à la lorgnette' (L179, London, British Museum) as well as for 'Violiniste et jeune femme' (cat. 111) and possibly 'La femme au bandeau' (L275, Detroit Institute of Arts).

43 For some of the literature on this painting see Bell 1965; Reff 1976, pp. 200–38; Geist 1976, pp. 80–82; Sidlauskas 1993.

44 Sidlauskas 1993, p. 684.

45 Sidlauskas 1993, p. 678, in which the objects are associated with the two opposing genders.

46 Reff 1976, pp. 204–08.

47 Paris, Orsay, RF 31779; published in Reff 1976, pp. 206–07, fig. 135, and 1988–89 Paris/Ottawa/New York, p. 145, fig. 77.

48 Armstrong 1991, pp. 93–100; Sidlauskas 1993.

49 Reff 1976, pp. 205–08, sums up the differences conscientiously although he believes some are the result of the influence of another novel by Zola, *Madeleine Férat*.

50 Emile Zola, *Thérèse Raquin*, Lausanne 1976, pp. 20–21; translation by Andrew Rothwell, edn. Oxford 1992, pp. 1–2.

51 Sidlauskas 1993, pp. 676–77.

52 Private collection; illus. Boggs 1962, no. 56.

53 Reff 23, BN 21, pp. 46–47; translation Kendall 1987, p. 37.

54 See note 42.

55 In addition to the traditional bibliography found in 1988–89 Paris/Ottawa/New York, no. 115, which includes the fundamental study, Rewald 1946, there are Armstrong 1991, pp. 27–35, Brown 1988, pp. 216–21, and Brown 1994.

56 *Degas inédit* 1989, BN 3(1), 18 February 1873, p. 361.

57 For letters to Deschamps in London, see *Degas inédit* 1989, D 2, 1 June [1876], p. 436, and D 3, Naples, 16 June 1876, p. 437.

58 For the letter to the mayor of 1 June 1876, see *Degas inédit* 1989, 30 March 1878, p. 428, and for the letter to the curator Charles Lecœur, 31 March 1878, *ibidem*.

59 It is not clear how much financial responsibility Achille did or could assume. Brown 1994, p. 60, note 5, publishes a letter in the Degas-Musson papers at Tulane University (D-M, box 111, folder 7) from the painter's uncle Henri Musson to his brother Michel in New Orleans on 17 January 1877 in which he writes: "Je vois à Paris, Edgar se priver de tout, vivre du moins possible. Les 7 enfants de Fevre [i.e. of Marguerite De Gas Fevre] vêtus de trous. Ils prennent seulement leur nécessaire. L'honneur est engagé." It may be significant that Achille is not mentioned.

60 Sutton/Adhémar 1987, p. 175.

61 *Lettres* 1945, III, p. 29.

62 For the fullest explanation of the financial problems of the Musson and Degas families, see Brown 1990, pp. 118–130, and Brown 1994.

63 Brown 1994, pp. 20–27.

64 McMullen 1984, pp. 250–51, based on newspaper accounts in *Paris Journal* and *Le Figaro*.

65 Harvey Buchanan, Professor Emeritus, Case Western Reserve University, Cleveland, in 1989 found the Marriage Record for 3 May 1878 between F.B. René de Gas and America Durrive in the Archives for Cuyahoga County, Ohio.

66 For the details of the announcement of the dissolution of the partnership see Brown 1994, p. 32, note 58.

67 Raimondi 1958, p. 107, letter of Hilaire Degas to his wife in Paris of 9 December 1835: "Ils voudraient se l'éviter [work] et être des Rothschild d'un coup de feu".

68 *Lettres* 1945, I, 11 November 1972, p. 19; translation *Letters* 1947, 2, p. 15.

69 *Degas inédit* 1989, BN 3(1), 18 February 1873, p. 362; translation *Letters* 1947, 5, p. 32.

70 These are the collections from which Degas borrowed works for the first Impressionist exhibition in 1874. See Charles S. Moffett. *et al*, exhibition catalogue, Washington, National Gallery of Art/San Francisco, Fine Arts Museums of San Francisco, 1986, p. 120.

71 He counted "*une quinzaine*": *Degas inédit* 1989, BN 3(1), 18 February 1873, letter to Tissot, p. 361.

72 This is a surprising lacuna. There exist only a study of a head (L322, New York, Pierpont Morgan), probably of the partner reading the accounts at the right, John Livaudais, but surprisingly identified by Lemoisne as René De Gas, and full-length oil sketches of jauntily hatted gentlemen, called either Achille or René, which were used for other works as well (L307, Minneapolis Institute of Arts; L308, private collection, Berne; L344, New York, Pierpoint Morgan).

73 Armstrong 1991, p. 34.

74 Halévy 1960, after 30 January 1891.

75 Sigwalt 1988, pp. 1188–91.

76 Reff 30, BN 9, p. 202; translation Kendall 1987, p. 117.

77 Loyrette 1991, p. 15.

78 Armstrong 1991, p. 34.

79 Meier-Graefe 1924, towards the end of the third paragraph; English edn., translation by J. Holroyd-Reece, New York 1923, p. 55.

80 *Degas inédit* 1989, BN 1(1), p. 358.

81 *Degas inédit* 1989, BN 2(1), p. 360.

82 Pickvance 1963, p. 260.

83 *Degas inédit* 1989, BN 4(1) [beginning of April 1873], p. 363.

84 Sickert in the foreword to the exhibition catalogue *Twentieth Century Art*, London, Leicester Galleries, 1932, quoted from Osbert Sitwell, *A free house!*, London 1947, p. 194.

85 Armstrong 1991, p. 34f.; Brown 1994, p. 48.

86 *Lettres* 1945, II [27 November 1872], p. 23.

87 Emile Zola, *Le Messager de l'Europe*, St Petersburg, June 1876. For a translation into French by Mme Morozov see Emile Zola, *Mon Salon/Manet/Ecrits sur l'art*, Paris 1970, p. 279.

88 *Degas inédit* 1989, BN 2(1), 18 February [1873], p. 361; translation *Letters* 1947, 4, p. 22.

89 *Ibid.*

90 Rouart 1950 (see note 36), p. 31; English edn., *Berthe Morisot, The Correspondence with her Family and her Friends*, translated Betty W. Hubbard, London 1986, p. 40.

91 *Degas inédit* 1989, BN 6(1), March 1874, p. 365.

92 *Lettres* 1945, XXXIII, 2 May 1882, pp. 62–63.

93 *Lettres* 1945, III, 8 December 1873, p. 26.

94 *Degas inédit* 1989, BN 3(1), 18 February 1873, p. 361; translation *Letters* 1947, 6, p. 31.

II. The Years of Mastery, 1873–1881

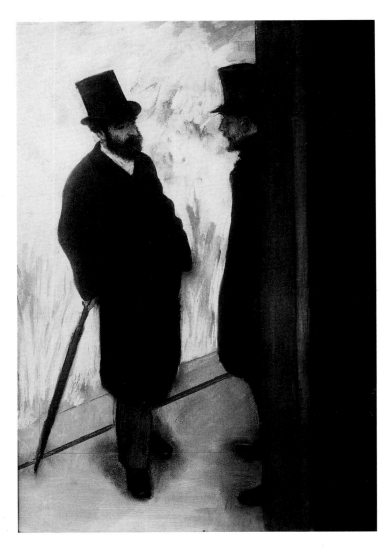

'Portraits d'amis sur la scène', 1879, pastel, 79 × 55 cm, Paris, Musée d'Orsay (L256)

After Degas returned from New Orleans, his portraiture took two directions. One was towards self-willed and independent individuals with some of the natural arrogance Degas had revealed in his drawings and etchings of Manet (cat. 62–69, 83–84, illus. pp. 254–58). This was true, for example, of his study in gouache of an Italian friend living in London, Carlo Pellegrino (cat. 131, illus. p. 259), who was himself a caricaturist for *Vanity Fair* under the pseudonym 'Ape'. It has been shown that Degas took one of Pellegrini's own drawings as the basis of his portrait of the Italian artist,[1] borrowing (but also exaggerating) the outstretched hand with the cigarette and naughtily adding the bowler hat, *'un melon'*, concealed behind his back. The Pellegrini portrait is nevertheless quite different from Degas's earlier drawing of Manet at the races (cat. 83, illus. p. 258): Pellegrini's body is not as trim and certainly not as adroit, his suit is more rumpled and of a heavier material, his beard and hair are less disciplined, and he is made more pedestrian by the use of a medium with colour and body – oil and pastel as well as watercolour – rather than the lighter pencil. Pellegrini's total silhouette, which is more exuberant than Manet's, reminds us of Degas's remark in a letter to Tissot from New Orleans, "J'aime tant les silhouettes".[2] And this silhouette is witty and individual; we feel we have met Pellegrini even if we may not know him intimately. But there is no clue to his occupation. This is portraiture and not genre.

The portrait of Pellegrini is not so different in kind from Degas's pastel and distemper of his schoolfriend Ludovic Halévy[3] and their mutual friend Albert Boulanger-Cavé,[4] which Degas called *"Portrait d'amis sur la scène"* (illus.) when he exhibited it at the fourth Impressionist exhibition in 1879. There are equally revealing silhouettes of rumpled clothes and accessories which are even more decisive – their top hats and Halévy's tightly furled umbrella. More refined and lethargic than Pellegrini, Halévy and Cavé bring to mind Achille De Gas in *Portraits dans un bureau (Nouvelle-Orléans)*, which has just been discussed – ostensibly idlers and *flâneurs*. Both men had connections with the theatre – Halévy, mostly in collaboration with Henri Meilhac, as a playwright and, principally, as a writer of

libretti for Jacques Offenbach in the 1860s, Cavé once as Director of Censorship – but neither reveals his occupation here. They are visitors, probably the season-ticket holders at the Opéra who figure prominently in the stories Halévy was publishing in the 1870s, which were brought together in 1883 as *La Famille Cardinal*.[5] Indeed, Degas had by 1879 produced a series of monotypes to illustrate Halévy's tales (cat. 132, illus. p. 222),[6] making his friend quite identifiable as the indolent observer and possible future protector of one of the young dancers. Two notebooks Degas left in the Halévy household make it clear that the Halévys could not be accused of prudery or lack of humour but there was probably some reservation about making their enjoyment of wit so public.[7] As a result Degas's monotypes were never published with the stories. The figure of Halévy (essentially dignified in the *Cardinal* series, if it were not for the context) could have provided the prototype for the humbler, more rustic and undeniably funnier visitors to the brothels (Janis 185, Ottawa) which Degas was also producing in monotype during these years and presumably showing only to a very few good friends.[8] The links of portraiture to genre were by no means severed; individuals might have been identified in compromising situations in genre compositions if the works had been exhibited or published.

As spectators to both Pellegrini and Halévy with Cavé we assume a certain height from which we look down at the figures, perhaps as if we were in a box over the stage. In one notebook Degas wrote, "set up tiers all around the room to get used to drawing things from above and below ... For a portrait, pose the model on the ground floor and work on the first floor to get used to retaining forms and expressions and to never drawing or painting immediately."*[9] The distance he achieved makes it possible for us to see the total silhouette (unless a flat of scenery intervenes) more clearly because it has been simplified. The consequent stylisation, often with sloping floors, has reminded many observers of Japanese prints, which Degas did collect.[10] On the other hand, as Eunice Lipton reminds us,[11] theatres such as Garnier's Opéra not only had sloping floors on the stage, where Halévy and Cavé

could be standing, but in the dance foyer as well. The distance that Degas placed between himself (and us) and his sitters was certainly the consequence of perspective devices that could measure those distances in space. It was also, as we know from his own notes, a question of time, of what, to speak figuratively, he remembered after seeing a sitter "on the ground floor" and drawing or painting later from the first floor. This provides another layer of simplification and selection in their execution. There is a third factor for which the first two are agents: a psychological distance he wanted to place between himself (and eventually us) and the people he drew and painted. The reasons for this are only too easy to find in the artist's hardships, already anticipated in New Orleans, those financial and familial embarrassments which the Chronology (pp. 86–95) documents. Degas did not want to expose his real feelings nor those of close family and friends. As a result he put up protective barriers like the spatial, temporal and psychological distances in his portraits and genre compositions and concentrated instead upon what was witty and memorable.

Usually he painted his friends in public places and these were normally in Paris, although Pellegrini might have been in London. But when he decided to paint Berthe Morisot's fiancé, Eugène Manet, about 1874 (cat. 125, illus. p. 263), he used his studio and then carried out what he had boasted to his sitter, "I am going to add a background of dunes so you will look as if you are at the seaside".[12] Eugène Manet is consequently somewhat informally dressed, stretched out listlessly on the painted shore with a cane between his legs. Such devices gave Degas the opportunity to make surprising and witty comments as he does with Pellegrini's hat, Halévy's umbrella or this Manet's cane. Then came a reversal of this perspective – looking down at his sitters – when at the beginning of 1879 Degas painted the mulatto acrobat Mlle Lala at the Cirque Fernando (illus. p. 93). We look dizzyingly up to see her hanging with her teeth from a rope dropped from the circus's elaborate ceiling, twenty metres high, for which Degas made detailed architectural drawings.[13] From this angle Mlle Lala is an unforgettable image, but, of course, more genre than portraiture.

In addition to reversing the perspective for Mlle

* ... établir des gradins tout autour de la salle pour habituer à dessiner de bas et de haut les choses ... Pour un portrait, faire poser au rez de chaussée et faire travailler au 1er, pour habituer à retenir les formes et les expressions et à ne jamais dessiner ou peindre immédiatement.

Frieze of portraits
(*'Portraits en frise'*)
1879
Pastel
65 × 50 cm
Private collection (L532)

Lala, Degas used similar perspective devices on a few occasions in studies of women, though he subdued the angle of vision. He inscribed one pastel and distemper drawing (illus.), "*Portraits en frise pour décoration dans un appartement*", perhaps a revival of a scheme he had proposed in a notebook much earlier[14] – but presumably he used the word "portrait" loosely. For this "frieze" he seems to have asked friends to pose for characters he and they invented. One, the figure on the right, is identifiable as Ellen Andrée, a pantomime actress Degas probably paid as a model and used in one of his most famous genre compositions of this period, *L'Absinthe* (L393, Paris, Orsay; illus. p. 105), for which she sat with the artist Marcellin Desboutin. The primly seated figure in the centre of this "frieze" is usually believed to be Mary Cassatt, presumably a volunteer. Cassatt confessed to her great friend Mrs Havemeyer that she posed for Degas "once in a while when he finds the movements difficult, and the model cannot seem to get the idea".[15] Ellen Andrée, who must have been a great mimic and appears, by contrast, enchantingly blonde in paintings by Renoir – she is the seated woman lower left in *Le déjeuner des canotiers* (Washington, Phillips Collection) – may also have been used for another pastel

drawing with two figures, a 'duo' (cat. 152, illus. p. 275) and a third of a single figure (cat. 151, illus. p. 272). In spite of the fact that in none of these compositions does Degas indicate a setting beyond implying a chair in the "frieze", the drawings seem genre and not portraiture. We know that the women are away from home because of their hats, umbrellas and jackets or coats. The "frieze" of three – lined up and not conversing – could be waiting; the same could apply to the single figure. The 'duo' could be looking at works of art in a gallery or museum, with a catalogue in the hands of the figure at the right. We may be reminded of *Portraits dans un bureau* or *The interior*. We seem to have been introduced to characters just after the theatre curtain has been raised; but it is up to us to invent a narrative.

The distinctions between the women in the three drawings are very subtle, and it may be rash to try to project ourselves into the niceties of bearing and dress in the later 1870s, though these are the kind of observations upon which nineteenth-century fiction by Balzac, Flaubert, Zola, Goncourt, Maupassant, Turgenev and others is based.[16] Fortunately one writer, Paul Valéry, has told us how observant Degas was of such matters and how much he enjoyed mimicking the behaviour of a woman he had seen in a tram.[17] It therefore does not seem inappropriate to observe that the single young woman (cat. 151, illus. p. 272) wears a drab and shapeless coat that is far too large and probably therefore, although warm, second-hand. In spite of the fact that she stands simply and modestly – even if the hands in her pockets are surely not a sign of the most refined behaviour in young women at the time – she has tied some black scarf around her throat to make a flattering frame for her face, which peers out provocatively under her neat but shabby hat. That glimpse, from behind, of the profile reveals a mischievous face with a tilted nose and an irresistible complexion, the colour of a pale rose. She must be intended to be a young woman of a certain propriety as well as certain charms, probably employed but leading a precarious life as a dancer? Seamstress? Milliner?[18] Of course she is in reality the actress Ellen Andrée performing one of her rôles with the mimicry both she and Degas practised so skilfully.

Ellen Andrée was identified by the critic Arsène

*... en casaque et en
chapeau Niniche, le nez
dans l'air ... la charmante
Ellen Andrée qui, par sa
grâce gamine, son tact
parisien capiteux et léger,
illumina le petit groupe
Halévy, Degas, Meilhac,
Renoir et tutti quanti.

Alexandre as the young woman in a tiny etching of the late 1870s by Degas (cat. 153, illus. p. 272), whom he described as being "in a jacket and a 'Niniche' hat, her nose in the air ... the charming Ellen Andrée who, by her urchin-like grace, her heady and light Parisian touch, illuminated the small group of Halévy, Degas, Meilhac, Renoir and *tutti quanti*".*[19] This figure seems a reversal in pose and dress of the figure at the right of the "frieze", in which she wears essentially the same costume, carrying an umbrella and a book and lifting her chin even more superciliously. Finally, in the same hat and coat and skirt (in different colours) she was probably the model for both figures in the 'duo'. As the figure at the left, she is pained and bored as Degas described women being when they visited museums;[20] her left hand is cockily on her waist, her right arm leaning heavily on the umbrella and her left hip shot out challengingly; a curl – probably an artificial 'rat' – escapes over her shoulder. Her companion – the right figure in the "frieze" – seems tentatively interested, peering myopically at what bores her companion so excruciatingly.

Although in the "frieze" Ellen Andrée's dress is more restrained in colour but more dashing in cut, she still conveys her conviction of her own superiority. Because in all three works (the etching, the 'duo' and the "frieze") she has a loosely bound book in her hand, we can assume intellectual ambitions, which her raised chin does not deny. There is no evidence that any of the women in Degas's own family had such aspirations, nor does it seem to have been manifest in the women in the families of his closest friends, the Rouarts, the Halévys and the Valpinçons. But Mary Cassatt, whom he had met by 1877, and Louisine Elder (later Havemeyer), whom he was to know through her, represented new feminine ambitions, the first as an artist, the second, more surprisingly, eventually as a suffragette. Their desire for independence, often at considerable cost, was echoed in the lives of other young women artists Degas knew: for example, the painter Suzanne Valadon, the singer Rose Caron and, of course, the actress Ellen Andrée herself. In addition, as Norma Broude has shown, one of Degas's Italian friends, Diego Martelli (see cat. 144–48, illus. pp. 266–69), was a supporter of the feminist cause, in which he was particularly active when in Paris for a year in 1878–79.[21] The rôles Degas has Ellen Andrée play (in the etching, the "frieze", the 'duo' but not the single figure) may not be militant but they do make some claim for the independence of women.

The central figure seated in the "frieze", who has long been identified as Mary Cassatt, in some ways seems closer to Degas's painting of her (cat. 168, illus. p. 276) which she so much disliked, although the head is rounder as indeed Cassatt painted herself (New York, Metropolitan Museum).[22] But we must remember that this is genre, and Cassatt may only have been willing to be helpful in sitting for Degas, as she would do later for his pastels of milliners, so long as the picture did not end up as another unflattering portrait. The pose seems to have emerged from a piquant pastel drawing (L533, private collection) in which the umbrella is unfurled and she (or some other sitter) wears a loose and untidy hat and shawl. It was probably a tribute to Cassatt, who went to the best hat-makers, that, although she is not in the least ostentatious, Degas did smarten her up, created or imitated a dignified large fur hat, cut her waist neatly to her body, and gave her a row of shining buttons and a tidier umbrella. Her costume is more harmonious and of finer material than that of the figure for whom Ellen Andrée posed. She sits with her feet crossed daintily, her eyes modestly shadowed by her hat, her head raised as if she were interested and alert but not aggressive, holding her book respectfully and moving her umbrella with some slight impatience. She may share interests with the figure posed by Ellen Andrée – their books, the outing – but she is both prissier and not insubordinate. The third young woman is tall and confident, probably as well born as Cassatt but simpler and not as defined. The women gain in strength of characterization from left to right. All three share certain avocations, if not at the moment the readiness to discuss them, but the Ellen Andrée character is unquestionably the liveliest and most purposeful.

Related to these three pastels are works Degas made of Mary Cassatt from the back, some with a woman who is believed to be her sister Lydia at her side. There exist a full pastel of her with 'Lydia' in

Mary Cassatt at the Louvre
1880
Pastel
63.5 × 42.9 cm
Philadelphia Museum of
Art (L582)

it has the same clarity – he painted a portrait of his great friend Henri Rouart, which is often compared to Piero della Francesca's portrait of the Duke of Urbino in the Uffizi in Florence. Rouart's profile is outlined clearly against the Louisiana Ice Manufacturing Company in New Orleans he had designed in 1868 – which Degas could have seen but Henri Rouart had probably not (L373, Pittsburgh, Carnegie Museum).[24] But the most sensational of the half- to three-quarter-length portraits is probably that of the artist Ludovic Lepic crossing the Place de la Concorde with his two daughters, Janine (born 1868) and Eylau (born 1869) (illus.).

Degas had already painted this artist friend in a more paternal rôle about 1870, proudly but nervously exhibiting his baby daughters as if they were a flower and a china doll (cat. 110, illus. p. 219). By the time Degas painted the *Place de la Concorde*, between 1875 and 1877,[25] the two charmingly and stylishly dressed little girls had unmistakably asserted their independence. A stranger at the left margin of the painting stops and stares in astonishment as the girls move with their wolfhound in one direction and their father strides in quite another. Lepic, handsomely clad, also has a memorable silhouette to which his jutting cigar and carelessly held umbrella contribute. Otherwise he gives an impression of energy, impatience, a self-assurance so absolute that he is not concerned with appearances; perhaps there is a certain dissipation in the features of his face since he had probably not as yet reached forty. As we see him with his daughters and the pedigree dog we are inclined to believe that we have glimpsed an aristocrat. Indeed, though he was not a member of the established nobility, the hereditary title of count had during the Restoration been given to his grandfather by Louis XVIII. Both his grandfather and his father had been Napoleonic brigadier-generals, the father with a certain artistic bent since he was in charge of the Imperial residences, including furnishing and the production of fêtes. The grandfather served Napoleon I, the father Napoleon III. On the Place de la Concorde as Ludovic Lepic crosses it there would have been a reminder that with the defeat of France by Prussia in the Franco-Prussian War the Napoleonic era had irrevocably ended: the statue that stood in the square to Stras-

the Louvre (BR 104, private collection), a pastel over a print (L583, Chicago, Art Institute), and drawings and prints (cat. 154, 155, illus. p. 273, 274) in which we never see Cassatt's face.[23] Nevertheless that slender, elegant back held so proudly erect as she balances on a delicate umbrella and the confident form of her hat reveal her as the supremely assured, well bred, European-educated American artist whose brother was to become President of the Pennsylvania Railroad. In that portrayal there are many factors related to her social position and personal independence, which is a form of genre, but it remains a distinctive portrait as the seated figure in the study for the "frieze" is not.

All the figurative works discussed here, dating from after Degas's return from New Orleans in the 1870s, have been, whether portraits or genre, full-lengths, showing the whole body seen from a certain distance (and usually from above) in a public place. Degas did, however, close in on some of his sitters, as he did on the back of Mary Cassatt in a pastel (illus.) where he uses vibrant touches of coral or pink or white to show his enjoyment of her femininity. In a completely independent work – though

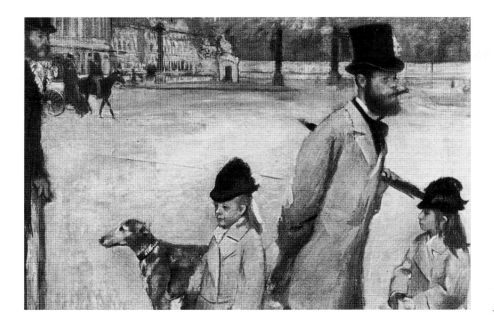

Place de la Concorde,
Vicomte Lepic and his
daughters
ca. 1876
Oil on canvas
79 × 118 cm
Currently held in a
Russian museum (L368)

bourg, the capital of Alsace-Lorraine, which France had lost in the war, was then draped in mourning, although it seems discreetly concealed, in the painting, by Lepic's top hat.[26]

Ludovic Lepic had his own avocations and interests. He was an artist of minor talents, who did, however, exhibit in the first two Impressionist exhibitions of 1874 and 1876 as a result of Degas's intervention. He was a skilful printmaker who co-signed Degas's first monotype (illus. p. 56) and wrote a book on printmaking.[27] He was a breeder of dogs to whom Degas wrote a charming letter, often quoted, asking him to help him provide a dog for Mary Cassatt.[28] He was fascinated by archaeology and helped establish museums at Saint-Germain-en-Laye and Aix-sur-Bains. He shared Degas's enthusiasm for the theatre and designed sets and costumes for the opera. In addition he had as a mistress a dancer at the Paris Opéra, Marie Sanlaville, to whom Degas dedicated one sonnet,[29] and in whose bed Lepic died at the age of fifty. A great deal of the character of this self-assured, worldly man emerges from Degas's portrait of him with his daughters. Admittedly much of the character is social, but enough eccentricity survives to make it a genuine portrait.[30]

Domestic portraits in the 1870s

If in one direction much of Degas's portraiture after his return from New Orleans involved the depiction of self-willed, independent individuals, there was nevertheless another side to his portraiture, at least in the 1870s, though a less forceful one. These are the portraits he painted in the protection of their sitters' Parisian or Neapolitan homes. Unlike the rooms Degas painted in 1872–73 in New Orleans with their suggestion of an escape from intense light, with high ceilings, almost bare walls and very pale colours, his French interiors of the 1860s as of the 1870s give an overall impression of comfortable sofas and chairs with great cushions, occasional pictures, soothing colours, shadowed light, together with hints of a feminine presence in bouquets of flowers, unfinished embroideries, and accessories such as gloves left casually on tables. It is very rare that any of these interiors has all these details, but all possess an unassuming informality, and the sitters appear protected in their houses by the occasional barriers of curtains, door-jambs and large vases of flowers. This does not mean that we necessarily feel a greater intimacy with the sitters but we often respond to Degas's greater tenderness.

One of these intimate, domestic portraits is the small *Woman putting on her gloves* ('*Femme mettant ses gants*'; L438, private collection), maddeningly unidentified and undated, in which we catch a glimpse of an elegant woman seated so that we see her distinguished profile as she leans forward while fitting on her gloves. That gesture can remind us of Degas's description much later to Valéry of the woman settling down on a tram, "She draws on her gloves, buttoning them with care".[31] Another is of Mme (Elisabeth) de Rutté (cat. 126, illus. p. 245), whom we know to have been a sister of the Alsatian painters Emmanuel and Jean Brenner and the wife of an architect, Frédéric-Louis de Rutté, who practised in Berne from 1871.[32] She sits surrounded by domestic paraphernalia – according to tradition, at her brother Emmanuel's in Paris – but looks at us without any subterfuge and perhaps even with a certain severity. Another woman Degas painted – twice – was Mme Jeantaud, born Berthe Marie Bachoux, the wife of Charles Jeantaud, his comrade during the Franco-Prussian War, and perhaps a

*Henri Rouart and his
daughter Hélène*
ca. 1877
Oil on canvas
63.5 × 74.9 cm
Private collection (L424)

cousin of Lepic.[33] In one (cat. 135, illus. p. 216) she is seated with her two dogs on a chaise, facing us with her bouffant hair and surprisingly harsh features almost as directly as Mme de Rutté. In the second portrait (cat. 124, illus. p. 217) she is dressed to go out, a cossetted woman with a pretty and elaborate hat back on her head, a charming cape and a fur muff; but, while we catch a glimpse of an appealing profile, her mirrored reflection even exaggerates the rough features of the other painting. Perhaps the most intimate of these domestic works, all probably painted in homes in Paris, is the portrait of Henri Rouart with his young daughter Hélène on his knee (illus.), her red hair glowing against the landscape her father had painted. (Rouart, though a successful engineer and industrialist, submitted works to all the Impressionist exhibitions except the seventh in 1882, which he boycotted with Degas.) Rouart was also very much a family man and here seems to be giving the tenderest moral support to his only daughter, whose face appears blurred by tears.

As they had in the past, Degas's Neapolitan relatives also provided him with the chance to paint portraits of families in their own environments. In this exhibition there is an exceptional group of the

family of the youngest of Degas's Italian aunts, his aunt Fanny, born Stefanina Degas, who was only fifteen when he was born. She was to marry Giocchino Primicile Carafa, Marquis of Cicerale and Duke of Montejasi, and have two daughters, Elena (born 1855) and Camilla (born 1857). In 1875 a series of events, which included the deaths in 1874 of the artist's father in Naples and the next year of his uncle Achille, who left property to the painter and his brother Achille, brought Degas to Naples for over four months. We know from a letter he wrote to his sister Thérèse in Naples after he had returned that he must have spent considerable time with his aunt Fanny's family and had been grateful for their hospitality and, we can suspect, for their posing for him as well.[34] In addition to the portraits of the duchess and her daughters (cat. 77, 97, 98, 120, 128, illus. pp. 195–98), the exhibition also has a portrait of Giovanna and Giuliana Bellelli, cousins of Camilla and Elena Primicile Carafa as well as of the painter (cat. 78, illus. p. 194), and another portrait of one more cousin with their uncle, Henri Degas, *Henri Degas and his niece Lucie* (cat. 127, illus. p. 199). This gives us an unequalled chance to study and compare these works in the original and may resolve certain questions about the years in which they were painted.

We may assume – as a basis for discussion – that it was in 1870 that Degas painted the double portrait '*Deux sœurs*' of Elena and Camilla Primicile Carafa (cat. 77, illus. p. 195), when they were aged thirteen and fifteen, passing from puberty into adolescence, and were probably in mourning for their uncle Edouard Degas, the widower of their aunt Candida Primicile Carafa, who had died the year before. This portrait is conceptually similar to Degas's equally melancholy portrait of his and their cousins Giovanna and Giulia Bellelli (cat. 78, illus. p. 194), which has been dated 1862–64 by this author – years in which Giovanna would have been fourteen to sixteen and Giuliana eleven to thirteen – and by others to 1865, when they would have been seventeen and fourteen, or to 1865–66 when these children – and they are undoubtedly that – would have been eighteen and fifteen.[35] There are stylistic and compositional arguments for 1865 as the date, but if it is correct we have to assume that Degas was

Mlle Malo
ca. 1877
Oil on canvas
81 × 65 cm
Washington D.C.,
National Gallery of Art,
Chester Dale Collection
(L441)

turns her head away from us, and it seems shadowed and distantly reflective, Camilla confronts us as daringly as Mme de Rutté but with a suggestion of a sexual awareness growing in those refined brows, nostrils and mouth.

Then, there are perhaps even greater difficulties in dating two portraits (cat. 97, 98, illus. p. 196) that Degas painted of his aunt Fanny, which show her as proud, severe, gaunt and probably ill. These are usually dated about 1868 when she was forty-nine.[37] This is not an impossibility, but her sisters, Laura Bellelli, forty-four and pregnant in *The Bellelli family*, and Rose, Duchess Morbilli, a dignified widow at fifty-two (cat. 28, illus. p. 186), did not age so quickly. It is tempting to push the dating of these two portraits of their younger sister Fanny up seven years to 1875 when Degas spent the four months in Naples, with the time to paint, and his aunt would have been fifty-six.

With these freely painted portraits of the duchess there seems to be no need for, or question of, photographic intervention. There are, however, problems with age and character. In the small seated portrait (cat. 97, illus. p. 196) she appears to shrink timidly as she hugs herself, her face thin and pinched. In the painting of her head from Cleveland (cat. 98, illus. p. 196) she is much grander although she has the same dark shadows smudged under her eyes. It is a tragic face but there is some remnant of beauty in the mouth and an indication of considerable pride. If we isolate the duchess from the family portrait (cat. 128, illus. p. 197) we find a severe figure, frontal and commanding, her head less austere because of the softening contours of her hat, while her wringing of her gloved hands exposes anxieties. Her flesh and skin are softer, less resilient than in the other paintings. But we have to remember that she was only fifty-six and would live on for more than a quarter of a century, dying in 1901. It is possible that Degas was dealing speculatively with the effects of aging as he may have done in a roughly contemporary group of portraits of a woman called 'Mlle Malo'.[38] In the exhibition there is a portrait of this woman (cat. 134, illus. p. 235), in which she is older and softer when compared with another portrait in which she has the same features (illus.). The similarity might, of course, also suggest that one is

working from an earlier photograph, even a daguerreotype, of the two sisters. The occasions upon which Degas used photographs seem to be rare, but they did occur: he worked, for example, from a photograph of the head of the dancer Eugénie Fiocre about 1865 (L129, whereabouts unknown),[36] and this painting bears some relationship to the handling of the head of Giovanna Bellelli in the double portrait.

But we should also consider whether 1870 is really an acceptable date for the '*Deux sœurs*'. This painting is lighter in handling and more refined in its detail than that of the Bellelli sisters, the mourning they wear relieved by some rose paint brushed into the freely painted background. Whereas Elena

*Remercie la tante Fanny d'avoir bien voulu accepter tout simplement la caisse de musique et prie Hélène [Elena] de tacher de s'habituer à cette belle musique.

*M. Duranty est là, au milieu de ses estampes et ses livres, assis devant sa table, et ses doigts effilés et nerveux, son œil acéré et railleur, sa mine fouilleuse et aiguë, son pincé de comique anglais, son petit rire sec dans le tuyau de sa pipe, repassent devant moi à la vue de cette toile où le caractère de ce curieux analyste est si bien rendu.

the mother and the other her daughter – a French equivalent of the duchess and her daughter Camille. Once again the exhibition will probably bring us closer to understanding whether the portraits of the duchess and the portrait of her family (and Mlle Malo or even Mme Malo) could have been painted in the same year.

We may be apt to think of the palazzo Degas in Naples with vast rooms, formal furniture and little decoration, the atmosphere somewhat dispirited after the death of Hilaire Degas in 1858. In some of the Neapolitan paintings in the mid-1870s there is, however, an agreeable indication of greater comfort and colour, probably to be located specifically in the house of the Primicile Carafa in what is now the Piazza d'Ovidio. An example is the predominant coral of a patterned armchair, a curtain and a wall covering behind a portrait Degas painted of Elena alone, who, despite her mourning clothes, seems to have casually pulled on a jade green shawl (cat. 120, illus. p. 198). We even look through into an adjoining room with grey walls, a window and the glint of a picture frame. Elena resembles herself in the earlier double portrait, but at eighteen she is more relaxed and more aware of her growing powers of seduction. It would be surprising if the date of Elena's portrait were changed.[39]

It seems natural that *The Duchess of Montejasi Cicerale and her daughters Camilla and Elena* (cat. 128, illus. p. 197) should also have been painted in 1875. There is a certain femininity about the light coming in through the window, the turquoise blue wall, the white cushion on the settee on which the duchess sits but, on the other hand, that turquoise blue inevitably conjures up the patterned wallpaper in the much larger *Bellelli family* in which the duchess's sister Laura and her two daughters feature, even if the unfortunate Baron Bellelli has no equivalent here – the duke never makes an appearance in Degas's work. There is again the same black of mourning against that blue. Even the wedge of space between the formidable but isolated mother and her two daughters, who are charming but remain peripheral, can remind us of the inverted triangle between husband and wife in the *Bellelli family* which Giuliana dramatically occupies. Here the division seems to be between generations, the

duchess implacably isolated, the two girls gentle, a little frivolous but fundamentally sad on the edge of the painting. Paul Jamot made the suggestion that Elena is playing a piano,[40] which a letter of Degas to Thérèse on his return to Paris would justify, because he writes, "Thank Aunt Fanny for having been willing to accept the box of music so simply and beg Hélène [Elena] to try to become accustomed to this beautiful music."*[41] More than any other of Degas's works of the 1870s in either portraiture or genre, this has the dignity and the immutability of tragedy.

There is a sadness, too, in the last of the works around the Primicile Carafa in Naples: *Henri Degas and his niece Lucie* (cat. 127, illus. p. 199). This could have been painted either on the 1875 trip or on a shorter stay in 1876. Lucie, born in 1867, was the daughter of the sister of the Duchess of Montejasi Cicerale, who died in 1869, and another son of Hilaire Degas, Edouard or Odoardo, who died in 1870. From the age of three Lucie lived with her two bachelor uncles Achille and Henri in the palazzo Degas until Achille died in 1875 and Henri in 1879, when Thérèse and Edmondo Morbilli, who were childless, became her guardians. In this painting, Henri very much resembles Edgar's father, Auguste De Gas, as we know him from Degas's paintings of him with Pagans (L256, illus. p. 26; L157, Boston, Museum of Fine Art). He seems to have raised his head and eyebrows both humorously but helplessly as he senses the presence of Lucie behind him. She, in turn, places her fingers tentatively on the back of his chair and looks wistfully at us. Their inability to communicate with one another makes it a painting of pathetic alienation, which could be classified as either genre or portraiture.

Literary portraits: Duranty and Martelli, 1879

Degas must have thought of the fourth Impressionist exhibition in 1879 as the climax of his work in that decade. In one of his notebooks he drew up an ambitious list of daring paintings such as *Mlle Lala at the Cirque Fernando* (illus. p. 93).[42] And he submitted essentially that same list, with more formal titles, for the exhibition's catalogue. The two great portraits he had planned to exhibit – each about a metre square and joyous in colour – were not ready for the opening on 10 April. He did, how-

Edmond Duranty
1879
Oil on canvas
Pastel and tempera
100 × 100 cm
Glasgow, Burrell
Collection (L517)

some indication of his experimentation with media and supports during the 1870s, which is, curiously, less obvious in his portraits than in his other subjects at the time. The painting's current owner, the Burrell Collection in Glasgow, attempts to state the position honestly on its postcards by describing the medium as "distemper, watercolour and pastel on linen". There are areas where the linen is not completely covered by paint or pastel, so that we can see its fine grain and subtle colour. The distemper and watercolour are used with great delicacy, shown in the choice of colours as well as in their application. Pastel is used for accents and for animating touches, particularly in the modelling of the head and the suit. In fact Duranty, who is at home – Degas indicated this by inscribing *"chez Duranty"* on the one dated drawing – may seem serious in his dark jacket and sweater, but he is living in a bower of light-hearted colours – those of the books around him.

In the exhibition there is a powerful charcoal drawing Degas made of Duranty's head and arms in preparation for the painting (cat. 149, illus. p. 265). The charcoal on the jacket may seem brusque but, together with white chalk, it describes the hands and, in particular, the skull with a remarkable sensitivity to sculptural form. Degas gives us a head that conveys both intellectual concentration and a detached humour. It is a slight surprise, but also natural, to find the head crowned by balding, short, curling hair. The drawing serves to prepare us for the reaction of the critic and writer Joris-Karl Huysmans to the painting when it was shown in the fifth Impressionist exhibition in 1880, brought in as a memorial to Duranty who died nine days after its opening. Huysmans wrote:

M. Duranty is with us, surrounded by his prints and books, seated at his table, with his slender, nervous fingers, his bright, mocking eye, his acute, searching expression, his wry, English humourist's air, his dry, joking little laugh – all of it recalled to me by the painting, in which the character of this strange analyst of human nature is so splendidly portrayed.*45

Indeed, Degas was almost establishing a typology of authors' portraits, one that Cézanne would take up in 1895 in his portrait of Gustave Geffroy (Paris, Orsay) and Vuillard in 1913 in one of Théodore

ever, manage to have his *"Portrait de M. Duranty (détrempe)"* (illus.) on display by 1 May – remarkably, since he dated one of the preliminary studies for it 23 March or only eighteen days before the actual opening.43 The other, *"Portrait de M. Diego Martelli"* (cat. 146, illus. p. 269), never seems to have materialised in an Impressionist exhibition.

Both these sitters were writers and critics of art, Duranty French, Martelli Italian. Degas was presumably closer to Edmond Duranty, who had written sympathetic reviews about the works Degas submitted to the Impressionist exhibitions. Degas may have been a silent collaborator on Duranty's pamphlet, *La Nouvelle Peinture*, first published in 1876,44 in so far as it is based on the ideas the painter formulated in their discussions and also because it covers the range of his work. When Duranty died the year after the portrait was painted, Degas and Emile Zola were the executors of his estate.

The title Degas used in the catalogue of the 1879 exhibition, *Portrait de M. Duranty (détrempe)*, gives

*Poi Degas col quale corro rischio di diventare amico; uomo di spirito ed artista di merito, minacciato sul serio di cecità … e che ha in conseguenza delle ore di umore tetro e disperato, analoghe alle circostanze.

*È un uomo piacevolissimo col quale passo delle ore veramente beate. Ora ha un grande studio arruffatissimo et non elegante che non arriverà mai e poi mai a mettere all'ordine. Alcune cose sue sono moderne, tanto è il sentimento delle forma e della realtà … Io veggo molto Degas che ha un vero talento ed una finezza di osservazione stupenda.

Duret (Washington, National Gallery). Degas himself developed the format immediately with his portrait of Diego Martelli and with a variation on that now in Buenos Aires (cat. 144, illus. p. 267). Huysmans also admired Degas as a painter and colourist.[46]

Degas's *Portrait de M. Duranty (détrempe)* is not genre, even though we see Duranty in the environment in which he worked; but even that space, in the fresh beauty of its colours, seems rarified. It is a portrait in which a formidable personality and intelligence assert themselves over the appealing corner of the room. The fact that the painting is a relatively large work gives it grandeur and makes Duranty even more imposing. His blue eyes may not meet ours, but he has no need to defend himself. Although Degas's earlier portraits of the 1870s are psychologically compelling and witty – Pellegrini, Cavé and Halévy together, Miss Cassatt, Henri Degas and his niece, and many others – the sitters are always trapped, diffident, unsure. Duranty on the other hand is alone and self-confidently master of his universe.

The portraits of Diego Martelli share that same sense of scale, assurance of the colour and independence of the sitter. The one dated drawing (Vente I: 326, private collection) is for the full-length figure of the Edinburgh portrait and is inscribed "*chez Martelli | 3 avril 79 | Degas*", only a week before the 1879 exhibition opened; so Degas had little hope of finishing the painting for this occasion. Diego Martelli must have been disappointed because he was being painted simultaneously by the Venetian painter and pastellist Federico Zandomeneghi, who was also a friend of Degas. They had expected this painting, now in the Galleria d'Arte Moderna in the palazzo Pitti, Florence, to be shown at the 1879 exhibition with Degas's. Sadly Diego Martelli, after having spent twelve months in Paris, returned to Italy without having seen either portrait exhibited; and he never came back to Paris again.

Degas had always had a certain number of Italian friends. We do not know exactly when he met Martelli but it is quite clear from Martelli's correspondence that they only became friends during his extended stay in 1878–79. In December 1878 he wrote to a friend that he had seen Degas:

Then Degas, whose friend I am in danger of becoming, a man of wit and an artist of merit, threatened by blindness … and who consequently spends hours in a dark and desperate mood, matching the gravity of his condition.*[47]

He was soon writing to the Florentine painter Telemaco Signorini of Degas:

He is an exceedingly pleasant man with whom I have passed several delightful hours. He has a huge studio in great disorder, not elegant at all, which he will never, ever, manage to sort out. Some of his things are modern, he has such feeling for form and for material things … I see a lot of Degas because he has real talent and an amazing subtlety of observation.*[48]

It was probably fortunate that the sittings were, as Degas inscribed a drawing, "chez Martelli". This of course would have been in rented or borrowed rooms, but the objects on the table suggest Martelli's critical interests, and there is a happy abandonment about the papers which fits with the seeming ebullience of the man. (The rest of the room, however, is orderly.)

We look down at Martelli, as we do at so many of Degas's male figures, and in the Edinburgh painting (cat. 146, illus. p. 269) we see him full length, perching his rotund body gingerly on a chair. Although he does not look at us directly he gives out an aura of benevolence that the cheerful colours seem to endorse. Duranty apparently told Degas that he was distressed by the sudden foreshortening of Martelli's legs that the angle of vision produces.[49] Probably for that reason Degas made other drawings and painted the horizontal canvas now in Buenos Aires (cat. 144, illus. p. 267), which he never brought to the same level of execution as the one in Edinburgh. But both are great domestic portraits of the informally clad Martelli in a place he finds professionally and personally compatible. On the basis of his experience in Paris meeting artists, seeing exhibitions, visiting studios, Martelli, on his return to Italy, was to give, on 16 January 1880 in Livorno, where Degas's paternal grandmother had been born, the first lecture in Italian on the Impressionists. On the other hand, as an active feminist, Martelli may have left Degas in Paris more sympathetic to the ambitions of women.[50]

These portraits of Duranty and Martelli seem

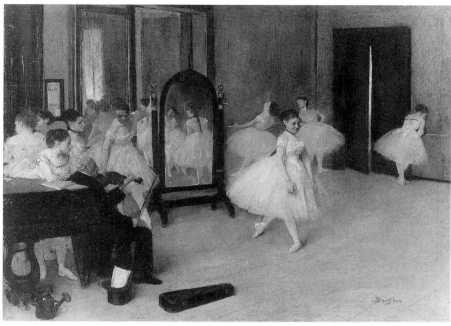

Dancing class
1871
Oil on panel
19.7 × 27 cm
New York, The
Metropolitan Museum of
Art (L297)

What attracted Degas to the dance? It probably began through the theatre itself and, specifically, the Opéra. By the age of twenty-two he was sufficiently enamoured with the Italian *tragédienne* Adélaïde Ristori to draw her faintly but convincingly on the stage in *Medée* by Ernest Legouvé at the Théâtre des Italiens in Paris on 15 April 1856. In addition to his dramatically conceived, if not as yet equally theatrically executed, drawings of the Greek tragedy, he also made notes. On one page he wrote, "Tuesday evening 15 April, I have seen the most adorable figure from a Greek vase walking and speaking".*[52] On another page it was, "When she runs it seems like the movement of the Victory from the Parthenon".*[53] This seems more suggestive of the dance as conceived by Martha Graham in the twentieth century than the endless rehearsals, classes and moments of rest by ballerinas in tutus we have come to associate with Degas. Nevertheless, besides substantiating his enchantment with the theatre, which his attendance at the Opéra in Paris throughout his life documents, these notes show a preoccupation with the movements of the human body that is fundamental to his later work on the dance.

It seems fairly clear that Degas's father and his two brothers shared, at least to some extent and in different ways, his enthusiasm for music and the theatre. His father's love of music is immortalised in the three double portraits Degas made of him with the singer and guitarist Lorenzo Pagans (L256, illus. p. 26; L257, Boston, Museum of Fine Arts; L345, private collection). In New Orleans René De Gas became involved in the preparations for the Mardi Gras parade, while their brother Achille's interest is revealed by the fact that his mistress and the mother of his child, Thérèse Mallot, was a former dancer. By the time Degas went to New Orleans in 1872 he had independently made friends who could provide an *entrée* to the world behind the scenes at the Opéra – classes and rehearsals as well as performances. Ludovic Halévy, whom he had known since childhood, could make it possible, as could Ludovic Lepic. Equally important as working members of the Opéra world were Lorenzo Pagans, who sang tenor rôles and later became a teacher,[54] and Désiré Dihau, a bassoonist in the Opéra orchestra. From New Orleans Degas wrote to Dihau, "Give my

declarations of independence – by the artist because working with such generosity and on such a scale, by the sitters because the portraits express their own freedom of will. Different as the two sitters must have been, we feel Degas would have enjoyed their independence of spirit – as well as his own. One may add that these are portraits completely liberated from genre.

Portraits and the dance, 1865–80

In the period from his first appearance at the Salon in 1865 until 1880, Degas produced a sequence of brilliant and original portraits, which are often so revealing about the social circumstances of the sitters that many could be considered genre as well. At the same time he was in the process of becoming immersed in a world that has been identified with his name – that of the dance. When he sent to the first Impressionist exhibition in 1874 his exquisite, tiny – 19 × 27 cm – *Dancing class* (illus.), one critic almost automatically associated it with genre, describing it as "a fine, profound study featuring something never to be found in certain genre painters".*[51] Once committed to the dance as a theme in his work, Degas was faithful to it until his death, although it went through many metamorphoses.

*... une fine et profonde étude ou ressort ce qu'on ne recontrera jamais chez les certains peintres de genre.

*Mardi soir 15 Avril j'ai vu marcher et parler la plus adorable figure des vases grecques.

*Quand elle court, elle a souvent le mouvement de la Victoire de Parthénon.

regards to our friends of the orchestra".[55] The only composer we can be certain Degas then knew was Emmanuel Chabrier, whom he included in his *Orchestra at the Opéra* (illus. p. 52) sitting in a box in the upper left-hand corner of the painting.

We are more uncertain still of Degas's knowledge of those directly involved in the ballet companies of the Opéra or the Opéra-Comique. By 1867 he obviously knew Joséphine Gaujelin (illus. p. 88), whom he later described in an inscription on a drawing (III:156a, Rotterdam) showing her as a dancer wearing a tutu: "1873/Joséphine Gaujelin/autrefois danseuse à l'Opéra/puis actrice au Gymnase". It is also believed that she posed for his most important early dance pictures and she is, for example, the most conspicuous dancer (in front of the mirror) in the Metropolitan's *Dancing class* (illus. p. 49), which Degas showed in the first Impressionist exhibition. We might expect that the fact he was making so many dance pictures would involve him further in their world, but he asked dancers like Gaujelin to pose for him in his studio, in individual poses which he would later pull together into convincing compositions. Essentially Degas liked a certain detachment from his subject-matter; so he might have been content to have remained an outsider in the *coulisses* of the Opéra.

Joséphine Gaujelin, so controlled, so beautiful and so austere in Degas's famous small portrait of her (illus. p. 88), which he submitted to the 1869 Salon and the 1877 Impressionist exhibition, was not the only dancer whose portrait Degas exhibited. In 1868 he had shown "*Portrait de Mlle E.F.; à propos du ballet de "la Source"*" (Portrait of Mlle E.F. at the ballet *La Source*; illus. p. 51) – Mlle "E.F." or Eugénie Fiocre, only twenty-one at the time of the first performance of *La Source* in 1866, was already more famous than Gaujelin or "Mme G.", though she was known rather for her beauty than for her dancing. Having performed at the Opéra since 1861, she would retire early after creating some principal rôles including that of Nourreda in *La Source*. (From 1864 to 1874 Marie Sanlaville, who would be the mistress of Lepic, seems to have danced with Fiocre regularly, in *La Source* as well, at the old Opéra house on the rue Peletier.) At the opening performance of *La Source* on 12 November

1866 at the same Théâtre Impériale de l'Opéra, the first gala for a full-length ballet in five years, Verdi and Ingres were both in the audience. That same year the German artist Franz Xaver Winterhalter, a favourite at all the European courts and, in particular, at that of Napoleon III and the Empress Eugénie, produced an oval portrait of Fiocre (private collection) wearing the sort of dress of layered tulle he so flatteringly painted. The famous sculptor Jean-Baptiste Carpeaux modelled a statuette of her as Psyche and made a bust of her in both marble and plaster which was shown at the Salon of 1870 where it was "ecstatically received".[56] However, although Mlle Fiocre and Degas continued to know each other and she left a calling card for him as late as 1888, they were not intimate friends, as most of the sitters for his portraits were. Degas may have chosen to paint her in this famous ballet partly because of her notoriety, which should have attracted interest at the Salon. Perversely, it did not.

It is difficult to classify Degas's picture of Mlle Fiocre. It is not traditional portraiture like Degas's painting of Mme Gaujelin. Even if Degas did make preliminary drawings of Mlle Fiocre, of her clothed figure or of her head, they are faint and not strongly characterized.[57] It is interesting, however, to discover that two are dated 3 August 1867, the summer after the gala opening the previous November. Degas must have had her sit for him, perhaps only on that documented day. The resulting canvas, which does not seem to be a portrait in the sense of revealing the idiosyncratic characteristics of a person, could hardly be considered a painting of the dance, either. There is no movement. Those who have studied *La Source* assure us that there was nothing in the dance itself to explain the quiet scene by a reflecting pool. Only the horse, which does lean towards the water, has a prototype in the several horses used in the original production. Mlle Fiocre's costume is based upon the one she wore in the dance – but she sits leaning upon her hand in a position of complete lassitude.

From another, smaller painting in the Albright-Knox Gallery, Buffalo (L148), we know that Degas also conceived of two of the women as idle and nude, with long plaits of hair, looking into a pool in which they are dreamily reflected. The handling of

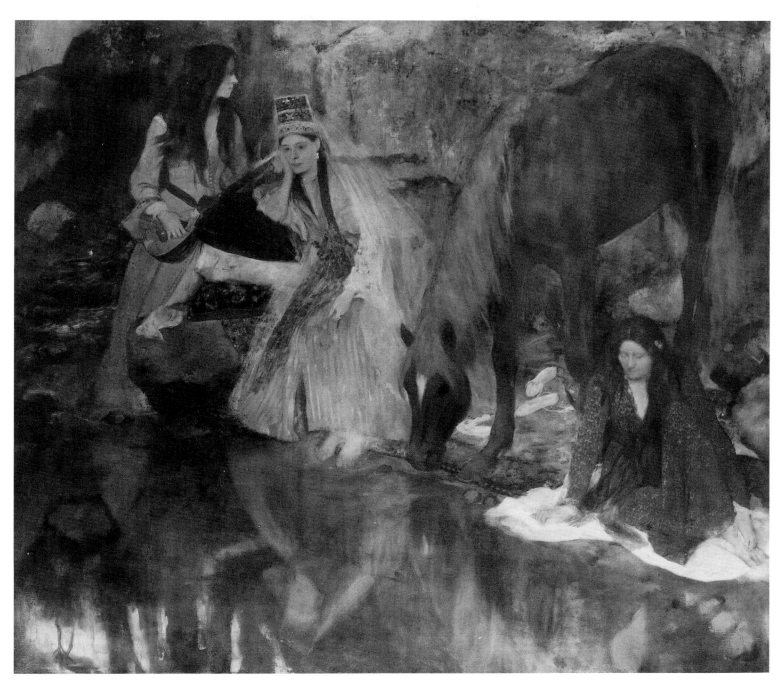

Portrait of Mlle Eugénie Fiocre at the ballet La Source ('*Portrait de Mlle Eugénie Fiocre ; à propos du ballet de "la Source"*'), oil on canvas, 130 × 145 cm, The Brooklyn Museum (L146)

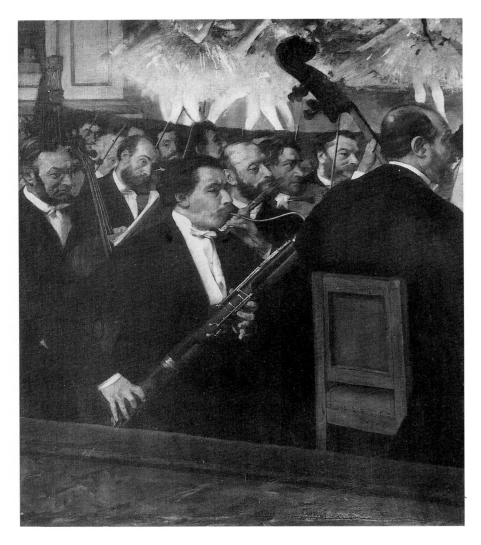

The orchestra of the Opéra
ca. 1870
Oil on canvas
56.5 × 46.2 cm
Paris, Musée d'Orsay
(L186)

Only the pair of pink ballet slippers to be seen through the legs of the horse, incongruously modern and western, provides us with the jolting realisation that this was Paris in 1867 at the Opéra. The shoes also convey the irony of their obvious uselessness to these performers.

Degas's next effort at combining portraiture and genre in the realm of the dance was more pedestrian but also more successful. He conceived a portrait of his bassoonist friend, Désiré Dihau, playing his instrument and surrounded by an orchestra in a pit, with a stage with a *corps de ballet* above (illus.). (Like *The family Bellelli* it seems to have been influenced by a lithograph by Daumier, this one published in 1852.)[59] Degas's orchestra was contrived, the location of the instruments not following any conventional pattern, and it contained friends of Dihau's and the painter's who were not even orchestral musicians. Dihau is slightly larger than the others and placed most frontally and centrally so that it remains his portrait. We nevertheless can count thirteen companions in the orchestra, in addition to Chabrier, the composer, in the box and to the dancers on the stage. (In the individuality of the forms of their heads, the members of this orchestra anticipate the extraordinary crania and hats of the plebeian orchestras and audiences that Degas would reproduce in his prints and paintings of *cafés-concert* and the ballet in the 1870s.) Against the orchestra, Dihau is very convincingly characterized, if not quite as completely absorbed in his music as he is in the freer monochromatic oil-sketch in the San Francisco Museums of Art (L187).

Above the sombre colours of the orchestra and the theatre, the pink and turquoise of the dancers' tutus on the stage open up the space and introduce a world of illusion and fantasy. They are nevertheless kept in their place by the way the top of the small painting cuts through their shoulders so that we cannot see their faces. In fact their movements do not seem particularly coherent. Nevertheless Degas must have found the dancers tantalizing, since in 1872 he combined the orchestra with the audience and compressed the band of the painting the former occupied in his *Ballet of Robert le Diable* (L294, New York, Metropolitan Museum), reducing the orchestra to three visible members in his *Musicians of the*

the nudes and of the landscape setting, theoretically in the Caucasus, reveals the influence of Courbet. In the larger painting, sent to the Salon, the solidity of the older artist's example is tempered by the introduction of garments and colour. Mlle Fiocre in her 'Georgian' dress presents a beautiful passage of blue, so decorative and so insubstantial that it reminded Emile Zola of Japanese prints, "so artistic in the simplicity of their tones".[58] The work could almost be classified as history painting, if the title were not a reminder that it is meant to be a painting of an actual person on the stage. The problem is that the stage is in itself a world of artifice. A dancer, like an actress, sheds her own personality and assumes another. We have unreal rocks and foliage, unreal water, an imitation heroine – very beautiful in themselves but evocative of fantasy rather than reality.

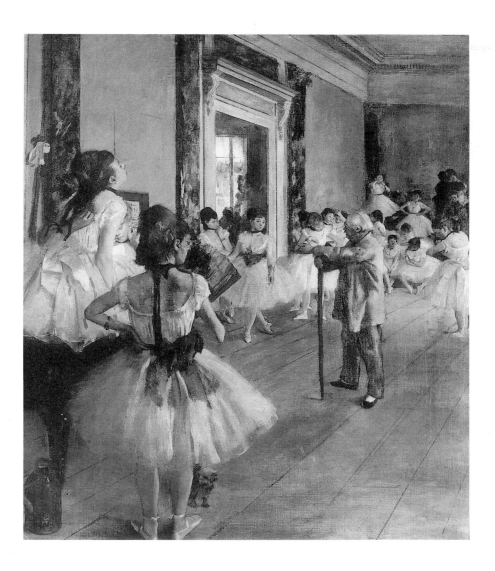

Dancing class
1873–76
Oil on canvas
85 × 75 cm
Paris, Musée d'Orsay
(L341)

sert", or, in another, "Kneel down, you fools, kneel down before the greatest master of them all".[60]

Degas soon moved from the orchestra pit to the stage and from the stage to rehearsal rooms and classrooms dedicated to the dance, and in the process from fantasy to reality. In the classrooms he was fascinated by the relative anarchy, as he recreates it in a work like the *Dancing class* of 1874–76 (Paris, Orsay, illus.), in which, while one dancer receives the concentrated attention of the male teacher, others practise different exercises and steps, others watch and others again chat, scratch their backs, yawn, tie their shoes or rest. Like the figures in *Portraits dans un bureau (Nouvelle-Orléans)*, they are all different but appear alike because they wear the same tutus. Within this lively cosmos Degas sought order, and found it about 1875 in that figure of authority, the ballet master.

Although performances of the dance, rehearsals on the stage or classes were predominantly female, and ballerinas commonly danced the male parts – Mlle Fiocre, for example, occasionally and Marie Sanlaville often – men worked beside them. There were male musicians (often a sole violinist), teachers, producers, directors and hangers-on and admirers. For an artist like Degas their presence provided desirably bold accents of masculinity and humour. However, the Orsay *Dancing class*, set in a high-ceilinged room like those in the old Opéra on the rue Peletier, appears particularly cloistered. The young dancers in tutus with coloured sashes include a bevy fluttering on the bleachers in the back, attended by their mothers – one embraces her daughter consolingly – but from the beginning Degas sought variation with only one male, the teacher or ballet master, and, as we know from the X-ray of the much reworked painting,[61] he originally intended to show only the male figure's back. The figure of the dance master revealed by the X-ray clearly derives from a pencil and charcoal drawing (Vente IV:206a, Chicago, Art Institute) of a rustic but muscular and strong young man who reveals, even from behind, the authority to command. Given Degas's predilection for backs, it is not too surprising that he arrived at this dramatic solution. But he changed his mind, perhaps because it was too simplistic, perhaps because he wanted an

orchestra (L295, Frankfurt, Stadelsches Institut). In these paintings at least half the canvas is now given to the stage, and the dancers on it are more articulated. Some elements of portraiture survive but the dance is in the ascendant. *The orchestra of the Opéra* is a great group portrait, an extension of a tradition going back to Dutch artists such as Frans Hals and Rembrandt, but original in the choice for its context of an orchestra pit in the theatre with a glimpse of the stage. It is good to know that a cousin of Désiré Dihau and his sister Marie, who taught singing, was Henri de Toulouse-Lautrec, who used to take some of his rowdy friends to the Dihau apartment where this painting hung, beside a beautiful portrait by Degas of Marie at the piano (L263, Paris, Orsay), and say, according to one version, "Voici mon des-

older, wiser and more paternal figure or perhaps just because he had recently met Jules Perrot.

Jules Perrot would have been sixty-five in 1875 when Degas dated the superb essence drawing (cat. 117, illus. p. 284) in which he holds a staff as he leads a ballerina we do not see through the steps of a dance. Perrot had been the leading male dancer and choreographer of the Romantic era in France, a partner of Marie Taglioni. In 1834, at what some would consider the end of the Romantic era, in the year of Degas's birth, Perrot left the Paris Opéra on a European tour, together with Carlotta Grisi, his mistress and, like Taglioni, one of the renowned Italian Romantic ballerinas. Until 1861, when he returned permanently to France, he was a freelance dancer and choreographer, working from 1842 to 1848 in London where he was the choreographer of the famous *Pas de quatre* for four great rival ballerinas of that period. Then he went to St Petersburg, where he became director and ballet master in 1851. When he returned to Paris at the age of fifty-one he did not succeed in finding an important appointment. Degas's personal opinion of the former great dancer and choreographer does not seem to have been recorded; we have only what we may infer from his paintings, drawings and one monotype.[62]

A chalk drawing (cat. 119, illus. p. 284) shows Perrot seated on an undefined bench in an otherwise abstract space, somewhat imperious, straining his conventional suit and revealing his well polished shoes. A painting (cat. 118, illus. p. 285), related to this, is even smaller, 35 cm high, showing Perrot in an almost identical position and with the same shining shoes. Colour reveals how nattily he is dressed, with a long black coat, gleaming white shirt and grey trousers. He is sitting in what must be his own sitting room with a rose-red settee and rug, greenish walls with frames, which could be for mirrors, pictures, miniatures or medals – under any circumstances souvenirs of his past glories. His head is worn and complex – the moustache white, but only a few touches of frost appearing at the periphery of his unconvincingly black hair. His frown seems gouged out of his forehead and extends angrily into his nose, his indecisive moustache and his discontented mouth. On either side of his nose, his eyes

and eyebrows are asymmetrical. He appears to be a small man, vain, a tragic wreck with great memories. Degas tried to moderate the impression in a much larger and softer pastel drawing of his head and arms (L367, owner unknown), but it is sad and sentimental, without the force that anger over present humiliations following past triumphs can bring.

Whenever it was that Degas decided to insert Perrot into the Orsay *Dancing class* as the great dancer of the past conducting a master class – it could have been before or after the sedentary portraits – he made a charcoal drawing, heightened with chalk (Vente III:157.2, Cambridge, Fitzwilliam), which harshly records the reality of Perrot in the position he assumes so much more harmoniously in the essence drawing (cat. 117, illus. p. 284) that followed. The glimpse of his profile is brutally unrelieved, his body and his suit are lumpy, and his stick seems more like a club than a wand. But for the essence drawing Degas presumably wanted some aura of the past. Although Perrot's position is the same, Degas makes it more expansive and more graceful. Perrot's clothes are simple working clothes but they enhance and conceal the body and are in their turn romanticised by the almost phosphorescent white. And the club has become a wand.

When he introduced Perrot as the commanding figure in *The dancing class* Degas did not glamorise him as he had in the essence drawing. His figure nevertheless provides a focus that unifies the young dancers in the painting, even when they ignore him. In this period, when the ballet had deteriorated,[63] Perrot must have evoked the greatest moments in its past. But there are different ways of seeing Perrot in this work. Eunice Lipton writes, "Jules Perrot, the renowned former dancer and instructor shown in the Musée d'Orsay's *The Dancing Class*, is an imperious figure, solidly rooted in place with the help of his stick. However, the complexity of the composition, especially the enormous size of the two dancers at the left and the intense oblique angle of the floor, turn him into a mere marker in the floor's path."[64] On the other hand George Shackelford comments: "When Degas inserted the figure of Jules Perrot, he charged the painting with an element of portraiture … *The Dance Class* became a

genre portrait."[65] It is Perrot, of course, who makes it such. The charming young, eager (or bored) little dancers are indistinguishable except in the colours of their sashes.

It cannot be denied that Degas saw Perrot as a hero – failed in the present, stellar in the past. As the floor empties around him – always a sign of tribute – we have to admit that *The dancing class* becomes a portrait acknowledging his past triumphs as a dancer. Degas retained his image and used it, reversed, in his first monotype (illus. p. 56), which he co-signed with Ludovic Lepic. In the predominantly black and almost cabbalistic underworld of the monotype a frail (and inevitably reversed) figure of Perrot somewhat diffidently encourages an exquisite dancer, behind whom the set explodes. Later Degas added jewel-like pastel to the second and lighter impression of this monotype (illus. p. 56). A loutish male spectator appears, apparently stunned, on the right, and female dancers emerge, including one at the left who seems to whisper into Perrot's ear. Perrot glows with enchantment with the young dancer before him, whose frail arms direct us heavenward. Nevertheless, although his right arm gracefully leads to her, it also follows the contours of the tutu of a young dancer who awkwardly bows (or leans) to rescue her costume. That this was intended to be something more indelicate than accidental is suggested by a drawing Degas made in one of the Halévy notebooks. In it Perrot, in the pose we know, faces his *alter ego* as he stretches his right arm over the *derrière* of a dejected young dancer.[66] We can suspect Degas admired his continuing or assumed desires.

Lipton's studies of the careers of the dancers in Paris in the second half of the nineteenth century indicate that they usually came from working-class families for which the ballet represented financial and social gains.[67] As Degas put it in one of his sonnets written in the late 1880s (VIII, *Petite Danseuse*), "Montmartre a donné l'esprit et les aieux" (If Montmartre gave the forebears, the spirit so wise . . .) and asks that she should ". . . garde, au palais d'or, la race de sa rue" (And see, for my sake, that, in her golden palace, she remembers her race, her descent from the street.) The girls' apprenticeship was, however, hard and demanding. In the late

1870s Degas was attracted by the dancers in puberty who tried so valiantly but seldom attained the grace for which they strove. In the same sonnet he mentioned "Le petit être neuf, à la mine hardie" (That creature so new, so gallant of mien.)[68] On his drawings he often made notes about their small successes and failures. And in another sonnet (IV, *Danseuse*) he juxtaposes their "dessins de plaisir" with this ending:

Mais d'un signe toujours cesse le beau mystère
Elle retire trop les jambes en sautant:
C'est un saut de grenouille aux mares de Cythère.[68]
But with a sign the beautiful mystery always comes to
 an end.
She pulls in her legs as she jumps
And in the pools of Cythera the dance becomes the leap
 of a frog.

Degas admired these young girls' efforts to master this difficult art, but it is seldom that any emerges from the anonymity of her tutu. Nevertheless he left us the names of a few. On one drawing of a youngster (illus. p. 57), with frail arms and untidy hair, seated on the floor as with great effort she flexes her ankles, Degas wrote at the lower left corner, "*Melina Darde/15 ans/d'aujourd'hui à la Gaïeté/Dec. 78*". At upper left he describes her, "pale, green, bruised hands, low bodice like a cuirass in white *piqué*",* and at upper right, "light chestnut hair, her head is covered all round with a spray of hair except at the front".* Another drawing in the Louvre (Vente III:133.3, RF 4643) shows a pose so similar that it also seems inescapably Melina Darde. A study of her legs and a hint of a profile with an arm outstretched in an arabesque (Vente IV:181, art market) has "*Melina*" written under her arm by Degas. On a drawing of her in the second position with both arms and her right leg outstretched (III:339.1, New York, private collection), Degas wrote "*Melina Darde*" below her tutu. It is possible to make other identifications of her in relation to these drawings, as Browse has done,[70] but a personality does not assert itself. And no information about her beyond Degas's notes on the drawings has been discovered. Obviously Degas found her posing useful in his study of the movements of the dance. And equally, when he made the two drawings of her seated on the floor, he felt a certain

*pâle, vert, marbré / mains brisées / corsage bas comme une cuirasse en piqué blanc.

*cheveux châtains clairs/ tout le tour de la tête est couvert d'une poussière de petits cheveux excepté le devant.

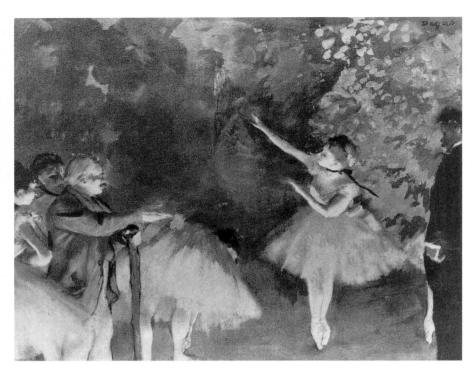

Ballet rehearsal, ca. 1875, pastel, gouache over monotype, 55 × 65 cm, Kansas City Museum of Art (L365)

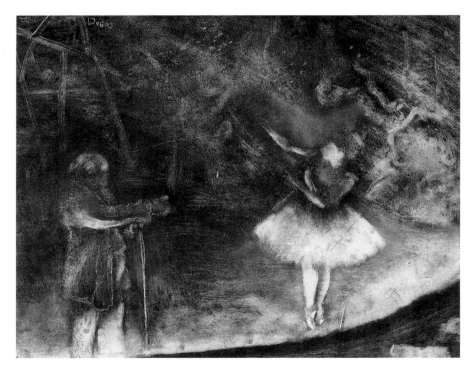

The ballet master ('*Le maître de ballet*'), ca. 1874–75, monotype, 56 × 70 cm, Washington D.C., National Gallery of Art (Janis 1)

affection as he looked down on the young dancer posing for him. The results, however, were never a form of portraiture.

At the top of one sheet, now in the Louvre (illus. p. 58), with four views, mainly half-length, of one young dancer, Degas wrote, "*36 rue de Douai. Marie*". Marie was Marie van Goethem, born 17 February 1864, one of three daughters of a tailor and a laundress who were originally from Belgium. All three sisters studied dance and Marie at least worked as a model as well.[71] Her chief claim to fame is that she posed for the only piece of sculpture Degas exhibited in his lifetime, *The little fourteen-year-old dancer* ('*La petite danseuse de quatorze ans*'). The drawing with her first name and address is one of sixteen on six sheets Degas made of her; he also made a smaller statue of her nude (illus. p. 58) leading up to the work of sculpture which has become beloved through posthumous bronze casts with tutus of gauze and her bronze hair tied by a silk ribbon (cat. 158, illus. p. 286).[72]

La petite danseuse de quatorze ans deserves to be in an exhibition of Degas's portraits because Marie van Goethem is the most idiosyncratic of Degas's dancers. Even if we did not know her name, she would be distinctive. One of her lesser individual characteristics, but one of which we assume Marie van Goethem was proud, was her mane of coarse black hair. Her eyes seem slanted, even at times exotic slits, which may explain Degas's reference in his Sonnet VIII to "La Chine les yeux" (eyes from China). Her head in itself is so distinctive because it is boldly modelled with strong, clear, uninterrupted planes. On the only occasion that the work was exhibited in Degas's lifetime, in the sixth Impressionist exhibition of 1881, there seemed to be unanimity in considering her ugly.[73] One reason for this may simply have been that she was a child of the streets and utterly without artifice. But that Degas saw more in Marie's face than his critics – and not just in the planes of interest to a sculptor – can be deduced from the drawing on which he inscribed her name and address. Three sketches of Marie – awkward, plain and almost colourless – are not directed towards, but lead to, the fourth in the upper right corner of the sheet, showing a frontal figure whose hair is black, whose eyebrows are

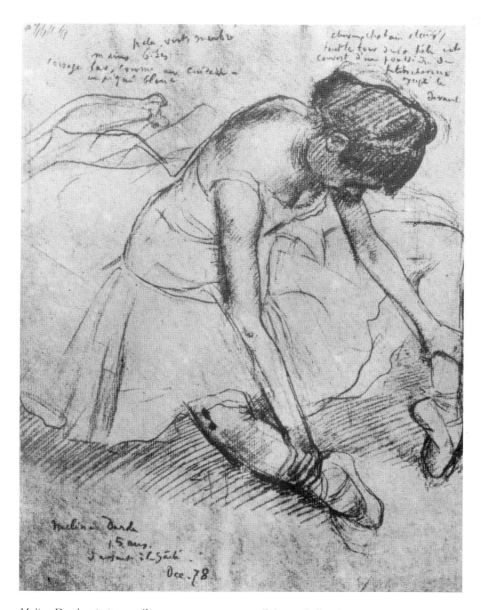

Melina Darde, 1878, pencil on paper, 31 × 23 cm, Private Collection

strong and slightly raised, whose eyes are reflective and whose mouth is sensual. Even her throat has a potential sexual appeal. It is as if Degas perceived the moth emerging from the cocoon.

But aside from the potential of adolescence itself, which is surely one of the attractions of the finished work of sculpture, Degas from the first seemed to have found individuality in the way Marie van Goethem handled her body. It was, again, not a beautiful body as we see it in his drawing of her nude (cat. 159, illus. p. 287) – thin from emaciation or at least poor nourishment, angular, even almost hermaphroditic[74] – stationary, but full of that potential for both movement and growth. Above all she carries herself proudly. We do not know the sequence of the six drawings of sixteen poses made of Marie for the statue – and no one has proposed an order that cannot be challenged – but it is generally believed that from the beginning Degas must have conceived her in a tutu with a ribbon around her hair, though he worked his way through nude studies to the final work.[75] The smaller statue of her nude would also have preceded the larger dressed figure.

The smaller statue would fit into the the late Kenneth Clark's classification as naked rather than nude.[76] She is the gosling, the cygnet, the Romanesque soul in Purgatory. But she never loses that self-confidence and pride. She stands with her spine straight, her shoulders back, her right leg thrust out ready to carry her in a dance, her arms reaching out behind her so that her hands find each other, forming a beautiful balance to her body. Her head is held upward. She may be only fourteen but she is indefatigable.

Degas's decision to dress the larger statue as if Marie were a doll in one way made her more accessible but in another may have made her more shocking. In any case Degas famously decided to give her a wig of real hair, a buttoned bodice of real fabric, real slippers whether made for her or off the shelf, a real tutu and a real ribbon, which seems to have been a pale green, around that famous lank of hair. This meant that the wax statue was polychromatic. Polychromy was not unknown in nineteenth-century sculpture in France and, as Reff most interestingly points out, the Grévin Museum of wax sculptures, which opened the year after *The little*

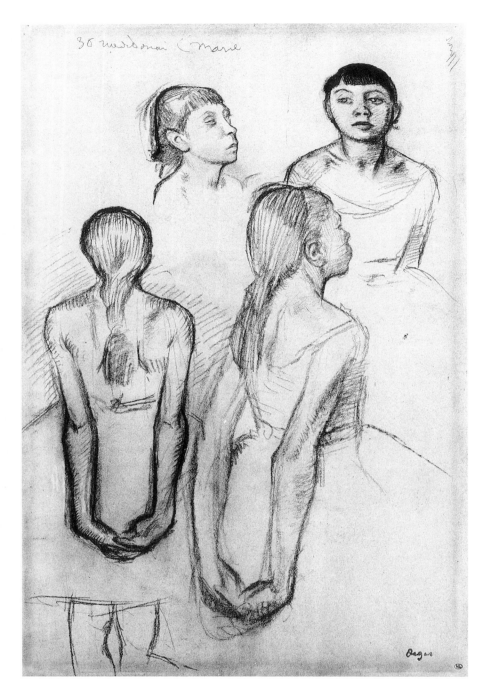

Four studies of a dancer, 1878–79, charcoal, heightened with white, on paper, 49 × 32.1 cm, Paris, Musée du Louvre, Cabinet des Dessins

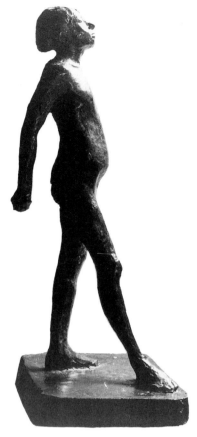

Nude study for *The little fourteen-year-old dancer* ca. 1878–80
Bronze
73.5 × 34.9 cm
Washington D.C.,
National Gallery of Art
(Pingeot 37)

dancer was shown, contained a diorama of Rosita Mauri, a more mature dancer Degas used as a model, against the sets of a dance.[77] But Degas's polychromy was rich and subtle, seeming to find its inspiration in the translucent depth of the dark wax from which it was formed.

The statue in itself is such an indestructable image that the remark of Mary Cassatt in 1918 that "it is more like Egyptian sculpture" is just.[78] The pride of the pose, the axiality of the body, the stride (if modified) of the right leg, could be Egyptian. We are convinced that the *Dancer* is equally enduring. But we can never forget the streets of Montmartre which made her such a valiant and memorable devotee of the dance.

NOTES

1 For information on both Pellegrini and Degas's portrait of him, see Ronald Alley, Notes on some Works by Degas, Utrillo and Chagall in the Tate Gallery, *The Burlington Magazine*, 100, no. 662, May 1958, p. 171, and *idem*, *Tate Gallery Catalogues: The Foreign Paintings, Drawings, and Sculpture*, London 1959, no. 3157, pp. 50–52.

2 *Degas inédit* 1989, BN 3(1), p. 361, letter to Tissot from New Orleans, 18 February [1873]; translation *Letters* 1947, 6, p. 31.

3 See Pantazzi in 1988–89 Paris/Ottawa/New York, pp. 278–80.

4 For the most complete description of Cavé, see Loyrette 1991, pp. 520–23.

5 For the most detailed description of the complicated publishing of the *Cardinal* stories between 1870 and 1883, with three different illustrations, see Pantazzi in 1988–89 Paris/Ottawa/New York, pp. 286–87. Some of Degas's monotypes illustrating the stories were exhibited in the third Impressionist exhibition in 1877.

6 Janis 195–200, 209, 211–15.

7 Reff 28, private collection, New York; Reff 29, E.V. Thaw collection. Both are reproduced in Halévy 1949.

8 Janis 82, 85, 86, 114, 184, 185. See Pantazzi in 1988–89 Paris/Ottawa/New York, p. 296, on the question of their being shown in the third Impressionist exhibition in 1877.

9 Reff 30, BN 9, 1877–83, p. 210; translation Kendall 1987, p. 113.

10 Vente, Collection Edgar Degas Estampes, Hôtel Drouot, Paris, 6–7 November 1918, nos. 324–31. Normally each lot contained many prints.

11 Lipton 1986, pp. 26–28.

12 Lemoisne 339, quoting Julie Manet, the daughter of Berthe Morisot and Eugène Manet, later Mme Ernest Rouart.

13 Dated pastels of Mlle Lala are L523, London, Tate, 24 January 1879; L524, private collection, 21 January 1879; L525, Speed Museum, Louisville, 19 January 1879; and there is a drawing dated 25 January 1879, IV: 255a, Barber Institute, Birmingham. For architectural studies, which are also perspective studies, see Reff 31, BN 23, pp. 30, 36, 37, and, in particular, IV:255b, Barber Institute, Birmingham.

14 Reff 18, BN 1, 1859–64, p. 204, with this note by Degas: "Portrait d'une famille dans une frise ... Il pourrait y avoir 2 compositions, l'une de la famille à la ville, l'autre la campagne".

15 Louisine W. Havemeyer, *Sixteen to Sixty, Memoirs of a Collector*, New York 1961, p. 258.

16 Reff 1976, pp. 147–99, discusses Degas's relationship to literature; see also the essay by Luzius Keller in this volume.

17 Valéry 1985, pp. 126, 128.

18 See Lipton 1986 for detailed information on probable occupations for women then.

19 Alexandre 1918, p. 14 (translation from Reed/Shapiro, p. 119); disputed by Pantazzi in 1988–89 Paris/Ottawa/New York, p. 320, note 5. For information and photographs of Andrée, see Pantazzi, *ibidem*, pp. 285–86, figs. 140, 142, and Rewald 1986, pp. 48–50, p. 49, fig. 60.

20 Sickert 1917, p. 186, quoting Degas on "that bored and respectfully crushed and impressed absence of all sensation that women experience in front of paintings".

21 See Broude 1988.

22 Reproduced in 1988–89 Paris/Ottawa/New York, p. 196, fig. 209.

23 See also IV:150b, private collection, and IV:299b, Reed/Shapiro 51, 52, which reproduces related drawings.

24 Brown 1994, pp. 122–25; p. 125, fig. 17.

25 In Reff 26, BN 7, a notebook Reff dates to 1875–77, is a preparatory drawing of the buildings by Gabriel in the background of the *Place de la Concorde*, p. 96, and Lepic's name is listed with others being considered for the second Impressionist exhibition in 1876, p. 99. These seem to be the only external clues to the dating of the painting.

26 Varnedoe 1980, pp. 68–78.

27 Ludovic Lepic, *Comment je devins graveur à l'eau-forte*, Paris 1876.

28 *Lettres* 1945, CXIC [no date], pp. 149–51.

29 Degas 1946, Sonnet VI.

30 The information on Lepic's life and background comes from Professor Emeritus Harvey Buchanan, Case Western Reserve University, Cleveland.

31 Valéry 1985, p. 126.

32 Loyrette 1991, pp. 741–42, note 179.

33 See Ann Distel, 'Jeantaud, Linet, Lainé', in *Degas inédit* 1989, pp. 203–10.

34 Pantazzi 1988, 7 July 1875, p. 125.

35 Boggs 1962, pp. 16–17, 10, fig. 18 (colour), as 1863–64; Lemoisne 126, as ca. 1865; Loyrette in 1988–89 Paris/Ottawa/New York, pp. 120–21, as 1865–66. I believe we all have ignored the probable ages of the Bellelli sisters.

36 Minervino 1974, p. 95, nos. 212, 212a.

37 BR 52, 53.

38 Lemoisne places question marks after Malo for L441, L442, but not for L443, L444 (Birmingham, Barber Institute). He dates the works to 1877. In Boggs 1962, p. 52, I suggested that Degas used one model and played with her age. The question of Mlle Malo is further complicated because the former dancer with whom Achille De Gas was involved in the 1875 shooting was named Thérèse Mallot. See McMullen 1984, pp. 250–51.

39 Camilla's son, Francesco Russo Cardone di Cicerale, assured the author that Camilla was the sitter.

40 Jamot 1924, p. 59, gave Mme Marcel Guérin credit for suggesting that the girls are at a piano.

41 Pantazzi 1988, 7 July 1875, p. 125.

42 Reff 31, BN 23, pp. 67–68.

43 Pickvance in 1979 Edinburgh, p. 53, no. 53, points out that the dated drawing was later enlarged by adding a piece of paper and largely covered with pastel. It is L518, private collection.

44 *La Nouvelle Peinture. A propos du groupe d'artistes qui expose dans les Galeries Durand-Ruel*, pamphlet, Paris 1876, is available in the exhibition catalogue, *The New Painting. Impressionism 1876–1886*, ed. Charles S. Moffett, Washington, National Gallery of Art/San Francisco, Fine Arts Museums, 1986, pp. 37–49 (English), pp. 447–84 (French).

45 Joris-Karl Huysmans 'L'exposition des Indépendants en 1880', 1883, p. 117; translation 1988–89 Paris/Ottawa/New York (English edition) p. 310.

46 Huysmans 1883 (see preceding note), p. 119.

47 Baccio M. Bacci, *Le '800 dei macchiaioli e Diego Martelli*, Florence 1969, p. 116, letter of Martelli to Matilde Gioli, 25 December 1877; translation 1988–89 Paris/Ottawa/New York (English edition), p. 312.

48 Piero Dini, *Dal caffè Michelangiolo al caffè Nouvelle-Athènes – I macchiaioli tra Firenze e Parigi*, Turin 1986, p. 59.

49 *Lettere dei macchiaioli*, ed. Lamberto Vitali, Turin 1953, p. 304, letter from Zandomeneghi, quoting Duranty, to Martelli, November 1894.

50 See Broude 1988, pp. 647–48.

51 Marc de Montifaud, Exposition du boulevard des Capucines, *L'Artiste*, ser. 9, vol. 19, 1874, p. 309.

52 Reff 6, BN 11, 1856, p. 14; translation 1988–89 Paris/Ottawa/New York (English edition), p. 174.

53 *Ibid.*, p. 9.

54 Loyrette 1991, pp. 268–71.

55 *Lettres* 1945, I, 11 November [1872], to Désiré Dihau, p. 20.

56 Dumas 1988, p. 22.

57 Dumas 1988, pp. 24–33. This is the most convenient place to see reproductions of the preparatory drawings together. It is also the fullest documentation of the painting.

58 Emile Zola, 'Mon Salon, M. Manet', *L'Evénement*, 9 June 1868; to be found in Emile Zola, *Mon Salon, Manet, Écrits sur l'Art*, Paris: 1970, p. 165.

59 Daumier, L'Orchestre pendant qu'on joue une tragédie, in *Croquis Musicaux*, no. 17, 1852 (LD 2243).

60 Henri Perruchot, *La Vie de Toulouse-Lautrec*, Paris

1958, p. 369. The second story had been told by Mlle Dihau to Professor Paul J. Sachs of the Department of Fine Arts, Harvard University, one of the most discriminating collectors of Degas's drawings.

61 For a reproduction of the X-ray see 1984 Washington, p. 48, fig. 2.5.

62 For the life of Perrot see Loyrette 1991, pp. 362–64, and Ivor Guest, *Jules Perrot, Master of the Romantic Ballet*, London 1984.

63 Browse 1949, p. 46, points out that "Degas lived through the period in which French ballet for the first time in its history lost its inspiration and became sterile".

64 Lipton 1986, p. 110.

65 Washington, 1984, p. 52. Shackelford's discussion of the work is found between pp. 49–53.

66 Reff 28, private collection, New York, p. 41.

67 Lipton 1986, pp. 79–80, points out that "The aura of the ballet dancer in the 1870s and 1880s was very much like that of the movie star today". On p. 89 she states that "The family backgrounds of the dancers working in France were roughly of two kinds. Some had fathers in the military, and others had at least one parent in the theater". She also believes, p. 89, "Concerning the dancers' finances, simple deductions from contemporary social data tell us that they could not possibly have been poor".

68 Degas 1946, Sonnet VIII; translation *Letters* 1947, p. 264.

69 Degas 1946, Sonnet IV.

70 Browse 1949 adds her nos. 66, 67, 69 to the works identified as Melina Darde.

71 Millard 1976, p. 8, note 26, for information on Marie van Goethem and her family. In addition to this book on the artist's sculpture and the extensive bibliography in 1988–89 Paris/Ottawa New York under 'Selected References', no. 227, pages 352–53, see Pingeot, plates 33–35, no. 73, pp. 188–90.

72 The drawings to which reference is not given in the text are: L586bis, private collection; L685ter, Chicago; III: 277, private collection; and IV: 297,a, Oslo.

73 See Millard 1976, Appendix, 'Critical Reaction to the Exhibition of the Little Dancer in 1881', pp. 119–26.

74 The drawing might be considered an evasion before female anatomy if Degas's drawings of the vulvas of female nudes had not been so specific in his studies, now in the Louvre, leading to *Les malheurs de la ville d'Orléans* (L124, Paris, Orsay), which he exhibited in the Salon of 1865.

75 It is difficult to summarise the history of this work. It was announced for the fifth Impressionist exhibition in 1880 where only an empty case was shown. It did appear in the exhibition the next year but apparently two weeks

after the opening. It was, of course, in wax with other materials such as fabrics, shoes and human hair. It was not publicly exhibited again during Degas's lifetime but some of his friends did see it. About 1903 Degas considered having one cast in bronze made from it for Mrs Havemeyer but she wanted the wax. Pantazzi has suggested in conversation that it may have been then that Degas rubbed wax into the fabrics and the hair to make the proposed casting possible. The cut, length and colour of the tutu have always been a matter of disagreement. The photographs of the wax statue taken in 1919 show it as layered, longer, and with an irregular hemline. The original wax is now in the collection of Mr and Mrs Paul Mellon in Virginia. The bronzes were cast in 1921 and 1922. It is thought that something like twenty-two were cast, but the figure is not certain. See Pingeot, p. 190.

76 Kenneth Clark, *The Nude*, 1956, chapter I, 'The Naked and the Nude', pp. 3–29.

77 Reff 1976, p. 247. Although there is no agreement about any dance work for which Mauri posed for Degas, his friend Georges Jeanniot (Jeanniot 1881, p. 153) has described a visit he made to Lepic's studio in 1881 where Degas and Lepic were drawing two young dancers and two stars (Sanlaville, Lepic's lover, and Mauri). He tells us, "Les mouvements étaient donné par les élèves du corps de ballet, les têtes par les deux étoiles". And he added, "La vie a de ces surprises".

78 Unpublished letter, The Metropolitan Museum of Art, New York, Mary Cassatt, Grasse, to Louisine Havemeyer, 9 May 1918.

III. Explorations from 1881 until the End

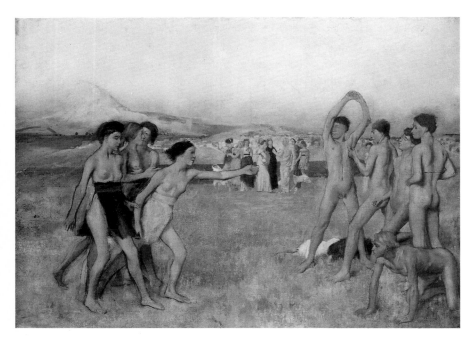

The little Spartiate girls provoking the boys, ca. 1860–62, oil on canvas, 109 × 155 cm, London, National Gallery (L70)

Portraits and sculpture

When Degas planned his submissions for the fifth Impressionist exhibition in 1880 he decided to revive a work he had probably begun exactly twenty years before. This is *The little Spartiate girls provoking the boys* ('*Petites filles spartiates provoquant des garçons*'; illus.), arguably the most beautiful and resolved of his early history paintings. Significantly, in relation to the young dancers he had been painting and drawing and, in particular, to *The little dancer*, which he meant to show in the same exhibition, *The little Spartiates* is a painting about adolescence. Conforming to the tradition of history painting, however, it is seen through the story of a ritual in which young Spartan girls taunted Spartan youths to compete in exercises, with their elders grouped in the background.[1] It has been suggested that between 1860 and 1880 Degas may have retouched the painting and that the version of *The little Spartiates* that is in the Art Institute of Chicago (L71) is closer to his original intention.[2] In the London version the two young girls at the front are less bellicose, more vulnerable and more appealing. Their hair is cut so that the wind blows through it. Their slender arms manage to indicate both daring and hesitation. The positions of the five youths have been changed so that they are more overtly defensive and self-confident. Whether these changes were made about 1880 or at some time during the twenty years before, the girls and boys seem Parisian urchins – brothers and sisters, in spirit and experience, of Marie van Goethem, *la petite danseuse*. It is probably relevant that in Degas's list for the 1880 exhibition the first item was *Les petites spartiates*, bearing the date of 1860, and the second was *La petite danseuse*. The term "*petite*" seems to have been used for both pictures as a form of affection rather than as an indication of scale.

In the London *Petites filles spartiates* importance has been given to the profiles of the male youths by redrawing the positions of their figures. These profiles could be described as awkward, gauche, impudent and always convincingly adolescent. The girls are somewhat more tender, like *La petite danseuse*. The *Petites spartiates* is a history painting with no hint of portraiture but with a whiff of the flavour of life in Paris in the second half of the nineteenth century.

Whether or not Degas retouched it in 1880, it was very much on his mind, as is clear from his desire to exhibit the painting.

Four months after the *Petites spartiates* and *La petite danseuse* were expected but did not appear in the 1880 Impressionist exhibition, on 27 August 1880 to be precise, Degas sat in a courtroom in Paris at the trial of three of four young criminals charged with three vicious murders. One had been of an old woman, the widow Joubert, whose newsstand was near Degas's apartment,[3] and the painter's friend Paul Valpinçon was one of the four jurors. Another friend, Ludovic Halévy, had recently visited, with police officials and a critic from *Le Figaro,* the quarters in Paris where the criminals had lived, and had been horrified by the slums that could have determined their characters. Halévy wrote in his journal of the devastating effects of the environment on the inhabitants: "There they were, dismal, dejected, stupefied, stunned".[4] Following the case in the newspapers, the public was titillated to learn that two of the criminals (Emile Abadie and Pierre Gille) had been employed as extras in the Ambigu Theatre where a dramatization of Zola's novel of 1877, *L'Assommoir*, was being performed – a powerful story of amorality, impoverishment and ultimate absolute degradation. There were many circumstances to explain why the urchins of *Les petites spartiates* might have turned into these hardened criminals: heredity, evolution, environment, poverty and even the influence of a powerful Zola novel; Druick and Zegers have brilliantly analysed the discussions of these by the articulate public of the time.[5]

In the courtroom Degas made strong drawings in black chalk in a small notebook of the profiles of at least three of the four prisoners who were ultimately sentenced to life imprisonment, their death sentences being commuted because of their youth. From these drawings he developed pastels, refined in execution and delicate in colour. It is interesting that he chose to use the profile for the two figures in *Criminal physiognomies* (cat. 161, illus. p. 289), perhaps because this was the view he had of them in the court itself, perhaps, as has been suggested by Loyrette,[6] because profiles, like police mug-shots, would be most immediately identifiable – perhaps

also because he had in mind his Spartan youths. His criminals are strongly characterized but stop short of caricature since there is no glimmer of humour. As if he were carving a cameo in relief, Degas made the delicate contours very precise.

Today there seems to be some confusion about which criminal is which. Presumably the one on the left with the black cap of hair, swarthy complexion, black suit, brows and slight moustache is Emile Abadie, the ringleader of the murderers, whose victims included his former mistress. He appears to be aggressive and not unintelligent. His companion, Michel Knobloch, who had confessed to one of the murders in December and implicated the other three, is overly refined with his untidy red hair, pink eyes, white skin and pale blue suit with a white cravat. Identification is difficult because Loyrette proposes that Degas may even have worked freely with their features, exchanging their noses, for example.[7] Loyrette concludes that there are "enough differences so as not to consider them portraits".[8]

When Degas showed two *Criminal physiognomies* at the sixth Impressionist exhibition in 1881 the critics not unnaturally regarded them as characterizations of the criminal mind – Abadie on the left brutal, Knobloch on the right more delicate but vicious still. Their destiny seems expressed by the white chalk épaulette of the guard at the left, which looks like a bone, a *memento mori*. Degas's suggestion of concentrated evil is almost claustrophobic. Whatever the explanation may have been, he recognised sin.

It has been believed – both in 1881 and recently – that as a result of his interest in physiognomy Degas was tempted to find analogies between human beings and animals; his interest in science, stimulated by his friend Edmond Duranty who died in 1880, made him consider criminality the consequence of evolution, and an interest in ethnographic models was encouraged by his friendship with Lepic, who was working on dioramas for the new ethnographic museum at Saint-Germain-en-Laye.[9] He was testing the premise that criminals would adhere to certain primitive physiological types and consequently that those same types would suggest a criminal. This *Criminal physionomies* and another

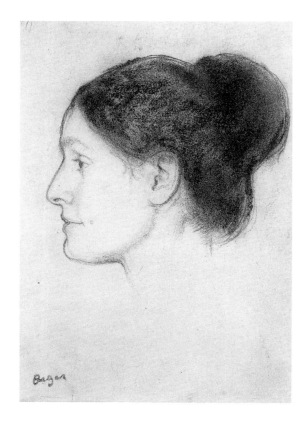

(L639, whereabouts unknown) were exhibited in 1881 at the same show as *The little dancer*, upon whom many of the same epithets were hurled – that she was like an animal or an ethnographic specimen or an Aztec figure. But where she is proud and optimistic, these two youths are degraded and defeated. Their tragedy is that their lives are essentially behind them before they are twenty, whereas she has a future, however precarious. They represent a denial of life rather than its affirmation.

In 1883 Degas drew two other remarkable profile portraits of a very different – and happier – kind. Both were of twenty-one-year-old Hortense Valpinçon at her family's place in Normandy, Ménil-Hubert, which Degas had been visiting for over twenty years and where he had painted a charming portrait of Hortense as a little girl in 1871 (L206, Minneapolis, Institute of Arts, illus. p. 111). He had introduced her, when she was younger still, into the background of his portrait of Henri Valpinçon as a child (cat. 106, illus. p. 207). The drawing that is inscribed "*Hortense/Ménil Hubert/août 1883*" (New York, Metropolitan Museum) is simple but strong, emphasizing her classical features (although it does

not ignore a small mole near her mouth) and building up her hair against the right of the sheet as if it were an architectural form like a caryatid. In the second (illus.), Degas used pastel to soften her skin and hair, pulled her head out from the edge of the page so that we see the beautiful contours of that hair, and made her daintier as if she had been drawn by an eighteenth-century pastelist such as Quentin de la Tour, whose works he so much admired.

The next summer, when Degas again visited Ménil-Hubert, the Valpinçon family persuaded him to try another portrait of Hortense.[10] This time he chose sculpture, a medium with which he had very little success for portraiture. A bust he was to make of his friend the Venetian painter Federico Zandomeneghi in 1895 (Pingeot 76) was considered a failure and destroyed. His two versions, probably of 1892, of a bust of Mathilde Salle (Pingeot 69 and 70), a dancer at the Opéra from 1888 to 1919, are compelling but ambiguous works, more interesting for their anticipation of twentieth-century sculpture than as portraits. The *Portrait, head leaning on hand* (Pingeot 71), dated between 1892 and 1895, has considerable charm but could be considered small and inconsequential. It has been identified as either the first Mme Bartholomé or Rose Caron, who, from the visual evidence we have, must have resembled one another.[11] Unquestionably the bust "with arms" (as Degas always added in his letters) of Hortense Valpinçon was his most ambitious attempt at a portrait in three dimensions.

Degas's description of the bust to his friend, Bartholomé, who had given up painting for sculpture with Degas's encouragement on the death of his first wife in 1887, does not augur well for its survival: "And so as to occupy myself I set to work on a large bust with arms, out of clay mixed with small pebbles".*[12] Nevertheless he persisted for what must have been several months at the Valpinçon château in the Normandy countryside. As he wrote to Henri Rouart it was "one of the longest stays in the country that I can remember".[13] He also admitted that he was finishing it "very patiently and laboriously".*[14] On the other hand he informed Ludovic Halévy, "C'est long, bien que fort amusant".[15]

In a long letter to Bartholomé towards the end of

Mlle Salle
1886
Pastel
50 × 50 cm
Private collection (L868)

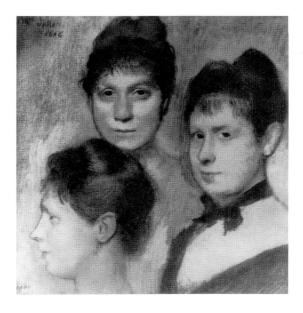

*Ce qui fait que je
m'acharne à de la
ressemblance et même à
quelque chose de plus.

*Il y a deux bras, je vous
l'ai dit ; qu'il vous suffise de
savoir aussi que,
naturellement, il y en a un,
celui dont on voit la main,
derrière le dos.

this stay at Ménil-Hubert, on 3 October 1884, Degas included a rough sketch of the "bust", which not only had arms but even some of the torso below the waist. From the rudimentary sketch the work promised to be classically simple. Hortense is hatless and wears a plain, fitted dress with a turtle neck and long sleeves. The drawing shows the proposed bust to be fundamentally frontal and symmetrical with as much apparent life as a rag doll. Pingeot cleverly places this drawing in her catalogue beside a small bronze by Degas of a full figure, '*L'Ecolière*' (Pingeot 74), which we have reason to believe Degas modelled about 1882 after his niece Anne Fevre, later comtesse de Caqueray.[16] They have in common an arm behind the back, the left in *L'Ecolière*, the right for Hortense Valpinçon. That this had a significance for Degas in his "bust" of Hortense is clear in the letter to Bartholomé with the sketch where he says, "There are two arms, I have already told you so; let it suffice you to know as well that naturally one of them, where the hand is visible, is behind the back".*[17]

Since 1884 was the summer in which Degas went to Dieppe and organized groups to be photographed by the Englishman Walter Barnes, it is amazing – and unfortunate – that the "bust" of Hortense was not photographed when in progress. It is even more disturbing when we realise that Degas wrote to Ludovic Halévy, "[this] makes me furiously pursue a likeness and even something more".[18] Degas had the problems of casting in mind and on 15 September informed Bartholomé, "I shall certainly be back in Paris by the end of this week, and . . . it will be necessary to return to Normandy with a mouldmaker to be sure of the cast and also the durability of the work".[19] Lemoisne succinctly describes its ultimate fate, "Unfortunately this bust . . . was destroyed as soon as an effort was made to cast it. Nothing survived except a piece of the back which led a wretched existence in his studio for a long time".[20]

The beautiful Hortense with the classical features was not to be made immortal by Degas in three dimensions. Ironically we know her best through a group of photographs, perhaps directed by Degas at Ménil-Hubert, when an older but still beautiful Hortense, with a husband, dog and, in one frame, a male visitor dance with Degas in front of the château.[21]

Three characteristics are probably already evident about Degas's portraits in the 1880s. First, his sitters are young but not so young as the adolescents who had interested him in the 1870s. Hortense was in her early twenties. Mathilde Salle, the dancer whose head Degas drew in pastel from three different angles and represented at three different ages, would have been nineteen when Degas dated the work "1886" and inscribed it with her name (illus.). She appears this age in the profile view in the lower left corner, which is reminiscent of his pastel profile of Hortense. Secondly, besides preferring young adults he was, after the *Criminal physionomies* were exorcised, essentially benevolent in his portraits. His sitters had always inevitably been his friends but now he did not subject them to the same penetrating analyses as in the past. Nor did he look down at them from a height; instead he confronted them directly and amicably. He was no longer witty at their expense. Thirdly, he seldom gave his sitters a setting, such as would place them in the social fabric of France in the 1880s. Admittedly he did give his two criminals the edge of a dock but the background is basically charcoal, freely and thinly stroked over brown paper. Mlle Salle's background is simply pastel richly and colourfully applied. He was more unselfconsciously subjective – apparently feeling no

need to find justification by recreating the reality of contemporary life.

These changes do not mean that Degas was no longer observant. A comparison of the profile of Mlle Salle (illus. p. 65) with the profile of Hortense Valpinçon (illus. p. 64) is instructive. Hortense is admittedly two years older but it is not age that accounts for the stronger chin, the more confident mouth, the straighter nose, the exposed forehead, the hair built up in a triumphant bun. There are no other indications that she is a young woman from a background that was privileged in its very security. Mathilde Salle, on the other hand, although adorable, has a chin that recedes, a nose that bows, eyebrows that almost disappear by contrast to Hortense's firm arches, soft bangs over her forehead, and hair which, although lustrous, does not have a decisive form. A smile nevertheless seems ready to break through her lips, her ear is very pretty, and, although slightly flawed, she appears prepared to please, as indeed she did. Although she was with the Opéra from 1888 to 1919 as a dancer and instructor, she also had two famous protectors, the collectors Isaac de Camondo and Henri Vever.[22]

In 1886 Mathilde Salle's formal career at the Opéra had not begun and her liaisons with Camondo and Vever were probably still in the future. Degas was nevertheless fascinated with what Mathilde Salle would become – self-assured and even brazen in the three-quarters view at the right or a faded beauty, with humour in the mouth still, in the frontal view towards the top – or perhaps, during a moderately long life, she would encompass both.

Degas's portraits in the 1880s, if not always reduced to a profile like a cameo, were on the whole simply composed. One young woman with deep black eyes in a wistful face was his model for three portraits of which this is true. In one (L802, private collection) she holds her head up proudly, the turtleneck of her dress and the large brooch at her throat emphasizing her independence. In another (L803, private collection) she sits perfectly symmetrically in a wide *bergère* chair, putting out her hands to its arms as if to seek support. In the third (cat. 170, illus. p. 247) she merely tilts her head and puts the fingers of her right hand on her chin a little as if

to prop it up, but more to suggest her hesitations. This gesture of her hand toward her chin has none of the drama of the earlier *Woman with her hand across her mouth* ('*Jeune femme la main devant la bouche*'; cat. 123, illus. p. 243) or even of Thérèse's right hand in the portrait of her with her husband Edmond Morbilli (cat. 73, illus. p. 185), although it also makes us aware of her mouth. It is a speculative gesture, thoughtful, emphasizing the lack of focus in her face as she dreams. Her hesitancy is echoed by Degas's own strokes of pastel, meagre in the background, changing direction in the contours of the bodice, reworked on the hand. It is a gentle portrait, as Degas's portraits of the 1880s tend to be.

Portraiture versus genre, 1880–86

Occasionally Degas broke away from the simplicity of his portraits in the 1880s. One such case was when planning a painting of Mme Ernest May in 1881 beside the crib of her new-born infant. Mme May's husband was the principal figure in *Portraits à la Bourse* (Portraits at the Paris Stock Exchange; illus. p. 94), which M. May lent to the 1879 Impressionist exhibition, along with Degas's *Dancing school* painted in essence (L399, Shelburne). When their first child Etienne was born on 31 May 1881, May asked Degas to paint the mother and child. Degas made at least three drawings of the head of the mother (cat. 164, 165, illus. p. 221) with a strong, open, responsable and attentive face, at times reflecting a certain smugness with her accomplishment, at others only the seriousness of her concern for the new born child. He also made a compositional black chalk drawing, heightened with white (Vente IV:133b, private collection), in which he showed her seated beside a cradle covered in a great curtain for which he made other drawings (Vente IV:133a and 133c, whereabouts unknown). In the lower right corner of the compositional drawing Degas wrote: "The sun has just brilliantly lit the feet and the front of the *chaise-longue* near her stocking as well as a little of the cradle's curtain".* Almost as if he were an orthodox Impressionist, Degas was recording the actual effects of sunlight in the room.

Degas next made a very large pastel drawing of Mme May and the cradle (cat. 163, illus. p. 220), giving the blue translucent curtain more promi-

*Le soleil vient d'éclairer vivement les pieds et le devant de la chaise longue par le bas ainsi qu'un peu des rideaux du berceau.

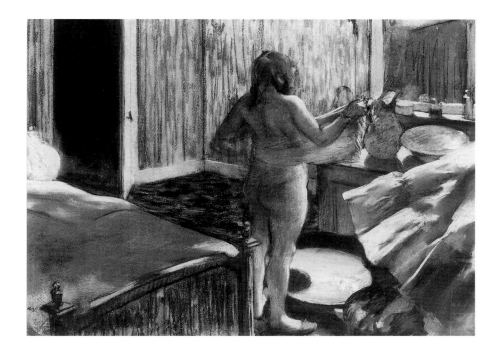

Woman at her toilet
1886—90
Pastel
43 × 58 cm
Pasadena, Norton Simon
Museum (L890)

*Tout est beau dans ce bas
monde. Mais une
blanchisseuse de fin, bras
nus, vaut mieux que tout
pour un Parisien décidé
comme moi.

nence than in the earlier drawing. It occupies a good half of the frontal plane, establishing an atmosphere of fragility and luminosity. Behind and to its left, her face younger and prettier than in the studies of her head alone, Mme May sits slumped as a reminder of reality. It also inevitably recalls *The nurse* ('*La garde-malade*') of about 1873 (L314, private collection), but without the same structural complexity. The suggestion of light as Degas had described it in his note suffuses the pastel. In particular, the bottoms of the feet fanning out are lit as he noted, adding a touch of informality and humour. The pastel, however, never progressed beyond this point. Whether the Mays, owners of the exquisite *Dancing school*, now at Shelburne, were hoping for something equally seductive and became discouraged and cancelled the sittings, or whether Degas gave up because this was not the direction in which his portraiture was then moving, is uncertain. All we know is that the Mays kept the pastel but not, as far as we know, the other drawings.

The problem for Degas was that his effort with Mme May and her baby was directed towards crossing portraiture with genre in the way he had done so often in the 1860s and 1870s, and yet, even this early in the 1880s, paradoxically, he seems to have determined now to keep them apart. This was not because of any indifference to genre, for most of his works from this decade — milliners, laundresses, nudes and even horses and riders — would be classified as genre. Interestingly, there are elements in the portrait of Mme May that show an affinity with the backgrounds of such pictures by Degas's nudes in the 1880s. We can see the same emphasis on a large piece of fabric, for example — like the crinoline in one of Degas's early *Bathers*, the pastel over monotype *Woman at her toilet* ('*Femme à sa toilet*', illus.). The *Bathers* are set in domestic interiors, which Degas might have tried to emulate in Mme May's portrait only selectively, but there is, further, the prominence of her shoes, which may be compared to the red slippers the bather wears in the pastel. Even though the interiors for the *Bathers* seem to have been his own studio or apartment, Degas may have felt uneasy with these similarities since the *Bathers* were commonly interpreted by his contemporaries as prostitutes or courtesans. He also probably stopped short of permitting his wit to focus on Mme May for, had it been permitted to penetrate, it would probably have revealed something very funny indeed. More than anything else it must have been his increasing sense of decorum that brought the portrait of Mme May to an end.

When we consider his genre work at this time we realise the degree to which Degas was trying to free himself from association with the dance; in so doing he was responding to increasing criticism of his work.[23] He deliberately sought other subjects, even the races, which were more interesting to him because of his knowledge of the photographs of Muybridge. When we remember that from New Orleans he had written to Tissot, "Everything is beautiful here in the south. But one Parisian laundress, with bare arms, is worth it all to a committed Parisian like me",*[24] we cannot be too surprised that laundresses should have been another subject Degas chose. Even before visiting New Orleans he had used Emma Dobigny to pose for a pastel (BR 62, Paris, Orsay) and a painting (illus. p. 89) of a single ironer, where genre and portraiture could be considered to be combined. In the Impressionist exhibitions in 1874 and 1876 he exhibited *Laundresses*. Two of his friends, Henri Meilhac and Ludovic Halévy, wrote a play, *La Cigale*, first pro-

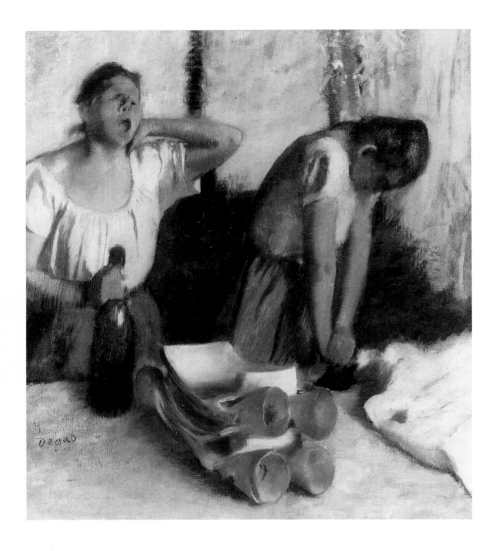

The ironers
1882
Oil on canvas
82 × 75 cm
Pasadena, Norton Simon
Museum (L687)

ably L686, was shown in the second Impressionist exhibition in 1876.[26] Degas worked further variations on the theme, as in a fourth version in Pasadena, which is no longer comedy (L687, illus.). Tinterow has suggested that the artist could have reworked this version at any time until he sold it in 1902.[27] Although the setting is humble, the girls' hair pulled back and their blouses loose and untidy because of the heat, the work's decorative effect has increased vastly over the painting shown in 1876. The figures are monumental and the colours soothing. The situation seems authentic but it is genre as it might have been represented on the stage; there is no interest whatsoever in the portrayal of the individual laundresses.

Another genre subject Degas chose was milliners. Although the hatmakers and saleswomen were working women, and suffered the same indignities as other working women – laundresses at the humblest extreme,[28] dancers at the most elevated[29] – their customers were women of privilege.[30] Degas would visit their establishments with Mary Cassatt or Mme Straus, née Halévy, Bizet's widow, who had become rich on the royalties from *Carmen* and then married Emile Straus, who had Rothschild connections. It has often been repeated that when Mme Straus asked Degas why he liked to accompany her, he said it was to look at the red fingers of the *modistes* handling their pins.[31] In fact, when he shows the hatmakers working their fingers are beautifully deft and unscarred by their trade. In 1882 Degas dated three pastels of the makers and sellers of hats including one, '*Chez la modiste*' (cat. 166, illus. p. 10), which was exhibited in London that year and very shortly afterwards belonged to Henri Rouart, and for which Mary Cassatt posed. Once again, although she is charming as she adjusts her bonnet while looking into a cheval glass, this is not in any sense a portrait of Cassatt. In *Chez la modiste*, just as in the other pastels and paintings set in milliners' shops, two ingredients triumph: the gestures of the customers, the milliners and their assistants, and the lavish bouquets of the hats themselves.

Finally, in 1886, in the last Impressionist exhibition, Degas emphasized his nudes, describing them famously in the catalogue as "a series of nudes of

duced 6 October 1877, which in the fifth scene of its third act has a model posing as a laundress before an artist. Degas made drawings of the actress washing clothes in the rôle in one of the Halévy notebooks and had also advised on the production of the play.[25] Degas seems to have preferred the arms of ironers to washerwomen but it was not until the 1880s that he became preoccupied with the theme.

Three of Degas's *Pairs of ironers* are comic (L785, Paris, Orsay; L786, private collection, Japan; L686). While the right-hand laundress in the background directs her full weight and attention on the iron, the one in front opens her mouth very wide in a yawn and clutches a bottle of wine with her right hand. This is caricature but certainly never portraiture. Although the sequence of these three *Pairs of ironers* is uncertain it has been determined that one, prob-

*... une suite de nudes de femmes se baignant, se lavant, se séchant, s'essuyant, se peignant ou se faisant peigner (pastels).

women bathing, washing, drying, rubbing down, combing their hair or having it combed (in pastel)".* They were not, in other words, intended to be erotic, but were subjects engaged in the routine activities of ordinary life. Nudes are well beyond the perimeters of this essay, even as a form of genre,[32] but it should be pointed out that they are thoroughly anonymous. It is very seldom that we see a face. They are placed in settings of wall-coverings, curtains, furniture and rugs that appear unpretentiously bourgeois, rather like Degas's own establishment as Martelli described it,[33] and far less glamorised than a brothel. The degree to which portraiture was not intended can be judged by the one work in which a portrait does appear, 'La toilette après le bain' (L706, Copenhagen), in which an actress, according to tradition Réjane (Gabrielle Réju), posed as the maid.[34] Her face, with lowered eyes, full lips, curls appearing under her cap, is so mobile and expressive that the normal neutrality of the nudes is destroyed. Portraiture and Degas's Bathers are not compatible. Genre as a whole has been divorced from portraiture.

Formal portraits, 1884–86

About 1885 Degas became fascinated by the formal groupings of people in photographs or pastels. The examples are few, but they are compelling. We do not know the date Degas made two pastels of The Mante family (L971 and 972, illus. p. 70), although it is possible that one was sold to Durand-Ruel in 1888.[35] The head of the family, though he does not appear in either pastel, was Louis-Amédée Mante, who was, like Désiré Dihau, an instrumentalist with the Opéra orchestra – he played the double-bass – and also a photographer whose reputation is growing.[36] He was therefore at the upper end of the social scale for fathers of aspirants to the dance and is said to have lived in the same building as Degas himself about 1887–80.[37] Among his seven children three daughters are reputed to have studied at the Opéra and to have become professeurs des classes des jeune filles: Suzanne, born in 1871, who was to become a 'first dancer' by 1897; Louise, born in 1875; and Blanche, born in 1877.[38] She would marry Edmond Goldschmidt who collaborated with her father and supported him in his photographic experiments.[39]

Although Suzanne herself, undoubtedly the most successful of the three sisters as a dancer, told Lillian Browse in an interview in 1947 that she had posed for the small ballerina in the pastel and that Blanche had posed for the dressed little girl,[40] it seems unlikely that there could have been as much as six years between the two figures in the portrait. Blanche and Louise would be more likely, since only two years separated them. (In the absence of proof I will refer to one as the dancer and to the other as 'Blanche'.) The dancer must also have been the model for a single figure at the bar, Dancer at the bar (L969, Shelburne), and for Dancer in blue (L970, Geneva, Galerie Jan Krugier), which was probably a new version of the Shelburne composition made without reference to a model in the 1890s.[41]

Degas fitted the family neatly into the large vertical piece of paper, almost a double square, setting them up, and therefore back, so that they are separated from us. This separation isolates the Mantes more than it does us, and it also helps us become aware of the expressive possibilities of the feet. 'Blanche's' in black boots have the toes pointed outwards in what seems almost a parody of a ballet position, since her thin legs are so badly splayed. The dancer's, in pink tights and dancing shoes, are ready to dance but are almost equally ungainly. The purpose of the work is clearly to compare the two sisters. The young dancer bends her head while her mother combs her hair but also in that moment of reflection that the anticipation of a class, rehearsal or performance brings. Unlike the dull brown hat and coat (or dress) of her sister she wears the traditional pale pink tights, slippers and blouse, with orange ribbons tied at her shoulders and around her neck – but they are shabby and do not contrast decisively with the drab, even mournful colours of the pastel overall. Her mother, with her head bowed also, dressed in sober and serious black, reinforces and comforts the young dancer, who resembles her. On the other hand 'Blanche' stands exposed while her hand holds an orange purse, another black bag hangs from her neck, and her orange curls peep out under the ridiculously tall hat to frame a very unhappy but expressive face. Her misery is conveyed by the heavily lidded black eyes with shadows under them, the nose that could be cold, and the

The Mante family, ca. 1889, pastel, 90 × 50 cm, Philadelphia Museum of Art (L971)

slightly opened mouth with the very full (and possibly swollen) lips. Her future may not be with the dance, she may be feeling utter alienation, but that face and that silhouette show the dramatic potential of a Réjane.

The compositions and palette of the two versions of *The Mante family* are artificially conceived to provide revealing and melancholy relationships, in which there are elements of humour but stronger doses of compassion.[42] They are not as far removed from contemporary pastels and paintings of the dance by Degas as we might suppose. Almost no dance pictures from this period are dated, but frieze compositions like *Dancers climbing a staircase* (L894, Paris, Orsay), which are diffuse and sad, are fairly certainly from the 1880s.

The formality of the disposition of Mme Mante and her two daughters for predominantly symbolic purposes is echoed in photographs which Degas directed, taken by Walter Barnes at Dieppe in 1885. There was a summer colony at this Norman seaside town in the 1880s, which was international to the extent that English and French visitors mingled with each other. Degas had visited Dieppe as a guest of the Halévys the previous October and obviously looked forward to his next visit the following summer. The Halévys (Ludovic, his wife Louise, their sons Elie and Daniel, Ludovic's mother and an aunt) had succeeded in renting a house on the rue de la Grève, situated, as Daniel pointed out later, between the cliff and the sea.[43] It was next to the house of Dr Blanche, the fashionable alienist. The Blanches' one son, Jacques, was indulged but talented and would become a painter fashionable in both England and France. Even at the age of twenty-four, as he was then, he played a rôle in mixing English and French visitors. That summer the most promising Englishmen seemed to be the painters James McNeill Whistler and Walter Sickert; Sickert came with his new and rich wife Ellen Cobden. On the other side of the Halévys' from the Blanches lived Olga da Caracciolo, reputed to be the natural child of Edward VII, who was certainly her godfather and a visitor; she was snubbed by fashionable (as against artistic) Dieppe society. As a guest of the Halévys Degas was in a position to have an amusing time at Dieppe.[44]

Six friends at Dieppe
1885
Pastel
115 × 71 cm
Providence, Museum of
Art, Rhode Island School
of Design (L824)

Blanche under a straw boater.

The most famous photograph Barnes took for Degas was an *Apotheosis of Degas*, a spoof both on the painter and on Ingres's *Apotheosis of Homer* painted for the Louvre. (This may have been the first equation of Degas with Homer but the convention was to persist until his death because in his late blindness he reminded others of the ancient Greek poet.) The location of this photograph is the same as that of the other group but there are only six performers – the three Lemoinne sisters, daughters of the editor-in-chief of the *Journal des débats*, who hold laurel branches in a row at the back, Degas seated humbly on a step in the centre with a staff, and the two Halévy boys crouched on either side on the step below, their hands touching in obeisance. Degas may not have been satisfied by the lighting in these photographs,[47] but he was amused to have them and distributed original prints to members of his family and presumably to his friends.[48]

Degas also produced his own group portrait that summer, the pastel *Six friends at Dieppe* (illus. p. 71). In it are Ludovic Halévy (at the top to the right) and Cavé (at the bottom to the right), whom he had already painted together about 1879 in '*Portraits d'amis sur la scène*' (illus. p. 38). Ludovic's thirteen-year-old son Daniel may have inserted himself into the group out of sheer curiosity, as he peers out somewhat ignominiously under his father. The other three were painters, a generation younger than Degas, all in different ways ambitious and all to become fashionable and successful. One was Henri Gervex, the oldest, aged twenty-eight, who had already caused a sensation by painting *Rolla*, a large nude for which Ellen Andrée posed, and which was rejected by the Salon of 1878, reputedly because Gervex followed Degas's advice and included a discarded corset. Gervex sits behind Cavé. Behind him, standing and almost concealing the two Halévys, is Jacques-Emile Blanche, aged twenty-four. These figures have been grouped, it has been suggested, almost totemically, certainly with an awareness that Gervex and Blanche, much as they seem to swell in the arrangement, are not finally as distinguished as the Halévys and Cavé. Walter Sickert, German-born but now British, is isolated from the rest. This may be chauvinism. The totem, which

One form Degas's amusement took was directing Walter Barnes in making group photographs to record this happy vacation. Barnes was not a great or even very experienced photographer,[45] although he did take some good shots of Degas by himself. But Degas stretched his talents by bringing fifteen people together for a photograph against a door of the Halévys' house where steps and seats permitted a modest variation in levels.[46] Loyrette has identified the sitters as follows: on the first row from left to right, Louise and Elie Halévy, Mme Leon Halévy (the grandmother), Valentine Halévy (the aunt), Mme Blanche, Marie Lemoinne and Daniel Halévy; on the second row, Catherine Lemoinne, Ludovic Halévy, Walter Sickert, Jacques Blanche, an unknown woman, Rose Lemoinne (whom Jacques Blanche would marry), Cavé and Degas. On the axis, and in the most conspicuous place within the doorway, are those two dandies, Walter Sickert in a natty light suit and fedora and Jacques-Emile

Sickert himself describes as "one figure growing on to the next in a series of ellipses and serving, in its turn, as a *point de repère* for each further accretion",[49] seems not only to assume indifference towards this young English colleague, whom Degas always called "le jeune et beau Sickert", but even to pass judgement upon him. (It could even be some form of theatre.) In the peach light of what we assume to be the beach, Sickert turns his back on the others and seems composed and indifferent in his turn.[50]

Another portrait that Degas exhibited in the Impressionist exhibition of 1886 deserves to be considered here, though comprising only the head and shoulders of a single sitter, for he could have joined the six artists at Dieppe. This is the portrait of a Turkish still-life painter, a friend of the Valpinçons, Zacharie Zacharian, whom Degas considered an obsessively limited artist but whom he must have admired for the same fastidiousness in manner and dress.[51] In a notebook Degas used between 1877 and 1883 he wrote Zacharian's name on one page[52] and a series of ideas for smoke as a theme on another, beginning, "Sur la fumée/fumée des fumeurs, pipes, cigarettes, cigars".[53] Here we have the obsessive smoker of cigarettes whose nasty stub in his slender fingers seems to contradict the elegance of his gilt-headed cane and his fine black bowler hat. On the other hand his eyebrows are raised, his eyes are deepened, his mouth is complacent and his nostrils are delicately distended as he savours the smoke that floats – interrupting the strokes of pastel – from that nose to the gilt on the cane. But he is more than a smoker. The bone structure of his head is fine, its expression sensitive, proud, tense, arrogant and finally melancholy.[54]

Portraits of the Rouarts, 1883–95

Of all Degas's closest friends the Rouarts as a family may have been the most steadfast and the most discrete. Indeed, on 27 December 1904, Degas – then seventy – wrote to his contemporary Alexis Rouart: "It is true, my dear friend, you put it well, you are my family".[55] Although Degas had been at school with Alexis and his brother Henri, it was the Franco-Prussian War that had brought them together again, when the painter served under Henri in the artillery. Degas was a friend not only of

Henri (1833–1912) and of his younger brother Alexis (1839–1911), but also of Henri's son Alexis (1869–1921).[56] Both Henri and the elder Alexis were engineers and art collectors.

Paul Valéry, who met Henri Rouart through another son, Eugène, and Degas through the Rouarts, writes of M. Rouart most glowingly.[57] Their house on the rue Lisbonne, crammed with its extraordinary collection, which contained El Grecos as well as Egyptian sculpture and Chinese textiles, would have been a sympathetic and stimulating setting for the regular gatherings there – every Friday.[58] We know Degas found it a relief that the guests were often engineers or army officers rather than people dedicated to the arts, although Mallarmé and Paul Valéry were frequent visitors. Degas professed to find Mme Rouart terrifying in her readiness to defend her husband,[59] but these evenings seemed to revolve around the wise, benevolent Henri, who was one of the great engineers of his time – inventing a new refrigeration process and a new form of telegraphy.[60] In addition Rouart was a respectable painter who exhibited in all the Impressionist exhibitions but one.

Henri Rouart had two other interests for Degas. One was as a great collector. Their enthusiasms did not always coincide because Henri preferred Corot, Daumier and Millet, whereas Degas, much as he respected these artists, coveted works by Ingres and Delacroix. Rouart also dabbled in the Old Masters, in particular in El Greco, an enthusiasm he shared with Degas and their friend from Pau, Paul Lafond. He supported his Impressionist contemporaries to some degree, owning five Monets, five Pissarros, three Renoirs, a fine Mary Cassatt, five small Cézannes and three Manets, in addition to a large group of works by Degas including *Dancers at the bar* (L408, New York, Metropolitan Museum), *The dance rehearsal* ('Répétition de danse'; L537, New York, Frick Collection), and '*Chez la modiste*' (cat. 166, illus. pp. 10–11). He made a gesture towards Gauguin, an artist whom Degas admired and whose works he was buying, with what we might suspect was one token painting, *Nave Nave Mahana* of 1896, now in Lyons.[61] Besides providing the setting of a civilized collection, Rouart also produced a family – a daughter born in 1863[62] and four sons born

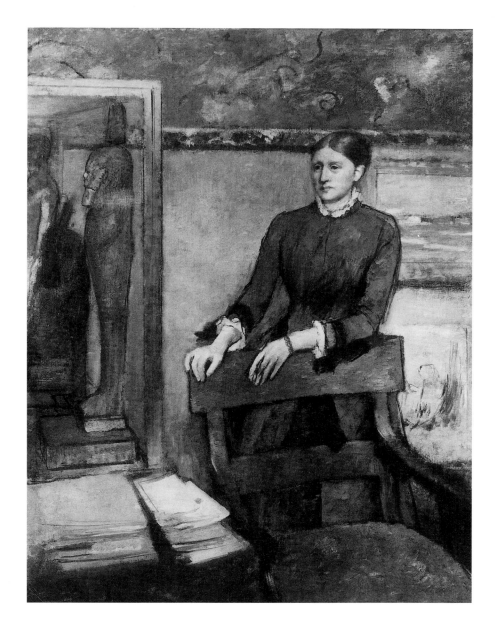

Hélène Rouart
1886
Oil on canvas
162 × 123 cm
London, National Gallery
(L869)

artist seemed to believe from the beginning most ideally characterized his friend (L293, private collection). Rouart would only recently have found himself in civilian clothes after the Franco-Prussian War. Pantazzi has proposed, logically,[65] that it was about the same time – between the spring of 1871 when the war ended and the autumn of 1872 when Degas went to New Orleans – that Degas painted Rouart in the same position, but now revealing his left arm and his knees, with which he supports his beloved but unhappy red-headed daughter Hélène, who in 1872 would have been nine (illus. p. 44). She is equally unhappy in a contemporary photograph.[66] Then there is the portrait (L373; Pittsburgh, Carnegie Museum) of Rouart standing, in a confident profile once more, against the background of the Louisiana Ice Works he had designed but probably never visited.[67]

About 1884 Degas may have felt somewhat guilty that he had painted Henri three times but never his wife. It is true that the artist and Mme Rouart were never at ease with one another but she had welcomed him into her house almost weekly over the years. She had been born Hélène Jacob-Desmalter, whose grandfather was Georges Jacob, the celebrated cabinetmaker, famous for the chairs he designed and for his furniture *à la grecque*. Her father, François Honoré, had established a factory under the name Jacob-Desmalter which reproduced his father's designs.[68] When Degas decided to draw a portrait of Mme Rouart in pastel (cat. 169, illus. p. 223), he showed her in the profile position (to the left) in which he had always painted Henri, and seated in a chair her grandfather or father must have designed and made. In addition she looks past a small Tanagra figurine on the table, which could have represented the classical world which had been such an inspiration to her father and grandfather.

There is no hint of the four sons to whom Mme Rouart had given birth between 1869 and 1875 but there is a suggestion of her daughter Hélène in the blue drapery at the left of the portrait drawing. That Degas had conceived this as part of a double portrait of mother and daughter is substantiated by a cursory drawing on a piece of paper exactly the same size as the pastel (illus. p. 74), although used vertically. The mother is thrust into the lower right

between 1869 and 1875.[63] These by extension became Degas's family; and one of the son's, Ernest, was a student of Degas and married Berthe Morisot's daughter, Julie Manet, with Degas's encouragement. Degas meant it when he wrote to Rouart on 25 May 1896 after the birth of his first grandchild, "So here is your posterity on the march. You will be blessed, you righteous man, in your children and your children's children".[64]

Degas painted several portraits of Henri Rouart. The first is a small canvas in which Rouart wears a modish black hat over his black hair and beard and is in a profile position (looking to the left) that the

*Hélène Rouart and her
mother*
1884
Pencil and crayon
36 × 25 cm
Private collection

corner and Hélène rises triumphantly wrapped in a shawl like a Tanagra figurine, with her right hand placed defiantly on her hip and her button eyes looking beyond her mother. A struggle between generations has been exposed.[69] In the pastel Mme Rouart seems remarkably frail – her fragile shoulders bent and wrapped in a blue shawl, her skin pale and her features gaunt, her thin wrist scarcely able to support her hand. She obviously does not have the strength to cope with four teenage sons, let alone one rebellious daughter. That daughter, Hélène, is ready to break out of the cocoon of the shawl. As Degas wrote to her father, "Elle doit sortir".[70]

Within the Rouart family – though it originated perhaps much later – there seems to have been a story that Degas was intending to produce a large portrait of their family, an equivalent a quarter of a century later of *The Bellelli family*.[71] Degas was certainly fascinated by the relationships between members of the family. Dillian Gordon argues that, since he had been so frank about his Bellelli relatives between 1858 and 1862, he should not have been so reticent in respect of Mme Rouart and Hélène – for the portrait never progressed beyond the pastel

drawing of the mother.[72] It was, however, twenty years later than his painting of the Bellellis, and portraits of the Rouarts could not be buried like those of his Italian relatives, only to be discovered after the artist's funeral. Discretion with the family of an old and cherished friend prevented Degas's going further, but Henri did keep the pastel drawing as some record of his wife and the mother of his children. She died two years later, in 1886.

Degas dated 1886 a pastel drawing of Hélène (illus.) which had grown out of the idea for the double portrait with her mother. Partly because the colour and texture of the pastel ameliorate the severity of Hélène's face and stance and partly because Degas reworked this drawing so much, Hélène does not seem as confrontational. Indeed she appears smaller, more indecisive, and somewhat sad, which could argue that Degas dated it correctly. An oil painting has sometimes been identified with Hélène in her chrysalis stage, *Woman in a red shawl* ('*La femme au châle rouge*'; cat. 173, illus. p. 249).[73] Certainly she is wrapped in a shawl as a Tanagra figure might wear it. On the other hand, when it is examined, the 'peplos' is composed of a white scarf tied around her head and a red, heavily fringed shawl wrapped around her shoulders and her hips over an evening dress with a train emphasized by heavy contours of paint. She stands chilled in an anonymous space, dramatized by the curtain at the right. With black hair, unlike the red Degas so much admired in Hélène, she is theatrical, provocative, desirable – in no sense Hélène Rouart.

Degas did consider, as he wrote to her,[74] replacing Mme Rouart in the portrait with her daughter with Henri, but there is no evidence he actually attempted it. By 1886 he was committed to a portrait of Hélène alone. In a notebook,[75] the last he seems to have kept, he made drawings on facing pages of Hélène seated rather cockily on the arm of her grandfather's chair, wearing a modern dress that is modest but also more revealing than the Tanagra shawl, and pointing her feet out from under its hem somewhat impudently. Although it is only in pencil, Degas emphasizes the shape and lustre of her hair, which he had always considered to be her crowning glory. (We could only wish there were evidence that as a girl she had posed for *Sea-bathing: little girl being*

Woman in blue (Hélène Rouart)
1886
Pastel on paper
49 × 32 cm
Los Angeles County
Museum (L866)

combed by her maid ('*Bains de mer, petite fille peignée par sa bonne*'; L406, London, National Gallery), which her father already owned when it was exhibited in the 1877 Impressionist exhibition.) On the facing page of the notebook there is a faint drawing of her face and bolder sketches of both the chair and her hand holding back a fold of her dress. Degas went on to make several pastels of her in this position, working variations in the background of her father's house, until he arrived at one (L870, Cologne, Lempertz), which he would give to her uncle, Alexis Rouart, in 1903. He must suddenly have decided to present Hélène differently and made two drawings, which were sufficient for the large painting: one (Vente IV:135a, whereabouts unknown) with her position changed so that she stands behind her grandfather's chair, which has grown in size, and the other (Vente IV:135b, private collection) of her hands placed on the back of that chair. Degas had presumably arrived at a solution for her portrait which he decided to paint on the largest canvas (in one direction) of any he had used for a portrait since *The Bellelli family*.

Degas was equally decisive in selecting the parts of the collection that would make up the background of Hélène's portrait.[76] Gordon tells us that, in fact, X-rays reveal few changes in the painting.[77] Degas chose a contemporary Chinese wall-hanging so red it subdues Hélène's copper hair, a painting by Corot of the Bay of Naples, now in a private collection, and a drawing by Millet of a peasant girl, now in the Louvre. To the left of Hélène a glass case is set into the wall with three Egyptian statues that Degas has doubled in size. Reff argues convincingly that "the presence of these works probably reflects Degas's own interests as much as his friend's".[78] Finally there is the Jacob chair, which Gordon sees, with the papers on the table, as a reference to Henri Rouart. Loyrette agrees but finds it more sinister, "the terrifying authority of the armchair by Jacob, the cabinetmaker grandfather, without the Olympian presence of Henri Rouart".[79] But the presence that is missing is not Henri but his wife, whose father or grandfather had made the chair. And, although Degas had responded to the tensions between mother and daughter in 1884, he had also associated them more agreeably in his letters to Henri over the years.[80]

Gordon has detected certain influences upon this portrait by Degas. She brings up Van Dyck, who had so much impressed Degas in Genoa in 1859 and in particular the painting of the Marchesa Spignole-Doria, which is now in the Louvre but was then in a Rothschild collection, in which the Marchesa stands beside an empty chair.[81] In addition, she points to one of Henri Rouart's most beautiful Corots, '*La dame en bleu*', now in the Louvre, which, although half the size of the portrait of Hélène, could have suggested the blue of her dress.[82] The possible influence of Cézanne must be considered, although it may only be coincidence that the style of her hair and her clothes suggest the dignity of the heads of Mme Cézanne that Cézanne was beginning to paint about 1885. In spite of the richness of the influences and the environment, including the drama of the empty chair, Hélène remains independent. As Reff points out, "How much at ease she seems".[83] At the same time she is never happy. Gordon observes, "She refuses to meet our gaze. Her expression is solemn and melancholy". She also adds with a cer-

Henri Rouart
1895
Pastel and charcoal
60 × 45 cm
Private collection (L1177)

tain frustration, "There is no evidence otherwise that her life was unhappy. She had three children by her husband, Eugène Marin, and died in 1929".[84] Nevertheless Hélène stands with solemnity and even grace as she symbolizes the passing of women from the Rouart household, her mother by death, herself by marriage. Curiously, the painting never took their place. It was in the artist's collection when he died. It is an exception among Degas's portraits of the 1880s in its description of the sitter's environment but characteristic, too, in its emphasis on symbols rather than analysis of character.

It was eleven years after he wrote to Mme Rouart telling her of his plan to replace her in the double portrait with Henri that Degas to some degree carried out his intention. In 1895 he made a pastel drawing of Henri (illus.) seated in the Jacob chair, which is empty in the large painting of Hélène; but at his side, in place of Hélène, Degas drew a pedestrian male figure cut off at the neck. Behind the head of Henri a great flower mysteriously blooms. In the almost twenty years that separates this portrait drawing from the painting of him against the New Orleans smoke stacks, Henri has seriously aged. We know that he was suffering from gout or arthritis,[85] which could explain the feeble body under the

shapeless suit and the hands folded across the head of the cane. He is certainly not as well dressed as he was in the past – his shirt and tie limp, his hat a soft black skullcap instead of a smart topper, the locks of his hair and his greying beard and moustache curling untidily. And yet there is still in the head that intelligence and spirit that made Paul Valéry so much revere Henri Rouart.[86] His eyebrows frown with concentration on something beyond him, his cheeks and mouth seem about to break into a smile. He remains noble still.

Behind Henri, emerging out of parallel strokes of pastel and charcoal that do not cover the paper, is another male figure, who turns out to be Henri's eldest son Alexis, now twenty-six years of age. He was named after his uncle and his grandfather Alexis-Stanislas Rouart, a prosperous manufacturer of passementier, braid, fringes and other ornaments.[87] Since it was in 1896 that this Alexis's first child, and Henri's first grandchild, Madeleine, was born,[88] he must have been married already in 1895. He may even have established the firm of music publishers, Rouart Lerolle, that he would found with a son of the artist and collector Henri Lerolle, whose two sisters would marry Alexis's brothers, Louis and Eugène.[89] Degas made two independent drawings of Alexis working towards the double portrait in oil (cat. 177, p. 225). One (cat. 178, illus. p. 224) is an understated drawing, which shows him dressed almost comically in a suit and overcoat that are too large and a bowler hat that seems jauntier than the man himself. He was red-headed like his sister, but even paler. Although his face is mobile, he seems extremely self-effacing. The second drawing (L1178; whereabouts unknown) appears to be more generous to him.

The final painting is an expressive and moving work, partly because of the helplessness of both men against the unexpected colours of the background – greens, yellows and oranges. Alexis tries to be dignified as he pulls on his gloves, but he appears ineffectual and infinitely sad. Henri seems to have suffered since the drawing – his mouth to have sunk, his eyebrows now almost diabolic, and his eyes red sores. Nothing suggests that Henri Rouart was having trouble with his eyes – as Degas was. It is almost as if the artist projected on to the figure of

his friend his sense of his own indignities. The portrait becomes, as a result, a tragic statement of the pathos of aging and the inadequacies of the young – Alexis, after all, is twenty-six – to supplant the old.

Projected into this work is Degas's consciousness of his own mortality and his sense of loss that came with the deaths of his friends and members of his family. In 1892 Eugène Manet died and in 1895 his wife, Berthe Morisot, in the month – March – in which Degas was working on the double portrait of Henri with his son. Paul Valpinçon died in 1894, as did Degas's cousin and brother-in-law Edmondo Morbilli, husband of Thérèse, in Naples. Degas would have mourned them individually but even more he must have regretted what he would have perceived as the passing of backbone, determination, will, the courage symbolized by *La petite danseuse de quatorze ans* and by Henri Rouart when he was young.

An intermission: Rose Caron and photography
Fortunately Degas's moods could swing. Just as, on 24 December 1867, he could make a charming drawing of his baby niece Céléstine Fevre in her bathtub listening to a maid tell her a story, and the next day work out the composition for the suppressed passions of *Intérieur*, so he could change from the compassion and pathos with which he painted the two male Rouarts to the wonder he always felt before the singer Rose Caron. Whenever we think of Degas in relation to Mme Caron, we think inevitably of the letter he wrote to Ludovic Halévy in September 1885 after he had been at an early performace of *Sigurd*, a new opera by Reyer:

The arms of Mme Caron are still what they were. How well she is able to raise those divinely thin arms, holding them aloft for a long time, without affectation, for ages and then lower them gradually! If you see them again you will cry out: Rachel, Rachel, as I do.*90

To Jacques-Emile Blanche he wrote on 1 October, "Mme Caron est une divinité".91 This infatuation continued. He dedicated one of his sonnets, VII, to her. He was ecstatic when she returned to Paris from Brussels in 1890 and greatly honoured to sit across from her at a dinner party given at the café Anglais by the collector and lawyer Paul-André Chéramy,

who had bought his portrait of Levert (cat. 116, illus. p. 261). He intended at least in April 1890 to make one of his rare trips abroad, to Brussels to hear Mme Caron in *Salammbô*. Because of strikes in Belgium from which he might need protection, he wrote to Bartholomé, "There are also the arms of Mme Caron which might be long enough to cover me".*92 On 22 October 1890 he went to hear her sing *Sigurd* for the twenty-ninth recorded time, and he would go nine more times before 1891 was over. To hear her as Elsa in *Lohengrin*, he would even listen to Wagner, whose music he disliked. His enchantment was complete.

It appears that Degas first heard Rose Caron in 1885 when she was twenty-eight.93 She had been born Rose Lucile Meuniez, the daughter of peasants in the village of Beauce (Seine-et-Oise), and had married a pianist called Caron, who found employment in the cafés and *cafés-concert* of Paris. He saw to it that her voice was trained; and in 1879 at the age of twenty-two she entered the Conservatoire. From 1882 to 1884 she was a regular member of a company at the Théâtre royal de La Monnaie at Brussels; she created her first rôle there as Brunhilde in *Sigurd* by Ernest Reyer, with which she returned to Paris and the Opéra in July 1885. The other rôle she created and with which she remained identified was Reyer's *Salammbô* in 1890. Caron was renowned for her beauty and her acting as well as for her voice – and not just by Degas. In retrospect she has been described somewhat flatly, "A lyrical-dramatic soprano of moderate range, Rose Caron was above all an inspired interpreter".*94

His portrait of Rose Caron (cat. 175, illus. p. 283) is not isolated in the work of Degas. There were moments when the theatre – the actual performance in an opera-house or in a *café-concert* – thrilled him so much that he celebrated it in his work. In these later years – the 1890s and the early part of the twentieth century – he often showed his dancers on the stage, and the stage with extravagantly painted flats, as he had very rarely done in the past. It is as if he were deliberately seeking in the artifice of the theatre, in its capacity to produce romantic dreams, a further step in divorcing his work from reality. Interestingly enough Lemoisne, in his catalogue raisonné of Degas's work, juxtaposes the portrait of

*Les bras de Mme Caron sont toujours là. Comme elle sait laisser longtemps en l'air, sans qu'il y ait affectation, longtemps, ces bras maigres et divins, puis les descendre doucement! Vous les reverrez, vous crierez: Rachel, Rachel, comme moi.

*Là aussi sont les bras de Mme Caron qui peuvent être assez longs pour me couvrir.

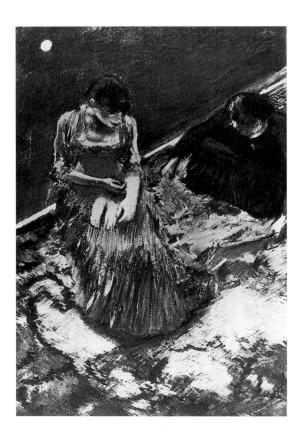

Before curtain-rise ('Avant le lever du rideau')
1892
Pastel
51 × 34 cm
Hartford (Conn.),
Wadsworth Atheneum
(L1116)

Rose Caron with the *Woman with a red shawl* (cat. 173, illus. p. 249), which is highly theatrical in pose, dress and setting.[95] Even closer is a pastel, *Before curtain-rise* ('*Avant le lever du rideau*'; illus.), in which a reddish-headed performer – an actress or singer – sits on a stool while her luminous green dress spreads out over a patterned rug and a maid straightens its train. The performer is pulling on elegant white gloves somewhat pensively. Behind her head a tiny moon is suspended. Even when we realise the moon is a peep-hole for the performers on the stage,[96] the magic is not lost.

Although we see much less of Mme Caron in the oil portrait and almost nothing of her setting, there is a similar sense of theatrical glamour. She is more heroically built – her gestures grander – a Brunehilde in *Sigurd* or, perhaps, in her rôle in *Salammbô*. As Degas had written, "Les bras de Mme Caron sont toujours là". The rose and gold of the wall in the background may remind us of his association of colours with the singer in one line of the sonnet he dedicated to her, "Diadème dorant cette rose pâleur" (The diadem gilding the pink pallor).[97]

It is improbable that she ever sat for the portrait. Even though her face and shoulders are cast in shadow, she seems the supremely beautiful, romantic and masterful diva who kept Degas's dreams alive.

By late December 1895 Degas was immersed in photography, about which Antoine Terrasse, the author of the only book on Degas as a photographer,[98] has written also in this catalogue. There are only two points I should like to make in passing. Degas made photographs of the Halévy family – of Ludovic, of Mme Halévy (illus. p. 304) and of Daniel (illus. p. 305) separately – which romanticise them. Each is in his or her own way beautiful, each relaxed, each fulfilled. The irony is that they are such a contradiction of the portrait of Henri and Alexis Rouart he was painting in the same year, in which we cannot escape his angry disappointment. In spite of this, because of the stand he took in the Dreyfus affair, Degas cut himself off from the Halévys while the Rouarts remained his constant (and conservative) friends.

Another important question that arises is that of Degas's double exposures. Donald Crimp has written of this most eloquently, of the figures "caught in the complex web of the photographic medium ... transformed into a hallucinatory, spectral image", which he sees as consistent with Symbolist poetry.[99] The connection between Degas's photography and the Symbolist poets is established, since he photographed both Emile Verhaeren and Stéphane Mallarmé.[100] They could have pointed other directions to Degas as he advanced further from reality.

The Rouarts and washerwomen, 1904–05
Although virtually nothing else resembling a portrait appears in Degas's work after the turn of the century, the Rouarts do not disappear. According to the sitters,[101] two sets of pastels – one of Henri's youngest son Louis, with his wife, and a second set of the wife of his eldest son Alexis, with their two children – were drawn about 1904 and 1905. Curiously, Degas never made portraits of the two sons who seem to have had the greatest interest in the arts – Ernest, who studied painting with Degas and married, with the older artist's encouragement, Berthe Morisot's daughter, Julie Manet, and

Eugène, whose letters to Picasso trying to buy his *Two harlequins*, painted the same year as the second set of Rouart portraits, 1905, provide the firmest evidence for the precise dating of Picasso's *Demoiselles d'Avignon* in the spring of 1907.[102]

Lemoisne publishes a photograph which shows the four sons of Henri lined up in the back row at La Queue-en-Brie, the family country place:[103] from left to right they are Ernest, Louis, Alexis (whose hat we remember from his portrait with his father (cat. 177, illus. p. 225)) and Eugène. In the front row sit Julie Manet Rouart, Ernest's wife and Berthe Morisot's luminously beautiful daughter; Mme Louis Rouart in front of her husband; young Madeleine Rouart; Degas, in front of Madeleine's father, Alexis; and Yvonne Lerolle Rouart in front of her husband Eugène. Apart from illustrating how different the four Rouart sons were in size and in girth and how natural Degas seemed with the family, this photograph significantly makes it clear that Louis, the youngest, was also the smallest and most animated, and that it was not unusual for Alexis and his wife to be apart.

Louis, born in 1875, would have been the family runt, probably missing his mother most when she died when he was eleven, the age Degas himself was sent as a boarder to the Lycée Louis-le-Grand two years before his own mother died. It is clear from a letter to Louis that Degas regarded him with a particular affection.[104] It was written when Louis was twenty-five and studying at the Institut français d'Archéologie Orientale at Cairo, and begins: "Although it is very late I am answering your affectionate letter, my dear redhead", and continues, "You are spending some of the happiest years of your life. And if you wish to add to the tales of the Thousand and One Nights you can write one tale of the joys of being redheaded". The letter ends, "Write to me again. You gave me so much pleasure. I embrace you, my dear child". Inevitably there were others who saw Louis Rouart differently. One was André Gide who was, however, capable of reversing his opinion sheepishly, writing in his *Journal* on 9 April 1908, "A fine visit from Louis Rouart; I note it down willingly because I have written intemperately about him before".*[105] It was not on that occasion but three years earlier that Gide

had written, "Met little Louis Rouart, redder and more bourgeois-looking than ever. As it was a long time since I had seen anyone, my smile suggested an exaggerated joy; he came along with me. As spotty, as strained conversation as ever; it seems like the spasmodic skirmishes of a fencing bout, but a bout without courtesy. With the very first words, from the start, he attacks.*"[106] When Degas drew Louis with his wife, this verbal fencer had not as yet committed himself to the revival of Catholicism in France; he would be the founder of the periodical *L'Occident*, and the publisher and director of the Librairie d'Art Catholique, which would publish books on such religious painters as Fra Angelico and Raphael.[107]

By 1904 Louis had married Christine, one of the two daughters of the *fin-de-siècle* painter Henry Lerolle. (His brother Eugène had married the other, Yvonne.) In 1897 Renoir had painted both Lerolle sisters at a piano in the Lerolle house (Paris, Musée de l'Orangerie) with two works their father had bought from Degas in the background, *Before the race* (L702, Williamstown, Clark Art Institute) and *Pink dancers* (L486, Pasadena, Norton Simon). Renoir made Christine very appealing in a red dress with puffed sleeves. In the group photograph at La Queue-en-Brie she can be identified easily by her bouffant hair, her dark eyes and her mouth slightly opened as if ready to smile. Before a camera lens, less indulgent than Renoir, she seems primmer than in the painting but not as austere as her sister Yvonne at the right.

For the portrait of Louis and Christine Degas made seven large compositional drawings (at least one metre in one direction) on tracing paper. Another drawing is smaller (illus. p. 81) and perhaps later. Characteristically for a late portrait of the Rouarts, the compositions revolve around a chair or chairs – although by no means necessarily designed by Louis's greatgrandfather, the Empire cabinetmaker, Jacob. There was no formula for a married couple Degas could fall back on like the one he had used for the Morbilli (cat. 73, illus. p. 185) almost forty years before. He tends to remove himself from the couple, whom he places in a park, probably at La Queue-en-Brie. In all of the drawings Mme Rouart is seated. In three of them Louis is

*Bien tard je réponds à ton affectueuse lettre, mon cher rouquin … Tu passe là-bas les plus jolies années de ta vie. Et si tu voulais ajouter aux Mille et une Nuits un conte sur le bonheur de la rouquinerie, tu ferais quelque chose de bien … Ecris-moi encore. Tu m'a fait tant de plaisir. Je t'embrasse, mon cher enfant.

*Excellente visite de Louis Rouart ; je le note volontiers à cause des excessives paroles que j'avais écrites plus haut.

*Rencontré le petit Louis Rouart, plus rouge et plus embourgeoisé que jamais. Comme il y a longtemps que je n'ai vu personne, mon sourire marque une joie exagérée ; il m'accompagne, conversation aussi brusque, aussi tendue que jamais ; cela semble les spasmodiques reprises d'un assaut d'escrime, mais d'un assaut sans courtoisie. Dès les premièrs mots, dès l'abord, il attaque.

bare-headed and stands behind her chair while he reads, his body twisted and forming a diagonal (illus. p. 82). In the two most resolved he sits in a chair behind her and tugs at his beard as he appears to converse with her. Their movements seem to be as formal and ritualistic as a dance – or a pantomime. In the third set of drawings, Louis, wearing a soft felt hat, stands quietly behind her with his hand on the back of her chair – almost as if, when the dance ceases – in the moment of stillness – the real meaning is exposed.

Louis may not be exactly flattered in the large drawings but he is not ridiculed or maligned. At the worst he could seem passive and somewhat ineffectual. When we look at the portrait of Christine Lerolle Rouart after having seen Renoir's portrait of her painted seven years before, however, we cannot believe Degas was as gentle with her as he was with Louis. She does have the same luxuriant dark hair, a pretty profile in most of them, and another red dress, but she is no longer a girl; she is ample and mature. Whereas Louis is in general self-contained she seems the source of an unresolved energy, running through her arms, her umbrella, the twist of her body, her head and, of course, the extraordinarily long shawl. Neither husband or wife could be described as portrayed analytically. Both remain somewhat diffuse. Their relationship is suggested as one of familiarity and inevitability but not of great intimacy. On the whole these portraits could be taken for a light comedy of manners, if it were not for the single smaller drawing (illus. p. 81). In this work where Christine Rouart's head is reduced to a mask with no resemblance to her pretty profile, their essential tragedy is exposed. Both look desperately unhappy but they do not communicate with each other. His hand on the back of her chair is tentative, and may remind us of the poignancy of Lucie's hand on the back of her uncle's chair in *Henri Degas and his niece Lucie* (cat. 127, illus. p. 199), which Degas had painted thirty years before. Rather ambiguously, what should probably be read as her shawl leads to the hand, almost as if it were her arm. This M. and Mme Rouart share unhappiness but not each other. (These are not works Degas was to give his sitters.)

That Degas made so many drawings of the

couple need not indicate indecisiveness. He often worked in series, particularly in his contemporary studies of the dance. It was a form of exploration enabling him to range from gentle humour to deep compassion. At the same time, as happened so often when he portrayed the Rouarts, more was exposed than he probably desired. The suggestion that the marriage of Louis Rouart and Christine Lerolle was not idyllic is indicated by a story from André Gide, reporting a conversation with Mme Rouart: " 'You must be very happy', someone said to his wife, 'to see him become so religious.' 'Why, I am as sorry as I can be!', she exclaimed; 'so long as he wasn't religious, I was able to count on religion to improve his character. Now I have given up counting on anything.' "*[108]

The next year, 1905, Degas worked somewhat more systematically toward a very large pastel (L1450, illus. p. 82), which is now in the Petit Palais, Paris. Valentine Rouart, the wife of Henri's eldest son Alexis (who had appeared in the portrait with his father, cat. 177, illus. p. 225), is shown with their two daughters, Madeleine, born in 1896 (and therefore nine) and Hélène, born in 1901 (four). They are in a park which is undoubtedly once more La Queue-en-Brie, but more fully realised than it is in the drawings of M. and Mme Louis Rouart.

Degas made one drawing of Mme Alexis Rouart by herself (cat. 180, illus. p. 224), seated twisted in a chair. He seems to have executed this *Mme Rouart*, mainly in charcoal but with some touches of pastel, with considerable irritation. We are made conscious of the energy as well as shortness of temper with which he drew. The cost to Mme Rouart is considerable – her body boney and angular under the dress, her right hand deformed, her hair like a scraggly wig too casually applied, and her face contorted with anguish or pain. It is only when we see the large pastel (illus. p. 82), which is gloriously opalescent in colour like many of Degas's late compositions of dancers, that we discover that he can be kinder to her. Her body is rounder under the pretty blouse and skirt, her hair fuller and more lustrous, her face with some remnant of comeliness. But more than that, he reveals the reasons for the deformations. In spite of the beauty of the pastoral glade, Mme Alexis Rouart is driven to distraction by the

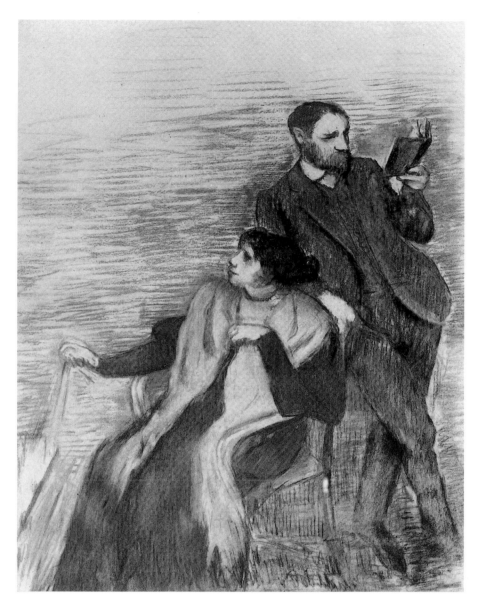

M. and Mme Louis Rouart, 1904, pastel, 152 × 115 cm, Private collection (L1437)

conflicting demands of her two children. As she leans down to listen to small Hélène, that misshapen – but no longer deformed – right hand pulls at a kerchief. Her hat has made its way to the ground. Most terrible of all, the nine-year-old daughter Madeleine has been transformed into an irrational monster with a predatory expression and undisciplined long hair who leans away from her mother and sister. This is a domestic situation to which Degas responds not only realistically but expressively. He does suggest some compassion for the mother. The very beauty of the colours makes her predicament even more harrowing.

This did not mean that Degas lacked affection for the Rouart family still. Even Madeleine, who seems like an evil witch in the pastel, could turn up in one of his letters, unfortunately not dated, as "That Madeline. I could pass entire days talking to her: she's really extraordinary." His ending "Bonjour à la pauvre petite femme, mère de Madeline", may reveal his compassion for the mother as well.[110]

At the same time that Degas was making pastels of Christine and Louis Rouart and of Valentine Rouart with her two daughters, he turned to his laundresses again, producing one large pastel drawing, *Washerwomen and horses* (cat. 179, illus. p. 298), in which he composed the two women very much as he had composed two with baskets of laundry in a small oil he had painted in the 1870s (L410, whereabouts unknown). This turning back to his earlier work was not rare at this time – encouraged perhaps by nostalgia, perhaps to compete with his younger self, perhaps because his deteriorating eyesight did not permit him to find so many subjects as in the past.[110] In any case these laundresses are not as winsome as their predecessors, for whom Emma Dobigny (cat. 100, illus. p. 223) may have posed. They are gaunt, ageless but not young, moving forcefully but without much articulation or suggestion of purpose, and certainly without any grace. In some ways they may remind us of the pastels of Louis Rouart with his wife and Mme Alexis Rouart with her daughters. They even seem to be in a stable yard which could be at La Queue-en-Brie or, more probably, because of the huge Percheron horses in the background, at Ménil-Hubert. A comparison with the last sets of Rouart portraits makes

Mme Alexis Rouart and her children, 1905, pastel, 160 × 141.5 cm, Paris, Musée du Petit Palais (L1450)

it clear that Degas has continued to make a distinction between working women and the bourgeoisie at leisure. Summary as the drawings seem – and bold and daring – the manners and dress still convey differences of class.

When the portraits and this rather stark and vigorous genre pastel are compared, however, the direction of the laundresses, and in particular the movement of the two horses behind them, may not be perfectly clear, but their energy remains intact. They do not in the end seem as vulnerable as the sitters in the portraits, who are exposed before us with considerable pathos. The aimlessness of these younger Rouarts is haunting but destructive. The Rouarts of 1904 and 1905 seem to crumple up visually and morally before us. The beautiful colour makes the disintegration all the more poignant. Madeleine Rouart, the most frightening figure, becomes a symbol, in her utter indifference to anyone else and in her demoniac intensity, for the world as Degas sadly saw it with what were now twentieth-century eyes. This is clearer in his portraits than in the genre of his last years because he was attached to these Rouart friends and deeply concerned with their vulnerability. He saw that they had given up their confidence in free will and their faith in reason. Their portraits could only demonstrate their lives' tragedies.

NOTES

1 The title was not given by Lemoisne, as stated in some of the literature, but by the artist in his aborted submission of it to the fifth Impressionist exhibition in 1880. The best concise summary of the evidence in a notebook (Reff 18, BN 1, p. 202) is to be found in Martin Davies (*National Gallery Catalogues: French School*, London 1957, pp. 69–72, à propos no. 3860, *Petites filles spartiates provoquant des garçons*). On l'abbé Jean-Jacques Barthélémy as the interpreter of classical history and myths for Degas through his *Voyage du jeune Anacharsis en Grèce* see Pool 1964, p. 309. Recent examinations of the meaning of the subject have been made by Salus and Broude 1988, pp. 640–48. See also Druick in *Degas inédit* 1989, pp. 244–45.

2 See Burnell 1969, who compares the Chicago and London versions and believes the London version later, but does not consider the question of retouching beyond the early 1860s. Broude 1988, pp. 642–48, assumes that it was retouched for 1880.

3 The accumulation of evidence about the trial was made by Douglas W. Druick and Peter Zegers for 'Scientific Realism: 1879–1884', in 1988–89 Paris/Ottawa/New York, pp. 197–211, in particular pp. 208–211. More was added and some changes made by Druick in *Degas inédit* 1989, pp. 224–50. See also Loyrette 1991, pp. 388–91.

4 Les carnets de Ludovic Halévy, *La Revue des Deux-Mondes*, p. 838.

5 Druick and Zegers in 1988–89 Paris/Ottawa/New York.

6 Loyrette 1991, p. 390.

7 *Ibid.*, also Druick and Zegers in 1988–89 Paris/Ottawa/New York, p. 209.

8 Loyrette 1991, p. 390.

9 Druick and Zegers in 1988–89 Paris/Ottawa/New York.

10 *Lettres* 1945, LXV [15 September 1884], p. 91.

11 See 1988–89 Paris/Ottawa/New York, no. 276, p. 455, where the bust is identified as Périe Bartholomé; fig. 251 is a detail of her head on her tomb by Bartholomé, and fig. 298, p. 533, is an engraving of Rose Caron.

12 *Lettres* 1945, LXV [15 September 1884], p. 91; translation *Letters* 1947, p. 91.

13 *Lettres* 1945, LXIII [no date], p. 89; translation, *Letters* 1947, p. 89. Many letters do not seem to have been dated. Pantazzi (from conversation) believes that they can be dated by external events such as a famous heatwave the week of 6 August 1884.

14 *Ibid.*; translation *ibid.*

15 *Lettres* 1945, LXIV, [no date], p. 90; translation, *Letters* 1947, p. 93.

16 In the Archives du Louvre, there is a letter of 15 January 1935 to Marcel Guérin from Jeanne Fevre, niece of Degas (and daughter of Marguerite) who writes that the statuette, *L'Ecolière* (Pingeot 74), which she seems to have retained so that it was not one of the 22 cast (plus *La petite danseuse* cast later), was modelled about 1882 after her sister, Anne Fevre, later comtesse de Caqueray, when she was thirteen or fourteen years old. Somewhat earlier, 1881 or 1882, Degas made a relief, *La cuillette de pommes* (Pingeot 72), which was never finished but intended to be a memorial to Marie Fevre, a sister of Jeanne and Anne. See Pantazzi in 1988–89 Paris/Ottawa/New York, no. 231.

17 *Lettres* 1945, LXVI [3 October 1884], p. 93.

18 *Lettres* 1945, LXIV [no date], p. 90.

19 *Lettres* 1945, LXV [15 September 1884], pp. 91–92.

20 Lemoisne I, p. 130.

21 See Terrasse 1983, nos. 40–45, and Lemoisne I, between pp. 154 and 155 (c).

22 Loyrette 1991, p. 541.

23 Druick in *Degas inédit* 1989, p. 225, points in particular to Philippe Burty, Exposition des œuvres des artistes indépendants, *La République française*, 10 April 1880.

24 *Degas inédit* 1989, p. 359, letter BN 2(1), 19 November [1872].

25 Reff 29, collection of Mr and Mrs Eugene V. Thaw, pp. 21, 23.

26 Alex[andre] Pothey, Chronologie, *La Presse*, 31 March 1876, described the work in the 1876 Impressionist exhibition: "Degas nous montre deux blanchisseuses: l'une pèse sur son fer dans un mouvement très juste, l'autre baille en s'étirant les bras". Ronald Pickvance identified L686 as the work; see sales catalogue, Christie's, London, 30 November 1987, lot 80.

27 1988–89 Paris/Ottawa/New York, no. 257, p. 428.

28 Lipton 1986, chapter 3, 'Images of Laundresses: Social and Sexual Ambivalence', pp. 116–50.

29 Lipton 1986, chapter 2, 'At the Ballet: The Disintegration of Glamour', pp. 73–115.

30 Lipton 1986, pp. 153–64.

31 Lemoisne I, p. 123.

32 For nudes or bathers see Lipton 1986, chapter 4, 'The Bathers: Modernity and Prostitution', pp. 164–86; and Thomson 1988.

33 As described by Martelli to Signorini in Piero Dini, *Dal caffé Michelangiolo al caffé Nouvelle-Athènes – I macchiaioli tra Firenze e Parigi*, Turin 1986, p. 59.

34 Rostrup 1977, pp. 7–13.

35 On 18 April 1888 Durand-Ruel bought from Degas '*La mère de la danseuse*', for 1500 francs (stock no. 1584) and sold it on 8 June 1888 to Paul-Arthur Chéramy. Tinterow, in 1988–89 Paris/Ottawa/New York, p. 387, believes it is unlikely that this was either version of *The Mante family*.

36 See Jacqueline Millet (grand-daughter of Suzanne Mante), La famille Mante, une trichromie, Degas, l'Opéra, *Gazette des Beaux-Arts,* vol. 94, 1979, pp. 105–112; A.S. Godeau, Louis Amedée Mante: Inventor of Color Photography?, *Portfolio* III, vol. 3, no. 1, January/February 1984, pp. 40–45.

37 According to Millet p. 109, this is supposed to have been rue de Norvins, Paris 18ᵉ, where we do not have any record of Degas living. On the other hand, in October 1877 Degas moved to 50, rue Lepic, which is close in the same arrondissement. The circumstances for the two moves might have been similar, Mante because he had just gone bankrupt, Degas because he was trying to prevent it.

38 Millet 1979, p. 105, for dates of births.

39 Millet 1979, p. 110; Godeau 1984 (see note 36) p. 43.

40 Browse 1949, pp. 54 n, 60, 61.

41 Pickvance, in 1993 Martigny no. 43, dates it to 1890 without allusion to the Mantes.

42 For a fuller description of the pastel, with the assumption, however, that the dancer is Suzanne, see Boggs 1962, pp. 66–67.

43 Halévy 1960, p. 170.

44 See Loyrette 1991, pp. 529–36, for a full account of life at Dieppe for Degas in 1885.

45 Françoise Heilbrun, 'Sur les photographes de Degas', in *Degas inédit* 1989, pp. 161–63.

46 The photograph is reproduced in 1988–89 Paris/Ottawa/New York, p. 382, fig. 189.

47 *Lettres* 1945, to Ludovic Halévy from Paris [September 1885], second last paragraph.

48 Heilbrun in *Degas inédit* 1989, p. 162.

49 Sickert 1917, p. 184.

50 For a fuller description of *Six friends at Dieppe*, see Boggs 1962, pp. 70–72.

51 Ambroise Vollard, *En écoutant Cézanne, Degas, Renoir*, Paris 1938, p. 117.

52 Reff 30, BN 9, p. 198.

53 Reff 30, BN 9, p. 205.

54 For a fuller description see Boggs/Maheux 1992, no. 33.

55 *Lettres* 1945, CCXXXVII, p. 238 [27 December 1904], to Alexis Rouart.

56 To confuse identification further, according to Jamot 1924, p. 298, Alexis Rouart (senior) had a son called Henri who was presumably the member of the Comité artistique for 1924 Paris.

57 Valéry 1965, pp. 11–16.

58 Lemoisne I, p. 147, lists the typical guests at the Rouarts. The quality of the welcome was recorded by Arsène Alexandre in his Preface to *Catalogue des Tableaux*

Anciens et Tableaux Modernes composant la collection de feu Henri Rouart, 2 vols., Galerie Manzi-Joyant, Paris, 9–11 December 1912, I, p. 1: "Son accueil était si engageant, si affable, si libéral, qu'on ne pouvait résister au désir d'y retourner, et c'était chaque fois de nouveaux plaisirs."

59 Characteristically he ends a letter to Mme Rouart *Lettres* 1945, LXXV, p. 101, Tuesday evening [1884 or 1885], "croyez à mon insupportable amitié".

60 See 1984 London.

61 See *Catalogue des Tableaux* (cited note 58).

62 1984 London, p. 6.

63 McMullen 1984, p. 383, is somewhat cavalier with their dates of birth. These dates are from Agathe Rouart-Valéry, 'Degas, ami de ma famille', in *Degas inédit* 1989, pp. 33–34.

64 *Lettres* 1945, CXCIV, p. 209, 25 May [1896] to Henri Rouart.

65 Pantazzi in Paris/Ottawa/New York, no. 143, pp. 249–250.

66 1984 London, p. 6, fig. 3.

67 Brown 1994, pp. 122–25.

68 Loyrette 1991, p. 502, supplemented by *Petite Larousse en couleurs,* Paris 1980, p. 1315.

69 Boggs 1956, pp. 13–17.

70 *Lettres* 1945, LVII, p. 84 [22 August 1884], to Henri Rouart.

71 See *Journal d'un collectionneur, marchand des tableaux,* Paris 1963, by René Gimpel, who had bought *Hélène Rouart* on 27 May 1924 (p. 267) and was curious about its history. On 10 March 1934 (pp. 441–42) he expressed his frustrations: "Je rencontre un Rouart, je crois l'aîné des frères . . . Comme il est difficile même d'écrire l'histoire de l'art ! Cet autre frère m'avait raconté que mon tableau était l'étude fort poussée pour un très grande tableau de la famille Rouart qui ne fut jamais exécuté, parce que leur mère était mort entre temps. Aujourd'hui ce frère me dit qu'il ne croit pas que ce soit exact, que leur mère mourut quelques années après, qu'il ne jamais entendre parler que d'un seul project du grand tableau."

72 1984 London, p. 8.

73 *Sammlung Emil G. Bührle,* Zurich, Kunsthaus, 1958, no. 163, p. 106.

74 *Lettres* 1945, LXXV, p. 101, Tuesday evening [1884 or 1885] to Mme Henri Rouart.

75 Reff 37, BN 6, pp. 206, pp. 206, 207.

76 See Reff 1976, pp. 137–40; 1984 London, pp. 12–17.

77 1984 London, p. 11.

78 Reff 1976, p. 138.

79 1984 London, p. 15, "Henri Rouart, ever present by implication through his pile of papers and empty chair", Loyrette 1991, p. 502.

80 *Lettres* 1945, LXII, p. 88, Saturday [1884] to Henri Rouart: "j'aime mieux lui redire toutes sortes de compliments sur la jeune acquarelliste à qui a donné la jour", and *Lettres* 1945, LXIII, p. 90, Ménil-Hubert [1884], to Henri Rouart: "Tous mes bons souvenirs à la vindicative Mme Rouart et à la jeune fleuriste".

81 See Chronology, 2 April 1889 and 26 April 1889.

82 1984 London, pp. 10–12.

83 Reff 1976, p. 137.

84 1984 London, p. 17.

85 J.-E. Blanche, *Propos de peintre : de David à Degas*, Paris 1914, p. 270.

86 Valéry 1965, p. 14.

87 Loyrette 1991, p. 254.

88 *Lettres* 1945, CXCIV, p. 204, Monday [25 May 1896], letter to Henri Rouart as a result of the birth of Madeleine to Alexis Rouart and his wife. See Agathe Rouart-Valéry, 'Degas et ma famille', in *Degas inédit* 1989, p. 29.

89 Rouart-Valéry in *Degas inédit* 1989, p. 29.

90 *Lettres* 1945, LXXXV, p. 110, Tuesday [September 1885] to Ludovic Halévy.

91 *Degas inédit* 1989, p. 371, Institut 2, 1 October 1885, to Jacques-Emile Blanche.

92 *Lettres* 1945, CXX, p. 151, Monday evening [received 29 April 1890 in Angoulême], to Bartholomé.

93 Information on Caron is from Loyrette 1991, pp. 545–47, and Roger Blanchard and Roland de Candé, *Dieux et Divas de l'Opéra*, Paris 1987, pp. 120–24.

94 Blanchard/de Candé 1987 (see preceding note), p. 174.

95 L862, L867.

96 Werner 1977, no. 20, p. 58.

97 Degas 1946, VII.

98 Terrasse 1983.

99 Crimp 1978, p. 91; see also Janis in 1984 Paris, pp. 475–76.

100 Janis 1984, pp. 473–81.

101 L1437–1444 (*M. et Mme Louis Rouart*) and L1450–1452 (*Mme Alexis Rouart et ses enfants*), to which BR 163 should be added. Lemoisne I, p. 163, suggests he had discussed the sittings with the Rouarts who could have confirmed the dates.

102 Judith Cousins and Hélène Seckel, 'Eléments pour une chronologie de l'histoire des Demoiselles d'Avignon', in exhibition catalogue *Les Demoiselles d'Avignon,* Paris, Musée Picasso, 1988, I, pp. 554–56. The painting he wanted is now in the Barnes Collection.

103 Lemoisne I, between pp. 220 and 223.

104 *Lettres* 1945, CCXXIVbis, 16 March 1900, pp. 228–29.

105 André Gide, *Journal, 1889–1939*, Paris 1949, p. 265.

106 Gide 1949 (see preceding note), p. 180, 8 November 1905.

107 L1437 for this information; and Rouart-Valéry in *Degas inédit* 1989, p. 34, note 21.

108 Gide 1949 (see note 105), p. 290, 6 January 1910.

109 *Lettres* 1945, CCXXI, Sunday, n.d., p. 226. Degas spells her name Madeline, although her family seems to have used the more conventional Madeleine.

110 Kendall 1988.

Degas and the Rouart family

A Chronology for Degas as a Portraitist

JEAN SUTHERLAND BOGGS

Paris should be assumed as the location if another is not given.

Unless otherwise noted, the sources used for this Chronology are: Reff 1976/1985; 1988–89 Paris/Ottawa/New York; Loyrette 1991

1832 *14 July*
The artist's parents, the Neapolitan-born Auguste De Gas and the New Orleans-born Célestine Musson, are married in the church of Notre Dame de Lorette, Paris, in the district (known variously, if approximately, as the 9th arrondissement, Montmartre or la Nouvelle-Athènes) where the painter will spend most of his life.

1834 *19 July*
Hilaire Germain Edgar De Gas (called Edgar) is born at 8 rue Saint-Georges, Paris 9ᵉ.

1835 *9 December Naples*
In one of several letters that the artist's grandfather, Hilaire Degas, writes to his wife, who is in Paris to see their new grandson, he expresses his worry that his Paris-based son's father-in-law is pressing Auguste to raise money to invest in New Orleans and has asked Hilaire for a guarantee of 1,500,000 francs: "ils ignorent, ou pour mieux dire, ils n'ignorent pas que de travail ce que nous possédons nous a couté? Ils voudraient se l'éviter et être des Rothschild d'un coup de feu!"
Raimondi 1958, p. 107.

1838–45
The artist's brothers and sisters who would survive, and of whom he would make many sympathetic portraits (see pp. 174–85), are born in these years – Achille in 1838, Thérèse in 1840 (in Naples), Marguerite in 1842 and René in 1845.

1845 *5 October*
Edgar Degas, aged eleven, is placed as a boarder in the Lycée Louis-le-Grand, where he is to make three enduring friendships – with Ludovic Halévy, Henri Rouart and Paul Valpinçon – friendships that will extend to include their families and will be recorded in the artist's paintings, drawings and photographs (see pp. 206–09, 222–25, 304–05).

1847 *5 September*
The mother of the future artist dies.

1849 *May Naples*
Gennaro Bellelli, married to the painter's aunt Laura Degas, his father's sister, is expelled from his native Naples where he had been active in the Revolution of 1848. In exile he goes to Marseilles, London, Paris and, finally, Florence, where he settles with his wife and two daughters

until the Unification of Italy in 1860. Edgar will visit them in Florence between 1858 and 1860, making the preliminary studies for his memorable portrait, *The Bellelli family* (L69, Paris, Orsay, illus. p. 16; see further pp. 188–94).

1853 *23 March*
Edgar graduates with a *baccalauréat* in literature from the Lycée Louis-le-Grand. On 7 April he is given permission to copy at the Louvre and two days later to copy in the Cabinet des Estampes at the Bibliothèque Nationale. Most of his notebooks will be given by his younger brother René to the same Cabinet des Estampes of the Bibliothèque Nationale, including one of 1853 (Reff 1, BN 14), in which, industriously if somewhat hesitantly, he makes drawings and notes from prints and books. Some of these will contribute to his portraiture; among them are studies of physiognomy in drawings or engravings after Leonardo's 'grotesque heads' or Michelangelo's own eccentric features, and considerations of both proportion and perspective in the description of the human body, and in particular the head, by Jean Cousin in *L'art de dessiner*.
Reff 1, BN 14.

12 November
Following his father's wishes, Edgar registers at the Faculty of Law of the University of Paris but does not persist with these studies.

1855 *6 April*
Edgar registers at the Ecole des Beaux-Arts, for which he has been accepted as thirty-third in his class.

Summer
In his second surviving notebook (Reff 2, BN 20), begun in September 1854, the twenty-one-year-old artist reveals his interest in the Exposition Universelle and the exhibition there of the work of Ingres. (He has been introduced to Ingres earlier in 1855 by the father of his schoolfriend Paul Valpinçon.) In the notebook there is a drawing after the older artist's *The composer Cherubini and the Muse of lyric poetry*, which the Luxembourg lends to the exhibition.
Reff 2, BN 20, p. 54.

In that same notebook are drawings after portraits by Mannerist artists whose stylised poses attract him: works by Andrea Solario and Franciabigio, both then attributed to Raphael, and Bronzino, all in the Louvre, as well as one by

Domenico Puligo, then given to Andrea del Sarto, which he can only have known from a reproduction.

Reff 2, BN 20, pp. 12, 31, 40, 57.

The notebook also contains thumbnail sketches for the compositions of some of Degas's own early portraits: 'Degas à la palette' (cat. 1, illus. p. 161); 'Degas au porte-fusain' (cat. 8, illus. p. 165); and 'René De Gas à l'encrier' (cat. 7, illus. p. 174). For this last two preliminary drawings (private collection) dated 1855 exist.

Reff 2, BN 20; L2, p. 13; L5, pp. 58B, 85; L6, pp. 32, 75.

July–September Lyons

A third notebook records the artist's stay of two months in Lyons, much of the time making drawings in the museum there. More important perhaps is the fact that the artist Louis Lamothe, under whom Degas is theoretically studying at the Ecole des Beaux-Arts – he seems to have been hardly more diligent there than at law school two years before – is assisting his own teacher Hippolyte Flandrin in the decoration of the church of Saint-Martin-d'Ainay. Although both these Lyons-born academic painters are history painters in a pious Christian tradition, they are also portrait painters whose correct, moral, bourgeois and even sanctimonious portraits can provide an antidote to the arrogance and flamboyance of the patrician portraits Degas has been copying in the Louvre and will find shortly in Italy. Jean Pierre Joseph Alfred Bellet du Poisat, of whom Degas was later to paint a portrait (cat. 70, illus. p. 260), is part of the 'Lyons School'.

Ref 3, BN 10.

1856 18 July Naples

The day after his arrival by boat from Marseilles to Naples to visit his grandfather at the beginning of a stay of what will prove to be a period of three years of disciplined self-education in Italy, largely in Rome, Degas is in the Naples museum taking notes on portraits attributed to Salviati and Raphael and also Titian's Pope Paul III, which he will use the next summer as the basis of his portrait of his grandfather (cat. 20, illus. p. 187).

Reff 4, BN 15, pp. 17, 18, 20.

1857 Rome

Degas dates two paintings of an old beggarwoman (cat. 21, illus. p. 281, and L29, New York, Metropolitan Museum).

Encouraged by a friend, the printmaker and copyist Joseph Gabriel Tourny, who in 1857 was probably also living in Rome, and inspired by Rembrandt's etchings, Degas makes remarkable portrait etchings, one a copy of Rembrandt's *Young man in a velvet cap* (cat. 35, illus. p. 157), another of Tourny (cat. 33, illus. p. 253), and a third a self-portrait (cat. 28–32, illus. pp. 168–69).

Summer San Rocco di Capodimonte

Degas paints the portrait of his grandfather, Hilaire Degas (cat. 20, illus. p. 187), at his villa outside Naples.

October Naples or Rome

Degas dates a drawing of his uncle Edouard (or Odoardo) (Paris, Louvre, RF 22998).

1858 4 August Florence

Degas moves into the Bellelli family apartment in Florence, although his aunt and two cousins are in Naples, where his grandfather is dying. He makes drawings in a notebook after portraits by Bronzino and Van Dyck in the Uffizi and by Botticelli in the Pitti.

Reff 12, BN 18: Bronzino, p. 43; Van Dyck, pp. 11, 62, 72; Botticelli, p. 19.

Florence

Degas inscribes a drawing (location unknown) "Mme Dembowski/sœur de mon oncle Bellelli/ Florence 1858". Enrichetta Bellelli Dembowski is married to Ercole Federico Dembowski, director of the Astronomical Observatory in Milan. A drawing of her daughter is inscribed – possibly later, mistaking the year – "Flo. 1857. Mlle Dembowski" (cat. 50, illus. p. 193).

11 November Paris to Florence

A letter is sent by the painter's father who has received a shipment of Edgar's recent work. He congratulates his son on having rid himself of "ce flasque et trivial dessin Flandrinien, Lamothien et de cette couleur terne gris". But he goes on to persuade his son to concentrate upon portraiture, which he assures him will be "le plus beau fleuron de ta couronne". He also warns Degas that he must be prepared to earn his living.

Lemoisne I, p. 30.

19 November Livorno

The artist's aunt Laura Bellelli (née Degas) finally returns from Naples and arrives at Livorno. From this time onwards, Degas is able to satisfy

his father's concern that he progress as a portrait painter with the studies he makes of the Bellelli family in Florence (cat. 40–49, 55, 78; illus. pp. 188–94).

27 November Florence

In a letter to Gustave Moreau Degas describes his two Bellelli cousins and something of his progress with the painting: "J'ai deux petites cousines à manger ... Je les fais avec leurs robes noires et des petits tabliers blancs qui leur vont à ravir ... Je voudrais une certaine grâce naturelle avec une noblesse que je ne sais comment qualifier."

Reff 1969, p. 283.

29 December Florence

Degas begins the composition for The Bellelli family.

Lemoisne I, p. 31, quoting a letter from his father to the painter.

1859 End of March Florence

Degas leaves Florence for France with most of his studies for The Bellelli family, even if he has not begun to work on the large canvas itself.

2 April Genoa

Having already made drawings after Van Dyck portraits in Rome and Florence, Degas is captivated by the Flemish artist's portraits of members of the Brignole-Sale family at the palazzo Rosso: the equestrian portrait of the Marchese Anton Giulio, the portrait of the Marchesa Geronima with her daughter, and, above all, that of Paolina Adorno alone – which makes Degas wonder if Van Dyck had not been in love with her. Undoubtedly his studies of this last portrait will influence his painting of his aunt Laura in The Bellelli family.

Reff 13, BN 16, p. 41.

6 April

Degas arrives in Paris.

26 April

Degas writes to Gustave Moreau about the Van Dycks he has seen in Genoa and comments, "On n'a jamais rendu la grâce et finesse de la femme, l'élégance et la chevalerie de l'homme, ni la distinction de tous les deux comme Van Dyck."

Reff 1969, p. 284.

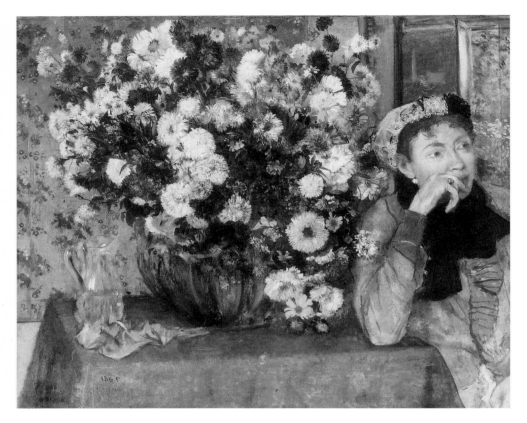

Mme Joséphine Gaujelin, 1867, oil on canvas, 59 × 44 cm, Boston, Isabella Stewart Gardner Museum (L165)

'*La femme aux chrysanthèmes*', 1865, oil on canvas, 73.7 × 92.7 cm, New York, The Metropolitan Museum of Art, Havemeyer Bequest (L125)

1 October

Edgar moves into a studio at 13 rue de Laval (later called Victor-Massé), Paris 9ᵉ, although it is possible that he continues to live in the apartment at 4 rue de Mondovi, Paris 1ᵉʳ, which his father has rented since 1853. The rue de Laval studio is large enough for him to work on *The Bellelli family*.

1859–60

Romanticism for Degas is not quite dead since in his notebooks he proposes imaginary portraits of both the Marquis de Vauvenargues and Alfred de Musset.

Reff 14A, BN 29, fol. 599, p. 37; Reff 16, BN 27, pp. 6, 7.

1860 *2 April*

Degas returns from a trip to Italy with a drawing of the head of Gennaro Bellelli for *The Bellelli family* inscribed lower right "Florence 1860" (Paris, Louvre, RF 15484). A drawing in the exhibition (cat. 55, illus. p. 192) must have been done at the same time.

1861 *14 January*

Degas's schoolfriend Paul Valpinçon marries Marguerite-Claire Brinquant. Degas presumably makes the Ingresque double portrait drawing of them (cat. 58, illus. p. 208), dated 1861, shortly after the wedding.

3 September

Degas enrols once again as a copyist at the Louvre. This leads to his etching after *The Infante Margarita*, attributed to Velázquez (cat. 61, illus. p. 157), and to his first meeting with Manet, according to a story which some consider apocryphal.

September–October *Ménil-Hubert*

Degas visits the Valpinçons at Ménil-Hubert in Normandy, as he records in one large notebook (Reff 18, BN 1). He projects a portrait of Mme Valpinçon in mourning.

Reff 18, BN 1, p. 96.

1863 *18 June*

The painter writes to his maternal uncle Michel Musson in New Orleans that his uncle's wife, two daughters and a grand-daughter have arrived in France in refuge from the American Civil War. By 12 August they seem to have moved to Bourg-en-Bresse.

Lemoisne I, p. 73.

7 November *Naples or Paris*

Mme Edmondo Morbilli (Thérèse De Gas) loses a child after her brother has painted her serenely pregnant with her husband, their cousin Edmond Morbilli (L131, Washington, National Gallery of Art).

Unpublished letters, The De Gas-Musson Papers at Tulane University.

1863–64 *New Orleans*

From New Orleans the painter's maternal uncle, Michel Musson, enlists the investments of the Degas family in Paris, including Edgar, in Confederate bonds. In 1864 Auguste De Gas approves the sale of a house the artist owns in

New orleans for this purpose.
Brown 1994, p. 29.

1863–67
There is little evidence for the dating of portraits by Degas during these years. Although Degas later inscribes 1863 on a drawing (cat. 89, illus. p. 230) of the head of Mlle Julie Bertin (or Burtey), Reff has argued convincingly that the preparatory drawings (see also cat. 90, illus. p. 230) and the painting (cat. 88, illus. p. 231) are no earlier than 1867.
Reff 22, BN 8, p. 37.

There are, however, three daguerreotype-inspired double portraits that probably fall within this period: *Degas and de Valernes* (L116, Paris, Orsay; illus. p. 23), *Giovanna and Giulia Bellelli* (cat. 78, illus. p. 194) and *M. and Mme Edmondo Morbilli* (cat. 73, illus. p. 185).

1865 *6 January Bourg-en-Bresse*
Degas inscribes a watercolour of his American aunt Odile Longer Musson with her two daughters, Désirée Musson and Estelle Musson Balfour, "Bourg-en-Bresse, 6 Janvier 1865/E. De Gas" (cat. 80, illus. p. 200). They have been living there in refuge from the American Civil War for the past year and a half.

Ménil-Hubert
It has recently been proposed by Loyrette that the drawing formerly considered to be of Mme Hertel (I:312, Cambridge (Mass.), Fogg Art Museum) and the painting known as '*La femme aux chrysanthèmes*' (L125, New York, Metropolitan Museum; illus. p. 111), both dated 1865, are actually of Mme Valpinçon.
Loyrette in 1988–89 Paris/Ottawa/New York, no. 60.

1867 *15 April*
Degas exhibits two "portraits de famille". Although Loyrette believes that one of these was *The Bellelli family*, it seems improbable that this large canvas would have been completely ignored at the time.

24 December
Degas inscribes a drawing (private collection) of his niece Célestine Fevre, the daughter of his sister Marguerite, "Ecoutant l'histoire de la bonne Mimi dans son bain".
For illustrations see Boggs 1962, pl. 56.

25 December
This is the date on a piece of commercial paper Degas uses to make an early compositional drawing (Paris, Louvre, RF 31779) for his genre painting *Interior* (L348, Philadelphia Museum of Art; illus. p. 27), which was probably finished the next year.
Reff 1976, pp. 206, 207, fig. 135.

1867
A portrait of Joséphine Gaujelin, a dancer at the Opéra (L165, Boston, Isabella Stewart Gardner Museum; illus. p. 88) is dated 1867. In the beginning of a notebook Reff dates 1867–74 (Reff 22, BN 8), Degas makes notes relevant to his portraiture. Of the skin he writes, "La peau humaine est aussi variée d'aspect, chez nous surtout, que le reste de la nature"; of hair, "Je me rappelle facilement la couleur de certains cheveux … de vrais cheveux avec leur souplesse et leur légèreté ou leur dureté et leur pesanteur." He also quotes Barbey d'Aurevilly, "Il y a parfois une certaine aisance dans la maladresse, qui, si je ne me trompe, est plus gracieux que la grâce même."
Reff 22, BN 8, pp. 3, 4, 6.

ca. 1867
Degas becomes part of the Manet-Morisot circle, which also includes Fantin-Latour and his future wife (L137, Toledo Museum of Art), Puvis de Chavannes and Mme Lisle and Mme Loubens (cat. 79, illus. p. 234). Much of the life of this group is documented by the Morisot family correspondence.
Correspondance de Berthe Morisot avec sa famille et ses amis, ed. Denis Rouart, Paris 1950.

1868 *1 May*
At the Salon Degas exhibits his '*Portrait de Mlle E.F.* [Fiocre]; *à propos du ballet de La Source*' (L146, Brooklyn Museum of Art; illus. p. 51), for which two drawings are dated August 1867.
1988–89 Paris/Ottawa/New York, p. 134, figs. 71 and 72.

26 August
Manet writes to Fantin-Latour, quoting the novelist and critic Edmond Duranty, that Degas "est en train de devenir le peintre du high life".
Etienne Moreau-Nélaton, *Manet raconté par lui-même*, 2 vols., Paris 1926, I, p. 103.

1869 *1 May*
Degas exhibits at the Salon his "*Portrait de Mme G.* [Joséphine Gaujelin]" of 1867 (L165, Isabella Stewart Gardner Museum of Art, illus. p. 88)

The ironer, ca. 1869, oil on canvas, 92.5 × 74 cm, Munich, Bayerische Staatsgemäldesammlungen, Neue Pinakothek (L216)

which Berthe Morisot describes as "un très joli portrait d'une femme très laide en noir … c'est très fin et distingué". A drawing of the head for this painting (cat. 87, illus. p. 228) and a painting, which shows her as prettier and more provocative (cat. 86, illus. p. 229), are in the present exhibition.
Morisot 1950 (cited under ca. 1867), p. 28.

[Wednesday before] 11 May
Degas asks permission to paint a portrait of Yves Gobillard Morisot, a sister of Berthe Morisot, who is visiting her mother Mme Morisot. The stages of the realisation of this wish in both an oil painting (L213, New York, Metropolitan Museum) and a pastel (L214, New York, Metropolitan Museum) are well documented in the correspondence of the Morisot family. At the end of June the sittings are finished but the artist completes the paintings in his studio.
Morisot 1950 (see under ca. 1867), pp. 29–32.

October London
Degas visits London, possibly for the first time, staying at the Hotel Conte, Golden Square. He presumably sees both the expatriate Frenchman James Tissot and the expatriate American James Abbott McNeill Whistler, friends who are living there.
Pickvance in 1993 Martigny, p. 316.

Mme Camus in red, 1870, oil on canvas, 73 × 92 cm, Washington D.C., National Gallery of Art (L271)

17 June New Orleans

René De Gas marries his and Edgar's cousin Estelle Musson Balfour, who will eventually become blind.

Loyrette 1991, p. 289.

1869

Degas dates a painting of the head of one of his favourite models, Emma Dobigny (cat. 100, illus. p. 233). It may have been in that same year that he uses her to pose for *Sulking* ('*La Bouderie*'; L335, New York, Metropolitan Museum) and *Ironer* (L216, Munich, Neue Pinakothek; illus. p.*.)

ca. 1869

In a notebook dated 1869–72 Degas makes notes from Lavater on physiognomy: "faire de la *tête d'expression* (style d'académie) une étude du senti-ment moderne – c'est du Lavater, mais du Lavater plus relatif ... avec symboles d'ac-cessoire quelquefois." He also reminds himself, "faire des portraits des gens dans des attitudes familières et typiques", and, "surtout donner à leur figure les mêmes choix d'expression qu'on donne à leur corps. Ainsi si le rire est le type d'un personnage, la faire rire."

Reff 23, BN 21, pp. 44, 46, 47.

1869–70 Late winter or Spring

Degas probably now paints *The orchestra at the Opéra* (L186, Paris, Orsay; illus. p. 52) and the freer study for it around his friend the bassoonist Désiré Dihau.

1870 1 May

In his last submission to the official Salon, Degas exhibits the pastel head of Mme Gobillard of 1869 (L214, New York, Metropolitan Museum) and '*Mme Camus en rouge*' (L271, Washington, National Gallery of Art; illus. p. 90). His other portrait of Mme Camus, an amateur musician (cat. 101, illus. p. 213), seems to have been rejec-ted. Degas also painted her husband, Dr Gustave Emile Camus, a physician and collector of por-celain (cat. 93, illus. p. 211).

Roquebert 1988, p. 118.

Summer

Degas presumably now paints the portrait of *Henri Valpinçon as a child* (cat. 106, illus. p. 207); Henri was born on 11 July 1869. In 1869 Degas made other studies of Valpinçon domestic life in the Norman countryside, including *Carriage at the races* ('*Aux courses en province*') of about 1869 (L281, Boston, Museum of Fine Arts).

This same summer Degas paints his friend the Vicomte Ludovic Lepic, an artist and dog-breeder, a man of many talents, and his daughters Eylau (born 14 June 1868) and Janine (born 26 November 1869) (cat. 110, illus. p. 219). About five years later Degas will paint them in the Place de la Concorde (L368, currently held in a Russian museum, illus. p. 43).

Professor Emeritus Harvey Buchanan, Case-Western Reserve University, has been making a study of Lepic, with the cooperation of his descendants.

September

With the outbreak of the Franco-Prussian War, Degas volunteers in the National Guard, as does Manet. Manet's letters to his wife document the cold and the shortage of food from which both suffered.

Moreau-Nélaton 1926 (cited under August 1868), I, pp. 123–26.

Early October

Degas is posted under the command of one of his old schoolfriends, Henri Rouart.

1871 March

Degas so dates a portrait of three of his comrades in the battery of the National Guard, Charles Jeantaud, Pierre Linet and Edouard Lainé (cat. 109, illus. p. 215). About five years later Degas will paint two portraits of Jeantaud's wife, the former Berthe-Marie Bachoux (cat. 124, 135, illus. pp. 216, 217), who is a cousin of Lepic.

16 March

Proclamation of the Paris Commune.

Spring Ménil-Hubert

At the Valpinçon's house in Normandy Degas paints the portrait of their daughter, Hortense (L206, Minneapolis Museum of Art; illus. p. 111).

1 June

Degas returns to Paris from Ménil-Hubert.

30 September

To his friend James Tissot in London, whose career has been similar to Degas's – he studied with Lamothe at the Ecole des Beaux-Arts, fol-lowed by a period in Italy – and of whom Degas had painted a large portrait about 1866 (L175, New York Metropolitan Museum, illus. p. 107), Degas writes that his *Orchestra* (with Désiré Dihau) is being shown in the rue Laffitte; such exhibitions of Degas's works were to prove rare.

Degas inédit 1989, BN 1 (I), p. 358.

1871

Degas paints a very small double portrait of a rabbi and a general who had been active with the French ambulance corps, *General Mellinet and Grand Rabbi Astruc* (cat. 108, illus. p. 214); this may have been a commissioned portrait.

1872 12 October Liverpool

Edgar and his brother René embark for America on board the *Scotia*.

24 October New York

Edgar and René arrive in New York, spending thirty hours on their way to New Orleans.

1872 New Orleans

Degas dates to this year a portrait of his blind cousin and sister-in-law, Estelle Musson, known as '*La femme à la potiche*' (L305, Paris, Orsay; illus. p. 110). He also dates 1872 a drawing of either Estelle or her sister Mathilde Musson Bell (cat. 113, illus. p. 201).

1873 18 February New Orleans

Degas writes to Tissot in London about the two versions of "*Le bureau de coton*" he is painting, *Portraits dans un bureau (Nouvelle-Orléans)* (cat. 114, illus. pp. 202–05) and *Cotton traders in New Orleans* (L321, Cambridge (Mass.), Fogg Art Museum; illus. p. 33). He is attracted by the possibility that the English dealer Agnew may sell the first to a rich spinner in Manchester.
Degas inédit 1989, BN 3 (I), pp. 360–62.

1873 New Orleans

Degas dates to this year the painting of Estelle Musson's daughter by her first marriage to Joe Balfour, which is known as *La pédicure* (L323, Paris, Orsay).

Late March

Degas returns to Paris from New Orleans with his brother Achille.

14 June

Durand-Ruel buys two works from Degas for 2,200 francs, his last purchase before December 1880; the dealer's money problems mean that he cannot buy from the artist for over seven years.

6 July London

His uncle Eugène Musson writes from Paris to New Orleans that Degas has gone to London.
Brown 1990, p. 122.

November Turin

The painter's father Auguste De Gas falls ill in Turin while on his way to Naples, where he hopes to straighten out the money problems of his firm, which had begun as a branch of his father's Neapolitan bank and is now surviving only on credit. Degas goes to him.

December Turin

Degas writes to the operatic tenor Jean-Baptiste Faure, who has been buying his works, to explain the delay in his finishing pictures Faure had commissioned: "[Je] me trouve confiné pour quelque temps, loin de ma peinture et de ma vie, en plein Piémont."
Lettres 1945, V, p. 32.

27 December

With Monet, Pissarro, Sisley, Morisot, Cézanne and others Degas forms the "Société Anonyme Coopérative à Capital Variable des Artistes, Peintres, Sculpteurs, Graveurs, etc.", which will hold the first exhibition of the group to be known later as the Impressionists.

1874 12 February

The writer and critic Edmond de Goncourt visits Degas in his studio and writes: "Un original garçon que ce Degas, un maladif, un névrosé, un opthalmique, à ce point qu'il craint de perdre la vue ; mais par cela même, un être éminemment sensitif et recevant le contre-coup du caractère des choses. C'est, jusqu'à présent, l'homme que j'ai vu le mieux attraper, dans la copie de la vie moderne, l'âme de cette vie."
Edmond and Jules de Goncourt, *Journal: mémoires de la vie littéraire*, 4 vols., ed. Robert Ricatte, Paris 1956, II, pp. 241–42.

13 February Naples

The painter's father dies.

March

In his efforts to organize the first Impressionist exhibition, Degas writes to Tissot, "Le mouvement réaliste n'a plus besoin *de lutter* avec d'autres. *Il est*, il *existe*, il doit se *montrer à part* – Il doit y *avoir un Salon réaliste*. – Manet ne comprend pas ça. – Je le crois, décidément, beaucoup plus vaniteux qu'intelligent."
Degas inédit 1989, BN 6 (I), p. 365.

4 April

The total value of the moveable effects in the estate of Degas's father, to be divided among five children, is estimated at 4,918 francs.

15 April

The first Impressionist exhibition opens in the studio of the photographer Nadar. Degas exhibits ten works, only three of which are for sale. None is listed as a portrait although '*Aux courses en province*' (L281, Boston, Museum of Fine Arts) might be described as a portrait of the Valpinçons.

1875 24 February

The artists Marcellin Desboutin and Giuseppe de Nittis etch drypoint portraits of Degas at the De Nittis house. It may be a year later that Degas paints Desboutin with another etcher friend, Lepic, both seated while Desboutin draws on a copper plate, *M. Desboutin and Vicomte Lepic* (L395, Nice, Musée Cheret).

28 February Naples

Achille Degas, the painter's uncle, dies. Degas travels to Naples for the funeral. He shares, with his brother Achille, the fixed property including the palazzo Degas (formerly palazzo Pignatelli) in Naples and the villa at San Rocco, but these cannot be sold until their orphaned cousin Lucie Degas reaches her majority and all debts and pensions are paid. Probably during this Neapolitan visit (or another the next year; see 1876, 16 June) Degas paints one of his Neapolitan aunts, Stefanina Primicile Carafa, Marchioness of Cicerale and Duchess of Montejasi (called Aunt Fanny by the artist), and her two daughters Elena (born 1855) and Camilla (born 1857) (cat. 128, illus. p. 197) as well as a portrait of twenty-year-old Elena alone (cat. 120, illus. p. 198).
Camilla's son, Francesco Russo Cardone di Cicerale, assured the author that Elena was the sitter.

Degas has already painted portraits of the two sisters together (cat. 77, illus. p. 195) and their mother alone (cat. 97, illus. p. 196). In addition on this visit or the other the next year he may have painted his uncle Henri Degas with Henri's niece (and the painter's cousin) Lucie Degas (cat. 127, illus. p. 199).

7 July Paris to Naples

Degas writes to his sister Thérèse in Naples as if he had just been there. He mentions his aunt Ste-

fanina twice and asks, "Remercie la tante Fanny d'avoir bien voulu accepter tout simplement la caisse de musique et prie Hélène [Elena] de tâcher de s'habituer à cette belle musique."
Pantazzi 1988, p. 125.

10 August
The painter's brother Achille shoots, but does not kill, the husband of his former mistress, Thérèse Mallot, in front of the Bourse in Paris.
McMullen 1984, pp. 250–51.

September London
Degas may have gone to London. A visit is proposed in a letter of 22 August 1875 to the dealer Charles W. Deschamps who manages Durand-Ruel's gallery there. The London address of Carlo Pellegrini, the Italian-born cartoonist who worked for *Vanity Fair* as 'Ape', of whom Degas makes a portrait (cat. 131, illus. p. 259), is found in a notebook of this period.
Reff 26, BN 7, p. 4.

24 September
Achille De Gas, the painter's brother, is sentenced to six months in prison.

20 November
Achille's sentence is commuted to one month in prison.

10 December
The condition of the estate of the painter's father and the debts of his firm are so pressing that Degas's maternal uncle Henri Musson writes from Paris to New Orleans requesting that René de Gas, the painter's younger brother, repay a loan made three years before.

1875
Degas dates gouaches of *Woman on a divan* (L363, New York, Metropolitan Museum) and *The ballet master (Jules Perrot)* (cat. 118, illus. p. 287).

1876 February
Henri Musson, the painter's maternal uncle, and the artist have Henri's brother and Edgar's uncle Eugène Musson committed as incurable in isolation at Charenton after many demonstrations including one at the Hôtel des Affaires Etrangères in Paris. Dr Camus (see cat. 93, illus. p. 211) is consulted.
Brown 1990, p. 129 and note 106.

30 March
The second Impressionist exhibition opens at the Durand-Ruel gallery, 11 rue Le Peletier. Twenty-two works by Degas are listed in the catalogue, most for sale, seven described as portraits including "*Portraits dans un bureau (Nouvelle-Orléans)*", (cat. 114, illus. pp. 202–05). Only two of the six others can be identified: "*M. E.M.*" as Eugène Manet, the brother of the painter and husband of Berthe Morisot (cat. 115, illus. p. 262), and "*Portrait, le soir*" as Mme Camus (L371, Washington, National Gallery of Art). One of the four remaining is described as a woman. In addition there is the oil sketch of the young New Orleans nieces, nephews and cousins, "*Cour d'une maison (Nouvelle-Orléans)*" (L309, Ordrupgaard), and in all probability the painting now known as *L'Absinthe* (L393, Paris, Orsay, illus. p. 105), for which the pantomime actress Ellen Andrée and Desboutin posed, although it is undoubtedly genre or theatre and not portraiture.

1 June
Degas writes to Deschamps in London offering him *Portraits dans un bureau (Nouvelle-Orléans)* and telling him that the De Gas firm in Paris will be liquidated: "Il va falloir non seulement donner dans notre liquidation, mais me mettre quelque chose en poche pour passer l'été."
Degas inédit 1989, D 2, p. 436.

16 June Naples
From Naples Degas writes to Deschamps of his need for money. "Et puis mon coton? Faites donc tout votre possible pour m'en fixer un prix … J'ai besoin d'argent, je ne façonne plus la dessus."
Degas inédit 1989, D 3, p. 437.

He may be in Naples for the funeral of his orphaned thirteen-year-old cousin Georges Degas, who dies that year in Montecassino. It is possible that he now paints the portrait of Georges's sister Lucie with their uncle Henri Degas (cat. 127, illus. p. 199).

4 July
The critic Jules Claretie writes to the wife of the Italian artist Giuseppe De Nittis, living in Paris, "Justement j'ai recontré hier Degas, retour de Naples et qui allait à la gare de l'Est attendre son frère [René] lequel revient de je ne sais où [New Orleans]."
M. Pittaluga and E. Piceni, *De Nittis*, Milan 1963, p. 339.

Degas has painted a portrait of Mme de Nittis (L302, Portland, Oregon, Art Museum) and will make a pastel of her son Jacques (L508, owner unknown.)

28 August
René De Gas leaves for New Orleans without paying his debts.

31 August
Achille De Gas notifies Michel Musson, their maternal uncle in New Orleans, that the family bank has finally been closed and that René's inability to settle his debts has forced Edgar, Marguerite and himself to live on a bare subsistence to pay what the bank owes.

ca. 1876
Between 1875 and 1877 Degas paints some of his most original portraits of individual women: *Femme mettant ses gants* (L438, private collection), *Mme de Rutté* (cat. 126, illus. p. 245), *Mme Jeantaud in front of a mirror* and *Mme Jeantaud on her chaise longue, with two dogs* (cat. 124, 135, illus. pp. 216, 217), '*Mlle Malo*' (cat. 134, illus. p. 235), *Woman with an umbrella* (cat. 129, illus. p. 244), none of which are dated.

1877 January
A judgement is made in favour of the Banque d'Anvers committing Degas and his brother-in-law Henri Fevre to repay 40,000 francs in monthly instalments.

4 April
The third Impressionist exhibition opens with *Mme Gaujelin* of 1867, exhibited at the Salon of 1869 (illus. p. 88), placed conspicuously on an easel. Beside this work there is one equally early and charming head of an unidentified young woman (L163, Paris, Orsay) and the "*Portrait de Monsieur H.R. [Henri Rouart]*" (L373, Pittsburgh, Carnegie Museum).

21 May
In a letter to Mme De Nittis Degas complains about his eyesight and about Deschamps in London whom he has asked to return the *Portraits dans un bureau (Nouvelle-Orléans)*. He is negotiating to sell the portrait of Mme Gaujelin, so prominently placed in the Impressionist exhibition, and which he describes as "cet ancien portrait de femme à l'huile, un cachemire sur les genoux". In the letter he regrets, "Vivre seul,

sans famille, c'est vraiment trop dur. Je ne me serais jamais douté que je dusse en souffrir autant. Et me voici vieillissant, mal portant et presque sans argent. J'ai bien mal bâti ma vie en ce monde."

Pittaluga and Piceni 1963 (see under July 1876), pp. 368–69.

1877

In two notebooks of the late 1870s (Reff 28, 29), kept by Ludovic Halévy in the Halévy household, Degas reveals his love of the theatre. It is a love he shares with Halévy who was born into a theatrical family and who himself (usually with Henri Meilhac) writes libretti for Offenbach as he has for Bizet's *Carmen*. In one of the large notebooks that Halévy is to keep Degas draws the dandy and author Jules Barbey d'Aurevilly entertaining a circle of admirers, Ludovic Lepic sprawled in the first row of an empty theatre, and Jules Perrot, among others, all nearly caricatured. There are also many singers, most from the *cafés-concert* of the boulevards; among them is Mlle Emilie Bécat (see pp. 292–97).

Reff 28, private collection, New York; Reff 29, Eugene V. Thaw Collection, New York.

1878 *March Pau*

The Museum in Pau buys Degas's *Portraits dans un bureau* (cat. 114, illus. pp. 200–205) through the influence of his friend Alphonse Cherfils, a collector from Pau whom he paints together with the future curator of the museum at Pau, Paul Lafond, examining a work of art (L647, Cleveland Museum of Art). (Lafond is to write books on El Greco, Goya and, the year after the painter's death, Degas). The museum pays 2000 francs for *Portraits dans un bureau*.

31 March

The forty-four-year-old artist writes with pleasure to the curator of the Pau Museum, "Je dois que vous remercier bien vivement de l'honneur que vous me faites. Il faut aussi vous avouer que c'est la première fois que cela m'arrive qu'un musée me distingue, et que cet *officiel* me surprend et me flatte assez fort."

Degas inédit 1989, pp. 428–29.

13 April New Orleans

René de Gas deserts his blind wife (and cousin) Estelle Musson and their five children in New Orleans.

5 May Cleveland

René de Gas [*sic*] marries America Durrive of New Orleans before a Justice of the Peace in Cuyahoga County, Ohio, both bigamously.

The marriage record was found by Harvey Buchanan in the Archives of Cuyahoga County, State of Ohio, for 5 May 1878, F.B. René de Gas declaring that he had no wife living and America Durrive declaring that she had no husband living.

Summer

Degas begins to use Marie van Goethem, then fourteen years old, as a model. She has become famous through Degas's sculpture of her wearing a real tutu (cat. 158, illus. p. 288).

September New Orleans

The painter's cousin, Mathilde Musson Bell, dies. Until his own death in 1885, Edgar's uncle Michel Musson keeps pressing the artist to send him the portrait he had painted of Mathilde in New Orleans, probably the version in the National Gallery of Art, Washington (L313).

Brown 1990, p. 128.

December

On the drawing of a dancer seated on the floor (II:230(1), private collection, illus. p. 57) Degas writes, "Melina Darde/15 ans/danseuse à la Gaieté", showing his desire to record her name, her age, her occupation and the date he drew her, with greater affection and sense of the individuality of these young dancers than is usually suspected.

1879 *January*

Degas makes drawings of Mlle Lala, a mulatto circus performer, dating them 19, 21, 24 and 25 January. From these he produces a remarkable painting (L522, London, National Gallery; illus.).

3 March

Degas dates a pastel (L518, private collection) of his friend the writer Edmond Duranty, for which there is a preparatory drawing in the exhibition (cat. 149, illus. p. 265). The portrait painting is L517, Glasgow, Burrell Collection.

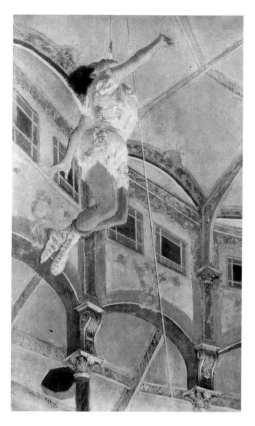

Mlle Lala at the Cirque Fernando, 1879, oil on canvas, 117 × 77.5 cm, London, The National Gallery (L522)

3 April

Two portraits (cat. 144, 146, illus. pp. 267, 269) of the Italian critic and collector Diego Martelli, who would give the first public lecture on Impressionism in Italy at Livorno in 1880, are dated by preparatory drawings (cat. 147, 148, illus. p. 268).

10 April

The fourth Impressionist exhibition opens. Degas has planned to show some of his finest portraits. He exhibits, in all, twenty paintings and pastels, in addition to five fans. Eleven works are listed as portraits in addition to "*Mlle Lola* [*sic*], *au Cirque Fernando*" (L522, London, National Gallery; illus.). Two are identified in the catalogue as Diego Martelli (cat. 146) and Duranty (L517, Glasgow). Others can be recognised by the titles: "*Portrait d'après un bal costumé, détrempe*" as Mme Dietz-Monin (L534, Chicago Institute of Art); "*Portrait des amis sur la scène, pastel*" as Ludovic Halévy and Albert Cavé

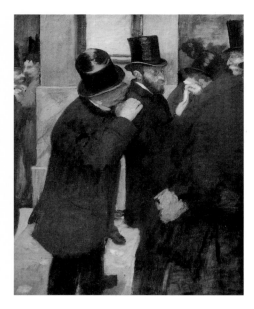

'Portraits à la Bourse', ca. 1879, oil on canvas, 100 × 82 cm, Paris, Musée d'Orsay (L499)

(L526, Paris, Orsay; illus. p. 38) and *"Portraits à la Bourse"* as Ernest May and M. Bolâtre (L499, Paris, Orsay). Other portraits more tentatively identified are: *"Portrait d'un peintre dans un atelier"* as L326, Lisbon, Museu Gulbenkian; *"Portrait de danseuse à la leçon, pastel"* as L450, New York, Metropolitan Museum; and more problematically *"Portrait dans une baignoire à l'Opéra ... pastel"* as L476, Providence, Museum of Art, Rhode Island School of Design.

Degas often did not exhibit exactly what was listed in the catalogue.

20 June Naples

Degas's uncle Henri Degas dies, the last male of his generation. He leaves his estate to Lucie Degas, with whom Degas had painted him (cat. 127, illus. p. 199).

29 September Paris and New Orleans

Henri Musson writes to his brother Michel in New Orleans to say that René and his new wife have had a baby daughter in New York and that René is in Paris, but the artist refuses to see him.
Brown 1990, p. 128.

1879–80

Degas makes several portraits from the back of Mary Cassatt in the Louvre, the American painter he had met by the time of the third Impressionist exhibition in 1877. The hand-somest may be the etching, aquatint and dry-point, *Mary Cassatt at the Louvre: the Paintings Gallery* (cat. 154, illus. p. 274), which seems a superb illustration of the statement Duranty had made in his *La Nouvelle Peinture* (1876), "Avec un dos, nous voulons que se revèle un tempérament, un âge, un état social".
Exhibition catalogue by Charles S. Moffett *et al.*, *The New Painting: Impressionism, 1874–1886*, Washington, National Gallery of Art/San Francisco, Fine Arts Museums 1986, p. 481.

1880 March

The wax statue of *The little fourteen-year-old dancer* (now collection of Paul Mellon), for which Degas used other materials in addition to his customary wax, is essentially finished.

1 April

At the opening of the fifth Impressionist exhibition, 10 rue des Pyramides, *Les petites filles Spartiates provoquant des garçons* (L70, London, National Gallery) and *La petite danseuse de quatorze ans* (wax, collection of Paul Mellon) are not exhibited as announced. On the other hand there are *"Portraits à la Bourse"* (L499, Paris, Orsay), *Duranty* (L517, Glasgow, Burrell Collection), and *"Etude de loge au théâtre"* (L584, Nitze Collection).

9 April

Edmond Duranty dies at the age of 47. Degas and Emile Zola are the executors of his modest estate. They will organize an exhibition to raise money for his companion.

27 August

Degas attends a famous trial of three youths, Emile Abadie (aged twenty), Michel Knobkoch (aged nineteen) and Paul Kirail (aged twenty) for three murders in 1879, one of a woman who ran a newspaper stand near the building where the artist lives. Paul Valpinçon is a juror. Ludovic Halévy in July 1879 had visited and been horrified by the neighbourhood in which the youths live. At the trial Degas makes drawings in a notebook and uses them later as the basis for pastels (cat. 161, illus. p. 291 and L638, owner unknown), which he will exhibit at the sixth Impressionist exhibition in 1881 as *"Physionomies de criminels"*. All three prisoners are sent to Devil's Island.
Reff 33, private collection, New York, pp. 10v–11, 14, 15v, 16.

1881 2 April

The sixth Impressionist exhibition opens, at which Degas exhibits the wax of the *La petite danseuse à quatorze ans* (see cat. 158, illus. p. 288) promised the year before and two of his pastels of *Physionomies de criminels* (cat. 161, illus. p. 291, and L638, owner unknown).

Early June

Marie Fevre, daughter of Marguerite De Gas, dies.

18 June

The artist's sister Thérèse Morbilli arrives in Paris from Naples with her young orphaned cousin Lucie Degas, for whom she is the guardian. The next day she writes to her husband of her painter brother, "Tu sais qu'il est devenu un homme célèbre. On s'arrache ses tableaux."
Guerrero de Balde archives, Naples.

Lucie poses for the artist for a relief, *Cueillette de pommes*, which is probably intended as a memorial for Marie Fevre, the daughter of Lucie's cousin and the artist's sister Marguerite.

8 December

The young painter Jacques-Emile Blanche runs into Degas at the sale of Courbet's studio and goes back with him to Degas's studio. He writes: "Il m'a montré une nouvelle sculpture de lui: une petite fille à moitié couchée dans un cercueil, mange des fruits ; à côté un banc où la famille de l'enfant pourra venir pleurer (car c'est un tombeau)."
Archives, Musée du Louvre. See Pantazzi in 1988–89 Paris/Ottawa/New York, no. 231, p. 358.

1882 28 January

Degas sells a "Portrait de Mlle X" [that is, the sitter presumed to be Mlle Malo] to Durand-Ruel for 400 francs (L444, Birmingham, Barber Institute).

1 March

Degas refuses to participate in the seventh Impressionist exhibition to the relief of some and the concern of others. Eugène Manet writes to his wife Berthe Morisot as if Degas were giving up his professional responsibilities for self-indulgence at the Opéra; "Degas a stalle à l'Opéra, vend très chèr sans songer à régler ses comptes avec Faure et Ephrussi." The "comtes" were paintings he had promised but not delivered.
Morisot 1950 (see under ca. 1869), p. 111.

16 March
To Lucie Degas in Naples Edgar writes, "Le bas-relief a été négligé cet hiver … J'ai trouvé une fillette dans tes proportions et je pourrai m'en tenir à ta place quand je remettrai après cette forte pièce."
Raimondi 1958, pp. 276–77.

2 May
Degas writes to Henri Rouart with more cynicism than enthusiasm about the 100th Anniversary Salon exhibition: "Un Whistler étonnant [*Arrangement in Black:* Lady Meux, Honolulu], *raffiné à l'excès*, mais d'une trempe ! Chavannes [presumably *Pro Patrie Ludis* for Amiens], noble, un peu resucé, a la tort de se montrer parfaitement mis et fier dans un grand portrait de lui qu'a fait Bonnat, avec grosse dédicace sur le sable où lui et une table massive, avec un verre d'eau, *posent* (style Goncourt). Manet [*Bar at the Folies-Bergère*, London, Courtauld Institute] bête et fin, carte à jouer sans impression, trompe l'œil espagnole, peintre."
Lettres 1945, XXXIII, pp. 62–63.

27 June Naples to Paris
Edmondo Morbilli answers his wife Thérèse in Paris about the painter's unwillingness to forgive his brother René for having deserted his wife, "Edgar fait probablement de la bonne peinture, je ne le conteste pas, mais quant au reste il faut le considérer toujours comme un enfant."
Bozzi archives, Naples.

6 November New Orleans to Paris
Michel Musson writes to Degas, "Pas un mot de toi … depuis ta lettre de 16 juillet, m'annonçant la mort de mon frère Henri …", and adds: "P.S. Par décret de Cour et notre notarie, je viens d'adopter mes petits enfants Odile et Gaston (Degas) qui dorénavant porteront mon nom – Je te prie d'en prendre note."
Brown 1990, p. 129.

1882
Degas dates several of his pastels of milliners 1882 (L681, Kansas City, Nelson-Atkins Museum; L682, New York, Metropolitan Museum; L683, private collection). He makes several drawings for a portrait of the wife of Ernest May, whom he had painted in *At the Bourse* (L499, Paris, Orsay); with her infant son Etienne (born 1881) (cat. 163–65, illus. pp. 220, 221). The portrait is never finished.

1883 *30 April*
Manet dies.

August Ménil-Hubert
Degas works on a profile portrait drawing of Hortense Valpinçon, which he dates 1883 (New York, Metropolitan Museum).

4 December
Degas writes to a friend, the painter and collector Henry Lerolle, "allez vite entendre Thérésa à Alcazar".
Lettres 1945, XLVIII, p. 74.

1884 *16 August Ménil-Hubert*
For some weeks Degas stays at the Valpinçons' to make a full-length statue of Hortense, only returning to Paris at the end of October. In the process he ruins the work and cannot reclaim it.

1884
Degas dates 1884 a pastel of Mme Henri Rouart (cat. 169, illus. p. 263) with allusions to her daughter Hélène.

1885 *March*
From 2 March 1885 Degas's faithful (even obsessive) attendance at the Opéra has been documented.
See the chronologies for Chapters III and IV of 1988–89 Paris/Ottawa/New York, and Loyrette 1991.

12 June
Degas attends the dress rehearsal of Reyer's *Sigurd* with Rose Caron as the principal singer.

September
To his good friend the sculptor Albert Bartholomé Degas writes of the singer Rose Caron whom he has seen in almost every performance of Reyer's *Sigurd* and whom he will later paint (cat. 175, illus. p. 285): "Divine Mme Caron, je lui ai comparé, parlant à sa personne, les figures de Puvis de Chavannes qu'elle ignorait."
Lettres 1945, LXXXIV, p. 108.

22 August–12 September Dieppe
On a visit with the Halévys at Dieppe, Degas directs the work of a local photographer, Barnes. He also makes a pastel of (from left) Walter Sickert, Daniel Halévy (French writer and son of Ludovic), Ludovic Halévy (librettist and school-friend), Jacques-Emile Blanche (painter and writer), Henri Gervex (sensational French

painter) and Albert Boulanger-Cavé (gentleman of leisure) at the sea-shore (L824, Providence, Museum of Art, Rhode Island School of Design; illus. p. 71).

1885
Degas dates a pastel of the head of an unidentified dancer (L813, private collection).

1886 *15 May*
The eighth and last Impressionist exhibition opens in which Degas exhibits only ten of the fifteen works listed in the catalogue. Included is the portrait of Zacharie Zacharian (L831, private collection). Degas has placed the emphasis in his submissions on his pastels of nudes (or bathers).

1886
Degas dates 1886 a pastel (L868, private collection), composed, like a Watteau, of three views of the head of Mathilde Salle, dancer at the Opéra and mime, protected by the collectors Isaac de Camondo and Henri Vever. In this year he also dates several portraits of Hélène Rouart (L866, Los Angeles County Museum; L869, London, National Gallery; L870, private collection; L870bis, private collection; L871, private collection).

1887 *22 July*
Theo van Gogh, Vincent's art-dealer brother, buys for the gallery Boussod & Valadon, with which he works, '*La femme aux chrysanthèmes*' of 1865 (L125, New York, Metropolitan Museum; illus. p. 88) for 4000 francs.
John Reward, *Studies in Post-Impressionism*, New York 1986, pp. 7–115, Appendix I, "Excerpts from the Goupil, Boussod & Valadon Ledgers", pp. 89–90.

1887
Degas dates to this year '*Femme assise*' (L897, private collection). Tinterow suggests this is a portrait of the Italian dancer and mime Rosita Mauri.
Tinterow in 1988–89 Paris/Ottawa/New York, no. 277, pp. 456–57.

1888 *15 February*
Sabine Neyt, Degas's housekeeper since 1873, dies. Degas inscribes a charcoal and white-chalk drawing of her he had made about 1880, which he kept, "Ma vieille bonne Sabine Neyt, morte à Paris, 21, rue Pigalle" (IV:272a, private collection). She is succeeded by Zoë Clozier (see photograph p. 303), who is with him when he dies some thirty years later.

18 April

Durand-Ruel buys '*La mère de la danseuse*' for 1,500 francs. This is probably one of the two versions of *The Mante family* (L971, private collection; L972, Philadelphia Museum of Art).

1888–89 *Winter*

Degas writes eight sonnets, one dedicated to the Opéra dancer and mime, Marie Sanlaville, who is the mistress of Lepic, a second to the singer Rose Caron (cat. 175, illus. p. 285) and another to Mary Cassatt.

Degas's sonnets will eventually be published by a great-nephew: Jean Nepveu Degas, *Huit Sonnets d'Edgar Degas,* Paris 1946.

1889 *10 July*

Degas's younger sister Marguerite Fevre with her architect husband Henri and her seven children leave for Buenos Aires where she will die in 1895, without the painter's having seen her again.

8 September Madrid

Degas arrives in Madrid with his travelling companion the Italian painter Giovanni Boldini. They go as far as Tangiers.

27 October

Ludovic Lepic dies in the house of his mistress, the dancer Marie Sanlaville.

1890 *31 January*

To Durand-Ruel Degas sells two portraits, "Portrait de femme" (L972, whereabouts unknown) and "Portrait d'homme" (both sitters unidentified), for 400 francs.

26 March

Degas probably sees and covets the portrait by Delacroix of Baron Louis-Auguste Schwiter at the sale in Paris of Schwiter's collection after his death.

9 May

Degas sells his early portrait of Ruelle (cat. 60, illus. p. 210) for 2000 francs to Theo van Gogh.

10 June

Theo van Gogh buys "Etude d'Anglaise" (perhaps cat. 157, illus. p. 298) and "Etude de femme" for 1000 francs each. They have not been certainly identified.

July

Degas dates and identifies a portrait of Gabrielle Diot (L1009, art market), whose father may have been a dealer.

29 July

Vincent van Gogh dies.

20 August

Degas sells "Tête de femme, étude" (L370, cat. 123, illus. p. 243) to Durand-Ruel for 500 francs; it is otherwise unidentified.

10 October

Theo van Gogh goes to hospital and therefore can no longer buy from Degas for Boussod & Valadon.

October London to Paris

When Degas is upset with George Moore for having published personal details about his family, Whistler writes: "Voilà ce que c'est, mon cher Degas, que de laisser pénétrer chez nous ces infâmes coureurs d'atelier journalistes."

Margaret MacDonald and Joy Newton, Letters from the Whistler Collection (University of Glasgow), Correspondence with 24 French painters, *Gazette des Beaux-Arts*, vol. 108, no. 1415, December 1986, p. 209.

22 October

Degas goes to hear and see Rose Caron (cat. 175, illus. p. 285) in *Sigurd* by Reyer for the twenty-ninth recorded time; he will go nine more times before 1891 is over. Caron has returned to Paris after three years in Brussels.

4 December

At a dinner given by the lawyer and collector Paul-Arthur Chéramy at the Café Anglais, Degas is placed next to Reyer and across from Rose Caron.

1891 *26 October*

Although he does not like Wagner's music, Degas goes to *Lohengrin* since Caron is singing the rôle of Elsa.

1892 *23 January*

In a letter to Thérèse Morbilli in Naples, Degas mentions "une visite à René", the first indication of a reconciliation with his brother.

Pantazzi 1989, p. 126.

13 April

Eugène Manet, whom Degas had painted in the 1870s (cat. 115, 125, illus. pp. 262, 263) dies. Degas had seen him earlier in the day.

1894 *October*

Paul Valpinçon dies.

December Naples

Edmondo Morbilli, husband of Degas's sister Thérèse, dies. He has been an invalid.

1895 *2 March*

Berthe Morisot dies. She has mentioned Degas in a letter to her daughter Julie Manet, written the evening before her death. Degas is to accept his responsibilities for Julie by arranging the memorial exhibition of the work of her mother and eventually by persuading Julie to marry one of the sons of his great friend Henri Rouart.

March

Degas dates one study of Alexis Rouart March 1895, for the painting of him with his father Henri (cat. 177, illus. p. 225).

June

From the dealer Montaignac Degas buys the large portrait of the Baron Schwiter of 1826 by Delacroix, an important acquisition, now in the National Gallery, London, for his growing collection. For it he exchanges three of his own pastels worth 12,000 francs.

October

Degas attends the burial of the body of his sister Marguerite Fevre, who had died in Buenos Aires in July, in the Degas family mausoleum in Montmartre cemetery. He had made the arrangements to have her body brought to Paris and to remove the body of their maternal aunt, Anne-Eugénie, comtesse de Rochefort (née Musson, who had died in Florence in 1857) from the mausoleum to make this possible.

29 November

Renoir brings Julie Manet to Degas's studio where the artist is working on sculpture, including a bust of the Venetian painter, Federico Zandomeneghi, which will not survive.

Julie Manet, *Journal (1893–1899)*, Paris 1979, pp. 73–74.

28 December

Degas, who has taken up photography, conducts one of his sessions of imaginative portrait pho-

tography after dinner at the Halévys.
Halévy, 1960, pp. 91–93.

1896 *23 January*
Durand-Ruel buys Ingres's two portraits of M. and Mme Leblanc (now New York, Metropolitan Museum) for Degas.

February and March
Degas occupies himself with the arrangements for the memorial exhibition for Berthe Morisot at Durand-Ruel.

5 March Carpentras
Evariste de Valernes dies. Degas attends the funeral.

5 June
From Vollard Degas buys a *Portrait of Victor Chocquet* by Cézanne (Venturi 375) for 150 francs; it is now in a private collection. He will already own a *Self-Portrait* of Cézanne (Venturi 367) from the same source for 130 francs, if he does not own it already, which is now in the Reinhart Collection, Winterthur.
Information kindly provided by Walter Feilchenfeldt.

16 August
With Bartholomé Degas visits the Ingres Museum at Montauban for several days.

1897 *10 November*
At auction Degas buys the portrait of Marquis de Pastoret of 1826 by Ingres, now in a private collection.

Probably 30 December
Degas writes to Mme Ludovic Halévy after having dined for the last time at their house the week before:
Jeudi
Il va falloir, ma chère Louise, me donner congé ce soir, et j'aime mieux vous dire de suite que je vous le demande aussi pour quelques temps. Vous ne pouviez penser que j'aurais le courage d'être toujours gai, d'amuser le tapis. C'est fin de rire – Cette jeunesse, votre bonté pensait m'y intercaler. Mais je suis une gêne pour elle, et elle en est une enfin insupportable pour moi. Laissez moi dans mon coin. Je m'y plairai. Il y a de biens bons moments à se rappeler. Notre affection, qui date de votre enfance, si je laissais tirer plus longtemps dessus, elle casserait.
Votre vieil ami
Degas
Halévy family archives.

1897
Degas is caught up in a conservative anti-Dreyfusard stand and seems to have succumbed to more general anti-Semitism as well. His (basically unforgivable) position is essentially that of other artists like Renoir and Cézanne and of more predictable conservatives like Henri Rouart and his brother, René de Gas. It cut short his long friendship with Ludovic Halévy (see cat. 132, illus. p. 222).

1898 *June*
Degas sees two portraits of Mme Moitessier by Ingres, one now in Washington, the other in London. Both are in the hands of her daughters, and apparently Degas is unable to buy either.
Brame archives, Paris

1899 *25 April*
At an auction house in Paris Degas tells Julie Manet that Ernest Rouart, a son of his great friend Henri Rouart (see pp. 222–25), is "un jeune homme à marier".
Manet, exhibition catalogue, Paris 1979, p. 228.

1899
Before the end of the year Degas writes to Paul Lafond, Curator of the Museum in Pau, to object to his *Portraits dans un bureau (Nouvelles-Orléans)* being lent to the Universal Exposition of 1900. It is nevertheless sent.
Sutton and Adhémar 1987, p. 175

1900 *31 May*
Degas attends the double wedding of Julie Manet to Ernest Rouart and of her cousin, Jeanne Gobillard, to Paul Valéry, the author who would write *degas danse dessin* (Paris, Vollard, 1934).

1903 *8 May Atuana (Marquesas)*
Paul Gauguin, whom Degas had always encouraged and whose works Degas had continued to buy, dies in the Marquesas Isles.

1904–05
Degas makes portraits in pastel of one of Henri Rouart's sons, Louis, an agricultural engineer and collector with his wife (L1437–1444, private collections). Louis will buy Picasso's large *Two harlequins* of 1905 in 1907 (now Barnes Collection).

Degas also makes large pastel portraits of one of Rouart's daughters-in-law, Mme Alexis Rouart (see cat. 180, illus. p. 224), with her two children (L1450, Petit Palais, and L1451–1452, private collections).

1906 *18 April*
Degas writes to Thérèse Morbilli to say he thought of their family with the news of the eruption of Vesuvius.
Pantazzi 1988, p. 129.

End of October Naples
Degas visits Naples for the last time.

3 December
Degas returns from Naples.

1908 *May*
When Degas hears of the death of Ludovic Halévy, he calls on the Halévys to see the body.

1911 *May*
At a large exhibition of the works of Ingres Degas, now almost blind, is seen touching the canvases lovingly with his fingers.

1912 *2 January*
Henri Rouart dies, the last of Degas's close friends from the Lycée Louis-le-Grand.

12 July
Degas writes to his Fevre nieces, who had come from the Argentine to the south of France after the death of their mother Marguerite De Gas Fevre, of the death of his sister Thérèse De Gas Morbilli in Naples.
Fevre 1949, p. 113.

10 December
When *Danseuses à la barre* (L408, New York, Metropolitan Museum) is sold from the collection of Henri Rouart for the highest price ever reached at auction for the work of a living artist, 430,000 francs, Degas is asked how he feels. He answers, "Je suis comme le cheval qui gagne le grand prix et qui n'a que son avoine."
Lemoisne I, p. 200.

1912
Although Degas has moved constantly around the 9th arrondissement most of his life, he is nevertheless much disturbed when the house on the rue Victor-Massé, in which he has rented three floors for twenty-two years, is condemned

for demolition. Suzanne Valadon, the painter, helps the seventy-eight-year-old artist find another apartment nearby on the boulevard de Clichy. This event seems to make Degas an old man. He even gives up sculpture to which he turned increasingly when his eyesight deteriorated.

1915 *17 November*

René de Gas writes to Paul Lafond about the condition of the painter:

L'état physique, étant donné son âge, n'est coup sûr pas mauvais ; il mange bien, ne souffre aucune infirmité, sauf sa surdité qui ne fait que s'accroître, et rend très difficile la conversation. Quand il sort, il ne peut guère marcher plus loin que la place Pigalle ; il passe une heure dans un café, et rentre péniblement ... Il est admirablement soigné par cette incomparable Zoé. Les amis ne viennent plus guère le voir, car c'est à peine s'il les réconnait et ne cause pas avec eux. Triste, triste fin ! Enfin, il s'éteint lentement sans souffrir, sans éprouver d'angoisses, bien entouré de devouements fidèles ; c'est l'essentiel, n'est-ce pas !

Degas was then eighty-one.

Sutton and Adhémar 1987, p. 177.

1917 *27 September*

Degas dies.

28 September

Degas is buried in the family vault in Montmartre cemetery, next to the tomb of Mme Moitessier, whose two portraits by Ingres he had so much admired. Mary Cassatt, who has remained a friend, has persuaded the painter's niece, Jeanne Fevre, to come from Nice the year before his death to nurse her uncle, and has advised the Fevre nieces and nephews on protecting their interests with their uncle René. She describes the funeral to her great friend, the American collector Louisine Havemeyer: "We buried him on Saturday, a beautiful sunshine, a little crowd of friends and admirers, all very quiet and peaceful in the midst of this dreadful upheaval [the Great War] of which he was barely conscious."

Nancy Mowll Mathews, ed., *Cassatt and her Circle, Selected Letters*, New York: Abbeville Press, 1984, Letter from Cassatt to Lousine Havemeyer, p. 328.

There were about one hundred mourners. It was not easy in war-time to get to the funeral. Daniel Halévy records, "The next morning my orders came to report to the Saxe barracks. I go there

and am given orders to leave for Nantes. I go to the office and ask for a delay ... Then home, a quick lunch with Mama and Léon, and we go to the funeral."

Halévy family archives, pp. 152–53.

Among those at the service there were several who had posed for their portraits by Degas: Mme Ludovic Halévy, Daniel Halévy, Mary Cassatt, Henri Gervex, M. and Mme Alexis Rouart and Louis Rouart.

Degas Family Names

Degas

This is the form of the name of the family of bakers from which the artist sprung (see Sigwalt 1988, pp. 1181–1191). His Neapolitan grandfather and the grandfather's children normally used this form; in fact, it is deeply incised into the red sandstone monument of the family tomb in Naples. The artist himself was using Degas by 1874 and possibly earlier.

De Gas

This is the form, with some pretensions, used by the artst's father when he moved to Paris to establish a French branch of his father's Neapolitan bank. His children used this form with the exception of the artist, who reverted to Degas, and his younger brother René, who preferred de Gas.

de Gas

This form, with the lower-case particle, implies an aristocratic background, which the Degas family did not possess, although it had laid some fictitious claims to such ancestry by commissioning a family tree going back to a nobleman in Languedoc. It was the artist's younger brother René who would use this form although it may have been their brother Achille who commissioned the genealogical chart of the de Gas.

Fevre

The painter's sister Marguerite married an architect whose name was Henri Fevre. Although Fevre is usually spelled with a grave accent over the first 'e', this family did not employ it. This is substantiated by civic records, Bottins and by the book written by the painter's niece, Jeanne Fevre, *Mon oncle Degas*, Geneva, 1949.

Portraits as Pictures: Degas between Taking a Likeness and Making a Work of Art (*Tableau*)

EMIL MAURER

Degas a portrait painter? The painter of ballerinas, race courses and women in tubs? In fact in his work overall – according to Lemoisne's catalogue of his œuvre[1] – there are more than 250 portraits. His early work alone from 1853 to about 1873 includes well over a hundred, i.e. about 45% of his total output for those years.[2] In this period, portraits were, of course, the most common kind of picture. Writing to his son a now famous letter of encouragement, in 1858, Degas's father had every reason to suppose that he would make his career as a portraitist. From about 1875 the proportion of portraits in Degas's work falls, at least in number, and there is a dramatic shift of interest from the individual to the 'modern genre'[3] and its new subject-matter – though he still continued to produce major portrait paintings. After about 1890 when his eyesight started to fail Degas produced very few further portraits, seeking some compensation, however, in the new medium of photography. Degas's deteriorating eyesight, his choice of rapid techniques such as pastel and mono-type, and his abandonment of the portrait and the depiction of individuals are surely interdependent.

It is immediately obvious that Degas created portraits predominantly when he was a young painter, with a particular eye for the excitement and fears of a developing personality. At the same time he was producing copies and ambitious history pictures as well as a few genre pictures and odd landscapes. The portrait was at the heart of '*haute peinture*', as the fledgling artist saw it, and helped define it. But this exhibition demonstrates that the older, sceptical, enigmatic Degas also stayed loyal to the individual in the portrait until about 1905, without illusions yet not without compassion. The pessimism of the old painter is expressed particularly in the portrait, confronted with the frailty of each and every individual, even his best friends.

The portrait is, moreover, the only genre that Degas cultivated throughout his life. A further remarkable fact emerges from a review of his œuvre, the fact that about three quarters of his portraits represent women. This indicates that there are considerable counter-arguments to mount against those who have reproached Degas with misogyny.

Who sat for Degas, and who did not, in Paris

society from about 1860 to about 1900? Were the portraits commissions, or the painter's own undertaking? What did he hope for in painting them – to achieve success in the Salons? In the art market? What happened to the pictures once completed?

The catalogue of this exhibition resembles an album of pictures of the painter's inner circle. They are Degas's own selection, in a very important sense – virtually his family saga, with brothers and sisters, aunts and uncles, cousins more or less removed, settled in Paris, Naples or New Orleans, painted when the opportunity presented itself (Degas travelled a great deal, especially on family affairs).[4] There are also a few friends, a few fellow-painters, a few writers. But we do not find the great men of the day, not even those he knew: no Baudelaire, no Zola, no Mallarmé, no Valéry. The painters Tissot and de Valernes of whom he did produce portraits did not belong to the first rank; Manet is outstanding, that is true, but Degas's portraits of Manet are not representative. There are no portraits whatsoever of the notables, princes or VIPs of his time. Time and space would certainly have allowed Napoleon III to commission his portrait from Degas rather than from Flandrin and Cabanel . . . It turns out, however, that with a very few exceptions, Degas did not undertake commissioned portraits.[5] Until the collapse of his father's bank around 1874 Degas was not really interested in commissions. After that he embarked on several new themes, for example that of dancers, with a view to selling. But from the artist's point of view the portraits were largely self-imposed assignments, and it can therefore be assumed that they particularly interested him as an artist.[6]

The fact that Degas restricted the range of his portraits to his personal, familiar circle is highly significant. He knew each of his models much better than was usual in the case of a commissioned portrait. His response to them was both tender, naturally, and discreetly distant – for all the familiarity there is never a lack of respect, even when the sitters are children, and his relationship with his sitters rules out intrusion or disclosure. Reservations, or implicit criticism – in the case of Gennaro Bellelli (cat. 55, illus. p. 192), de Valernes (illus. p. 23), or Tissot (illus. p. 107) – are discernible only at a second glance. Yet he does not conceal occasional boredom with the work, for example in New Orleans in 1873 when family pressure forced him to keep at it.[7] But there can be no question that the unique conditions of his portraiture also gave him a special freedom and room for manoeuvre in making artistic decisions. To this extent Degas is a solitary figure among his contemporary portraitists. About half of all his portraits were created during the Second Empire, a period when portraiture was very much in vogue.[8] Yet industrialist, capitalist clients of the many specialist portrait painters in the splendour of the late Empire passed him by. Although in the critical years around 1868 he could himself have become a 'society' portraitist,[9] he never resorted to the type of grand ceremonial portrait of which the primary aim was 'aping the aristocracy'.[10]

Among fellow-painters of his own generation only Manet could afford to be similarly selective, coming from a similarly privileged social position. And among the Impressionists, in the strict sense, Monet, whose portraits were also limited to his very close family, gave up portraiture as early as 1868.[11] Portrait commissions were otherwise 'la question du pot-au-feu',[12] the painter's bread and butter.

In mid-nineteenth-century art theory, the portrait was not regarded as a properly artistic task. As a visual warrant of an individuality, a physiognomic record, a commonplace copy, it was tied to reproduction and mere imitation more than any other genre, at the opposite end of the spectrum from 'invention'. It therefore was placed well down in the hierarchy of genres, especially in a period in which the academic canon was challenged by the advocates of Realism.[13] Ingres (died 1867) was still able to observe the Aristotelian canon – "making portraits resemble the sitters while at the same time making them harmonious". But Realism together with the spread of caricature had already driven rifts through the concept of the individual and made portraiture problematical.

On the formal level, neither the bust nor the full-length portrait really lends itself to a picture. The usual pictorial formats do not fit, the living form of the model is ill adapted to the flat picture surface, and the individual sitter may be disinclined to conform with the requirements of Art.

As a highly intelligent and well informed man, Degas was aware of the inherent contradiction between the requirements of a likeness and of making a satisfactory picture. Free from the constraints imposed by commissions, he was bold enough to compose pictorially even when reproducing a simple mirror likeness – though 'taking a likeness' is actually a complex process which also had its formal aspects. It is on these formal interventions – against the "tyranny exercised by nature"[14] – that we must concentrate our attention. In the interests of his picture the painter obviously was responsible for numerous crucial decisions, ranging from the type of image to the format, from the degree of formality he wanted to the use of colour, and so on. "Il faut être peintre bien peintre": this was also true in preparing portraits.[15] When he was engaged on the long process of painting his early portrait masterpiece *The Bellelli family* (illus. p. 16) he commented: "I am painting it as if I were painting a picture (*tableau*)."[16]

The development of his portraiture is based on the idea of giving the portrait all the dignity of a picture, raising it from the status of a mere '*portrait*' to that of a '*tableau*', to make it a work of art or potential masterpiece.

The contradiction was frequently observed and commented on at the time. The critic Hector de Callias rebuked the monotony of the portrait section in the 1864 Salon in the following terms: "It is not a question of just making a portrait, it is essential to make a picture."[17] A certain F. Martin praised Monet's portrait of Mme Gaudibert in 1868 saying: "It is a work of art, not a portrait."[18] In his essay 'Le Portrait' of 1859 Baudelaire had already spoken of the transformation of the portrait into a 'picture'. And in 1867 Castagnary expressed the opinion that art's ultimate culmination was the portrait, which demanded supreme artistic skills.

In the 1860s Degas set about to realise portraits that would become a '*haute peinture*' – with syntactically significant compositions, heightened dynamics, and colouring that went beyond the purely descriptive. Degas experimented in the portrait, breaking the restrictions of the genre wide open. He expanded the vocabulary of the portrait not by sharpening his observation, but rather by formal innovation. In a series of bold steps, Degas rethought the design, the framing, the viewing angle, the compositional structure, the repertoire of attitudes and gestures and the functions of colour in the portrait.

In Degas's view the portrait was also a work of imagination, 'invention', basically no different from the history or genre picture. The obligation to be descriptive no longer dominated over the obligation to be pictorial, nor the value of similitude over that of the picture, nor the amour-propre of the sitter over the composition. To this extent Degas's portraiture is totally anchored in his work as a whole, not pursued in a vacuum following the rules of a specialist genre. Hence also his easy transition back and forth between portrait painting on the one hand and history and genre painting on the other. (Two great art historians, Jacob Burckhardt and Theodor Hetzer, observed a similar relationship in the work of the greatest ever portraitist, Titian – the portrait as a work of art, created using the same pictorial methods as religious, mythological or historical painting.)[19]

Degas did a lot of copying, especially of portraits (see pp. 150–59), and not just as part of the academic theory of training. The young portraitist was making himself conversant with the prototypes in the history of the genre, in all its many variants, as they had been formed at the time of the Italian Renaissance. In copying he was laying out his imaginary portrait gallery.

He was primarily concerned with artistic questions rather than physiognomy. His interest as a copyist was directed primarily to the composition, from head only to full length, from profile to full face. It is indicative that in these pictorial notes the faces themselves are hardly filled in, sometimes not at all.

It is also striking that Degas frames most of the portrait sketches in his notebooks, even very quick ones, with emphatic lines. This means that the person portrayed appears not as an imitation of a real body, but from the start is placed as an object of art. Framing establishes important formal values, the *mise-en-scène*, the compositional architecture, the balance of light and dark, the proportions, the pattern of surfaces on the picture plane. Attitudes and

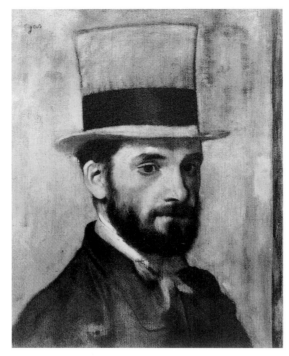

Léon Bonnat
1863
Oil on canvas
43 × 36 cm
Bayonne, Musée Bonnat
(L111)

gestures can be articulated properly only within the strict quadrangle of the frame. Degas's unique sensitivity for the format of the picture and its section of the figure is already in evidence. On the other hand he pays little attention to the personality of the person portrayed.

On occasion Degas's interests were so diverse that he undertook several analyses of the same portrait. In copying the head-and-shoulders portrait of a young man by Brescianino (in Montpellier, then believed to be by Raphael), he notes in one version the almost abstract linear structure of the composition, in another the noticeably cubic layout of the light and shade, which function as elements of the picture structure.[20] He also made a note of the half-length figure of a youth by Franciabigio, then attributed to Raphael, on two different visits to the Louvre, first as a soft web of contours and tonal values, then as a spontaneous, lively after-impression of the pose.[21] In neither case did he record the historic prototype as a finished product. From the beginning he sought to capture the principle governing the composition.

II

Any survey of Degas's portraiture immediately confronts an extraordinary wealth of types and kinds.

With this Degas's knowledge of the history of the portrait since the fifteenth century has much to do. Even more important is the irrepressible urge to find new solutions, with the idea of "painting our time", and specifically "of turning the 'expressive head' (academy exercise) into a study of modern sensibility".*[22]

In his early work Degas's point of departure was still the programme of Ingres and his followers and other Second Empire conventions (both Romantic and Realist). But as early as ca. 1865 this painter of histories, the race course and ballet dancers (from 1871) developed the portrait as a representation of the whole individual, the whole social, active animal, inaugurating a fundamentally richer and more complex syntax for it. Heads and head-and-shoulders portraits predominated only in his early work. Degas used this format only for self-portraits (which ceased as early as ca. 1865),[23] for the heads of his familiars and for studies of faces that interested him, mostly in a fairly small format and generally with a neutral background. Close study, penetrating analysis and unremitting observation of detail were not what concerned him. The only person he did not spare was himself, in the self-portraits. However, carefully drawn and painted face studies served as a preparation for larger portraits, for example for *The Bellelli family* (illus. p. 16; cat. 41–48, illus. pp. 189–92), for the double portrait of the *Morbilli* (cat. 73, illus. p. 185), for *Mme Gaujelin* (cat. 86, illus. p. 229) and *Mlle Malo* (cat. 134, illus. p. 235).[24] Occasionally he recorded psychological and physiognomic points in this way,[25] and in later years employed the head-and-shoulders formula for quick pastel notes, like those made by Manet.

Degas opted most frequently by far for the three-quarter view, as the most comprehensive. Frontal, full-face presentations are rare in his work, though he used them for ladies of serene dignity and authority.[26] Pure profile views – severe and definitive – are also exceptional.[27] Nonetheless, in the study of his brother-in-law Edmondo Morbilli (cat. 74, illus. p. 184), the fresh, mobile head reveals how sharp and penetrating Degas's eye could be, as does the incomparable medallion-like concision with which he captures his aunt Laura Bellelli (cat. 41, illus. p. 191), or another aunt, the Duchess of Montejasi, in a

* ... de faire de la tête d'expression (style d'académie) une étude du sentiment moderne.

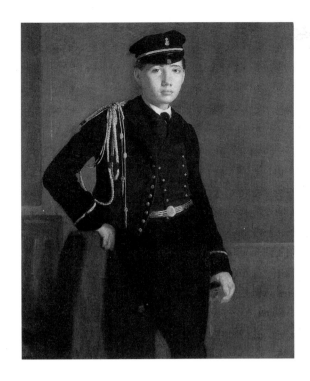

Achille De Gas
ca. 1857
Oil on canvas
64 × 51 cm
Washington D.C.,
National Gallery of Art,
Chester Dale Collection
(L30)

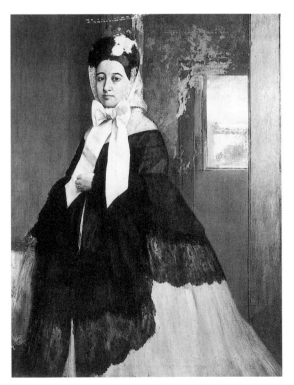

Thérèse De Gas
1863
Oil on canvas
89 × 67 cm
Paris, Musée d'Orsay
(L109)

head-and-shoulders portrait – a tragic, old woman's face, pitilessly lit (cat. 98, illus. p. 196).[28]

Even here, where the traditional bust format would lead us to expect an aggressive plasticity, Degas managed to achieve a very pictorial arrangement of planes, notably in his portrait of *Léon Bonnat* (illus.).[29] Both the tall top hat with its black ribbon and the area of the shoulder are applied flat, while a vertical stripe at the edge of the picture assures the harmonious relationship between figure, field and frame, so that the young man "looks like a Venetian ambassador" (as Degas put it). A wonderful head of a young woman (L163, Paris, Orsay) is distinguished by a similar equilibrium between plastic and planar.

Degas's favourite format is the half-length, ranging up to three-quarter length; this enabled him to introduce additional information about stature, movement, social status and to include the variable motifs of arms and hands. Early examples include his portrait of his brother René (cat. 7, illus. p. 174), as severe as a modern-day Bronzino, and that of his second brother Achille De Gas (illus.) in the uniform of a naval cadet, a self-conscious piece of showmanship in Ingres style, as well as his self-portraits and numerous drawings, which also carry some resonances of contemporary portrait photography. However, Degas sometimes chose to ignore some of the physical facts of the half-length figure for the sake of the picture, to superb effect in the portrait of his sister, Thérèse De Gas (illus.). The young fiancée is presented in all her fine clothes, ribbons and bows in such a way as to form a narrow, off-centre triangle in the rectangle of the picture. By various means, Degas contrives to enclose, encurtain and emphasize the harmonious oval of her face, against the virtually abstract surroundings of coloured oblongs, stabilising and harmonizing her almost disembodied figure like the subject of a composition. He went a step further still in *Mme Jeantaud before a mirror* (cat. 124, illus. p. 217). The half-length view not quite in profile is duplicated by the mirror image (almost full-face) on the left. One image is light against dark, the other dark against light, contained within subdued, unified colours. The double viewing angle both expands the statement made by the portrait and complicates the pic-

Mme Edmondo Morbilli
(Thérèse De Gas)
ca. 1869
Pastel
51 × 34 cm
Private collection (L255)

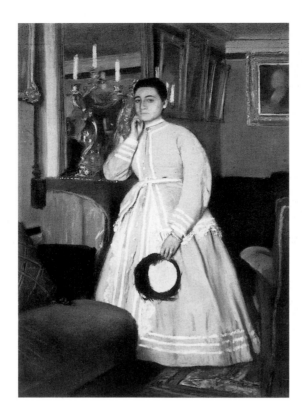

ture's layout; it is a deconstructed portrait, a sophistical confusion.

In contrast to his contemporary Manet, Degas seldom attempted the formal full-length portrait, '*le portrait en pied officiel*'. In his early years he had admittedly been impressed by the power of the format, when the subject was depicted full-face from head to toe in all his dignity in the work of Van Dyck and Philippe de Champaigne, Delacroix or Ingres.[30] But it had been massively over-exposed in Salon art and its would-be royal presumption had become trivialised. To Degas, it evidently seemed insufficiently responsive to the subject and inexpressive, it was too bold, too cardboard, and too simple for pictorial development. He attempted it only in sketches and studies.

So much is apparent in the portrait of about 1869 of Degas's sister Thérèse, Mme Edmondo Morbilli (illus.), a pastel just 51 cm high.[31] The light-toned full-length figure, slightly on the slant, with her arm propped up, only makes a picture when the accessories in the foreground, the reflections and the rows of paintings come into play. Possibly Degas may have had Manet's '*grandes figures*' painted in the

mid-1860s and Ingres's *Comtesse d'Haussonville* in mind.

Degas produced his portraits amidst a wide-ranging output of history paintings, genre pieces, cycles of graphic work and landscapes. It is important to observe how these categories, though still firmly compartmentalised at the time by academic definition,[32] kept house together in Degas's work, dominating and mutually influencing one another, displacing and mingling with one another.[33] Already in the 1860s Degas was experimenting at the edges of categories and with the transitions between them.

As early as 1865 he abandoned history painting, although he had a special talent for it.[34] A short time later, about 1866, he began to turn to the race course, to horses and jockeys, and after 1870 to scenes from the theatre and ballet. Still pursuing '*haute peinture*', meanwhile, he started to try different subjects, moving over to 'modern life', without relinquishing the claim to 'great painting', even though poaching on 'lesser' subject-matter. Degas's portraiture in these years, after 1865, covered a wider formal range, influenced by contact with other genres. His single portraits became significantly more dynamic, in variations on the seated figure. He produced a striking series of double portraits – double and group portraits were preeminently the compositions in which he attempted grandeur, with a novel, 'modern' syntax. They took on narrative and genre-like characteristics and expressed a kind of group psychology, expanding and straining the concept of the portrait. Degas's picture of the Bellelli family (illus. p. 16) is a group portrait with the structure of a history painting. Conversely, because of the number of portraits present in it, the genre picture *The cotton office* ('*Portraits dans un bureau (Nouvelle-Orléans)*'; cat. 114, illus. pp. 202–05) is a hybrid, a group portrait genre picture.[35] The prospect had arisen of something on a new level that might be described as "a composition that paints our time".[36]

Degas's interest in portraiture coincided with a general triumph of the genre picture at the Salon.[37] *The orchestra of the Opéra* (illus. p. 52) is a portrait of the bassoonist Désiré Dihau in the middle of the orchestra (also all portraits), a kind of genre group

'L'Absinthe' ('Dans un café')
1875–76
Oil on canvas
92 × 68 cm
Paris, Musée d'Orsay
(L393)

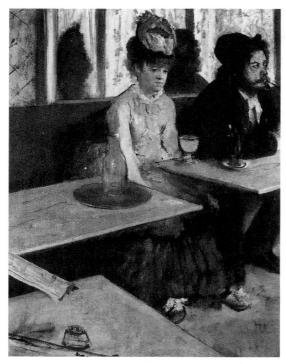

portrait. The painting known as *L'Absinthe* (illus.) is a portrait of Ellen Andrée and Marcellin Desboutin in a café. The little ballet dancer Marie van Goethem was the sitter for Degas's famous sculpture *The little fourteen-year-old dancer* (cat. 158, illus. p. 288). And so on for many scenes from the ballet, opera and *café-concert*. We know the names and recognise the faces. The portrait became an essential element of 'modern' genre painting; it served to give it credibility and to guarantee its authenticity. These new parameters of the portrait entailed a new freedom for the painter, a typically 'modern' *disinvoltura*, informality, spontaneity.

Particularly in his portraits of seated figures Degas most successfully achieved what Duranty liked to see as the "special note of the modern person": figures whose pose of attitude imparts telling information about their temperament, age and status, whose gestures, clothing and setting demonstrate "a whole range of feelings".[38]

Bold angles and movements enabled the painter to pass from a physiognomy of the face to a physiognomy of the body. The early seated portrait of Degas's grandfather Hilaire Degas (cat. 20, illus. p. 187) is still wholly in the style of Ingres, perfect, dignified and severe, at the same time a little old-fashioned, perhaps at the sitter's request, although

the extended left arm strikes an accent of relaxation. His stoop has already characterized *The collector of prints* ('*Amateur d'estampes*'; L138, New York, Metropolitan Museum of Art) even before we take in his face and his collections. Degas portrayed two women acquaintances in an extremely bold and abrupt manner: *Mlle Dihau at the piano* (illus. p. 106) suddenly turning her back on the piano, and *Mary Cassatt holding cards* ('*Mary Cassatt assise*'; cat. 168, illus. p. 276) dealing cards and leaning forward in such an uninhibited fashion that this proper young woman found it "repugnant". But no other seated half-length figure is presented so theatrically as Mme Dietz-Monnin in Degas's pastel of 1879 (illus. p. 106) – even though this was a commission. The loose movement of this lady in fancy garb greeting someone outside the picture is complicated to the point of confusion by the crossing lines made by her stripes of dark fur and by the reflected repetition of the figure. The smudged pastel entirely corresponds with the instantaneity of the precarious situation, being hardly more fixed than the sitter herself.

Degas came to terms with the full-length portrait, which was so problematical for him, by converting it into a seated-figure portrait. He devoted a lot of attention to the seated figure, conceiving it not rigidly like an enthronement, but much more freely, as conveying an attitude personal to the sitter, as part of how he or she felt. To that extent his seated portraits relate closely to the configurations of his early pictures of dance.

In addition, Degas made two 'directorial' choices of primary importance: he posed the sitter within his or her personal surroundings, and looked downwards on the sitter, using the '*vue plongeante*'. With the first he achieved a material enrichment of the portrait's content, filling what was otherwise neutral ground with information about the sitter's social position and profession; with the second, he gave the viewer an arresting, dramatic entry into the world depicted (in ballet pictures, the world backstage). At the same time, he improved his options for the picture's composition. Having set up the *mise-en-scène*, he could point the portrait the way he wanted it to go.

Significantly he used this formula in portraits of his artist and writer friends, and produced master-

Mlle Marie Dihau at the piano
ca. 1869
Oil on canvas
39 × 32 cm
Paris, Musée d'Orsay (L263)

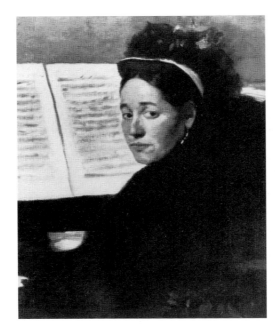

Mme Dietz-Monnin
1877–79
Gouache, charcoal, pastel, oil
on canvas
85.5 × 75 cm
The Art Institute of Chicago
(L534)

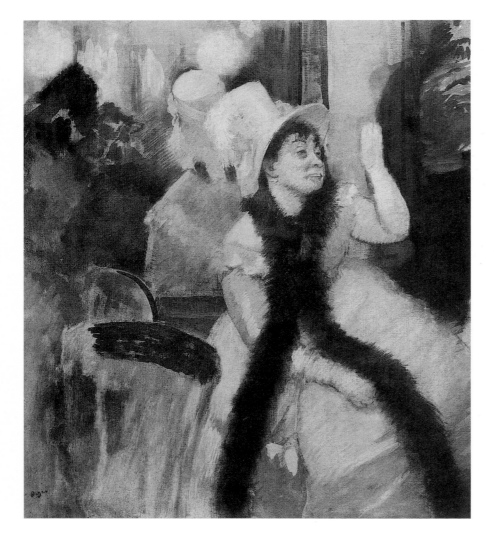

pieces: those of his fellow-painter Tissot (illus. p. 107) and of writers on art such as Martelli (cat. 146, illus. p. 269) and Duranty (illus. p. 47) and of woman artists such as Victoria Dubourg (Mme Fantin-Latour) and the pianist Mme Camus. There were two main bursts of such portraits, ca. 1868–69 and 1879. We must confine ourselves to commenting on a few, famous examples.

James Tissot (illus. p. 107) was Degas's friend and himself a painter, though not here depicted as such. His figure, occupying comparatively little of the picture space, is all the more agitated and restless in effect. Though seated, his pose is slanting, diagonally across the picture, extremely momentary, unstable, nonchalant and playful. He is visiting a studio that is not his own; the room is surrounded on three sides by paintings, stabilising factors, also offering a sample of his eclectic taste: the portrait by Cranach beside his head makes a small pictorial joke on the resemblance in pose and moustache. The pose reveals his friend as a dandy, a smart operator, an adaptable artist who has 'arrived'; he is painted sympathetically and with scrupulous care, but also a little ironically.

Diego Martelli (cat. 146, illus. p. 269) was a Florentine art critic; his massive body is poised on a small folding chair, compact with his arms crossed, weighty yet precarious; the picture as a whole is a dialogue between his figure on the left and the multicoloured still life spread out on the right to illustrate his background, the writer's world. Duranty criticized the foreshortening of the legs; in fact Degas is here using a perspective that is astonishing in the portrait, not face to face, but slightly from above to below so that the outlines of the sitting body are compressed and the still life can appear in the view (detail illus. p. 14).

The seated figure of Edmond Duranty (illus. p. 47; a study is cat. 149, illus. p. 265) is quite hemmed in by his papers and books; only his upper body is visible, dark against the light background of his own study; an alert, powerful head; the arms 'rowing' in the piles of paper, a dark criss-cross pattern, active, but without reference to the body. Both of Degas's new compositional devices are employed here: rich surroundings which define the sitter in his social and professional environment, and the slant-

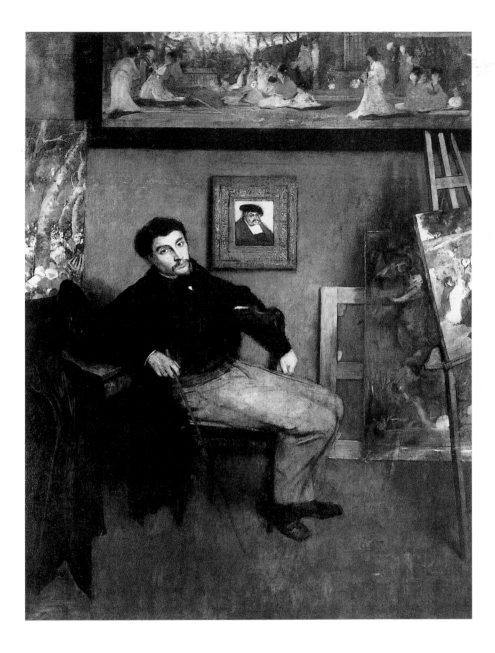

James Tissot
1867–68
Oil on canvas
151 × 112 cm
New York, Metropolitan
Museum of Art (L175)

tionships, was a prerequisite for these paintings. Communication (or non-communication), dialogue, agreement or antagonism were now themes for a portrait, for which Degas developed appropriate pictorial means, sometimes contradictory, sometimes almost clandestine. Duranty spoke, around 1870, of Degas's extreme sophistication, "systematic strangeness" and "seeking out of the unusual".[39]

In 1865, the year he painted his last history picture, Degas attempted the double portrait in three important variants, depicting two sisters, two friends and a married couple.[40] He had already familiarised himself in 1858 with the sisters Giovanna and Giulia Bellelli by way of preparation for the large family picture,[41] but in the meantime they had almost grown up. The independent double portrait (cat. 78, illus. p. 194) shows them half-length, Giulia ranged a little behind Giovanna, each turning away from the other, both looking outwards – pseudo-symmetrically. One is fair-haired and dressed in black, the other dark in a lighter dress; Giovanna's fresh face has warm skin tones, Giulia tends towards the pale, turned to show her profile. Their responses are differentiated, but the contrast is not emphasized. Their different colouring is unified within the overall brown tone, the areas of colour counterpointed against a background of soft brown striped wallpaper: a duet in gentle contrasts.

The double portrait of Degas with his friend and colleague Evariste de Valernes (illus. p. 23) is more complex, with its overtones and undertones. De Valernes was twenty years Degas's senior, but inferior to him as an artist. However, they are not portrayed in the studio, but as bourgeois gentlemen in the black uniform of their class, the elder of the two even wearing a black top hat. X-rays of the picture show that Degas, too, was to have worn one, but that would have made the two equal and produced a comic silhouette. In the end de Valernes's hat was tied in with a powerful band of architecture on the left-hand side. As the picture developed Degas elaborated the differences between the two. The older man sits at the front, across the whole breadth of the picture, relaxed and self-assured, not without a certain conceit (his pose anticipates that of Tissot's portrait). Degas is

ing view downwards on the figure, close up on to the papers so that the writer is glimpsed virtually burrowed in his littered den. In sum, the portrait has been raised to the level of a complete picture, with its own rhythms, colours and contrasts.

The challenge the double portrait represented was to depict duality in the singular – the resolution of consonances and dissonances on both the formal and the psychological level. Each of the pair can be recognised as an individual standing off from the other; but each is a mirror of the other. Degas's familiarity with the sitters, with their lives and rela-

slightly behind his friend, narrower than him and very upright, with his left hand thoughtfully and hesitantly raised to his chin,[42] gazing with that sibylline gaze which has since been a feature of our image of him – this was Degas's last self-portrait. "I was cross with everyone and with myself," he wrote about himself at the time, "while I felt that my artistic calculations were so right."*[43] The share of the picture assigned to de Valernes is larger, but his head lacks aura; it is the reverse with Degas. This "calculation" was in fact correct, but it is presented discreetly. The large black planes of their bodies form a single unit with a shared outline out of which Degas's head surges enigmatically into the lightness. A pictogram town extends behind them, illusory and artificial, and the light in the picture in which the two unequal friends sit in silence is artificial, too. There can be no doubt that Degas had studied Raphael's Louvre double portrait (also including a self-portrait).

The subjects of Degas's portrait of his sister Thérèse and her husband, *M. and Mme. Edmondo Morbilli* of ca. 1860 (cat. 73, illus. p. 185) are still more unequal. Although both turn directly towards the viewer with parallel gazes, clearly posing for their picture, arranged, nonetheless the man is dominant: he sits at the front, a little uncomfortable between the table and chair, a lordly, rather arrogant *seigneur*; the woman appears as a half-figure behind the table, smaller, in something of a trance, shown full face with unusual directness, her right hand at her chin and her left on the shoulder of her protector; a dark, questioning gaze, the mouth slightly open. This is the picture of a not happy and not unhappy couple (as Loyrette has put it), after the loss of a child. (Degas made at least four portraits of his sister at different stages of her life between hopes and disappointments.) The woman is assigned a grey panel of her own in the ochre-coloured background. Above all the picture is very tightly constructed, and in that respect recalls Degas's history picture of *Semiramis* of 1860–62. The man's downward hanging hands and the woman's upturned ones are one of many eloquent motifs.

Even in his late work (where portraits are rare) the double portrait does not entirely disappear.

Gripped by pessimism in his old age, Degas deemed virtually only the Rouarts, his best friends, worthy of being portrayed. *Henri Rouart and his son Alexis* (cat. 177, illus. p. 225), father and son, are depicted as two single, utterly unconnected people, a young standing figure and an old seated one, in front of an abstract, rust-coloured ground. The son towers up, dominant but insignificant; the father is right at the bottom, hunched, his face wasted by age, the socket of the eye a red spot, but it is an expressive head. Degas shows them both in black, bringing the two silhouettes together in a steep, asymmetrically interrupted triangle. Two generations, two strangers, torn apart by cruel time, held together by the family. Both are playing with their gloves, both helplessly subject to the terror of time, with the son looking "as if he were already attending his father's funeral" (Loyrette). Degas's own experience of age was in line with his friends' experience of different generations. He used broad, transparent strokes to construct this picture of inevitability that goes well beyond the personalities of the two men.

Degas applied his experience in history and genre painting most fully to group portraits with a large number of people. The 'high art' syntax used in them brings out a wealth of relationships inside the picture that is unusual in portraiture. It is Degas's skill in composition that turns *The Bellelli family* (1858–67, illus. p. 16, cf. cat. 40–49, illus. pp. 188–92) into the portrait of its sitters' destiny.[44] (There is even an 1837 caricature by Daumier mocking *nouveaux riches* that influenced this portrait – what a distance from that to a masterpiece!) As was only appropriate, Laura, upright as a statue, is still the dominant figure: dressed completely in black, because in mourning for her father who had died in 1858 (his portrait can be seen just beside her head) and for the infant son lost in 1860, she is pregnant so that the generation span opens up over three stages, with death and birth; her melancholy gaze is directed into the distance; she has authority and natural nobility, she is a kind of antique *tragédienne*. Giovanna is huddled into the larger silhouette of her mother like a good girl. The husband and father is sitting apart on the right-hand side, an incidental half-length figure, seen partially from behind and in profile; he is in half-shadow, making no eye contact,

lit by a little glancing light, whereas the main group is standing in full light. By the way she turns, Giulia, sitting restlessly on the chair, serves as a kind of hinge between left and right. The interior of the bourgeois drawing-room is emphasized on the right above the man, where a mantelpiece, a clock, a candle and reflected mirrors appear. Together with the internal portrait and the framing elements on the left edge of the picture, these elements create a firm architecture: what we see is stable security and peaceful familiarity.

Only within this tranquil geometry does the portrait emerge as a constellation of difficult relationships: no contact between wife and husband, their eyes looking in different directions across the empty centre; the dominance of the woman, her endurance in spite of everything. The distances, the dissonances, consonances and assonances are made visible in detail, up against the picture plane, down the many diagonals: gazes, hands, outlines, colour relationships, all work together as signals in the composition. We know that Degas developed this picture of history-painting size over many years with great ambitions for it, hoping its worth would be recognised in the Salon. The composition is on a par with related solutions in the work of David, Ingres, Courbet, Daumier, Bonnat and even Goya. The memorable figure of Laura has resonances of Van Dyck's portraits of Genoese aristocrats. This is a work of art rather than a portrait, a point Degas himself insisted upon. In fact the theme is the fate of a marriage, marriage as a kind of history.[45]

The most unusual of all Degas's portraits must be *The cotton office* (1873), conceived as a portrait according to Degas's own title "*Portraits dans un bureau (Nouvelle-Orléans)*" (cat. 114, illus. pp. 202–05).[46] A portrait with fourteen people in it! A group portrait? A collective portrait? A family portrait? The portrait of a profession? A cotton office? It is none of these exclusively, but a bit of each. It also has many of the characteristics of a genre picture.[47] Degas took the liberty of overstepping the boundaries between categories and of mixing their rules. Whether it is seen as a genre picture made more concrete by portraits, or as a group portrait enlivened by using genre means, or as the two combined, depends on the way it is read.

Degas himself differentiates the faces, however small they are, in such a way that they can all be identified, and the activities and clothes match the professional rôle of each person. The painter loved the Musson family in New Orleans and admired his uncle's cotton business, apparently not noticing that it was run in such an old-fashioned, casual way that a little while later the firm went bankrupt. Degas does not marshal the fourteen male portraits in line, binding them together in a common action or episode, in the Dutch manner. Instead, each is portrayed totally absorbed in his own activity regardless of what is happening around him: "There they live for cotton and by cotton". There is no real interaction.

Portrait and genre, but more besides. The interior, too, is represented, almost as a separate subject – an oblique space viewed from a wide-angle perspective, with the viewer off centre and elevated so that he has an overview; the room is light and delicately drawn. Objects demand attention, first and foremost the substance of the cotton itself, then the wastepaper basket right at the front, commonplace and yet the most beautiful cluster of colour in the picture. Even still life is mingled into this concoction of genres. (Degas has yet to be discovered as a still-life painter.)

This painting with fourteen portraits – Degas himself spoke of it as an "assez fort tableau" – is also formally unique. The elements are evenly distributed, with a lot of scattered small accents, but no focal point or centre. The concept of the portrait disintegrates, but the director of the action is a portraitist still. The brightness of the light in the picture is even, too, although it is an interior scene: it is a diffused brightness appropriate to the practical nature of the scene. The colour is generally even, creating a cool, severe unity, the white of the cotton and the black of the clothes constituting the two tonal poles, and the walls an ivory tone, with no strong contrasts. Yet the effect is not monochrome, for small accents of colour enliven the whole. The "disconnectedness", as Growe has termed it, of the plethora of portraits is obviated by coherences of this kind in the picture. Does it not indeed make things seem a little better than they actually were? Is it not even slightly Biedermeier?

Woman with a vase ('La femme à la potiche')
1872
Oil on canvas
65 × 34 cm
Paris, Musée d'Orsay
(L305)

were still in mourning.[48] The background is a turquoise-coloured, unarticulated wall, abstract rather than part of an interior.

The contrast between the mother and the daughters could hardly be greater. The mother is completely isolated, with an aged, over-long face, her gaze tired and resigned, still with pride and dignity, directed into the void. The daughters on the other hand are close together, in the same black area, mobile, cheerful, perhaps playing the piano. In the long narrative 'track' of the oblong picture, the areas of black introduce notes of contradiction into the unison. Their rhythms determine the pictorial field with unusual definiteness. The open, broad brushstrokes are directed not towards description, but towards structural cohesion.

Two generations, two stages of life, cannot be united, yet they belong together. In the elderly matron Degas clearly perceives collapse of the features, frailty of the flesh, but not cynically, not as a 'triumph of death'; the resignation has a solemn note. Nor is the daughters' frivolity made despicable. Degas registers the slipping away of time as it is reflected in the portraits of his relations with equanimity. There is no story: the black figure in the picture says it all.

Surprisingly enough Degas also combined portrait with still life. This fusion in his work, occurring between 1865 and 1875, must surely be one of the 'difficult things' the painter spoke of in 1872.[49] While rare and paradoxical, the combination is not unique: Courbet and a few Dutch painters had anticipated him and others such as Bazille came after.[50] However, when Degas combines a large bunch of country flowers with the portrait of Mme Valpinçon (L125, New York, Metropolitan, illus. p. 88) for the competition between the genres, the *paragone*, to work successfully, the two have to be balanced rather artificially:[51] the portrait of the woman is off-centre, right at the edge, and the picture is completely asymmetrical. The bunch of flowers occupies two thirds of the picture area, the woman one third, and even then she is rather hemmed in. But she is so alert, with her gaze out of the picture, so intelligent and vital, that she dominates the picture, reversing the balance of the proportions. The light, ochre tones of her face and dress, the calligra-

An elderly lady, Stefanina Primicile Carafa, marchesa di Cicerale e duchessa di Montejasi, another of Degas's Neapolitan aunts, with her two daughters Elena and Camilla (cat. 128, illus. p. 195): up to this point the cast is the same as that of the first phase of the Bellelli family portrait, without the husband. The duchess was a widow. But the theme is different: it is the gulf between the generations, and in that respect it can be compared with the late double portrait of the Rouarts (cat. 177, illus. p. 225). The lady is sitting on the right on a curving sofa, enthroned, completely frontal, forming a pyramid, with her hands in her lap. On the left at the very edge, even overlapping slightly and with their attention directed outside the picture, are the two daughters, aged twelve and fourteen. All three are dressed completely in black; at that time the family

phic outlines of the black of her scarf, the white frills on her cap all harmonize with the subdued colour of the still life. The arm on which she leans acts as a prop and a barrier, in their own right, and the lady is far from being like a flower herself. It is a portrait seen out of the corner of the eye – a novel, impertinent way of looking at things, no doubt stimulated by Degas's encounter with Japanese prints.

Other solutions to the tricky polarity of portrait and still life are proposed in *A woman with a vase* ('*La femme à la potiche*'; illus. p. 110) and *Mme de Rutté* (cat. 126, illus. p. 245), both painted between 1872 and 1875, both in upright format. The woman portrayed appears in subdued contemplation as a half-length figure on one side behind several layers including the vase of flowers and the furniture. The proportions are unequal, but are co-ordinated in a subtle balance. The portrait asserts itself even from behind its barriers. In *Hortense Valpinçon* (illus. p. 111) the relationship between portrait and still life is completely straightforward; both are symmetrical in the wide format. The girl dressed all in white, visibly forced into the pose, is balanced on the left by a still life with a work basket that is rich in form and colour.

Finally *Place de la Concorde, vicomte Lepic with his daughters* (L368, currently held in a Russian museum, illus. p. 43), painted ca. 1875–77, is a unique undertaking, radical in many respects.[52] Is it really a portrait? A family one? Or a genre picture? A chance everyday view? A scene from 'modern life'? A Paris townscape (as the title indicates)? This picture places Degas quite outside the academic system. Not only was he experimenting with new subjects, but with new subjects perceived in a new way – sudden, surprising, fleeting, accidental. He answered the need for a kind of picture that reflected the modern urban experience.

Even in such revolutionary territory the portrait did not disappear, even though it is no longer literally in the centre of things. The viscount, Degas's esteemed colleague, "that tall gangling fellow" (Loyrette), could nonetheless be recognised at first glance, as a hurrying outline, shown in profile, an impatient, complacent non-conformist with a cigar held skew-whiff in his mouth. Nor is his family proper or well behaved, with the two girls turning

Hortense Valpinçon
1871
Oil on canvas
76 × 110.8 cm
The Minneapolis Institute of Arts (L206)

in the opposite direction, as is the elegant dog, each for herself. In the colourful frieze of colours at the upper edge of the picture the Place de la Concorde is merely suggested. The emptiness of the open square is more important. Chance seems to be in charge, but the form of the picture has it under control. The disconnected scene has been worked out according to new, totally unacademic pictorial rules. The viewer's encounter with the Lepics takes place in the foreground, as in a detail; they are half-length figures, brutally cut off at the bottom and side by the edge of the picture, as if they were in the process of walking through the pictorial field – and leaving it. An instant, and it is over. The picture is perceived as a glance. The theme is movement, haste in the city, sudden emptiness, the tension between full and empty. How incorrect the onlooker on the left edge of the picture is: but cut right through and fragmented as he is, he serves as a marker without which the structure of the picture would collapse. The main group also consists of striking silhouettes. As an oblique triangle, itself containing tensions, it is beset by opposing forces on all sides, even above. In this unstable stability, this eternal moment, movement is fixed and held by the painter-director in a composition.

Here Degas is straining all the traditional pictorial rules, especially those of the portrait. There is no attempt to convey status, the people portrayed are

taking no notice of the viewer. Admittedly we see their essential characteristics, but there is no descriptive emphasis, they are captured in haste. But in pictorial adventures such as these it turns out in fact that the portrait is an indispensable guarantee of authenticity. The figures are still portraits of people, in conditions similar to those prevailing in Degas's ballet pictures.

It is significant that as his eyesight began to fail Degas tried to pursue portraiture using the new medium of photography. He had owned his own Eastman-Kodak camera since 1896, and it was for him a machine for experiments. His photographic sitters recount how he spent hours giving orders and making arrangements under artificial lighting with all his "artist's fierceness" (Halévy).[53]

Degas's interest in Japanese coloured prints had a still more enduring impact.[54] But for them he would certainly not have gone so far so quickly in his 'directorial' approach to the picture, with his cutting and highlighting of detail, overall fragmentation, polarisation of near and far, full and empty, the upward or downward angle of the viewing axis, always led back to the decorative surface, to pictorial rhythms. These elements were all weapons with which to drive realistic illusionism into retreat and to rout academic idealism. Degas was a collector of Japanese prints and subjected the portrait to their influence, too. The Lepic picture epitomizes this tendency, but *japonaiserie* also made its presence felt in many other portraits, from *Madame Camus in red* (illus. p. 90) to *Woman with a vase* ('*La femme à la potiche*'), or from the portrait of Tissot to those of Martelli and Duranty and on into the late period.

III

Did Degas, a well read, argumentative man, in any way believe in a theory of the portrait?[55] Did he himself develop and express any such theory? There is very little evidence that he did, even though regular frequenters of the café Guerbois regarded Degas as a 'great theorist'. Discussions on aspects of portraiture must sometimes have taken place there in the 1870s in the presence of Manet, Duranty, Whistler and Fantin-Latour. Degas's reported comments on the portrait are, however, admittedly few and far between and not coherent – thoughts aloud in the studio, impulsive, unconnected, paradoxical remarks, far removed from dogma and system. There are traces of these in his notebooks, his famous and often repeated *mots*, his letters and the reports of friends and acquaintances.

It would appear that Duranty's *La Nouvelle Peinture*, published in 1876, amounts to a sort of anthology or compilation.[56] Written on the occasion of the second Impressionist exhibition in 1876, this milestone publication may be regarded as the product of Duranty's and Degas's shared thoughts on 'modern' painting. Georges Rivière even talks of a "manifesto by Degas signed by Duranty".[57] It is clear from the text – the opinions expressed and the representatives cited – that this is not purely and simply a treatise on Impressionism; it is concerned rather with founding a new realism independent of '1848'. If Degas features in it as a "philanthropist of art" without his name being mentioned, Duranty is thinking of the inventor of countless innovations in '*la nouvelle peinture*'.

'Modern' painting, including portraiture, wants to leave rules and conventions behind and go "among men", "into the world". "The modern person" was to be shown "in his clothes amidst his social customs, at home or on the street". "Neutral, empty, vague backgrounds" were to be replaced by distinctive atmosphere and appropriate attitudes and gestures so that the "wealth", "class", "background" and "profession" of the sitter should be depicted. The sitter should not stand out in the middle of the picture, but should be pushed to one side, "cut" and "sliced", and the picture itself should no longer be a 'window', a dimensional box of space, but should also be "cut off", "unexpected". The following exhortation is addressed directly to portraitists:

Through someone's back, we want temperament, age, social condition to be revealed; through a pair of hands, we must express a magistrate or a businessman; through a gesture a whole range of emotions. A face will tell us unerringly that one is a tidy, dry, meticulous man, another carelessness and disorder personified. Pose will let us know that this person is going to a business meeting, while that one is returning from a lovers' tryst.

There are similar comments by Degas himself in his notebooks.[58]

Degas's interest in physiognomy is also linked with Duranty, who had published his studies *Sur la Physionomie* in 1867.[59] For Degas modern physiognomy brought the prospect of a kind of scientific grammar for his observation of faces. Critics were struck by the "frightening realism" of the portraits he painted around 1880: "Moreover M. Degas is a cruel painter", Mantz wrote in 1877. Yet his observations of atavistic and animalist specimens are hardly reflected in the portraits themselves, but in his depiction of prostitutes, of *La Famille Cardinal*, of female dancers and singers, a genre which Degas explored more with curiosity and sympathy than with cynicism. On two occasions, however, this interest crops up directly in his exhibited portraiture: in *Criminal physiognomies* (cat. 161, illus. p. 291) – according to Duranty, "the savages of the civilised world"[60] – and in the famous *Little fourteen-year-old dancer* ('*Petite danseuse de quatorze ans*', cat. 158, illus. p. 288), where the dark foundations of grace are revealed – both were shown at the 1881 Impressionist exhibition.

Degas's reflections on caricature also led to a sharpening of the physiognomic observation in his portrait painting. He confided to his notebooks his own caricatures, of which the most remarkable are those of Napoleon III, Bismarck and Thiers.[61] Together with the physiognomic studies they constitute a background knowledge of the boundaries and hazards of the portrait.

IV

Degas's work as a portraitist was carried out mainly between 1854 and about 1890, a period when portraits were being produced in hitherto inconceivable quantities, while at the same time being newly challenged by photography. The question of the conflicting aims of likeness to the sitter and pictorial originality had constantly to be faced by so called 'artist painters' (*peintres peintres*).[62]

The countless commissioned formal portraits of the Second Empire and the Third Republic, widely known through the Salons and World Exhibitions, by artists such as Winterhalter, Cabanel, Baudry, Couture, Carolus-Duran and many others, continued to predominate. At the same time in intellectual and artistic circles more personal, innovative portraits were attempted by such as Courbet, Manet, Fantin-Latour, the young Renoir and others. The Impressionists were interested in portraiture only in the early years. Degas was fully up to the minute, working in amongst his colleagues, regularly visiting exhibitions, the Salon, galleries and studios and himself actively involved in the organization of the Impressionist exhibitions. So how does his portraiture relate to the portraiture of his period? As yet there has been very little discussion of this in research on Degas, which has mainly been in the form of monographs.[63] In view of the paradoxical and contradictory structure of Degas's creative work – "avant/rétro", "within and without", as Armstrong has put it – it is difficult to classify according to a history of development or even of style.[64]

In *La Nouvelle Peinture* Duranty placed those nearest to Degas in the field of the portrait – no doubt with Degas's concurrence – under the banner of an updated Realism. He mentioned Ingres, Courbet, Millet, Manet ("the head of the movement"), Fantin-Latour, Whistler, Stevens, Carolus-Duran and Bracquemond. That is a fixed point of reference from which we can still start even today, despite any reservations.

In spite of the realist orientation of the treatise "the great Ingres" is given pride of place, not really as a classicist, but because from the Greeks he derived "only respect for nature", so creating "those rigorous, violent, strange portraits which are so simple and true". Ingres lived and worked until 1867. Degas met him and was in any case linked with the revered master through his own teacher Lamothe, himself a pupil of Ingres. The importance of Ingres to Degas, in the field of portraiture too, has always been stressed – perhaps too much. The younger man unquestionably used formulas taken from Ingres and his circle, albeit selectively, until about 1860. These included the placing of the sitter, the 'lay-out'; statuesque presentation – the sitter as idol; an utterly impersonal finish. Even so Degas's emancipation and 'modernism' in psychological differentiation and formal boldness is obvious.

In the 1890s Degas was a passionate collector of Ingres's works, including his portraits, and he used

to quote his maxims like texts from the Gospels. His lifelong veneration of Ingres as a portraitist rests on more general things they had in common: both restricted themselves to sitters among their family, friends and fellow artists; for both portraits were part of an exchange of gifts between friends (though many of Ingres's were also commissions); both made reference to Renaissance and Mannerist models; both faced a dilemma between 'portrait' and 'history', physiognomic likeness and idealisation, and the conflict between the portrait as such and the picture as such. Already in Ingres the quality of the portrait was seen to reside not only in the handling of physiognomy, but also in the pose, in the "complexion of the body", as Naef has termed it, and in the clothes (more for Ingres than for Degas); it should have brightness, alertness and cheerfulness; the artist should show complete discretion towards the sitter, without intrusiveness, unmasking or exaggeration. Finally, both were possessed by overriding artistic ambition, with the portrait, too, in the thrall of their obsessive search for perfection.[65]

From the 1860s Manet, whom Duranty described as "the head of the movement", was Degas's most important associate. Degas and Manet knew each other well and from about 1866–68 until Manet's death in 1883 were linked by a fragile friendship. Degas, however, hardly reacted to Le déjeuner sur l'herbe and Olympia. Like Degas Manet was not dependent on portrait commissions and undertook portraits most frequently on his own initiative. As in Degas's, so in Manet's versatile œuvre the portraits cannot be seen in isolation, there being many transitions from them to the 'modern genre' in particular. For both the portrait was directly a part of ambitious painting, with claim to being a work of art.

Degas valued his famous colleague as a great independent, in the field of portraiture as well. Manet was certainly his superior in the elegance of his presentation and in his painterly verve, as well as in establishing contact with important people. Nor did Degas compete with Manet's many grand full-length portraits, nor with his Spanish and Venetian references. He was apparently most directly influenced by Manet's portraits of Zola (1868) and

Astruc (1866), especially in his own portrait of Duranty (1879). He portrayed his colleague sitting alertly in his studio as early as ca. 1866–68 in a series of three drawings and three etchings, and in the ill-fated double portrait of Manet listening to his wife play the piano (L127, Kitakyushu, Museum of Art; illus. p. 25) where Manet is depicted sprawled on the sofa.[66] Their relationship was reciprocal, with Manet taking an interest in Degas's mixed techniques.[67]

Between the Impressionists in the strict sense, i.e. Monet as a young man and Renoir prior to 1880, and Degas there can be no comparison in respect of portraiture.[68] For Degas the portrait was a completely unspontaneous, artificial task. The plein-air portrait was foreign to him, and he never attempted disintegrating the colours of the spectrum in the pointilliste technique. Nor were Monet and Renoir, despite his contacts with these younger colleagues, close to him on a personal level. Degas used angrily to reject the description 'Impressionist' as applied to himself. The fact that portraits by him were shown on several occasions at Impressionist exhibitions is not significant, given the heterogeneous composition of the 'Société'.

In Duranty's list in La Nouvelle Peinture the significance accorded to fashionable portraitists influenced by English painting is striking – the American James Whistler ("amazing portraits") and the Belgian Alfred Stevens ("highly talented") – and there was also Degas's friendship (actually fizzling out at that time) with James Tissot. The fact that they could be regarded as associated movers of 'modern' painting demands that we look at them more seriously in this context than has perhaps been the case hitherto.

From about 1860 to about 1877, James Tissot, whose portrait by Degas is his main claim to fame, developed along similar lines to Degas, working from a similar starting point. A pupil of Ingres's pupil Lamothe, like Degas, and like him also a friend of Whistler's, he continued to follow classicist portrait formulas, though he dressed them up with 'troubadour' neo-Gothic and neo-Rococo frills. 'La femme de Paris' was the focal point of his subject-matter – closer to drawing-room genre than to portrait painting. In the 1860s the parallels

to Degas are close, with similar interest in gesture and psychology and a similar concern to depict background and atmosphere. But in Tissot's work the portrait usually turned out anecdotal in the manner of the genre painting. Underneath its worldly glitter it is affected and empty. Virtuosity got the upper hand, prettification. His Salon pictures with their colourful surfaces, without deeper question, glitter like banal paradises of the Victorian plutocracy. Degas must have recognised the danger, and turned away from this social climber in the very years when he himself could have become a 'society' portrait painter.[69]

Alfred Stevens reduced the portrait to a genre depicting pomp, high fashion and modish *beaux* and *belles*. Even in his informal portraits, the sitters had to be represented to suit such titles as '*La rêverie*', '*La toilette de bal*' or '*Un sphinx parisien*'. If we compare Stevens with Degas, we find that the design of the picture is sometimes similar, but the excess of decor prevents Stevens's portraits from becoming powerful compositions.

There was more depth in Degas's professional friendship with Whistler (1834–1905, Degas's exact contemporary).[70] Where painting was concerned Whistler opined that "there is only Degas and myself". Degas would never have returned the compliment. They were similar in their intelligence,

difficult personalities and total independence, and for a time they developed similar ideas on the portrait, leading to "new possibilities for modern portraiture":[71] the bourgeois interior as a surrounding to set off the individual, complicated by both painters in confusing perspectives, overlappings, cut-off edges – permitting no easy access for the viewer. In the work of both the portrait is slightly or more distanced and does not reveal all its secrets. On the other hand Degas did not share Whistler's fondness for the isolated full-length figure. The closest bond between them might be their return to the idea of a portrait as a work of art, a possible masterpiece. For instance, Whistler put "*Arrangement in grey and black*" first in his title before he revealed that Thomas Carlyle was the subject of the picture (illus.). In declaring the picture to be basically "an arrangement of line, form and colour first", though he did not hold to this as strictly as Degas, Whistler had Degas's verbal concurrence in a statement made to Jeanniot. The distinction of both their portraits resides in the fact that they are simultaneously great 'portraits' and great 'paintings'.

The connections and approximations I have mentioned are only tangential. Fundamentally Degas towers above all comparisons as an incomparable, intransigent outsider. It is the task of this exhibition, as a collection of his original works, to make clear what is different and peculiar to Degas in the field of portraiture.

James McNeill Whistler

Arrangement in grey and black no. 2
(Portrait of Thomas Carlyle)
1872–73
Oil on canvas
171 × 143.5 cm
Glasgow, City Art Gallery and Museum

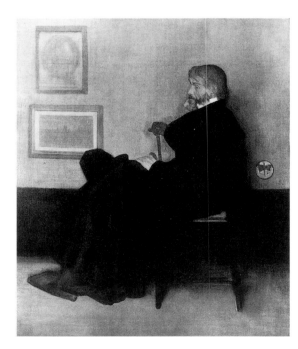

NOTES

1 Listed by genres: IV, p. 121. Lemoisne is no longer sufficient as regards numbers (cf. Supplement BR 1984), and the further problem of the boundaries between genres has to be taken into account; in the studio sales of 1918 and 1919 there was a large number of anonymous likenesses which must have been created as portraits.

2 Cf. Loyrette in 1988–89 Paris/Ottawa/New York, p. 43.

3 See further below and Boggs, above pp. 27ff.

4 Cf. Loyrette in 1988–89 Paris/Ottawa/New York, p. 43.

5 On the commissioned portrait of Désiré Dihau, see Henri Loyrette in the exhibition catalogue *Impressionnisme, Les origines*, Paris 1995, p. 225; 1988–89 Paris/Ottawa/New York, no. 97; Loyrette 1991, p. 241; on the portrait of Mme Dietz-Monnin, see 1988–89 Paris/Ottawa/New York, p. 252.

6 But Degas did not disregard the claims of his sitters:

"as portraits are not intended for us painters alone" (Kendall 1987, p. 37).

7 *Lettres* 1945, p. 23. Degas described the portraits in New Orleans as "family painting" produced more because of "general demand" from his relations than from personal inclination.

8 Cf. *L'Art en France sous le Second Empire*, Paris 1979; Patricia Mainardi, *Art and Politics of the Second Empire*, New Haven/London 1987; *eadem*, *The End of the Salon, Art and State in the Early Third Republic*, Cambridge 1993.

9 According to Loyrette 1989, note 65.

10 Loyrette in *Impressionnisme* (see note 5), p. 183.

11 Cf. Emil Maurer, 'Zur Krise des Bildnisses im Impressionnismus' in *idem*, *Im Bann der Bilder*, Zurich 1992, p. 187.

12 According to Degas's father, cf. Loyrette 1989, p. 20.

13 Cf., for example, Jacob Burckhardt's studies on the history of the portrait (as a "history of resemblance"), most recently in 'Beiträge zur Kunstgeschichte von Italien', in *Gesamtausgabe*, XII, Berlin and Leipzig 1930, pp. 143–291; also Gottfried Boehm, *Bildnis und Individuum, Über den Ursprung der Porträtmalerei in der italienischen Renaissance*, Munich 1985 (with further references); Richard Brilliant, *Portraiture*, London 1991 (further relevant references p. 176); Rémy G. Saisselin, *Style, Truth and the Portrait*, Cleveland 1963; Isa Lohmann Siems, *Begriff und Interpretation des Porträts in der kunstgeschichtlichen Literatur*, Hamburg 1972; 'Art. Portraiture' in *Encyclopedia of World Art*, XI, New York 1966, esp. col. 469 ('Concepts of Portraiture').

14 Jeanniot 1933, p. 158; Reff 1976, p. 22: "art as artifice rather than mere image".

15 Reff 1985, BN 13, p. 150.

16 Letter to Moreau, 27 November 1858.

17 Quoted Loyrette, *Impressionnisme* (see note 5), p. 193.

18 Daniel Wildenstein, *Claude Monet*, I, Paris 1974, p. 445.

19 Burckhardt (see note 13); Theodor Hetzer, 'Tizians Bildnisse', *Aufsätze und Vorträge*, I, Leipzig n.d., pp. 43–74.

20 Reff 1985, BN 4, pp. 99, 101.

21 Reff 1985, BN 2, p. 31, and BN 14, p. 66.

22 Reff 1985, BN 16, p. 6; BN 21, p. 4; BN 23, p. 44.

23 Cf. p. 158f.

24 Boggs 1962, plates 53/55, 89/91. 1988–89 Paris/Ottawa/New York, nos. 21, 22, 23, 64, 243.

25 For instance in the case of the painter Albert Melida, L112.

26 For example L50–60, L133, L89, L336; cf. Richard Thomson, 'Les poses chez Degas de 1875 à 1886: lecture et signification', in *Degas inédit* 1989, pp. 211–25.

27 For example L99, L239, L254, L249.

28 1988–89 Paris/Ottawa/New York, nos. 64, 23 and fig. 125.

29 Cf. Boggs 1962, plate 30.

30 Cf. p. 150f.

31 1988–89 Paris/Ottawa/New York, no. 94; Boggs/Maheux 1992, no. 3. Two standing women (on either side of a third seated one) were described by Degas as "ideas for a frieze of portraits", but it can hardly be verified that they are portraits (L532; Boggs/Maheux 1992, no. 26).

32 Cf. Mainardi (see note 8); Andrée Sfeir-Semler, *Die Maler am Pariser Salon 1791–1880*, Frankfurt 1992, p. 296.

33 On the relationship between portrait and genre see Boggs, pp. 16ff., and Bezzola, pp. 280ff., in this catalogue; see also John House, 'Degas's "Tableaux de Genre"', in Kendall/Pollock 1992, pp. 80–95.

34 The 'death of history painting' was unanimously announced by the critics on the occasion of the 1867 World Exhibition – the year of Ingres's death: cf. Mainardi, as note 8, p. 154.

35 Degas dreamt of an "epic portrait of Musset" and a family portrait in the style of Rembrandt's *Night Watch* (Reff 1985, BN 16, p. 6 and BN 13, p. 50). A notebook in use between 1867 and 1869 contains studies for a seated portrait of Tissot as well as of jockeys (BN 22).

36 *Ibid.*, BN 16, p. 6.

37 Cf. Mainardi (see note 8) and Sfeir-Semler (see note 32).

38 Edmond Duranty, *La Nouvelle Peinture*, Paris 1876/1988; also in the exhibition catalogue *The New Painting, Impressionism 1874–1886*, San Francisco/Washington 1986.

39 Duranty, quoted in *Impressionnisme* (see note 5), p. 213.

40 There are several studies of Italian Renaissance double portraits in the manner of Bellini and Raphael in the notebooks, cf. Reff 1985.

41 Regarding the opposite characters of the two sisters, see their mother Laura Bellelli's letters to Degas, 25 September and 17 December 1858.

42 This gesture, which had denoted the *pensieroso* and the melancholic since Michelangelo's day, was very widespread in nineteenth-century portraiture.

43 *Lettres* 1945, p. 178.

44 Fundamental to this topic is J.S. Boggs's essay, 'Edgar Degas et les Bellelli', in 1983 Copenhagen, pp. 14ff.; 1988–89 Paris/Ottawa/New York, no. 20.

45 Paul Jamot talks of a "domestic drama" and "hidden bitterness" (Jamot 1924, p. 43). There are scathing comments by Laura about her husband in several letters to Degas.

46 Title used at the second Impressionist exhibition in 1876.

47 See Boggs in this volume and Bezzola (pp. 280ff.). On

the 'replacement' of the history picture (élitist, cultured, narrative) by the genre picture (middle-class, anonymous) see Mainardi (see note 8): obituary notice of the 'great' (religious, mythological, historical) subjects by Castagnary in his report on the Salon of 1867 (1000 genre pictures among 1581 exhibits, "genre everywhere"); definition of the genre picture by the same author, 1868; Zola on *The cotton office*: "halfway between a seascape and a cutting from an illustrated newspaper" ('Salons', p. 195); "a little picture full of little social observations" (Armstrong 1991, p. 30) in contrast with Courbet's great genre paintings.

48 Like her sister Laura, the Marchesa had "a pronounced liking for misfortune" (Loyrette 1991, p. 87).

49 *Lettres* 1945, 11 November 1872.

50 *Impressionnisme* (see note 5), pp. 223–25.

51 The flowers are not chrysanthemums, and the woman portrayed is most probably Mme Valpinçon at Ménil-Hubert where Degas stayed as a guest on several occasions.

52 On this cf. Imdahl 1970; Armstrong 1991, p. 127.

53 Cf. 1988–89 Paris/Ottawa/New York, p. 535. On the relationship between photography and painting in Degas's work, cf. Antoine Terrasse and Eugenia Parry Janis, 'Le théâtre photographique de Edgar Degas' in 1984 Paris, pp. 451–87; Françoise Heilbrun, 'Sur les photographies de Degas', in *Degas inédit* 1989, pp. 159ff.

54 Cf. Jacques Dufwa, *Winds from the East*, Uppsala 1981; Gabriel Weisberg, *The Independent Critic, Philippe Burty and the Visual Arts of Mid-Nineteenth Century France*, New York 1993 (p. 97, 'The Cult of Japan'; p. 223 'Japonisme').

55 There is no existing history of the theory of the portrait in the nineteenth century in France. In his early notebooks Degas occasionally copied out comments by Leonardo and Cousin. There is as yet no research into whether he responded to seventeenth- and eighteenth-century theories, to Baudelaire, Delacroix, Castagnary and others.

56 Edmond Duranty, *La Nouvelle Peinture*, Paris 1876/1988; also in the exhibition catalogue *The New Painting, Impressionism 1874–1886*, San Francisco/Washington 1986. Cf. Armstrong 1991, p. 73; Loyrette 1991, p. 226.

57 Rivière 1935, p. 81.

58 Reff 1985, BN 23, p. 46; BN 14A, p. 599v; BN 18, p. 194; BN 16, p. 6; BN 22, p. 3.

59 *Revue libérale*, 25 July 1867, pp. 499–523. On this topic, see 1988–89 Paris/Ottawa/New York, pp. 205–11; Reff 1985, Introduction, pp. 25–28; Armstrong 1991, p. 133; Loyrette 1991, p. 385; Anthea Callen in 1989 Liverpool. Fifteen editions of Lavater's *Physiognomische Frag-*

mente had been published in France by 1845. Cf. also Judith Wechsler, *Physiognomy and Caricature in 19th Century Paris*, London 1982. References to works on physiognomy in Brilliant 1991 (see note 13), p. 180.

60 For the two 'criminals', both in pure 'scientific' profile views, cf. Boggs/Maheux 1992, no. 30.

61 Cf. Reff 1985, Introduction, pp. 25–28; Armstrong 1991, pp. 133, 136. Duranty also wrote about caricature. Champfleury's standard work *Histoire de la caricature moderne* was published in 1865.

62 On this topic cf. Melissa McQuillan, *Porträtmalerei der französischen Impressionisten,* Rosenheim 1986; Kermit Swiler Champa, *Studies in Early Impressionism*, New Haven/London 1973; the exhibition catalogue *L'Art en France sous le Second Empire*, Paris 1979; ed. F. Frascina, *Modernity and Modernism, French Painting in the Nineteenth Century*, New Haven/London 1993; exhibition catalogue *Il ritratto nell'Ottocento*, Florence 1978.

63 See now also the contribution of Pierre Vaisse in this volume, p. 118f.

64 Armstrong 1991, pp. 16, 247. Degas "was so out of context, so determinedly without a proper generation, so stubbornly an outsider within his group, and so obstinately the odd man out" (p. 18).

65 Ingres: "cursed portraits! They always prevent me from going on to great things". Cf. Loyrette 1991, pp. 42, 58 etc.; Hélène Toussaint, *Les portraits d'Ingres, peintures des Musées Nationaux,* Paris 1985; masterly characterizations in Hans Naef, *Die Bildniszeichnungen von J.-A.-D. Ingres,* 5 vols., Berne 1977.

66 1988–89 Paris/Ottawa/New York, nos. 72, 73, 82; Loyrette 1991, p. 219.

67 Cf. George Mauner, *Manet, Peintre-Philosophe,* London 1975; Anne Coffin Hanson, *Manet and the Modern Tradition,* New Haven/London 1977; Eric Darragon, 'Degas sans Manet' in *Degas inédit* 1989, pp. 89ff.

68 Cf. Emil Maurer note 11; *idem,* 'Impressionismus vor dem Impressionismus', *Neue Zürcher Zeitung,* 4/5 June 1994; a more open definition of Impressionism recently in the *Impressionnisme* catalogue (see note 5); cf. also Armstrong 1991, p. 21.

69 Cf. Michael Wentworth, *James Tissot,* Oxford 1984; exhibition catalogue *James Tissot,* Paris 1985.

70 Theodore Reff gives a brilliant account of it: Reff 1976, pp. 15–37. Cf. also Roy McMullen, *Victorian Outsider, a Biography of J.A.M. Whistler,* London 1973; Stanley Weintraub, *Whistler, A Biography,* New York 1974; A. Young/M. Macdonald, *The Paintings of J.M. Whistler,* New Haven 1980.

71 Reff 1976, p. 26.

Between Convention and Innovation – the Portrait in France in the Nineteenth Century

PIERRE VAISSE

Writing about history means making a diversity of phenomena fit into a comprehensible order. In order to achieve this, the history of modern art uses two main theoretical models. One sees history as a development, a logical sequence of styles that fade in and out – Classicism, Romanticism, Realism, Impressionism ... every genre must then be slotted into this development, so there would be Classicist portraiture, then Romantic portraiture and so on. The other, linked with the concept of modernism, posits the idea of a break with the past, a revolution, an opposition between tradition and modernity or between the academic and the free, independent creation of art. At what point this break took place is, of course, generally decided by the individual art historian depending on the period or artist he is particularly interested in. Accordingly, anyone studying Degas will be inclined to emphasize his originality and ascribe certain innovations to him.

While models are certainly necessary in order to avoid being overwhelmed by the flood of factual details, we should nonetheless be aware of their limitations. On the one hand they themselves are conditioned by historical conditions, and on the other they take only selected factors into consideration. The history of styles tends to neglect the function of works of art and the typologies resulting from it. This neglect becomes particularly clear in the case of the portrait, as its form is usually determined primarily by a commission. To call a portrait Impressionist means no more than to suggest that a portrait produced by a certain painter uses the same typically Impressionist method of painting as do his landscapes or still lifes; in its conception of the individual human figure it need not differ from portraits that are categorized as being in different styles. To illustrate an extreme example of Impressionist portraiture, just think of the painter Claude Lantier in Zola's novel *L'Œuvre* who, when confronted with his dead mistress, is interested only in the play of light and colours on her face.

In 'Salon de 1846' Baudelaire tried to differentiate between two basic concepts of portraiture[1] – the portrait as a historical record and the portrait as novel, two categories which he saw as corresponding to those of *dessinateurs* and *coloristes*. These two concepts dominated French art criticism of the

*Les portraits, ces tableaux de la vie ordinaire, devraient évidemment, par leur caractère même, représenter le moderne. Il n'en est rien. Bien entendu, les modèles sont pris dans la vie, mais presque toujours l'artiste songe à imiter une école quelconque. Il veut peindre comme Rubens ou Vélasquez. Il a dans la tête un vieil idéal; il déploie tous ses efforts à mentir au lieu de représenter sincèrement l'individu qui pose devant lui. C'est ainsi que nous voyons des copies pitoyables, des poupées fabriquées d'après les recettes connues; un manque absolu de vie : nous ne reconnaissons ni l'homme moderne, ni la femme moderne, ni leurs mœurs ni leurs coutumes.

*Vrai d'une vérité typique [...] comme une personification de la haute bourgeoisie de notre temps, classe forte, intelligente et tenace, dédaigneuse de ce qui est au-dessous et au-dessus d'elle, et en qui l'orgueil du doctrinaire se mêle au positivisme du négociant et au sans-gêne que donnent les fortunes conquises par le travail.

period, more or less coinciding with the opposition between Romanticism and Classicism. Baudelaire's distinction obviously had to do with the continuance of an age-old opposition with regard to portraiture that had underlain academic teaching and aesthetic thinking for centuries – the opposition between mere reproduction and free invention. Baudelaire does not see the two as being equal. He sets greater store by the type of portraiture produced by *coloristes* – i.e. the portrait as a novel ("art is more difficult here because it is more ambitious"). This will hardly surprise anyone aware of Baudelaire's love of colour and admiration for Delacroix. However, if we read the names of the artists he uses to support his thesis, it immediately becomes evident that the formal categories of his typology do not apply to them. On the one hand we find Hippolyte Flandrin, Amaury-Duval and Henri Lehmann, i.e. pupils of Ingres, who, as such, accordingly ought to be described as *dessinateurs*. Ranged against them are Claude-Marie Dubufe, Franz Xaver Winterhalter and a few painters who have now sunk into oblivion, who can hardly be regarded as genuine *coloristes*. If we read Baudelaire's words carefully it also becomes clear that he is, in fact, concerned with a completely different distinction than that between line and colour. The difference he stresses is between portraitists who concentrate on reproducing the features of the face and those who attempt to express the personality of the sitter by their rendering of the atmosphere around him or her, or even more by attributes that characterize the subject.

It would also be misleading to locate the real key to understanding nineteenth-century portraiture in the oppositions between tradition and innovation, convention and life, academicism and modernism. A portrait is *ipso facto* modern if it depicts a contemporary individual. Thus, a lack of modernity can only be inherent in the concept, in the use of obsolete ways of representing the sitter. In 'Salon de 1875' Emile Zola wrote:

Portraits, those pictures of everyday life, ought obviously by their very character to represent what is modern. Not a bit of it. Of course the models are from life, but almost always the artist sets out to imitate some school or other. He wants to paint like Rubens or Velázquez. He has an old

ideal in his head; he concentrates all his efforts on lying, instead of giving an honest picture of the individual posing in front of him. That is why we see wretched copies, dolls manufactured according to well known recipes; a total lack of life – we cannot recognise modern man, modern woman, or their ways of thinking and living.*[2]

Zola's strictures are directed both against uninspired, formulaic works ("wretched copies, dolls manufactured according to well known recipes") and against the exploitation of Old Masters as sources of inspiration, i.e. against the historicism typical of the nineteenth century. As most sitters are portrayed wearing modern dress and in modern surroundings (unless they are against a neutral background) in spite of the contemporary liking for dressing up – think of the young Courbet – we may well ask what may make a modern person recognisable. Zola himself did not give his views on this essential point.

The concept of academicism is just as ambiguous as that of modernity. In fact there should hardly be discussion about academic portraiture because academic teaching regarded it as a subordinate category, and it was not included in the training of painters. The human face was studied, of course: at the Ecole des Beaux-Arts in Paris there was even a prize for a '*tête d'expression*'. However, such study was in no way concerned with the individual characteristics required in the portrait; on the contrary, it focussed on the typical, in the way that certain states of mind are expressed, and was perceived as part of the artist's training for history painting. The few pages devoted by Charles Blanc to the portrait in his *Grammaire des arts du dessin* are revealing in this respect.[3] Although he starts off by describing it as "one of the highest branches of the art", he is of the opinion that it merits this status only if mere imitation of nature is subordinated to style, i.e. if an individual becomes a type, as in the case of Ingres's portrait of Monsieur Bertin (illus. overleaf):

True with a typical truth [...] like a personification of the *haut bourgeois* of our day, a strong, intelligent, tenacious class, contemptuous of what is below and above it, in which the pride of the doctrinarian is combined with the positivism of the businessman and the cool confidence derived from fortunes acquired through work.*

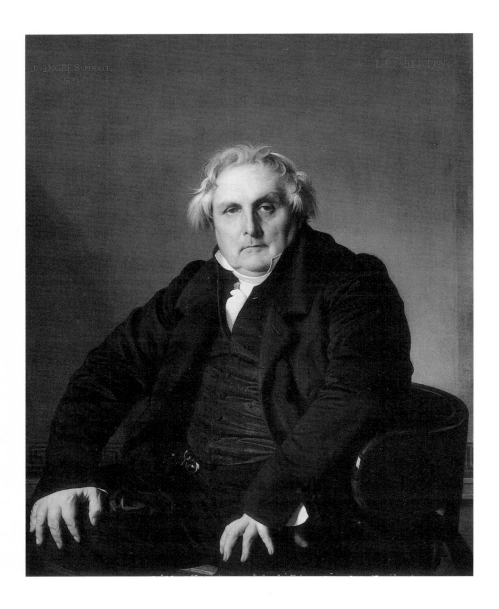

Jean-Auguste-Dominique Ingres
M. Bertin
1832
Oil on canvas
116 × 95 cm
Paris, Musée du Louvre

Abdication of Gustavus IV. Hersent had managed to depict the Swedish king in such a way that his features revealed both the human destiny of a ruler who could be compared with the "Homeric kings" and "patriarchs" and an episode in history.[5] The opposition between the individual and the typical, the depiction of specific people or facts and the highlighting of the general human or historical significance concealed behind a chance phenomenon were some of the most important distinctions in nineteenth-century art criticism: it was through these that the difference between genre and history painting could be described and legitimised. Thus, Charles Blanc's or Théophile Gautier's remarks on the portrait should be understood as attempts to raise the category from a subordinate position. In addition, their intention was to provide a theoretical basis for the unrestrained admiration elicited by portraits by artists such as Titian, Rembrandt or even Ingres – with the result that in the end the specificity of the portrait was denied.

Meanwhile, the portraitist's standing remained far from high. Even Ingres, one of the greatest portraitists of the century, regarded portraiture as work of an inferior nature, a means of earning a living so that he could devote himself to the high art of history painting. Although in the course of the nineteenth century there was no lack of painters who painted almost nothing but portraits, building their careers on portraiture – sometimes even achieving contemporary fame and relative wealth – they were regarded as specialists. Unlike landscape painting – we need only think of Courbet or the Barbizon painters – portraiture never emerged at the heart of aesthetic debates in art criticism and art history.

One possible reason for the portrait's lowly status was the deep contempt that both art critics and artists had felt, since the Romantic period, for the middle class, the bourgeoisie, which had a corresponding influence on the respect accorded by contemporaries to the portrait. It was a regularly recurring complaint in the nineteenth century that the Salon was inundated with unimportant, even ugly portraits: supposedly these owed their existence only to the vanity of the bourgeois who, though he regarded himself as worthy of being perpetuated in art, would otherwise never buy a paint-

There is no need to decide whether there really are as many sociological indicators in this great portrait, already widely admired in its time, as Charles Blanc suggests. Such a conception of the portrait was, in any case, very widely held. It also crops up in Théophile Gautier's 'Salon de 1859',[4] which rejects *a priori* the mere copying of external features. The painter should reveal the soul behind the mask of the face; he is set a higher goal, going beyond that which is merely individual, "to resume an entire period, an entire caste in a simple head standing out against an indeterminate background". Forty years earlier, in the 'Salon de 1819', Kératry had used similar words to praise the painter Hersent and his

*Les portraits figurent en grand nombre à l'exposition, cette année comme toujours; ils sont le seul côté par où l'art s'introduit aujourd'hui dans la vie bourgeoise. L'innocente vanité de voir son image reproduite et encadrée d'une bordure superbe, le désir de laisser à ses aimés une ressemblance qu'on suppose devoir leur être chère, et par-dessus tout, sans qu'on s'en rende bien compte, la préoccupation secrète d'arracher au temps qui détruit toutes les formes une empreinte de ce que l'on était, expliquent pourquoi le vulgaire, qui ne commande ni n'achète aucune peinture, dépense encore des sommes assez considérables pour se faire portraire.

*M. Sigalon a un autre parti à prendre; c'est de rester à Paris, et de s'enrichir en faisant le portrait. Il aura, dans dix ans, vingt mille livres de rente peut-être, et dans trente ans l'on parlera de lui comme nous parlons aujourd'hui de MM. Lagrenée, Carle Vanloo, Fragonard, Pierre, et autres héros des Salons de Diderot.

*Comme les grands tableaux se vendent difficilement, on est malgré soi entraîné à peindre des duchesses ou de simples bourgeoises, ce qui rapporte des sommes honnêtes. Un artiste qui se respecte ne fait pas de portraits à moins de dix mille francs.

*Dès que les procédés de Daguerre furent publiés, on vit de tous côtés s'élever aux étages supérieures des maisons, de fragiles construc-

ing or have any contact with art. This was Théophile Gautier's judgement in 'Salon de 1847':

There is a great number of portraits in the exhibition, this year like every other year; they are the only aspect of art that makes its presence felt in bourgeois life today. The harmless vanity of seeing our image reproduced and surrounded by a superb frame, the wish to leave to our loved ones a likeness which we assume they must hold dear, and above all, though we are not aware of it, the secret desire to snatch from all-destroying time an impression of what we were will explain why the uncultured man who neither commissions nor buys any painting is still willing to part with considerable sums of money to have his portrait painted.*[6]

Again and again feelings of disdain and antipathy affect the critics' judgements, resulting in some plainly ignorant comments about the vulgarity and ugliness of the faces portrayed, as if physical beauty were the privilege and symbol of a social élite. That these comments were rooted in deeply anchored prejudices can be inferred from the fact that they were often linked with the contradictory reproach that the sitters had been made more beautiful or idealised. Moreover, it is open to question whether those individuals portrayed even belonged to the bourgeoisie, and whether it is even possible to speak of a bourgeoisie in the sense of a single economically and culturally indivisible group. It is worth remembering how little the hostile image of the bourgeoisie conveyed by Romantic artists resembles the middle class described by the social historian.[7]

It is certain that the portrait enjoyed increasing popularity in the nineteenth century. The number of portraits in relation to the rest of the works exhibited in the Paris Salons can serve as proof of this: 8% in 1808, 11% in 1824, 28% in 1834, 32% in 1844.[8] However, information such as this can only be properly evaluated if further factors are taken into consideration. As early as 1704 the proportion of exhibited portraits was almost 50%. While it decreased considerably after 1737, and was subject to fluctuations that are hard to explain, it settled at an average proportion of about 30%: in 1799, of the 643 examples of painting and graphic art in the Salon, 260 were portraits, and in 1800 there were 216 out of a total of 650.[9] To interpret the dramatic

decrease in the 1804 Salon properly we have to bear in mind the artistic policy of the First Empire and the perception of the Salon as an official prestige exhibition – always assuming that the figures given by the various authors are correct! As the nineteenth century progressed the Salon developed more and more into a sales outlet for pictures. This led to an increase in the proportion of portraits, not because they were there to be sold, but because painters wanted to draw the attention of potential clients to their talents.

Throughout the century art critics lamented the fact that portrait painting had degenerated into a purely commercial activity, an industry. There was a sense that anyone who wanted to earn a great deal of money need only devote himself to portraiture. For example, Stendhal noted:

M. Sigalon has another choice: he can stay in Paris and get rich painting portraits. In ten years time he will perhaps have an income of twenty thousand *livres*, and in thirty years time he will be spoken of in the tones we use today in speaking of Messrs Lagrenée, Carle Van Loo, Fragonard, Pierre and other heroes from Diderot's Salons.*[10]

A similar comment can be read, over fifty years later, in Zola's 'Salon de 1876':

As great paintings are hard to sell people are drawn against their will into painting duchesses or mere bourgeoise women, which brings in tidy sums. No self-respecting artist will paint a portrait for less than ten thousand francs.*[11]

The inundation of the Salons with portraits, of which the same writer complains, is, however, at odds with his indignation about excessively high prices.[12] Prices were, in fact, extremely varied. Someone who could not afford even a small oil painting could commission a watercolour from a modest portrait painter. And anyone could go to a photographer. We know how rapidly portrait photography developed and how photographic studios sprang up in every town:

As soon as Daguerre's techniques were publicly known you saw fragile glass constructions being erected on all sides on the upper storeys of houses, looking rather like greenhouses, where the public went and posed with commendable patience beneath the burning rays of the sun.*[13]

James Tissot
*Mlle L.L. ('Jeune fille en
veste rouge')*
1864
Oil on canvas
124 × 100 cm
Paris, Musée d'Orsay

course of the nineteenth century inevitably led to a decline in artistic standards, even more striking in photography than in painting. Possibly the often noted fall in the standard of photography between 1870 and 1890 may be attributable to this demand. Right from the start, professional photographers – who were, quite often, trained painters – adopted the conventions of painting: even Nadar's portraits of famous writers and artists are no exceptions in this respect, with the seemingly natural attitude of those portrayed always reliant upon a well planned setting. Photographic portraits tended to repeat traditional formulae because the professional photographer in his studio had the same scenic accessories ready for every customer, enabling greater profitability. Columns and curtains were the favourite backdrops right into the twentieth century. They had originally been signs of elevated status in portraits of rulers, but in photographic portraits they lost their meaning, only serving to fulfil a vague need for social prestige. In painting they were less widespread, whether because awareness of their original significance and a feeling of propriety prevented them from being used on every occasion, or because their use in paintings required a high investment in materials and artistic skill.

Typology plays an important rôle in portraiture, which can therefore hardly be treated as a single genre. This applies particularly to the first half of the nineteenth century because the portrait later evolved in the same way as painting overall: the boundaries separating the various genres gradually disappeared. This was not only owing to the fact that the forms of private and official portraits became more closely related, but also that in many cases it became difficult to determine whether a painting was a portrait at all. While it would be hard to confuse with portraits the genre-like expressive heads such as *Les souvenirs, Les regrets, La terreur* and *La surprise* painted by Claude-Marie Dubufe in 1827, in the case of Manet or James Tissot it becomes almost impossible to assign certain pictures to a specific genre – the portrayal of the individual human being has become a painterly theme, no different from a still life or a landscape. Thus Tissot's picture known as *Lady with the sunshade* (ca.

The hunger for portraits that gripped all strata of society was most clearly recognisable here. Baudelaire, from his idealistic standpoint, inveighed against the phenomenon: "From that moment [the invention of daguerreotype] on, the dregs of society rushed like a composite Narcissus to contemplate its trivial image on metal."[14] With gentle irony painters, too, made the photographic vogue into a subject: Dagnan-Bouveret's 1878 picture of *The wedding at the photographer's* is well known, but as early as 1843, four years after the daguerreotype was invented, a painter by the name of Dolard depicted a touching, petty bourgeois family having their photograph taken.[15]

The demand for portraits of every kind in the

tions vitrées, ressemblant assez à des serres chaudes, dans laquelle le public venait poser avec une louable patience, sous les rayons brûlants du soleil.

1878) – a brilliant piece of *japonaiserie* – is basically a portrait of Kathleen Newton, the woman he loved, while the '*Portrait de Mlle L.L.*' (illus.) which he exhibited in the 1864 Salon is, in fact, no more than the picture of a professional model in an interior.[16] It must have been in connection with this development that towards the end of the century the French government began to buy portraits for its museums, especially the Musée du Luxembourg – then the national museum for modern art – regardless of the identity of the person portrayed.

No type of picture was more bound by conventions than the portrait of the king or emperor in his coronation regalia. There is a direct line leading from Rigaud's *Louis XIV*, Van Loo's *Louis XV* and Callet's *Louis XVI* to Gérard's *Napoleon I* and Ingres's *Charles X*. And official portraits, such as David's *Napoleon in his study*, Winterhalter's *Louis-Philippe* (painted in 1839) or Hippolyte Flandrin's *Napoleon III*, are almost as formulaic, even if there are considerable differences in the method of representation. The same conventionality applies to the grand portraits of important or successful people who display themselves with the attributes of the profession or rank to which they owe their position. In spite of stylistic differences, Delaroche's portrait of the marquis de Pastoret (1829) and Bonnat's portrait of Cardinal Lavigerie (1888) both belong to this type, as does the portrait of Madame Clicquot with Mademoiselle de Mortemart which Léon Cogniet painted ca. 1860: the famous Veuve Clicquot is seated on a throne-like armchair placed at the top of three steps in front of her Château de Boursault. The self-assurance of the rich bourgeoisie is displayed more spectacularly here than in any other nineteenth-century portrait. But the magnificence of the setting, which goes beyond the bounds of all credibility, also documents the power of invention and originality of an art that was supposedly governed by convention and tradition.

In Cogniet's œuvre, the portrait of Madame Clicquot is exceptional. Winterhalter's pictures, on the other hand, belong mainly to the category of official or grand portraits of rulers and aristocrats. In spite of the conventions of the genre many are often staggeringly original, such as the large portrait of the beautiful Princess Sayn-Wittgenstein-Sayn lying in

a park landscape like an odalisque. Besides the still recent vogue for depicting odalisques, two basically different portrait conventions from the Romantic movement are unwittingly combined in this complex painting. The formula of the figure in a landscape comes from England, and the pattern of the figure in front of a landscape background with a deep horizon was adopted from bust portraits of the Quattrocento. This historicist form continued developing until the second half of the nineteenth century; furthermore it was used by the Nazarenes, and by Ingres (in his portraits of the painter Granet or Count Gurjew for example), although it had lost its original significance.

Inscriptions in large Roman letters, such as became fashionable around the middle of the century, were no less orientated towards the archaic. Léon Bénouville, for example, used such lettering on the portrait of his friend the sculptor Eugène Guillaume, painted in Rome in 1845. In the painting Guillaume has that sombre, sad yet penetrating romantic gaze which is a feature of many young artists in their portraits or self-portraits at that time. The dedication and signature on the portrait of Sarah Bernhardt by Bastien-Lepage (1879) use the same lettering. But the stylisation here does not stop at the inscription: the famous actress is seen in profile, as in early Italian portraits inspired by antique medals.

Another formula rooted in earlier art was even more widespread in the nineteenth century: the frontal, symmetrical view. It was used predominantly by Ingres and his pupils, and flourished again in the Symbolist period. The first, and most striking, example must be Ingres's Napoleon, enthroned as a Byzantine emperor. His Charles X in his coronation regalia departs from the pattern in so far as he is shown in unbroken frontality. This formula with its hieratic imprint was used not only for portraits of rulers: it was adopted by Hippolyte Flandrin, for instance, for his severely symmetrical portrait of Madame Oudiné (1840) too. Its use was not confined to the school of Ingres, which it outlived: for example there is the portrait of the widow of the composer Bizet (who died young) painted by Elie Delaunay in 1878, as a Madonna dressed in black, enthroned on her historicist chair (illus. overleaf).

Elie Delaunay
Mme G. Bizet
1878
Oil on canvas
104 × 75 cm
Paris, Musée d'Orsay

Of course the pathetic formula was deliberately employed here. In a similar way Edouard Dubufe in 1850 had expressed the artistry of the actress Rachel, famous for her interpretation of classical tragedies, by severe frontality.

A tradition that was adopted from England towards the end of the eighteenth century seems like a contrast to these highly stylised forms. It shows a standing, walking or resting figure in the middle of more or less untamed nature. Gros's portrait of

Lucienne Boyer or Girodet's portrait of Chateaubriand are early examples. The portrait of Louis-Philippe, duc d'Orléans (the future King of France), painted by Horace Vernet in 1817 (illus. p. 126) is less well known, but no less important: it shows the duke set against a Swiss landscape. The distinction between type and style is particularly clear in the case of this work, as the painter is otherwise very little indebted to English painting. But in spite of the naturalness they aim at, portraits of this kind are no less bound by conventions that the formulae already described. Usually the landscape, whether it is the park of a country house or uncultivated nature, has a well defined meaning: Vernet's Swiss landscape was intended as a reminder of the Duke of Orléans's exile.[17]

Portraits of children and families were equally dependent on tradition and convention. They increased in number in the course of the nineteenth century; late eighteenth-century English portraiture was usually their standard yardstick, even if other sources of inspiration can be recognised from time to time. For instance in his *Family of the artist in 1820* (illus.), with its cluster of faces filling the entire surface of the picture, Claude-Marie Dubufe refers back to an otherwise rare compositional scheme dating from the early seventeenth century. For all their modernity, Renoir's portrait of Mme Carpentier and her children or '*L'Après-midi des enfants à Wargemont*' are still indebted to the English tradition. A tendency towards increased naturalness and intimacy only established itself slowly in the course of the century, as the early family portraits by Bonnat, for instance, demonstrate.

This tendency, not confined to family portraits, did not, however, exclude contrary trends. We have already mentioned the resurgence of portraits composed on a strict symmetrical basis, or the formal full-length portraits of bourgeoise ladies, in their finest clothes, which were widespread in the second half of the century. As these ladies are quite frequently standing in a garden – think of Renoir's '*Lise à l'ombrelle*' (1867) or Gervex's portrait of Valtesse de la Bigne (1879) – it might be thought that they reflected a scene of modern life. But this type of work seems rather to result from the *plein-air* fashion and the desire to find a solution to the prob-

Paul Baudry

Charles Garnier

1868

Oil on canvas

103 × 81 cm

Versailles, Musée National

du Château

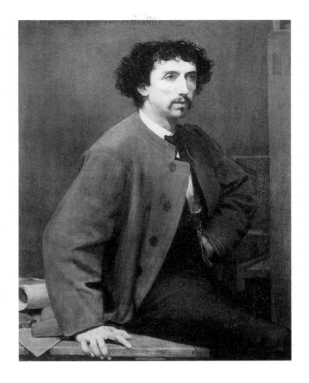

Claire-Marie Dubufe

The Dubufe family in 1820

1820

Oil on canvas

63 × 83 cm

Paris, Musée du Louvre

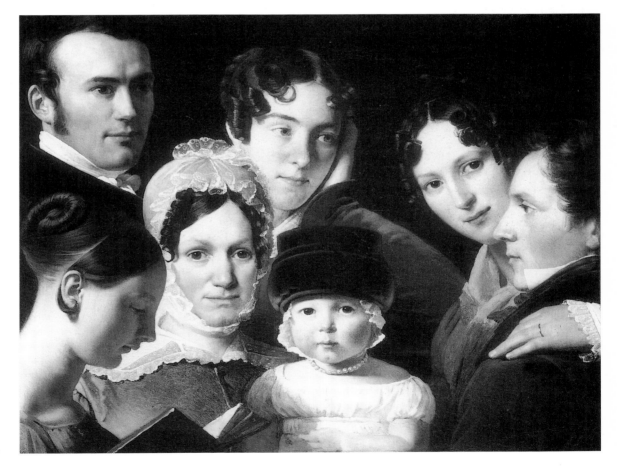

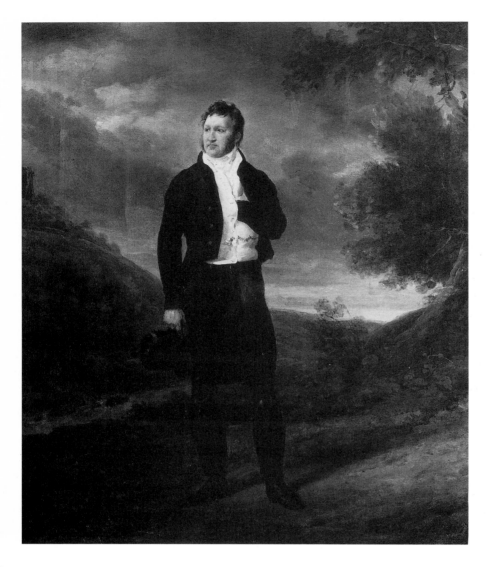

Horace Vernet
*Louis-Philippe, Duke of
Orléans, in a Swiss landscape*
Probably 1817
Oil on canvas
53 × 45 cm
Chantilly, Musée Condé

lem – widely debated at the time – of how to adapt a figure painted in the studio to outdoor light.

Nevertheless, such reservations apart, the trend towards the natural should not be neglected. But the trend lacks coherence, for naturalness and intimacy are not equivalent to one another. The desire for intimacy has nothing to do with the artist or his concept of art; rather, it reflects the wishes of the person commissioning the work and the portrait's function. Thus, people in high social positions, of whom official portraits also existed, had themselves painted in their everyday appearance. The portrait of Queen Victoria as a young woman, with her hair loose against a fine red cushion, is an extreme case in point (illus.): she commissioned the picture from Winterhalter in 1843 as a present for her husband.

The undisguised sensuality – and England at that time was not exactly noted for moral freedom – can be explained only in terms of the person for whom it was intended, i.e. in terms of the function of the picture.

On the other hand the question of intimacy does not arise in Ingres's portrait of Monsieur Bertin, as the work was intended to be imposing. In it, the artist refrained from using conventional attributes or accessories and tried to get his client to sit in as natural a pose as possible. How difficult it was to establish this natural pose is attested by the large number of preparatory drawings. This portrait is not an exception in nineteenth-century art. Twenty-six years later Paul Baudry painted his friend, the architect Charles Garnier (illus. p. 125), in a pose that seemed so spontaneous that it attracted great attention in the 1869 Salon.[18] There are pictures in which apparent spontaneity of pose and intimacy coincide, portraits that were intended for private use and had no need for grandeur, in which perfectly ordinary people appear in perfectly ordinary moments of their everyday lives. They depict moments of tranquillity, of tiredness even, as in Alexandre Cabanel's undated portrait of his brother Pierre in the Musée Fabre in Montpellier, or in Henri Lehmann's impressive self-portrait in the Kunsthalle at Hamburg. Lehmann depicts himself as an aging man, with an unshaven, wrinkled face, glasses on his nose and a cigarette in his mouth. Pierre Cabanel, too, is holding a cigarette, but between his fingers. The cigarette is featured in many nineteenth-century portraits, more often even than the pipe. While Cabanel's cigarette may be a symbol of Bohemianism, as in a famous self-portrait by Courbet (ca. 1849). Lehmann's indicates an endeavour to convey an impression of naturalness: in portraits of women this is often suggested by the graceful gesture where the head rests lightly on two fingers.

Of course such poses raise crucial questions: when is a human being's attitude natural? Does it not become second nature for many people to adopt a pose when in company? Consequently, should the artist not be guided by what is perceived as natural if he wants to convey the impression of naturalness, i.e. must he refer back to conventions? But what if,

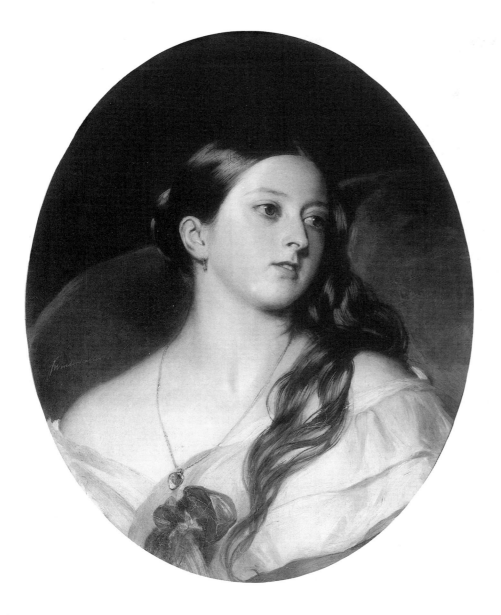

Franz Xaver Winterhalter

Queen Victoria

1843
Oil on canvas
65.4 × 53.3 cm
British Royal Collection

for some reason or other, this convention suggests the conventional? Will not any unexpected or unusual attitude then be perceived as automatically natural?

Degas was unquestionably a better artist than Cabanel or Elie Delaunay. But it is, perhaps, fallacious to suggest, as critics of the time often did, that *la vie moderne* is better expressed in his portraits than in theirs, i.e. that there is less artifice in his art. This view is a fallacy arising from a conception of art that still measures the value of a work of art by its verisimilitude.

NOTES

1. Charles Baudelaire, *Salon de 1846*, text established and introduced by David Kelley, Oxford 1975, p. 157.

2. Emile Zola, 'Salon de 1875', in Emile Zola, *Écrits sur l'art*, edited, introduced and annotated by Jean-Pierre Leduc-Adine, Paris 1991, pp. 302–03.

3. Charles Blanc, *Grammaire des arts du dessin*, Paris 1867, 3rd edition, 1876, pp. 610–14.

4. Théophile Gautier, *Salon de 1859* [...], edd. Wolfgang Drost/Ulrike Henniger, Heidelberg 1992, p. 127.

5. Kératry, *Annuaire de l'école française de peinture ou Lettres sur le Salon de 1819*, Paris 1820, pp. 142–43.

6. Théophile Gautier, *Salon de 1847*, Paris 1847, pp. 153–54. Similar quotations from other critics in Henri Loyrette, 'Portraits et figures', in the exhibition catalogue *Impressionnisme. Les origines 1859–69*, Paris, Grand Palais, 1994, pp. 183–86.

7. Cf. also Pierre Vaisse, Thomas Couture, ou le bourgeois malgré lui, *Romantisme* XVII–XVIII, 1977, pp. 103–22, and Maurice Agulhon, Réflexions sur l'image du bourgeois français à la veille de 1848: Monsieur Prudhomme, Monsieur Homais, Monsieur Bamatabois, *Quarante-huit/Quatorze* VI, 1994, pp. 4–13.

8. Emmanuel Bréon, 'Le portrait et le métier de portraitiste au XIXe siècle', in the exhibition catalogue *Claude-Marie, Edouard et Guillaume Dubufe. Portraits d'un siècle d'élégance parisienne*, Paris 1988, p. 36.

9. Georg Friedrich Koch, *Die Kunstausstellung. Ihre Geschichte von den Anfängen bis zum Ausgang des 18. Jahrhunderts*, Berlin 1967, pp. 160–61.

10. Stendahl, 'Salon de 1824', in Stendhal, *Mélanges d'art*, Paris 1932, p. 66. Stendhal regarded these and other "heroes of Diderot's Salons" as bad painters.

11. Emile Zola, cited note 2, p. 335.

12. Emile Zola, 'Mon Salon' [1868] (see note 2), p. 192: "The flood of portraits rises each year threatening to take over the whole Salon".

13. Ernest Lacan, *Esquisses photographiques*, Paris 1856, new edition Paris 1986, p. 125.

14. Charles Baudelaire, 'Salon de 1859', Baudelaire, *Œuvres*, Paris 1954, p. 770.

15. Dagnan-Bouveret, *La noce chez le photographe*, 1878, Lyons, Musée des Beaux-Arts; C. Dolard, *La séance de daguerréotype*, exhibited at the Lyons Salon in 1843, private collection.

16. *James Tissot 1836–1902*, Paris, Musée du Petit Palais, 1985, no. 14.

17. *Horace Vernet 1789–1863*, Rome, Académie de France à Rome, Paris, Ecole Nationale Supérieure des Beaux-Arts, 1980, no. 17.

18. *Baudry 1828–1886*, La Roche-sur-Yon, Musée d'Art et d'Archéologie, 1986, no. 36.

Portraiture between Tradition and Avantgarde: Proust and Degas

LUZIUS KELLER

Charles Haas (model for Swann), photograph by Edgar Degas

*Un jour [...] Swann voyant passer un omnibus pour le Luxembourg où il avait à faire, avait sauté dedans, et s'y était trouvé assis en face de Mme Cottard qui faisait sa tournée de visites 'de jours' en grande tenue, plumet au chapeau, robe de soie, manchon, en-tout-cas, porte-cartes, et gants blancs nettoyés. Revêtue de ces insignes, quand il faisait sec elle allait à pied d'une maison à l'autre, dans un même quartier, mais pour passer ensuite dans un quartier différent usait de l'omnibus avec correspondance.

*Je ne vous demande pas, Monsieur, si un homme dans le mouvement comme vous a vu, aux Mirlitons, le portrait de Machard qui fait courir tout Paris. Eh bien, qu'en dites-vous? Etes-vous dans le camp de ceux qui blâment? Dans tous les salons on ne parle que du portrait de Machard, on n'est pas chic, on n'est pas pur, on n'est pas dans le train, si on ne donne pas son opinion sur le portrait de Machard.

*Hé bien, moi je l'ai vu, les avis sont partagés, il y en a qui trouvent que c'est un peu léché, un peu crème fouettée, moi, je le trouve idéal. Evidemment elle ne ressemble pas aux femmes bleues et jaunes de notre ami Biche. Mais je dois vous l'avouer franchement, vous ne me trouverez pas très fin de siècle, mais je le dis comme je le pense, je ne comprends pas.

In order to make a connection between Degas's portrait painting and Proust's literary portraiture one has to follow a circuitous route: towards the end of 'Un amour de Swann' – the part of *Du côté de chez Swann* in which Proust describes Swann's love for the *demi-mondaine* Odette de Crécy – Swann meets Madame Cottard, whom he knows through the Verdurins' salon, in an omnibus:

One day [...] Swann saw a bus heading for the Luxembourg where he had something he wanted to do, jumped on and found himself sitting opposite Mme Cottard who was doing her round of visits of 'at home' days, grandly attired with a feather in her hat, a silk dress, a muff, an umbrella-sunshade, a visiting-card case and cleaned white gloves. Decked out in these insignia, when it was dry she went from one house to another in the same district on foot, but then used a connecting bus to travel between districts.*

As if she were in one of the twenty-five salons she was due to visit on her rounds, the *bourgeoise* Mme Cottard immediately launches into the topic of the day:

I hardly need ask if a man of the world such as yourself has seen the Machard portrait at the Mirlitons which is drawing anyone and everyone in Paris. So what do you think of it? Are you among those who condemn it? Machard's portrait is the only talking point in all the salons, you are not smart, you are not with it, you are not in the swim, unless you can give your opinion of Machard's portrait.*

Swann, who moves among different circles, in a different *tout Paris*, has to confess that he has not seen Machard's portrait, although this confession in no way stems the enthusiasm of the art-obsessed lady:

Well, I have seen it, opinions differ, some people find it a little finicking, lacking in substance, but I think it is perfect. Of course she is nothing like the blue and yellow ladies our friend Biche paints. But I have to be honest with you, you will say I am not up to the minute, but I speak as I find, and I don't understand them.*

In the subsequent comparison of modern and traditional portrait painting the doctor's wife seems to regret that Mme Verdurin had not commissioned Machard or Leloir to do the portrait of Cottard rather than Biche, the young painter who was then a protégé of the Verdurins and who could not refrain from giving Cottard – to the great annoyance of his

*Vos plus délicieuses amies sont là. Me le pardonneraient-elles si vous leur montriez l'éventail ? Je ne sais. La plus étrangement belle, qui dessinait devant nos yeux émerveillés comme un Whistler vivant, ne se serait reconnue et admirée que portraiturée par Bouguereau. Les femmes réalisent la beauté sans la comprendre.

*[overleaf] Le monocle du marquis de Forestelle était minuscule, n'avait aucune bordure et obligeant à une crispation incessante et douloureuse l'œil où il s'incrustait comme un cartilage superflu dont la présence est inexplicable et la matière recherchée, il donnait au visage du marquis une délicatesse mélancolique, et le faisait juger par les femmes comme capable de grands chagrins d'amour. Mais celui de M. de Saint-Candé, entouré d'un gigantesque anneau, comme Saturne, était le centre de gravité d'une figure qui s'ordonnait à tout moment par rapport à lui, dont le nez frémissant et rouge et la bouche lippue et sarcastique tâchaient par leurs grimaces d'être à la hauteur des feux roulants d'esprit dont étincelait le disque de verre, et se voyait préféré aux plus beaux regards du monde par des jeunes femmes snobs et dépravées qu'il faisait rêver de charmes artificiels et d'un raffinement de volupté ; et cependant, derrière le sien, M. de Palancy qui, avec sa grosse tête de carpe aux yeux ronds, se déplaçait lentement au milieu des

wife – a blue moustache.[1] Hence Mme Cottard's conclusion: "But I think that the main quality of a portrait, especially one costing ten thousand francs, is that it should be a likeness, and a pleasing likeness."[2] It is no coincidence that the meeting between Swann and Mme Cottard takes place on a bus. As Karlheinz Stierle has shown, the bus and its network of routes and transfers are symbols of modern city life.[3] They are the meeting places for different social strata, and the points of intersection for travellers in different directions. Mme Cottard is travelling 'in the Machard direction', i.e. towards a *bourgeois* salon; Swann, the connoisseur of art, is travelling 'in the Impressionist direction', i.e. to visit the Musée du Luxembourg.[4]

Proust had already written on the subject of the opposition between the academically traditional and the modern in portrait painting in the remarkable prose piece 'Eventail', published in the *Revue Blanche* in 1893. This involves the description of a fan – he obviously had Degas in mind; the author has depicted a society salon on it and hands it to his hostess. The most glamorous guests are not actually portrayed; instead they are characterized by their aesthetic views:

Your most delightful friends are there. I wonder if they would forgive me if you showed them the fan? I don't know. The most extravagantly beautiful woman among them, who appeared before our dazzled eyes like a Whistler come to life, would only have recognised and admired herself portrayed by Bouguereau. Women embody beauty without understanding it.*[5]

'Eventail' mirrors the *fin de siècle* culture of the society salon and its aestheticism as represented, for example, by Robert de Montesquiou. In this context Whistler can be used as an example of modern painting as opposed to the traditional portrait painting of someone like Bouguereau. In 'Un amour de Swann', however, Proust brings truly modern painting into play by citing Swann's knowledge and love of art and Biche's blue and yellow women.

Proust as a portraitist

Nonetheless it would be a mistake to conclude from the conversation between Swann and Mme Cottard that Proust, as a novelist, was on the side of Swann

the sensitive art connoisseur, and that he mocked Mme Cottard's Philistinism with its emphasis on being true to life. On the contrary, he did not refrain from depicting Machard's admirer in such a way that she would easily have recognised herself, even if she would have been far from delighted with some of the details, which verge on caricature ("the height of her plume, the number on her visiting-card case, the little ink-mark number inscribed on her gloves by the dry-cleaner"[6] or "her white-gloved hand releasing a vision of high society – and a transfer ticket – that filled the bus, mingled with a smell of dry-cleaning fluid").[7]

It can be assumed that there must have been quite a few real people who would have recognised themselves in the portrait of Mme Cottard. We do, in fact, know that several of Proust's friends and acquaintances thought they had stumbled across a portrait of themselves in *A la recherche du temps perdu*. Camille Barrère, a diplomat who was a frequent visitor at Proust's parents' house, was enraged when he thought he recognised similarities between himself and the pompous marquis de Norpois. The comtesse de Chevigné, who was at first rather flattered at being the model for the duchesse de Guermantes, changed her mind when Proust endowed his fictional character with the plumage and profile of a bird. In an early piece of prose written in 1892, 'Esquisse d'après Mme ✳✳✳', Proust had already given one of his characters the birdlike features of the countess. He republished this sketch along with another portrait in 1896 under the title 'Cires perdues' in his first published work, *Les plaisirs et les jours*.[8] It is unlikely that the two ladies portrayed understood the subtle play on words that Proust used in the title to establish the relationship between the text and the model. The specialist term 'cire perdue' refers to the lost wax process, a method of casting in which the original form or model is lost – in this case the comtesse de Chevigné! Finally Robert comte de Montesquiou was only too well aware that Proust's Charlus was modelled on him, but refrained from any outburst of anger. He had doubtless come to terms with being remembered by posterity not as a poet (and a pretty poor poet), but as a subject portrayed by his painter friends (La Gandara, Boldini, Whistler) and two major novel-

fêtes, en desserrant d'instant en instant ses mandibules comme pour chercher son orientation, avait l'air de transporter seulement avec lui un fragment accidentel, et peut-être purement symbolique, du vitrage de son aquarium, partie destinée à figurer le tout, qui rappela à Swann, grand admirateur des *Vices* et des *Vertus* de Giotto à Padoue, cet Injuste à côté duquel un rameau feuillu évoque les forêts où se cache son repaire.

*Odette de Crécy retourna voir Swann, puis rapprocha ses visites ; et sans doute chacune d'elles renouvelait pour lui la déception qu'il éprouvait à se retrouver devant ce visage dont il avait un peu oublié les particularités dans l'intervalle et qu'il ne s'était rappelé ni si expressif ni, malgré sa jeunesse, si fané ; il regrettait, pendant qu'elle causait avec lui, que la grande beauté qu'elle avait ne fût pas du genre de celles qu'il aurait spontanément préférées. Il faut d'ailleurs dire que le visage d'Odette paraissait plus maigre et plus proéminent parce que le front et le haut des joues, cette surface unie et plus plane était recouverte par la masse de cheveux qu'on portait alors prolongés en 'devants', soulevés en 'crêpés', répandus en mèches folles le long des oreilles ; et quant à son corps qui était admirablement fait, il était difficile d'en apercevoir la continuité (à cause des modes de l'époque et quoiqu'elle fût une des femmes de Paris qui

ists (Huysmans and Proust). It is only fair to mention that Montesquiou's essays of art criticism fully deserve to be republished and reassessed.

The hunt for the models behind individual characters in the novel is still a favourite pastime with some critics of Proust. Proust himself gave his view on the matter to Jacques de Lacretelle in a dedication dated 20 April 1918 in a copy of the original edition of *Du côté de chez Swann*: "Dear friend, there are no keys to the characters in this book; or maybe there are eight or ten keys for a single character."[9] Likewise he wrote to Gabriel Astruc in December 1913 that there was no single portrait in *Swann* "except for a few monocles".[10]

Given this express reference to the portrait genre, Proust's 'Monocles' deserve to be considered in connection with portrait painting. They form the conclusion, the final 'collection', of that extraordinary sequence in 'Un amour de Swann' in which Swann, on entering the Hôtel Saint-Euverte – at the start of the evening in the course of which Vinteuil's sonata reminds him painfully of his lost love – considers the people he meets "as a series of pictures"[11] which Proust has turned into a kind of literary gallery of sculptures and pictures. The servants who receive him represent images of male beauty to Swann (in the style of Dürer, Mantegna or Cellini), while Madame de Saint-Euverte's guests, with their monocles, embody male ugliness. Looking at Degas's portraits, we can contrast Proust's precision and extravagant imagery with the vague casualness with which Degas treats the count's face and monocle in *Ludovic Lepic and his daughters* (cat. 110, illus. p. 219).[12] Looking at Degas's work, the observer's eye is involuntarily drawn to the 'realistically' painted daughters, only to turn immediately back to the fascinating empty space in the centre of the picture; reading Proust, on the other hand, the reader's attention swings from the realistically drawn detail to its meaning. Proust's picture is explicitly – as opposed to that produced by Degas – a picture and an allegory, emphasized by the concluding mention of Giotto's *Vices* and *Virtues*. Proust's monocle collection includes five portraits. The following are three examples:

The Monocles

The marquis de Forestelle's monocle was tiny and had no rim; it forced the eye where it was incrusted like a superfluous cartilage made of a rare substance whose presence could not be explained to screw up constantly and painfully, endowing the marquis's face with a melancholy delicacy so that women thought he was capable of suffering greatly for love. But M. de Saint-Candé's, encircled in a large ring like Saturn, was the centre of gravity of a face which ordered itself always in relation to it, the trembling, red nose and the fleshy, sarcastic mouth endeavouring by their grimaces to measure up to the brilliantly witty fire emitted by the glass disk, and it was preferred to the most beautiful gazes in the world by snobbish, depraved young women, making them dream of artificial charms and exquisite voluptuousness; yet M. de Palancy behind his, with his large carp-like head and round eyes, moving slowly amidst the festivities unclenching his mandibles every second moment as if to find his way, appeared just to be carrying an accidental and perhaps purely symbolic fragment of glass from his aquarium around with him, a part intended to represent the whole, reminding Swann, a great admirer of Giotto's *Vices* and *Virtues* at Padua, of the Unrighteous Man at whose side a leafy branch evokes the forests where his lair is concealed.*[13]

In the already mentioned letter to Jacques de Lacretelle of 20 April 1918, Proust mentioned the real monocles that he had adopted as part of his portrait gallery. Thus, from Proust's literary creativity it is possible to see his society career, which has often been condemned as élitism, as a training in observation, and his career as a chronicler of high society as practice for literary portraiture. Starting with an early report on a literary party at the home of Robert de Montesquiou in 1894,[14] a party that brought Proust into contact with the great figures of the Faubourg Saint-Germain for the first time, and continuing right up to the *Le Figaro* articles on the great Paris salons of 1903 and 1904,[15] Proust built up a comprehensive stock of features ('*traits*'), sketches ('*crayons*') and portraits ('*portraits*') to which he referred in his own literary works proper, from *Les plaisirs et les jours* to *A la recherche du temps perdu*. In his early work there are mainly character portraits in the style of La Bruyère (portraits of individual types, for example of a snob), whereas in *A la recherche du temps perdu* there are realistic portraits modelled on Balzac's approach: characterization through descriptions of physiognomy, dress, social

s'habillaient le mieux), tant le corsage, s'avançant en saillie comme sur un ventre imaginaire et finissant brusquement en pointe pendant que par en dessous commençait à s'enfler le ballon des doubles jupes, donnait à la femme l'air d'être composée de pièces différentes mal emmanchées les unes dans les autres ; tant les ruches, les volants, le gilet suivaient en toute indépendance, selon la fantaisie de leur dessin ou la consistance de leur étoffe, la ligne qui les conduisait aux nœuds, aux bouillons de dentelle, aux effilés de jais perpendiculaires, ou qui les dirigeait le long du busc, mais ne s'attachaient nullement à l'être vivant, qui selon que l'architecture de ces fanfreluches se rapprochait ou s'écartait trop de la sienne, s'y trouvait engoncé ou perdu.

*Le docteur Cottard ne savait jamais d'une façon certaine de quel ton il devait répondre à quelqu'un, si son interlocuteur voulait rire ou était sérieux. Et à tout hasard il ajoutait à toutes ses expressions de physionomie l'offre d'un sourire conditionnel et provisoire dont la finesse expectante le disculperait du reproche de naïveté, si le propos qu'on lui avait tenu se trouvait avoir été facétieux. Mais comme pour faire face à l'hypothèse opposée il n'osait pas laisser ce sourire s'affirmer nettement sur son visage, on y voyait flotter perpétuellement une incertitude où se lisait la

behaviour and, particularly, speech. After the portrait of Mme Cottard in her visiting attire, uttering her modish speech – intriguingly at its most fashionable when it comes to describing what is 'fashionable' and 'up to the minute' – and after the gallery of monocles, we can demonstrate that Proust's art is that of a portraitist with two more examples taken from 'Un amour de Swann', the part of *Du côté de chez Swann* in which Proust concerns himself particularly intensely with Balzacian forms of expression:

Odette De Crécy

Odette de Crécy went back to see Swann, then visited him at more frequent intervals; and no doubt each visit renewed the disappointment he felt when confronted with that face whose peculiarities he had slightly forgotten in the meantime and which he had not remembered as being so expressive or, in spite of its youth, so faded; while she chatted with him, he felt sorry that her great beauty was not of the type he would spontaneously have preferred. Moreover, it must be said that Odette's face looked thinner and bonier because her forehead and the upper part of her cheeks, the smooth, flatter surfaces, were covered by the mass of hair which was then raised by back-combing and worn in extended front 'bangs' with stray locks spread along the ears; and as for her body which was superbly formed it was difficult to see its line (owing to the fashions of the day and despite the fact that she was one of the best-dressed women in Paris), because the bodice, jutting out as if over an imaginary stomach and finishing abruptly in a point while the curves of the double skirts started to balloon out below, made women look so much as if they were constructed of different pieces that fitted together badly; and so much did the ruffs, flounces and waistcoat, quite independently of one another and depending on the whim of their design or the texture of the material of which they were made, follow the line leading to knots, puffs of lace or perpendicular

Charles Haas (model for Swann), photograph by Paul Nadar

Mme Emile Straus (model for Odette, later Duchess of Guermantes), photograph by Paul Nadar

question qu'il n'osait pas poser : Dites-vous cela pour de bon ? Il n'était pas plus assuré de la façon dont il devait se comporter dans la rue, et même en général dans la vie, que dans un salon, et on le voyait opposer aux passants, aux voitures, aux événements un malicieux sourire qui ôtait d'avance à son attitude toute impropriété, puisqu'il prouvait, si elle n'était pas de mise, qu'il le savait bien et que s'il avait adopté celle-là, c'était par plaisanterie.

*Le génie artistique agit à la façon de ces températures extrêmement élevées qui ont le pouvoir de dissocier les combinaisons d'atomes et de grouper ceux-ci suivant un ordre absolument contraire, répondant à un autre type. Toute cette harmonie factice que la femme a imposé à ses traits et dont chaque jour avant de sortir elle surveille la persistance dans sa glace, chargeant l'inclinaison du chapeau, le lissage des cheveux, l'enjouement du regard, d'en assurer la continuité, cette harmonie, le coup d'œil du grand peintre la détruit en une seconde, et à sa place il fait un regroupement des traits de la femme, de manière à donner satisfaction à un certain idéal féminin et pictural qu'il porte en lui. [. . .] Ainsi une cousine de la princesse de Luxembourg, beauté des plus altières, s'étant éprise autrefois d'un art qui était nouveau à cette époque, avait demandé au plus grand des peintres naturalistes de faire son portrait. Aussitôt l'œil de

slivers of jet or directing them along the whalebone, but remaining completely unattached to the living being inside, who, depending on how the architecture of these frills and furbelows approximated to or departed from her own, was either bundled up or lost in it.*[16]

Cottard

Doctor Cottard was never quite sure of the tone he should adopt when answering someone, whether the person speaking to him meant to laugh or was serious. And as a precaution he added to all his facial expressions the offer of a conditional, provisional smile whose expectant subtlety would exonerate him from being dismissed as naïve if the remark addressed to him turned out to have been meant to be facetious. But to guard against the opposite eventuality he did not dare let the smile become clearly established on his face, on which one could see perpetually floating an uncertainty where the question he dared not ask could be read: 'Do you really mean that?' He was no more sure of how to behave on the street, and even in life in general, than in a salon, and he could be seen confronting passers-by, vehicles and events with a sly smile which forestalled the possibility of any impropriety in his attitude since it proved, if his attitude was inappropriate, that he was well aware of this and if he had adopted it, it was by way of a joke.*[17]

The portraits of Odette and Cottard are elements of the exposition. They reflect the need to introduce two new characters into the action; but they are also, as can be inferred from the subtle composition of both passages, examples of literary portraiture. Proust here produces two classic forms (external and internal views). Remarkably enough Odette and Cottard are further associated with the problem of portraiture through Proust's having both fictional figures sit as models for the painter Biche. We learn, a little further on, that Biche is to paint a portrait of Cottard when Mme Verdurin, proud of her *bon mot*, calls out to the painter: "You know what I want most of all, his smile; what I asked you for was the portrait of his smile."[18]

The real point of this *bon mot* is that Proust in his portrait of Cottard, with which the reader is now familiar, has already fulfilled Madame Verdurin's commission: his portrait of Cottard is in fact the portrait of Cottard's smile. We do not learn that Biche had previously painted a portrait of Odette until the following volume of *A la recherche du temps perdu*, *A l'ombre des jeunes filles en fleurs*. On his visit to

Elstir's studio, the thematic focal point of the second part of that volume, Marcel discovers a watercolour depicting an actress in man's clothing, with the inscription 'Miss Sacripant, octobre 1872'. Shortly afterwards it dawns on him that the model must have been Odette before her marriage to Monsieur de Crécy. Proust uses this early work by Elstir (from the time before he emerges in the Verdurins' salon as Monsieur Biche) as a pretext for some fundamental reflections on portrait painting. His basic thesis is that a painter always depicts himself rather than the model posing in front of him:

Artistic genius works in the same way as extremely high temperatures which are capable of breaking up combinations of atoms and regrouping them according to a completely contrary order, responding to a different type. All the artificial harmony a woman has imposed on her features, daily supervising its continuation in her mirror, giving the angle of her hat, the smoothing of her hair and the brightness of her eyes the job of ensuring its constancy, the glance of a great painter can destroy it in a second, and in its place he regroups the woman's features in such a way as to satisfy a certain feminine and pictorial ideal that he carries within him. [. . .] Thus a female cousin of the princesse de Luxembourg, a very haughty beauty indeed, having become infatuated some years ago with an art that was then new, asked the greatest of the naturalistic painters to paint her portrait. Immediately the artist's eye found what it was looking for everywhere. And on the canvas instead of the great lady there was a dressmaker's errand girl and behind her a huge purple, sloping background which suggested the Place Pigalle.*[19]

The central idea of Proust's aesthetics is that a true artist always remains faithful to himself, i.e. to his essence, his artistic 'instinct', and can therefore be recognised by his style and his subject-matter. This lies behind both his commentary on Ruskin and his polemic against Sainte-Beuve. In *A la recherche du temps perdu* this is illustrated not only by the works of Bergotte, Elstir and Vinteuil but also by many references to real artists. While the example cited above of course refers to Bonnard, Proust's thesis could equally well be exemplified by Degas's portraiture; Degas's portraits can often be recognised as his, not just by their stylistic and thematic features, but often by the nature of the facial features too. Degas seems to have developed an ideal model whose features he subsequently transfers on to

l'artiste avait trouvé ce qu'il cherchait partout. Et sur la toile il y avait à la place de la grande dame un trottin et derrière lui un vaste décor incliné et violet qui faisait penser à la place Pigalle.

*comme ces peintres qui, cherchant la grandeur de l'antique dans la vie moderne, donnent à une femme qui se coupe un ongle de pied la noblesse du «Tireur d'épine» ou qui, comme Rubens, font des déesses avec des femmes de leur connaissance pour composer une scène mythologique [. . .].

*Je veux dire que ce qui est vraiment antique, ce qui est l'équivalent dans l'art moderne du jeune héros arrachant l'épine, ce n'est pas tel tableau académique qui singe l'antique mais une femme moderne de Degas qui s'arrache un ongle ou une peau du pied.

*Je voudrais, si je ne souffrais tant, vous remercier longuement de votre admirable et pathétique Degas, que j'ai lu et relu, quoique n'y voyant plus clair. Je ne l'ai vu que deux ou trois fois dans ma vie [. . .] La dernière fois que je l'ai vu (et une des dernières fois où je suis sorti) j'avais demandé à Mme Straus de me faire entrer chez Bernheim qui était fermé, pour voir un Claude Monet. Il n'y avait dans la boutique que Degas, brouillé par l'affaire Dreyfus avec Mme Straus. Malgré cela il s'approcha, vint lui parler un instant, avec une allusion aux événements

other faces when painting portraits of himself and his family.

Proust and Degas

Marcel's visit to Elstir's studio is at the centre of the sequence of action in *A l'ombre des jeunes filles en fleurs*, which starts with the emergence of the girls on Balbec beach and finishes with the departure from Balbec at the end of the novel. Proust made this part of *A la recherche du temps perdu* a kind of encyclopaedia of painting and painterly writing. In the various phases of his œuvre Elstir represents modern painting, with the horse-racing scenes clearly referring to Degas. As we have already seen from the example of Cottard's portrait, the author vies with the figure he has created, basing many scenes in this part of the novel on painterly models (beach scenes, seascapes, still lifes, etc.). It is particularly relevant to look at the last of these scenes in connection with Degas. It takes place during an excursion to the cliffs and depicts Marcel ("*allongé*") in a circle of girls, those beautiful dark and light bodies about him ("spread around me in the grass"), "as if, like Hercules or Telemachus, I had been playing amidst nymphs".[20] The latent reference to painting (Manet's *Déjeuner sur l'herbe* and mythological scenes by Poussin, for example) is made explicit in a parenthesis. Marcel watches the girls

like those painters who, looking for the grandeur of the antique in modern life, endow a woman cutting her toenail with the nobility of the 'Youth pulling out the thorn' or who, like Rubens, turn women they know into goddesses to compose a mythological scene [. . .].[21]

While Rubens is explicitly named, it is at first an open question who is meant by 'those painters who [are] looking for the grandeur of the antique in modern life'. Proust has adopted the theme from Baudelaire's essay on Constantin Guys, 'Le peintre de la vie moderne'. However, on closer inspection the specific example refers to Degas, as a passage in a letter 'proves'. In December 1913 Proust wrote to Gabriel Astruc:

I mean that what is truly antique, what is the equivalent in modern art of the young hero pulling out the thorn, is not some academic picture aping antiquity but a modern

woman painted by Degas pulling a nail or a piece of skin off her foot.*[22]

There were no direct links between Proust and Degas. Although they had a few acquaintances in common (the Halévy, Straus and Blanche families) and despite Proust's high opinion of Degas, Proust's decided stance in favour of Dreyfus and Degas's against him stood in the way of any rapprochement between the two artists. Proust described a meeting with Degas in a letter written on 1 or 2 July 1921 to Georges de Traz, who had just published a book on Degas (Albert Messein, 1921), writing under the pseudonym François Fosca:

If I was not so ill I would like to thank you at length for your admirable, yet pathetic Degas which I have read and reread although I can no longer see clearly. I saw him only once or twice in my life [. . .] The last time I saw him (one of the last times I went out) I had asked Mme Straus to take me into Bernheim's which was shut to see a Claude Monet. The only person in the gallery was Degas who was on bad terms with Mme Straus because of the Dreyfus affair. Even so he came up and spoke to her for a minute, referring to the events now beyond redress that had come between them (though strangely enough not between him and the Bernheims).*[23]

In Proust's work it is always Degas who is being alluded to when the decisive question of modernity, i.e. the relationship between tradition and innovation, is under discussion. Thus in 1904 Proust suggested – in an answer (not published at the time) to an inquiry about the State and artistic activity – that official art, which was rigidly set in academic forms, should be renewed by giving Monet, Fantin-Latour, Degas or Rodin teaching contracts at the Ecole des Beaux-Arts.[24] Elsewhere he recalls Degas's esteem for Ingres[25] and Poussin.[26] He continually reverts to the idea proposed by Baudelaire in 'Le peintre et la vie moderne' that true art is simultaneously modern and classical. Writing at the end of 1920 in response to an inquiry about 'Classicism and Romanticism' Proust said with reference to Manet's *Olympia* and Baudelaire's poems, which had been banned by the public prosecutor's office:

These great innovators are the only true classical artists and form an almost continuous sequence. At their finest moments those who imitate the classics can only give us pleasure based on erudition and taste which has no great

irrémédiables qui les avaient séparés (et qui chose curieuse ne le séparaient pas des Bernheim).

*Ces grands novateurs sont les seuls vrais classiques et forment une suite presque continue. Les imitateurs des classiques, dans leurs plus beaux moments, ne nous procurent qu'un plaisir d'érudition et de goût qui n'a pas grande valeur. Que les novateurs dignes de devenir un jour classiques, obéissent à une sévère discipline intérieure, et soient des constructeurs avant tout, on ne peut en douter. Mais justement parce que leur architecture est nouvelle, il arrive qu'on reste longtemps sans la discerner. Ces classiques non encore reconnus, et les anciens pratiquent tellement le même art, que les premiers sont encore ceux qui ont fait la meilleure critique des seconds.

The quotations from Proust's work are taken and translated from the following editions:

Correspondance, Paris 1970–94 = Corr; *Contre Sainte-Beuve* preceded by *Pastiches et mélanges* and followed by *Essais et articles*, Paris 1971 = CSB; *Jean Santeuil* preceded by *Les plaisirs et les jours*, Paris 1971 = JS; *A la recherche du temps perdu*, Paris 1987–89 = Rech

value. There can be no doubt that innovators worthy of some day being regarded as classical artists obey a strict inner discipline and are first and foremost builders. But for the very reason that their architecture is new it may be a long time before it is perceived. These still unrecognised classical artists and the old classical artists practise the same art to such an extent that the former are still the people who have provided the best criticism of the latter.*[27]

Proust knew what he was talking about: after the publication of *Du côté de chez Swann* nothing had annoyed him more than the reproach that his novel was nothing but a shapeless string of associations of ideas. He frequently responded to this criticism by pointing out that every detail would acquire its significance in the context of the whole. And when he relates Manet's *Olympia*, Baudelaire's poems with a lesbian theme or (elsewhere) Degas's intimate scenes to classical models, Proust is primarily speaking about himself. The lesbian scene in *Du côté de chez Swann* had already attracted violent criticism in 1913 and it was to be expected that *Sodome et Gomorrhe, II*, the volume of *A la recherche du temps perdu* shortly to be published, would give offence in the moralistic climate of the 1920s. Proust took every opportunity to stress the fact that at all periods it had been precisely whatever was held to be morally reprehensible and forbidden that had been the theme of great works of art. And just as Baudelaire in his censored poems surpassed even Racine in classical beauty, so must Proust's descent into the world of Sodom – with the meeting between Charlus and Jupien and the detailed portrait of Charlus that completed the "first sketches of M. de Charlus"[28] – be measured against the model of Balzac, which Proust felt sure he would surpass. He himself is that innovator whom his contemporaries refused to recognise as the classical artist that he represents for us all today.

NOTES

1. Unlike Machard or Leloir, Biche, who later becomes Elstir, is a character invented by Proust.

2. Rech, vol. I, pp. 368–69.

3. Cf. Karlheinz Stierle, *Der Mythos von Paris*, Munich 1993.

4. Modern painting (Impressionist paintings from the Caillebotte bequest) had been on view in the Musée de

Luxembourg since 1897. Proust did not care about making his novel correspond with precise chronological accuracy: 'Un amour de Swann' takes place between 1879 and 1881.

5. JS, p. 52.

6. Rech, vol. I, p. 369.

7. Rech, vol. I, p. 370.

8. JS, p. 41.

9. CSB, p. 564.

10. Corr, vol. XII, p. 387.

11. "une suite de tableaux", Rech, vol. I, p. 317. Proust had been familiar with the structuring principle of the sequence of pictures from the time he first started writing. There is a kind of portrait gallery, 'Portraits de peintres et de musiciens', at the centre of *Les plaisirs et les jours*, eight poems that try to capture the specific style and mood of the painters and composers 'portrayed'. In *Jean Santeuil*, an unfinished fragment of a novel written between 1896 and 1902, there is a chapter about an art collector from Rouen in which Proust, using five precisely described Monets, a Sisley and a Corot landscape as examples, tries to establish where the true essence of an artist lies and what enables a Monet for example to be recognised as such (JS, p. 890). But Proust's finest picture gallery is in *A l'ombre des jeunes filles en fleurs* where the description of the view over the sea at Balbec from Marcel's hotel room as it changes in the course of the season forms a series, a collection of literary seascapes.

12. L272, Stiftung Sammlung E.G. Bührle, Zurich.

13. Rech, vol. I, pp. 321–22.

14. Cf. CSB, p. 360 (and *Essais*, p. 72).

15. Cf. CSB, p. 436 ff. (and *Essais*, p. 181 ff.).

16. Rech, vol. I, p. 194.

17. Rech, vol. I, p. 197.

18. Rech. vol. I, p. 200.

19. Rech, vol. II, pp. 216–17.

20. Rech, vol. II, p. 302.

21. Ibid.

22. Corr, vol. XII, p. 390.

23. Corr, vol. XX, p. 302.

24. CSB, p. 497.

25. CSB, p. 555.

26. Rech, vol. III, p. 208.

27. CSB, pp. 617–18.

28. In the List of Contents in the original edition of *A l'ombre des jeunes filles en fleurs* the sequence of the action revolving round Charlus and Robert de Saint-Loup was described as 'Premiers crayons de M. de Charlus et de Robert de Saint-Loup'.

Degas's Printed Portraits

BARBARA STERN
SHAPIRO

"Work calmly now and stick to this path, I tell you, and rest assured that you will succeed in doing great things."[1] These prophetic words by Degas's father were meant to encourage his eldest son, who had turned away from the banking profession to pursue a career as an artist. Auguste De Gas, whose true passion was painting and music, followed the development of his son's career and urged him to consider portraiture as a potential "beautiful jewel in your crown". By the time Degas was in his early twenties he had completed at least eighteen portraits of himself not the least of which was a remarkable etched self-portrait of 1857 that depicts a solemn and focused young man (cat. 28–32, illus. pp. 168–69).

For some forty years, from the late 1850s until the 1890s, Degas made etchings and lithographs. Given this great time span, his production of sixty-six prints was relatively small; yet his output is considered serious and significant. Three small landscape etchings in a classicising style document his initial efforts in the medium a series of large lithographs that relate to his late drawings and pastel studies of bathers close his printmaking years. The early, lightly bitten landscape etchings and a delicate etched portrait of the artist's grandfather, *Hilaire Degas* (cat. 18, illus. p. 186), must have been conceived and executed in Paris under the tutelage of Prince Gregoire Soutzo, an engraver and family friend. They are experimental in both design and process and reflect the tentative attempts of an artist grappling with an unfamiliar medium. Degas, however, soon gained a sureness of drawing style and a knowledge of intaglio procedures; of those prints executed before the late 1860s, the most successful were his portrait etchings.

None of Degas's painted self-portraits was sold or exhibited during his lifetime, whereas the etched self-portrait was distributed to friends: Prince Soutzo, Alexis Rouart, the sculptor Bartholomé, the collector Alfred Beurdeley and Philippe Burty were among the few who owned impressions of this handsome image. Burty the enthusiastic art critic, collector and etcher, amassed a major collection of prints by his friends. In the sale held in 1891 after his death, there was a listing under lot 152: "Degas. Académie. Portraits et croquis. Cinq pièces gravées

à l'eau-forte." (Degas. Academic studies. Portraits and sketches. Five etchings). Five early portraits have a Burty provenance: *Hilaire Degas* (cat. 18, illus. p. 186); *The engraver Joseph Tourny* (cat. 33–34, illus. p. 137); *Nathalie Wolkonska* (cat. 57, illus. p. 157); *René De Gas* (cat. 59, illus. p. 175); and the self-portrait (cat. 28–32, illus. pp. 168–69). The reference to "academic studies" remains unexplained; possibly we may one day discover more etchings to add to Degas's early, experimental œuvre.[2]

In 1853, then aged eighteen, Degas applied and received permission to copy at the Louvre and at the Cabinet des Estampes of the Bibliothèque Impériale (now Bibliothèque Nationale). Frequent exhibitions of prints from the fifteenth to the eighteenth centuries in the Galeries de la Bibliothèque Impériale would have also made familiar the art of the past – a large number of Rembrandt etchings, for example, were regularly included. This exposure initiated for Degas a profound respect and admiration for the Old Masters that were eventually expressed in a number of history paintings, drawings and two small prints. *Young man seated, in a velvet cap*, after Rembrandt (cat. 35, illus. p. 157), is a close copy of Rembrandt's etching dated 1637. It is clear that this direct representation influenced Degas's printed portraits made later in Rome. *The Infanta Margarita*, after Velázquez (cat. 61, illus. p. 157), was executed about 1862–64; here Degas reproduced in reverse a Velázquez painting now attributed to the Spanish master's workshop.

In 1855 Degas made his first forays beyond Paris, although from late September until mid-July 1856 he remained in the city, where he continued to make copies at the Louvre. In the summer of 1856 he arranged his own extended study tour of Italy, and, by way of Marseilles, reached Naples. Degas stayed with the Italian members of his family, studied antique art, and made numerous copies in the national museums. In the autumn of 1856 he travelled to Rome and remained there until the following summer, again studying in churches and Vatican museums, the Villa Borghese, the Villa Medici and Tivoli. He moved between Naples and Rome until July 1858 when he set off to wander slowly through central Italy, arriving back in Paris in April 1859. This three-year artistic and intellectual odyssey clearly established the foundation for Degas's disciplined career.

The young artist probably met the painter Gustave Moreau early in 1858 after Moreau had arrived in Rome in late October 1857. The intelligent, cultured Moreau became an artistic mentor to the young Degas. Moreau admired the Italian masters, particularly the Venetians, but he also greatly appreciated the style, content and colour of some of his contemporaries, such as Corot, Chassériau and Delacroix. It was Moreau who modified Degas's intense commitment to the classic achievements of Ingres and enabled the younger painter to strive for greater artistic freedom. Moreau was curious about different techniques and kept Degas informed on his investigations into colours, pigments and textures of old paintings.

There is considerable evidence of contact between the two artists: similar academic studies of the same model, mutual portrait drawings, numerous letters both from and about Degas, an oil painting by Degas of Moreau (illus. p. 142), and, significantly, a previously unknown impression of the etched portrait of *The engraver Joseph Gabriel Tourny* (see cat. 33–34, illus. p. 137).[3] Degas knew Tourny when they were both in Paris, and it was probably when they met again in Rome in 1857 that he made this serious picture of his friend in the manner of Rembrandt. The impression of Tourny owned by Moreau is an unrecorded first state. Although the print and its variations have been previously examined and described,[4] this impression reveals new changes in the development of the print. The Tourny portrait was formerly catalogued as "Etching. One state". This unique sheet, however, was printed before fine cross-hatching lines were etched on Tourny's second collar (between the shirt- and coat-collars), before the distracting area of tone and the short vertical lines near the right edge of the sitter's chin were removed, and before the addition of a few extra lines on the cravat. This impression is fully inked and printed, including the middle zone of the three-quarter-length portrait. The inky platemark is impressed into a sheet of soft, white wove paper, a kind not used in the other known impressions. There are no signs of corrosion nor of the fine scratches that appear on the plate

Edgar Degas
The engraver Joseph Tourny
1857
Etching
1st state
Paris, Musée Gustave
Moreau (see also
cat. 33–34)

**Jean-Auguste-Dominique
Ingres**
*Mgr Gabriel Cortois de
Pressigny*
1816
Etching
Boston, Museum of Fine
Arts

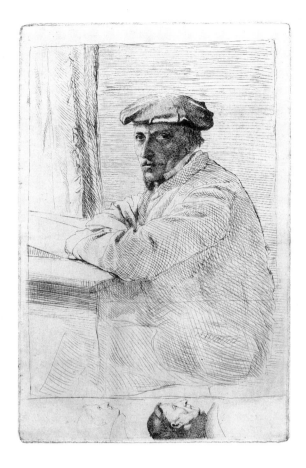

when it was printed in the mid-1860s after Degas's return from Italy.

It is generally accepted that Degas made this Tourny portrait in 1857, but this impression of the first state could not have come into Moreau's possession until at least 1858 when the two artists met. Indeed, Tourny may still have been in Paris in 1857 because he submitted two portrait engravings to the Salon of that year. It is known that he was in Rome in 1858 for a commission to copy the Sistine Chapel frescos and his correspondence with Degas in Italy takes place primarily in 1858–59. All this suggests a slightly later date than 1857 for the etching, perhaps early 1858. On the other hand, there is a small oil portrait of Tourny dated "Rome 1857", a study for the painting of *Dante and Virgil* that Degas finished in the autumn of 1858.

After his return to Paris Degas continued to maintain close ties with Moreau into the early 1860s, but as Moreau's paintings accumulated more picturesque figures and symbolic details and Degas turned, instead, to depicting scenes from contem-

porary life, the two artists, as well as Tourny and other friends from Degas's Italian sojourn, drifted apart. Nevertheless, it was these attentive friends who encouraged Degas to turn to portraiture in all media.

The etchings of *The engraver Joseph Tourny* and the self-portrait of 1857 (cat. 28–32, illus. pp. 168–69) show an indebtedness to Ingres's etched portrait of *Mgr Gabriel Cortois de Pressigny* (illus.), an impression of which was owned by Degas.[5] The slightly turned three-quarter-length pose and the elegant linear structure are shared characteristics. Of greater impact on Degas were the etchings of Rembrandt, already mentioned, and the works of Anthony Van Dyck. The Flemish artist's well known *Iconography* or *Icones*, a collection of open-line etchings of artists and collector friends of his time, was very influential.[6] Van Dyck first drew and etched the heads of his sitters in some detail, indicating the torso areas with hatching and long contour lines. He then turned over his plates to professional engravers who 'finished' the figures and backgrounds for pub-

lication. In the nineteenth century, when there was a renewed interest in the *Iconography*, Seymour Haden, the English artist and collector, lamented that Van Dyck watched "his own inimitable etchings ruined by the so called 'finish' of hireling hands".[7] In 1857 the editor and critic Charles Blanc, who was also minister of fine arts, commented enthusiastically on the fine impressions of Van Dyck etchings shown at the Manchester Art Treasures exhibition. Degas was in Rome at the time but Blanc's pleasure in the show and his knowledge of print quality would have been conveyed to him through the many journals that publicised the exhibition. In a notebook used in 1858–60 (BN 13, p. 96) Degas made a copy after one of Van Dyck's etched portraits, the artist Orazio Gentileschi, but Van Dyck's portrait of the landscape painter Joos de Momper (illus.) reveals a more profound resemblance to the portrait of Tourny in attitude, glance and style of execution, with its simplified linear vocabulary. Even the small background landscape in the De Momper portrait seems to have attracted Degas in his earlier *Mountain landscape* of 1856 (illus.).

In 1851 the Louvre purchased a large number of the Van Dyck copperplates from a dealer in Liège and impressions have been printed continuously from that time (some eighty plates comprised the album of which Van Dyck etched eighteen and for the rest made drawings).[8] Van Dyck's graphic influence and that of Rembrandt reached new heights with the so called Etching Revival in France and England during the 1850s and 1860s. In May 1862 Alfred Cadart, publisher and ardent champion of original etchings, and the master printer Auguste Delâtre formed the Société des Aquafortistes marking a renewed interest in etching as a fine art. Although Degas was not a participant, his manipulation of ink on both the Tourny and self-portrait plates that were reprinted in the mid-1860s indicates that he was aware of the 'artistic' inking common to the Société's folios.

The impression of the self-portrait that belonged to Etienne Moreau-Nélaton (cat. 32, illus. p. 169) is a remarkable Rembrandtesque study. Moreau-Nélaton, an art historian, great collector and an important donor, assembled a vast collection of prints, especially those of Manet, about whom he made a catalogue in 1906. Through Bracquemond and other artist friends he acquired many unique or very rare impressions, but when his print collection was bequeathed to the Bibliothèque Nationale in 1927, none by Degas was part of the donation. This rich and dramatic impression of the self-portrait remained in the Moreau-Nélaton family until its recent acquisition.

In his book on nineteenth-century graphic art, the author and critic Claude Roger-Marx claimed in reference to Degas's self-portrait that "with the exception of Ingres's *Pressigny*, nineteenth-century etching had included very few portraits".[9] Recent studies have shown clearly that this was not the case. In their informative introduction to the catalogue *Edgar Degas: The Painter as Printmaker*, Douglas Druick and Peter Zegers listed and commented on Degas's circle of artistic friends and their influences. They have made us aware of the etchings of Delacroix, of the etched illustrations for Othello by Théodore Chassériau, of the painter-etcher Charles-François Daubigny, and of the prolific Alphonse Legros. I hope to case a wider net and tighten many of these historical associations.

Certainly the possibilities of photography, the new mechanical technique for the reproduction of images, was not lost on Degas. The 1855 Exposition Universelle had presented photography as a commercial art, but by the time Degas returned to Paris from Italy in April 1859 he would have been aware of the 'benchmark' exhibition of the same year when, for the first time, large numbers of photographs were admitted to the annual Salon des Beaux-Arts. Félix Bracquemond, who became a close friend of Degas's around 1860, was among the first printmakers to make use of photographs in an artistic way. He was a colleague of Gaspard-Félix Tournachon, called Nadar, who photographed the literati of Paris. These images were of great interest to Bracquemond and provided sources of portrait material and technical procedures that also tempted Degas.

Braquemond's portraits after Nadar, such as his celebrated etching of Théophile Gautier of 1857 (illus. p. 140) found its counterpart in Degas's *Edouard Manet* (bust-length) of 1864–65 (cat. 68–69, illus. pp. 140, 257). A poet, writer and critic, Gau-

tier championed the revival of etching in the 1860s but was decidedly pleased with Bracquemond's study of him from the Nadar photograph. The plate of Gautier was etched in 1857, deposited (*dépôt légal*) by the printer Delâtre in 1858, and published for the first of many times in *L'Artiste* in March 1859. Bracquemond was well aware of its success and exhibited the portrait (with the addition of aquatint in the later states) at the Salon of 1859.[10]

Bracquemond subscribed to the '*tradition ingriste*' of making etchings directly from nature or from preliminary drawings, but was willing to invade the camp for whom photograph was a new tool. Nevertheless, he probably would not have disagreed with the statement that "there is not a photographic portrait that is able to be compared, without disadvantage, to the magnificent etchings of Van Dyck".[11]

Bracquemond's popular portrait of Gautier was reproduced about 1863 in *L'Alliance des Arts* (and even printed and sold as a *carte de visite*) when Degas was preparing his etching of the painter Manet, whose pugnacious visage, prominent brow and hooded gaze replicate the power and forcefulness found in the Gautier image. Degas was mindful of Bracquemond's skills with etching techniques and in the fourth state of the Manet print – the first instance in which Degas used aquatint – Braquemond probably assisted in its skilful application.[12] Pierre Bracquemond, Félix's son and heir, owned at least two impressions of this print in different states.

Another image that must have affected Degas's depiction of Manet was Goya's masterful self-portrait (illus. p. 140), etched as a frontispiece for the first edition of the *Caprichos* published in 1799. Of timely interest was the reissuing of Goya's prints by the Calcografía Nacional in Madrid throughout the nineteenth century: for example, there was an edition of the *Tauromaquia* published in 1855 and another one issued in 1876, sets of the *Caprichos* were sold previously but also in 1855 and in 1868, and the *Desastres de la guerra* and the *Disparates* plates were published for the first time (even though posthumously) in 1863 and in 1864 respectively.[13] Goya was greatly admired by Manet and it is conceivable that Degas adapted the etching style, format and carriage of the Goya self-portrait when

he created his image of Manet. The profile portrait derives from the portrait busts found on antique coins and medals that emphasize the bearing and bone definition rather than the physiognomy of the sitter. Degas's print of Manet evolved primarily in the same fashion as Goya's portrait, in which the subsequent application of aquatint layers built up a structure and gave a prominence and strength of character to the sitter's visage. (It is known that Degas acquired an 1863 edition of *Los desastres de la guerra* which is still in the artist's family.)[14]

Another type of contemporary photograph that proved of interest to artists were *cartes de visite*, small photographic visiting-cards that became highly popular in Paris after Disdéri patented the technique in 1854. Degas made two etchings of Mlle Nathalie Wolkonska in 1860–61 (see cat. 57, illus. p. 157); the static, formal pose of the young woman and the studio-like setting bear a resemblance to photographic cards. The collector and cataloguer Marcel Guérin classified both Wolkonska plates as "after daguerreotypes".[15] Jean Sutherland Boggs suggests that Degas's full-length drawings and paintings of his artist friends from this period – James Tissot, Gustave Moreau, Emile Lévy, and particularly the dapper Manet – may have been influenced by these abundant and collectable visiting-cards. The relaxed, natural poses and urbane attitudes of the gentleman hint at photographic sources; see, for example, Nadar's handsome portrait of Gustave Doré, about 1855 (illus.) as well as his photograph of Manet of about 1865.[16] Like the Gautier photograph, Nadar made a series of portraits of Parisian men in the arts – the image of Doré, with his scarf tied in a cavalier manner,[17] may have influenced Degas's etched portrait of *Manet seated, turned to the left*, 1864–65 (cat. 63, illus. p. 142). Photography encouraged casual and candid poses even though these positions required that they be held for an inordinate amount of time. The medium captured a sense of personality that made the images more than mechanical records. Pages of Degas's notebooks contain the names of workmen, shops, addresses of studios, photography formulas, and printmaking experiments attesting to his profound interest in the 'techniques' of his time.

Although it is frequently claimed that Manet's

Félix Braquemond, *Théophile Gautier*, 1858, aquatint etching, 1st state, London, British Museum [top left]

Edgar Degas, *Edouard Manet*, 1864–65, aquatint etching, 4th state, Boston, Museum of Fine Arts (cat. 69) [top right]

Francisco Goya, Self-portrait, frontispiece to *Los caprichos*, 1799, aquatint etching, Boston, Museum of Fine Arts [bottom left]

Paul Nadar, *Gustave Doré*, ca. 1855, Paris, Bibliothèque Nationale [bottom right]

paintings of modern life established influential new directions for Degas, one cannot ignore Degas's own 'modern' style displayed in his painting of Gustave Moreau (illus. p. 142) made about 1860 when the two artists had returned to Paris and before they pursued their separate careers. Moreau's turning pose in his chair with legs crossed, and the offhand gesture of Moreau's gloves and hat discarded on to the floor provide a sense of bourgeois lassitude that is duplicated in Degas's portrait of *Manet seated, turned to the right* (cat. 65, illus. pp. 143, 256), a visual comparison made by Richard Thomson.[18] This formulaic debonair pose is repeated in Degas's work including the large oil portrait of James Tissot painted in 1867–68 (L175) as well as in the monotypes conceived by Degas in 1876–77 as illustrations for *La Famille Cardinal*, a group of short stories by the novelist and librettist Ludovic Halévy (see cat. 132, illus. p. 222). The corpus of monotypes describes in a somewhat exaggerated but recognisable manner the *flâneur* Halévy as he followed the careers of two young dancers. He is often surrounded by equally fashionable men whom Degas attires and poses as 'lions' of Parisian society. In one monotype (illus. p. 143), a seated man bears a distinct resemblance to the etching of *Manet seated, turned to the right* executed a decade earlier, suggesting that this is another image of Manet, although less clearly realised.[19]

The small portrait of *Marguerite De Gas,* the artist's sister, from 1860–62 (cat. 56, illus. p. 143) has been stylistically compared to prints by Rembrandt, Delacroix, Tissot and Legros.[20] The composition of Degas's etching and drypoint owes much to those earlier artists. Another source of inspiration may have been a *cliché-verre* self-portrait made in 1858 by Camille Corot (illus. p. 143). Although the Corot salt print does not show the same pose of the head resting on the hand, it is, nevertheless, similar in the overall use of 'etched' lines and darkened cross-hatching. The sense of intensity as well as melancholy in Corot's direct gaze is likewise presented in Degas's portrait of his sister. The veil-like effect and tonal fluency were accomplished in both works even though one is an etching and the other an offshoot of photography. Degas became an admirer of Corot's pictures after he had

been introduced to them by Prince Soutzo, and he continued to follow Corot's career. Given Degas's interest in photography as an art form (although he did not make any *cliché-verre*), it is probable that he knew this photographic portrait and incorporated the image as an *aide-mémoire*. Degas himself permitted a heliogravure to be made to the second state (of six) of the *Marguerite*, indicating his awareness of photomechanical processes and his willingness to consider them as part of the development of a print.

The use of photographs as reproductions of works of art and, alternatively, as models for pictures was widespread. According to Michel Melot, this reliance was "only a modernized equivalent of means used by reproductive engravers of the eighteenth century, a technological extension that did not alter the nature of the process".[21] It is possible that Degas made his own 'reproduction', namely the small photographic-like print of *René De Gas*, the artist's brother (cat. 59, illus. p. 175). The large eyes and full face, the fixed expression, as well as the hair with its distinct waves and carefree placement on his forehead share the same characteristics as earlier drawings and paintings. (The print reveals an uncanny likeness to an oil on cardboard portrait of René, BR 32.) In these various works, the thick head of hair is parted on the left. In the print, executed in softground etching, a medium associated with a drawing style, the hair, now parted on the right, is printed in reverse (as is the nature of the printing process). Is it possible that Degas attempted his own *portrait-visite* in the softground etching medium (only eight are known) and offered impressions of his younger brother, some printed by hand, to members of the family and close friends?

With the completion of the Manet etchings in 1865, Degas concluded his years of making printed portraits in the conventional manner. One exception is a portrait of *Alphonse Hirsch* (Reed/Shapiro 21) made in 1875, and even here the sketch-like drypoint lines and the haphazard application of the aquatint grain that serves more as a decoration than as a re-enforcement of the image suggest that Degas was moving away from established procedures. His use of a previously worked and imperfect plate for the drypoint and aquatint image further confirms his lack of commitment towards this minor effort.

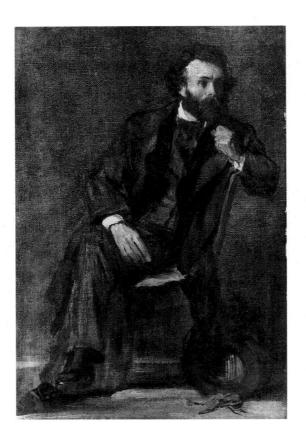

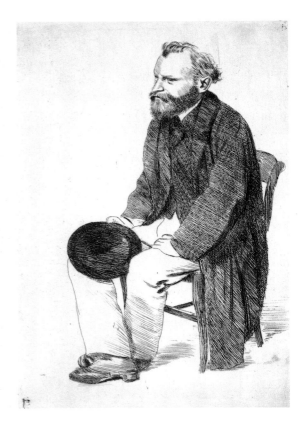

Edgar Degas, *Gustave Moreau*, ca. 1860, oil on canvas, 40 × 27 cm, Paris, Musée Gustave Moreau

Edgar Degas, *Manet seated, turned to the left*, 1864–65, etching, 1st state, 31.4 × 22.5 cm, Copenhagen, Statens Museum for Kunst (cat. 63)

However, the indefatigable Marcellin Desboutin, whose charming drypoint portraits amused his friends, encouraged Degas to produce the Alphonse Hirsch portrait that was the result of one of their many meetings.

After 1865 Degas ceased making prints, and when his interest was aroused once again in the mid-1870s, his portraits take on a new element of caricature and spontaneity. In 1876 Edmond Duranty, the novelist and critic, composed his famous tract on *La Nouvelle Peinture* and his lively comments – many of them referring to his friend Degas – coincided with the artist's interest in depicting scenes from Parisian night-life. Duranty refers to "new" aspects of making etchings and comments on the free handling of drypoint, the inclusion of unexpected accents and, most important, the manipulation of ink on the etching plate: lightening, creating a mysterious aspect, and literally painting with ink. Degas embraced the new subject-matter and understood the working methods described by Duranty, and both are particularly apparent in his abundant and striking monotypes.

Degas's return to printmaking can be further

Edgar Degas
Manet seated, turned to the right 1864–65
Etching and drypoint, 1st state
19.5 × 21.8 cm
Boston, Museum of Fine Arts (cat. 65)

Edgar Degas
Man seated and dancer, from the *La Famille Cardinal* series
1876–77
Monotype
Whereabouts unknown

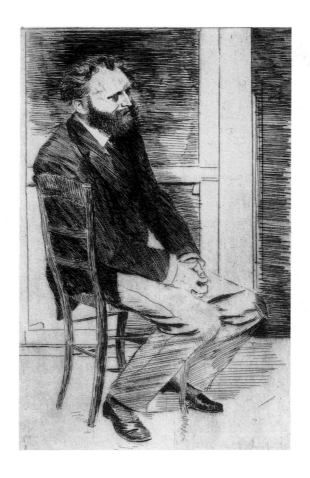

Edgar Degas
Marguerite De Gas
1860–62
Etching and drypoint, 5th state
12.5 × 11 cm
Boston, Museum of Fine Arts (cat. 56)

Camille Corot
Self-portrait
1858
Salt print
21.7 × 15.8 cm
Detroit Institute of Arts

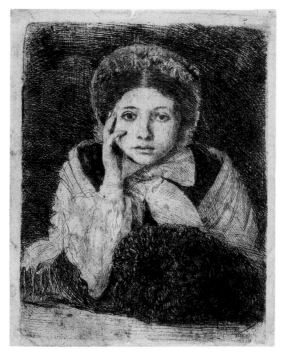

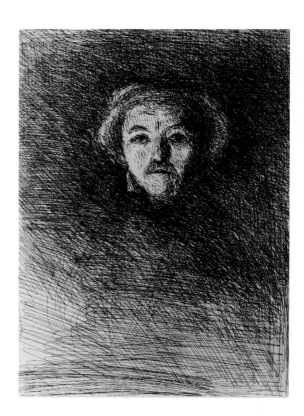

Edgar Degas
Ellen Andrée
1879
Etching and drypoint,
2nd state
11.3 × 7.9 cm
Boston, Museum of Fine
Arts (cat. 153)

explained: the featuring of prints in the first Impressionist exhibition (1874), his friendship with artists such as Bracquemond, Desboutin and Giuseppe de Nittis, all active printmakers, and the Noir et Blanc print exhibitions that took place in London and Paris (1872 and 1876 respectively) may have created an atmosphere in which Degas wanted to participate. What led him to turn to lithography at this time for his caricatural portraits is more difficult to ascertain: artists such as Manet and Fantin-Latour made lithographs in 1862 reflecting a new attitude towards the medium; a de-luxe publication of transfer lithographs by Corot entitled *Douze croquis et dessins originaux* was issued in 1873; and some lithographs by Pissarro assigned to 1874 – all these may have contributed to Degas's spirited embrace of the revived medium. But perhaps the most influential cause was Degas's fondness for Daumier and a true admiration for his lithographs. Even though Daumier had ceased to produce prints for the weekly *Le Charivari* in 1872, Degas eventually collected more than one thousand impressions, creating for himself a library of singers, musicians and spectators. Degas's direct interest in Daumier is reflected in his own frequent incorporation of figural types, gestures and technical means that were 'of the family of Daumier'.

In the mid-1870s Degas embarked in a different direction of portraiture by documenting the popular singers at the *cafés-concert*. Making use of his newly developed technical dexterity, he expressed his enthusiasm for the singers by conveying their special characteristics and by describing the outdoor environments. Both lithographs of *Mlle Bécat at the café des Ambassadeurs* (cat. 136, 137, illus. p. 294) record the individual style of this popular performer and exhibit all forms of natural and artificial nocturnal lighting. Rather than creating a serious and telling portrait that is worked through several states in its evolution, Degas transferred monotypes to a stone; then with a lithographic crayon he defined Bécat's distinctive type, a petite figure with puglike features and jabbing hands who leans towards her audience. He depicted the star performer and then scraped and scratched directly into the stone to attain brilliant effects and patterns suggestive of the setting. There are seven known

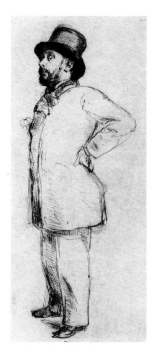

Marcellin Desboutin
Edgar Degas, standing
1876
Etching and drypoint,
2nd state
Paris, Bibliothèque
Nationale

impressions of *Mlle Bécat…three motifs*; one impression of the top subject was touched with pastel and given by Degas to an artist friend thereby extending the artistic possibilities of his lithographic images.[22]

The small drypoint of Ellen Andrée (cat. 153, illus. p. 145) further opens a window to Degas's change in the representation of his portrait subjects. Ellen Andrée, the popular pantomime actress who also served as a model for Manet and Renoir, achieved lasting fame for her multiple appearances in Degas's work. She posed as a café habituée in the major painting *L'Absinthe* (illus. p. 105) completed by 1876; she has now been identified in one of Degas's rare monotype portraits;[23] she is recognised in a monotype transferred to a lithographic stone for *Four heads of women* (Reed/Shapiro 27); and she may be one of the figures in Degas's repertoire of drawings of well dressed women: *Portraits in a frieze* (private collection), *Mary Cassatt at the Louvre* (cat. 152, illus. p. 275) and *Woman in street clothes* (cat. 151, illus. p. 272).[24] If these various productions are all correctly accepted as studies of Ellen Andrée, then it is curious that Degas would also execute a delicate portrait in drypoint, considering it, perhaps, as a technical experiment. Her sprightly figure and distinctive costume were delineated by unorthodox drypoint tools, namely a carbon rod or emery pencil that Degas adopted at this time. In 1918 the critic Arsène Alexandre wrote with appreciation about the print: "In several scribbles, Degas has evoked no more, no less than the charming Ellen Andrée…It is only a little nothing, but a perfect, exquisite nothing."[25] Although some scholars have recently questioned Alexandre's identification,[26] it was Degas's intention to have this drypoint portrait represent someone well known to his friends – a young woman who may be a museum-goer in simple dress with her guidebook in hand, but is not necessarily the stylish Mary Cassatt. Of the nine impressions known, two belonged to Rouart and one to Burty, while the remainder were found in Degas's studio after his death. The placement of the figure on the sheet, the slightly exaggerated posture and the detached air of someone less than interested in her surroundings is comparable to an amusing drypoint portrait of the somewhat haughty Degas (illus.) executed in 1876 by his friend Desboutin, the talented portraitist who made a veritable gallery of Impressionist portraits in drypoint.

The last of Degas's printed portraits and, perhaps, the most eccentric and bold are the two 'Mary Cassatt' prints: *Mary Cassatt at the Louvre: the Etruscan Gallery* (cat. 155, illus. pp. 146, 273) and *Mary Cassatt at the Louvre: the Paintings Gallery* (cat. 154, illus. p. 274). It was acknowledged in Degas's time that the two prints represented Mary Cassatt even though she is turned away from the viewer. Degas followed the point made by Edmond Duranty when he commented in 1876 that "with a back we can discover a temperament, an age, a social position".[27] Indeed, this unusual view realistically described the independent, sophisticated stylish and professional woman who Degas admired. In 1912 Lemoisne claimed that "standing, from the back, leaning on her umbrella, [was] Miss Cassatt, his [Degas's] pupil, looking at paintings in the Louvre",[28] and in a recently published letter written in 1918 to Louisine Havemeyer, Mary Cassatt claimed, "I posed for the woman at the Louvre leaning on the umbrella".[29] Without conveying any facial expression, Degas depicted his real-life model and gave her a distinct personality in a number of works, including paintings, pastels and these two prints, all observed from the back. Cassatt's companion, probably her sister Lydia, was shown in *profil perdu*.

It was Mary Cassatt who merged the two Degas prints and moved the gallery setting into an interior room. Her own print, *The visitor* (illus. p.146), was executed with the same assortment of techniques: softground etching, pronounced areas of hatching, a variety of aquatint grains, and scraping. Although she turned the visitor to the viewer, there is no descriptive likeness of a known personage. Cassatt may have been more of a disciple in 1879–80 when she was closely allied with Degas, but in her highly inventive set of ten colour prints made in 1890–91 for the Galerie Durand-Ruel she included one drypoint and aquatint, *Woman bathing* (illus. p. 147), that attracted Degas's attention. Soon after her exhibition Degas indicated to a friend that he planned to make a suite of lithographs, a series of nude women at their toilet; like Cassatt he focused on the back of

a hired model.

The two remarkable Degas portraits and Mary Cassatt's etching were part of a large collaborative project that Degas had conceived for the promotion of original prints. The journal *Le Jour et la nuit* was meant to include a number of works by Degas and his friends; in fact, Bracquemond assisted with the preparation and made a pen and ink maquette for the cover.[30] No issue was published, although some of the prints and their creators can be identified and several images were printed in a possible edition of fifty: contributions by Degas, Pissarro and Cassatt are known in a number of impressions. More important, the efforts for the production of the journal introduced the artists to unorthodox print-making methods, such as the mixing and superimposing of intaglio processes and the use of unusual commercial or found tools.

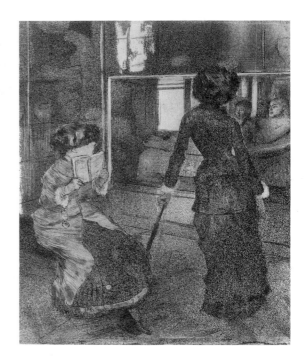

In his forty years of printmaking, Degas produced sixty-six prints of which nearly a third are portraits. They range from serious studies that show the realistic intensity of daguerreotype photographs to caricatural depictions of contemporary figures. His method of working on the plates and stones for these various portraits altered with his times and social interests. Portraits of family members and friends were etched in a traditional manner with sensitive accuracy. Later, the prints of distinct personalities depicted from a rear view incorporated a cuisine of processes that nearly obliterated the readability of the subjects – some critics felt that Degas went too far in his persistent development of a plate, losing his images in the silvery tones (see, for example, the more than twenty-two states of *Mary Cassatt at the Louvre: the Paintings Gallery*). For his lithographs Degas drew and scraped freely on the stones to portray the animated figures with their special 'low-life charm'.[31] The relatively small number of prints belies the broad range of psychological intentions and the diverse and often complex working procedures employed in their production.

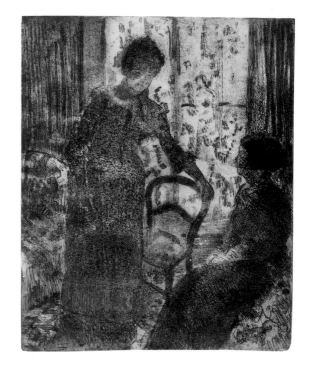

After 1880 Degas discontinued making etchings and lithographs with the exception of a few illustrations possibly meant for books and one printed design to publicize an artistic evening. His last great effort in printmaking was the series of sequential

Edgar Degas
Mary Cassatt at the Louvre: the Etruscan Gallery
1879–80
Drypoint and aquatint, 7th state
Boston, Museum of Fine Arts (see also cat. 155, illus. p. 273)

Mary Cassatt
The visitor
ca. 1879–80
Drypoint and aquatint, 6th state
Williamstown, Sterling and Francine Clark Art Institute [lower left]

Mary Cassatt
Woman bathing
1890–91
Etching and aquatint, 4th state
Boston, Museum of Fine Arts [right]

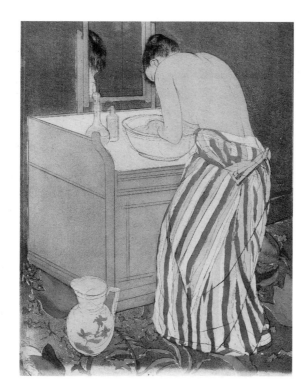

lithographs of bathers executed in 1891–92.

The printed portraits occupy a significant position in the artist's œuvre – they were private, expressive statements rather than 'reproductions' of paintings and drawings. Most of the impressions were found in Degas's studio after his death and thus did not serve as articles of commerce. (One could possibly exempt the handful of prints that were reworked with pastel or paint.) In spite of his ravishing pastels, Degas never worked in colour in his prints, and given his stated passion for black and white they assume a greater dimension in his lifelong study of friends, family and cabaret characters.

When considering the etched portraits, we can agree with Picasso who, enamoured of Degas's monotypes of prostitutes in their brothel parlours, concluded that "printmaking itself is the true voyeur . . . when you look at your copperplates, you are always the voyeur".[32] Picasso, who was thirty-six years old at the time of Degas's death, recognised that Degas was a most perceptive voyeur of personality and character who manipulated the inks and rags, the acids and tools, as well as the reflective plates of the print medium to convey his uncompromising observations of mankind.

NOTES

1 Cited in 1988–89 Paris/Ottawa/New York, p. 52.

2 Correspondence with the author about the Philippe Burty sale from Theodore Reff, 16 February 1992.

3 All at the Musée Gustave Moreau, Paris. I am grateful to Geneviève Lacambre, Conservateur of the Musée Gustave Moreau, for bringing the impression of the Tourny etching to my attention.

4 Reed/Shapiro 5, pp. 8–20.

5 Noted by Douglas Druick and Peter Zegers in Reed/Shapiro, p. xx.

6 Jean-Paul Bouillon, *Bracquemond, Le Realisme absolu*, Editions Skira, 1987, p. 29 suggests that Félix Bracquemond's four etched portraits of 1853 from the "Galerie des jolis garçons" were influenced by the *Iconography* of Van Dyck.

7 Quoted in Katherine A. Lochnan, *The Etchings of James McNeill Whistler*, The Art Gallery of Ontario, 1984, p. 104.

8 Impressions were eventually taken from electrotypes – duplicate printing surfaces of the original copperplates.

9 Claude Roger-Marx, *La Gravure originale au XIXe siècle*, Editions Somogy, 1962, p. 108: "En dehors du Pressigny d'Ingres, l'eau-forte du XIXe siècle a compté jusqu'alors très peu de portraits".

10 Bouillon 1987 (see note 6), pp. 171–72.

11 Boissard de Boisdenier in *Le Siècle*, 6 October 1858, cited in Bouillon, Les Portraits a l'eau-forte de Félix Bracquemond et leurs sources photographiques, *Nouvelles de l'estampe*, no. 38, 1978, p. 5.

12 See Reed/Shapiro, pp. 56–58.

13 Throughout the nineteenth century, there was a growing interest both within and beyond Spain for Goya's etchings. The copperplates were steel-faced and bevelled, enabling a significant number of printings to be made, although the quality declined. I appreciate Stephanie Stepanek's information about these many printings.

14 1988–89 Paris/Ottawa/New York, p. 106, Eleanor A. Sayre has kindly brought to my attention the fact that a copy of the *Caprichos* was in a Paris public collection (Bibliothèque Royale) as early as 1842. Furthermore, it was Théophile Gautier, Bracquemond's friend, who introduced Goya and the *Caprichos* to the French public in an article first published in 1838, then reissued in 1842 and twice in 1845. With some changes it was included in the popular and long-lasting journal, *L'Artiste*, 22 June 1845. (See Ilse Hempel Lipschutz, *Spanish Painting and the French Romantics*, Cambridge (Mass.) 1972, p. 387.)

15 Reed/Shapiro, p. 34.

16 Reproduced in the exhibition catalogue *Manet*, New York, Metropolitan Museum of Art/Paris, Grand Palais,

1983, frontispiece.

17 *After Daguerre: Masterworks of French Photography (1848–1900) from the Bibliothèque Nationale*, New York Metropolitan Museum of Art, 1980, p. 40 and no.109.

18 1987 Manchester/Cambridge, p. 25.

19 Charles F. Stuckey of the Art Institute of Chicago has discussed these ideas with me.

20 Reed/Shapiro, pp. xviii and 37–41.

21 *Manet* 1983 (see note 16), p. 36.

22 Two other lithographs, not illustrated here, are inventive but more traditionally executed portraits of café singers: *La chanson du chien* (Reed/Shapiro 25) is a crayon lithograph made from transfer paper depicting Thérèsa, the reigning queen of the *café-concert*, and *Singer at a café-concert* (Reed/Shapiro 26) is a crayon lithograph drawn directly on a stone that may represent Mlle Bécat with her slim figure and usual wreath of flowers in her hair.

23 1988–89 Paris/Ottawa/New York, no. 171 (Art Institute of Chicago).

24 All reproduced in 1988–89, Paris/Ottawa/New York, p. 319.

25 Quoted in Reed/Shapiro, p. 119, no. 40.

26 See the opinion of Michael Pantazzi, in 1988–89 Paris/Ottawa/New York, pp. 318–20, nos. 204 and 205.

27 Quoted in Boggs 1962, p. 136.

28 Lemoisne 1912, p. 90.

29 Quoted in 1988–89 Paris/Ottawa/New York, p. 321.

30 Bouillon in *Degas inédit* 1989, illustrated p. 252.

31 Armstrong 1991, p. 171. Armstrong is referring to Degas's ballet imagery but her comments on "the attraction to caricatural features ... and the vivid evocation of movement, sound, and life" are relevant to Degas's *café-concert* pictures.

32 Quoted in Loyrette, 1993, p. 91. I am grateful to Henri Loyrette who tells me that this quotation is to be found in Pierre Daix, *Picasso créateur, la vie intime et l'œuvre*, Paris 1987, p. 375. "C'est la gravure, le vrai voyeur ... Devant ton cuivre, tu es toujours le voyeur."

The Album

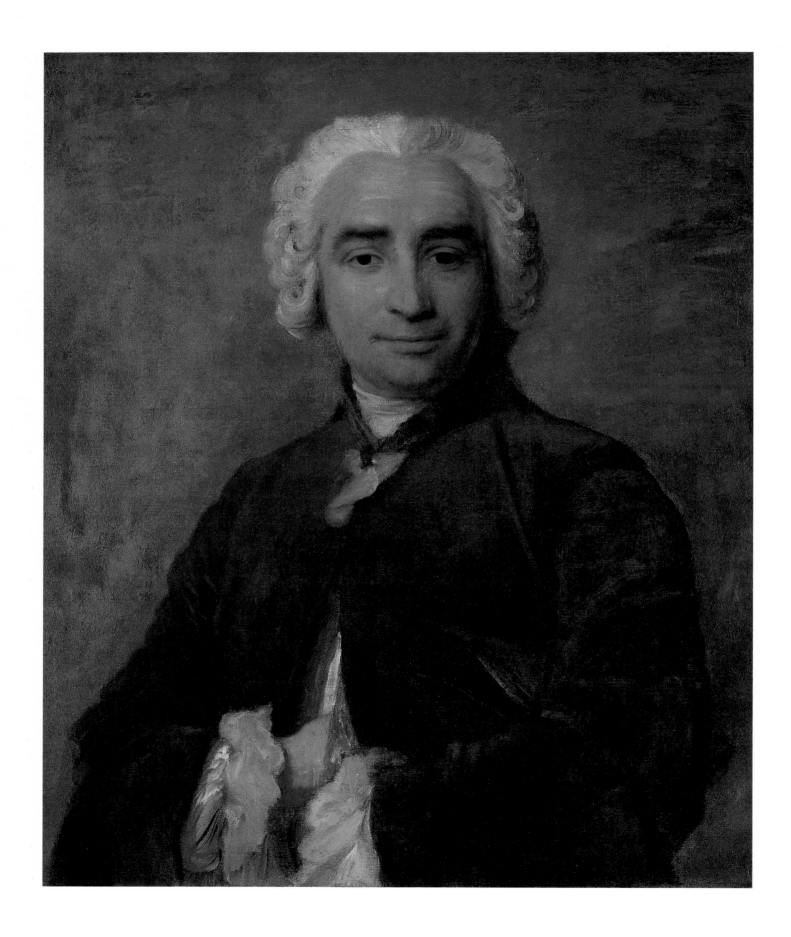

Degas's Copies

EMIL MAURER

6
Portrait of a man
Study after Raphael
1854–55
Pencil on paper
30 × 23 cm
Collection of Margot W. Milch-Heller

95
Portrait of a man
Copy after Quentin de la Tour
1868–70
Oil on canvas
75 × 62.5 cm
Lausanne, Musée Cantonal des Beaux-Arts
(BR 48) [left]

When Degas was young copying the Old Masters was still regarded in art schools as obligatory.[1] The making of drawn and painted copies was an essential preliminary to the more difficult stage of studies after antique sculpture and before the live model. The basis of this approach was the doctrine that many aspects of painting could be learnt – for example anatomy, perspective and composition; further, that artistic perfection had more than once been attained in the course of history – in the sculpture of antiquity, during the Italian Renaissance and in the work of Nicolas Poussin. These were the peaks of perfection, but the Parisian academies also recognised other sources on which the painter might draw: Venetian painting for its light and colour (particularly prized by the English); the great Spanish painters, especially Velázquez and Murillo, as displayed in Paris in the 'Musée espagnol' from 1838 to 1848; and the seventeenth-century Dutch, who offered precedents for Realist painters such as Courbet and Daumier.

The Louvre was a peerless storehouse of acknowledged masterpieces then as now. From the time of its opening to the public in 1793 artists were given preferential access to its treasures. Even Cézanne remained convinced that "the Louvre is the book from which we learn to read".[2] Even after the breakthrough of 'modern painting' Cézanne would recall: "Pissarro used to say that the Louvre should be burnt down; he was right in a way, but it can't really be done."[3] Further, a stream of copies after the Italian masters was continuously being undertaken at the Académie de France in Rome.

There are numerous ways of copying: one can reproduce the whole picture or part of it, in its original format or reduced, reproducing the general composition or studying a particular detail. One can copy in black and white using drawing media or in colour with paint. But the question is, why make copies at all? Clearly, in order to grasp the original, and to understand the creative mind of the genius responsible; in order to tease out its secrets in the process of reconstructing the work; and in order to learn something about oneself at the same time. In other words, to assimilate the model, to inculcate it into one's own being; to set oneself off against it, to argue with it critically; to use it as a starting-point for one's own tests and trials – *copier pour créer*.

Together with Ingres, Delacroix and Cézanne, Degas was one of the most passionate and convinced copyists of his time.[4] "No art is less spontaneous than mine; what I do is the result of contemplation and study of the great masters."[5] Degas gorged himself with their works, but according to his own taste – he was never a slave to the past, nor was he an eclectic. He was a follower of the Old Masters – and at the same time a founder of 'modern' painting; and in Degas's work this is not a contradiction. It would not be right to see him as a Janus figure, looking straight back and straight ahead; rather, keeping within the 'ground rules' of painting as laid down by the Old Masters, he managed to unearth the principles of the new.

Degas's great series of copies were begun in 1853 at the Louvre and at the Cabinet des Estampes of the Bibliothèque Nationale. He continued to copy in Italy in the museums of Florence, Naples and Genoa from 1856 to 1860, then resumed his studies at the Louvre in 1861. He continued to make copies, when the opportunity arose, until about 1890.[6] They range from rapid pictorial notes in the sketchbooks to relatively finished colour copies in oils of the same size as the original, for example a copy after Mantegna's *Crucifixion* in the Louvre in which Degas sought to capture "the spirit and love of Mantegna".[7] "You must copy and recopy the masters, and it is only after you have fully proved that you are a good copyist that you may reasonably be allowed to paint a radish after nature."[8] As an old man Degas once outlined a programme for teaching artists

15
Portrait of a man, study for a copy (L59) of the double portrait in the Louvre formerly attributed to Gentile Bellini, now to Giovanni Cariani, ca. 1855–56, pencil on paper, 44.5 × 29.5 cm, Collection of Barbara and Peter Nathan, Zurich

on the analogy of a building with a hierarchy of storeys: at the top the beginners, drawing after engravings and reproductions of the masters, then copyists working in paint, and only right at the very bottom those permitted to indulge "the dangerous temptation of working from nature".[9]

At first Degas's choice of works of art to copy conformed to the academic doctrine promoted, in turn, by Ingres, Hippolyte Flandrin and Degas's own teacher Louis Lamothe. It consisted predominantly of antique sculpture and Renaissance painting. Degas's father also emphatically advocated this tradition in letters to his son.[10] But the fledgling artist widened his horizons after advice from Moreau, under the influence of Delacroix, and as a result of his own experience – in Italy, paradoxically enough – to include also Van Dyck, Rubens, Rembrandt and Velázquez, while Poussin became a special favourite. It is possible to trace Degas's assimilation of these mentors – by direct quotation, adaptation and transformation – blow by blow in the history pictures he painted between 1859 and 1865. In Poussin ("Degas copied Poussin admirably", said Duranty) the copyist found "purity of drawing, fullness of modelling, grandeur of composition".[11] This sympathy, this sense of identification, went so far that Degas was able to copy Poussin's *Triumph of Flora* in the Louvre in a wash and pen drawing so convincingly that it could almost have been taken to be a sketch drawing by the master himself. Duranty characterized his friend Degas as an "artist of rare intelligence, preoccupied by ideas". The same could be said of Poussin.

In particular as a portraitist Degas dug for treasure in the tradition of portraiture. As he copied he encountered the great landmarks one by one.[12] The focal points of his interest left their mark in his sketchbooks.[13] In loose drawings, too, and more rarely in oils, he recorded memorable portraits as he encountered them. Initially, both at the Louvre and

51
Filippino Lippi
Copy after Filippino's self-portrait in the Uffizi, Florence
ca. 1858
Pencil, heightened with white, on paper
47 × 31.7 cm
Hamilton, Ontario, McMaster Art Gallery
Gift of Herman H. Levy, O.B.E.

in Italy he went back to the 'primitives' of the Early Renaissance – Botticelli, Gentile Bellini, Filippino Lippi. Sometimes he singled out individual heads in altarpieces or frescos and treated them as portraits, as he did for instance with heads by Fra Angelico. His liking for the precision, for the unadorned purity of early portraits persisted for decades, although Degas did not sentimentalise in the manner of the Nazarenes or the Pre-Raphaelites; he used them to 'feed the spirit'. "So there is no bias in art? What about the Italian Primitives who express the gentleness of lips by imitating them with hard lines and make eyes come to life by cutting the eyelids as if with scissors?"[14]

Portraits of the Italian High Renaissance made the most enduring impact on Degas: works by Raphael (or what was thought to be his work), Leonardo da Vinci (similarly), Franciabigio, Puligo, Caroto and Titian, but also Clouet and Holbein. It is also noticeable that about 1860 Degas responded to the early Mannerists such as Pontormo, Bronzino and Parmigianino. Occasionally he also registered the influence of Baroque portraits, especially the brilliant standing figures of princes by Van Dyck and Philippe de Champaigne, or by Velázquez and La Tour.[15] There are sporadic references to the nineteenth century, notably to David and Ingres. It goes without saying that, as a pupil of Lamothe, Degas followed the classicist tradition.[16] The bias, both in numbers and in the intensity in the copying, falls clearly in the 'Golden Age' around 1500, including both the balance and assurance of Raphael and the formal elegance and veneer of the Mannerists.[17] This direct referral to the classics was to prove more enduring than his inherited debt to Ingres.

It was also in his sketchbooks that the young Degas carefully noted the variety of pictorial types generated in the course of the history of the portrait. Every possible kind of format is noted, although there are relatively few heads in pure profile, which he

54
Anne of Cleves, copy after the portrait of Anne of Cleves by Hans Holbein the Younger in the Louvre, ca. 1860, oil on canvas, 64 × 47 cm, collection of Mr und Mrs David Little (L80)

71
Portrait of a woman, copy after Caroto, 1865–68, oil on canvas, 69 × 53 cm, Private collection, Zurich (L133bis) [right]

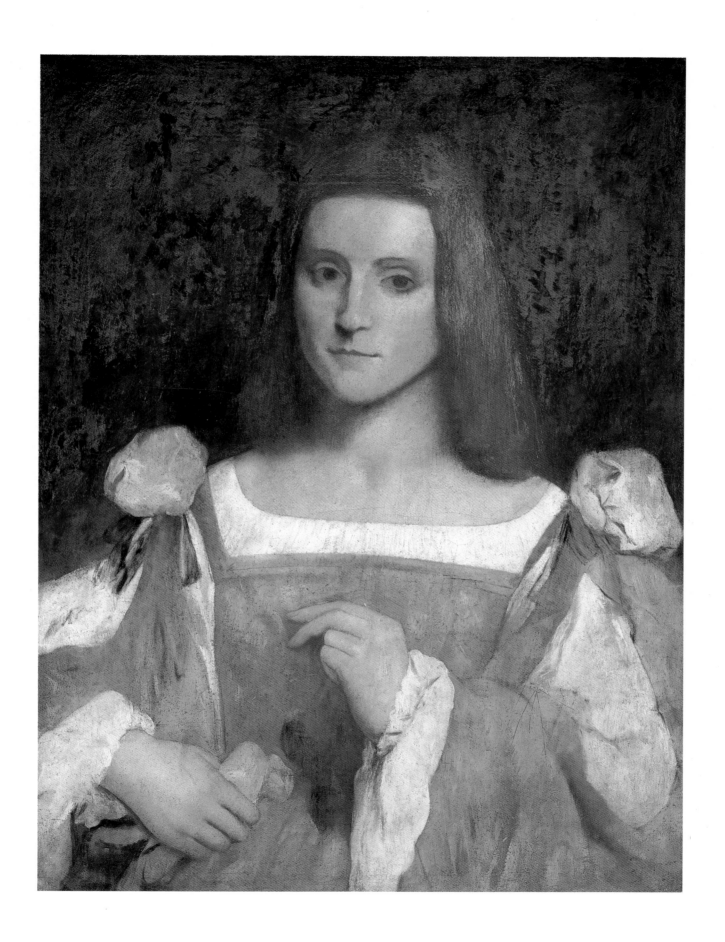

81

Elisabeth of Valois
copy after Anthonis
Mor
ca. 1865–70
Charcoal on paper
40.5 × 27.4 cm
Cambridge,
Fitzwilliam Museum,
Gow Bequest

by Degas, himself a pastellist, that he bought several of his works.[18] The etchings after Velázquez and Rembrandt reflect Degas's first 'unconventional' interest, in Baroque painting – encouraged by Moreau with an eye to Delacroix – as well as his involvement in printmaking after 1856.[19]

These works were mostly painted in Degas's early period when he was working as a copyist at the Louvre and the Cabinet des Estampes after 1853 and again after 1861 and on his Italian journeys from 1856 to 1860. Only the colour copies after Caroto and La Tour seem to date from the late 1860s, and reflect Degas's more painterly interests at the time. In copying Cariani and Lippi he laid down authoritative prototypes of firmly characterized, self-assured three-quarter lengths, with nevertheless a keen awareness of stylistic and psychological subtleties.[20] In his fine picture of Elisabeth of Valois after Anthonis Mor he managed a virtuoso representation of the skin in that delicate, vital face.

On another level, too, that of colouring, Degas got inside Renaissance portraiture. Holbein's *Anne of Cleves*, future Queen of England, fascinated the young painter with her severe, idol-like frontality and symmetry – though it was a formula Degas himself was never to use with such absoluteness. It was, above all, the brilliance of the colouring that the copyist admired: rust-red and golden yellow in front of a neutral dark ground.[21] The copy after Caroto is a completely free colour study – a response to the fascination of the colour gold which dominates the picture in its many gradations.

The three small etchings are primarily technical exercises by a skilled printmaker. However, in their softness and directness they, too, left their mark on Degas's own portraiture.

may have found too linear, definite and abstract, nor many full-face portraits, with their open, commonplace symmetry. Degas most frequently copied three-quarter views; their many alternative angles of view allowed the greatest scope for characterization. The striking wealth of portrait types in Degas's work has its origins here.

It was not the individuals portrayed or particular faces that attracted Degas; often the features are hardly drawn in or are wholly ignored. He was anxious to assimilate proven types and conventions of picture-making and add them to his repertoire. Through copying Degas acquired at a very early stage that sureness and maturity which always astonished critics. In his early

portraiture, as in his work overall, he took none of the wrong turns or blind alleys typical of the beginner.

The works in this exhibition provide an insight into various aspects of Degas's copies of portraits: three complete copies in colour, four in monochrome (pencil and charcoal), and three small-format copper engravings. Most of the originals Degas chose to copy, if not by Raphael, date from his period and in that respect the little group is representative; there is also a brilliant example of the Mannerist court portraiture of Anthonis Mor. The half-length figure of a man after Quentin de La Tour may be a surprise; yet La Tour was one of the greatest ever pastellists, and was so highly regarded

NOTES

1 See the exhibition catalogue *Copier créer*, Paris, Louvre, 1993, and Albert Boime, *The Academy and French Painting in the Nineteenth Century*, London 1971.

2 Letter written by Cézanne to Emile Bernard from Aix, 1905 (no date); but he says the study of nature is even more important.

3 R.P. Rivière and J.F. Schnerb, in *Conversation avec Cézanne*, ed. P. M. Doran, Paris 1978, p.91.

4 See in particular Loyrette 1991, pp. 44–50; Loyrette in 1984–85 Rome and in *Copier créer* (see note 1); Reff 1963, 1964, 1965, 1971, 1985.

5 Reported by George Moore; cited in Kendall 1987, p. 311.

6 Though at this stage with different interests: he was chiefly curious about the skill, the '*dessous*' or ground and the '*cuisine*' or mixture of colours and media by Renaissance painters. See Loyrette 1991, p. 48.

7 Cf. 1988–89 Paris/Ottawa/New York, no. 27. Even so, Degas remarked that "The air one sees in pictures by the masters is not air that can be breathed" (*Copier créer*, p. 34 [see note 1]).

8 Vollard 1924, p. 64.

9 Rouart 1937, p. 10.

10 Quoted in Loyrette 1991, p. 48.

11 Quoted from the catalogue of *Copier créer* (see note 1), p. 302.

12 Cf. above, p. 101f.

13 Published by Reff 1976, 1985.

14 Halévy 1960, p. 56.

15 On Van Dyck see Reff 1985, no. 13, pp. 41–43, 49.

16 Copies after Ingres in Reff 1985, BN 2; Loyrette 1991, p. 62.

17 Degas was also interested in Leonardo da Vinci's grotesque heads and Cousin's doctrine of proportion. As well as the originals he used reproductions as models, quite often from the Bibliothèque Nationale in Paris.

18 Reff 1971, p. 539.

19 1988–89 Paris/Ottawa/New York, pp. 71, 128.

20 Cf. 1967 Saint Louis, no. 18.

21 Cf. *Copier créer* (see note 1), pp. 325, 327. The same picture was copied by Ingres a hundred years earlier in a drawing where the model is given a mask-like face (no. 33).

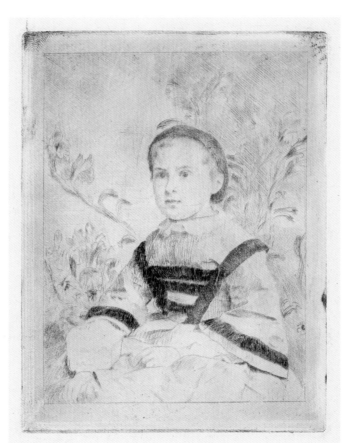

35
Young man wearing a velvet cap
Copy after the etching by Rembrandt, Bartsch 268
ca. 1857
Etching, 1st state
11.5 × 9.5 cm
Sammlung E.W.K., Berne

61
The Infanta Margarita
Copy after Velázquez
1862–64
Etching with drypoint, 2nd state
18 × 15 cm
Sammlung E.W.K., Berne [above left]

57
Mlle Natalie Wolkonska
1860–61
Etching, 2nd state
12 × 8.8 cm
Private collection, Berlin [left]

Degas's Early Self-Portraits

FELIX BAUMANN

The number of self-portraits created in the second half of the nineteenth century and the decades immediately following is unparallelled in any other period of European history. Degas is one of the first painters of this period in whose work an interest in self-questioning, previously unawakened, can be observed stirring.

The long tradition of autonomous self-portraits started in the first half of the fifteenth century in Italy: Leon Battista Alberti may have been the first to portray himself in an autonomous work,[1] thus taking a crucial step beyond the practice of earlier artists who had integrated their self-portraits into religious or secular scenes, usually among a large number of figures.[2] North of the Alps Albrecht Dürer, a self-aware Renaissance artist influenced by humanism, was the first to develop the autonomous self-portrait as a picture type, in the years immediately before 1500. It has since become customary for nearly all important painters to record their outer appearance in picture form, although usually in any particular case no more than a single picture or a relatively small number of self-portrayals have been preserved. The value placed on these pictures within the artist's total œuvre is correspondingly high. This is particularly true of Dürer's three self-portraits;[3] the last of the series, the panel in Munich, in which the painter makes a deliberate pictorial identification of himself with Christ, stands at the head of the fruitful tradition whereby the artist when portraying himself takes on a rôle outside his everyday experience. Titian painted two portraits of himself, both when he was already at a ripe old age.[4] In his famous self-portrait in the Louvre Poussin – anything but a portrait painter – depicted himself quite simply as the personification of inspiration and order in painting,[5] and in *Las Meninas* Velázquez surrounded himself with half the Spanish court, turning the many-layered composition into a mirror image of the Baroque artist's greater sense of self-

worth.[6] Rubens[7] and Van Dyck[8] transmitted themselves to posterity in worldly, sometimes even courtly grandeur.

Rembrandt occupies a unique place as a self-portraitist. With seventy-five paintings, drawings and etchings[9] he stands out a long way from other painters in the frequency with which he came to terms with his own outer appearance; even the most indefatigable self-questioners of the late nineteenth century such as Cézanne, Van Gogh, Hodler, Liebermann, Corinth or Beckmann hardly compiled a comparable body of work.[10] However, Rembrandt's perseverance in portraying himself in such a large number of self-portraits is only one aspect of his activity – the wide range of different manners of self-representation he invented is even more significant. Besides the psychological questioning of his own face, he adopted a diversity of rôles, unique in its range. While Rembrandt, like Rubens, was certainly not averse to depicting himself as a successful gentleman,[11] his delight in masquerading far exceeded glorification of his social rank. And in the heartrending pictures of himself he painted in old age[12] he interpreted the frailty of the human face more honestly and unsparingly than any other seventeenth-century artist – only Goya and later still artists like Corinth or Hodler have achieved comparable stringency of expression in their self-portraits in old age.

In the course of the eighteenth century the monumental, self-confident self-portrait gave way to a more private atmosphere, and artists increasingly showed themselves at work – for example, Chardin,[13] Reynolds[14] and above all Goya, the most important painter of self-portraits in the late eighteenth century. Gudiol's catalogue of Goya's œuvre lists nine painted and seven graphic self-portraits,[15] and Goya also included his own face in other compositions, particularly group portraits of the royal family[16] – though unlike Velázquez he

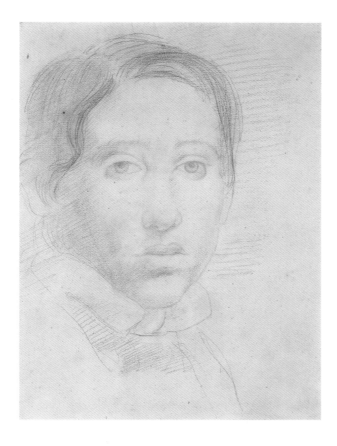

2
Self-portrait
1854
Pencil on paper
33 × 23.8 cm
Private collection

2
Portrait study after Bacchiacca
(Verso of above)

depicted himself not at the centre of a scene at court, but in the rôle of a 'humble servant'. Goya was about twenty-seven years old in his earliest self-portrait (illus. p. 170), a head-and-shoulders picture in three-quarter view against a dark background. The subsequent portraits enable us to follow Goya's development through his career: the maturing of his character reflected in increasingly firm features,[17] his success as a painter,[18] his resignation to his fate overshadowed by deafness,[19] and finally the pathetic portrait of 1820 depicting the seventy-five-year-old artist stricken with illness, his face racked by pain, in the arms of his doctor, Arrieta.[20]

It would be hard to find a greater difference in conception of the function of a self-portrait than that between the unadorned self-revelation of Goya and the highly controlled stage management of Ingres. If the impetus for the older artist in familiarising himself with his own outer appearance was obviously the question 'Who am I?', the equivalent question in the case of the painter from Montauban would be: 'How do I want posterity to see me?' The evolution over a period of years of his *Self-portrait aged twenty-four* (illus. p. 164) very clearly demonstrates his pretensions. The painting underwent an astonishing metamorphosis, as the initially rather casual swipe of a face on the canvas gave way to a stricter pose, the face was tautened and stylised to give it greater expressive force, and the more informal light-coloured jacket was replaced by an elegant dark cape with a velvet collar.[21] Ingres's image of himself in old age, of which three versions have been preserved, also demonstrates unequivocally how the artist manipulated his outer appearance as he wished it to be remembered: this is in no way the face of a frail old man (in the latest version which the artist painted when he was eighty-five years old the flesh tints of the emotionless face are surprisingly – or rather indicatively – even firmer than in the

versions painted when he was seventy-eight and seventy-nine).[22] The fact that the orders on the extremely correct black suit are brought out in the liveliest splashes of colour confirms the point: this is the deliberate, self-confident stage-setting of his own ego. In a sense, Ingres's self-portraits represent a last peak in the tradition of self-portraits as images of grandeur; Ingres left his marker beside those of Dürer, Titian, Rubens and Poussin.

However, this component, the obsession with status and projection, played virtually no rôle in the intensified concern with the self-portrait in the second half of the nineteenth century. To a large extent photography took over the job of providing formal portraits, interestingly enough always using as props stylistic and compositional elements borrowed from painting: with the sitter striking an attitude, and fake architectural elements such as pillars and hangings in the background. However, the aspect which photography in the early phases of its development could not yet convey became more significant in the work of painters, reflecting an obviously increasingly acute preoccupation: the psychological discovery of one's own being, or, expressed in simpler terms, the need to answer the question, 'Who am I?'

In her preface to the exhibition *The self-portrait in the age of photography* Erika Billeter wrote:

The 'age of photography' turned out to be an era of ever increasing emancipation for the artist. His liberation from patrons and his increasingly independent position in society, amounting in fact to total autonomy, also drove him into isolation, and threw him back upon himself far more than would have been possible in earlier centuries. In many cases the self-portrait became a kind of refuge allowing the artist to get a clear idea of himself and his own personal circumstances.[23]

In fact it is often young artists who try to overcome the unresolved aspect peculiar to the transition from adolescence to adulthood by coming to terms with themselves pictorially. Of the twenty-five self-portraits by Courbet listed in Robert Fernier's catalogue of his œuvre, eighteen were produced in the decade between 1840 and 1850, i.e. in the period when Courbet, born in 1819, was between twenty and thirty years old.[24]

Courbet's interest in himself in his early years links him with Degas, only fifteen years his junior, of whom there are nineteen known painted self-portraits[25] and about the same number of drawings dating from between 1854 and 1864. However, the differences separating these two painters are far more significant than any connecting element. Although he later developed into an exponent of Realism, in his youth Courbet was a Romantic who loved giving expression to the exuberance of his emotions in exaggerated poses. Tearing his hair and with wide staring eyes he slips into the rôle of '*Le désespéré*',[26] only to look down on the viewer a year later as a vain dandy in '*Courbet au chien noir*'.[27] In '*L'Homme à la pipe*' painted in 1844 he looks thoroughly in love with himself, with his half-closed eyes and his soulful gaze.[28] The following year he depicted himself dancing with great enjoyment in '*Les amants dans la campagne*',[29] but also as '*L'homme blessé*'.[30] Courbet was posing – his rôle-play is too theatrical in effect to be interpreted as a genuine study of his own psyche: he used his own face to express states of mind that were not necessarily his own.

If we now turn from Courbet to consideration of Degas, Degas's diametrically different behaviour as a painter of self-portraits becomes particularly evident. In a review of his series of self-portraits what strikes us first is undoubtedly their uniformity. Of all the painted versions only three stand out because of their size: the self-portrait 'with a port-crayon' ('*Degas au porte-fusain*'; cat. 8, illus. p. 165), his self-portrait making a greeting ('*Degas saluant*';

L105, Lisbon, Gulbenkian Museum); and the double portrait of himself with Evariste de Valernes (illus. p. 23). It is only in these three works that Degas depicts himself half-length, and only here that the hands play a part in the picture. In all the other pictures, generally in small format, he concentrates on the face, except in the frontally viewed self-portrait 'in a green waistcoat' ('*Degas en gilet vert*'; cat. 9, illus. p. 166) where he appears at a slightly oblique angle against a neutral, mainly dark background (the double portrait with de Valernes with its light background is another exception in this respect). The relative uniformity of these portrait studies can also be explained not least by the fact that most of them were produced in the short time span between 1855 and 1858. In other words, the months preceding his crucial journey to Italy (arrival in Naples, 17 July 1856; return to Paris, 6 April 1859) and the first phase of his time there, particularly the periods spent in Naples and Rome, represent the period of Degas's most intense scrutiny of his outer appearance. But simply pointing to his age, between adolescence and full maturity, generally a phase of self-doubt and self-discovery, does not adequately explain the stubbornness with which Degas devoted himself to this theme. Motives relating to the specific psychological temperament of the incipient artist must also be considered.

Several events crucial to Degas's future career as an artist occurred in the spring of 1855. At the beginning of April he was accepted as a student of Louis Lamothe, a pupil of Ingres, at the Ecole des Beaux-Arts, but he stopped attending that very same term, so making himself ineligible to compete for a Prix de Rome. Through the father of his school friend Paul Valpinçon he met Ingres, whom he revered – a meeting he often liked talking about even in his later years;[31] at the World Exhibition he studied the many pictures assembled there, Ingres's in particular, and painted his very first

1
Self-portrait
('*Degas à la palette*')
1854
Oil on paper, mounted on
linen
44 × 33 cm
Private collection (L2)

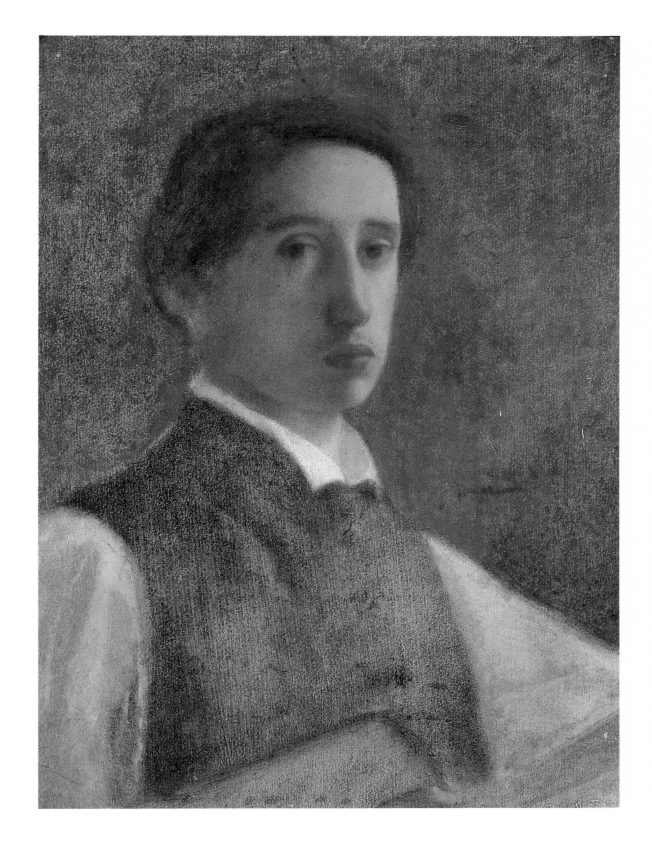

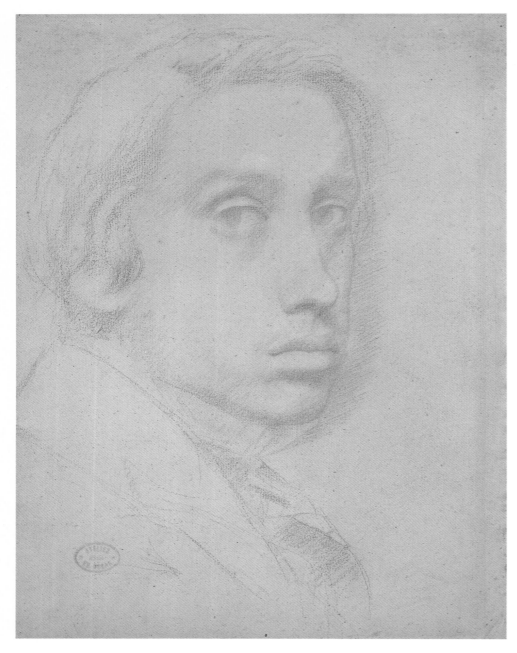

23
Self-portrait, ca. 1857, red chalk on paper, 31 × 23.3 cm, Washington D.C., National Gallery of Art, Woodner Family Collection

important picture: self-portrait 'with a port-crayon' ('*Degas au porte-fusain*'; cat. 8, illus. p. 165). If we review his total output in the mid-1850s, only the copies after paintings by Old Masters in the Louvre and then in Italy outnumber the portraits in which the first stages of Degas's artistic development can be traced: in other words, he was still searching, still sticking to the formulations of the masters he admired, hardly yet per-mitting himself to attempt any pictorial invention of his own. In contrast to this diffidence, which must surely also reflect Degas's still fairly undeveloped level of training as a painter, available sources reveal how intensely Degas reflected upon himself. A letter written by Degas from Florence on 7 September 1858 to Gustave Moreau who was staying in Venice is particularly reveal-ing in this respect.[32] Even if the basic mood of depression in the letter, written imme-diately after the first series of self-portraits mentioned above, had been accentuated by circumstances of the moment, it may be assumed that Degas had earlier experienced similar moods. He writes:

I am talking only about myself, though I told you I wanted to say nothing about it. You would not be aware that I am reading with great interest *Les lettres provinciales*, in which the self is described as hateful.*

And a little further down in the same letter:

Myself again. But what do you expect a man on his own and so abandoned to his own devices as I am to say? He has only himself in front of him, sees only himself, and thinks only of himself. He is a great egoist.*

It would hardly be possible to express a young man's obstinate self-questioning more clearly, with the process of self-searching even being taken to the point of self-hatred: Degas mentions Pascal's 'hate-ful self' to his older colleague with just a suggestion of both maudlin and aggressive enjoyment. The two passages quoted also reveal defiance, and uncertain shyness;

*Je ne vous parle que de moi et je vous disais pourtant que je ne vous en voulais rien dire. Vous ne vous apercevrez pas que je lis avec intérêt *Les Lettres Provinciales* où le moi est recommandé comme haïssable.

*Toujours de moi. Mais que voulez[-vous] qu'un homme seul aussi abandonné à soi-même que je le suis dise? Il n'a que lui devant lui, ne voit que lui, et ne pense qu'à lui. C'est un grand égoïste.

Degas has to excuse himself almost compulsively for writing in such detail about how he feels. Through these contradictory elements, which must have confronted the young artist with many an inner ordeal, we can recognise the driving forces that led Degas again and again to allow his inner life to glimmer out in the self-portrait. The reserve with which the painter projected his states of mind on to the canvas produced the marked uniformity in Degas's self-portraits between 1855 and 1857, yet on closer examination it is possible to discern very different expressive possibilities in the face. For example, two early drawings (cat. 23, illus. p. 162, and cat. 2, illus. p. 159) show a noticeably determined, almost wilful expression on his face, an impression most clearly created by the lower half of the face with its distinctive mouth and pouting lips. It is probably no accident that on the reverse side of the drawing there is a copy of a self-portrait then ascribed to Raphael, now to Bacchiacca (cat. 2, illus. p. 159)[33] – a self-confident flourish on the part of the twenty-year-old, who hardly made the gesture of putting the two drawings together just to save paper. It is also significant that Degas did not adopt the whole composition of the model, concentrating instead on the face and hand, with the elbow supported on a balustrade and the reclining left arm being omitted; the drapery of the robe enclosing the upper body did not interest him either and was reduced to a minimum. He seems to fix his entire concentration on the light eyes, finishing up with the distinctive oblique position peculiar to most of the early self-portraits – most strikingly in cat. 19 (illus. p. 171). The similarity is pushed so far that in looking at the copy after Bacchiacca one is tempted to speak of a disguised, historicist self-portrait.

The drawing cat. 3 (illus. p. 173) also stands to some extent between self-portrayal and copying. When the picture was first shown, at the 1988 exhibition in the Isetan

4
Self-portrait, 1854–56, red chalk on paper, 26 × 20.5 cm, Private collection

Museum in Tokyo, it was identified as a self-portrait of around 1854. If this is really what it is, the drawing stands completely apart from the rest of the series; it should also be pointed out that self-portraits can hardly be made in profile[34] but necessarily with the eyes turning to the viewer, reflecting the situation of the painter looking at himself in the mirror, a distinctive feature running through almost all self-depictions since Leon Battista Alberti.[35] It clearly has a certain 'family resemblance' to the other self-portraits,[36] as the Isetan Museum catalogue points out, yet there is a question whether this should correctly be identified as a study of Degas's own face. In our opinion it cannot be ruled out that Degas here overlaid a copy with certain features of his own appearance. We know that he copied the left profile of a near-adult youth from Pintoricchio's fresco of the *Funeral of St Bernardino* in the Bufalini chapel in Santa Maria in Aracoeli in Rome[37] in three colour studies,[38] and there is a striking resemblance between our profile drawing and these studies. Did Degas in fact pick out this face, which in no way plays a dominating rôle in the overall composition, from the multitude of figures depicted by Pintoricchio because it enabled him to overlay it to some extent with his own? There can be no definite answer to this question, but in the meantime it is unacceptable to interpret the drawing as a self-portrait without some reservations.

Let us return to the works which can be recognised unequivocally as self-portraits and to the attempt to read different states of mind in that so very controlled, hermetic face. Perhaps cat. 9 (illus. p. 166) most clearly reveals the Degas described rather unflatteringly by Carol Armstrong in the brilliant closing chapter of her book *Odd Man Out*, devoted to the self-portraits, as "a constricted, arrogant, and no doubt disagreeable quasi-adolescent".[39] The judgement may be somewhat harsh, but possibly Degas pushed the facial expression to

greater and more self-assured resolution in this, his most complete and satisfying picture among the early small portrait studies, than in the more or less contemporaneous versions in a Paris private collection and in the Pierpont Morgan Library, New York, which are less decided in compositional terms (cat. 1, 17, illus. pp. 161, 166). However, the equation 'the more finished the painterly execution, the better resolved the facial expression' does not apply when we come to consider the masterpiece of the series, the self-portrait from the Musée d'Orsay (cat. 8, illus. p. 165). It almost seems – in articulating these nuances that can hardly be put into words, extreme diffidence of language is called for – it almost seems as if in this first real painting the artist would not let himself reveal any emotion whatsoever. Everything seems to be repressed: the body hardly stands out from the ground of the picture, no detail of the totally correct clothing is invested with any significant content, the resting hands make no indicative gesture, and the attributes – the portcrayon and the drawing folio – identifying the person portrayed as an artist (really a graphic artist) are presented so discreetly that they hardly have any pictorial impact.

This painting has quite rightly been frequently compared with Ingres's portrait of himself as a young man (illus. p. 164).[40] Degas must have known the picture, whether he had already seen it before his momentous visit to Ingres, or slightly later in the French Gallery at the 1855 World Exhibition.[41] His still unqualified admiration for Ingres at that time, which Delacroix and Moreau were later to moderate slightly, allows us to infer that the artist at the start of his career wanted to emulate the supreme model. If this was the case, however, he was starting from a completely different frame of mind. We may recall how Ingres embellished his youthful self-portrait years later – it would be absurd to expect Degas to act in a similar way, though there is a story that he,

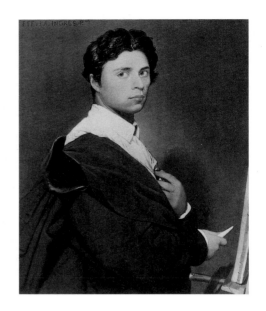

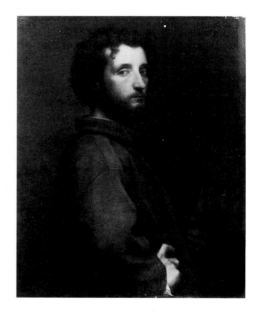

8

Self-portrait ('*Degas au porte-fusain*')
1855
Oil on canvas
81 × 64 cm
Paris, Musée d'Orsay (L5)
[right]

Jean-Auguste-Dominique Ingres
Self-portrait aged twenty-four
1804
Oil on canvas
78 × 61 cm
Chantilly, Musée Condé
[left]

Louis Lamothe
Self-portrait
1859
Oil on canvas
53 × 41 cm
Lyons, Musée des Beaux Arts [below left]

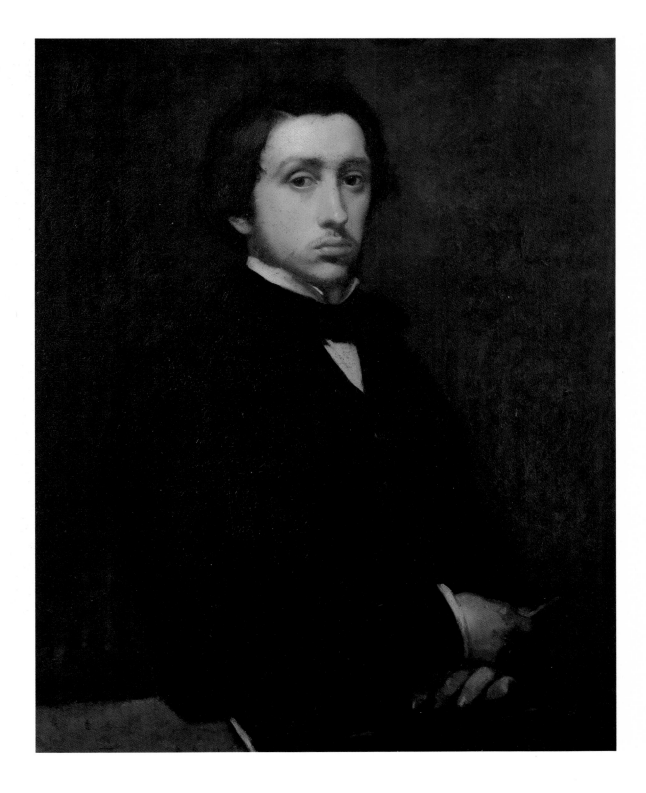

9

Self-portrait ('*Degas en gilet vert*')
1855–56
Oil on canvas
41 × 32.5 cm
Private collection (L11)

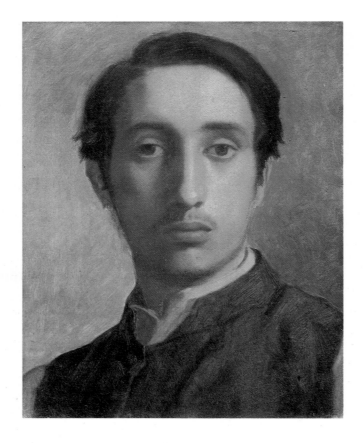

17

Self-portrait ('*Degas en gilet brun*')
ca. 1856
Oil on paper, mounted on linen
24 × 19 cm
New York, The Pierpont Morgan Library, Bequest of John S. Thacher (L13)

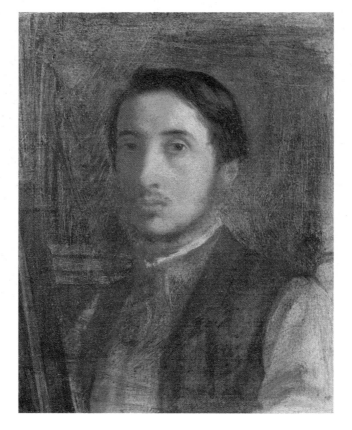

too, later overpainted his self-portrait. According to Lemoisne, Ernest Rouart about 1895 observed that Degas had overpainted the ground of the picture.[42] It is not possible today to discover what was altered then;[43] in any case we can certainly rule out any intervention heroicizing the image in the way Ingres did with his youthful portrait. For as far as Degas was concerned his self-portraits were an entirely private matter; except for a very few prints of his etched self-portraits (cat. 28–32, illus. pp. 168–69), which he gave as presents to chosen close friends, not one ever left his studio during his lifetime. Even his closest associates are unlikely to have been aware how often he familiarised himself with his own image during the mid-1850s. Of course the private nature of this series also explains his constant preference for a small format and above all for a sketch-like approach. The smallest picture in the whole sequence (cat. 19, illus. p. 171) – 26 cm in height, 19 cm across – is not only the most consistent in this respect, but also the most significant artistically. In this enchanting portrait – I am using this unscholarly epithet deliberately – all the artistic freedoms which Degas was to continue to develop throughout his life were tried out for the first time: above all, a new attitude towards colour – prompted apparently by his acquaintance with Gustave Moreau, though he did not meet him until the beginning of 1858. Might this work traditionally dated 1857 not in fact have been created until the first months of the following year? In any case a desire for fresh colour contrasts, foreign to the earlier pictures with their tonal harmony, is evident in the clear orange of the neckerchief and the white of the collar of the painter's smock.

In this little picture the problem of technique comes to the fore; not that this is the first portrait sketch in Degas's work, but in no previous portrait is there a comparable deliberate juxtaposition of detailed painterly execution and free suggestion. It is as if

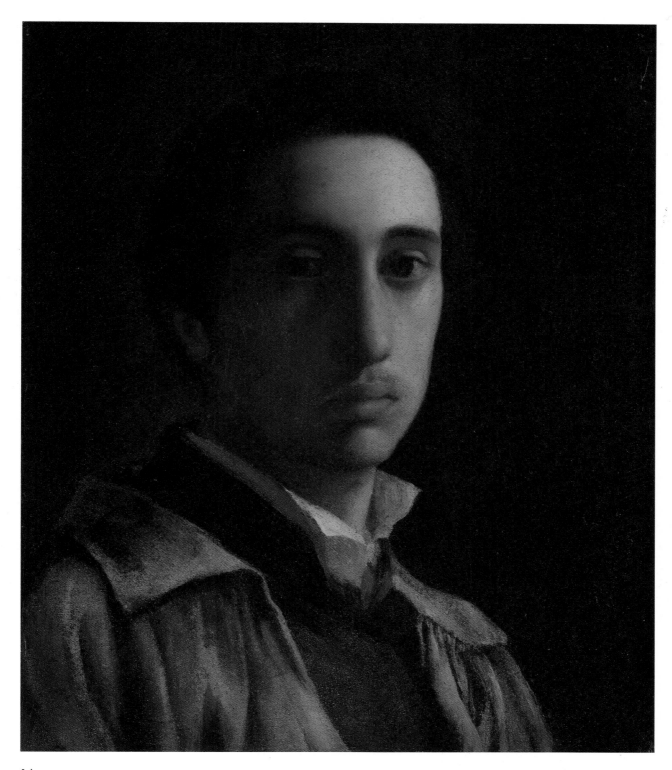

16
Self-portrait ('*Degas en blouse d'atelier*'), ca. 1856, oil on paper, mounted on linen, 39 × 33 cm, New York, Metropolitan Museum of Art, Bequest of Stephen C. Clark (L12)

28

Self-portrait
1857
Etching, 1st state
27.2 × 23.2 cm
New York, The Metropolitan Museum
of Art, Gift of Mr and Mrs Richard J.
Bernard, 1972

29

Self-portrait
1857
Etching, 2nd state
26.3 × 17.2 cm
New York, The Metropolitan Museum
of Art, Jacob H. Schiff Fund, 1922

Degas, in this unassuming work, opened a creative avenue which caused him finally to move away from Ingres. The new and much more modern approach would culminate in such pictures as *Vicomte Lepic with his daughters* (cat. 110, illus. p. 219) or *Madame de Rutté* (cat. 126, illus. p. 245), to mention only two particularly telling examples. The witty play with *non finito* became an accepted pictorial language; sketch techniques were no longer consigned to the private domain as Ingres had demanded,[44] but had become a means of directing the eyes of the viewer at varying degrees of speed, so giving rhythmic dynamics to a pictorial field. In this sense the anchor in the Williamstown picture (cat. 19, illus. p. 171) can unequivocally be recognised in the obliquely placed eyes: if the viewer's own eyes wander over the pictorial field, he is always drawn back to this penetrating gaze.[45] This phenomenon is common to all Degas's self-portraits: the large, dark, questioning, wondering eyes are always at the centre of the pictorial expression. As it were to make the point for us, in a drawing (cat. 4, illus. p. 163) which seems like a preliminary study for the Orsay portrait (cat. 8, illus. p. 165)[46] Degas fragments his own face: provided the eyes are caught, the rest can be dispensed with. Can Cézanne's observation about Monet also be applied to Degas? "Monet is only an eye, but what an eye!" Hardly, for Cézanne wanted to express the fact that Monet had a greater gift than any other painter for capturing the epidermis of things with his eye – Degas's questioning gaze seeks to establish the essence of things. Let it be said once more, Degas is not an Impressionist!

It is astonishing to observe how close formulations can be to one another over the centuries when artists ask the same question with similar intensity. The youthful self-portraits of Rembrandt (illus. p. 170), Goya (illus. p. 170) and Degas (cat. 19, illus. p. 171) all have the same construction: bust against neutral background, face in three-

30
Self-portrait, 1857, etching, 3rd state,
46.2 × 31 cm, Boston, Museum of Fine Arts,
Katherine Eliot Bullard Fund in Memory of
Francis Bullard and proceeds from sale of
duplicate prints

31
Self-portrait, 1857, etching and drypoint, 4th
state, 4th proof (Bartholomé), 23.3 × 14.4 cm,
Josefowitz collection

32
Self-portrait, 1857, etching and drypoint, 4th
state, 4th proof (Moreau-Nélaton),
23.3 × 14.4 cm, Josefowitz collection

quarter view. Rembrandt and Degas – the younger man's familiarity with the work of Rembrandt can be seen in the etchings he made at the same time[47] – both also bring light in from the left in the same way, lighting up the collar and the right cheek but casting the eyes into shadow. Three pictures without empty flourishes, without any ambition to suit the taste of the time or the dictate of fashion and in that respect 'timeless' – Degas produces a more 'modern' impression only because he permits himself a new 'sketchy', painterly freedom in certain passages.

Degas's self-portraits are both bound to tradition and pioneering, in equal proportions. In so far as the self is questioned in them with unparalleled exclusivity, free of any masquerading, any trace of self-staging, they reflect the artist's isolation in the nine-

teenth century, the fact that artists were thrown back on themselves as never before. It was characteristic of Degas's refined and reserved temperament, encompassing some shyness and inhibition, no doubt, that establishing his own identity turned into a process of reduction: the lids sit on his eyes both revealing and concealing his innermost being. On the other hand, Degas is at the head of the long line of painters who have sought the solution to the questions oppressing them by coming to terms with their own body. Degas's discretion would soon give way to more drastic expression: in the case of Van Gogh, and again of Kirchner, self-mutilation;[48] flirtation with death in Böcklin[49] and Ensor;[50] youthful muscle and later frailty in Hodler[51] and Corinth;[52] grimacing in Gerstl[53] and Schiele.[54]

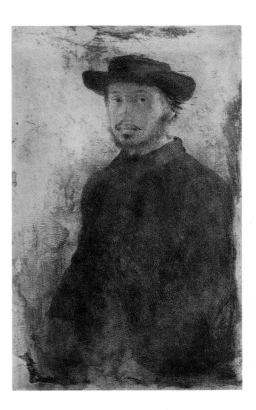

NOTES

1 Wolfram Prinz, *Die Sammlung der Selbstbildnisse in den Uffizien*, vol. 1, Berlin 1971, p. 13 and fig. 16.

2 For the concept of the 'by-stander' portrait see Manuel Gasser, *Das Selbstbildnis*, Zurich 1961, p. 9f. and figs. on pp. 21ff.

3 Giorgio Zampa, *L'opera completa di Dürer*, Milan 1968, pls. I, XI, XVI.

4 Corrado Cagli/Francesco Valcanover, *L'opera completa di Tiziano*, Milan 1969, pls. LII, LV.

5 Anthony Blunt, *The Paintings of Nicolas Poussin, A Critical Catalogue*, London 1966, p. 8 and fig. 2. See also Wolfgang Kemp, 'Teleologie der Malerei, Selbstportrait und Zukunftsreflexion bei Poussin und Velázquez', in Matthias Winner, ed., *Der Künstler über sich in seinem Werk, Internationales Symposium der Bibliotheca Hertziana*, Rome 1989, pp. 407ff.

6 José López-Rey, *Velázquez, A catalogue raisonné of his œuvre*, London 1963, no. 229, pl. 147; see also p. 182f.

7 Michael Jaffé, *Rubens, Catalogo completo*, Milan 1989, p. 379 (Jaffé notes four self-portraits of the artist alone and four group portraits in which he appears). See also Justus Müller Hofstede, 'Rubens und das Constantia-Ideal, Das Selbstbildnis von 1623', in Winner 1989 (see note 5), p. 365ff.

8 Erik Larsen, *The Paintings of Anthony van Dyck*, Freren 1988, cat. 40–44, 1017–1020.

9 H. Berry Chapman, *Rembrandt's Self-Portraits, A Study in Seventeenth-Century Identity*, Princeton 1990, p. 3. Fritz Erpel, *Die Selbstbildnisse Rembrandts*, Berlin 1967, counts 109, Christopher Wright, *Rembrandt: Self-Portraits*, London 1982, makes it 98 self-portraits.

10 Twenty-five oil paintings and fifteen drawings by Cézanne and 35 paintings by Van Gogh seems to be the number (kindly communicated by Walter Feilchenfeldt). In the exhibition catalogue *Ferdinand Hodler, Selbstbildnisse als Selbstbiographie*, Basle, Kunstmuseum, 1979, Jura Brüschweiler noted, "according to the latest state of research Hodler 113 self-portraits, 47 in oils or watercolour and 66 drawings". The handlist of paintings by Lovis Corinth made by Charlotte Berend-Corinth (Munich 1992) includes 42 self-portraits. For Liebermann's self-portraits see Günter Busch, *Max Liebermann*, Frankfurt am Main 1986, pp. 109ff. The catalogue of the paintings of Max Beckmann by Erhard Göpel and Barbara Göpel (Berne 1976) counts 39 self-portraits, and in addition 27 paintings in which self-portraits or figures with features resembling the artists appear.

11 For example in his *Self-portrait aged 34*, 1640, London, National Gallery (Chapman 1990 (see note 9) col. pl. IV).

12 In particular the self-portrait of 1666, Cologne, Wallraf-Richartz (Chapman 1990 (see note 9), fig. 145).

13 Pierre Rosenberg, *L'opera completa di Chardin*, Milan 1983, nos. 191, 191A, 191B, 194, 194A, 201.

14 Gasser 1961 (see note 2), p. 116.

15 José Gudiol, *Goya, Biographie, Analyse critique et Catalogue des peintures*, Paris 1970, vol. I, p. 385.

16 See, for example, *The sermon of St Bernardino of Siena*, 1782–83, Gudiol 1970 (see preceding note), cat. 138; *The family of Infante Don Luis de Bourbon*, 1783, cat. 152; *The family of Charles IV*, 1800, cat. 434.

17 Gudiol 1970 (see note 15), cat. 139.

18 *Ibid.*, cat. 96.

19 *Ibid.*, cat. 637, 638, 639.

20 *Ibid.*, cat. 697.

21 Gaëtan Picon, *Jean-Auguste-Dominique Ingres*, Geneva/Stuttgart 1981, figs. pp. 6, 8.

22 Picon 1981 (see preceding note), figs. p. 9.

23 *L'autoportrait à l'âge de la photographie: Peintres et photographies en dialogue avec leur propre image*, ed. Erika Billeter, Musée cantonal des Beaux-Arts, Lausanne, 1985, p. 16.

24 Robert Fernier, *La vie et l'œuvre de Gustave Courbet, Catalogue raisonné*, Geneva 1977.

25 1988–89 Paris/Ottawa/New York, p. 61, numbers 15 self-portraits ("Lemoisne en catalogue douze; Brame et Reff en ajoutent trois"). The following Lemoisne numbers are self-portraits: L2, 3, 4, 5, 11, 12, 13, 14, 17a, 31, 32, 37, 51, 103, 104, 105, 116.

26 Fernier 1977 (see note 24), p. 12, cat. 20.

27 *Ibid.*, p. 16, cat. 27.

28 *Ibid.*, p. 24, cat. 39–41.

29 *Ibid.*, p. 28, cat. 46, 47.

30 *Ibid.*, p. 32, cat. 51.

31 Loyrette 1991, pp. 55ff.

32 Reff 1969, vol. II, p. 281f.

33 About twenty years after Degas Cézanne copied the same picture; see Götz Adriani, *Paul Cézanne, Zeichnungen*, Cologne 1978, p. 256 (incl. fig. of the painting by Bacchiacca).

34 The most significant exception in this respect is in Titian's self-portrait in old age in the Prado

19

Self-portrait ('*Degas au chapeau mou*')
1857–58
Oil on paper, mounted on linen
26 × 19 cm
Williamstown (Mass.), Sterling and Francine Clark Art Institute (L37) [right]

Rembrandt van Rijn
Self-portrait
1629
Oil on canvas
15.5 × 12.7 cm
Munich, Bayerische Staatsgemäldesamm-lungen [left]

Francisco de Goya y Lucientes
Self-portrait
ca. 1773
Oil on canvas
58 × 44 cm
Private collection [below left]

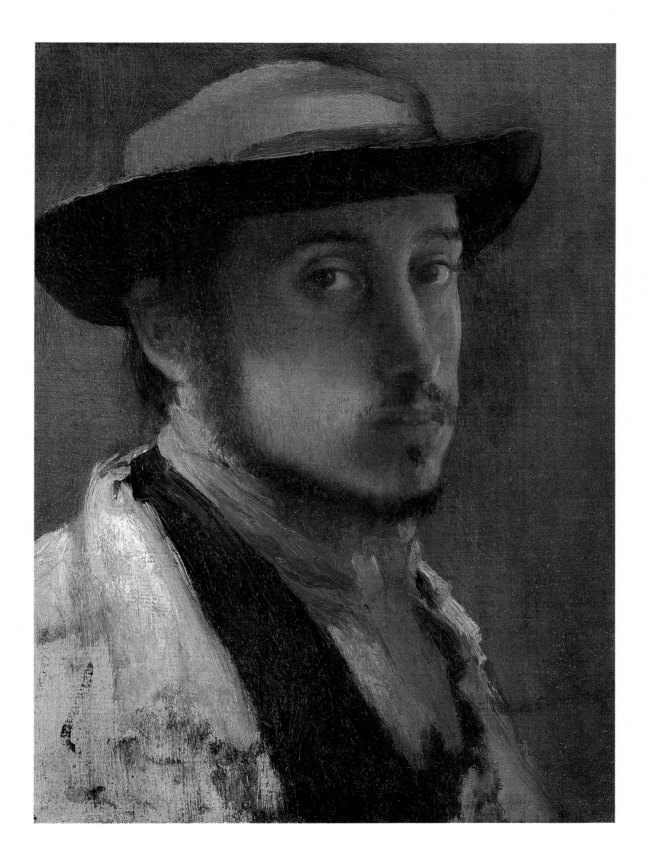

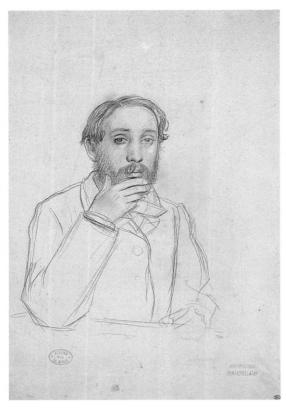

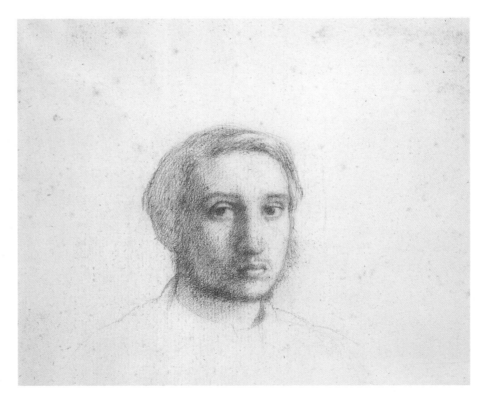

82
Self-portrait, ca. 1865, pencil on paper,
36.5 × 24.5 cm, Paris, Musée du Louvre,
Département des Arts Graphiques, Fonds du
Musée d'Orsay (RF 24232)

25
Self-portrait with studies of detail, ca. 1857, pencil,
15.3 × 23.2 cm, Mr and Mrs Eugene V. Thaw

24
Self-portrait, ca. 1857, pencil, 15.7 × 18.3 cm,
Mr and Mrs Eugene V. Thaw

3
Self-portrait, ca. 1854, pencil on paper, 32.5 × 24.5 cm, private collection

(see note 4). Rembrandt and Courbet, the most versatile and theatrical presenters of themselves, more than once adopted the profile view.

35 See also in this connection Alfred Neumeyer, *Der Blick aus dem Bilde*, Berlin 1964, in particular pp. 68ff.

36 1988 Tokyo, no. 2.

37 Enzo Carli, *Il Pintoricchio*, Milan 1960, pl. 30; detail of the youth copied by Degas, pl. 34.

38 BR 4–6.

39 Armstrong 1991, p. 226.

40 Boggs 1962, pls. 11, 12; 1988–89 Paris/ Ottawa/New York, p. 61; Armstrong 1991, pp. 226–27.

41 Loyrette 1991, p. 61.

42 Lemoisne II, no. 5.

43 1988–89 Paris/Ottawa/New York, p. 61.

44 On the sketch and French terminology of the sketch see Werner Busch, *Die notwendige Arabeske*, Berlin 1985, pp. 256ff.

45 On the "eye" and "sight" in the Williamstown self-portrait see Armstrong 1991, pp. 231ff.

46 The fall of light is not identical: in the picture his forehead is lit from the left, in the drawing from the right.

47 1988–89 Paris/Ottawa/New York, p. 71.

48 *Self-portrait as a soldier*, 1915, Oberlin, Ohio, Allen Memorial Art Museum.

49 *Selfportrait with death (with cut-off right hand)*, 1872, Berlin, Nationalgalerie.

50 *My portrait in the year 1960*, 1888, etching.

51 *Wilhelm Tell (Self-portrait)*, 1897, Solothurn, Kunstmuseum (see Jura Brüschweiler in 1979 Basle (see note 10), p. 81: "Wilhelm Tell ist ein verhülltes und stark stilisiertes Selbstbildnis"), and *Last self-portrait*, 1918, Geneva, Musée d'Art et d'Histoire.

52 One may simply compare the two self-portraits in the Zurich Kunsthaus, *Self-portrait with a model*, 1903, and *Last self-portrait*, 1925.

53 See exhibition catalogue *Richard Gerstl*, Vienna, Kunstforum/Zurich, Kunsthaus 1993–94, cat. 4, 68.

54 See exhibition catalogue *Egon Schiele und seine Zeit*, Vienna/Zurich 1988–89, cat. 5, 6, 9, 10 (*Self-portrait grimacing bitterly*, 1910), 19, 24.

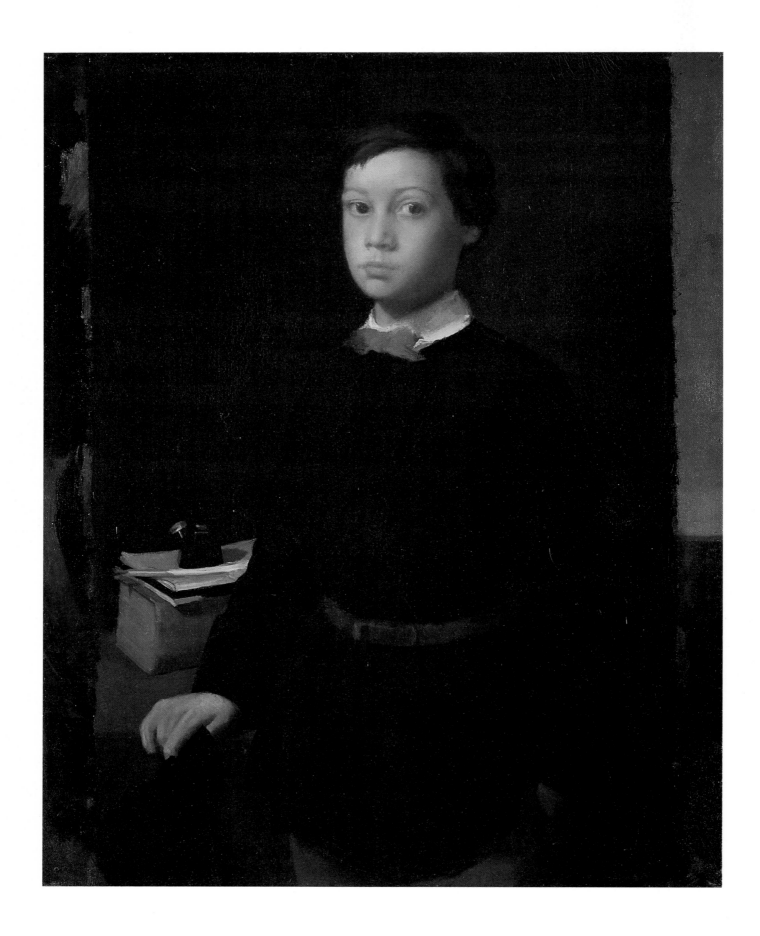

Family Portraits

TOBIA BEZZOLA

Degas started his career as a portraitist with copies after the classical painters, a series of self-portraits and by chronicling his own family. There were obviously pragmatic reasons for this: the young painter could not afford professional models, nor were commissions forthcoming from well heeled clients. But his preference was also more deeply rooted. Not only do the pictures of his closest relatives come at the start of Degas's career as a portraitist as regards time, they also form its affective core. As we know, even when he became successful Degas did not paint to commission. He had a personal relationship with all his models. All those he portrayed can be thought of as a circle, with Degas himself at the centre, and the referential circles of his personal world disposed concentrically around him.

Of course his family occupies the most favoured position, especially as he himself never founded a family of his own. As a bachelor he remained closely attached to his brothers and sisters throughout his life. There were differences of opinion, but they in fact demonstrate the sense of responsibility the painter felt for his younger brothers and sisters. They were always the people closest to him. His portraits began logically within the family circle which widened as Degas on his travels made portraits of his Italian relations and later his American ones. In these works he acquired his vocabulary; interestingly enough this no longer seemed appropriate for depicting those closest to him when his development was complete: there are very few family portraits in Degas's mature style. They were a means whereby Degas was able to work his way out into the world. The way of looking at his fellow men he developed in the process seems increasingly to have excluded what was most private to him as a subject area.

59
René De Gas
1861–62
Etching
8.7 × 7.2 cm
Private collection

7
René De Gas
1855
Oil on canvas
91.5 × 74.9 cm
Northampton (Mass.), Smith College of Art
(L6)

René De Gas, Achille De Gas, Marguerite De Gas

Degas spent the years 1856–59 in Italy. He painted portraits of his brothers and sisters immediately before this long study tour and in the period following it. The year 1855 was crucial. Degas was admitted to the Ecole des Beaux-Arts, met Ingres whom he regarded as a model, and painted his first two masterpieces: the self-portrait with a port-crayon (cat. 8, illus. p. 165) and the portrait of his brother René (cat. 7, illus. p. 174). René who was born in 1845 was the youngest of the family. The ten-year-old boy must have stood patiently as a model for his painter brother after school day after day. Degas shows René in a solemn pose: the fat dictionary, exercise books and ink bottle and his uniform turn him into a representative of his social class; his gaze is serious in front of a dark background, and his bearing is distinguished and slightly melancholic. The expression is reminiscent of many of Degas's self-portraits, but the early paintings of his sisters Marguerite and Thérèse also reveal the same vein of sadness. The picture clearly shows that Mannerist portraits of young men, by Bronzino in particular, were making an impression on Degas at that time as well as his great idol Ingres. Degas never painted his youngest brother again, and for a time all contact between the two was even broken off. René had tried to make a career for himself in the United States in the cotton industry; he moved to New Orleans where he married one of his cousins, Estelle Musson. In 1878, abandoning his wife, who had lost her sight, and his children, he ran off with his mistress, who was also a married woman, to France where he subsequently worked as journalist. It was years before Degas could forgive his brother for his behaviour and renew contact with him. One of Degas's photographs shows us René in 1900 as an uncertain, weak, old man.

Achille De Gas who was born in 1838 also

13
René De Gas
ca. 1855
Black chalk on paper
34.6 × 28 cm
The Art Institute of Chicago

14
René De Gas
1855–56
Pencil on brown paper
36.2 × 29.2 cm
London, Colnaghi Drawings

5
Marguerite De Gas
1854
Chalk on watercolour paper
29.3 × 23.8 cm
Stuttgart, Staatsgalerie, Graphische Sammlung
[right]

39

Marguerite De Gas, study for cat. 36, 1858–60, pencil on paper, 28.2 × 20.8 cm, Paris, Musée du Louvre, Département des Arts Graphiques, Fonds du Musée d'Orsay

56

Marguerite De Gas, 1860–62, etching and drypoint, 12.5 × 11 cm, Boston, Museum of Fine Arts, Katherine E. Bullard Fund in Memory of Francis Bullard

led an unstable life, far removed from the bourgeois solidity Degas always admired. His career in the navy came to an abrupt end because of disciplinary problems. He then tried his luck with René as a businessman in New Orleans, returning to France as a soldier in 1871. Four years later he fired a shot at his mistress's husband in front of the Bourse in Paris, for which he was condemned to six months' imprisonment. He spent the rest of his life in Geneva. Degas never forgave his brother for the scandal, and had very little further contact with him up to the time of Achille's death.

Degas's portrait of Achille dates from the late 1850s (L30, Washington, National Gallery, see illus. p. 103). The young man in his naval uniform poses proudly, even looking a little blasé. In his only superficially relaxed expression we can detect the arrogance and lack of control which were later to do him so much harm.

Degas's sensitive, intelligent sister Marguerite, born in 1842, with her regular features was one of his favourite models. He did several portraits of her before leaving for Italy (BR 24, 25, 26). Most of them were studies of her head in profile or three-quarters view. The Stuttgart drawing (cat. 5, illus. p. 177) is linked with these works: the young girl gazes dreamily at the world, a little perplexed.

After his return from Italy Degas painted the two portraits of Marguerite which are now at the Musée d'Orsay in Paris (cat. 36, illus. p. 179 and L61). The pose has altered decisively: gone are the Raphaelite attitude and the dark tone. Marguerite now faces the viewer frontally without theatricality in an even, bright light; the drawing which shimmers through still has classical strictness, while the light, loose, sketch-like application of colour attests to a new painterly concept. Marguerite who had trained as a singer married the architect Henri Fevre in 1865, later emigrating with him to Buenos Aires where she died in 1895.

38

Marguerite De Gas, study for cat. 36, 1858–60, pencil on paper, 28 × 20.8 cm, Paris, Musée du Louvre, Département des Arts Graphiques, Fonds du Musée d'Orsay

Marguerite De Gas
1858–60
Oil on canvas
80 × 54 cm
Paris, Musée d'Orsay (L60)

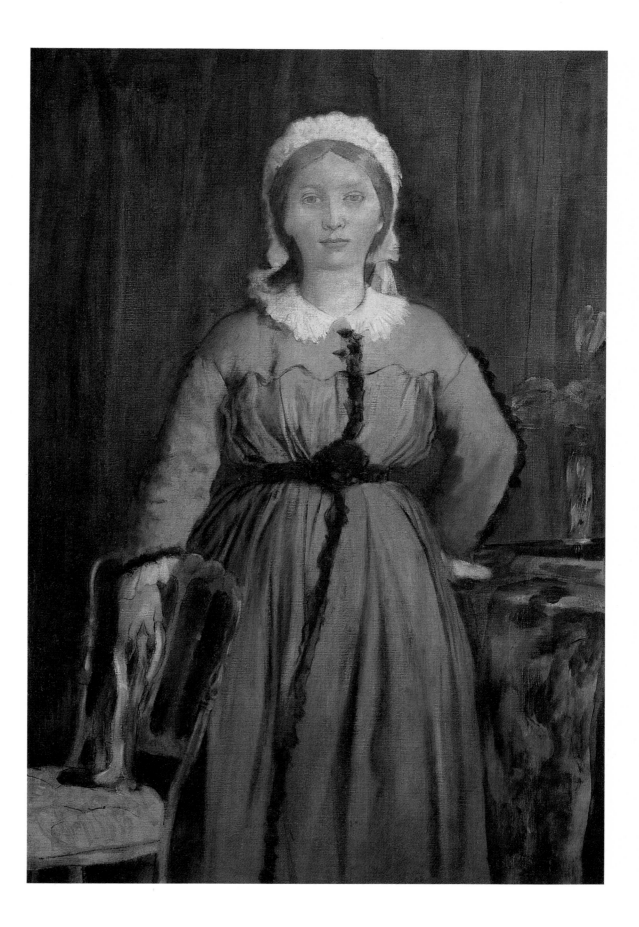

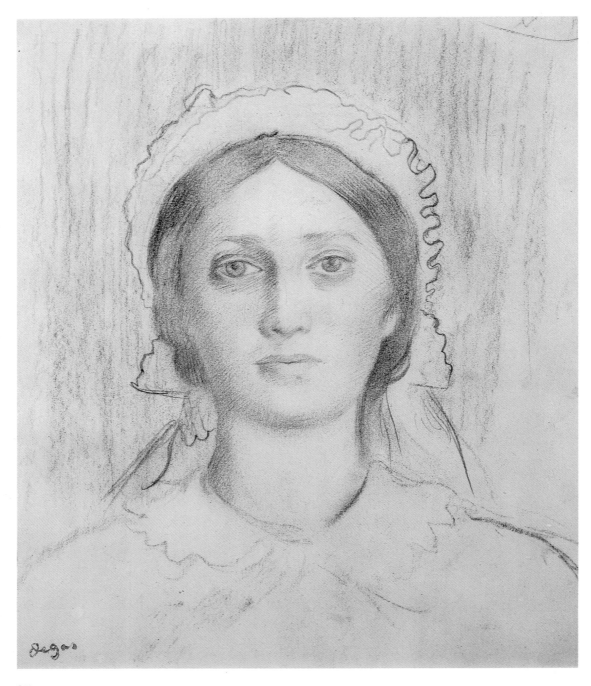

37
Marguerite De Gas, 1858–60, pencil and charcoal on paper, 31.4 × 26 cm, Private collection

96
Marguerite De Gas, ca. 1868, oil on canvas, 24.5 × 19 cm, Private collection (L185) [right]

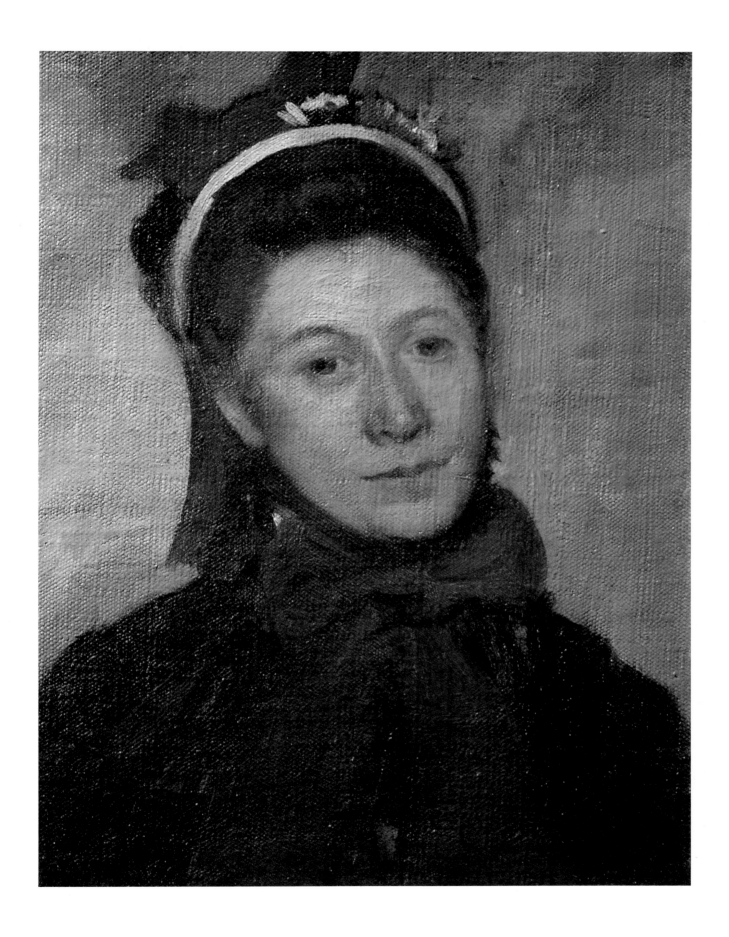

11
Thérèse De Gas
ca. 1855–56
Pencil on paper
28.5 × 23.6 cm
Cambridge, Fitzwilliam Museum

Mme Edmondo Morbilli (Thérèse De Gas)

Degas also made frequent portraits of the elder of his two sisters, Thérèse (born 1840). The beautiful pencil drawing now in Boston (cat. 10, illus.) and a mutilated oil painting (BR 27) have been preserved from the period before he went to Italy. The portraits mark the stages of her life from bride (L109, Paris, Musée d'Orsay; illus. p. 103) to young married woman expecting her first child (L131, Washington, National Gallery; illus. p. 23) to mature married woman (cat. 76, illus. p. 183). At the end of the decade Degas shows his sister once more alone, without her husband, her features shadowed by resignation (L255, private collection, see illus. p. 104).

The Morbilli family portrait now in Boston (cat. 73, illus. p. 185) occupies an important position in Degas's work. The artist breaks away from compositional and painterly conventions, allowing himself to make subtle, but definite comments on his sitters. He contrasts Edmondo Morbilli's hard, disdainful gaze with his sister's perplexed bearing, looking for protection while at the same time keeping her distance. Material hardship and childlessness caused problems in the marriage; while Degas does not dramatize the tensions, neither does he draw a veil over them.

Edmondo Morbilli, a cousin of Degas and his brothers and sisters, was a son of Rose Adelaide Degas, born in 1805. She had lost her husband Don Giuseppe Morbilli in the upheavals associated with the 1848 Revolution. In 1857 Degas also painted a portrait of his aunt, standing full-face in front of a wall mirror; except in the portraits of Marguerite he virtually never used this pose again.

12
Thérèse De Gas
1855–56
Pencil on paper
28.4 × 23.4 cm
Paris, Prat collection

10
Thérèse De Gas
1855–56
Pencil on paper
32 × 28.4 cm
Boston, Museum of Fine Arts, Julia Knight Fox Funds

76
Mme Edmondo Morbilli
(Thérèse De Gas)
ca. 1865–66
Oil on canvas
37 × 29 cm
Private collection (L132)

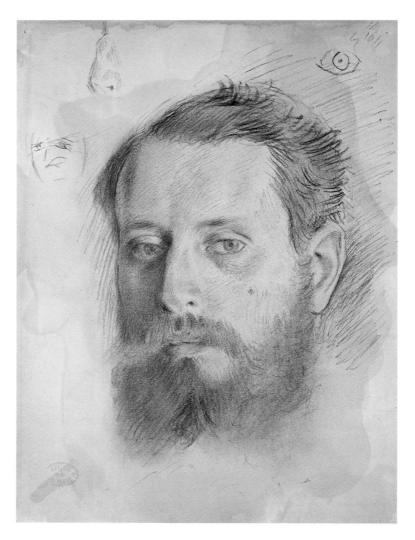

75
Mme Edmondo Morbilli, study for cat. 73, ca. 1865, pencil on paper,
35.2 × 23.3 cm, Paris, Musée du Louvre, Département des Arts
Graphiques, Fonds du Musée d'Orsay

74
Edmondo Morbilli, study for cat. 73, ca.1865, pencil on paper,
31.7 × 22.8 cm, Boston, Museum of Fine Arts, Julia Knight Fox
Funds

73
M. and Mme Edmondo Morbilli, ca. 1865, oil on canvas, 116.5 × 88.3 cm,
Boston, Museum of Fine Arts, Gift of Robert Treat Paine II (L164)

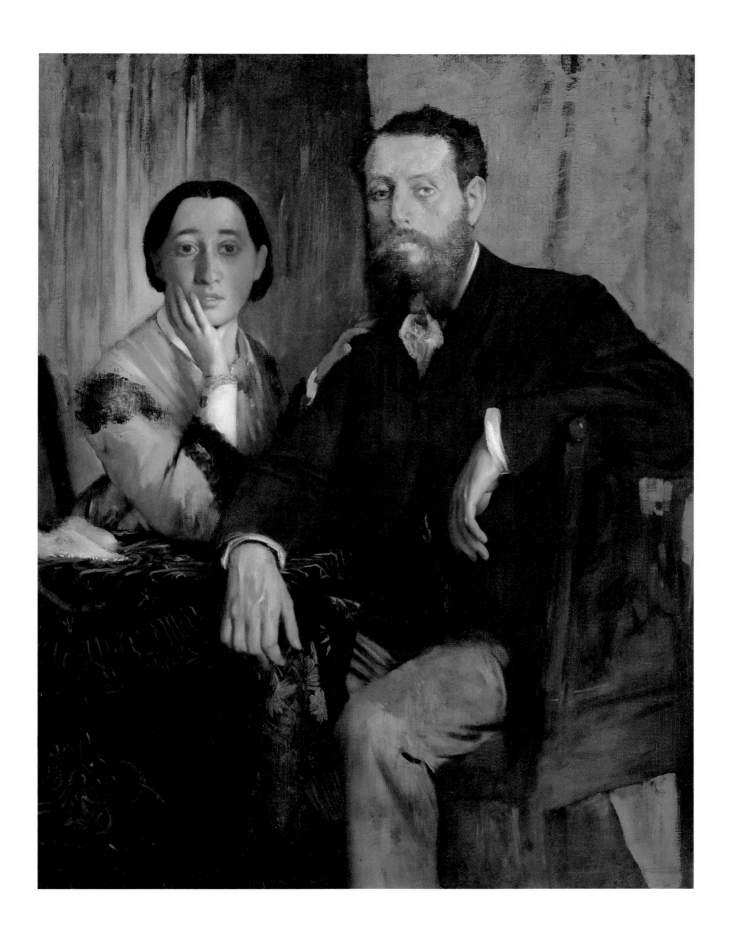

27
Rosa Adelaida Morbilli
1857
Pencil, black chalk, watercolour and body colour, black indian ink
35 × 18.6 cm
Mr and Mrs Eugene V. Thaw

Hilaire Degas

While in Naples Degas spent a lot of time with his grandfather. Hilaire Degas was born in Orleans in 1770, and had been working in the grain trade in Paris when the French Revolution forced him to flee from the city. He settled in Naples, in 1804 marrying Aurora Freppa who came from a respected, well-to-do family. Hilaire Degas built up a flourishing banking house and acquired a considerable fortune. During his second stay in Naples in 1857 Degas twice painted his grandfather in oils. One portrait (L33, Paris, Musée d'Orsay) shows him as a connoisseur of art examining an engraving. The second picture (cat. 20, illus. p. 187) is a classic interior portrait in the style of mid-nineteenth-century Salon painting, but there are also unmistakable undertones of Titian's portraits of popes. Correctly dressed and with a very alert bearing, his grandfather presents the dignified, severe appearance of a man who has founded a company and is head of the family. The picture passed straight into his grandfather's possession; we can assume that his grandfather commissioned it and that the traditional, rather stiff portrayal was also in line with his wishes and ideas.

26
Auguste De Gas, ca. 1857, pencil on paper, 31.7 × 24.7 cm, Private collection

18
Hilaire Degas
1856
Etching and drypoint
24.6 × 16.6 cm
Washington D.C., National Gallery of Art, Rosenwald Collection

20
Hilaire Degas
1857
Oil on canvas
53 × 41 cm
Paris, Musée d'Orsay,
Don de la Société des
Amis du Musée du
Louvre, 1932 (L27)

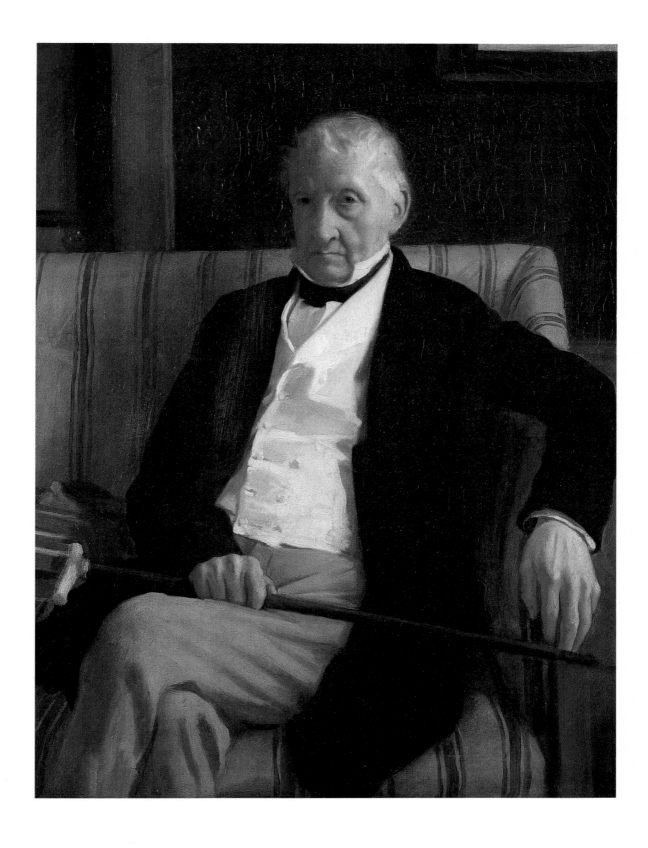

40
The Bellelli family, 1858–59, pastel, gouache and pencil on paper, 55 × 63 cm,
Copenhagen, Ordrupgaardsamlingen (L64)

The Bellelli family

In the autumn of 1858 Degas travelled from Rome to Florence to visit his Aunt Laura. After the uprising in 1848 she had been obliged to leave Naples with her husband, the polemicist Gennaro Bellelli. Their exile took them to Marseilles, London, Paris, Turin and finally Florence. Degas stepped into a tense situation. His forced inactivity and material difficulties weighed heavily on Gennaro Bellelli; her husband's downcast mood and tormented behaviour caused Degas's aunt to suffer from repeated bouts of depression, as many letters attest.

Shortly after his arrival Degas – who did not get on with Bellelli, but developed a great liking for his aunt and cousins – conceived the plan of a family portrait of the Bellellis. He was quite ambitious about the project: it was to be not merely a portrait but a proper picture ("un tableau"), helping him achieve success in the Paris Salon. He started the many preliminary studies with double portraits of his two cousins, but later seems to have decided on a portrait of Laura Bellelli with her two daughters. When he left Italy in 1859 Edgar took a lot of drawings back with him to Paris. A year later he returned briefly to Florence, when he obviously made sketches of Gennaro Bellelli as well. Once back in Paris, Degas must have tackled the final composition but presumably the picture was not completed until 1867. It was exhibited in the Salon that year, though it did not bring Degas the recognition he had hoped for.

The Bellelli family occupies a key position in Degas's work. Most commentaries on it rightly emphasize the psychological subtlety and the sense of everyday misery in marriage and of family drama with which Degas counterbalances the formal pose. With this picture Degas takes leave of his early portraits: the interest shifts from the stylised setting to the close-to-life situation. The group with Laura Bellelli and her daughters still respects the formal traditions

43

Giovanna Bellelli
Study for *The Bellelli family*
1858–59
Pencil on paper
32.6 × 23.8 cm
Paris, Musée du Louvre,
Départment des Arts
Graphiques, Fonds du
Musée d'Orsay

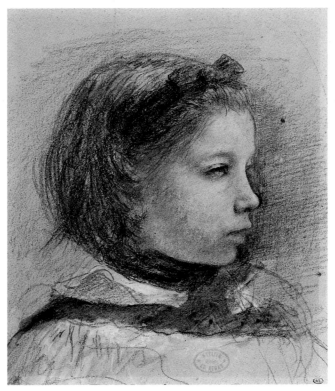

44

Giulia Bellelli
Study for *The Bellelli family*
1858–59
Pencil, oil, white
heightening on paper
23.4 × 19.6 cm
Paris, Musée du Louvre,
Départment des Arts
Graphiques, Fonds du
Musée d'Orsay

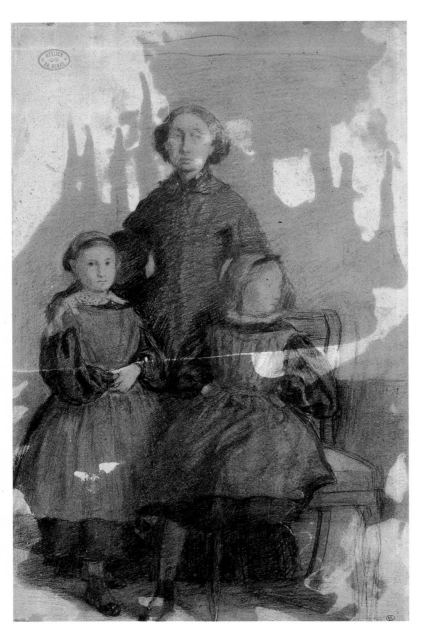

46
Laura Bellelli and her two daughters, study for *The Bellelli family*, 1858–59, pencil
and dilute oil paint on paper, 43 × 27.5 cm, Paris, Musée du Louvre,
Département des Arts Graphiques, Fonds du Musée d'Orsay

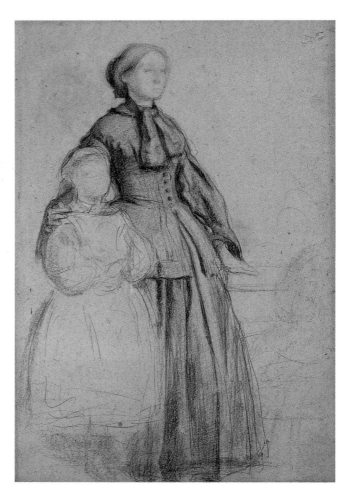

49
Laura Bellelli and her daughter Giovanna, ca. 1858, black Conté
crayon, traces of white heightening, on paper, 42.3 × 29 cm,
Private collection

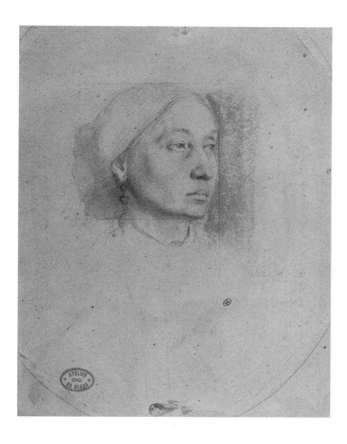

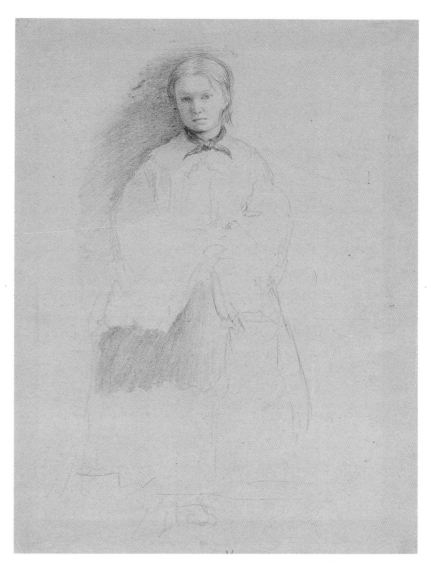

41
Laura Bellelli, study for *The Bellelli family*, 1858–59, pencil and pastel on paper, 26.1 × 20.4 cm, Paris, Musée du Louvre, Département des Arts Graphiques, Fonds du Musée d'Orsay

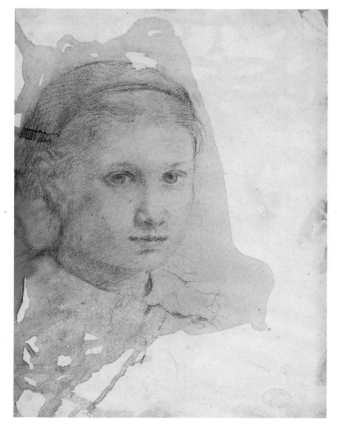

47
Giovanna Bellelli, study for *The Bellelli family*, ca. 1858, black Conté crayon on blue paper, 31.5 × 24 cm, Private collection, Zurich

48
Giovanna Bellelli, study for *The Bellelli family*, ca. 1858, Conté crayon or charcoal on paper, gone over with shellac, 32.1 × 23 cm, Private collection, Zurich [left]

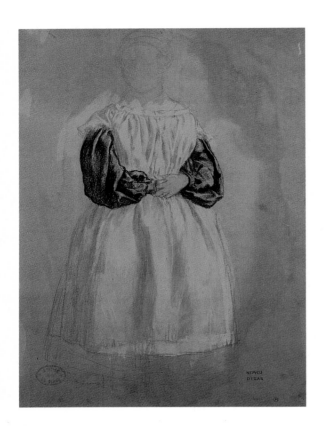

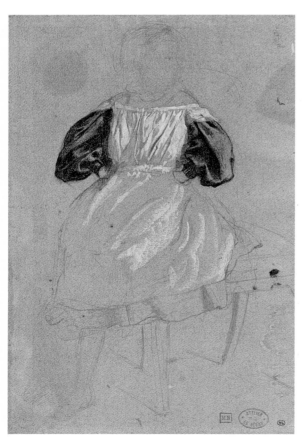

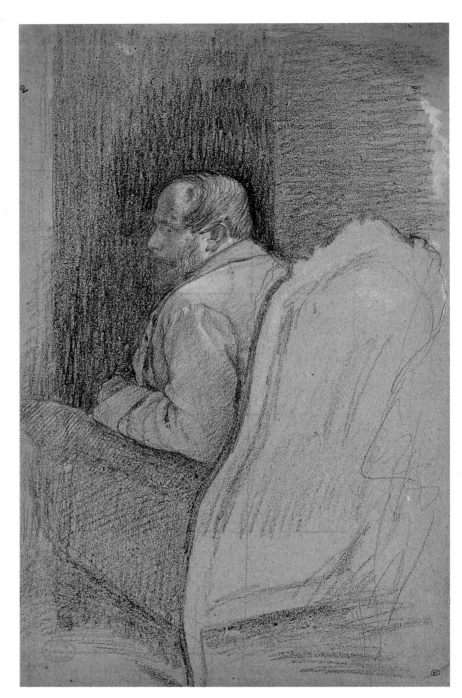

42

Giovanna Bellelli, study for *The Bellelli family*, 1858–59, pencil, black chalk and gouache on paper, 29.5 × 21.8 cm, Paris, Prat collection

45

Giulia Bellelli, 1858–59, study for *The Bellelli family*, pencil, charcoal and white heightening on paper, 31.4 × 21.2 cm, Paris, Musée du Louvre, Département des Arts Graphiques, Fonds du Musée d'Orsay [left]

Gennaro Bellelli, study for *The Bellelli family*, ca. 1860, charcoal, heightened with body colour, on paper, 44.7 × 28.4 cm, Paris, Musée du Louvre, Département des Arts Graphiques, Fonds du Musée d'Orsay [left]

52

Ulysse, 1859, pencil on paper, 30.8 × 23.3 cm, Private collection

50

Mlle Mathilde Dembowski, 1858–59, black chalk on pink paper, 40 × 28 cm, Private collection [above right]

of portrait painting. But then Gennaro Bellelli also intrudes abruptly into the picture; it is as if he were morosely watching his family as they pose for his painter nephew. The unposed everyday situation becomes the theme of the picture, and the classic portrait pose is elevated to the status of a picture: the pose is still integrated into the picture, but it is laid bare by Degas's indication of the actual psychological situation of which it forms a component. Laura Bellelli's sombre mien, Giovanna's embarrassment and Giulia's nervous fidgeting can also be explained only by this breaking of the frame. Obviously in setting out to paint more than a portrait Degas had discovered his own portrait style.

The small pastel version (cat. 40, illus. p. 188) must have been the final study: there are only differences of detail between it and the final, large picture in oils.

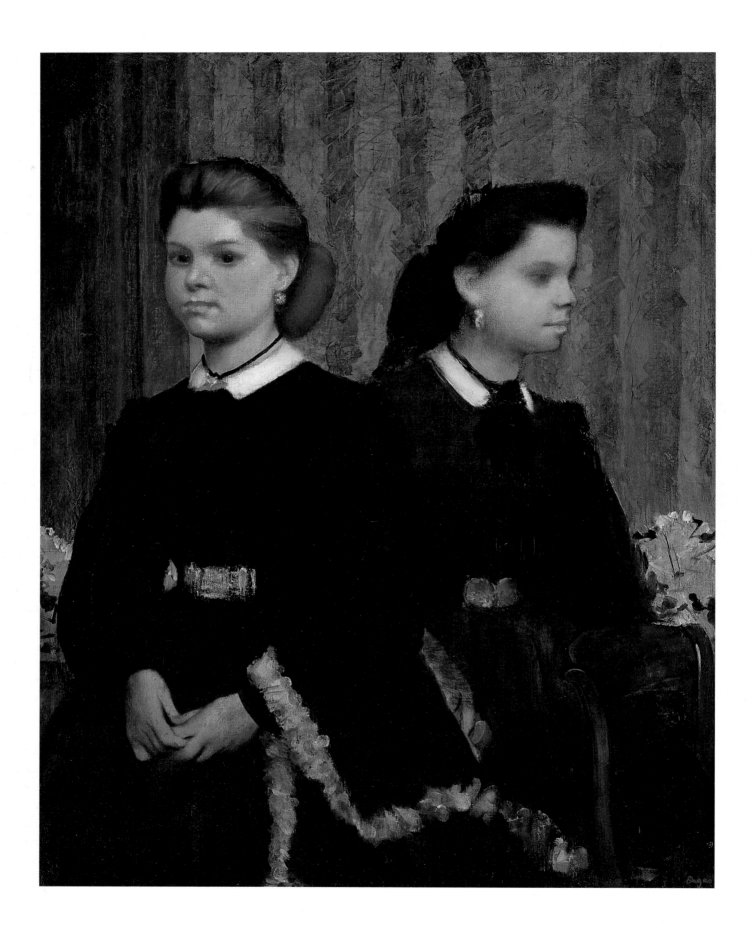

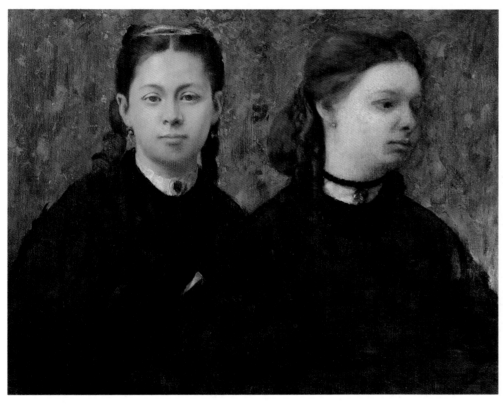

77

Elena and Camilla Montejasi Cicerale, 1865–68, oil on canvas, 58 × 75 cm, Hartford (Conn.),
Wadsworth Atheneum, The Ella Gallup Sumner and Mary Catlin Sumner Collection Fund
(L169)

78

Giovanna and Giulia Bellelli ('*Deux sœurs*'), ca. 1865–66, oil on canvas, 92 × 73 cm, Los Angeles
County Museum of Art, Mr and Mrs George Gard De Sylva Collection (L126) [left]

The Duchess of Montejasi Cicerale and her daughters Elena and Camilla

As well as Rosa Adelaida Morbilli and Laura
Bellelli Edgar Degas had a third aunt in
Italy. Stefanina, commonly known as
Fanny, was the youngest of the three sisters.
She married a rich nobleman, Gioacchino
Primicile Carafa, Marchese di Cicerale and
Duca di Montejasi, so making a brilliant
match. Her daughter Elena was born in
1855, and Camilla followed two years later.
Their friendly contacts with their Parisian
cousin bore fruit: in the course of the years a
series of important portraits of the family
were painted. The earliest is Degas's double
portrait of the two sisters, Elena and Camilla
(cat. 77, illus.) which dates from between
1865 and 1868. The picture has strong simi-
larities with the one Degas painted of his
other two cousins, Giovanna and Giulia
Bellelli (cat. 78, illus. p. 194) at about the
same period. He inserted the two pairs of
sisters into similar compositional schemes.
While in the case of the Montejasi sisters we
see only the top half of the two bodies in
front of a neutral background which none-
theless suggests an outdoor situation, as
does the young women's clothing, in the
portrait of the Bellelli sisters we are looking
into a bourgeois interior. On the other hand
there is a startling resemblance in the rela-
tionship in which Degas places both pairs of
sisters with regard to one another. Both are
standing frontally, at slightly different
levels, with no mutual eye contact. In both
portraits one of the sisters seems to be on the
offensive, turned towards the world, while
the other seems to turn away with a with-
drawn expression.

In 1868 Degas made two portraits of
Elena and Camilla's mother, his Aunt Ste-
fanina. The two works are closely connected
and it can be assumed that the Cleveland
picture (cat. 98, illus. p. 196) was made as a
preliminary study for the whole-figure por-
trait (cat. 97, illus. p. 196). Like her sister
Laura Bellelli, Fanny too seems to have been

melancholy by nature. The fact, revealed by her dress, that she was obviously in mourning may have reinforced this characteristic. In any case as well as stoical resignation her expression still indicates a decided, almost domineering trait; in the group portrait painted in 1876 depicting her with her daughters (cat. 128, illus p. 197) this has given way to helpless grief.

In 1875, before this picture was painted, came Degas's portrait of his cousin Elena Carafa Montejasi Cicerale (cat. 120, illus. p. 198); it is not clear whether this was painted in Naples or on one of her visits to Paris. The young woman is sitting relaxed in a comfortable armchair, looking at the viewer curiously, slightly pertly, as if she had just been interrupted in her reading. The mood is happy and relaxed, spontaneous, familiar and casual, yet the fleeting impression gives an extremely concise character portrait.

The 1876 family portrait already mentioned (cat. 128, illus. p. 197) concludes Degas's preoccupation with the Montejasi-Cicerale family. The dignified wide format already indicates the situation of mourning. The Duchess of Montejasi Cicerale sits enthroned in the centre of the picture as a bitter, Neapolitan widow. Degas's aunt has changed since the portraits painted seven years earlier. A deep, inconsolable sadness dominates, her eyes gaze fixedly out of the picture through the viewer and beyond. Degas has placed her two daughters right at the left edge of the picture; they do not appear really to share their mother's deep sorrow; they might even be playing a piano duet. Their gentle liveliness and Camilla's enquiring eyes are in sharp contrast with their mother's frosty stare.

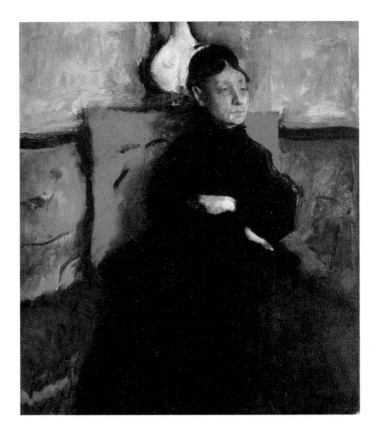

97
The Duchess of Montejasi Cicerale
ca. 1868
Oil on canvas
43.8 × 36 cm
Private collection
(BR 52)

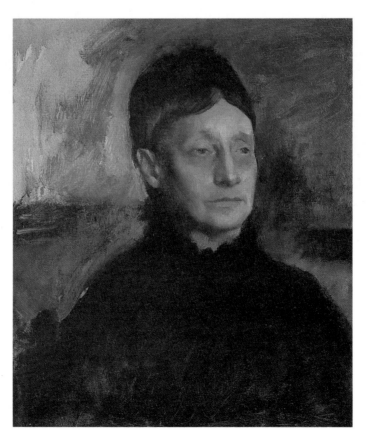

98
The Duchess of Montejasi Cicerale
1868
Oil on canvas
49 × 39.5 cm
Cleveland Museum of Art, Bequest of Leonard C. Hanna
(BR 53)

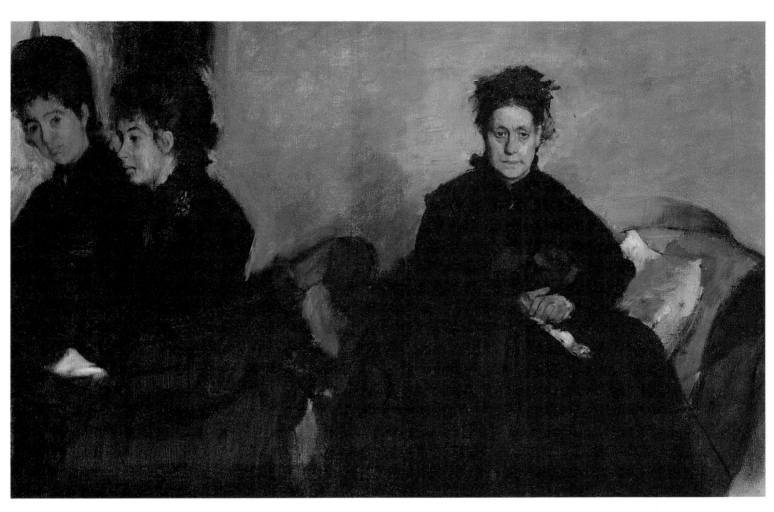

128
The Duchess of Montejasi Cicerale and her daughters Elena and Camilla, 1876, oil on canvas,
66 × 98 cm, Private collection (L637)

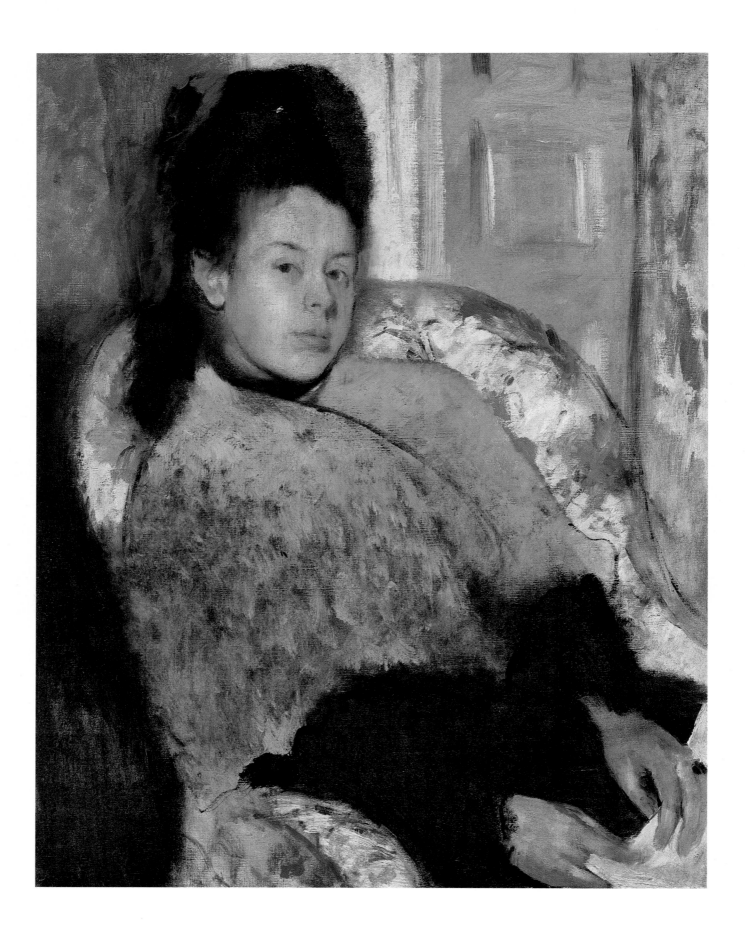

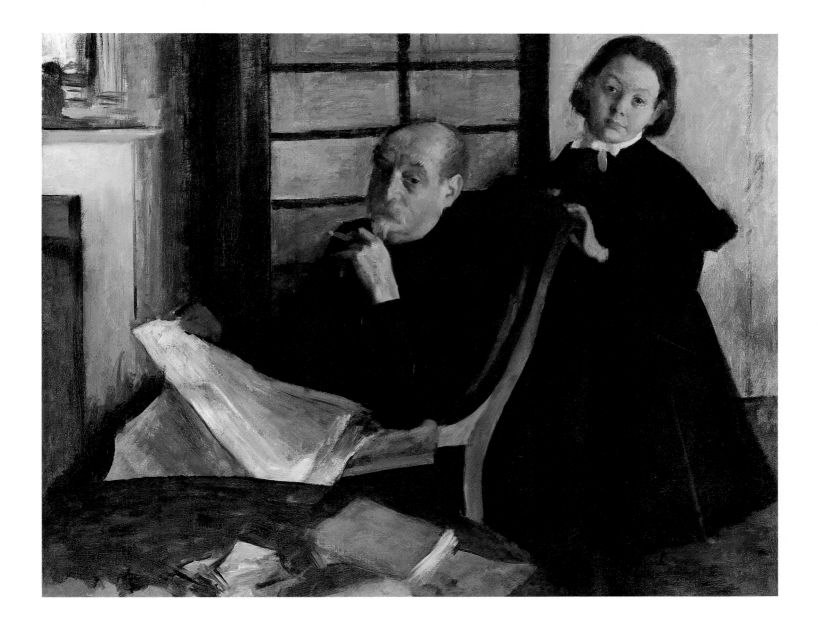

120
Elena Primicile Carafa di Montejasi Cicerale
1875
Oil on canvas
69.8 × 54.6 cm
London, National Gallery (L327) [left]

Henri and Lucie Degas
Edgar Degas's cousin Lucie, born in 1867, was the daughter of his Uncle Edouard. After her father's premature death his brother Achille became Lucie's guardian. But he too died in 1875 so that the young girl was placed under the protection of the last surviving brother, Henri Degas. Edgar Degas painted a portrait of Lucie and Henri in Naples (cat. 127, illus.); opinions differ as to the exact year. The very large picture is one of Degas's most mature and harmonious double-portrait compositions.

127
Henri Degas and his niece Lucie Degas
1876
Oil on canvas
99.8 × 119.9 cm
The Art Institute of Chicago, Mr and Mrs Lewis Larned Coburn Memorial Collection (L394)

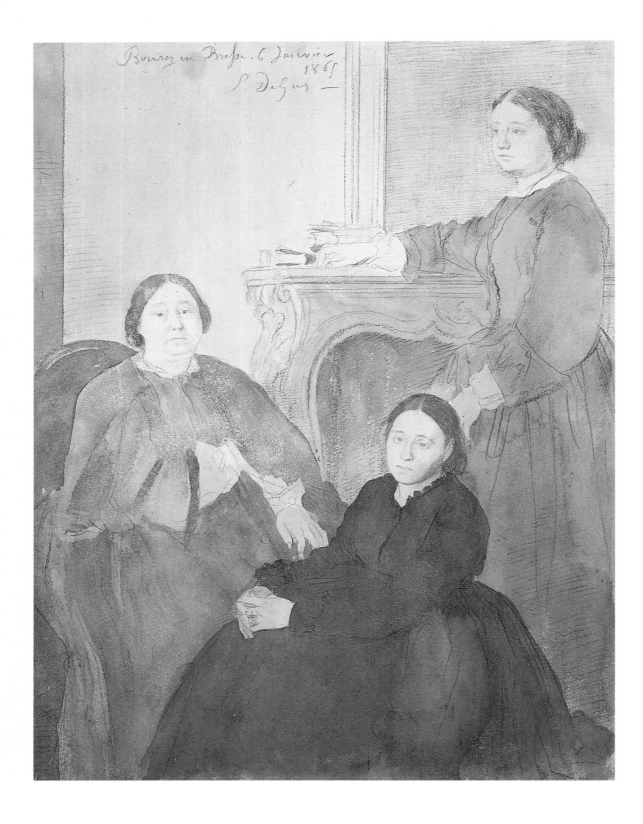

*Mme Michel Musson and her
daughters Estelle and
Désirée*
1865
Pencil and chalk and
wash, heightened with
white, on paper
35 × 26.5 cm
The Art Institute of
Chicago, Margaret Day
Blake Collection

The Musson family

Edgar Degas's mother, Célestine Musson, was born in New Orleans where her father, Germain Musson, had made a fortune in the cotton trade. In the 1830s he returned to France with his children, but one of his sons, Edgar Degas's uncle Michel Musson, was soon drawn back to Louisiana where he continued to manage his father's business affairs. He and his wife Odile née Longer had seven children only three of whom survived: Désirée, Mathilde and Estelle.

In 1863 the American Civil War led Odile Musson to seek refuge in France with two of her daughters, Estelle and Désirée. After spending a short time in Paris they settled in Bourg-en-Bresse where Degas paid several visits to his American cousins and their mother as well as making a portrait of the three women at the beginning of 1865. He shows them as a unified group, as if their difficulties had driven them still closer together; they are posing for their portraits, but their worry is constantly threatening to break through the attitudes adopted. Mme Michel Musson is sitting in a chair in front of the hearth with Estelle dressed in mourning at her feet. Estelle's husband Joe Balfour had been killed a short time previously at the Battle of Corinth. On the right we see Estelle's sister Désirée standing, leaning on the mantelshelf; she is the only one who seems to look towards the future with any confidence.

During their stay in France Degas's brother René in particular was in close contact with the three women. His incipient love for Estelle and his desire to have a brilliant career in the New World led him to accompany the Mussons on their return home in 1865. René returned to Paris a year later, but only to persuade his brother Achille to go into the export trade in New Orleans with him. The two did in fact found the firm De Gas Brothers, Importers of Wine, shortly afterwards. In 1869 in New Orleans René De Gas married his cousin Estelle who had

113
Mathilde Musson Bell, 1872, pencil and yellow chalk on paper, 31 × 24 cm, Richard and Carol Selle, New York

meanwhile lost her sight. When René made a brief visit to Paris in 1872, Degas decided to go back to the United States with him. In October they both set out by steamer from the port of Liverpool and on arrival in New York went on to Louisiana by train. This journey overseas marks a break in Edgar Degas's life which is rather bereft of external experiences. The painter wrote innumerable letters telling his friends all about the New World opening before him. Meanwhile though he was certainly happy to see his brothers, uncle and other American relations, the hot, humid climate of the southern States, the harsh sun and cultural desert soon caused him to miss Paris and the peaceful orderliness of his bachelor life. Although the dazzling light of Louisiana affected Degas's eyes, forcing him to restrict his painting, some portraits of his relations were painted. Among them is the lovely pastel of his cousin Mathilde Musson Bell (L318, Copenhagen, Ordrupgaardsamlingen) standing fanning herself on the veranda of her parents' house, a dreamy southern belle.

The most important result of Degas's voyage to America artistically is the famous *Cotton office*, or, as Degas himself called it, "*Portraits dans un bureau (Nouvelle-Orléans)*" (cat. 114, illus. pp. 202–05), a group portrait that takes us into the business activity of a cotton market office. It is the only painting by Degas to have been purchased by a public collection in his lifetime (the museum of the city of Pau, where it still is). As a letter to his painting colleague Tissot indicates, Degas conceived the picture partly with an eye to possible buyers in the textile trade. This commercially speculative approach would also explain the poster-like wide-angle perspective and the picture's tendency towards genre painting, with its emphasis on detail and the cosily anecdotal. Even so, it is a group portrait and, as John Rewald was able to demonstrate, most of those in it can be identified. In the foreground we see Degas's

uncle Michel Musson teasing a sample of cotton between his fingers; behind him are his two sons-in-law, René De Gas reading a newspaper and William Bell sitting on the edge of the table. At the far left Degas's brother Achille is leaning casually against the wall, and at the far right we see the bookkeeper John Livaudais absorbed in the accounts. Finally, behind René De Gas on a stool we recognise James Prestidge, Michel Musson's business partner, wearing a beige jacket.

114 (detail): *René De Gas*

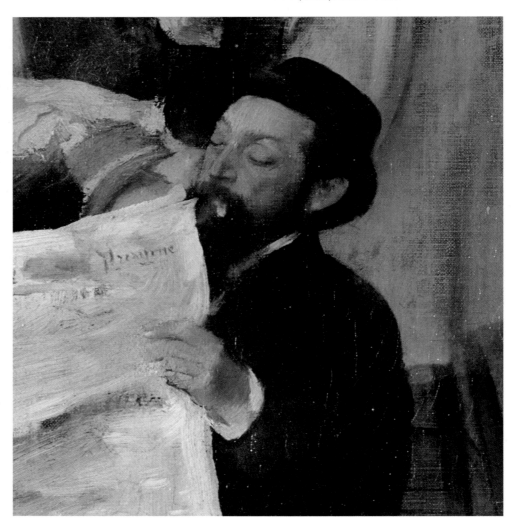

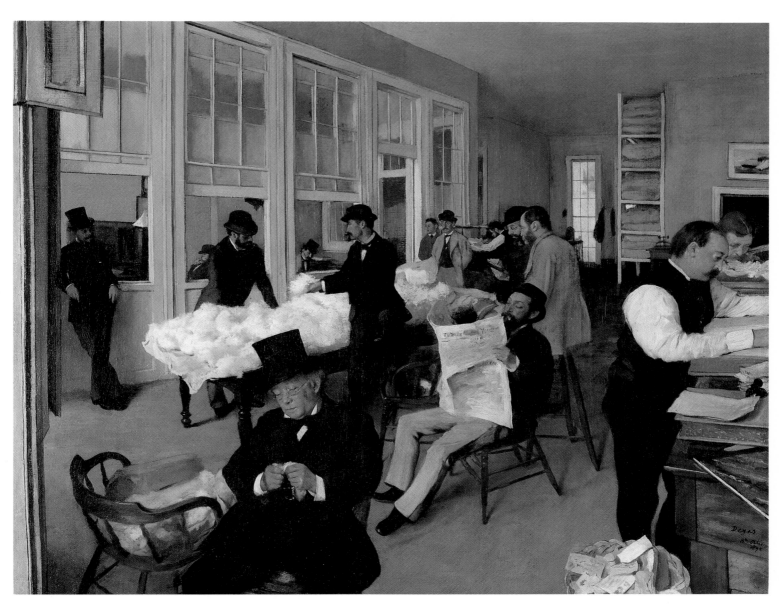

114
The cotton office ('Portraits dans un bureau (Nouvelle-Orléans)'), 1873, oil on canvas, 73 × 92 cm, Pau,
Musée des Beaux-Arts (L320)

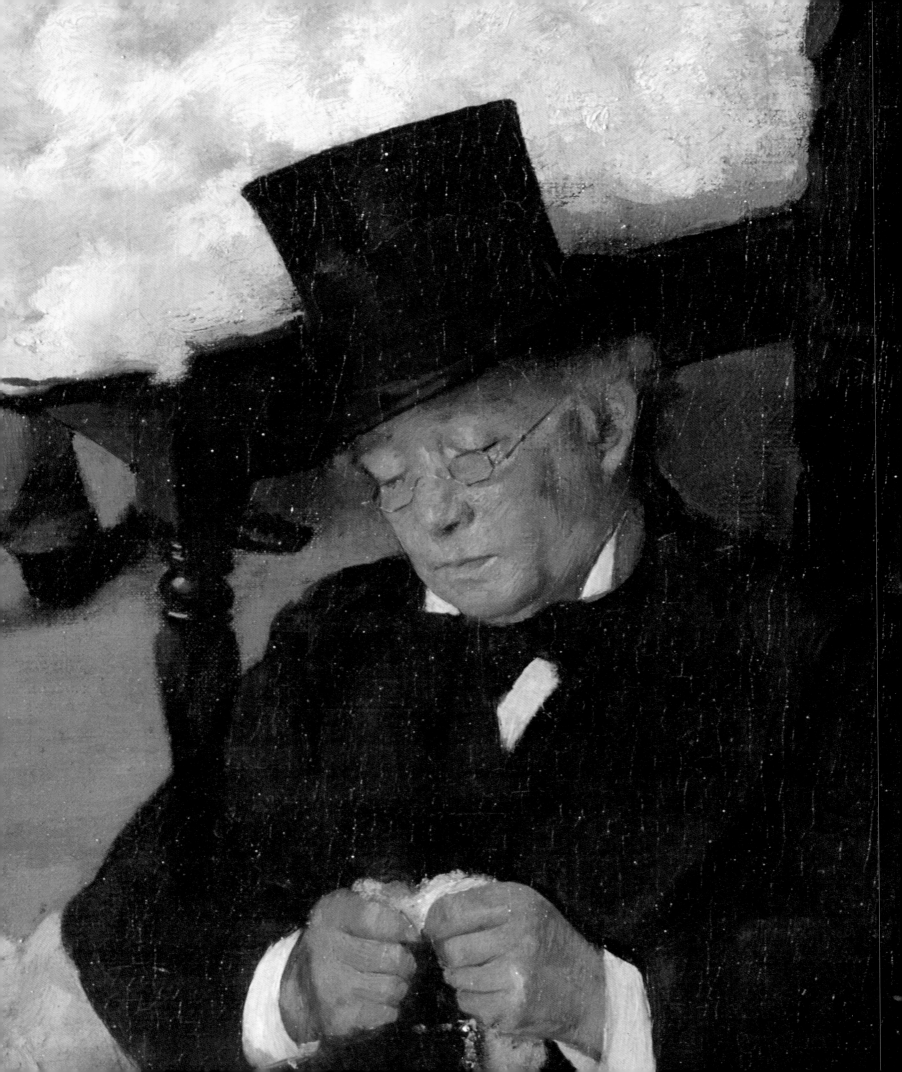

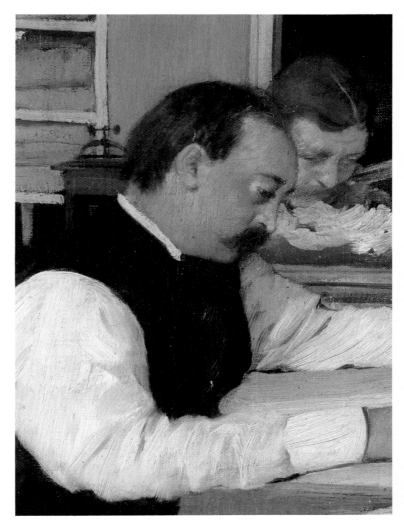

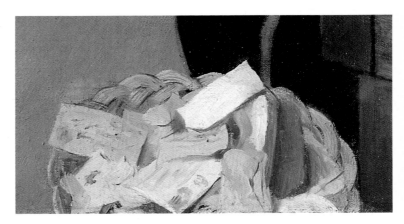

114 (detail): *Achille De Gas* [above]

114 (detail): *John Livaudais* [above, right]

114 (detail): *The wastepaper basket*

114 (detail): *Michel Musson* [left]

Friends and Acquaintances

TOBIA BEZZOLA

Degas's portraits of his friends and acquaintances often have the same private, intimate character as his family portraits. This may be because in the course of his life he attached himself to what might be termed substitute families – those of his friends Paul Valpinçon, Ludovic Halévy and Ernest Rouart. This attachment qualifies the widely held view (which appeared even during his lifetime) of Degas as a misanthropic recluse: the sarcastic loner was also perfectly happy sometimes to be an entertaining, good-natured uncle. Even after the death of his friends Rouart and Valpinçon, Degas remained loyal to their families, becoming a friend of their children and grandchildren and maintaining his relations with them until his death. The painter was glad to find relief in this way from a bachelor existence that he experienced, in his old age, as oppressive, lonely and bleak.[1]

It is significant that Degas's three closest friends, Valpinçon, Halévy and Rouart (the only people outside his family with whom he used the familiar 'tu' form of address) attended the Lycée Louis-le-Grand with him. They came from a similar background to Degas's own, and they, their wives and their circles of friends formed the nucleus of his social life and became subjects for his portraits. Accordingly, unlike his good friend James Tissot, who painted the rich, famous and powerful, Degas confined his portraiture largely to the social group to which he himself belonged. His understanding of his own milieu endows his portraits with a special power and veracity, so that the new, capitalist, positivist, industrial bourgeoisie of the period between the Second Empire and the Belle Epoque found its most potent portraitist in Degas, its own son. Degas knew from the inside the social life of these circles – the dinner parties and soirées, the drawing-room concerts and the outings to the opera, to the country. Better than anyone else he was able to record the special nature of that life without distortion, and without denunciation.

106 (detail)

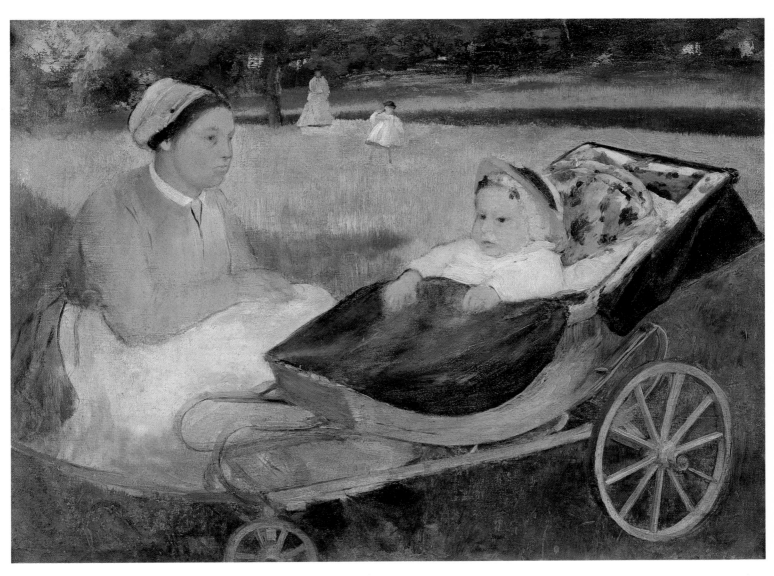

106
Henri Valpinçon as a child, 1870, oil on panel, 30 × 40 cm, private collection (L270)

The Valpinçon family

As mentioned above, Degas befriended Paul Valpinçon at the Lycée Louis-le-Grand. Paul's father, Edouard Valpinçon, was a great connoisseur and collector of art and a friend of Degas's father. Edouard Valpinçon made it possible for Degas in his youth to meet his great idol Ingres. Ingres had asked the collector to lend the picture now known as the Valpinçon *Bather* ('*La baigneuse Valpinçon*') for a large exhibition of his work to be held as part of the 1855 World Exhibition, but Valpinçon was afraid his favourite painting might be damaged and refused. Only Edgar Degas's passionate intercession made him change his mind, and subsequently Valpinçon called on Ingres, taking his young admirer with him. The meeting with Ingres made a lifelong impression on Degas; as an old man he still talked about the impact the laconic suggestions of the master had made on him.

On his return from Italy Degas renewed his friendship with Paul Valpinçon. In 1861 he started to make regular, sometimes extended visits to his château in the small hamlet of Ménil-Hubert in Normandy. Degas enjoyed the country life, the leisurely pace, and the landscape which reminded him of the England which he so loved; but if he so wished, he was also able to work. Valpinçon was himself an amateur painter and installed a small studio at Ménil-Hubert where Degas created several important works.

58

M. and Mme Valpinçon, 1861, pencil on paper, 34.4 × 25.6 cm, New York, Pierpont Morgan Library, Bequest of John S. Thacher

In 1861 Valpinçon married Marguerite-Claire Bringuant, a member of a prominent Parisian family, and Degas made a drawing of the couple that same year. Possibly intended as a study for a portrait of the newly wed couple (cat. 58, illus. p. 208), it still respects Ingres's authority in every regard, and is strongly influenced by his classic family pictures. This was the prelude to a whole cycle of portraits of the Valpinçon family and their friends. The first oil painting of Paul Valpinçon (cat. 94, illus.) dates from 1862, a study of the head which is still mainly conventional. In 1865 his friends inspired one of Degas's first masterpieces. As Henri Loyrette has proved, the picture known as *A woman with chrysanthemums* ('*La femme aux chrysanthèmes*'; illus. p. 88) depicts Mme Paul Valpinçon. The boldness of the asymmetrical composition, the psychological subtlety and the unorthodox combination of still life and portrait demonstrate how, in just a few years, Degas had matured into an original portraitist. We also know that the work *Carriage at the races* ('*Aux courses en province*'; L281, Boston, Museum of Fine Arts) depicts the Valpinçon family. Here Degas's love of England and English painting shines through. Paul Valpinçon is driving his tilbury home from an outing to the races; he turns round for a moment from the driving box to look at his wife and a nurse at the back of the carriage tending their newly born son Henri.

94
Paul Valpinçon, 1868–72, oil on canvas, 32.5 × 24 cm, private collection (L197)

Henri Valpinçon is at the centre of one of the most unusual portraits Degas ever painted. It shows a small child in his pram tended by a nurse, and in the background we see his mother and his sister Hortense (cat. 106, illus. p. 207). The atmospheric way in which the landscape is depicted gives the picture an Impressionist charm – it is one of Degas's few *plein-air* portraits. At the same time it is a realistic picture of a summer family scene. The nurse's stolid demeanour, the baby's helpless gaze and Degas's pleasure in the stylish pram which he places at the centre create a happy snapshot of domestic life.

It was Henri's sister Hortense, born in 1862, rather than Henri himself who was a particular favourite with Degas. She was the subject of one of his masterpieces (illus. p. 111), again in the early 1870s. The picture was painted at Ménil-Hubert, and shows the little girl in half profile leaning on a table; the slightly hovering, off-centre construction of the picture, the abundance of ornamental elements, the subtlety of the observation and Degas's fondness for Hortense give the picture a cheerful, cheeky freshness which the artist normally eschewed. Degas was Hortense's admirer throughout his life: reportedly he wept all day long when she married Jacques Fourchy in 1885. He jealously guarded the drawing he had made of her two years earlier (New York, Metropolitan Museum of Art): it is one of the few profile studies in his mature œuvre, and it hung in his studio for a long time .

Paul Valpinçon died in 1894. His relationship with Degas had already become a little less close as other friends had become more important, but even after Paul's death Degas visited Ménil-Hubert several times to see Hortense, retaining contact with her until his death.

60

M. Ruelle, ca. 1862, oil on canvas, 46 × 38 cm, Lyons, Musée des Beaux-Arts (L102)

Acquaintances

From the mid-1860s Degas associated with Edouard Manet and his circle. At the regular gatherings that took place at the homes of the Morisot family, Alfred Stevens or even Auguste Degas, there was generally also music: Mme Manet, the tenor Lorenzo Pagans, sometimes Degas's sister Marguerite or Mme Blanche Camus entertained the guests by playing and singing. Mme Camus, the wife of Gustave Emile Camus, a highly regarded doctor who was also well known as a great collector of porcelain and glass, was considered a talented musician. Degas made a portrait of Gustave Emile in 1868 (cat. 93, illus.) – a quite serious bourgeois portrait. Degas was especially fond of Mme Blanche Camus, however. An attractive, delicate woman, who reminded many people of the porcelain dolls her husband collected, she is at the centre of two of Degas's portraits. In 1869 Degas showed her at her piano (cat. 101, illus. p. 213). The open score, the pile of music to her left and the relaxed, yet energetic pose indicate his respect for her musical abilities. Degas painted her again a year later in a work now in Washington (illus. p. 90). The portrait, conceived and executed entirely in terms of light and atmosphere, bathes her completely in red: she sits in a red interior, wearing a red dress and holding a fan.

93
Le docteur Camus, 1868, oil on canvas, 40 × 32 cm, private collection (L183)

104
Mme Camus
Study for cat. 101
1869
Pencil on paper
35 × 22 cm
Private collection

102
Mme Camus
Study for cat. 101
Black chalk and pastel on
paper
43.5 × 32.5 cm
Zurich, Stiftung
Sammlung E.G. Bührle
[right]

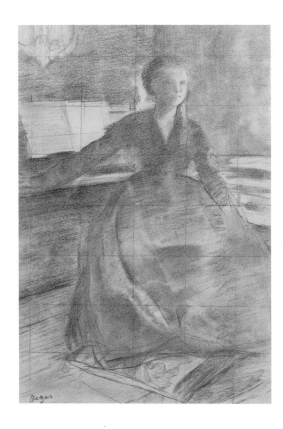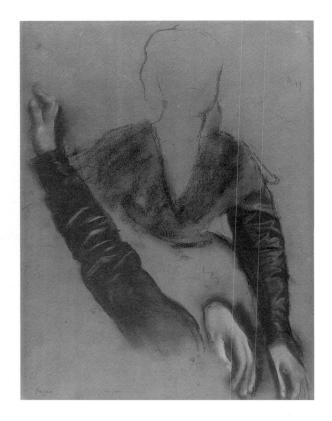

103
Mme Camus
Study for cat. 101
1869
Black chalk and pastel on
paper
32 × 43.5 cm
Zurich, Stiftung
Sammlung E.G. Bührle

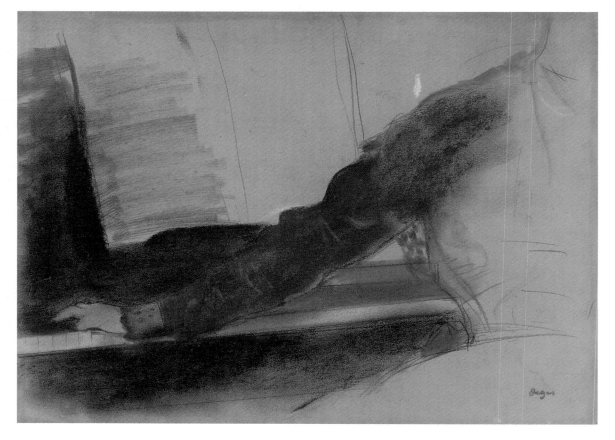

101

Mme Camus at the piano
1869
Oil on canvas
139 × 94 cm
Zurich, Stiftung
Sammlung E.G. Bührle
(L207)

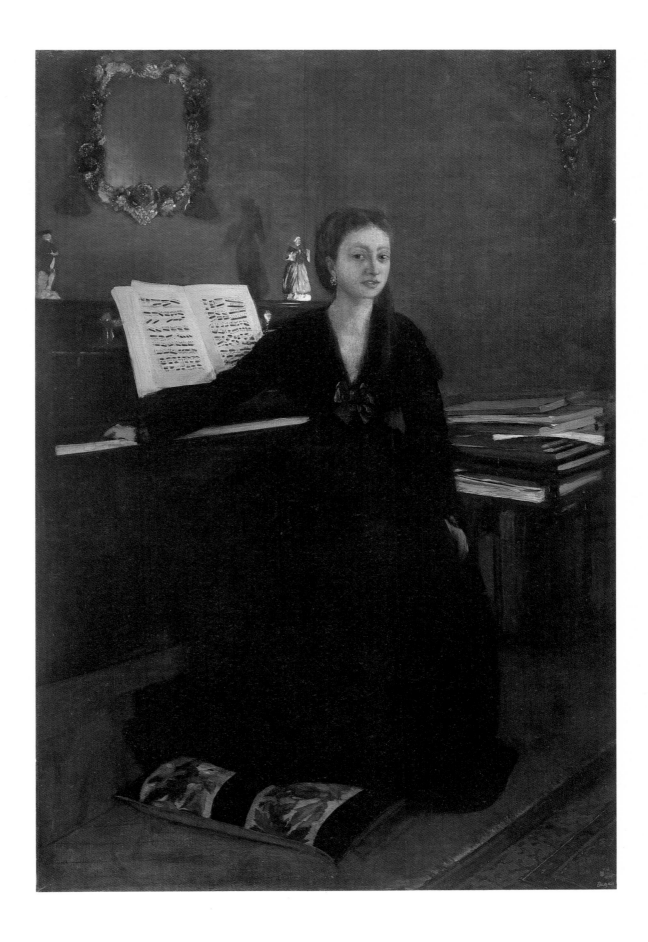

In 1871 the Prussians besieged Paris, and Degas was, like many others, conscripted into the Garde Nationale. He served in a unit commanded by his old friend Henri Rouart, to which three young Parisian industrialists, Charles Jeantaud, Pierre Linet and Edouard Lainé, also belonged. A month after demobilisation Degas painted the three friends (cat. 109, illus. p. 215). Now in civilian clothes, they allowed themselves to be portrayed as young bourgeois, possibly as a reminder of the time of the siege. On the left, Charles Jeantaud, a successful engineer who introduced the first electrical vehicle in Paris in 1881, is leaning on the table. In the foreground with a cylinder is Pierre Linet, who was a building materials merchant. Edouard Lainé, sitting on the armchair absorbed in his newspaper, was also an engineer, a manufacturer of sanitary equipment; he owned a considerable art collection. Degas shows the three young representatives of the industrial upper-middle class as cheerful and self-confident, pleased to have regained their civilian status.

Degas's double portrait of General Emile Mellinet and the chief rabbi Elie-Aristide Astruc (cat. 108, illus.) was equally a product of the war, although very little is known about the circumstances that gave rise to it. As chief rabbi of Belgium, Astruc came to Paris on a humanitarian mission in connection with the siege, organizing care for the starving population. He must then have met the general who was blockaded in the city with his troops. Degas combines the two very different men in a small-scale work which depicts them in bust-length, side by side against a neutral background.

A year after the group portrait of the three friends Jeantaud, Linet and Lainé had been painted, Charles Jeantaud married Berthe-Marie Bachoux and in the 1870s the couple formed part of Degas's regular circle of friends. *Mme Jeantaud before a mirror* (cat. 124, illus. p. 217) was one product of

the friendship. Degas shows the young woman in front of a mirror; she is obviously about to go out and is having a final look to check her dress and hair. We see only her profile directly, with her face in three-quarter view visible only in the mirror. There was a second portrait of Madame Jeantaud (cat. 135, illus. p. 216), made ca. 1877: here she is resting on a *chaise-longue* with two little dogs, looking straight at the viewer. The tone is fresh and matter-of-fact: Madame Jeantaud is neither idealised nor demonised – she is not one of the *rêveuses* so beloved at the time, and is certainly not a *femme fatale*. Degas concentrates his interest on the face, with everything else being suggested in a free, sketch-like manner.

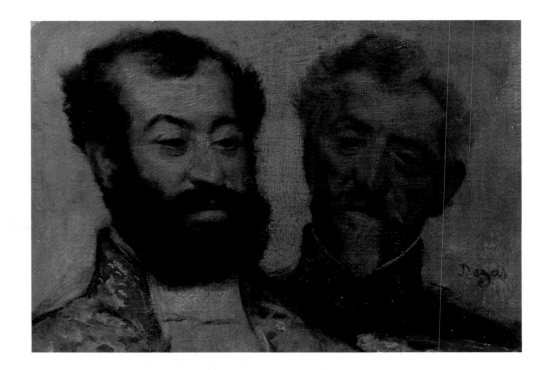

108
General Mellinet and Chief Rabbi Astruc
1871
Oil on canvas
22 × 16 cm
Gérardmer, Ville de Gérardmer (L288)

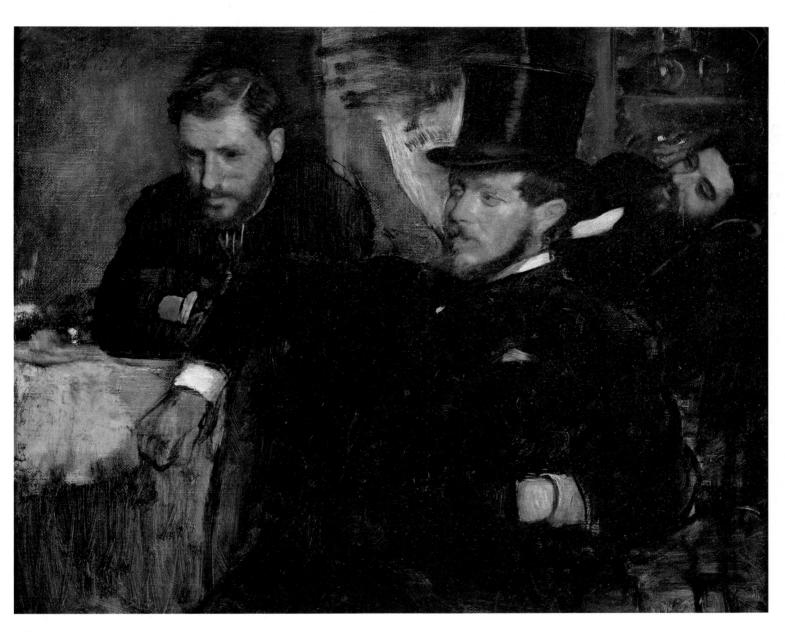

109
MM. Jeantaud, Linet and Lainé, 1871, oil on canvas, 38 × 46 cm, Paris, Musée d'Orsay (L287)

124
Mme Jeantaud in front of a mirror, ca. 1875, oil on canvas, 70 × 84 cm, Paris, Musée d'Orsay (L371)

135
Mme Jeantaud, ca. 1877, oil on canvas, 83 × 75.5 cm, Karlsruhe, Staatliche Kunsthalle (L440) [left]

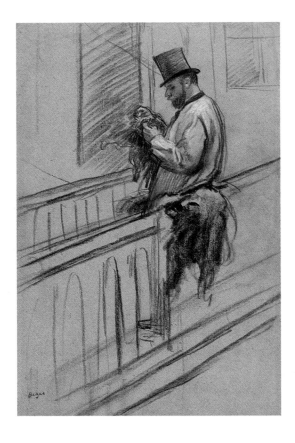

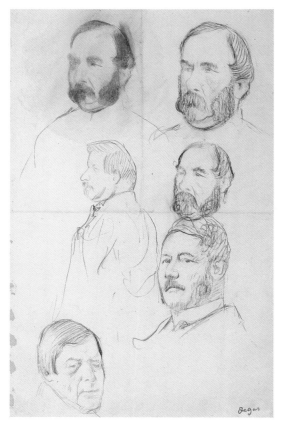

Madame Jeantaud was a cousin of another friend of Degas, vicomte Ludovic Lepic. A grandson of the famous General Lepic, he was a man of many talents. He undertook copper engraving and graphic work, designed costumes for the Paris Opéra, bred dogs, collected weapons, banners and curiosities of every kind and founded an archaeological museum in Aix-les-Bains. Lepic was also the inventor of a technique of image reproduction which he called 'eau-forte mobile'; Degas's own technique for monotypes was probably refined in collaboration with Lepic. Degas made several portraits of his eccentric, life-loving friend, showing him as an engraver busy working on a copper plate (L395, Nice, Musée Chéret) or – in a picture that was central to 'modern painting' – as a nonchalant man-about-town on the Place de la Concorde with a grey-hound, accompanied by his two daughters Eylau and Janine (368, currently held in a Russian museum; illus. p. 43). We also meet these girls in a portrait painted a little earlier, showing them presented by a proud Lepic (cat. 110, illus. p. 219). This painting is a quiet tribute to Velázquez, and further confirmation of Degas's gifts as a portraitist of children.

However, Degas did not regard only his closer friends as worthy of depiction; there are also many likenesses of fleeting acquaintances. Among these was the furrier Hermann de Clermont, brother of Auguste de Clermont, the horse painter and friend of Degas. Degas's drawing (cat. 150, illus. p. 218) shows Hermann de Clermont at work – he is obviously busy examining some pelts. Rumour had it that Degas was infatuated with Clermont's wife, and portrayed him going about his prosaic everyday work as a way of ridiculing the hostile, jealous husband.

Degas also painted another acquaintance, the banker Ernest May, at his place of work in *Portraits at the Bourse* ('*Portraits à la Bourse*'; illus. p. 94). Shortly after the birth of

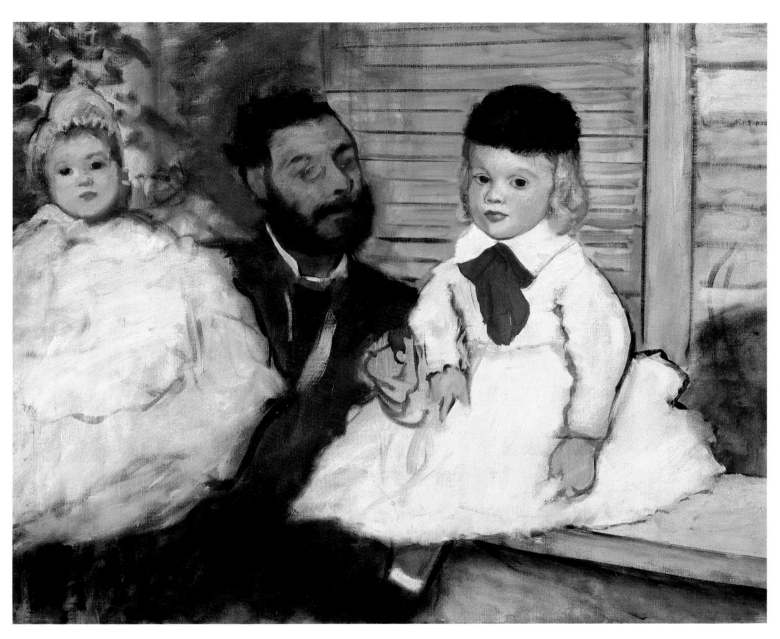

110
Vicomte Lepic and his daughters, ca. 1871, oil on canvas, 66.5 × 81 cm, Zurich, Stiftung Sammlung
E.G. Bührle (L272)

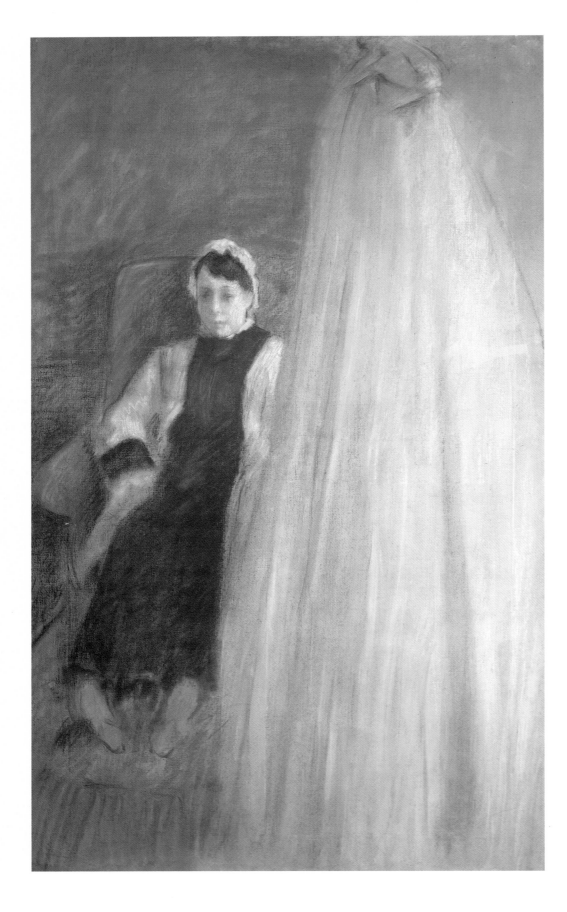

163
Mme Ernest May beside a cradle
1881–82
Oil on canvas
130 × 80 cm
Private collection (L656)

his eldest son Etienne in 1881, May asked Degas to paint his wife. Degas prepared several studies showing Madame May beside the cradle of her newborn child (cat. 163–65, illus. pp. 220–21); but a quarrel about the composition of the picture is believed to have been the reason why a finished version was never produced – not the only time that a commissioned portrait was never realised as a result of Degas's refusal to compromise artistically.

The Halévy family

Ludovic Halévy was one of Degas's classmates at the Lycée Louis-le-Grand, and he played an important rôle in his life. Halévy embarked initially on a political career. As secretary to the duc de Morny, president of the legislative chamber, he mixed with the most important personages of the Second Empire. At the same time he worked as an author, writing libretti for numerous operettas and operas, working with Jacques Offenbach among others; and he and his cousin were the authors of the libretto for his brother-in-law George Bizet's opera *Carmen*.

Degas renewed his friendship with Halévy at the end of the 1860s after Halévy's marriage to Louise Breguet, also a great friend of Degas. The marriage brought Degas into contact with the Halévys' circle which, in its worldliness, was quite distinct from the upper-middle-class milieu of the Valpinçons or the Rouarts. Halévy was also important to Degas because he gave him privileged access to the world of ballet and opera. In 1883 a series of short satirical stories, which Halévy had published in the preceding decade, appeared under the collective title *La Famille Cardinal*. The stories revolve around the adventures of two young dancers, Pauline and Virginie Cardinal. They tell of amorous entanglements, advances from rather mature admirers and the ambitious marriage plans hatched by the girls' parents. Degas obviously planned to

165
Mme Ernest May
1881
Black chalk with white heightening on paper
30 × 23.5 cm
Private collection (L657)

164
Mme Ernest May
1881–82
Pastel on paper
43.5 × 29.5 cm
Geneva, Collection Jan and Marie Anne Krugier-Poniatowski (L656bis)

illustrate an edition of the book, but the work was never completed, and there remain only isolated compositions. In some of these, Degas also portrays Ludovic Halévy: he thus appears as a figure in his own stories. He is seen conversing in a box at the theatre with Madame Cardinal (cat. 132, illus. p. 222), or chatting backstage with his friend Albert Cavé in *Friends on the stage* ('*Portraits d'amis sur scène*'; illus. p. 38).

Degas's closer involvement with the Halévy family coincided with the period when he turned for subjects to the world of the ballet and attempted the great theme of '*baigneuses*' (women bathing). This movement was accompanied by a corresponding clear decline in his interest in portraiture in the 1880s, and is perhaps why there are so few portraits of the Halévys. We know of none of Louise Breguet, who was a close friend of Degas, and none of her son Daniel Halévy, who idolised the sometimes grumpy, sometimes charming house-guest, jotting down Degas's table talk and *bons mots* which he later published under the title *Degas parle*. However, Degas did produce a sequence of photographic portraits of the family. These were made when he had just discovered a passion for photography, and for a short time he revived his portraiture in this new medium.

In 1897 Degas's friendship with the Halévys came to an abrupt and bitter end. Though in his youth the painter had strongly criticized Napoleon's Italian policy and had even expressed sympathy with the Communards, in his old age his views developed increasingly into those of a die-hard nationalist and fierce anti-Semite: the attitude he consequently adopted in the Dreyfus affair very quickly destroyed his old friendship with the Protestant-Jewish Halévys.

132
Ludovic Halévy finding Mme Cardinal in the dressing room, 1876–77, monotype in black ink (1st state, of two), pastel, 21.3 × 16 cm, Stuttgart, Staatsgalerie, Graphische Sammlung

169
Mme Henri Rouart, 1884, pencil and pastel, 26.6 × 36.3 cm, Karlsruhe, Staatliche Kunsthalle, Kupferstichkabinett (L766bis) [right]

The Rouart family

Henri Rouart had also attended the Lycée Louis-le-Grand with Halévy, Valpinçon and Degas. After studying at the Ecole Polytechnique, he embarked on a military career. Then, having an inventive turn of mind, in the early 1860s he founded a business which very successfully manufactured and sold the refrigeration equipment he had developed. Rouart was also an ambitious amateur painter, exhibiting his landscapes on several occasions alongside the Impressionists. Finally he owned a large art collection with important works by Delacroix, Corot and not least Degas – as did his brother Alexis.

Chance brought Degas together with

Rouart again, when he served under Rouart in the Garde Nationale during the Franco-Prussian War. Thus began a decades-long friendship that was to unite Degas, Henri Rouart and his wife Hélène, their children Hélène, Alexis, Ernest and Louis, and Henri's brother Alexis.

Degas charted the Rouart family's development in portraits for nearly thirty years. The first picture dates from 1875, presenting Henri as an alert industrialist, his distinctive profile standing out sharply against the background where his factory, with its smoking chimneys, interrupts our field of vision (L373, Pittsburgh, Carnegie Museum of Art). The double portrait of Rouart and

his daughter Hélène must have been painted just a short time later (L424, privately owned; illus. p. 44). In 1884 Degas painted a portrait of Rouart's wife Hélène (cat. 169, illus.): she is sitting on an armchair leaning on her left arm; in front of her on the table is what is known as a Tanagra figurine. (These little clay figures of the Hellenistic period had first been discovered in a burial site, Tanagra, in Asia Minor in 1873, and their like soon became extremely fashionable with Parisian collectors.) Alexis Rouart, the sitter's brother-in-law, also collected such statuettes.

The large portrait of Henri Rouart's daughter Hélène must have been painted about 1886 (illus. p. 73): she is standing in her father's studio, leaning against a chair; on the right, in the background, is a landscape by Corot, and in a glass case beside her are Egyptian statues. The large number of preliminary studies, the large scale – which is unusual for Degas – and the otherwise rare use of the convention of the imposing whole figure, like an official portrait, make it clear that Degas was ambitious to forge a link with the revered masters of portrait-painting, Titian and Van Dyck.

In 1895 Degas initiated studies for a double portrait of Henri Rouart and his son Alexis (cat. 177, illus. p. 225). Although Henri was then still leading an active life, Degas depicted him as an exhausted old man, with dull eyes and a hunched posture; his house-coat and cap form a striking contrast with the upright stance and business-like appearance of his son. Degas's last portraits were also of the Rouart family. Two pastels drawn in 1905 show Mme Alexis Rouart, the daughter-in-law of Henri (who had died by that time): one depicts her alone (cat. 180, illus.), and the other shows her together with her children (illus. p. 82). Degas's progressively deteriorating eyesight had by that time discouraged him from working. Madame Rouart later recounted what a torment the sittings had been: Degas was almost desperate about his poor vision and his consequent inability to realise the portrait in the way he wanted. Annoyance and frustration may account for the turbulent dynamics of the drawing, which imbue it with an energetic, almost prematurely Fauve quality.

NOTE

1 Information about Degas's life is taken principally from the standard works by Boggs 1962, Loyrette 1991 and 1988–89 Paris/Ottawa/New York.

178
Alexis Rouart
1895
Charcoal and pastel on paper
58.5 × 40.5 cm
Private collection (BR 139)

180
Mme Alexis Rouart
ca. 1905
Charcoal and pastel on paper
59.7 × 45.7 cm
Saint Louis Art Museum

177
Henri Rouart and his son Alexis
1895–98
Oil on canvas
92 × 72 cm
Munich, Bayerische Staatsgemäldesamlungen
(L1176) [right]

Facing Defacement: Degas's Portraits of Women

ELISABETH BRONFEN

72
Woman in grey
(*'La Femme en gris'*)
ca. 1865
Oil on canvas
91.5 × 72.4 cm
New York, Metropolitan Museum of Art,
Gift of Mr and Mrs Edwin C. Vogel, 1957
(L128)

In his memoirs of the artist, the painter Georges Jeanniot quotes Degas as saying, "It is all very well to copy what you see, but it is much better to draw only what you still see in your memory. This is a transformation in which imagination collaborates with memory. Then you only reproduce what has struck you, that is to say the essential, and so your memories and your fantasy are freed from the tyranny which nature holds over them."[1] Even though this gesture of privileging the belated recreation over the actual event is not specific to Degas's portraiture of women, the transformation at stake contains a particular resonance when the tyranny of nature to be outwitted refers to the face of another human being. For the portrait, intended first and foremost to represent a particular woman in her specific context, comes in the process to depict its very opposite as well – the effacement of the model as she turns into a figure, signifying other than herself.

This ambivalence is, of course, written into the very definition of portraiture. In its simplest terms, a portrait is a painting of an individual meant to intensify an aspect of something seen by the artist. It is the result of a sympathetic visual response to another human being. But given that the artist must always make choices in respect to gesture, pose and setting, the question that any viewing of a portrait immediately raises is whether it is merely the imitation of a particular model or whether it does not also signify the painter himself. Indeed the Latin etymology – *protrahere* – suggests that the act of picturing is not just one of drawing or painting a figure upon a surface so as to represent a human face by mirroring reality. Rather, the act of copying from life is one that reveals by drawing forth, by bringing to light, by extending something seen in the sitter's appearance, by prolonging a physiognomic detail, a gesture, a pose. The act of producing a simulacrum of any given human face with body, whether this be an

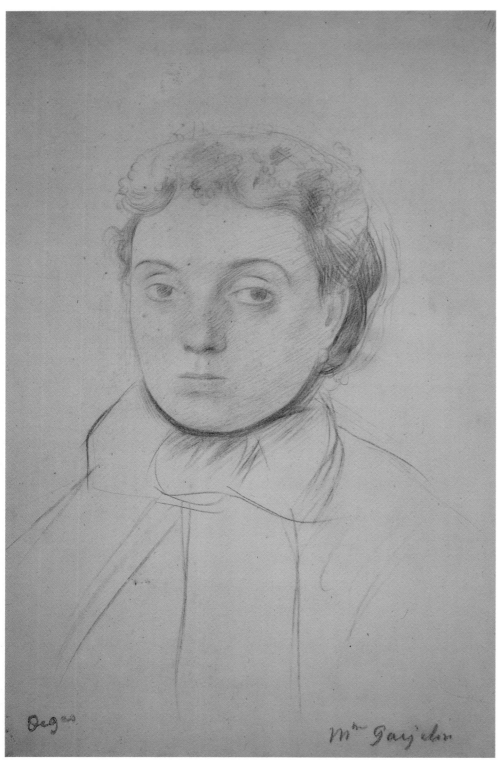

87

Joséphine Gaujelin, 1867, charcoal on paper, 36 × 23 cm, Frankfurt, Adolf & Luisa Haeuser-Stiftung, deposited with the Graphische Sammlung des Städelschen Kunstinstituts

exact or an idealised likeness, entails a rendition of the visible and a reproduction of the invisible. Thus Hegel can argue in his *Aesthetics* that "a portrait must be an expression of individual and spiritual character. This nobler element in a man, which the artist introduces into the portrait, is not ordinarily obvious in a man's features."[2] As the portrait painter draws out something from the appearance of the sitter, he also introduces something by virtue of his vision that is not seen by the ordinary eye. The portrayer is not a mere copier but rather part of the transformational process. The individual psychology of the portrayed can emerge only because the painter has brought it out in his impression of the uniqueness of this personality.

In his portrait of Elena Primicile Carafa di Montejasi Cicerale (cat. 120, illus. p. 198), for example, Degas captures a moment of intimacy, as his cousin, comfortably seated in a flowered armchair, looks up from her reading. Rather than maintaining a distance from the sitter, he stages a scene of proximity and familiarity. The particular impression he has chosen to draw forth is above all one of a marked discrepancy between the relaxed and self-assuredly poised body on the one hand and an enigmatic facial tension on the other. The pouting mouth, the rigid tilting of the head, the sharply questioning, weary and annoyed gaze all indicate her irritation. Yet her expression remains equivocal. Is hers an irritation at having been interrupted in her reading, a general discomfort with her bourgeois life or a statement about being portrayed? Privileging what he considered to be an essential expressive quality in the physiognomy of his cousin over any verisimilitude, Degas allows a haughty, withholding and at the same time challenging feminine figure to emerge on his canvas, who can be read either as a particular woman, or as a representative of a given class or as an example for the situation of the model in general.

Joséphine Gaujelin
1867
Oil on panel
35 × 26.5 cm
Hamburg, Hamburger
Kunsthalle (L166)

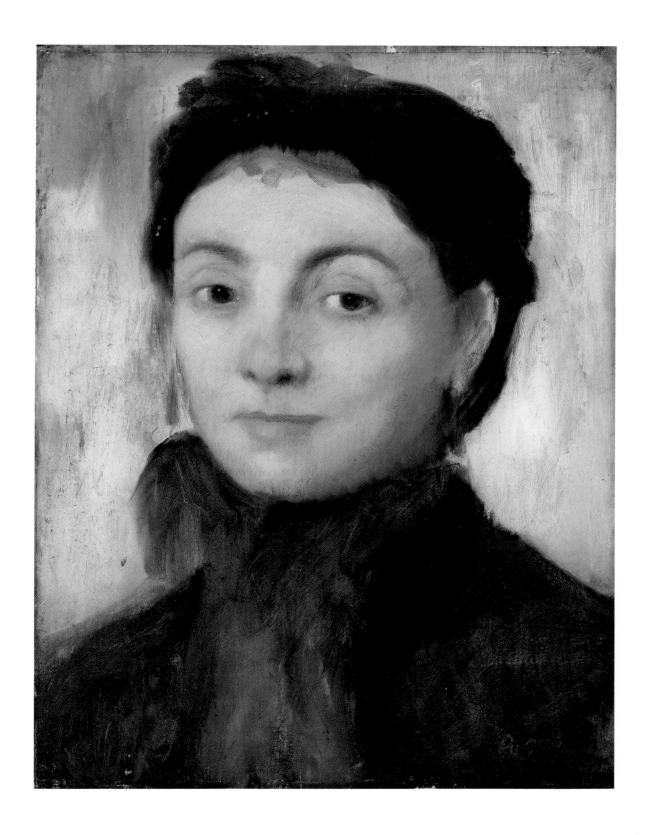

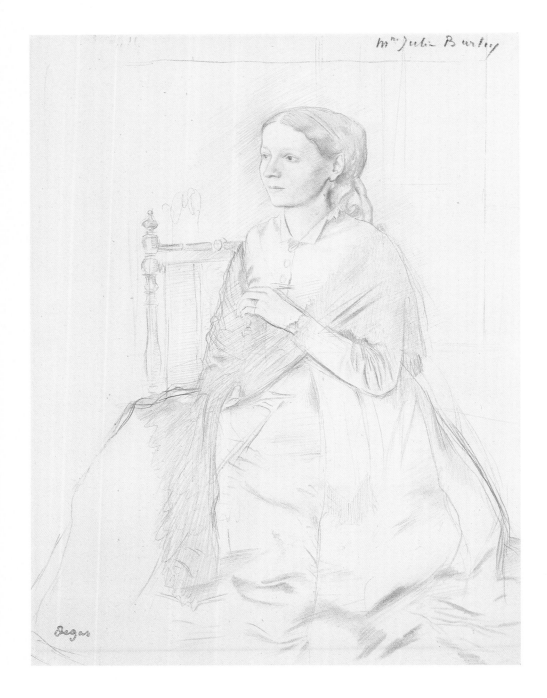

90
Julie Burtey
ca. 1867
Pencil with white heightening on paper
36.1 × 27.2 cm
Cambridge (Mass.), Harvard University Art
Museums, Fogg Art Museum, Bequest of
Meta und Paul J. Sachs [left]

89
Julie Burtey
1863–67
Pencil and chalk on paper
30.8 × 21.6 cm
Williamstown (Mass.), Sterling and Francine
Clark Art Institute

88
Julie Burtey
ca. 1867
Oil on canvas
73 × 59.7 cm
Richmond (Va.), Virginia Museum of Fine
Arts, Collection of Mr and Mrs Paul Mellon
(L108) [right]

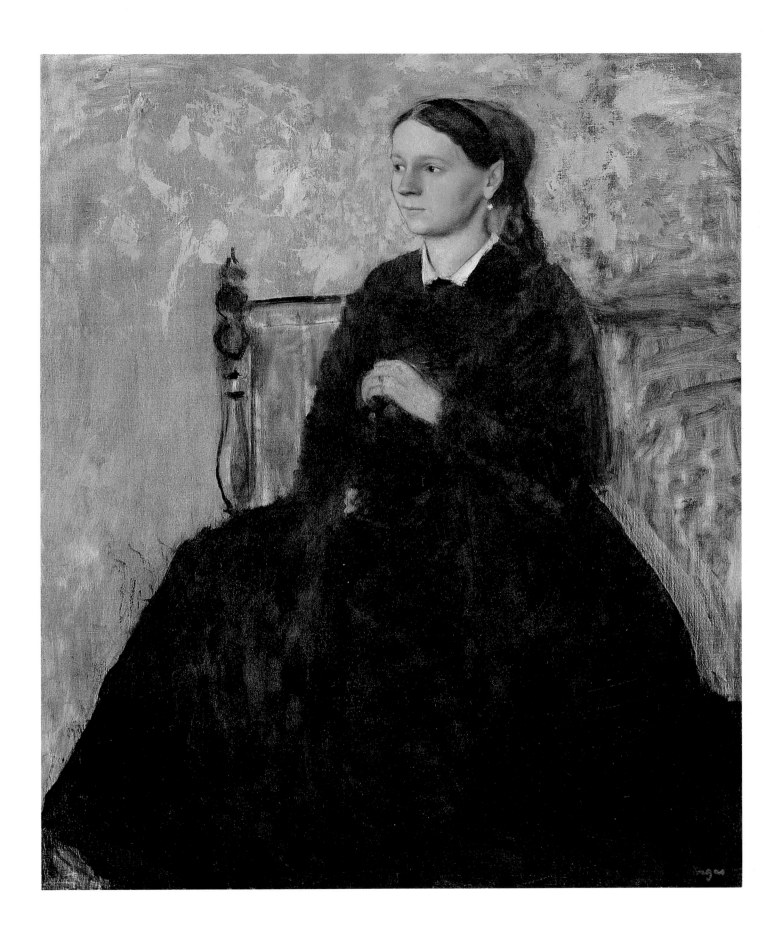

One could say Degas characterizes her as a woman well aware of her privileged position in a socially powerful family. At the same time the portrait could also be read as depicting the artist's anxiety about his model's resistance to his portraying her. The X-ray of this painting corroborates the more oblique interpretation that, in addition to a personality or status study, the woman's image comes to signify the artist as well. For it shows that initially her face was turned to the left, away from Degas, with her eyes looking at some unidentified object outside the pictorial frame.[3] The decision to have his cousin look directly at him was apparently a belated choice. If, as Degas concentrated on what he could still see after the actual portrait-session, memory mixed with imagination induced him to turn her head to confront both his and the spectator's gaze, then that may explain the startling quality of her facial expression. The disempowering look she casts upon him, and implicitly us, is in fact also a sign of his empowerment. For this glance that seemingly challenges our visual appropriation of her appearance is precisely a look he invented in elaboration of his impression of her, over and against the tyranny nature posed to his remembrance and his fancy. At the same time Degas breaks the convention that the viewer be, in Griselda Pollock's words, "both absent from and indeed independent of the scene while being its mastering eye/I".[4] Countering the conventional mastery of the artist's gaze over his passive object, the model, he stages an interchange of a parity of gazes.

The act of portraying, then, conjoins disparate gestures. A portrait is the pictorial copy of a particular human face and body within a specific historical and geographical context, with similitude linking the model and the image. In a transitive sense, however, to portray also means to adorn a surface with a picture or a figure, so that the emphasis is on the artistic medium rather than on the reality of the rendered person. Finally, in the figurative sense, a portrait also entails the act of forming a mental image of something that represents or typifies something else by virtue of resemblance to the depicted figure. Thus, even as the portrait implies a binding relation to a particular referent it also implies its very opposite, namely the artist's freedom from any naturally given context. To return to Degas's desire to liberate himself from the tyranny nature has over memory and fancy, to portray someone also means to picture to oneself, to conceive or fashion. Ultimately, to portray means to invent in reference to but also surpassing a given empirical body. Furthermore, once portraiture has become as explicitly subjective and impressionistic as Degas's representations of women have, it inadvertently enmeshes three aspects that need to be explored in greater detail – the model's desire to have herself portrayed as a sign of social status, the traditional fear of having one's image taken as a sign of disempowerment and the prominence with which the artist's signature came to be endowed by the late nineteenth century, as portraiture turned into auto-portraiture.

Traditionally, portraits were always meant as visual embodiments of power, commissioned and financed by patrons so as to assert inherited or achieved positions of authority. The social status of the model was usually as important, if not more so, than any personal appearance, and the sitters were often cast in rôles, while a formal distance was maintained to the staged scene. Given that most conventional portraits represented someone, who in turn was representative of a particular privileged class and its interests, the face and body depicted readily transformed into a figure for the social values he or she stood for, be this wealth, culture or, as in the case of some women, beauty and social graces. As Gordon and Forge argue, "a portrait was

100
Emma Dobigny
1869
Oil on panel
30.5 × 16.5 cm
Private collection (L198)

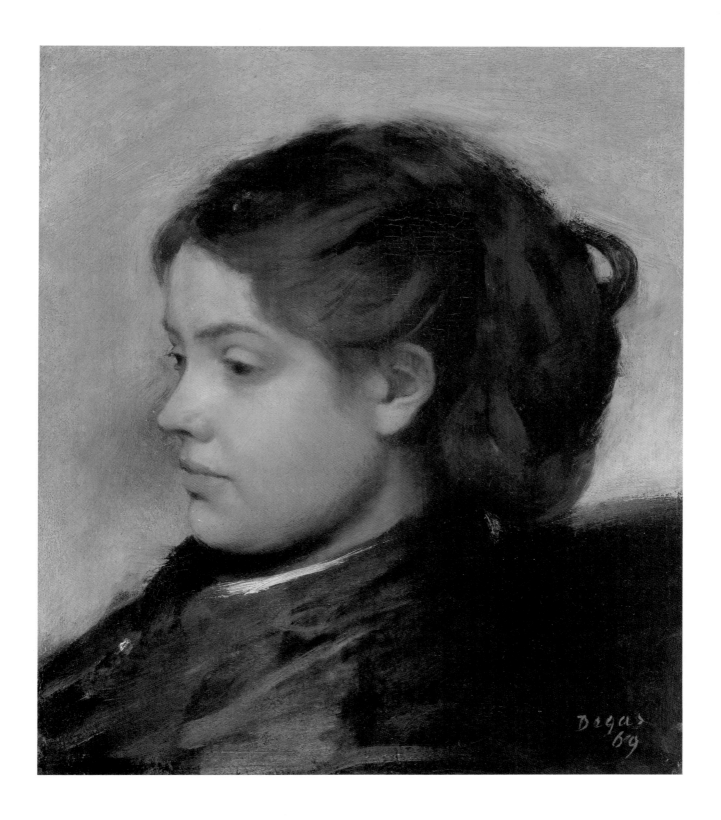

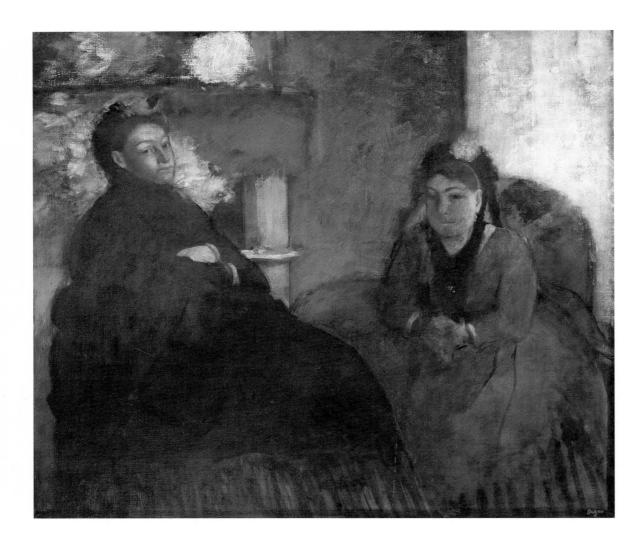

79
*Mme Lisle and Mme
Loubens*
1865
Oil on canvas
84 × 96.6 cm
Chicago, The Art Institute
of Chicago, Gift of Annie
Laurie Ryerson in
memory of Joseph Turner
Ryerson (L265)

134
*Portrait of a woman
(Mlle Malo?)*
1877
Oil on canvas
64.8 × 53.3 cm
Detroit, The Detroit
Institute of Arts, Gift of
Ralph Harman Booth
(L274)

both a likeness and a social statement. The particular and the general supported and authenticated each other'',[5] the individual always also representative of a type, the likeness always also signifying a social station.

Although Degas painted comparatively few commissioned portraits, choosing primarily to render himself or his family, his relatives and his friends, the depersonalizing shift from face to figure can, nevertheless, be found in his portraits in so far as his sitters often disappear behind their rôle as model. It is significant that many of the names of the female models have not been recorded. With labels such as 'Portrait of a woman', '*Young woman*', '*Woman in black*', their portraits merely attest their anonymity. Obliterating

to a degree the precise historical reference, Degas transforms his models into types, reproducing not only the physiognomy of a particular character but also placing the portrayed within the milieu for which each is typical – be this a particular métier, a specific geographical area or a prominent social group.[6] The refigured women function as representatives of the contemporary mode, placed within spaces at times intimate and domestic, at times public, yet always defined by the urban bourgeois culture surrounding them.

Like his contemporaries, Degas no longer took for granted that outward appearances mirror the inner truth of a person, believing that an objective rendition

of another human being was in fact not possible. Rather, he explicitly chose to disturb any easy correspondence between physiognomy and essential being by using imprecise lines as well as a mixture of clarity and obscurity to signify his subjective vision imposed on the portrayed. One part of the body or the face will often be imperfectly drawn, smudged over or even entirely obliterated, while another part will appear in exquisite, minutely descriptive detail. Nevertheless, he believed that a person's appearance does signify, albeit as an equivocal expression of contemporaneity. In one of his studio notebooks he dictated to himself, "make the expressive heads [academic style] a study of modern feeling – it is

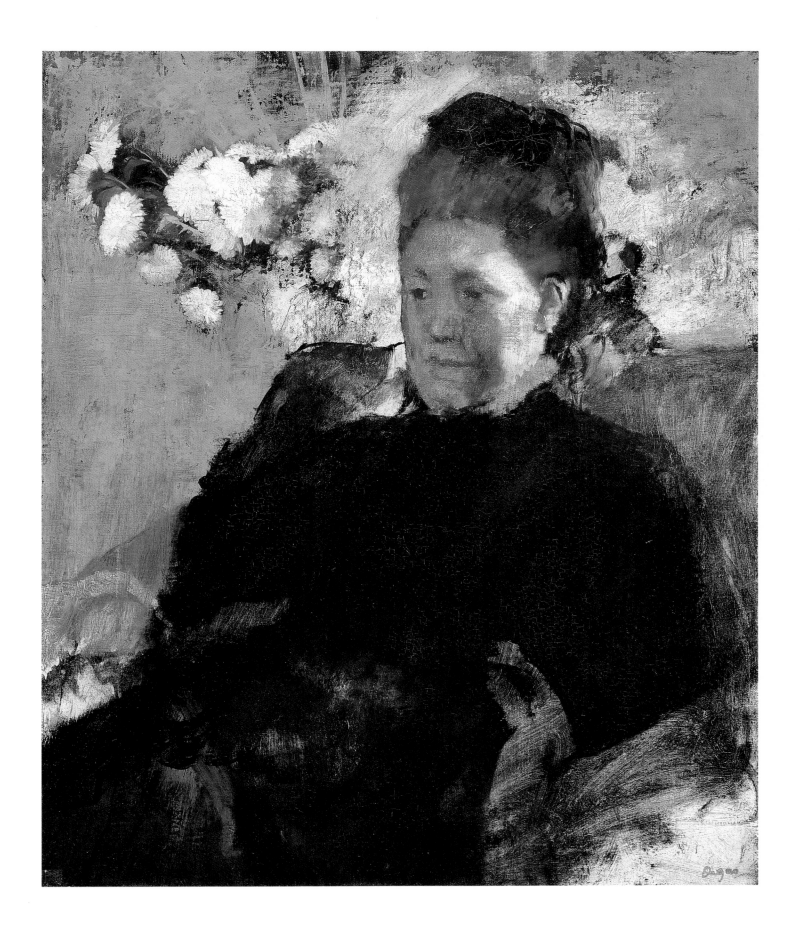

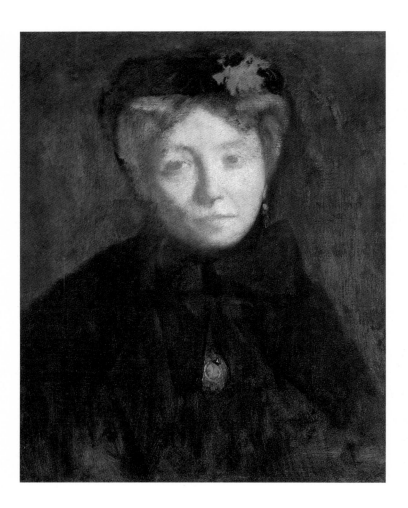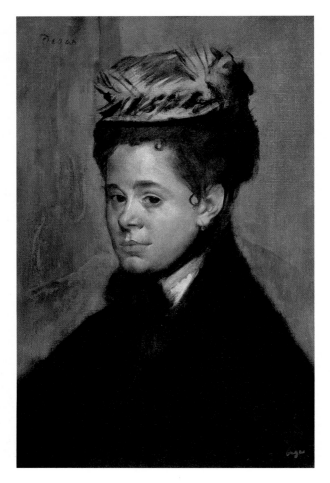

Lavater, but a more relativistic Lavater, so to speak, with symbols of today rather than the past".[7]

The contradiction at stake is, then, that while many of his portrayed women seem to pose as typical figures for what is specific about the late nineteenth-century individual, they are in fact removed from their concrete historical context and relocated as actresses in a multifarious spectacle of urban modernity, with Degas as director. The woman standing behind a bench in what could be a private garden or a public park, a reddish-brown oval hat squarely placed on her head, a blue-green shawl lightly draped beneath her shoulders to offer some warmth, sturdy bootlets on her feet, possibly meant to indicate a robust walking nature, her gaze alertly fixing some unseen object, remains unidentified except as a representative of English culture ('L'Anglaise'; cat. 157, illus. p. 298), enjoying the freedom of mobility that the modern city offers her. The woman in a rust-coloured dress with white collar, a bit of a hand visible as she clasps herself across her chest while bending over one side of her sofa, listlessly staring into the space before her as though in a trance or in agony, is simply a figure for melancholia ('La mélancolie'; cat. 92, illus. p. 242), representative of the fatigue, weariness, dislocation and isolation that, too, is characteristic of the modern city. Even when the models are known, such as his aunt, the Duchess of Montejasi Cicerale (cat. 97, 98, illus. p. 196), the specific details of her individual character come together in such a manner that she could also be

91
Portrait of a woman
ca. 1867–68
Oil on canvas
57 × 46 cm
Isabella Brandt Johansen (BR 49)

174
Bust portrait of a woman
1887–90
Oil on canvas
55 × 36 cm
Private collection (L922)

105
Woman seated on a sofa
1868–72
Oil on canvas
45 × 37 cm
Private collection (courtesy Galerie Schmit, Paris) (L196) [right]

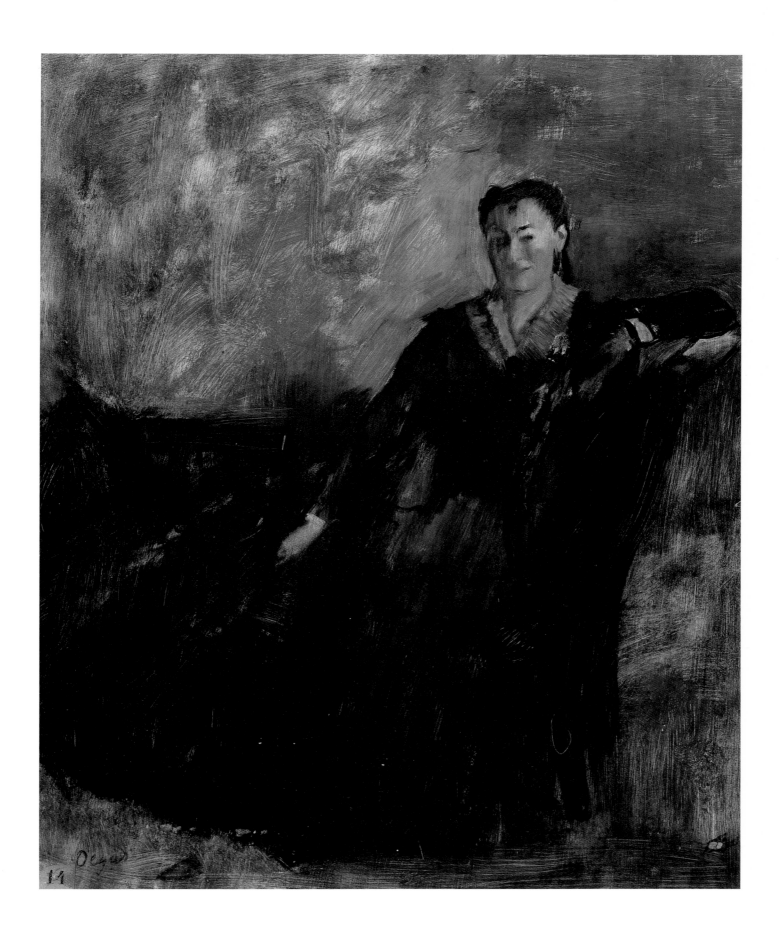

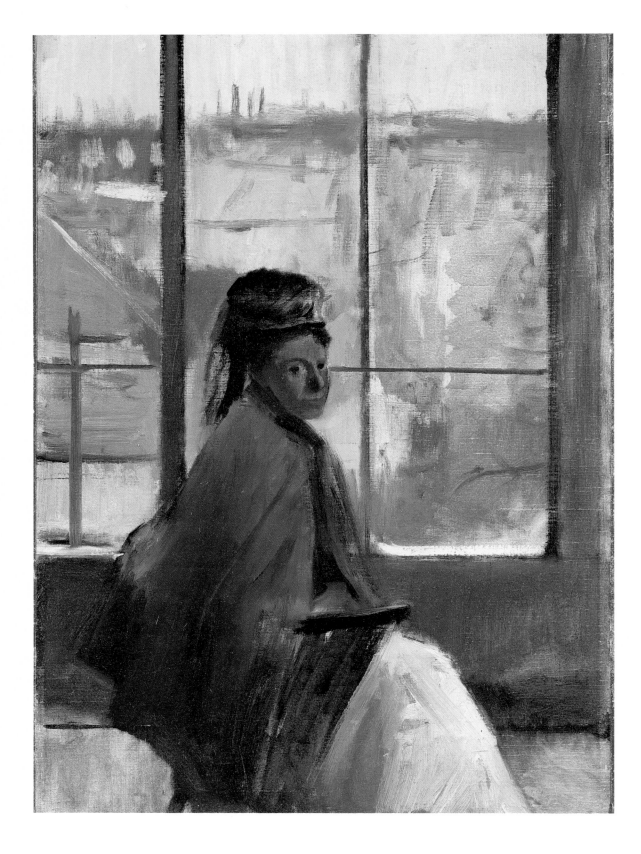

112
Mme Olivier Villette
1872
Oil on canvas
46.3 × 32.7 cm
Cambridge (Mass.),
Harvard University Art
Museums, Fogg Art
Museum
Gift of C. Chauncey
Stillman, Class of 1898, in
memory of his father,
James Stillman (L303)

122
Woman at a window
('*Femme à la fenêtre*')
1875–78
Oil on paper
Printed on linen
61.3 × 45.9 cm
London, Courtauld
Institute Galleries (L385)
[right]

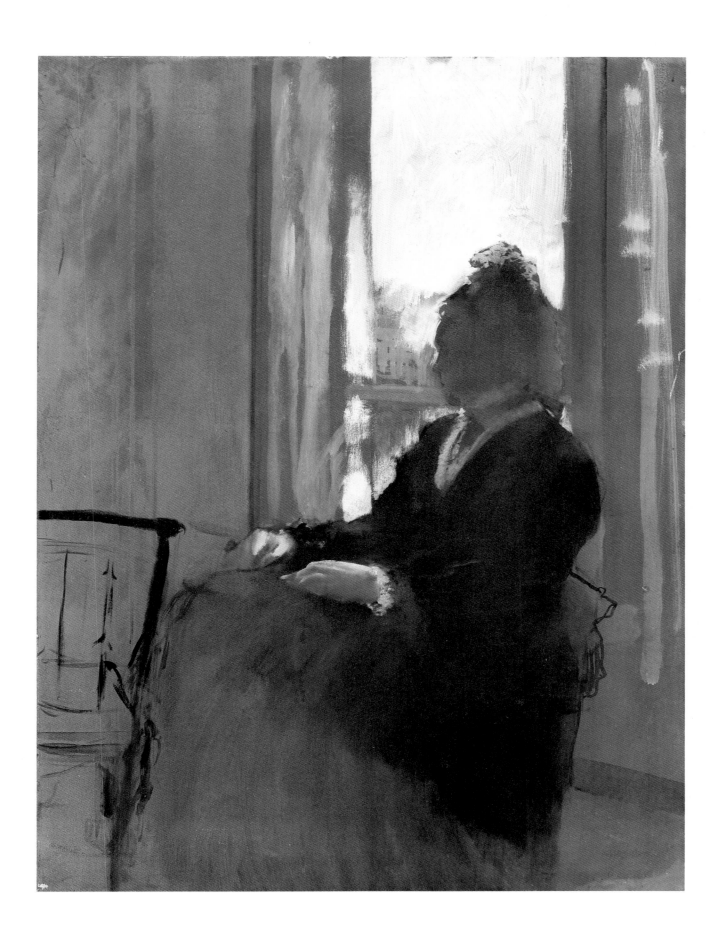

perceived as a composite type. Regally posed on her red cushioned sofa, her arms tightly crossed over her black gown to indicate poise but also containment, her face expressing dignity, authority, resignation and benevolence all in one, with the oil lamp placed almost ironically behind and partially above her head like a source of crowning light, she comes to signify a stately figure representative of the privileges, leisure and the constraints of an entire age and class.

The dialectic of displacement at work in such transformations, however, cuts both ways. For even as family members or friends are drawn into typified scenes, with their faces, the comportment of their bodies, their characteristic gestures turned into tropes for contemporaneity, these stagings nevertheless also illuminate their individual characters. Degas is thus one of the first to explore the belief so prevalent in modernity that a subject emerges precisely as the result of the multiple rôles she or he performs. For he turns to portraiture as an epistemological tool because it allows him to straddle fiction and realistic rendition, as though to illustrate that we need to turn a familiar person into a figure in a narrative in order to discover her essential being.

In that sense Charles Baudelaire's distinction between a historical and a novelistic understanding of portraiture is apt. While the former, as archivist of what he sees, renders the model as truthfully, severely and minutely as possible by focusing on her most characteristic physiognomic attitude and spiritual or psychic comportment, the latter, as storyteller, adds an allegorical dimension by turning the portrait into a tableau, a poem filled with fanciful accessories, the product of imagination rather than reproduction. Baudelaire's conclusion, that "a good portrait always appears like a dramatic biography, or rather like the natural drama inherent to every man",[8] actually only confirms that the portrait invariably calls forth an oscillation between verisimilitude and imagination. However, allowing the reference to a specific historical woman to be obliterated by the rôle or type she is meant to play in one of many scenes dramatizing both modern life in general and the artist's subjective vision in particular not only points up the uneasy alliance between the appearance of a woman and her essential being. Further, it articulates the fact that power resides with the one who can negotiate the boundary between model and image, between reference and figure, between visibility and obscurity.

European folklore has always believed the portrait to be a double of the portrayed, with the body or part of it translated into the picture that represents it. The portrait has thus always served as a pictorial site where the boundary between a vital representation and the vital presence of the portrayed becomes blurred. To picture the human face was, therefore, not only seen as a sign of social authority. Functioning rather as the diametrical opposite of the traditional representational portrait, the likeness of the human face came also to be seen as an embodiment of demonic or magic powers that disempower the model.[9] Thus an anxiety about having one's picture taken often came to underlie any sense of control and power that the self-representation initially seemed to confer upon the portrayed. While the image potentially captures and contains the soul of the model, so that having one's portrait taken was also often thought of as a harbinger of death, the maker or owner of a portrait in turn was thought to gain possession, power and control over the portrayed – at times even the ability to exercise a fatal influence over the model.[10] Given this fluid boundary between vital presence and vital representation, portraiture serves to empower the maker and owner in yet another sense, by endowing him with the ability to manipulate visible presence and absence. Since to be visible is a sign of presence while absence is marked by being invisible, the function of the portrait, John Berger argues, "is to fill an absence with the simulacrum of a presence", while the "main task of painting has been to contradict a law which governs the visible: to make what is not present 'seen' ".[11]

The irony is, of course, that by the same token, a further function of the painted likeness is that it makes what is seen absent. Degas's *Woman seated, pulling her glove* ('*Femme assise tirant son gant*'; cat. 175, illus. p. 285) in one sense makes visible and thus present the absent soprano Rose Caron, not only after she has left the portrait session but indeed after her demise. At the same time, however, she is present not as a private person but as a woman acting the part of an actress, playing an unidentified fictional character to boot. Perfectly aware that she is the object of a gaze, the elegance with which she pulls her glove while firmly holding a closed fan in her left hand is clearly meant to manipulate her implied spectator even though she does not directly confront him. The eroticism of the moment is further brought forward by virtue of the fact that while she seems barely clothed, her dress matching the colour of her flesh, her back is just slightly raised above a chair laden with multicoloured though imperfectly visible dresses. Indeed her appearance is so powerful because of the contrast between the calculated bodily poise and the gesture of self-absorption. While the scene she is part of remains obscure – is she on stage, is she in her dressing room, is she at a public event? – she acts the part of one withdrawn from any audience, as though lost in thought. Degas thus uses this portrait to illustrate the nexus between presence and absence, visibility and invisibility. Though highly staged as a spectacle, Rose Caron also recedes from the field of vision, not only because neither she nor the context within which she is placed are directly named, but also because what she performs is the act of withdrawing. This

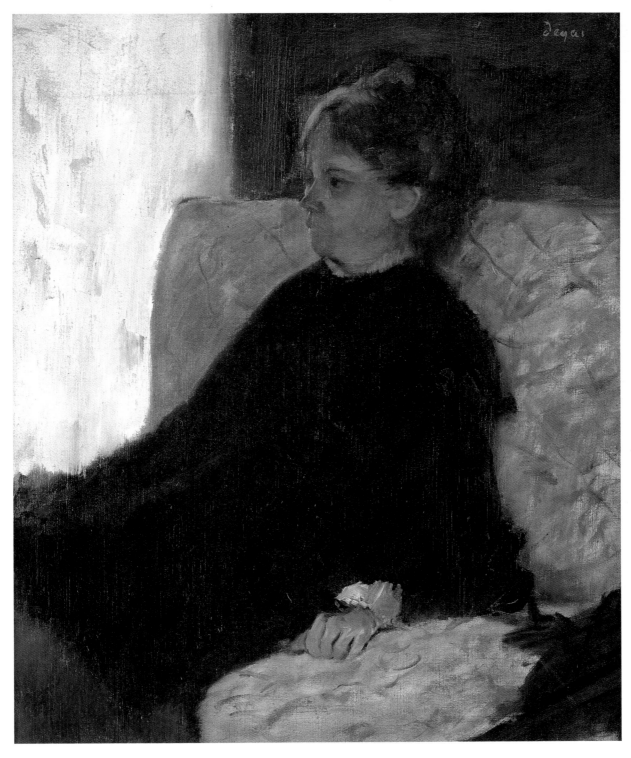

121
Woman in black ('*La dame en noir*'), 1875–78, oil on canvas, 60 × 51 cm, Stockholm, Nationalmuseum (L386)

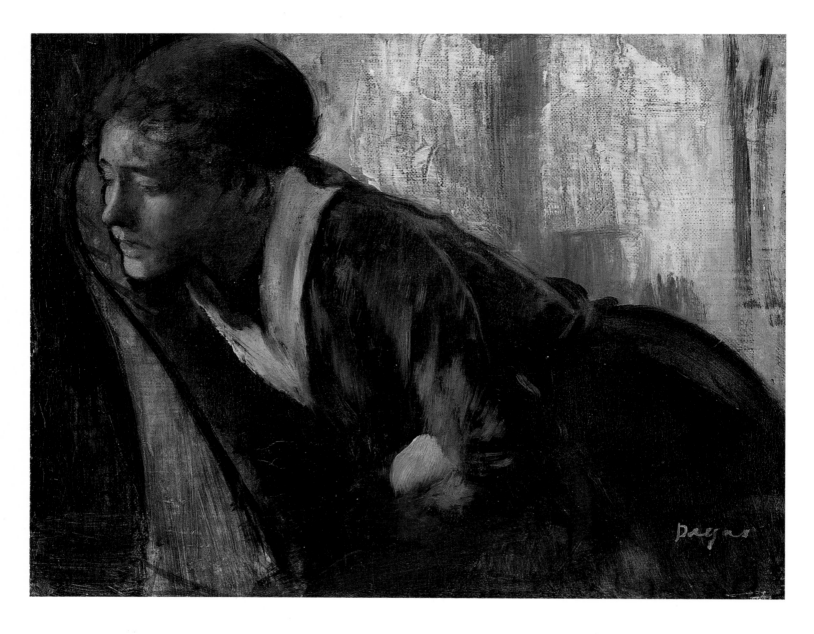

92

'La mélancolie', ca. 1867–70, oil on canvas, 19 × 24.7 cm, Washington, D.C., The Phillips Collection (L357)

elusive quality is further enhanced by Degas's technique of blurring most of the painted figure. The lower part of her seated body is smudged, the face, especially the eyes, though discernible is obscured through shadows. The woman as object of the representation seems caught in the process of absenting herself, she marks the vanishing point of the image. She not only performs the act of removing herself though in plain sight, but is also occluded by the artist in the very act of being portrayed. The transformation at stake here seems to be less

Young woman with her hand
over her mouth
ca. 1875
Oil on canvas
42 × 33 cm
Private collection
(L 370)

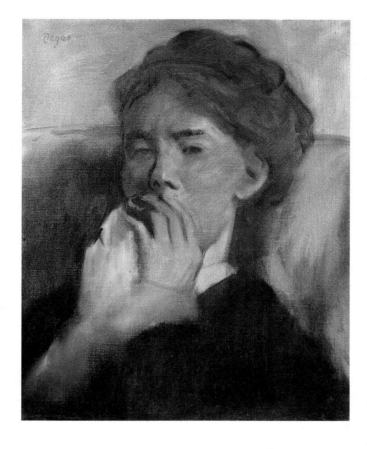

Young woman in an
armchair
ca. 1880
Pencil and pastel
24 × 19.5 cm
Switzerland, private
collection

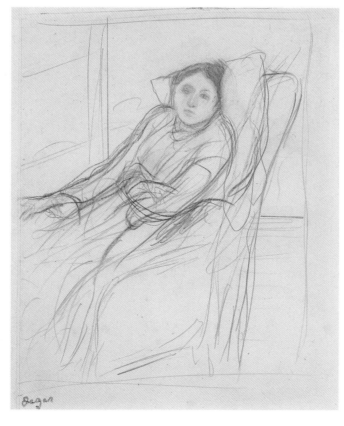

the move from face to figure than an effacement of the particularity of a face. Indeed, what Degas presents us with is the configuration of absence.

As Griselda Pollock argues, the specificity of gender is written into the scene of portraiture by virtue of the fact that, in dominant patriarchal ideologies of art, the rôle ascribed to the feminine position is either as model or as muse in such a manner that "the construction of the masculine artist is made in opposition and in precedence to absent femininity",[12] with the woman functioning as a sign, a fiction, a confection of meanings and fantasies "not of woman, but of that fantastic Other in whose mirror masculinity must define itself".[13] The hierarchy of power invoked is such that the implicitly masculine spectator, as the owner and consumer of the image, actively looks at and can utterly and timelessly possess the feminine object, who in turn is seemingly reduced to the passive function of being "looked-at, the surveyed which is reconstructed in *his* image".[14] Man is the "eye, a powerful metaphor in the west for knowledge, liberated from the body by means of his *enjoyment* of a *mastering* gaze", whereby enjoyment colloquially means pleasure but also contains the legal meaning of possession, as in the enjoyment of rights of property.[15]

The exchange thus invoked by the portraiture of the feminine figure through a masculine artist is, however, never simple, constant or secure, for even as the feminine body refigured in the interest of the implicitly masculine artist and spectator is meant to satisfy a desire to possess what is fugitive or absent precisely because it is Other, so her rendition cannot help but signify the opposite as well. Not only that, the portrait stands in for and eternalises an absent and thus at least figurally dead woman. As it recasts the woman in the artist's image, something is invariably disturbed in his own mastery. It is precisely this aporia which

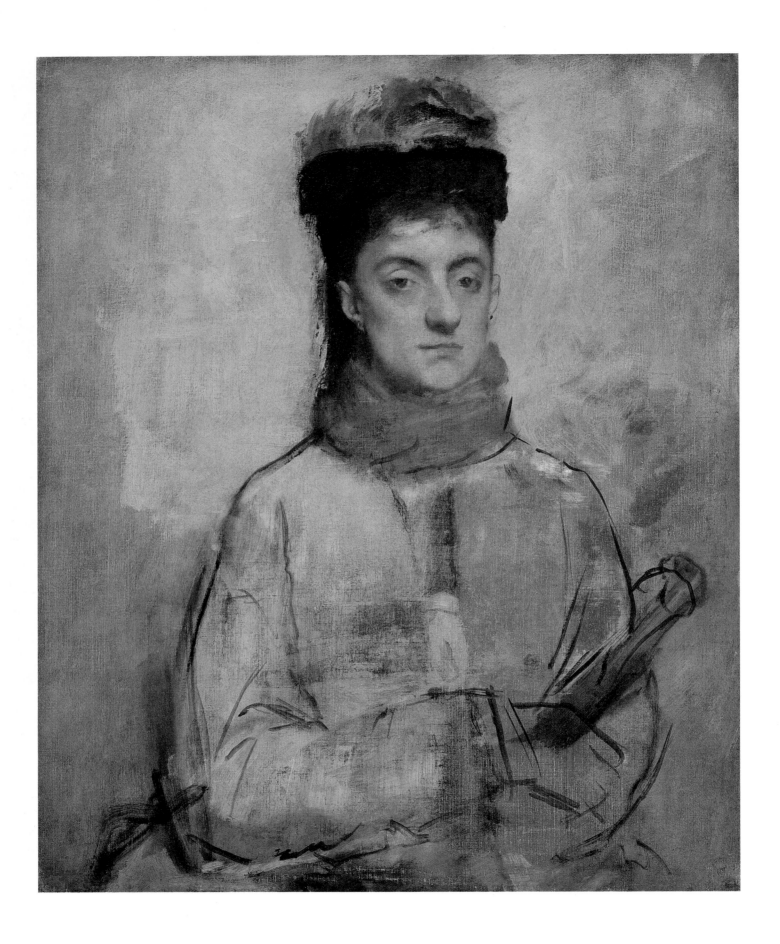

129

Woman with an umbrella
ca. 1876
Oil on canvas
61 × 50.4 cm
Ottawa, National Gallery
of Canada (L463)

126

Mme de Rutté
ca. 1875
Oil on canvas
62.5 × 51.7 cm
Zurich, private collection
(L369)

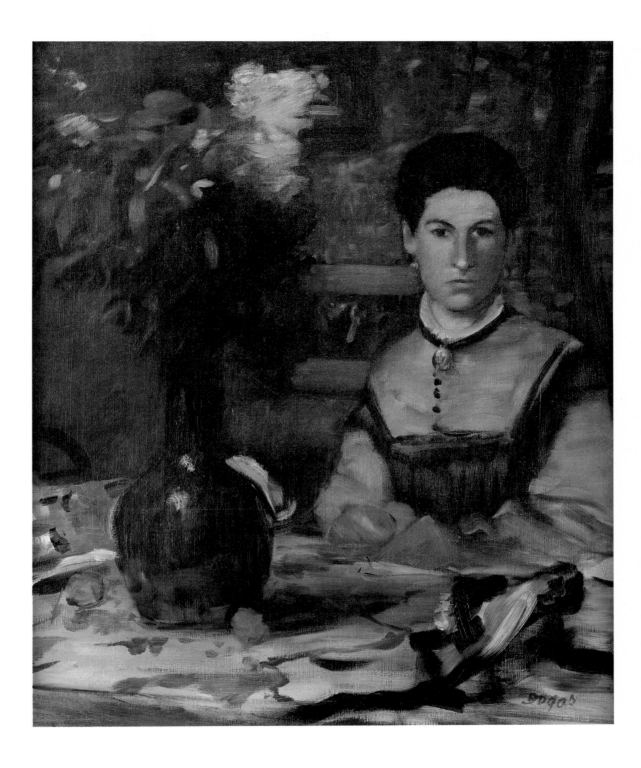

comes to the fore in so many of Degas's portraits of women. Though he designs them as figures and configurations meant to outwit the tyranny of nature, he also uses the space of the portrait obliquely to illustrate precisely that quality which eludes the grasp of the artist's mastering gaze and hand, which recedes from his power, which thwarts his imagination and fancy by remaining enigmatic and yet persistently present – the irreducible, equivocal subjectivity of the Other.

In classical rhetoric, prosopopoeia is the name for a figure of speech that serves as an apostrophe to an absent person, to the act of giving a face to the faceless, thereby conjured into a semblance of existence. But, as Paul de Man reminds us, it is a double-edged tool, for it calls forth an interminable interplay of figuration, where the symmetrical structure of the trope implies, by the same token, an act of disfiguration. It uses fancy and memory to outwit the tyranny of nature's constraints, like absence, mutability, invisibility, even as it acknowledges them, for owing to its gesture "the dead are made to have a face and a voice which tells the allegory of their demise and allows us to apostrophize them in our turn".[16]

Owing to this duplicity, where giving face or drawing forth a face is also an act of defacement, prosopopoeia is the rhetorical correlate most apt to describe the visual gesture repeatedly undertaken by Degas in his portraiture of women. In the painting *Woman at a window* ('*Femme à la fenêtre*'; cat. 122, illus. p. 239), the model's invocation is also the precondition and result of her obliteration. While she sits calmly next to an open window, her face is completely obscured, her body amorphously painted, imprecise except for the careful delineation of the hands that seem almost to belong to a different painting. Outside, traces of buildings can be discerned as they are reflected in water. But inside, in the shadows of a rust-coloured room, she is the embodiment of an

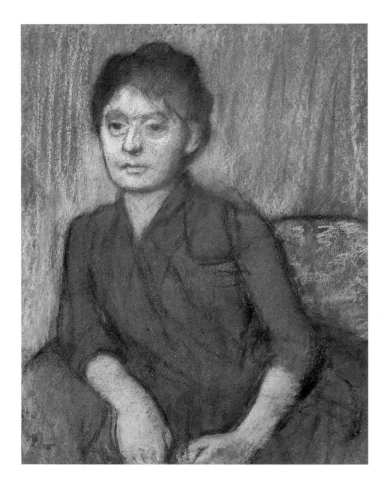

176
The brown dress
('*Femme assise*')
ca. 1893
Pastel
65 × 49 cm
Manchester, the
Whitworth Art
Gallery (L1140)

enigma. She sits in stark contrast to the bright whiteness of the opened window, a nexus between vagueness and brilliance. Any details of her face have been washed out. It will never become any clearer, even though this unnamed woman is forever resurrected from the dead. She gives figure to the failure of representational verisimilitude, to the breakdown of shape, to a celebration of disintegration. As Robert Harbison argues, "Degas seems to say that there are things a painting can't legitimately tell you".[17]

She could be anyone, old or young, respectable or *demi-mondaine*, quietly anticipating someone to appear, pensively lost in thought, withdrawn from the world or speaking to the artist. Neither her physiognomy, nor the status she is meant to represent, nor the precise conditions of the sitting

170
Bust portrait of a woman in a green bodice, ca. 1884, pastel, 49 × 33 cm, private collection
(courtesy Galerie Schmit, Paris)

can be made out with any certainty. Yet precisely the performance of her imperfect visibility, with its contingent instability in meaning, makes her such a perturbing spectacle. What sticks out from the frame, disturbing any stabilising visual enjoyment, is the disjunction between the smoothly textured hands, the stark white blank of the window and the dematerialisation of the body. Completely equivocal, she elicits an endless series of questions and plural interpretive projections.

Given that any portrait is on some level also an auto-portrait, it ultimately always negotiates the uneasy alliance between the artist's signature, as representative first and foremost of his gaze, with the alterity of his model. For the scene of portraiture entails a journey encompassing several stages. The first, the primal sitting, is a situation or session where the artist interlocks in an exchange or dialogue with his model, collecting the impressions that her appearance in all its complexity makes on him. Then, owing to his power of memory and creativity, a material image emerges. Belatedly, the artist has taken the woman's face, drawn out essential qualities to make the unseen visible, translating the face on to the space of his canvas. As this second face emerges, however, it is also inscribed with distortions, for the portrayed face comes to represent various things indeterminately – the model as a specific historical person, with her physiognomy mirroring a particular psychic make-up; her social status, geographical and/or class origins; but also values such as power, authority or beauty attributed to her; and finally the artist's vision. She thus obliquely comes to signify absence, either because, representing a type, she has lost her contextual specificity, or because she has become the cipher for the ideas the painter wants to transport by virtue of her figure, which may include his subjective reading of her and their interaction, but which may also pertain to a statement about

his artistic medium. This is the case in Degas's more radical paintings, where, in privileging the paintedness of the image over the woman's face or parts of her body, both are often partially obscured.

The portrait turns the event of a session into a scene, in the process of which the emergence of the image also entails dislocation, a transformation I have discussed as the move from face to figure, from face to a configuration of effacement, and finally as the performance of defacement itself. While the various strategies of disfiguration make any reference elusive and transform the depicted face into an equivocal figure, once the portrait faces the spectator, it invites a stabilising interpretive narrative. Yet, as Carol Armstrong points out, although Degas's images ask to be turned into telling, their readability places them on the edge of illegibility. His conspicuously messy technique of rubbing out, covering over and negating levels of depiction produces the specifically modern hybridity of constitutive and obliterative portraits. As he endlessly explores the boundary between physiognomic expression and effacement, the visual space of his portraits elicits a "free play of decipherment and detective work, of gestures and physiognomies which can be underread, or overread, in any way you like".[18] With the model caught in a process of dissolution and erasure, his portraits disturbingly negotiate the reconstitution and negation of corporeal representation.

In the portrait of the woman by the window, Degas deconstructs the very scene of portraiture, for what he draws out is precisely the act of defacement that underwrites all attempts at making an image of another's face. The scene he recreates is one where in the act of figuration, the feminine figure, far from being absent, visibly disintegrates, but so, too, does the artist's facture. As though to perform the mutual implication at the heart of the portrait scene, Degas illustrates that to enjoy the feminine model, to take

possession of and obliterate her in the process of pictorial figuration, only imperfectly hides what is lost in the exchange, namely the irreducible subjectivity of the Other. By self-consciously illustrating his inability to capture a woman's face, Degas performs what eludes his sight and his brush. Figuration defaces the model by empowering the artist, but portraiture can also serve to celebrate the artist's own disempowerment. What is ultimately portrayed, or rather drawn forth, in this vortex is the clear-sighted, albeit disturbing insight into the fugitive inter-subjectivity inherent in any exchange between feminine model and masculine artist, fraught as it is with fragility and mutability.

NOTES

1 Jeanniot 1933, cited in Harbison 1993, p. 66.

2 G.W.F. Hegel, *Aesthetics: Lectures in Fine Art*, trans. T.M. Knox, vol. I, Oxford 1975, p. 165.

3 Thomson in 1989 Liverpool, p. 30.

4 Kendall/Pollock 1992, p. 64.

5 Gordon/Forge 1988, p. 87.

6 *Impressionnisme: Les origines 1859–1869*, catalogue by Henri Loyrette, Gary Tinterow, Paris, Grand Palais/New York, The Metropolitan Museum of Art 1994–95, p. 194.

7 1988 Paris/Ottawa/New York, p. 205.

8 Charles Baudelaire, 'Le Portrait', in *Œuvres Complètes*, ed. Claude Pichois, vol. II, Paris 1976, pp. 564–659, at p. 655.

9 Hans Bächthold-Stäubli/Eduard Hoffman-Krayer, *Handwörterbuch des deutschen Aberglaubens*, 1927, reprinted Berlin 1987, vol. I, p. 192.

10 David Freedberg, *The Power of Images: Studies in the History and Theory of Response*, Chicago 1989, p. 278.

11 John Berger, *The Sense of Sight*, New York 1985, p. 212.

12 *Vision and Difference: Feminity, Feminism and the Histories of Art*, London 1988, p. 101.

13 *Ead.*, p. 153.

14 *Ead.*, p. 113.

15 Kendall/Pollock 1992, p. 23.

16 Paul de Man, *The Rhetoric of Romanticism*, New York 1984, p. 122.

17 Harbison 1993, p. 66.

18 Armstrong 1991, p. 145.

173
Woman in a red shawl
(Hélène Rouart?)
1886
Oil on canvas
75 × 62 cm
Switzerland, private
collection (L867)

Au Milieu des Artistes et des Hommes de Lettres

MARIANNE KARABELNIK

85
Portrait of a man
ca. 1866
85 × 65 cm
Oil on canvas
Brooklyn, N. Y., The Brooklyn Museum,
Museum Collection Fund (L145)

"They'll shoot us, then they'll go through our pockets" is only one of the many, characteristic aphorisms that contributed to Degas's legendary reputation among his peers.[1] But Degas was also a painter's painter, who while he was feared for his sharp tongue was held in high esteem for his bold innovations in the field of art.

Pissarro judged him to be "the greatest artist of our period",[2] while Redon noted in his diary that Degas's name was a "synonym for the principle of independence" and that he held his leading position on the basis of "respect here, total respect".[3] Writing shortly after Degas's death the Italian artist Federico Zandomeneghi called him "the noblest and most independent artist of our period".[4] In their comments on the Impressionist exhibitions the critics of the time also repeatedly emphasized his independence, tending to describe him as "the most intransigent of the intransigents".[5] Gauguin, writing in a similar but less flattering vein, expressed the same opinion unequivocally: "there is a spirit of contrariety in that man that destroys everything".[6]

Degas, coming from a well-to-do upper middle-class background, regularly attended the artistic circle that met in the café Guerbois between 1866 and 1875 when Impressionism first became a movement, and later in the early 1870s at the Nouvelle-Athènes as well, places where the painters, musicians, writers and intellectuals of the time foregathered. The list of those who went there reads like a *Who's Who* of the modern way of seeing: Manet, a dominating figure who sometimes presided over the gatherings, Whistler, Fantin-Latour, Renoir, Monet, Pissarro, Nadar, Alfred Stevens, Bazille, de Valernes, Alphonse Legros, less important colleagues such as Desboutin, Zacharie Astruc, Giuseppe De Nittis, Zandomeneghi, as well as people who supported and publicized the ideas of the group, including Zola, Duranty and Antonin Proust. Monet rarely went, Cour-

34

The engraver Joseph Tourny, 1857, etching, 3rd state, 23 × 14.4 cm, Cambridge, Harvard University Art Museums, Fogg Art Museum, Bequest of Meta and Paul J. Sachs

bet and Sisley never, and Cézanne purportedly joined the gatherings two or three times.

Degas was a driving force in the new movement, a founder and shareholder, in it from the start when 'new painting' and the painting of 'modern life' became topics of discussion. But he was always remote and opinionated, offending people with his incisive, uncompromising judgements, arousing controversy as a man though not as an artist. Many of the people in this circle were acquaintances rather than friends, and quite often friends became enemies. Who did he invite to his studio and who among his peers did he consider worthy of becoming the subject of one of his pictures? In the early days Moreau and Tourny (illus. p. 137, 142 and cat. 33–34, illus. pp. 252–53), then Manet, Tissot, Mary Cassatt, Martelli and Duranty; but Renoir, Whistler, Pissarro and Monet never. On the other hand, lesser figures from French bohemian life in the second half of the nineteenth century have gone down in history as portrayed by Degas: *Bellet du Poisat* in this exhibition (cat. 70, illus. p. 260), *Léopold Levert* (cat. 116, illus. p. 261) whose name cannot be found in any encyclopaedia, and Evariste de Valernes, included by Degas in his famous self-portrait (illus. p. 23), who touchingly wrote on the back of a second portrait Degas painted of him (L177): "My portrait painted by my close and renowned friend Degas in his studio at 6 rue Laval, Paris, in 1868 when I had nearly achieved my goal and almost become famous".[7] Or take the example of the painter in cat. 85 (illus. p. 250), universally referred to in art literature as '*Portrait d'homme*', unhappily submerged amidst still-life arrangements and canvases, recently but not yet incontrovertibly identified as the English painter Robert Grahame, who did in fact exhibit *Une entrecôte, nature morte* in the Salon of 1868 and was a friend of Manet, though little more is known about him.[8] Why was Degas not attracted by the woman

painter Berthe Morisot who belonged to his circle, and who was so delightfully portrayed by Manet with a bunch of violets, although he was attracted by her evidently plain sister Yves Morisot-Gobillart? He reportedly was anxious at all costs to paint her shortly before she left Paris.[9] Again Fantin-Latour, whose pictures of friendship to some extent epitomize this period with its preoccupation with self-depiction within the artistic community, neither portrayed the 'outsider' Degas, nor was himself portrayed by Degas. On the other hand one of Degas's most beautiful, peaceful portraits with its rich range of middle tones was inspired by Fantin's future wife Victoria Dubourg (L137, Toledo Museum of Art), who herself painted still lifes of flowers. The only picture commemorating a friendship, the only group portrait of friends of this kind that Degas undertook, was not one including fellow artists, but of acquaintances he knew only briefly, whom he had met only by chance as a result of the siege of Paris in 1870: *Jeantaud, Linet and Lainé* (cat. 109, illus. p. 215). As if to prove the rule, Degas's *Six friends in Dieppe* (illus. p. 71) which might have been a 'friendship picture', eventually turned into six portraits of people in a group but otherwise isolated.

In this connection Degas's remark as reported by André Gide, "How can I draw a man who does not know how to draw himself?",[10] is relevant, but with the reservation that Degas made no distinction between an important fellow artist and a less important one. It is also significant that Degas usually did not depict his colleagues in their studios (Tissot, the painter Henri-Michel Lévy and the previously mentioned unknown artist in cat. 85 are exceptions in this respect), not, therefore, in the exercise of their craft. With their top hats and neat bow ties Bellet du Poisat and Léopold Levert (cat. 70 and 116) as well as Léon Bonnat (L111, Bayonne, Musée Bonnat, illus. p. 102) – who later painted portraits of the notables of the

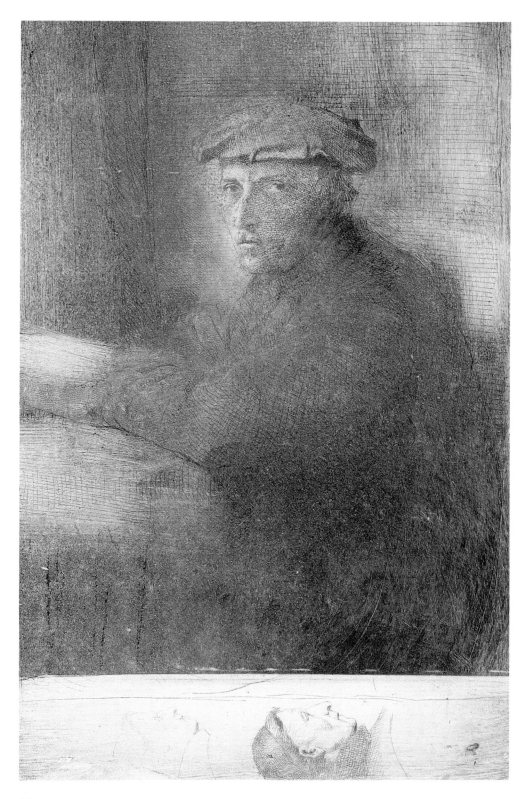

33

The engraver Joseph Tourny, 1857–58, etching, 1st state, 3rd proof, printed in monotype ink, 23 × 14.4 cm, Sammlung E.W.K., Berne

Edouard Manet, assis
1864–65
pencil on paper
33.1 × 23 cm
New York, The
Metropolitan Museum of
Art

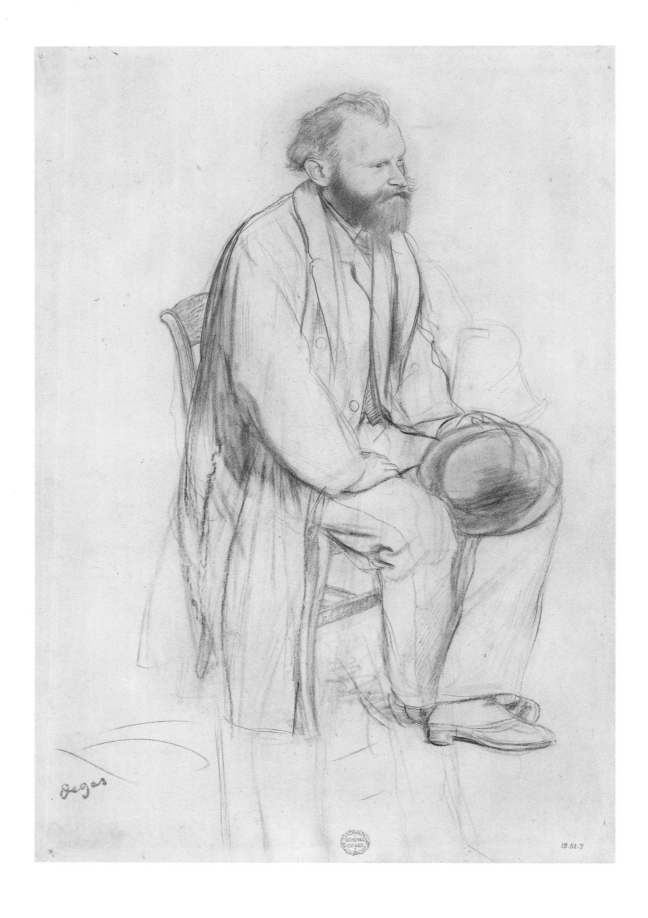

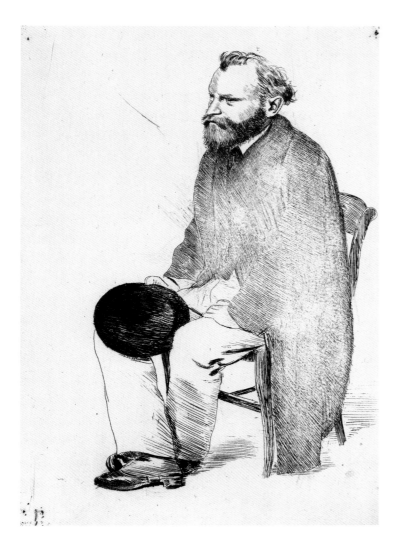

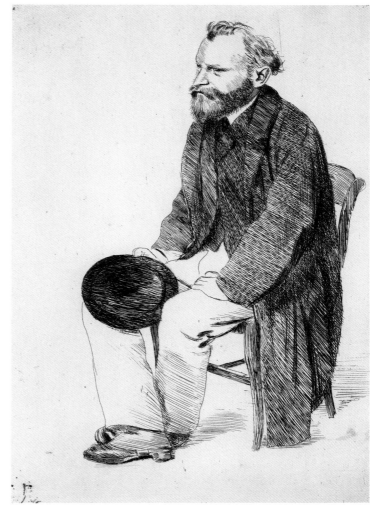

64
Manet, seated, turned to the left
1861–64
Etching, 2nd state
36 × 27 cm
Sammlung E.W.K., Berne

63
Manet, seated, turned to the left
1864–65
Etching, 1st state
31.4 × 22.5 cm
Copenhagen, Den Kongelige
Kobberstiksamling, Statens Museum for
Kunst [right]

Third Republic – would qualify in every respect as representatives of the bourgeois classes, if the acutely sensitive, melancholy, rather uncertain gaze of du Poisat did not suggest a rather different idea and the prominent floral decoration of the background behind Léopold Levert were not reminiscent in its liveliness of the striking, idiosyncratically *japoniste* 'wall' in Manet's portrait of Mallarmé. In the double portrait of Degas and de Valernes (illus. p. 23), de Valernes, too, is altogether the man of the world; Degas asks only himself what constitutes an artist, appropriating for himself alone the protective gesture of the sensitive man and the interrogative gesture of youth. Nor does Tissot (illus. p. 107) figure in

Degas's eyes primarily as a painter. We see him just entering a studio that cannot be his own; it may justifiably be interpreted as a neutral place or meeting ground of two different artistic temperaments, if the portrait of Frederick III by Cranach displayed in the most prominent position on the wall may be taken as a third artistic position beside those of Degas and Tissot. Tissot has just taken off his hat and overcoat and is slumped in a chair, turning his questioning gaze towards Degas, and the viewer, asking 'Now what?' The same position for the figure, this time against a neutral background, can be found in the portrait of Moreau painted seven years earlier (illus. p.142); the painter turns round casually and almost anonymously on

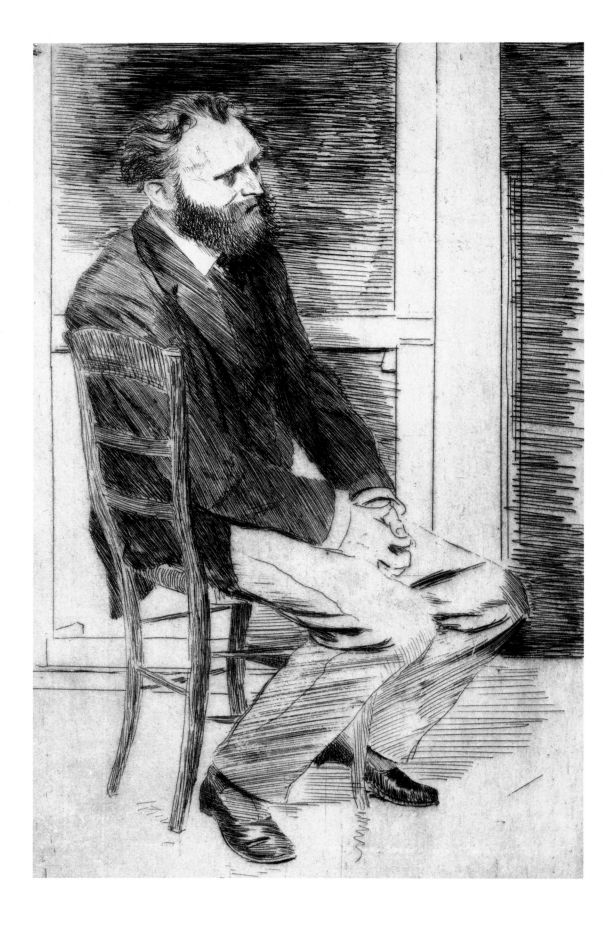

Manet, seated, turned to the right
1864–65
Etching with drypoint, 1st state
19.5 × 21.8 cm
Boston, Museum of Fine Arts,
Bequest of W.G. Russell Allen

66
Manet, seated, turned to the right
1864–65
Etching, intermediary state between 2nd and 3rd states
31.5 × 22.5 cm
Private collection

67
Manet, seated, turned to the right
1864–65
Etching and drypoint, 4th state
19.3 × 12.2 cm
Paris, Bibliothèque d'Art et d'Archéologie, Fondation Jacques Doucet
[above right]

68
Manet (bust-length)
1864–65
Etching with drypoint and aquatint, 1st state
13 × 10.6 cm
Paris, Bibliothèque d'Art et d'Archéologie, Fondation Jacques Doucet

69
Manet (bust-length)
1864–65
Etching with drypoint and aquatint, 4th state
36 × 27 cm
Boston, Museum of Fine Arts, Katherine Eliot Bullard Fund in Memory of Francis Bullard and proceeds from sale of duplicate prints
[below right]

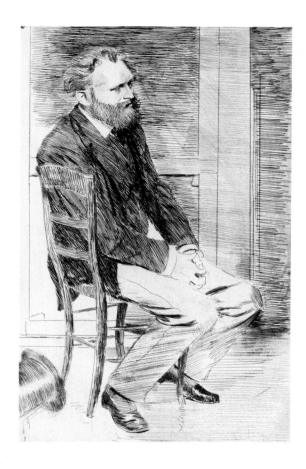

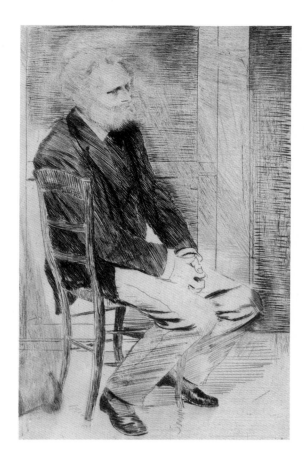

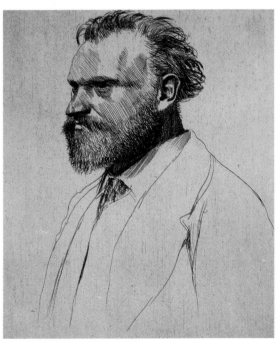

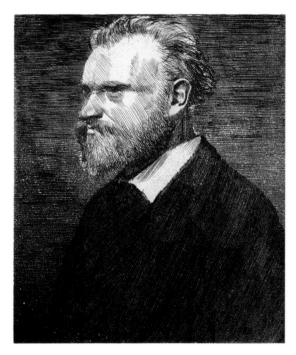

83

Manet at the races ('Manet aux courses')
1865–68
Pencil on paper
32 × 24.1 cm
Rotterdam, Museum Boymans-van Beuningen

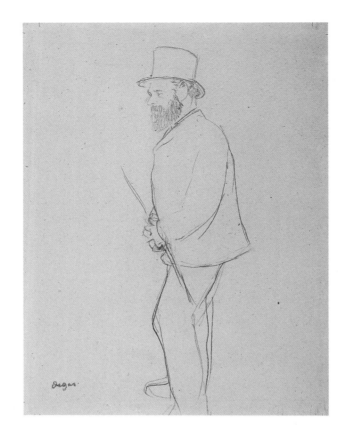

84

Manet at the races
ca. 1870
Pencil on paper
38 × 24,4 cm
New York, The Metropolitan Museum of Art, Rogers Fund, 1919

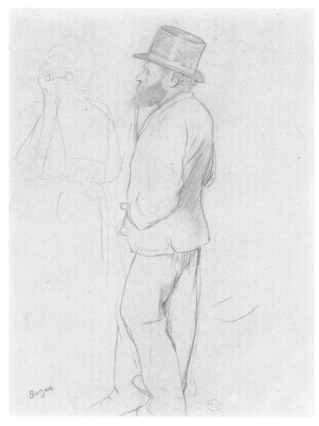

his chair, with his hat and gloves laid heedlessly on the floor. The artist is always in his Sunday best, his visiting clothes, portrayed as a 'social' creature and not an exponent of his profession, as a private person and a man of leisure. Even Mary Cassatt, whose portrait (cat. 168, illus. p. 276) is supposed to have been painted in her studio, is wearing her hat and is not recognisably a painter.[11]

The portrait of Henri Michel-Lévy which Degas exhibited at the fourth Impressionist exhibition in 1879 as *"Portrait d'un peintre dans son atelier"* (L326, Lisbon, Museu Calouste Gulbenkian) is an exception in this respect. The picture currently identified as that of Henri Michel-Lévy, of whom very little is known, has a melancholy expression (with an unmistakable closeness to the study in cat. 99, illus. p. 264), and more readily corresponds to our image of an artist immersed in his world, momentarily pausing in his work only so as to pose for his fellow artist. But here again, for all that we are incontrovertibly dealing with a 'portrait of a painter in his studio', the question of Degas's arbitrary treatment of the deportment of his sitters and of portraiture as such is raised. For how can we explain the fact that Degas used the same figure in the same pose and the pose, leaning against the wall with hands in pockets, is significant ten years earlier for the male protagonist in the picture generally described as his purest genre picture, *Interior – The rape* (illus. p. 27; see further Boggs's contribution on p. 27f.).[12]

In conclusion we may say that in his art Degas preferred not to identify his artist friends as artists and that there is no discernible systematic correlation between their talent and his choosing them as portrait subjects. On the contrary, rather than portraying the great painters of his day (Manet excepted) Degas obviously chose to portray less able artists whom he liked personally or who spoke the same language because of a similar background, or talented, well born

131
Carlo Pellegrini
1876–77
Watercolour and oil and
pastel on paper
63 × 24 cm
London, The Tate Gallery
(L407)

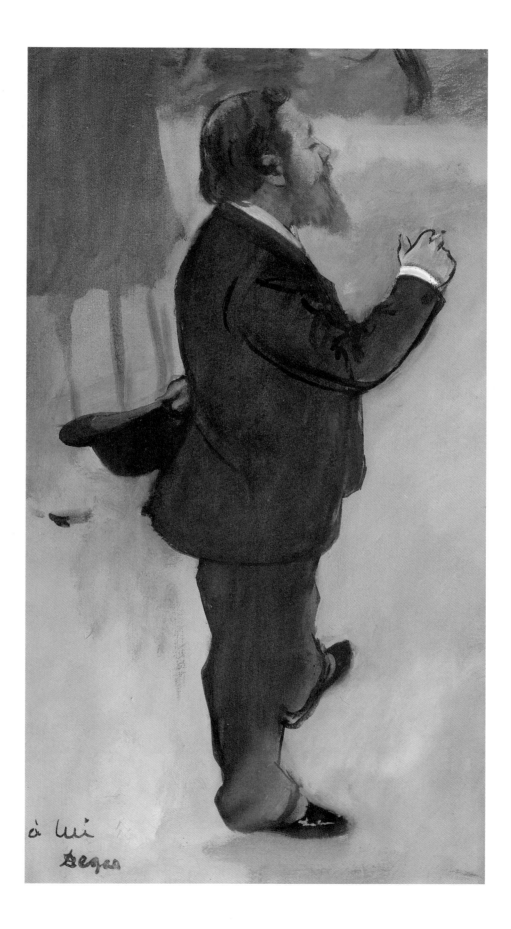

amateurs such as Rouart, Lepic or De Nittis, whose most important characteristic was not their contribution to art, but their gift for friendship and the atmosphere of their family homes whose doors were always open to him.

It almost seems as if Degas were happy to be influenced by the photography of the day when the worldly demeanour of an artist was to be stressed: this applies not only to the influence on Degas of Bracquemond's celebrated portrait of Théophile Gautier (see illus. p. 140 and comments by Shapiro on p. 140f.), but also to Degas's image of Manet in his series of etchings (cat. 63–69, illus. pp. 255–57) which approximate quite closely to Nadar's famous photograph of Manet.

If we take the collected remarks which Degas generally addressed with razor sharpness to 'literary figures',[13] pronouncing dreaded judgement on his colleagues (Bonnat reportedly never liked talking to Degas for long as it subsequently impaired his painting),[14] and then consider Degas's fond affection for many of his moderately talented painter friends, we get the impression that Degas liked to operate as an artist and a person where he could be sure of his own superiority. Interestingly enough, Degas was at odds with the other great painters participating in the Impressionist exhibitions on this very point, encouraging his closer friends to participate keenly and always strongly advocating their retention – men such as Zacharie Astruc, Bracquemond, Levert, De Nittis, Desboutin, Lepic, Henri Rouart or Zandomeneghi.[15] He even tried to engage Tissot, who had become a fashionable painter in London, for the common cause and to deploy one Jean François Raffaelli against "Monet and his friends".[16]

Degas would hardly have had any illusions about the quality of the work of these painter friends, and there are quite a few passages in his letters indicating his awareness

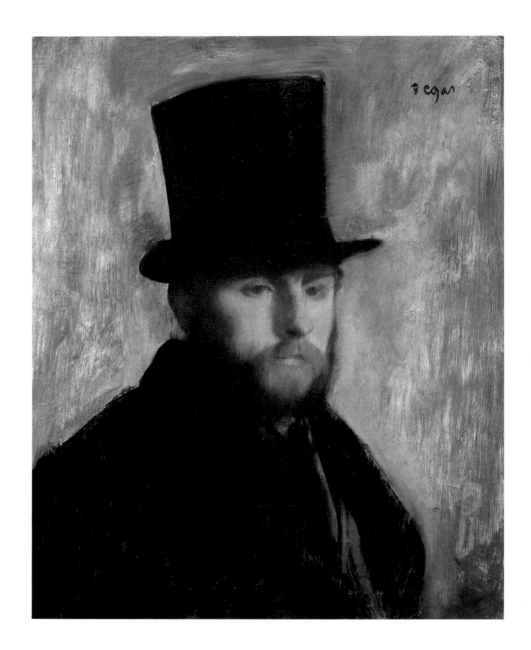

of his own superiority, using the tell-tale epithet 'poor . . .' to describe those others.

The relationship between Degas and Manet was of a different nature; it arose through art and they measured one another by it. "He was greater than we thought,"[17] Degas is reported to have said after Manet's early death, a comment expressing both the admiration and the irritation Degas must have experienced in the long course of a chequered friendship. Degas expressed his recognition of Manet as a 'painter'. Degas

used, and reserved, the term as his supreme accolade.[18] Many achieved what Degas was incapable of giving: an overt expressiveness in his depiction and handling, a charming unstudiedness, and a bold simplicity which endorsed the concept of 'modern' life with a splendid new dress. Degas was well aware of these qualities, touchingly immersing himself in pictures by Manet and accepting them into the magnificent collection of his personal Parnassus.[19] In return Manet must have recognised Degas's compositional

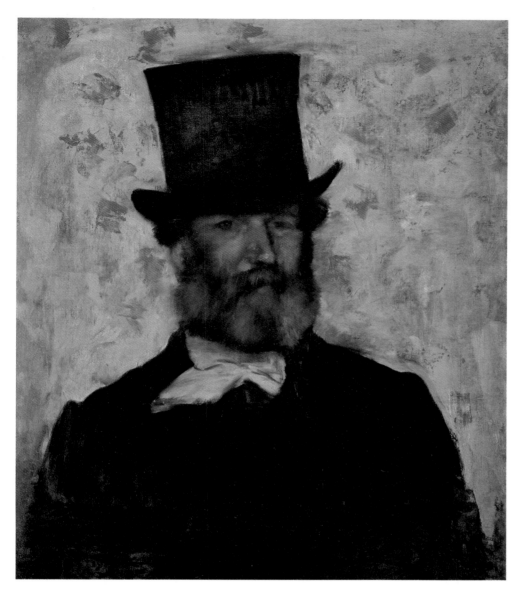

116
Léopold Levert, ca. 1874, oil on canvas, 65 × 54 cm, Tokyo, Bridgestone Museum of Art (L358)

70
Bellet du Poisat, 1865–66, oil on canvas, 41 × 31.8 cm, New York, private collection (L133) [left]

genius and valued his intelligence and ability to capture movement. They had in common both respect for the Old Masters and their search for the form to be taken by the 'modern icon'. This becomes particularly apparent in their portraiture, and in their expanded concept of the portrait, which ultimately set out to depict the whole figure, guided by the pattern or archetype that the individual represented. Both artists were virtually independent of commissions, and so were free of commercial pressures and formulas necessary for success. Both perceived the portrait no longer as merely reproducing a physiognomy but as comprehending the whole person within the conditions of the environment which helped determine his or her personality. Like Manet, Degas turned away from the portrait simple and elevated it to a higher category: Manet entitled his portrait of Mme Manet "*Lecture*" ('Reading'), while Degas's *Collector of prints* (which must be compared with Manet's portrait of Zola) originally depicted an identifiable individual whom our ignorance has now made anonymous, turning the picture into genre.

The things Degas and Manet have in common go even beyond similar ideas and concepts of painting and the shared destiny of outsiders within a group of outsiders: they used the same models, shared an iconography and indulged in a reciprocal quotation that is almost amusing in its consistency, suggesting that they actually delighted in crossing brushes. For example, is the similarity between the little slippers falling off the feet of Manet's otherwise naked *Olympia* and the discarded house shoes belonging to the large feet of Degas's *Martelli* an iconographical accident or a witty allusion? In any case there are numerous such instances; the few selected here in what follows are intended to serve only as illustrations. Manet kept coming back to Degas – in his late café scenes, the depiction of the individual in the context of

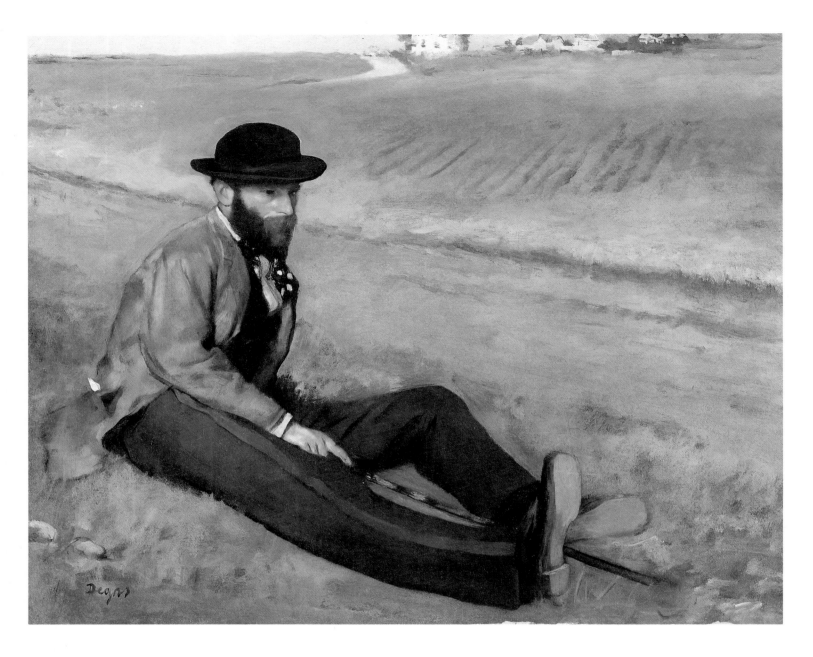

115
Eugène Manet
1874
Oil on canvas
65.2 × 81 cm
Private collection (L339)

his or her profession, his 1868 portrait of Zola, and so on.[20]

Degas's portrait of Manet listening to his wife play the piano, *M. and Mme Edouard Manet* (illus. p. 25), of ca. 1868–69 is generally supposed to have been painted shortly after Manet's *Mme Manet au piano* (1867–68), although the literature on Manet suggests that the chronology of the two works should be reversed.[21] In any case Degas shows his friend, who was known not to be musical, lounging on a sofa lost in thought

as he supposedly listens to his wife playing. As we know (and see also Jean Sutherland Boggs's discussion of the matter, p. 25f.), Manet's dissatisfaction with this visual judgement on him cast a temporary shadow over their friendship; Manet straightaway cut off the right side of the Degas picture depicting his wife playing the piano, and Degas in turn took offence and returned a present of Manet's to him with the words: "Sir, here are your feathers!" What interests us here, however, is the sofa, an item which

served as the background for many of Manet's portraits of reclining ladies and existed like this in Manet's studio; Degas must surely have interpreted it with irony as the location of the event, to some extent turning the perpetrator into the victim. While in *L'Absinthe* (1875; illus. p. 105) the actress Ellen Andrée is playing a rôle, so in Manet's *La prune* (1878) she is once again a protagonist; if we disregard the differences in temperament between the painters and the different formats of the pictures, it is only the type of alcohol that is different.

Manet also followed Degas to the races, but overtook him by a lap shortly after the start: he set out to capture the fleeting moment and to take bold new angles on the scene – he virtually placed himself in front of the racing horses, so attempting what is a total impossibility in painting, which cannot be so instantaneous (*Racing at Longchamps*, Chicago, Art Institute).

Conversely Degas followed Manet's formula for the figure of his brother Eugène Manet stretched out on the ground; he had lain on the grass in Manet's *Le déjeuner sur l'herbe* painted in 1863 and was again depicted 'drawn from life' in the same position on the beach at Berck-sur-Mer for the picture *On the beach*; the two brothers spent three weeks there on holiday in 1873. Eugène Manet married Berthe Morisot the following year, and it is generally accepted that Degas's portrait *Eugène Manet* (cat. 115, illus. p. 262) dates from then. In it Degas takes over the same reclining position which Manet had chosen for his brother in the two pictures mentioned above, also tucking the walking-stick which he had already had with him in *Le déjeuner sur l'herbe*, surely intended to characterize him as something of a *flâneur*, between his legs. Although at the time Degas had condemned Manet's pretence of *plein air* in *Le déjeuner sur l'herbe*, in his version of Eugène Manet he totally accepted the idea, likewise integrating the figure into a landscape background worked

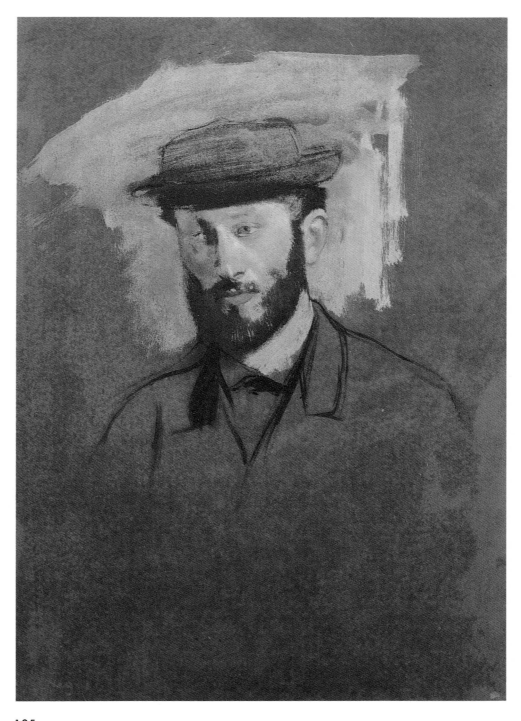

125
Eugène Manet, ca. 1875, oil on paper, 30.7 × 22 cm, private collection (L136)

99
Study for *Interior (The Rape)*
1868–69
Pencil
35 × 24.75 cm
Zurich, private collection

out in the studio.[22]

The series of portraits which Degas produced of Manet (see cat. 62–69, illus. pp. 254–58, and essays by Boggs and Shapiro in this catalogue) is unique as a document of the friendship and familiarity between the two painters, and also within Degas's œuvre – although Manet did not return the compliment with a single portrait of Degas.

When Duranty spoke of Degas as the pioneer of a new movement in his 1876 essay *La Nouvelle Peinture* which provided a theoretical framework for Impressionism, Manet at the same time found a champion in Mallarmé who described him as the "father of the Impressionists", despite the fact that Manet refused to participate in the group exhibitions by the Impressionists and did not represent the new movement in a strict form any more than did Degas. Both Mallarmé and Duranty were trying to come to terms with the movement as a phenomenon and find as broad and comprehensive a definition for it as possible.[23]

Manet painted his champion in 1876 (*Stéphane Mallarmé*, Paris, Orsay) while Degas paid tribute to his man of letters in 1879 (*Edmond Duranty*, L517, Glasgow, Burrell Collection, illus. p. 47; a study is cat. 149, illus. p. 265). Again the differences between the two painters' temperaments are to the fore, but at the same time they have much in common with regard to iconography and their approach to the portrait. While Manet painted his Mallarmé in an intimate, small format (27 × 36 cm) and Degas staged his sitter in a large one (pastel and tempera, 100.9 × 100.3 cm), both are bust pictures in an interior. Mallarmé's right hand is placed on an open book with a cigar stuck between his fingers, his left hand in his jacket pocket; he blends into the soft flowing lines of the painting, which are echoed in his slightly lopsided, relaxed posture. Degas's portrait of Edmond Duranty is represented in this exhibition by a very fine preliminary study (cat. 149) which gives a good idea of the

concept of the figure. Degas's man of letters also has his right hand placed on a book, is also seated in an interior, but his left hand with the index and middle fingers outstretched is raised to his forehead in the gesture of a thinker. Nor is there any *japonisme* in the wallpaper, there are books (in the finished picture) instead. Manet depicts a dreamy poet, Degas an intellectual and theorist. Perhaps the basic differences between the temperaments of the two painters are revealed in their relative closeness to the object and the warmth of their gaze: Manet more emphatic and spontaneous, whereas Degas is cooler, more remote and calculating.

Duranty was the founder of the journal *Réalisme* (1856–57) and worked as a journalist and art critic. He was very closely bound up with the group of 'modern painters' centred on Manet and Fantin-Latour and took an active part in the discussions at the café Guerbois; he first got to know Degas more closely there, keenly appreciating his sharp-tongued observations about art. His polemical treatise on *La Nouvelle Peinture* was published in 1876 on the occasion of the second exhibition of the 'Société anonyme des artistes, peintres, sculpteurs et graveurs' held at the Galerie Durand-Ruel, which later came to be described as the 'Impressionist' exhibition. Duranty's concept of Realism in *La Nouvelle Peinture* is generally traced back to the influence of Degas, to such an extent that Degas rather than Duranty has sometimes been credited as its author.[24] It is to Duranty's credit that in attempting to class complex tendencies and very varied styles of expression together under the concept of realism he gave what is possibly the widest and most complete definition of Impressionism. His praise of a painter not specifically named who embodied all the requirements for a new type of painting with no thought of private gain ("as a philanthropist of art")[25] was no doubt directed towards Degas. Degas's por-

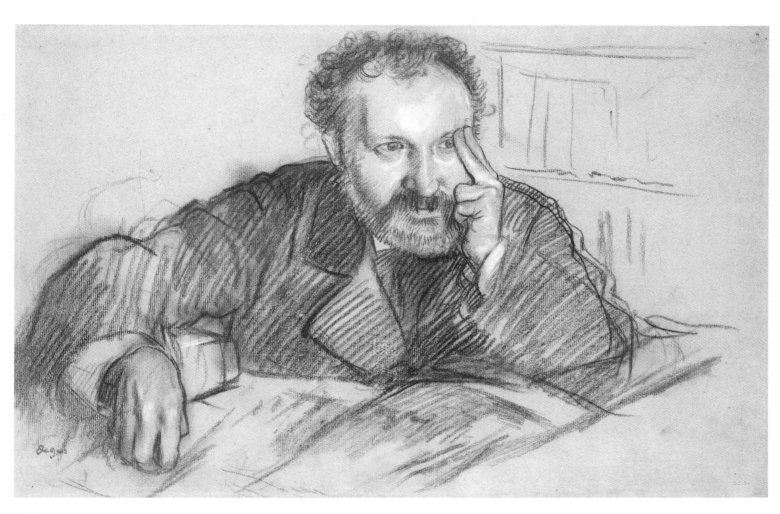

149

Edmond Duranty, 1879, charcoal on blue paper, heightened with white, 30.8 × 47.3 cm, New York, The Metropolitan Museum of Art, Rogers Fund, 1918

145
Diego Martelli, study for cat. 144, 1879, pencil, 11.1 × 16.8 cm, Edinburgh, The National Gallery of Scotland

trait of Duranty can in turn be read as illustrating his comments, in an amazingly pointed and perhaps unconscious way defining a new category of portrait: "Farewell to the human body treated like a vase . . ." or "What we need is the special note of the modern person, wearing his usual clothes, amidst his social habits, at home or in the street . . . the observation of man's intimacy with the place where he lives . . .".[26]

Degas's portrait of *Diego Martelli* (cat. 144, 146, illus. pp. 267, 269), of which there are two versions in oils and several preliminary studies, was less cool in effect and correspondingly more daring. His acquaintance with Martelli may have dated from the time he spent in Italy where they could have met in the caffè Michelangiolo in Florence which was a haunt of artists; Telemaco Signorini later described Martelli's first appearance there as follows: "he was only a boy, not just a boy even, he was a putto, as plump and round as an apple".[27] Degas's Martelli also imparts this impression of a putto. In his depiction of the interior, which sets out to convey a deliberately spontaneous impression, we may again feel that Degas is following Duranty's demand for the person to be represented in his or her own surroundings particularly faithfully.

The way Martelli – an undoubtedly complex character, as Degas would have known – is depicted recalls Degas's claim that he only enjoyed drawing people who were themselves "poseurs".[28] Here Degas is in his element: witty, cultivated, pitiless – qualities to which he certainly could not have given free rein in dealing with a conventional model. What Martelli particularly prized in Degas was his questioning, fresh approach to painting and the unusual way he went about it. Degas used these very qualities in this portrait of a man of intellect, combining an uncommon portrait formula with unusual and novel colouring using broad planes of colour.

Martelli was sent as a correspondent to

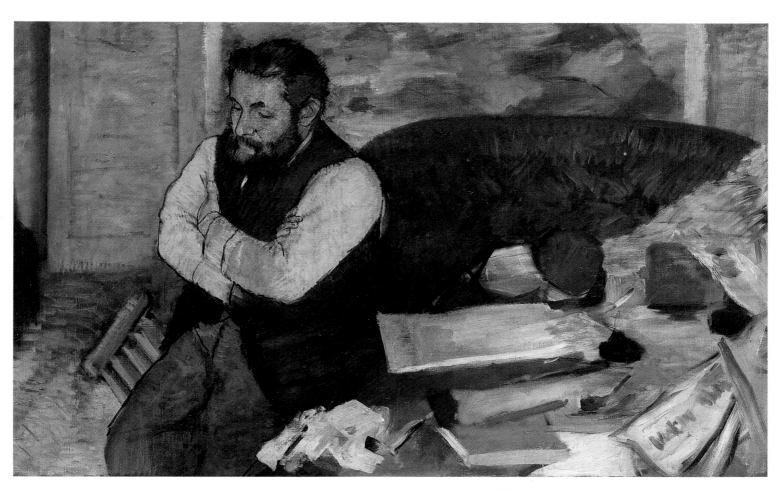

144
Diego Martelli, 1879, oil on canvas, 75.5 × 116 cm, Buenos Aires, Museo Nacional de Bellas
Artes (L520)

the World Exhibition (April 1878) in Paris and stayed there until April 1879 – his longest period in Paris. The sittings for the portrait must have taken place shortly before he left, as the study for the Edinburgh version has the note "At Martelli's – 3 April 1879". Three features dominate this picture: Martelli, the blue sofa and the picture on the back wall. Martelli's unusually corpulent figure is viewed unexpectedly from above, as if Degas's viewing angle could overcome the gravitational pull of the heavy body and by looking down on it push it even further back into the picture ground, at the same time modifying the circumference of the body seen from this distance and so making it more animated. The Savonarola chair conveys Martelli's link with Italy. The intellectual still life, the jumble of papers, the pipe and the bottle of ink characterize him as a man of intellect rather than a man of action, though in a strange twisting movement he is turning away from the desk and the sofa (and in Degas's work nothing is accidental). The third thing in the picture that catches our eye, the most puzzling and in this context the most interesting, is the cut-off picture on the wall; in the Buenos Aires version it is characterized by blobs of colour, in the Edinburgh one by flat fields of colour. This element in the picture – which is extraordinarily bold, anticipating the abstract painting and colour games of someone like Delaunay – is plausibly explained by Calingaert;[29] according to him the dispersed blobs of colour in the Buenos Aires picture are a free interpretation of contemporary paintings such as the small landscape studies the Italian *macchiaioli* or 'blob painters' and certain French artists (Pissarro and Alphonse Mareau) were then experimenting with. Martelli had collected works by these artists and hung them closely spaced round the walls of his flat, and Degas wanted to indicate Martelli's importance as a comrade-in-arms and patron within this movement.

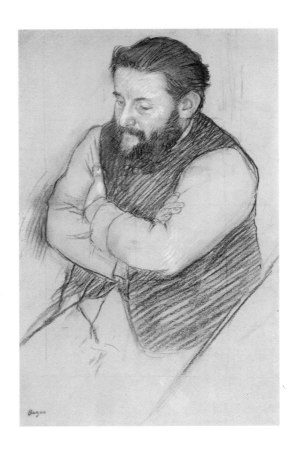

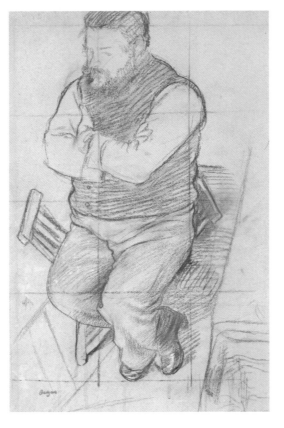

147
Diego Martelli
Study for cat. 146
Black chalk heightened with white, on buff wove paper
45 × 28.6 cm
Cambridge (Mass.), Harvard University Arts Museums, Fogg Art Museum, Bequest of Meta and Paul J. Sachs

146
Diego Martelli
1879
Oil on canvas
110 × 100 cm
Edinburgh, National Gallery of Scotland (L519) [right]

148
Diego Martelli
Study for cat. 146
ca. 1879
Charcoal on paper
45 × 29.7 cm
Cambridge (Mass.), Harvard University Arts Museums, Fogg Art Museum, Bequest of Meta and Paul J. Sachs

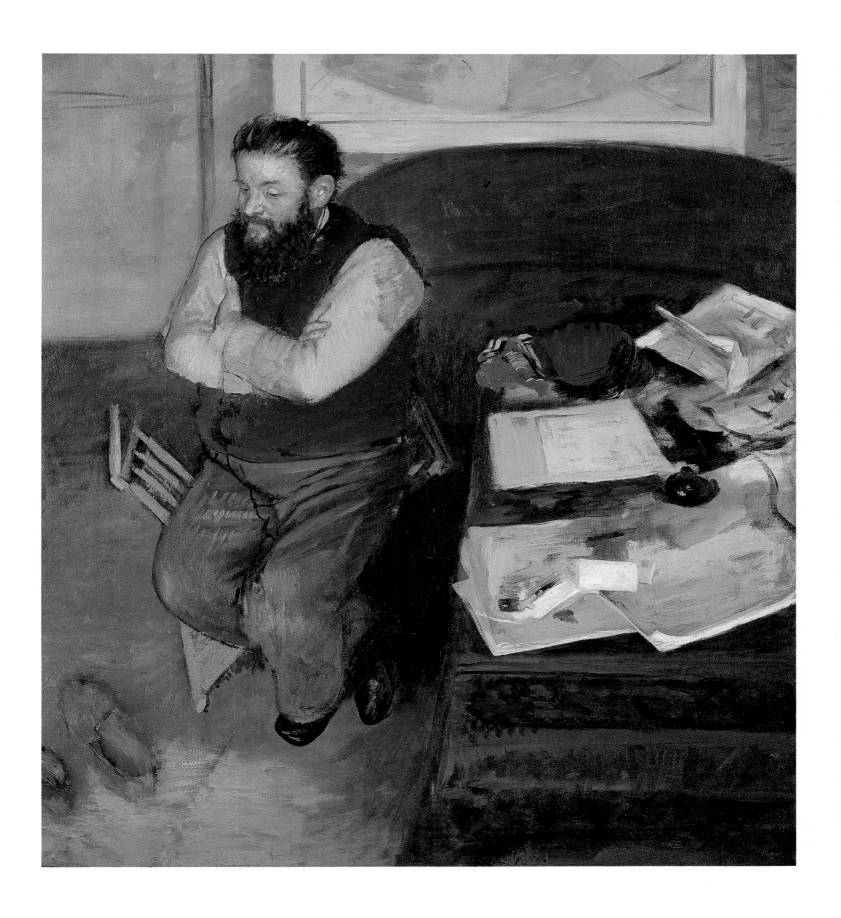

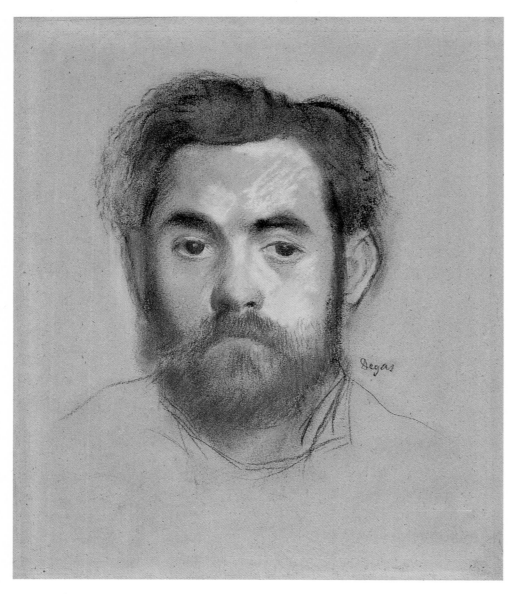

143

Jacquet, ca. 1878, pastel on paper, 26 × 20 cm, Los Angeles, The Armand Hammer Foundation

The Edinburgh version on the other hand is a metaphorical expression of the nature of the critic's interests: he was preoccupied with the scientific resolution of what was known as 'spontaneous' painting, and had therefore studied the observations on colour theory and the colour circles of people like Chevreul.[30] Martelli obviously liked this idiosyncratic image of himself, for he later tried to get hold of one of the two portraits, using a common friend, Federico Zandomeneghi, as his intermediary; Degas must have refused. Zandomeneghi commented on the matter in a letter to Martelli written in October 1894. According to this a second request to Degas again met with a refusal, Degas arguing that Duranty (before he died) had been critical of the optical foreshortening of the legs.[31]

Mary Cassatt's reaction to the 'classical' portrait (cat. 168, illus. p. 276), in which Degas depicted her – over and above the well known series of figure studies described by Boggs in this book (cf. her comments on cat. 151–55 on p. 40f.) – was less enthusiastic. At the end of her life she wanted this to be sold and certainly not left in her family; she wrote about her decision in a letter to the art dealer Durand-Ruel: "It has some qualities as art, but is so painful and represents me as such a repugnant person, that I would not want it known that I posed for it."[32] No doubt Mary Cassatt would have had enough in common with Degas and provided enough material for an outstanding 'portrait of an artist', just as Manet, Duranty, Martelli, Tissot or Henry Michel-Lévy could and did. It is all the easier to understand her annoyance – though for us it is no longer surprising – that Degas had represented her as a fortune-teller setting out her cards, an occupation which at that time was not far removed from the world of prostitution and pimping. It is understandable that the self-assured American artist was displeased, but rather less so that the joint story of two fellow artists, hit-

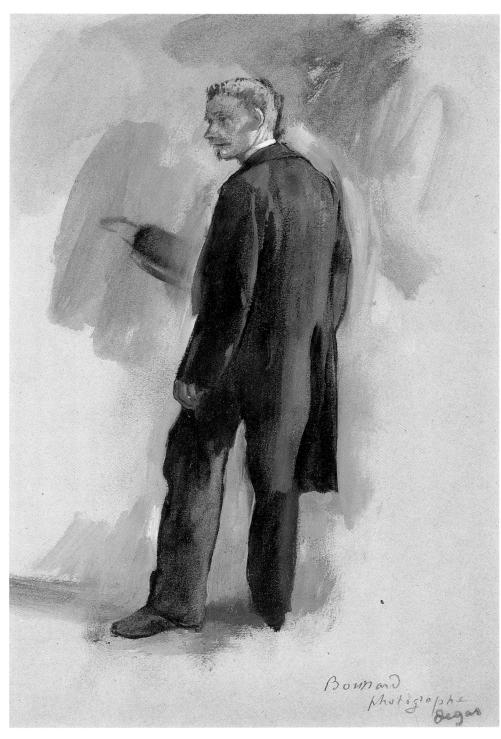

162

The photographer Boussard, 1881–85, watercolour and gouache, 30 × 20 cm, Detroit, The Detroit Institute of Arts, Bequest of John S. Newberry (L677)

herto marked by mutual esteem and reciprocal help, should end with the older, more famous artist viewing his talented, eager-to-learn pupil in such a light. At the same time Mary Cassatt, for her part, did not do justice to Degas's wittiness, his gift for observation and the concealed gesture of affection which he could express only in paint. In the very place where Mary Cassatt's portrait hangs today, in the National Portrait Gallery in Washington, surrounded by a large number of formal, imposing portraits of American notables, it catches our eye because of its exceptional warmth and subtlety; its most striking feature is the glowing white-painted light forming a modern, abstract halo round her head. As he had Tissot, Martelli, Manet and another woman artist, Victoria Dubourg, some fifteen years earlier, Degas posed Mary Cassatt as a solitary figure on a chair, with his view from above falling downwards on her person; in the final analysis so much personality remains in Degas's portrayals of these people precisely because they appear first and foremost human beings and not artists. As Degas so pithily summed up the situation of the modern artist in one sentence: "On nous fusille, mais on fouille nos poches".

NOTES

1 Quoted from G. Geffroy, *Claude Monet, Sa vie, son œuvre*, edited and annotated C. Judrin, Paris 1980 (first edition 1924), p. 140.

2 Quoted from Loyrette 1991, p. 467.

3 *Ibid.*

4 Letter dated 30 September 1917 to the Italian critic Vittorio Pica, quoted from Vitali 1963, p. 273.

5 *Le Constitutionnel*, 10 April 1876, quoted here from the exhibition catalogue 'The New Painting, Impressionism 1874–1886', San Francisco, Fine Arts Museum/Washington, National Gallery of Art, 1986, p. 176.

6 Gauguin to Pissarro, 18 January 1882, in *Correspondance de Paul Gauguin*, ed. Victor Merlhés, Paris 1984, p. 27.

7 Quoted from Cabanne, *L'amitié de Degas et de Valernes*, Musée de Carpentras, 1968, unpa-

153

Ellen Andrée

1879

Etching

3rd state, 3rd proof

11.3 × 7.9 cm

Josefowitz collection

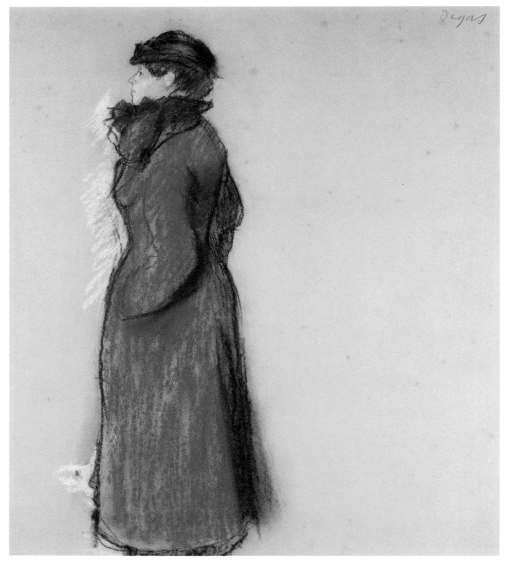

151

Woman in street clothes, ca. 1879, pastel on paper, 48 × 43 cm, Walter and Maria Feilchenfeldt, Zurich

155

Mary Cassatt au Louvre, Musée des Antiques, 1879–80, etching with drypoint and aquatint, 9th state, 3rd proof, 26.7 × 23.2 cm, Private collection, Berlin [right]

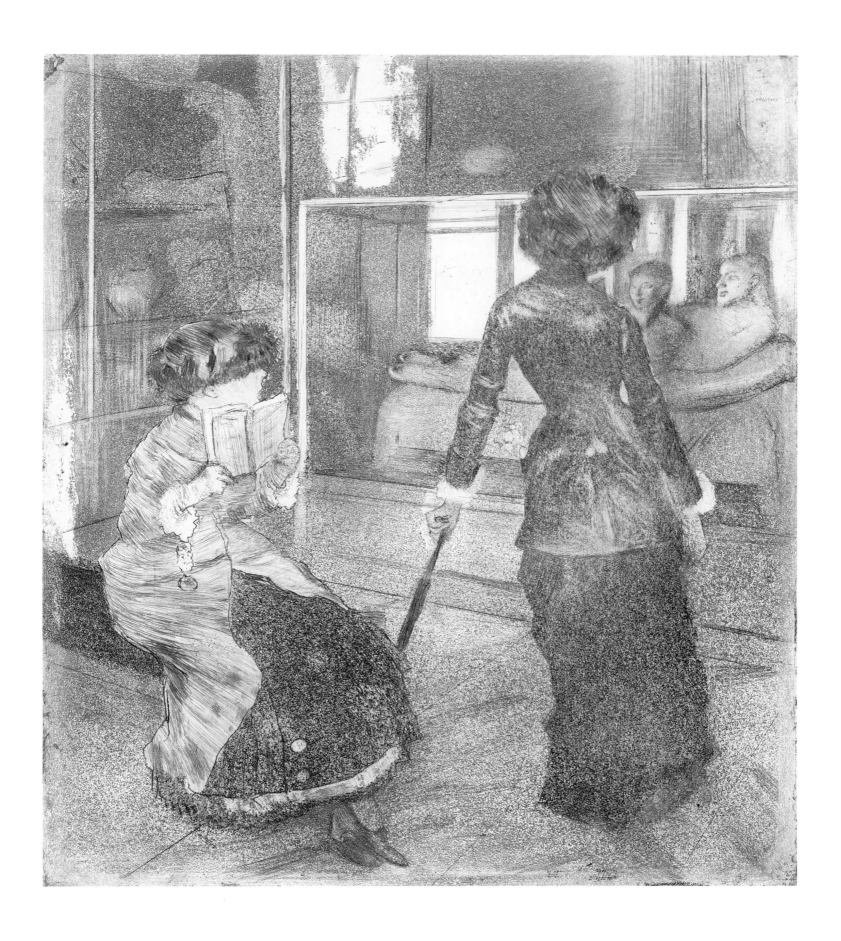

154

Mary Cassatt au Louvre
1879–80
Etching, 9th state
34 × 17 cm
Amsterdam,
Rijksmuseum,
Rijksprentenkabinet
(1961–794)

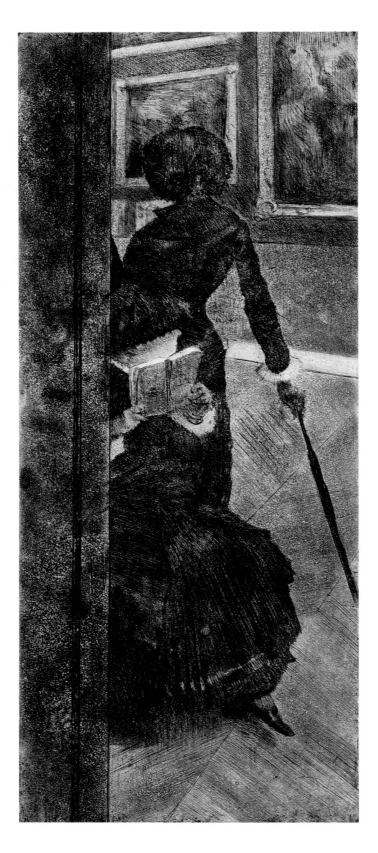

ginated, and Loyrette 1991, p. 225.

8 Denys Sutton in *Degas inédit* 1989, p. 283; Loyrette repeats this theory in the exhibition catalogue '*L'impressionisme, les origines, 1859–1869*', Paris, Grand Palais/New York, Metropolitan Museum of Art, 1994, p. 156. Felix Baumann suggests that the person depicted might be Auguste Renoir. This idea is based on the one hand on a physiognomic resemblance between the painting and early photographs of Renoir, in particular the large nose, the crease in the forehead and the large hands and feet. The cut-off picture in the top right corner would support the same conclusion as Renoir is known to have prepared several detail sketches on one canvas and this practice can be clearly recognised in Degas's picture in the background.

9 Cf. *Correspondance de Berthe Morisot*, Paris 1950, and Burroughs 1963, pp. 169–72.

10 André Gide in *Journal, 1889–1939*, quoted here from Loyrette 1991, p. 175.

11 Cf 1988–89 Paris/Ottawa/New York, no. 268, p. 442f.

12 The drawing shown here is a study for L353, which is in turn a study for the picture *Interior*, and it is connected to Michel-Lévy. At all events Brame/Reff see a connection between no. 51, the portrait of M. Romain (possibly called M. de Saint-Arroman), and the man depicted in *Interior*.

13 Cf. Halévy 1960, pp. 14f. and 110f.

14 *Ibid.*, p. 64. Agathe Rouart-Valéry, 'Degas, ami de ma famille' in *Degas inédit* 1989, p. 27, also relates that Gide once said after a meeting with Degas: "Fortunately he is not a writer! He would have made me sterile."

15 Lists of the Impressionist exhibitions in San Francisco/Washington 1986 (see note 5).

16 A detailed description of the quarrel within the group in Loyrette 1991, p. 396.

17 Jacques-Emile Blanche, *Manet*, Paris 1924, here quoted from Darragon in *Degas inédit* 1989, p. 89.

18 Degas in Reff 1985, BN 13, p. 50: "mais il faut être peintre bien peintre", and in Sickert 1917, p. 186, it is reported that Degas once retorted: "Sir, he is not a genius. He is a painter." In a letter to Henri Rouart dated 2 May 1882 Degas gave vent to his feelings about Manet's *Bar aux Folies-Bergères*, at the same time tempering his succinct negative commentary by granting that he was a "painter": "Manet bête et fin, carte à jouer sans impression, trompe l'oeil espagnol, peintre ..." (*Lettres* 1945, XXXIII, p. 62f.)"

152
Mary Cassatt au Louvre, ca. 1879, charcoal and pastel on paper, 47.8 × 63 cm, New York, private collection (BR 105)

172

Visiting the museum

ca. 1885, oil on canvas, 81.3 × 75.6 cm, Washington, National Gallery of Art, Mr and Mrs Paul Mellon Collection (L465)

168

Miss Cassatt, seated, holding cards, ca. 1884, Oil on canvas, 71.5 × 58.7 cm, Washington, D.C., The National Portrait Gallery, Gift of the Morris and Gwendolyn Cafritz Foundation and Regents' Major Acquisitions Fund, Smithsonian Institution (L796) [left]

19 Degas owned several works by Manet, including the pastel *Mme Manet sur un canapé bleu*, the famous *Plumes* and *Le jambon et la poire*. He acquired *Le gitane fumant une cigarette* from Durand-Ruel in 1896, bought the lithograph *Polichinelle* at the sale organized by Durand-Ruel after Duranty's death in 1881 and was also given *Départ du bateau de Folkestone* by Berthe Morisot and Eugène Manet. For more detailed information about Degas's activities as a collector, cf. Anne Roquebert, 'Degas collectionneur', in *Degas inédit* 1989, pp. 65–85.

20 Cf. Halévy 1960, p. 110 f.: "Confound Manet! No sooner did I do dancers than he did them ... he has always copied ... He could do nothing but copy". Cf also Loyrette in Paris/New York 1994 (see note 8), p. 213.

21 Exhibition catalogue *Manet*, Paris, Grand Palais/New York, Metropolitan Museum, 1983, no. 107, p. 286f.

22 Cf. Halévy 1960, p. 110f and Boggs in this volume, p. 39.

23 Mallarmé's essay 'Les Impressionistes et Manet' was published only in an English translation; the French original is now lost. Reprinted in San Francisco/Washington 1986 (see note 5).

24 Cf. Marcel Crouzet, *Un Méconnu du Réalisme: Duranty, l'homme, le critique, le romancier*, Paris 1964, pp. 333ff.

25 Duranty, *La Nouvelle Peinture*, reprinted Paris 1988, p. 36.

26 *Ibid.*, p. 34.

27 Quoted from Vitali 1963, p. 270.

28 Cf. note 10.

29 Calingaert, 1988, p. 40.

30 *Ibid.*, p. 42: Martelli apparently met the scientific researcher in 1870, as attested by an unpublished letter from Martelli to his mother.

31 Vitali 1963, p. 304.

32 Mary Cassatt in a letter to Durand-Ruel, 1912–13, quoted here from 1988–89 Paris/Ottawa/New York, p. 442.

Portraits and Genre

TOBIA BEZZOLA

Degas himself described one of his works, *Interior – The rape* ('*Intérieur – Le Viol*', L348, Philadelphia Museum of Art; illus. p. 27), as "my genre picture". The painting captures a moment at the dramatic climax of a story: it is assumed that the painting has a subject from contemporary literature, although the various attempts to identify it have been unconvincing. In any case, Degas's ironic description notwithstanding, the picture does not fit in with the genre-painting trends of his day. Dutch-inspired genre painting had increased greatly in popularity in the second half of the nineteenth century, resulting in a great proliferation of 'typical' subjects, both anecdotal and idyllic. But Degas was certainly not a fashionable genre painter in this sense – we find no monks sipping wine, no auctions of alluring female slaves, no gnarled peasants, no country scenes of Bible reading, plump ducks, funny little dogs and so forth in his work. If we understand by genre painting the depiction of cosy, peaceful, picturesque scenes, accepting existing convention and reproducing everyday life or history with an uncritical complacency, there are no genre paintings in Degas's work.

On the other hand, 'modern painting' itself invented a new, naturalistic canon of genre subjects, as can now be recognised with the benefit of historical perspective. With the erosion of the norms for 'official' portraiture bourgeois private life began to make its presence felt, and scenes and various aspects of domestic life began to replace or appear alongside more traditional accessories. Thus, genre motifs from contemporary domestic life, such as the drawing-room music recital, reading on the sofa or a peaceful conversation, crept into portraiture. Other kinds of figure pictures and portraits of celebrities in their professional rôles also took on genre-like characteristics: one example is Degas's portrait of the model Emma Dobigny ironing (illus. p. 97). The propensity of the exponents of 'modern

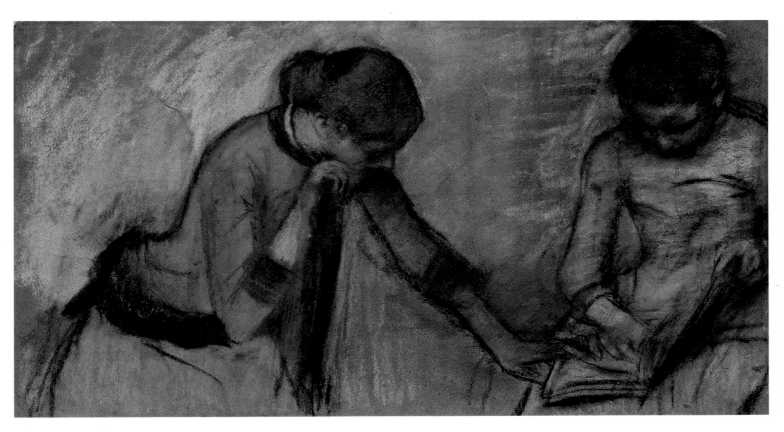

171
Two girls looking at an album, ca. 1885, pastel, 41 × 74 cm, Zurich, Fondation Rau pour le Tiers-Monde (L779)

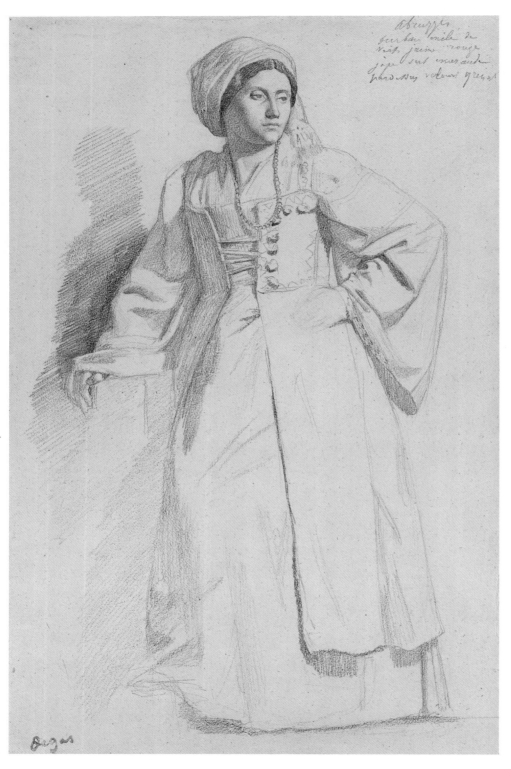

22

Italian woman, 1857, pencil on paper, 33 × 21.5 cm, Private collection

painting' to use settings from modern urban life therefore opened up quite dramatically a new repertoire of motifs for genre painting. The depiction of open-air concerts, visits to the opera, boating parties, scenes at the races or in the café obviously implied a rejection of the escapist, historicist cosiness of the genre painting that had appealed to the Second Empire, but at the same time these new images created a new typology of their own. Viewed in this way, Degas's portraits from the worlds of ballet, opera, *café-concert*, bistrot and brothel, together with his portraits of milliners and laundresses at work, belong to the new naturalistic kind of genre associated with 'modern painting'.

Folklore genre painting

In Degas's early work there are a few genre portraits which he painted in Italy. They were influenced by the penchant for scenes from Italian popular life currently in vogue among painters then living in Rome: in particular Victor Schnetz, at that time director of the Académie de France in Rome, promoted the fashion. These depictions of folkloric simplicity and picturesque poverty with their added references to Spanish painting – to Murillo, Ribera and Zurburán – were regarded as realistic and thoroughly progressive. During his time in Italy Degas preferred to copy the Old Masters, creating only a few completely original works such as the drawing of a young woman in Abruzzese costume (cat. 22, illus.) or the portrait of a Roman beggar woman (cat. 21, illus.) in the 'picturesque Italian genre'. In these, rather than being content just to assimilate the conventions of the genre, the young painter took pains over individuality of expression and originality of composition. However, under the influence of Gustave Moreau, Degas quickly turned away from this trend. The portrait of a Savoyard girl in local costume (cat. 53, illus. p. 282), which must have been painted shortly after his return from Italy, is the final echo of the folklore genre in Degas's work.

Roman beggarwoman
1857
Oil on canvas
100.3 × 75.2 cm
Birmingham, Birmingham
City Museum and Art
Gallery (L28)

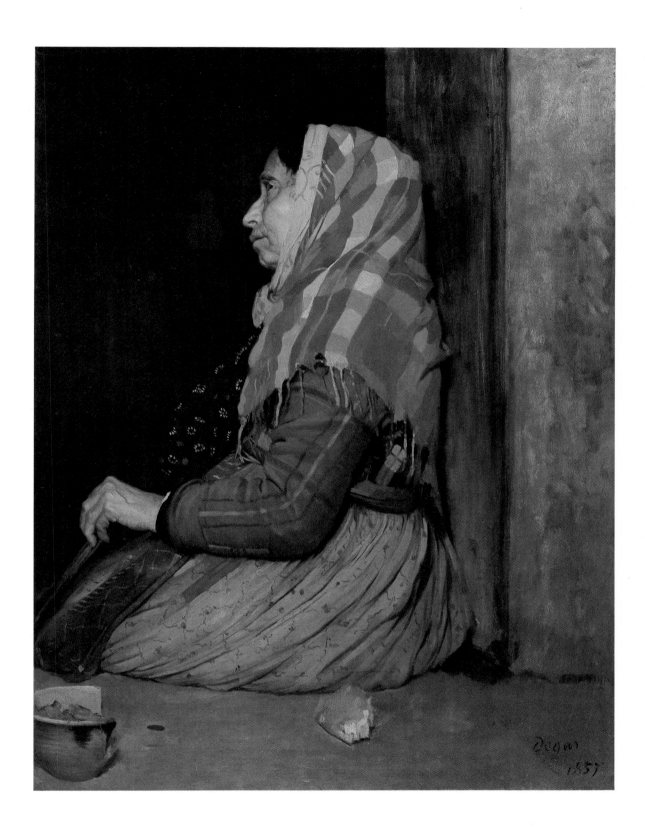

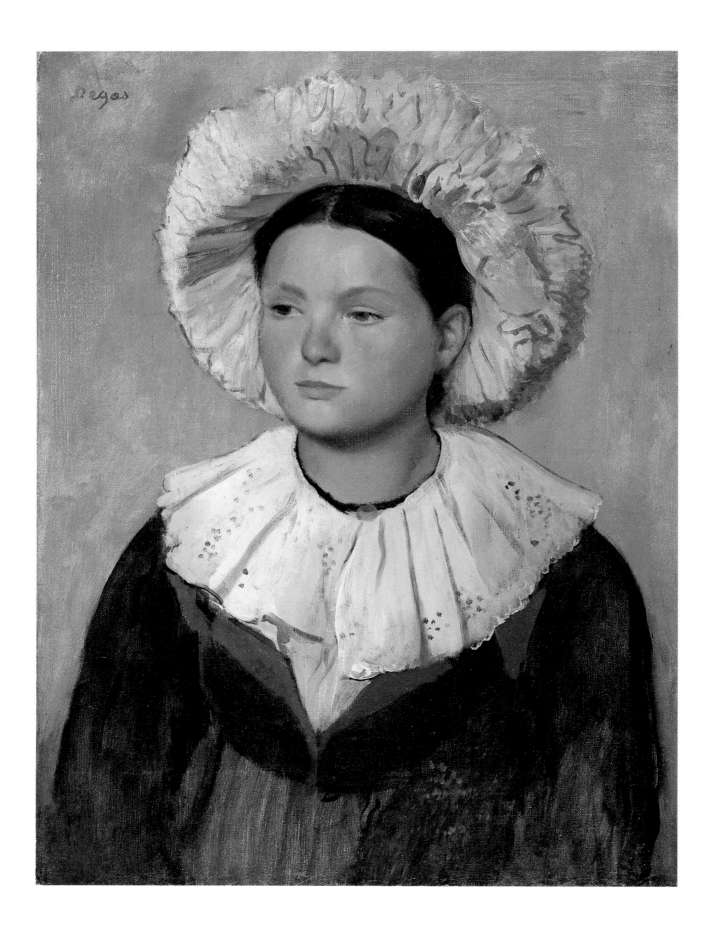

53

Woman of Savoy, ca. 1860, oil on canvas, 61.5 × 46.3 cm, Providence, Rhode Island, Museum of Art, Rhode Island School of Design (L333)

133

The impresario (Pierre Ducarre), ca. 1877, oil on paper, 48.9 × 35.6 cm, San Francisco, The Fine Arts Museums, Gift of Mr and Mrs Louise Benoist (BR 71)

'Modern' genre

The central appeal Edmond Duranty addressed to artists in his programmatic essay on '*Nouvelle Peinture*' written in 1876 (which may partly be read also as a manifesto of the artists praised in it) was that they should stop depicting historical costume pieces and instead portray "the spectacle of reality and contemporary existence". Degas was a friend of Duranty, and Degas's aesthetic philosophy is certainly formulated in Duranty's work. While in most of his portraits Degas expresses the private aspects of modern life – bourgeois intimacy, social intercourse and domestic culture – he owes his lasting fame to the fact that he became the chronicler of public 'entertainments' of the ballet, opera, theatre, *café-concert* and the world of fashion. He was also a regular visitor to a 'public' institution which, though relatively discreet, was an established ficture in male middle-class entertainment, the brothel.

Music and opera

Music played a central rôle in Degas's life. Admittedly, he did not distinguish himself in this field, unlike his sister Marguerite; but he inherited a deep love of music from his father, through whom he formed his first personal friendships with musicians, friendships that were soon reflected in his work. About 1870 he painted two portraits of the bassoon-player Désiré Dihau. They show him among the players in the orchestra pit at the opera (L186, illus. p. 51, and L295, Frankfurt, Städelsches Institut). For Degas, these portraits represented an important breakthrough to a repertoire of subjects in which he could express his personal view of life. In a letter to Dihau, Degas's father expressed his gratitude, because thanks to him his son had, for the first time, completed a 'proper' picture.

Degas set the double portrait of a violinist and a young woman ('*Violiniste et jeune femme*'; cat. 111, illus.) in a bourgeois

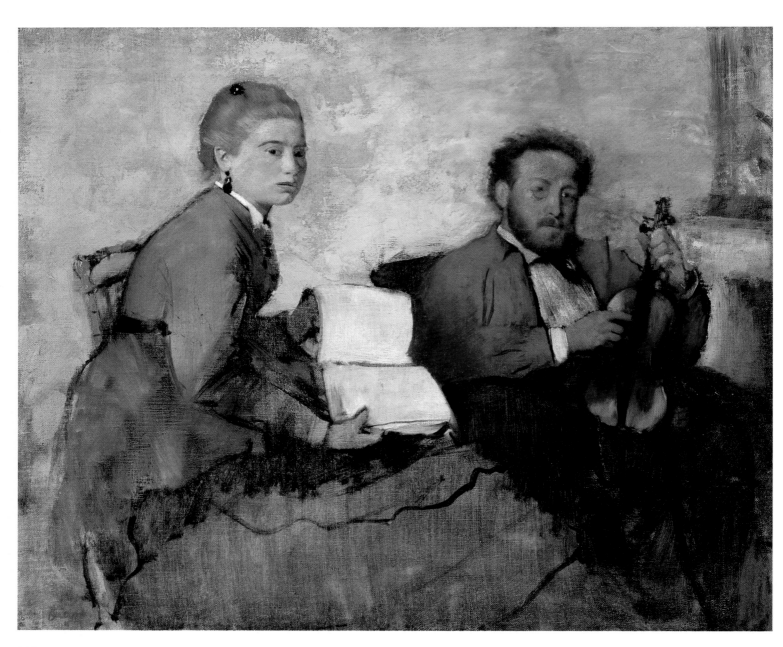

111

Violinist and young woman, ca. 1872, oil on canvas, 46.4 × 55.9 cm, The Detroit Institute of Arts,
Bequest of Robert H. Tannahill (L274)

175

Rose Caron ('Femme assise tirant son gant'), ca. 1892, oil on canvas, 76.2 × 86.2 cm, Buffalo, Albright-Knox Art Gallery, Charles Clifton, Charles W. Goodyear and Elisabeth H. Gates Funds, 1943 (L862)

drawing-room rather than the concert hall. Are we looking at a rehearsal, a lesson, or a short interval during a drawing-room concert? The identity of the individuals depicted is equally uncertain – the singer might be Degas's sister Marguerite.

Until a ripe old age Degas was a regular subscriber to the Paris Opéra, visiting many of its productions again and again. Of course at that time people did not go to the Opéra just to enjoy the performances: the Opéra also served as a kind of public reception area, and people went there to mingle with society, to see and be seen. Men also went to form liaisons with pretty dancers or *demi-mondaines*.

Degas's admiration for the women performing at the Opéra tended to be platonic yet fervent. In 1890 he took as the subject of one of his most important genre portraits (cat. 175, illus. p. 283) the soprano Rose Caron. She is depicted in her full costume, with her face mysteriously in half shadow and the emphasis placed on the graceful gesture with which she pulls on her long gloves. Rose Caron was one of the most famous singers of her day, enthusiastically applauded at both the Opéra and the Théâtre de la Monnaie in Brussels. Her 'Aztec' beauty was just as legendary. Degas saw her for the first time in the opera *Sigurd* by his friend Ernest Reyer in 1885, and missed hardly any of her performances in the following years; he even bought tickets for *Lohengrin* by Wagner, whose work he did not really enjoy, to see Caron as Elsa. He was elated when he was able to meet Rose Caron, at a dinner, and following this encounter he dedicated a eulogistic sonnet to her.

117
Jules Perrot
1875
Dilute oil-paint on paper
48 × 30 cm
Philadelphia, Philadelphia Museum of Art, The Henry P. McIlhenny Collection in memoriam Frances P. McIlhenny (L364)

119
Jules Perrot ('Le danseur Perrot')
ca. 1875
Chalk on paper
49.5 × 33.2 cm
Private collection

Jules Perrot
1875–79
Oil on panel
35.5 × 26 cm
Private collection (L366)

158

The little fourteen-year-old dancer ('La petite danseuse de quatorze aus')
1880–81
Bronze, part-painted, cotton tutu, satin ribbon
Height 81 cm
Zurich, Stiftung Sammlung E.G. Bührle

159
Nude studies for *The little fourteen-year-old dancer*, ca. 1878, charcoal, heightened with white chalk, on paper, 47.7 × 62.3 cm, London, private collection

The ballet

No other painter can vie with Degas as a chronicler of the world of ballet. The intensity of his studies of dance rehearsals, of ballerinas perfecting their poses and of brilliant ballet productions remains unrivalled. As well as the erotic ambience of the world of dance, it was undoubtedly the spectacular lighting effects, the rhythm of the bodies, the precarious poses and the ephemeral effects that particularly fascinated Degas the painter of movement. However, there are very few portraits as such from the world of

ballet. At the end of the 1860s Degas painted the dancer Eugénie Fiocre in her rôle in the ballet *La Source* (illus. p. 52). He set the group portrait of a ballet pupil with her mother and sister (*The Mante family*; illus. p. 70), which he completed in the 1880s, backstage: it gives a vivid picture of the poverty and hardship behind the surface glitter of the Opéra world. His portrait of the dancing instructor Jules Perrot (cat. 118, illus. p. 285), which is almost classicist in its composition, was painted a few years earlier. Perrot had been one of the star dancers

at the Opéra at the time of the Romantic movement, and he later worked as a dancer, choreographer and *maître de ballet* in London and St Petersburg. He returned to Paris in 1861 and from then on worked there as a dancing teacher. He appears in an almost identical pose in two of Degas's most important impressions of the dancing school (L341, Paris, Orsay, and L397, New York, Metropolitan Museum of Art). A very beautifully worked oil study (cat. 117, illus. p. 284) must have been preparatory for this picture.

The sculpture *The little dancer of fourteen years* ('*La petite danseuse de quatorze ans*'; cat. 158, illus.) occupies a special place in Degas's work. It was the only one of his sculptures to be exhibited during his lifetime – in 1881, at the Sixth Impressionist exhibition. We know the name of the young girl depicted, Marie van Goethem, and there are many accounts giving us some idea of the shocked reaction that the polychrome sculpture with its raw realism provoked at the time. It was originally a unicum in wax, given artificial hair and silk ribbons and dressed in a genuine bodice, tutu, stockings and ballet shoes. It was not until 1921–22, i.e. several years after Degas's death, that the wax sculpture was cast in bronze by Hébrard at the instigation of Degas's heirs. It is not known for certain how large an edition was cast, but it is assumed that twenty-two copies were produced, as was the case with most other sculptures by Degas. It was not just the colourfulness and the use of new materials and genuine clothes that made an impact on his contemporaries. The striking physiognomy of the model produced a powerful, sometimes negative resonance: Degas did not care about contemporary ideals of beauty – he was more interested in being true to life in his portrayal. The fragile structure of the body and the expression on the fourteen-year-old girl's face, which was perceived as animalistic and depraved, disconcerted art audiences in the early Belle Epoque, who preferred (and expected) women to be portrayed as shapely and sensuous.

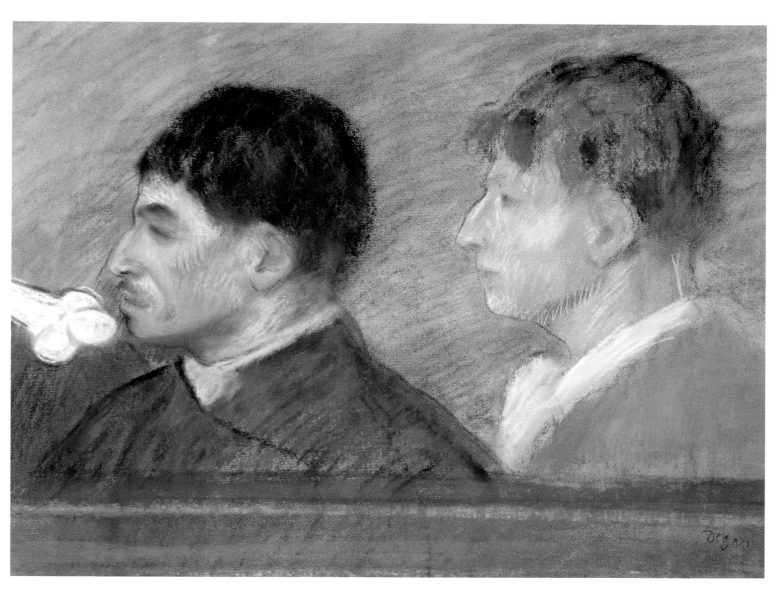

161
Criminal physiognomies, 1881, pastel, 48 × 63 cm, Private collection (L639)

The café-concert

Café-concerts appeared in Paris during the 1830s and were among the most popular forms of entertainment until the end of the nineteenth century. As the name suggests, they were cafés where one could eat, drink and smoke, while mime artists, acrobats or clowns, sometimes, but more often singers and dancers performed on a stage. Many *café-concerts* were located in the open air — these included some of the best known such as the *Ambassadeurs*, the *Jardin de Paris* or *L'Alcazar d'été*. *Café-concerts* should not be confused with the cabarets then developing in Montmartre, with their literary pretensions and political motivation: *café-concerts*, by contrast, addressed a mass audience and accordingly took place along the great boulevards (with most of the open-air ones in the vicinity of the Champs-Elysées), and were intended as straightforward, plebeian entertainment. (René de Gas was, in fact, rather put out that his brother even frequented such places.) The characteristic risqué *chansons* were extremely simple, with musically unchallenging chorus passages with which the audiences could join in. Another important aspect of *café concerts* was their function as popular meeting places for the *demi-monde*.

The *café-concert* reached the height of its popularity in the 1870s, at which time Degas was a regular attender. As can be seen from

138
Mlle Bécat at the Ambassadeurs
ca. 1875
Pastel over lithograph
12.8 × 22.3 cm
Private collection (courtesy Galerie Schmit, Paris) (L372)

137
Mlle Bécat at the Ambassadeurs
1875–77
Lithograph
1st state
20.5 × 19.3 cm
Sammlung E. W. K., Berne [right]

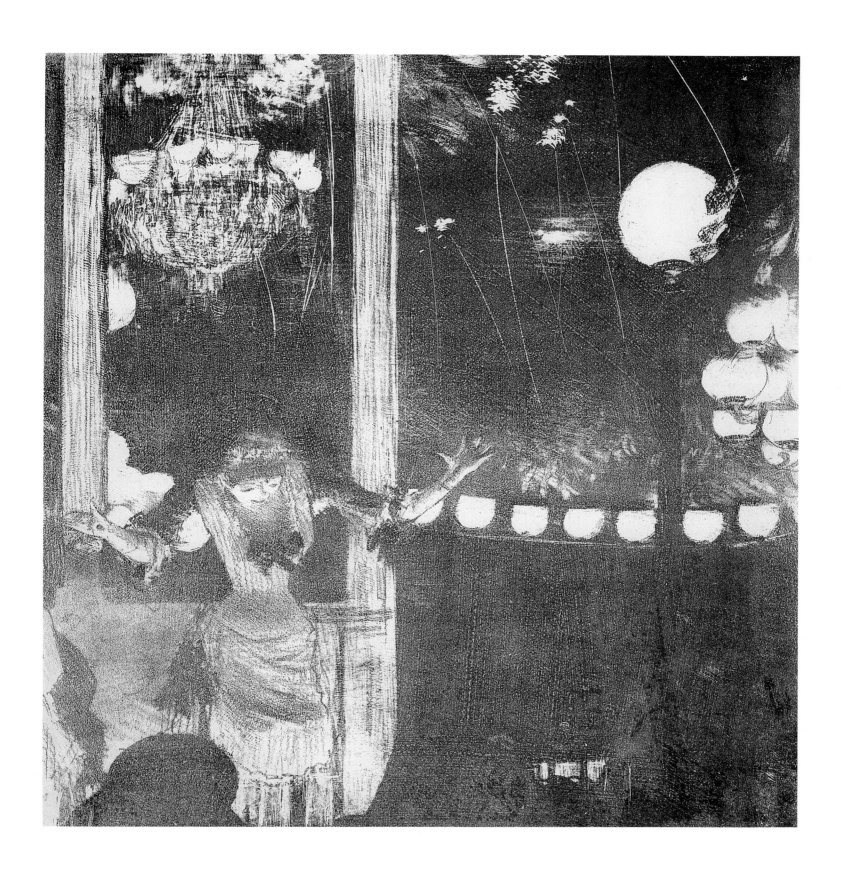

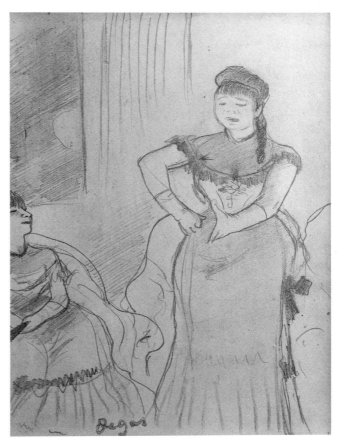

136
Mlle Bécat at the Ambassadeurs, 1875–77, lithograph, 1st state, 29.1 × 24 cm,
Sammlung E. W. K., Berne

139
Mlle Bécat, ca. 1876, pencil on paper, 16.2 × 12.2 cm, private
collection (courtesy Galerie Schmit, Paris)

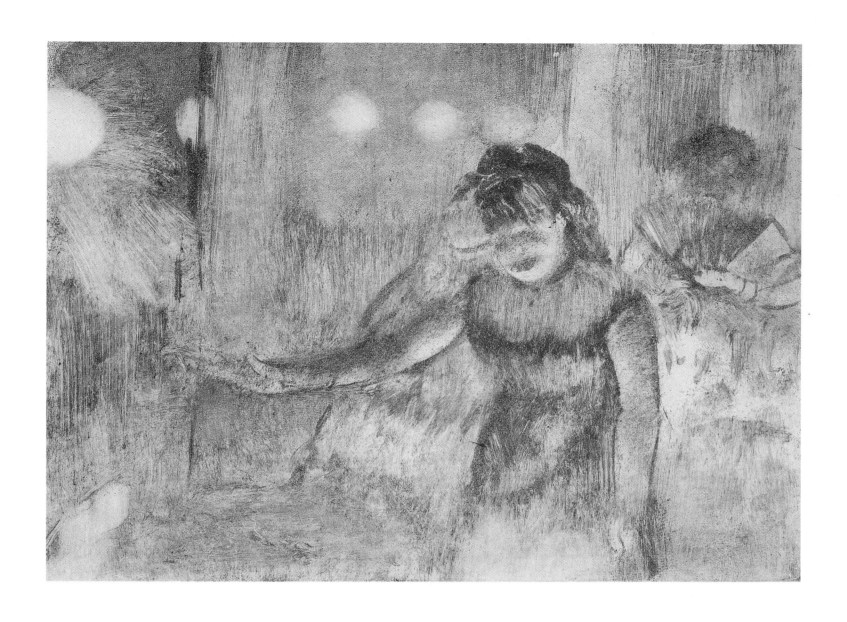

140
Singer at a café-concert, ca. 1877, monotype in black oil paint, 12 × 16.2 cm, Sammlung E. W. K.,
Berne

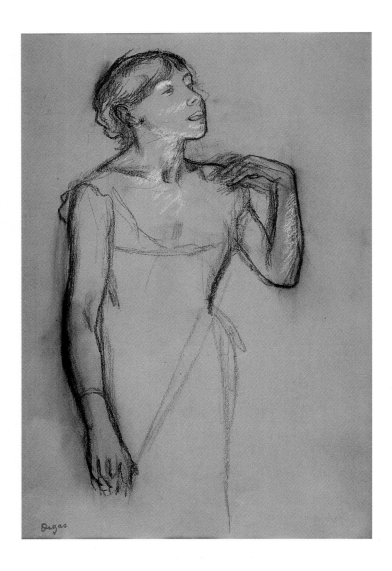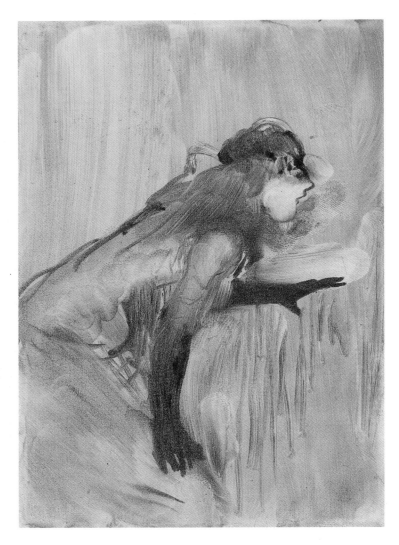

the works he devoted to this subject, he was extremely interested in the spectacular gesticulation and facial miming of the female singers, and, even more particularly, in the novel effects which the bright stage light, the garish make-up and the garish costumes produced against the dark night sky. It is noticeable that Degas treated this topic mainly in etchings, lithographs and (worked-over) monotypes – techniques that allowed him to experiment with varieties and gradations of directed light. Of the *café-concert* 'stars' portrayed by Degas in performance, two are known by name: one was the famous, highly paid Thérésa (really Emma Valadon) (cat. 142, 167, illus. pp. 294–95); the other was Emilie Bécat whose expressive 'epileptic' style also attracted an enthusiastic following (cat. 136–40, illus. pp. 290–93).

167
Singer at a café-concert (Thérésa)
1883–84, charcoal on paper, heightened with white, 46 × 30 cm
Sammlung E. W. K., Berne

141
Singer at a café-concert – 'diseuse'
1877–78, monotype in black oil paint,
18.5 × 13.4 cm
Sammlung E. W. K., Berne

142
Café singer
ca. 1878, oil on canvas, 53.5 × 41.8 cm
Chicago, The Art Institute of Chicago
Gift of Clara Lynch (L477)

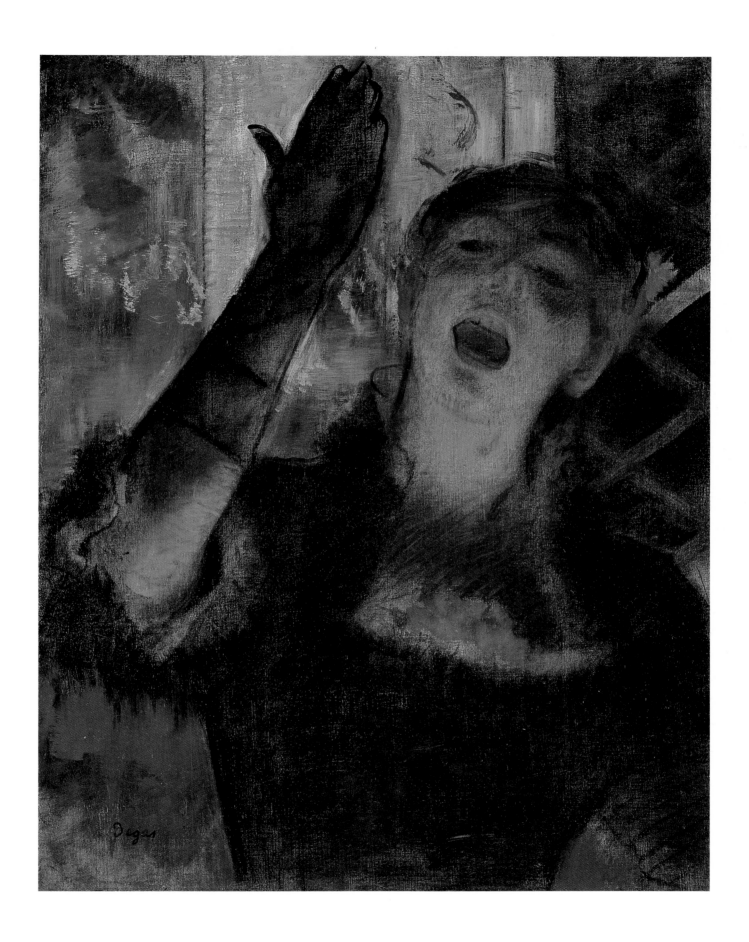

Work and love

It is not known whether Degas had sexual relationships with women; at any rate there is no evidence that he did. His platonic friendships with women from his own milieu, such as Louise Breguet (the wife of Ludovic Halévy), and his youthful adoration for great actresses and singers went hand in hand with a lifelong fascination for women from the lower strata of society. Degas's series of monotypes depicting brothel scenes (cf. cat. 156, illus. p. 299) is the most extreme example of the mixture of voyeurism and abhorrence with which he reacted to female sexuality. However, the bitter scenes from the *maisons closes*, sometimes reminiscent of Goya, represent only the most extreme example in a range of social spheres recorded by Degas in drawing and painting in which sexuality is portrayed as an economic phenomenon. The working women we encounter in his art are there, of course, on the one hand as a result of the demand for the realistic representation of modern everyday life; but on the other hand they are all working in professional rôles understood by his contemporaries as ciphers for sexual availability: dancers, milliners (cf. cat. 166, illus. pp. 10–11), laundresses (cat. 179, illus. p. 300) and ironing women. In Degas's work, women at their toilet, unaccompanied women in cafés (cat. 130, illus. p. 301), women strolling on the racecourse, and so on, always convey a willingness, occasionally or regularly, deliberately or by chance, to sell their bodies for money.

157

L'Anglaise
ca. 1880
Oil on paper
Mounted on linen
84.6 × 40 cm
Jan and Marie-Anne Krugier-Poniatowski collection (courtesy Galerie Jan Krugier, Geneva) (BR 98)

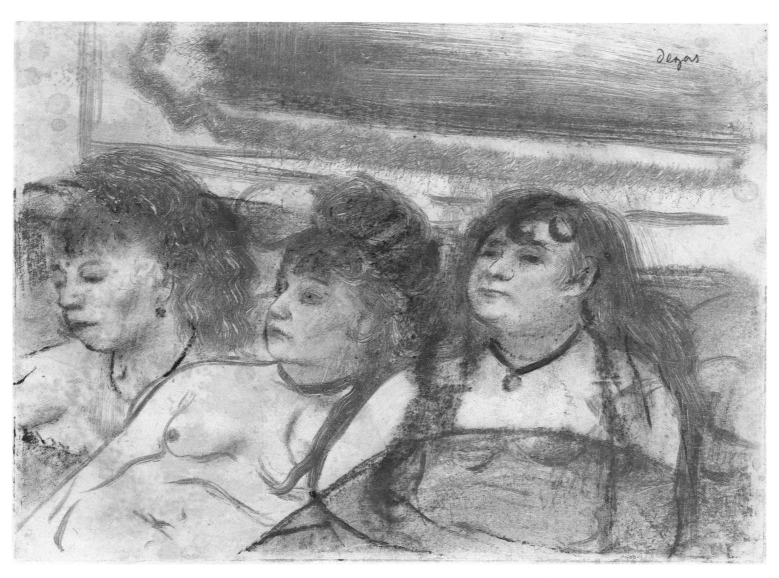

156

Three girls seated, ca. 1879, pastel over monotype in grey, on beige paper, 16 × 21.5 cm, Amsterdam, Rijksmuseum, Rijksprentenkabinet (L550)

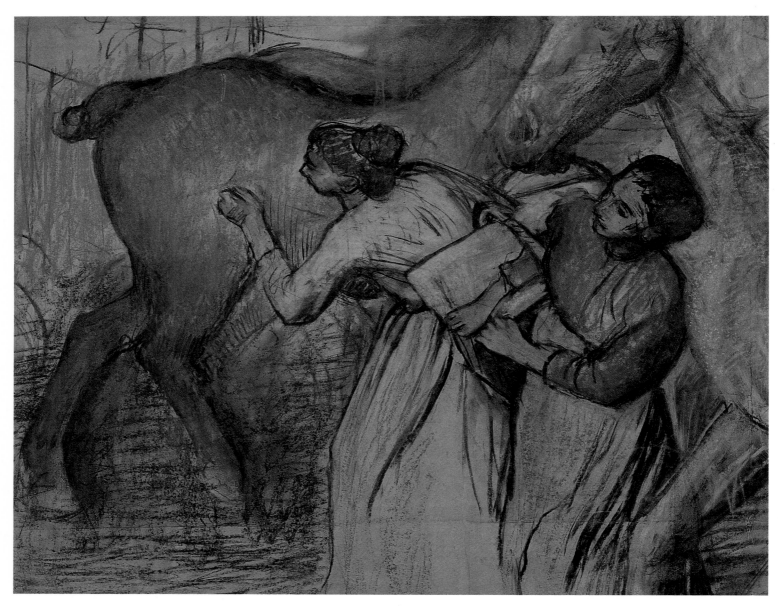

179
Washerwomen, horses, ca. 1904, charcoal and pastel on strengthened paper, 84 × 107 cm, Lausanne, Musée Cantonal des Beaux-Arts (L1418)

130
At the café, ca. 1876–77, oil on canvas, 64 × 53.3 cm, Cambridge, Fitzwilliam Museum, Hindley Smith Bequest (L467)

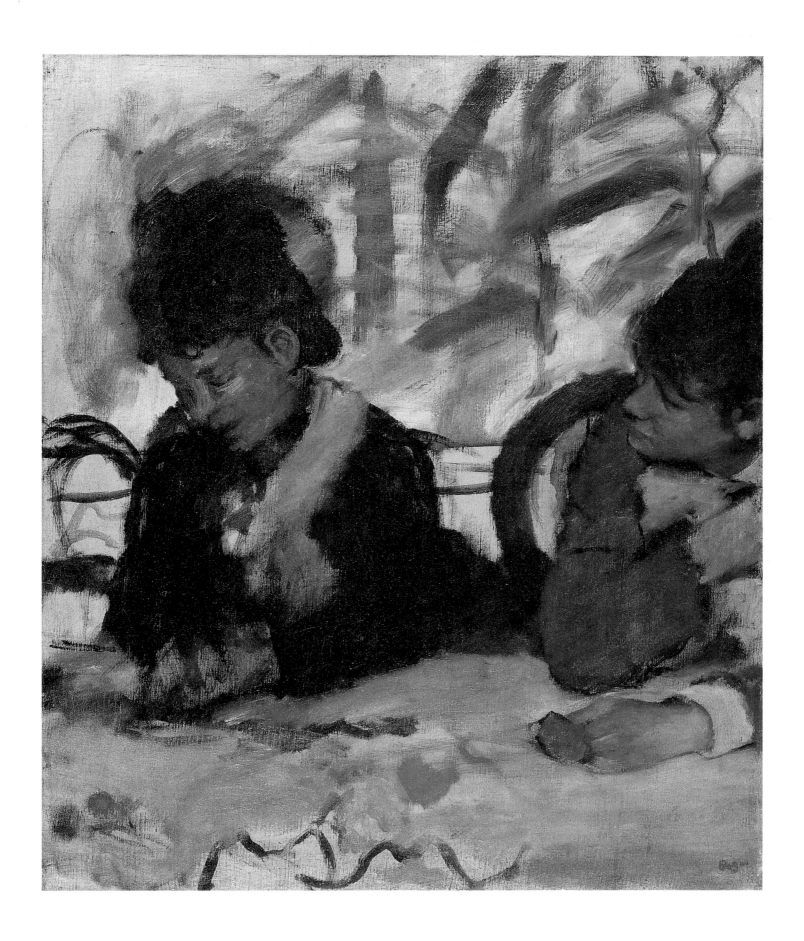

Portraits: Painting and Photography

ANTOINE TERRASSE

Dedicated to the late Philippe Néagu

*Je n'aime pas les fiacres, moi. On ne voit personne. C'est pour ça que j'aime les omnibus. On peut regarder les gens. On est fait pour se regarder, quoi?

Although Degas was an independent, solitary, touchy figure, he did need company. He was alone and reclusive in his studio, and lived alone in a succession of apartments. But he enjoyed getting into conversation with other artists at the café and going out to dinner with friends in the evening, and would mingle with the crowd at the theatre, opera, *café-concert* or the races. To the very end of his life he seemed to need this stir of activity around him, the animation of the city he travelled through on foot or by tram. "I have no time for hansom cabs. You don't see anybody. That's why I like travelling by omnibus, because you can look at people. Surely we're made to look at one another, aren't we?"*

His work offers a gallery of portraits: portraits of relatives, fellow painters or engravers, women and friends, not to mention the figures he copied in museums. From the beginning of his career there are self-portraits of the kind all young artists paint, displaying themselves purposefully with their palette or crayon in their hand. In Degas's case there seems to be a special insistence. Was he particularly inclined to be introspective as a result of the Protestantism on his mother's side, or was he simply a solemn individual? His sketchbooks were like a diary, in which he confided a whole range of intimate observations and reflections: they were a book of truth in which he could set down both his feelings and his resolutions. The self-portraits, whether in pencil, charcoal, engraved or in oils, show him gazing into his own eyes, a melancholy, remote young man. The predominant impression is one of detachment. The same is true of the portraits of his brothers and sisters, Achille and René, Thérèse and Marguerite. He was the eldest child, and their mother died when he was thirteen. No doubt this coupled with his rather strict upbringing largely explains why he should have been haunted by sadness. He nevertheless had a great aptitude for catching the feelings of his models, for seeing "the trace of their fleeting soul gliding across their features". He was a subtle psychologist, interested not only in the character expressed by

a face, but beyond the physiognomy, some peculiarity in a familiar attitude or gesture. He goes on to show the ambience the person he is observing lives in, designating the objects surrounding him or her: among his single portraits alone, consider those of Edmond Duranty, Diego Martelli, Henri Rouart or his sister Thérèse.

Following a tradition that goes back to the Renaissance, Degas had a fondness for composing double portraits, depicting two friends, two sisters, a father and daughter, or a musician and the person listening to him together. We see Degas himself with the painter Evariste de Valernes (illus. p. 23), and recognise his father with the singer Lorenzo Pagans (illus. p. 26), or his cousins Giovanna and Giulia Bellelli (cat. 78, illus. p. 194) who also appear in his large *Bellelli family* (illus. p. 16). He used these double portraits as a means of revealing the links that existed between his sitters, emphasizing liking and affection, but also exposing differences. For as a psychologist he quickly perceived all the inner tensions and conflicts that arise from character and oppositions between different characters. Pictures such as '*La mélancolie*' (cat. 92, illus. p. 242), '*La bouderie*' (Sulking), '*Interior – the rape*' (illus. p. 27) or '*L'Absinthe*' (illus. p. 105) all express solitude and remoteness, a certain antagonism between male and female. He had an analytical and moralistic side linking him with novelists and short-story writers such as Zola and Maupassant. For all his severity towards 'scribblers' he was the most cultured and literary painter of his generation. We have only to compare him with Renoir, Monet or even Manet, despite the fact that Manet was a friend of Baudelaire and Mallarmé. Like Flaubert, whom he greatly admired, Degas had an underlying vein of Romanticism and scepticism. Even so, his eye was always in charge. Where a writer would see a picture to describe, he saw a scene to paint. He set a new task for himself – how to convey a psychological feeling or drama using only painting.

Not only an observer of human manners, capable of revealing inner conflict in his portraits, Degas also recorded attitudes, gestu-

Degas and his housekeeper Zoë Closier, ca. 1890–95

Mme Ludovic Halévy, 1895

res and fleeting changes in them, paying careful attention to expression and the language of the body. This kind of awareness stemmed perhaps from his Neapolitan origins. No painter had previously attempted to convey the unusual phenomena that occur when a pose suddenly goes rigid or is abruptly abandoned. This concern lies behind the staged effect, the sense of theatre, in some of his compositions. His settings are primarily the product of his tyrannical gaze. His mind, curious about every possible consequence of vision, found the irruption of the unexpected extremely seductive, and he wanted to convey this sense of surprise.

To convey this element of surprise as best he could, Degas was prepared to go to enormous lengths, judging by the numerous pencil, crayon or pen drawings and sketches Degas produced before he got down to the picture. We may wonder how this great painter with his classical training, passionately enamoured of drawing, believing in his art with all his soul, could at one point have become enthusiastic about images formed purely by the action of light, with the hand playing no rôle. Photography, however, is, as much as painting, a question of seeing, of perspicuity. Both depend on looking properly. The painter and the photographer both have a choice to make when they observe. "The photograph is the photographer", Lamartine exclaimed admiringly when confronted with "the marvellous portraits made with a flash of sunlight" of Adam Salomon. Painting and photography are also both created on a flat surface, that is, a space that does not reflect real life. Degas must have been struck by another element, too: photography initially only reproduced shadow and light, reproducing the world in black and white, like pencil drawings or engravings. He must have been delighted by this transposition, loving the play of chiaroscuro as he did – he explored the mysterious combinations of white and black in his monotypes. Monotypes are drawn with oily ink on a copper or zinc plate, then pressed on to a sheet of paper. The intermediary act of printing slips in between the gestures of the hand that

draws and the result – as in photography. Finally, the 'snapshot' produces some unexpected effects. In one the wheel of a hansom cab or a profile may be printed in the corner of the image, in another there is a large-scale face on the edge of the snap; passers-by disappear into the distance at the bend of an avenue. It was this kind of astonishing effect that had already struck him as an observer. Photography confirmed his desire to exploit the strangeness of vision in composing his pictures.

When photographic exhibitions started in 1855 Degas went to look at them. He was twenty-one years old. He did not devote himself enthusiastically to photography until nearly forty years later, though he took an interest in all the technical innovations of photography and all the work produced by photographers. The attention he devoted to the work of Eadweard Muybridge, whose series of 'snapshots' broke down very precisely the movement of a horse trotting or galloping, provides further proof of his interest. At one time he drew inspiration from Muybridge's series to represent the horses correctly in his racecourse scenes. Subsequently he preferred the instinctive truth required by the life of a painted picture to the correctness of photographic movement. As Paul Valéry wrote, "Degas was one of the first to understand what photography could teach the painter and what the painter had to guard against borrowing from it".

Degas's intellectual curiosity and thirst for new means of expression were such that photography became another application, another exercise for his visual ability. In the practice of photography he showed a definite preference for portraits. In painting and sculpture he often strove to convey movement and exertion, whether of jockeys, washerwomen or women ironing, of musicians and female dancers at the Opéra or women about their toilet, but none of this is typical of his work as a photographer. The little outdoor scenes he enjoyed enacting with his hosts in their gardens at Dieppe or Ménil-Hubert, a few 'snapshots' of a ballerina and in particular an admirable nude

Daniel Halévy, 1895

Auguste Renoir and Stéphane Mallarmé, 1895

Jules Taschereau, Degas and Jacques-Emile Blanche in Ludovic Halévy's drawing room

study of a woman drying her back are exceptional.

In photography it was faces that interested him first and foremost, and among those faces his own in particular. It was a long time since he had used himself as a model in painting, but he seemed to rediscover himself with a new intensity on the sensitised plate; the portrait where he depicts himself with his housekeeper Zoë standing behind him is one of his finest (illus. p. 303). He was equally interested in trying out his friends. "One fine morning I will get you with my camera",* he told them. But in fact he came in the evening. After dinner when the silence of night began to weigh heavily, Degas liked to take photographs. We find him in Julie Manet's drawing-room taking a photograph of Mallarmé and Renoir together (illus. p. 306); or in the drawing-rooms of Mme Ludovic Halévy, Mme Ernest Chausson, Mme Arthur Fontaine or Mme Léouzon Le Duc (illus. pp. 304, 305, 308). Whether he was photographing one face or several, it meant "two hours of military obedience" for all his consenting victims. First the models were shown their pose in minute detail, then the light was put in place. He brought in more and more lamps – he used nine paraffin lamps for the portrait of Renoir and Mallarmé – deployed the reflectors, then moved them again, "running from one corner of the room to the other, with a look of immense happiness", Daniel Halévy later recalled. Finally he went into action with a wooden-box camera on a stand.

There are very few formal connections between these photographs and his painted work, with the exception of the photographs of Degas with Christine and Yvonne Lerolle (illus. p. 312), or with Mme Arthur Fontaine and their friend Paul Poujaud (illus. p. 308). The composition of these may be compared to that of 'La bouderie' and 'La mélancolie' (cat. 92, illus. p. 242), pictures painted much earlier in his career. His own portrait in which he sits beside a small statue by Bartholomé can also be linked to these because it has the same diagonal line. Vice versa, there is a study in pastel and three oil paintings of a *Nude drying her back*, composed in exactly the same way as this photograph; similar pastels of *Dancers* are perceptibly inspired by a ballerina's series of figure poses for the camera. These are the very few examples that enable us to make a true connection between Degas's practice as a photographer and as a painter. They demonstrate how original he was in both fields, as well as the extent to which photography and painting offer two different alchemies. In the one case, the actual model and all the grace that emanates from a young body are there – "Emanating from a real body which was there are radiations which affect me who am here; the length of time taken to transmit them is irrelevant; the photograph of that vanished being reaches and touches me like the deferred rays of a star …" , wrote Roland Barthes. In the other, there is an interpretation by the painter of the body in his picture.

Degas's photographs of a *Little girl reading* (Odette Degas) and his portrait of Claudie Léouzon Le Duc (illus. p. 311) employ compositions based on triangles, evoking the geometry of Japanese prints, but nevertheless unexpected. His groups of characters are always staged in a kind of silent confrontation which only he could produce. It is their lighting that makes Degas's photographs instantly recognisable, the deep blacks accentuated by the white beside them, the highly mysterious harmonies of shade and light. These seemingly simple portraits refer back to the classical effigies of his first paintings. In the finest of them the lighting can justifiably be compared with the inner light in some of Rembrandt's paintings.

Paul Poujard, Mme Arthur Fontaine, Degas, 1894

*Je vous tomberai un beau matin avec mon appareil . . .

Little girl reading, ca. 1898

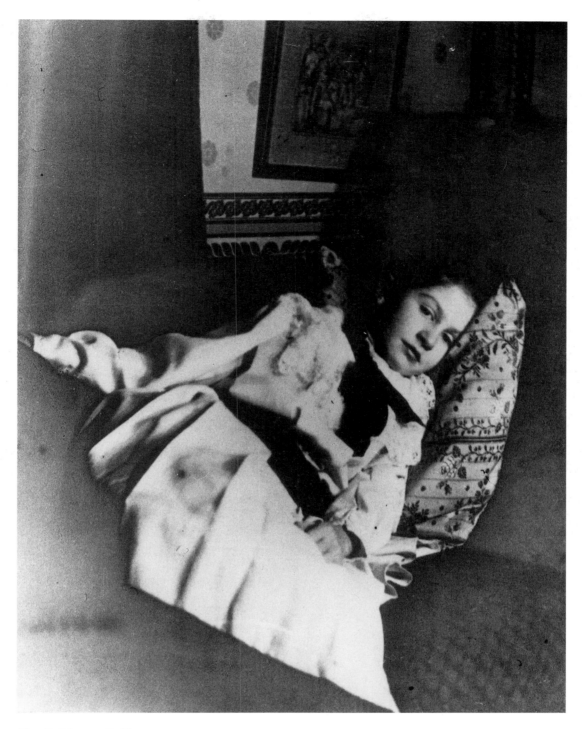

Claudie Léouzon Le Duc, ca. 1898–1900

Degas and Christine and Yvonne Lerolle, ca. 1898

Geneviève and Marie Mallarmé, ca. 1895

Geneviève and Marie Mallarmé, ca. 1895

Catalogue
and Bibliography

1

Self-portrait

(*'Degas à la palette'*)

1854

Oil on paper, mounted on linen

44 × 33 cm

L2

Private collection

Colour illus. p. 161

PROVENANCE: Gabriel Fevre, Nice; Comte Hubert de Ganay, Paris

EXHIBITIONS: 1924 Paris, no. 1, illus.; 1939 Paris, no. 37, illus.

LITERATURE: Guérin 1931, illus.; Minervino 1974, no. 109; Reff 1985, I, pp. 38f.

2

Self-portrait

1854

Pencil

33 × 23.8 cm

Verso: portrait study after Bacchiacca, 1854

Private collection

Colour illus. p. 159

PROVENANCE: Grete Ring, London; Erich Maria Remarque, Porto Ronco

LITERATURE: Götz Adriani, *Paul Cézanne, Zeichnungen*, Cologne 1978, p. 256 (illus. of the verso)

3

Self-portrait

ca. 1854

Pencil on paper

32.5 × 24.5 cm

Nepveu-Degas stamp lower right

Private collection

Colour illus. p. 173

PROVENANCE: Jean Nepveu-Degas, Paris; Sotheby's, London, 5 July 1979, no. 407

4

Self-portrait

1854–56

Red chalk on paper

26 × 20.5 cm

Private collection

Colour illus. p. 163

LITERATURE: Gordon/Forge 1988, p. 2

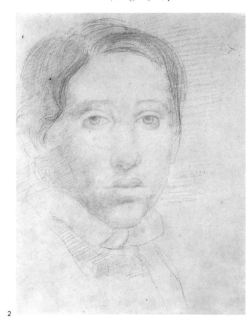

2

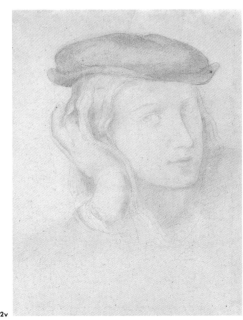

2v

5

Marguerite De Gas

1854

Chalk on wove paper

29.3 × 23.8 cm

Stuttgart, Staatsgalerie Stuttgart, Graphische Sammlung (C 63/1059)

Colour illus. p. 177

PROVENANCE: Marguerite De Gas, Paris; Jeanne Fevre, Nice; Maurice Loncle, Paris

EXHIBITIONS: 1967 Saint Louis, no. 2, illus.; 1969, Stuttgart, Staatsgalerie, Graphische Sammlung, *Von Ingres bis Picasso, Französische Zeichnungen des 19. und 20. Jahrhunderts*, no. 29, illus.; 1984 Tübingen, no. 3, illus.; 1984 Stuttgart Staatsgalerie, Graphische Sammlung, *Meisterwerke aus der Graphischen Sammlung, Zeichnungen*

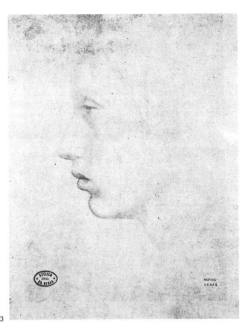

3

4

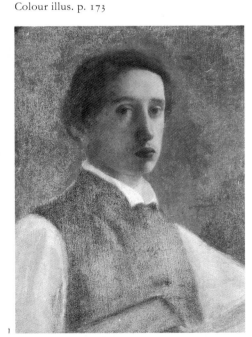

1

19. und 20. Jahrhundert, no. 38

LITERATURE: Fevre 1949, after p. 32, illus.; Janis 1967, p. 414; Ulrike Gauss, *Die Zeichnungen und Aquarelle des 19. Jahrhunderts in der Graphischen Sammlung der Staatsgalerie Stuttgart*, Stuttgart 1976, no. 168, illus.; Dunlop 1979, illus.; Horst Keller, *Aquarelle und Zeichnungen der französischen Impressionisten und ihrer Pariser Zeitgenossen*, Cologne 1980, pp. 34f., illus.

6
Portrait of a man
Study after Raphael
1854–55
Pencil on paper
30 × 23 cm
Vente stamp lower left
Margot W. Milch-Heller
Colour illus. p. 151

5

6

PROVENANCE: Vente IV, 1919, no. 103 c, illus.; art market, London; Feilchenfeldt, Zurich; Milch collection, Baltimore

EXHIBITION: 1984 Tübingen, no. 6, illus.

LITERATURE: Minervino 1970, no. 18, illus.

7
René De Gas
1855
Oil on canvas
91.5 × 74.9 cm
L6
Northampton, Massachusetts, Smith College Museum of Art, purchased Drayton Hillyer Fund (1935.12)
Colour illus. p. 174

PROVENANCE: Atelier Degas; René de Gas, Paris; Vente Succession René de Gas, Drouot, Paris, 10 November 1927, no. 72, illus.; Ambroise Vollard, Paris; Knoedler and Co., New York, 7 October 1933; Bignou, Paris, Bignou, New York, 1934; acquired by the Museum in 1935

EXHIBITIONS: 1933, New York, M. Knoedler and Co., *Paintings from the Ambroise Vollard Collection, XIX–XX Centuries*, no. 16, illus.; 1934, London, Alex Reid and Lefevre, *Renoir, Cézanne and their Contemporaries*, no. 16; 1938, New York, Wildenstein & Co., *Great Portraits from Impressionism to Modernism*, no. 7; 1939, Boston, Institute of Modern Art/New York, Wildenstein & Co., *The Sources of Modern Painting*, no. 3, illus.; 1947 Cleveland, no. 1, illus.; 1948 Minneapolis; 1949 New York, no. 2, illus.; 1953, New York, M. Knoedler & Co., *Paintings and Drawings from the Smith College Collection*, no. 11; 1954, Detroit, The Detroit Institute of Arts, *The Two Sides of the Medal: French Painting from Gérôme to Gauguin*, no. 65, illus.; 1955 San Antonio; 1960 New York, no. 2, illus.; 1961, Chicago, Arts Club of Chicago, Smith College Loan Exhibition, no. 8, illus.; 1962, Northampton, Smith College Museum of Art, *Portraits from the Collection of the Smith College Museum of Art*, no. 16; 1963, Oberlin, Allen Memorial Art Museum, *Youthful Works by Great Artists*, no. 22, illus.; 1963, Cleveland, Museum of Art, *Style, Truth and*

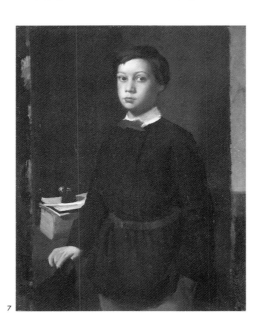

7

the Portrait, no. 89, illus.; 1964, Chicago, National Design Center, Marina City, *Four Centuries of Portraits*, no. 8; 1965 New Orleans, illus.; 1968, Baltimore, Baltimore Museum of Art, *From El Greco to Pollock: Early and Late Works by European and American Artists*, no. 59, illus.; 1969, Waterville, McColby College Art Museum/Manchester (N.H.), Currier Gallery of Art, *Nineteenth and Twentieth Century Painting from the Smith College Museum of Art*, no. 24, illus.; 1970, Waterville, McColby College Art Museum/Manchester (N.H.), Currier Gallery of Art, *Nineteenth and Twentieth Century Painting from the Smith College Museum of Art*, no. 16, illus.; 1972, New York, Wildenstein & Co., *Faces from the World of Impressionism and Post-Impressionism*, no. 19, illus.; 1974 Boston; 1978 New York, no. 2, illus.; 1988–89 Paris/Ottawa/New York, no. 2, illus.

LITERATURE: Guérin 1928, pp. 371f.; Jere Abbott, Portrait by Degas recently acquired by Smith College, *The Smith Alumnae Quarterly*, vol. 27, no. 2, February 1936, pp. 161f., illus.; Jere Abbott, A Portrait of René de Gas by Edgar Degas, *Smith College Museum of Art Bulletin*, 1936, pp. 2–5; Smith College Museum of Art, Catalogue, Northampton 1937, p. 17, illus.; Rewald 1946, pp. 105–26, illus.; Lemoisne I, p. 14; Boggs 1962, p. 8; Minervino 1974, no. 113

8
Self-portrait
('*Degas au porte-fusain*')
1855
Oil on canvas
81 × 64 cm
L5
Paris, Musée d'Orsay (RF 2649)
Colour illus. p. 165

PROVENANCE: Atelier Degas; René de Gas, Paris; Vente Succession René de Gas, Paris, Drouot, 10 November 1927, no. 69, illus.; acquired by the Museum

EXHIBITIONS: 1931, Paris, Orangerie, no. 2; 1936, Venice, no. 1; 1937, Paris, Orangerie, no. 1, illus.; 1956, Limoges, Musée Municipal, *De l'impressionnisme à nos jours*, no. 6; 1969, Pau, Musée des Beaux-Arts, *L'autoportrait du XVe siècle à nos jours*, p. 44; 1976–77 Tokyo, no. 1, illus.; 1988–89 Paris/Ottawa/New York, no. 1,

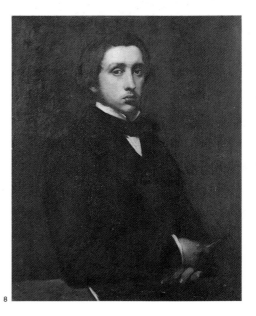

8

illus.

LITERATURE: Lafond 1918–19, p. 103, illus.; Lemoisne 1927, illus.; Paul Jamot, *Acquisitions récentes du Louvre, L'Art Vivant*, 1928, pp. 175f.; Guérin 1931, illus.; Musée National du Louvre, *Catalogue des peintures, pastels, sculptures impressionnistes exposés au Musée de l'Impressionnisme*, Jeu de Paume des Tuileries, Paris 1958, no. 53; Boggs 1962, p. 9, illus. 12; Minervino 1974, no. 112, illus.; Musées du Louvre et d'Orsay, *Catalogue sommaire illustré des peintures du Musée du Louvre et du Musée d'Orsay*, Paris 1986, p. 196, illus.; Charles de Couëssin, Technique, transformations dans les toiles de Degas des collections du Musée d'Orsay, in: *Degas inédit*, pp. 144ff.

9

Self-portrait

('*Degas en gilet vert*')

1855–56

Oil on canvas

41 × 32.5 cm

L11

Private collection

Colour illus. p. 166

PROVENANCE: René de Gas, Paris; Odette Nepveu Degas, Paris; Nepveu-Degas family, Paris; Christie's, London, *Impressionist and Modern Painting and Sculpture*, 2 April 1990, no. 12

EXHIBITIONS: 1931 Paris, no. 5; 1946, Paris, Galerie Charpentier, *Portraits Français*

LITERATURE: *Gazette des Beaux-Arts*, 25 August 1931, p. 22; Lemoisne I, p. 14; Boggs 1962, pp. 9, 105, illus.; Minervino 1974, no. 118; Christie's, London, *Impressionist and Modern Painting and Sculpture*, 2 April 1990, pp. 33ff.

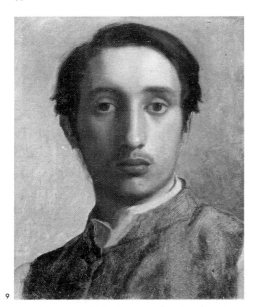

9

10

Thérèse De Gas

ca. 1855–56

Pencil on paper

32 × 28.4 cm

Atelier stamp lower left

Boston, Museum of Fine Arts

Julia Knight Fox Funds (31.434)

Colour illus. p. 182

PROVENANCE: Atelier Degas; René de Gas, Paris; Vente Succession René de Gas, Drouot, Paris, 10 November 1927, no. 17; purchased by the Museum through Paul Rosenberg

EXHIBITIONS: 1947 Cleveland, no. 54, illus.; 1947 Washington, no. 25; 1948 Minneapolis (not numbered); 1965 New Orleans, illus.; 1967 Saint Louis, no. 4, illus.; 1984 Boston; 1988–89 Paris/Ottawa/New York, no. 3, illus.

LITERATURE: Hendy 1932, illus. p. 44.

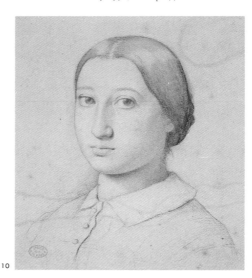

10

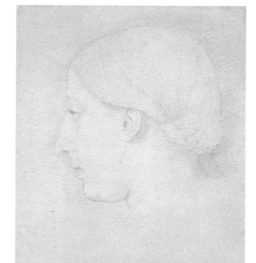

11

11

Thérèse De Gas

ca. 1855–56

Pencil on paper

28.5 × 23.6 cm

Verso: study of drapery, *A bare-footed monk*(?); chalk, heightened with white; atelier stamp, and inscribed "Les plis de la robe sont très tirés", "manteau"

Cambridge, The Fitzwilliam Museum

Gow Bequest

Colour illus. p. 182

PROVENANCE: Guiot, Paris; Sir T.D. Barlow; A.S.F. Gow

EXHIBITIONS: 1978, Cambridge, The Collection of Andrew Gow; 1978, Hazlitt, Gooden & Fox, Selected Works from the Gow Bequest; 1984, Berlin, Nationalgalerie; 1987 Manchester, no. 8, illus.; 1989, London, Sotheby's, *A Century of British Collecting, Impressionism and After*, no. 42.

12

Thérèse De Gas

1855–56

Pencil on paper

28.4 × 23.4 cm

Atelier stamp lower left; Nepveu-Degas stamp

Collection Prat, Paris

Colour illus. p. 182

PROVENANCE: Atelier Degas; Nepveu-Degas collection; Vente Hôtel Drouot, Paris, 6 May 1976, no. 3, illus.

EXHIBITION: 1984 Rome, no. 28, illus.

12

13

René De Gas

ca. 1855

Black chalk on paper

34.6 × 28 cm

Atelier stamp lower left

Verso: Sketch of a landscape

Chicago, The Art Institute of Chicago

Helen Regenstein Collection (1961.792)

Colour illus. p. 176

PROVENANCE: Atelier Degas; René de Gas, Paris; Paul Brame, Paris; Marianne Feilchenfeldt, Zurich; acquired by the Museum in 1961

EXHIBITIONS: 1963, Oberlin, no. 23, illus.; 1963, New York, Wildenstein Gallery, *Master Drawings from the Art Institute of Chicago*, no. 100, illus.; 1974, Palm Beach, Society of the Four Seasons, *Drawings from the*

Art Institute of Chicago, no. 11; 1984 Chicago, no. 1, illus.

LITERATURE: 1974 Chicago, no. 79, illus.; *The Art Institute of Chicago, French Drawings and Sketchbooks of the Nineteenth Century*, Chicago 1979, 2, D 12

14

René De Gas

1855–56

Pencil on brown paper

36.2 × 29.2 cm

Colnaghi Drawings, London

Colour illus. p. 176

PROVENANCE: Atelier Degas, Paris; René de Gas, Paris; Odette Nepveu-Degas, Paris; Georges Wildenstein, New York; Stephen R. Currier, New York, until 1990

EXHIBITIONS: Possibly 1955 Paris, no. 2 (incorrect measurements); 1967 Saint Louis, no. 3; 1991 New York/London, Colnaghi, *An Exhibition of Master Drawings*, no. 55, illus.

LITERATURE: Ira Moskowitz/Agnes Mongan, *Great Drawings of All Time*, vol. 3, New York 1962, no. 775, illus.; Joseph T. Butler, The Connoisseur in America: Drawings by Degas, *The Connoisseur*, June 1967, p. 114, illus.; Nottingham 1969, under no. 1; Harold Joachim, *The Helen Regenstein Collection of European Drawings; The Art Institute of Chicago*, 1974, p. 160, under no. 79; *Degas in the Art Institute of Chicago*, Chicago 1984, p. 17, under no. 1

15

Portrait of a man

(Study for a copy of the double portrait in the Louvre formerly attributed to Gentile Bellini, now to Giovanni Cariani, L59)

ca. 1855–56

44.5 × 29.5 cm

Pencil on paper

Zurich, collection of Barbara and Peter Nathan

Colour illus. p. 152

PROVENANCE: Marcel Guérin, Paris; Hôtel Drouot, Paris, 29 October 1975, no. 39; Cremetti collection; private collection, Zurich

EXHIBITIONS: 1976–77 Tokyo/Kyoto/Fukuoka, no. 65; 1984 Tübingen, no. 7; 1984 Rome, no. 10; 1993, Paris, Musée du Louvre, *Copier créer*, no. 219, illus.

16

Self-portrait

('*Degas en blouse d'atelier*')

ca. 1856

Oil on paper, mounted on linen

39 × 33 cm

L12

New York, The Metropolitan Museum of Art

Bequest of Stephen C. Clark, 1960 (61.101.6.)

Colour illus. p. 167

PROVENANCE: René Nepveu-Degas, Paris, until 1946; Sam Salz, New York, until 1950; Stephen C. Clark, New York

EXHIBITIONS: 1977 New York, no. 1; 1978 Richmond, no. 1; 1989, Yokohama, Museum of Art, *Treasures from the Metropolitan Museum of Art: French Art from the Middle Ages to the Twentieth Century*, no. 89; 1993, Fort Lauderdale, Museum of Art, *Corot to Cézanne, 19th Century French Paintings from the Metropolitan Museum of Art*

LITERATURE: A.M. Frankfurter, Twenty Important pictures by Degas, *Art News*, vol. 35, March 1937, p. 24; Charles Sterling and Margaretta Salinger, *Metropolitan Museum of Art, French Paintings*, III, *XIX–XX Centuries*, New York 1967, pp. 57f.; Minervino 1974, no. 117; C.S. Moffett, *Degas' Paintings in the Metropolitan Museum of Art*, New York 1979, p. 5, illus.; Brame/Reff

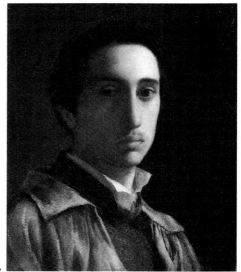

1984, under no. 29; 1984 Tübingen, under no. 29; C.S. Moffett, *Impressionist and Post-Impressionist Paintings in the Metropolitan Museum of Art*, New York 1985, pp. 11, 50f., 250, illus.; Roger Hurlburt, Free Spirits, *Sun Sentinel* (Fort Lauderdale), 20 December 1992, p. 4; Helen Kohen, Lasting Impression, *The Miami Herald*, 20 December 1992, p. 61

17
Self-portrait
('*Degas en gilet brun*')
ca. 1856
Oil on paper, mounted on linen
24 × 19 cm
L13
New York, The Pierpont Morgan Library
Bequest of John S. Thacher (1985.46)
Colour illus. p. 166

PROVENANCE: Atelier Degas; Jeanne Fevre, Nice; Paul Cassirer, Amsterdam; Paulette Goddard Remarque; Sotheby's, New York, 7 November 1979, n. 512; E.V. Thaw, New York; John S. Thacher
EXHIBITIONS: 1931, Paris, Marcel Guérin, no. 20, illus.; 1931, Paris, Orangerie, no. 9; 1936, Venice, *XX Esposizione Biennale Internazionale d'Arte*, no. 202; 1938, Amsterdam, Stedelijk Museum, *Honderd Jaar Fransche Kunst*, no. 95; 1941, New York, The Metropolitan Museum of Art, *French Painting from David to Toulouse-Lautrec*, no. 33; 1943, New York, Knoedler & Co., *Loan Exhibition of the Collection of Pictures of Erich Maria Remarque*, no. 8; 1963, Schaffhausen, Museum zu Allerheiligen, *Die Welt des Impressionismus*, no. 38
LITERATURE: Boggs 1962, p. 87, no. 36; Minervino 1970, no. 116, illus.; *Report to the Fellows of the Pierpont Morgan Library*, 21, Pierpont Morgan Library, New York 1989, pp. 311f., 333f.; C. Denison, *French Master Drawings*, Pierpont Morgan Library, New York 1993, p. 252

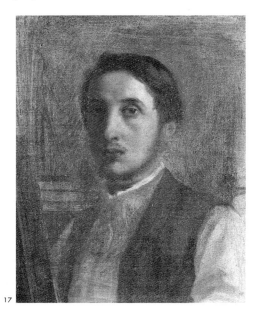
17

18
Hilaire Degas
1856
Etching with drypoint
12.9 × 10.9 cm (plate mark); 24.6 × 16.6 cm (sheet)
Washington, D.C., National Gallery of Art
Rosenwald Collection (1951.16.42)
Colour illus. p. 186

PROVENANCE: Lessing J. Rosenwald, Alverthorpe, Pennsylvania; gift to the Museum, 1951
EXHIBITION: 1960 New York, no. 110
LITERATURE: Delteil, no. 2; Adhémar/Cachin, no. 6; 1984 Boston/Philadelphia/London, under no. 4

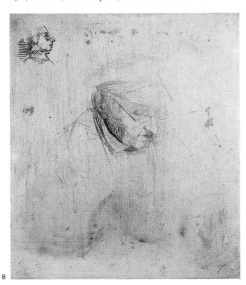
18

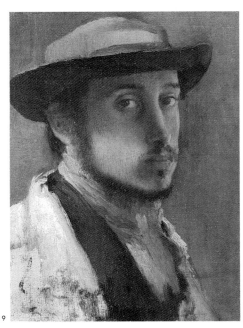
19

19
Self-portrait
('*Degas au chapeau mou*')
1857–58
Oil on paper, mounted on linen
26 × 19 cm
L37
Williamstown, Massachusetts, Sterling and Francine Clark Art Institute (544)
Colour illus. p. 171

PROVENANCE: Marcel Guérin, Paris; Daniel Guérin, Paris; Durand-Ruel, Paris; Robert Sterling Clark, 1948; Sterling and Francine Clark Art Institute, 1955
EXHIBITIONS: 1925, Paris, Musée des Arts Décoratifs, *Cinquante ans de peinture française*, no. 27; 1931 Paris, Orangerie, no. 13; 1936 Philadelphia, no. 1, illus.; Williamstown, Clark Art Institute, *Exhibit 5: French Paintings of the 19th Century*, no. 103, illus.; Williamstown 1959, no. 5, illus.; Williamstown 1970, no. 1, illus.; 1978, Chapel Hill, N.C., *French 19th Century Oil Sketches, David to Degas*, no. 23, illus.; 1988–89 Paris/Ottawa/New York, no. 12, illus.
LITERATURE: Manson 1927, p. 41; Guérin 1931, p. 55, illus.; Lemoisne 1931, p. 285, illus.; Grappe 1936, illus.; Williamstown: Nuove Opere alla Galleria Clark, *Emporium*, February 1959, illus.; Eloise Spaeth, *American Museums and Galleries*, New York 1960, p. 27; John Canady, Portraits: Self and Other, *The New York Times Magazine*, 13 November 1963, illus.; John Canady, *Mainstreams of Modern Art*, New York 1961, 1981, p. 203, illus.; Boggs 1962, p. 11, illus.; Gordon C. Aymar, *The Art of Portrait Painting*, Philadelphia 1967, p. 180, illus.; Ellen Wilson, *American Painter in Paris: A Life of Mary Cassatt*, New York 1971, illus.; Minervino 1974, no. 125; Dunlop 1979, illus.; John H. Brooks, *Highlights: Sterling and Francine Clark Art Institute*, Williamstown 1981, p. 54, illus.; Edgar Degas, Frauen und Ballett, *Pan*, no. 1, 1983, p. 7; 1983 Copenhagen, *Pan*, p. 20; Gaisford 1985, p. 482, illus.; Sutton 1986, illus.; Israel Shenker, "Of spontaneity I know nothing", *Smithsonian*, vol. 19, no. 7, October 1988, illus.; Gordon/Forge 1988, illus.; Keller 1988, illus.; Armstrong 1988, pp. 116ff.; Deborah Schneider, Edgar Degas: A perennial theme, *Equine Images*, 4, Summer 1989, illus.; Tom Coates, *Creating a Self-Portrait*, London 1989, illus.; Trewin Copplestone, *Methods of Masters: Degas*, London 1990, illus.; Armstrong 1991, p. 227, illus.; Boggs/Maheux 1992, p. 78, illus.

20
Hilaire Degas
1857
Oil on canvas
53 × 41 cm
Dated upper right: Capodimonte 1857
L27
Paris, Musée d'Orsay (RF 3661)
Don de la Société des Amis du Musée du Louvre, 1932
Colour illus. p. 187

PROVENANCE: Degas family, Naples; Mme Bozzi (née Marquise Guerrero de Balde), daughter of Lucie Degas, cousin of the artist; purchased by the Société des Amis du Musée du Louvre, 1932
EXHIBITIONS: 1933, Paris, Orangerie, *Les achats du musée du Louvre et les dons de la Société des Amis du Musée du Louvre*, no. 81; 1934, Paris, Musée des Arts Déco-

ratifs, *Les artistes français en Italie de Poussin à Renoir*, no. 108; 1947 Paris, Orangerie, *Cinquantenaire des "Amis du Louvre" 1897–1947*, no. 62; 1969 Paris, no. 3; 1984–85 Rome, no. 40, illus.; 1988–89 Paris/Ottawa/New York, no. 15, illus.

LITERATURE: Marcel Guérin, Trois portraits de Degas offert par la Société des Amis du Musée du Louvre, *Bulletin des Musées de France*, no. 7, July 1932, pp. 106f.; *Lettres* 1945, p. 251; Fèvre 1949, pp. 18–21; Raimondi 1958, pp. 121, 127, 256, illus.; Paris, Louvre, *Impressionnistes*, 1958, no. 55; Boggs 1958, p. 164, illus.; Boggs 1962, p. 11, illus.; Boggs 1963, p. 273; Valéry 1965, pp. 55ff.; Reff 1965, p. 610; Minervino 1974, no. 120; Louvre et Orsay, *Peintures*, Paris 1986, p. 197

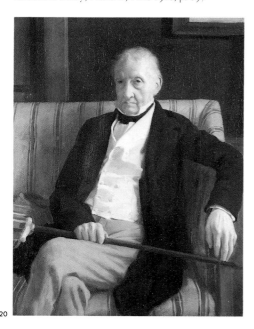

20

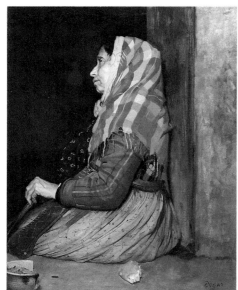

21

21
Roman beggarwoman
('*Mendiante romaine*')
1857
Oil on canvas
100.3 × 75.2 cm
Signed and dated below right: Degas 1857
L28
Birmingham, Birmingham City Museum and Art Gallery (P44.60)
Colour illus. p. 281

PROVENANCE: Durand-Ruel, Paris; Maurice Barret-Decap, Biarritz; Paris, Drouot, sale Maurice B., 12 December 1929; Paul Rosenberg, Paris; Mrs Alfred Chester Beatty, London; on loan to the Tate Gallery, London, 1955–60; acquired by the Museum in 1960
EXHIBITIONS: 1934, New York, Durand-Ruel Galleries, 12 February–10 March, *Important Paintings by Great French Masters of the Nineteenth Century*, no. 13, illus.; 1936 Philadelphia, no. 4, illus.; 1937 Paris, Orangerie, no. 2; 1962 London, Royal Academy of Arts, *Primitives to Picasso*, no. 212, illus.; 1988–89 Paris/Ottawa/New York, no. 11
LITERATURE: Camille Mauclair, *The French Impressionists*, London/New York 1903, p. 77, illus.; Camille Mauclair, *The Great French Painters*, London 1903, p. 69, illus.; Mauclair 1903, p. 382; Geffroy 1908, p. 15, illus.; Lemoisne 1912, pp. 21–22, illus.; Lafond 1918–19, II, p. 2, illus.; Jamot 1924, p. 129, fig. 1; Alexandre 1935, p. 154, illus.; Roberto Longhi, Monsù Bernardo, *Critica d'Arte*, 3, 1938; Minervino 1974, no. 71; *Foreign Paintings in Birmingham Museum and Art Gallery, A Summary Catalogue*, Birmingham 1983, p. 28, no. 41, illus.; Rome 1984–85, pp. 116–18, illus.; Loyrette 1991, p. 97

22
Italian woman
1857
Pencil on paper
33 × 21.5 cm
Private collection
Colour illus. p. 280

EXHIBITION: 1994, New York, Marc de Montebello Fine Art, *Edgar Degas, Drawings*, p. 7, illus.

23
Self-portrait
ca. 1857
Red chalk on paper
31 × 23.3 cm
Atelier stamp below left
Washington D.C., National Gallery of Art
Woodner Family Collection (1991.182.23)
Colour illus. p. 162

PROVENANCE: René de Gas, Paris; Vente Succession René de Gas, Paris 1927, no. 12; Paul Rosenberg; John Nicholas Brown, Providence, R.I., 1927; David Tunick, New York; Ian Woodner, New York, 1986; Andrea and Diane Woodner; gift to the Museum 1991
EXHIBITIONS: 1935, Buffalo, Albright Art Gallery, *Master Drawings Selected from the Museum and Private Collections of America*, no. 113; 1936 Philadelphia, no. 58; 1962, Cambridge (Mass.), Fogg Art Museum, *Forty Master Drawings from the Collection of John Nicholas*

Brown, no. 5; 1967 Saint Louis, no. 1; 1987, London, Royal Academy of Arts, *Master Drawings, The Woodner Collection*, no. 91; 1988–89 Tokyo, no. 9; 1990, New York, Metropolitan Museum of Art, *Master Drawings from the Woodner Collection*, no. 115
LITERATURE: Guérin 1931; Jakob Rosenberg, *Great Draughtsmen from Pisanello to Picasso*, New York 1959, no. 197; Sutton 1986, illus.

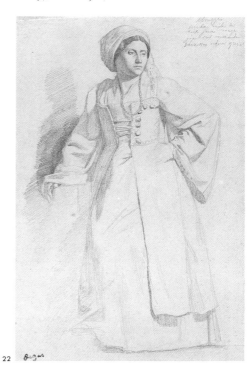

22

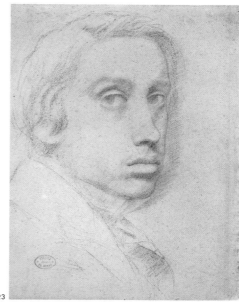

23

24

Self-portrait

ca. 1857

Pencil on paper

15.7 × 18.3 cm

Atelier stamp top right

Mr and Mrs Eugene V. Thaw

Colour illus. p. 172

PROVENANCE: Jeanne Fevre, Nice; Vente 1934, no. 40A; Marcel Guérin, Paris; Daniel Guérin, Paris

EXHIBITIONS: 1975–76, New York, The Pierpont Morgan Library/Cleveland, The Museum of Art/Chicago, The Art Institute/Ottawa, The National Gallery of Canada, *Drawings from the Collection of Mr. and Mrs. Eugene V. Thaw*, no. 90, illus.; 1979, London, Galerie David Carritt, London, no. 1, illus.; 1984 Tübingen, no. 29

LITERATURE: Guérin 1945, illus. 12

25

Self-portrait with studies of detail

ca. 1857

Pencil on paper

15.3 × 23.2 cm

Mr and Mrs Eugene V. Thaw

Colour illus. p. 172

PROVENANCE: Mlle Jeanne Fevre, Nice; Vente 1934, no. 40B, Marcel Guérin, Paris; Daniel Guérin, Paris

EXHIBITIONS: 1975–76, New York, The Pierpont Morgan Library/Cleveland, The Museum of Art/Chicago, The Art Institute/Ottawa, The National Gallery of Canada, *Drawings from the Collection of Mr and Mrs Eugene V. Thaw*, no. 91, illus.; 1984 Tübingen, no. 28

LITERATURE: Guérin 1945, illus.; London 1983, under no. 1

26

Auguste De Gas

ca. 1857

Pencil on paper

31.7 × 24.7 cm

Private collection

Colour illus. p. 186

PROVENANCE: René de Gas; Vente 1927, no. 11, illus.; Galerie Rosenberg, Paris; Galerie Wildenstein, New York; John Nicholas Brown, Providence

EXHIBITIONS: 1929, Cambridge (Mass.), Fogg Art Museum, Exhibition of French Painting of the 19th and 20th Centuries, no. 31; 1936 Philadelphia, no. 77, illus.; 1974 Boston, no. 64; 1984 Tübingen, no. 5, illus.; 1994, New York, Marc de Montebello Fine Art, Edgar Degas, Drawings, p. 8, illus.

LITERATURE: Mongan 1932, p. 63, illus.; Mongan 1938, p. 295; Boggs 1962, p. 114

27

Rosa Adelaida Morbilli

1857

Pencil and black chalk, watercolour and bodycolour, black Indian ink

35 × 18.6 cm

Vente stamp below right; inscribed in an unidentified hand below left

L50bis

Mr and Mrs Eugene V. Thaw

Colour illus. p. 186

PROVENANCE: Vente IV, 1919, no. 102b, illus.; Durand-Ruel, Paris; William M. Ivins, Milford; Parke Bernet, New York, 24 November 1962, no. 32, illus.

EXHIBITIONS: 1964 New York, no. 10; 1965 New

Orleans, p. 65, illus.; 1967 Saint Louis, no. 22, illus.; 1975–76, New York, The Pierpont Morgan Library/ Cleveland, The Museum of Art/Chicago, The Art Institute/Ottawa, The National Gallery of Canada, *Drawings from the Collection of Mr. and Mrs. Eugene V. Thaw*, no. 92, illus.; 1984 Tübingen, no. 30

LITERATURE: Champigneulle 1952, illus.; Boggs 1962, p. 88, note 49, p. 105; Boggs 1963, p. 275, illus.; Minervino 1974, no. 131; Dunlop 1979, p. 30, illus.

28

Self-portrait

1857

Etching, 1st state

27.2 × 23.2 cm

Signed lower left

New York, The Metropolitan Museum of Art

Gift of Mr and Mrs Richard J. Bernhard, 1972

(1972.625)

Illus. p. 168

PROVENANCE: Ambroise Vollard, Paris; Marcel Guérin, Paris

EXHIBITION: Boston 1984

LITERATURE: Delteil, no. 1; Adhémar, no. 13; Reed/ Shapiro 8

24

25

26

27

29

Self-portrait

1857

Etching, 2nd state, 26.3 × 17.2 cm

New York, The Metropolitan Museum of Art

Jacob H. Schiff Bequest, 1922 (22.63.31)

Illus. p. 168

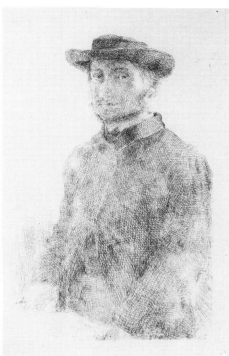

28

LITERATURE: Delteil, no. 1; Adhémar, no. 13; Reed/
Shapiro 8

EXHIBITION: Boston 1984, no. 8

30

Self-portrait

1857, etching, 3rd state, 23 × 14.4 cm

Boston, Museum of Fine Arts

Katherine Eliot Bullard Fund in Memory of
Francis Bullard and proceeds from sale of
duplicate prints (1983.306)

Colour illus. p. 169

PROVENANCE: Viau collection

EXHIBITION: 1984 Boston

LITERATURE: Delteil, no. 1; Adhémar, no. 13; Reed/
Shapiro 8

31

Self-portrait

1857, etching and drypoint, 4th state, 4th proof
(Bartholomé), 23.3 × 14.4 cm

Josefowitz collection, colour illus. p. 169

LITERATURE: Delteil, no. 1; Adhémar, no. 13; Reed/
Shapiro 8

32

Self-portrait

1857, etching and drypoint, 4th state, 4th proof
(Moreau-Nélaton), 23.3 × 14.4 cm

Josefowitz collection

Colour illus. p. 169

LITERATURE: Delteil, no. 1; Adhémar, no. 13; Reed/
Shapiro 8

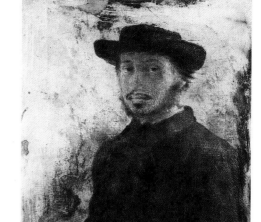

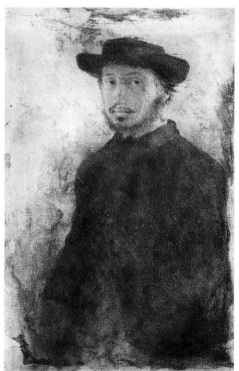

31

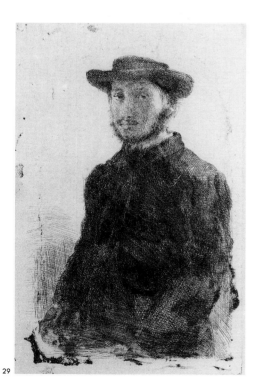

29

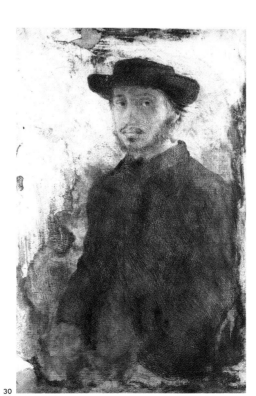

30

32

33

The engraver Joseph Tourny

1857–58

Etching, 1st state, 3rd proof, printed in
monotype ink

23 × 14.4 cm

Sammlung E.W.K., Berne

Colour illus. p. 253

LITERATURE: Delteil, no. 4; Adhémar, no. 7; Reed/
Shapiro 5

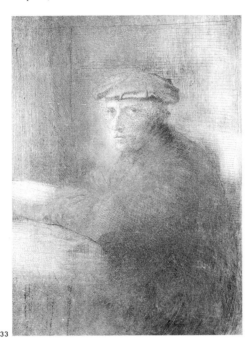

33

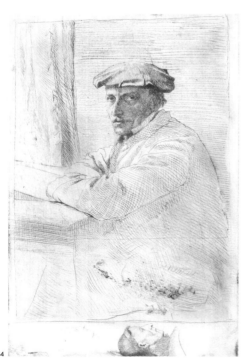

34

34

The engraver Joseph Tourny

1857

Etching, 3rd state

23 × 14.4 cm

Cambridge, Harvard University Art Museums,
Fogg Art Museum, Bequest of Meta and Paul J.
Sachs (M14296)

Colour illus. p. 252

PROVENANCE: Collection of Meta and Paul J. Sachs
EXHIBITION: 1984–85 Boston, no. 5
LITERATURE: Boggs 1962, pp. 11, 131; Delteil, no. 4;
Adhémar, no. 7; Reed/Shapiro 5

35

Young man wearing a velvet cap

(Copy after the etching by Rembrandt, Bartsch
268)

ca. 1857

Etching, 1st state

11.5 × 9.5 cm

Sammlung E.W.K., Berne

Colour illus. p. 157

LITERATURE: Delteil, no. 13; Adhémar, no. 11; Reed/
Shapiro 6

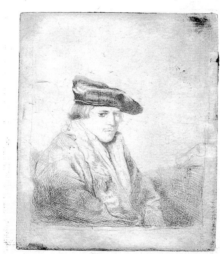

35

36

Marguerite De Gas

1858–60

Oil on canvas

80 × 54 cm

L60

Paris, Musée d'Orsay (RF3585)

Colour illus. p. 179

PROVENANCE: Jeanne Fevre, Nice; acquired by the
Musée du Louvre, 1931

EXHIBITIONS: 1931 Paris, no. 20; 1932, Paris, Musée de
l'Orangerie, *Achats du Musée du Louvre*, no. 83a

LITERATURE: P. Jamot, *L'Amour de l'Art*, no. 5, 1931,
p. 186, illus.; J. Guiffrey, *Bulletin des Musées de France*,
1931, no. 3, p. 42; Minervino 1970, no. 133

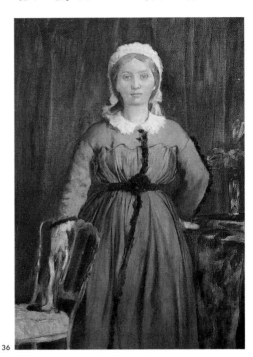

36

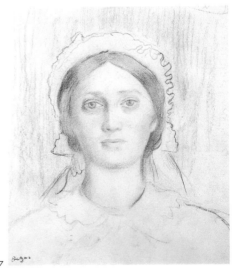

37

37

Marguerite De Gas

Study for cat. 36

1858–60

Pencil and charcoal on paper

31.4 × 26 cm

Private collection

Colour illus. p. 180

PROVENANCE: Vente II, 1918, no. 240, illus.; Vitale Bloch, Paris; Benjamin Sonnenberg

EXHIBITIONS: 1952, Paris, Bernheim-Jeune, *Cent-Cinquante ans de dessin*; 1955 Paris, no. 22; 1971, New York, The Pierpont Morgan Library, *Artists and Writers: Nineteenth and Twentieth Century Portrait Drawings from the Collection of Benjamin Sonnenberg*, no. 16, illus.

LITERATURE: Mahonri Sharp Young, Treasures in Gramercy Park, *Apollo*, vol. 85, no. 51, March 1967, p. 173, illus.

38

Marguerite De Gas

Study for cat. 36

1858–60

Pencil on paper

28.2 × 20.8 cm

Vente stamp lower right

Paris, Musée du Louvre, Département des Arts Graphiques, Fonds du Musée d'Orsay (RF 16949 recto)

Colour illus. p. 178

PROVENANCE: Henri Fevre, Paris; purchased by the Museum, 1931

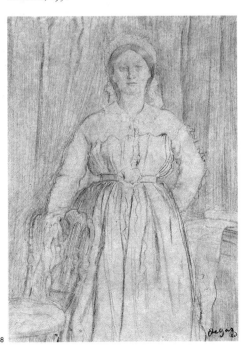

38

39

Marguerite De Gas

Study for cat. 36

1858–60

Pencil on paper, 28 × 21.8 cm

Vente stamp lower right

Paris, Musée du Louvre, Département des Arts Graphiques, Fonds du Musée d'Orsay (RF 16950 recto)

Colour illus. p. 178

PROVENANCE: Henri Fevre, Paris; purchased by the Museum, 1931

40

The Bellelli family

1858–59

Pastel, gouache and pencil on paper

55 × 63 cm

Vente stamp lower left

L64

Copenhagen, Ordrupgaardsamlingen

Colour illus. p. 188

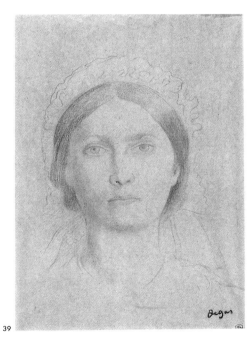

39

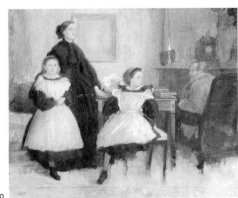

40

PROVENANCE: Vente I, 1918, no. 117, illus.; Vente René de Gas, Hôtel Drouot, Paris, 10 November 1927, no. 44; Wilhelm Hansen, Copenhagen

EXHIBITIONS: 1957, Copenhagen, Statens Museum for Kunst, *Fransk kunst udvalgt fra Ny Carlsberg Glyptotek, Kunstakademiet, Nivaagaard, Ordrupgaard og Statens Museum for Kunst*, no. 35a; 1983 Copenhagen, no. 44

LITERATURE: Guérin 1928, pp. 372ff.; Lemoisne I, pp. 32–36; Leo Swane, *Etatsrad Wilhelm Hansen og hustru Henny Hansens malerisamling, Katalog over kunstvaerkene paå Ordrupgaard*, Copenhagen 1954, no. 30; Boggs 1955; Haavard Rostrup: *Franske malerier i Ordrupgaardsamlingen*, Copenhagen 1958, no. 30; Meir Stein, *Frans impressionisme*, Copenhagen 1962, illus. p. 21; Haavard Rostrup, *Etatsrad Wilhelm Hansen og hustru Henny Hansens malerisamling, Catalogue of the Works of Art in the Ordrupgaard Collection*, Copenhagen 1966, no. 30; Haavard Rostrup, Studier i fransk portraetmaleri, Degas og Toulouse-Lautrec, *Meddeleiser fra My Carlsberg Glyptotek*, 25, 1968, pp. 27–54, illus.; Minervino 1970, no. 139, illus.; Haavard Rostrup, *Etatsrad Wilhelm Hansen og Hustru Henny Hansens malerisamling, Fortegnelse over kunstvaerkerne paå Ordrupgaard*, Copenhagen 1973, no. 30; Anne Dayez, *Centenaire de l'Impressionnisme*, exhibition catalogue Paris 1974, no. 9; Anette Stabell, *Katalog over Ordrupgaardsamlingen*, Copenhagen 1982, no. 29; Degas and the Bellelli Family, *Apollo*, 118, October 1983, pp. 278–80, illus.; Britta Martensen-Larsen, Degas and the Bellelli Family, New Light on a major Work, *Hafni, Copenhagen Papers in the History of Art*, no. 10, 1985, pp. 181–91, illus.; Sutton 1986, pp. 40f., illus.; 1988–89 Paris/Ottawa/New York 1988, pp. 80f., illus.; Nicholas Wadley, *Impressionist and Post-Impressionist Drawing*, London 1991, pp. 100f., illus.; Boggs/Maheux 1992, pp. 42f., illus.; Bente Scavenius, *Vejen ad hvilken, Se pa verdenskunst i Danmark*, Copenhagen 1993, pp. 9–29, illus.; Mikael Wivel, *Ordrupgaard, Udvalgte vaerker/Selected Works*, Copenhagen 1993, no. 23, illus.

41

Laura Bellelli

1858–59

Study for *The Bellelli family*

Pencil and pastel on paper

26.1 × 20.4 cm

Atelier stamp lower left

Paris, Musée du Louvre, Cabinet des Dessins, Département des Arts Graphiques, Fonds du Musée d'Orsay (RF 11688)

Colour illus. p. 191

PROVENANCE: Atelier Degas; René de Gas; Vente Succession René de Gas, Paris, Drouot, 10 November 1927, no. 13, illus.; acquired by the Museum

EXHIBITIONS: 1931 Paris, Orangerie, no. 90; 1937 Paris, Orangerie, no. 61; 1962, Rome, Palazzo Venezia, *Il ritratto francese da Clouet a Degas*, no. 72, illus.; 1967 Saint Louis, no. 23, illus.; 1980 Paris, no. 15, illus.; 1984–85 Rome, no. 61, illus.; 1988–89 Paris/Ottawa/New York, no. 23, illus.

LITERATURE: Boggs 1955, pp. 130f.; Keller 1962, p. 30; 1983 Ordrupgaard, p. 85, illus.

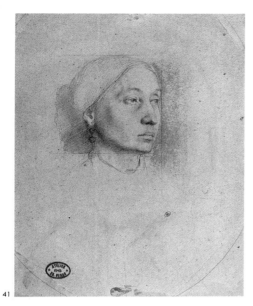

41

42

42

Giovanna Bellelli

Study for *The Bellelli family*, 1858–59

Pencil and black chalk and gouache on paper

29.5 × 21.8 cm

Atelier stamp lower left; Nepveu-Degas stamp
lower right

Collection Prat, Paris

Colour illus. p. 192

PROVENANCE: Atelier Degas; René de Gas; Nepveu-
Degas collection; Vente Hôtel Drouot, Paris, 6 May
1976, no. 3, illus.

EXHIBITIONS: 1955 Paris, no. 19; 1983 Ordrupgaard,
no. 31, illus.; 1984 Rome, no. 60, illus.

LITERATURE: Louis-Antoine Prat, *La ciguë avec toi*,
Paris, La Table Ronde, 1984, p. 133

43

Giovanna Bellelli

Study for *The Bellelli family*, 1858–59

Pencil on paper, 32.6 × 23.8 cm

Atelier stamp lower right

Paris, Musée du Louvre, Département des Arts
Graphiques, Fonds du Musée d'Orsay (RF
16585)

Colour illus. p. 189

PROVENANCE: Atelier Degas; Degas estate stamp,
Lugt 658bis; probably acquired by Marcel Guérin on
behalf of the Musée du Luxembourg, 1925; transferred
to the Musée du Louvre, 1930

EXHIBITIONS: 1931, Paris, Orangerie, no. 88; 1934,
Paris, Musée des Arts Décoratifs, *Les artistes français en
Italie de Poussin à Renoir*, no. 411; 1957, Paris, Musée du
Louvre, Cabinet des Dessins, *L'enfant dans le dessin du
XVe au XIXe siècle*, no. 44; 1969 Paris, no. 64; 1980
Paris, no. 5, illus.; 1983 Ordrupgaard, no. 9, illus.;
1984–85 Rome, no. 58, illus.; 1988–89 Paris/Ottawa/
New York, no. 22, illus.

LITERATURE: Keller 1962, p. 31

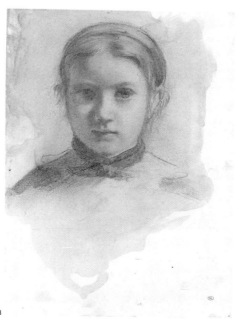

43

44

Giulia Bellelli

Study for *The Bellelli family*

1858–59

Pencil and oil on paper, heightened with white

23.4 × 19.6 cm

Atelier stamp below centre

Paris, Musée du Louvre, Département des Arts
Graphiques, Fonds du Musée d'Orsay
(RF11689)

Colour illus. p. 189

PROVENANCE: Atelier Degas; René de Gas, Paris;
Vente Succession René De Gas, Paris, Drouot, 10
November 1927, no. 8, illus.; acquired by the Musée du
Luxembourg

EXHIBITIONS: 1931 Paris, Orangerie, no. 89; 1934
Paris, Musée des Arts Décoratifs, *Les artistes français en
Italie de Poussin à Renoir*, no. 409; 1935, Paris,
Orangerie, *Portraits et figures de femmes*, no. 41; 1938,
Lyons, Salon du Sud-Est, no. 20; 1955–56, Chicago,
The Art Institute, *French Drawings: Masterpieces from
Seven Centuries*, no. 148, illus.; 1957, Paris, Musée du
Louvre, Cabinet des Dessins, *L'enfant dans le dessin du
XVe au XIXe siècle*, no. 43; 1959–60, Rome, Palazzo di
Venezia, *Il disegno francese da Fouquet a Toulouse-Lautrec*,
no. 178; 1967, Copenhagen, Statens Museum for
Kunst, Dept. of Prints and Drawings, *Hommage à l'art
français*, no. 36, illus.; 1969 Paris, no. 65, illus.; 1980
Paris, no. 12, illus.; 1983 Ordrupgaard, no. 26, illus.;
1988–89 Paris/Ottawa/New York, no. 21, illus.

LITERATURE: Leymaire 1947, no. 7, illus.; Boggs 1955,
pp. 130f.; Keller 1962

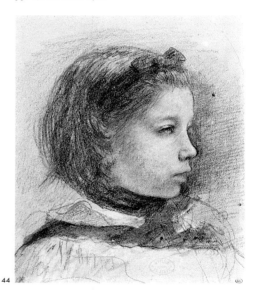

44

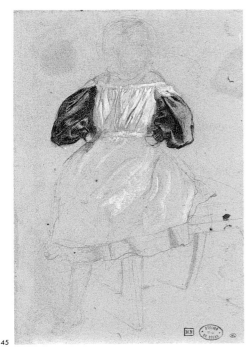

45

46

45

Giulia Bellelli

Study for *The Bellelli Family*

1858–59

Pencil, charcoal, white heightening on paper

31.4 × 21.2 cm

Paris, Musée du Louvre, Département des Arts Graphiques, Fonds du Musée d'Orsay (RF 16581)

Colour illus. p. 192

PROVENANCE: Atelier Degas; René de Gas; sale 1927, Musée du Luxembourg

EXHIBITIONS: 1969 Paris, no. 67; 1980 Paris, no. 7; 1983 Ordrupgaard, no. 32; 1985/85 Rome, no. 59

LITERATURE: Keller 1962, p. 31

46

Laura Bellelli and her two daughters

Study for *The Bellelli family*

1858–59

Pencil and dilute oil paint on paper

43 × 27.5 cm

Atelier stamp top left

Paris, Musée du Louvre, Département des Arts Graphiques, Fonds du Musée d'Orsay (RF 23413)

Colour illus. p. 190

PROVENANCE: Atelier Degas; René de Gas; Nepveu-Degas family; gift of the Société des Amis du Louvre, 1933

EXHIBITIONS: 1969 Paris, no. 60; 1983 Copenhagen, no. 16

LITERATURE: Hanne Finsen, Degas and the Bellelli Family, *Hafnia, Copenhagen Papers in the History of Art*, no. 10, 1985, pp. 181ff.

47

Giovanna Bellelli

Study for *The Bellelli family*

ca. 1858

Black Conté crayon on blue paper

31.5 × 24 cm

Private collection, Zurich

Colour illus. p. 191

PROVENANCE: Private collection

48

Giovanna Bellelli

Study for *The Bellelli family*

ca. 1858

Conté or charcoal on paper, gone over with shellac

32.1 × 23 cm

Private collection, Zurich

Colour illus. p. 191

PROVENANCE: Private collection

49

Laura Bellelli and her daughter Giovanna

Study for *The Bellelli family*, ca. 1858

Black Conté crayon on paper, traces of white heightening

42.3 × 29.2 cm

Private collection, Zurich

Colour illus. p. 190

PROVENANCE: Private collection

EXHIBITIONS: 1931 Paris, no. 92; 1934, Paris, Musée des Arts Décoratifs, *Les artistes français en Italie de Poussin à Renoir*, no. 410; 1955 Paris, no. 20?; 1983 Ordrupgaard, no. 17

LITERATURE: Lemoisne 1931, p. 286, illus.

47

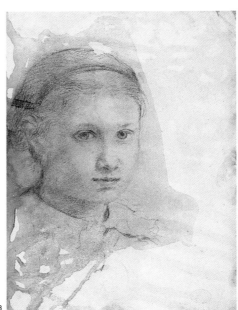

48

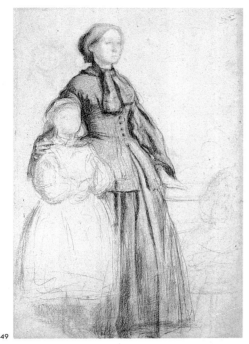

49

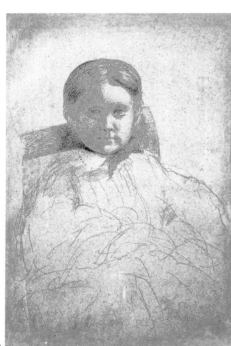

50

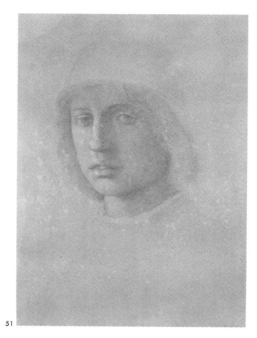

51

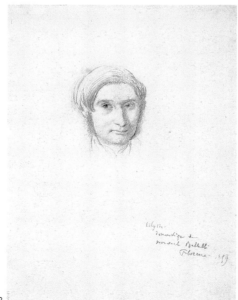

52

50

Mlle Matilde Dembowska

1858–59

Black chalk on pink paper

40 × 28 cm

Vente stamp lower left

Private collection

Colour illus. p. 193

PROVENANCE: Vente IV, 1919, no. 98a, illus.; private collection, Paris; Galerie Arnoldi-Livie, Munich

EXHIBITION: 1984 Tübingen, no. 33, illus.

LITERATURE: Boggs 1962, p. 115; Vitali 1963, p. 266, note 4; Reff 1964, p. 251, note 15; Loyrette 1991, p. 134

51

Filippino Lippi

(Copy after Filippino's self-portrait in the Uffizi, Florence)

ca. 1858

Pencil, heightened with white

47 × 31.7 cm

Atelier stamp

Hamilton Ontario, McMaster Art Gallery

Gift of Herman H. Levy, O.B.E.

(1984.007.0175)

Colour illus. p. 153

PROVENANCE: Mlle Jeanne Fevre; Gimpel Fils, London, 1958; Herman H. Levy, O.B.E., Hamilton, Ontario

EXHIBITION: 1967 Saint Louis, no. 18, illus.

LITERATURE: Reff 1967, pp. 261ff.

52

Ulysse

1859

Pencil on paper

30.8 × 23.3 cm

Inscribed in pencil, lower right: Ulysse/ Domestique de/ mon oncle Bellelli/Florence 1859; Atelier stamp at left

Private collection

Colour illus. p. 193

PROVENANCE: Marcel Guérin, Paris

EXHIBITIONS: 1934, Paris, Musée des Arts Décoratifs, *Les artistes français en Italie de Poussin à Renoir*, no. 412; 1937, Paris, Galerie Guiot, *Le portrait dessiné*, no. 40; 1951–52 Berne, no. 84; 1984 Tübingen, no. 32

LITERATURE: Guérin 1928, p. 373; Boggs 1962, p. 131

53

La Savoisienne

ca. 1860

Oil on canvas

61.5 × 46.3 cm

L333

Providence, Rhode Island, Museum of Art, Rhode Island School of Design (23.072)

Colour illus. p. 282

PROVENANCE: Bernheim-Jeune, Paris; Durand-Ruel, Paris/New York; acquired by the Museum 1923

EXHIBITIONS: 1903, Paris, Galerie Bernheim-Jeune, *Exposition d'œuvres de l'Ecole Impressionniste,* no. 13; 1904, Brussels, La Libre Esthétique, *Exposition de peintres Impressionnistes*, no. 25; 1908, Pittsburgh, Carnegie Institute, *Exhibition of Painting by the French Impressionists*, no. 21; 1911, Cambridge, Fogg Art Museum, *Loan Exhibition of Paintings and Pastels by E. Degas*, no. 7; 1913, Boston, Saint Botolph Club, *Impressionist Painting lent by Messrs. Durand-Ruel and Sons*, no. 11; 1915, New York, Knoedler & Co., *Loan Exhibition of Masterpieces by Old and Modern Painters,* no. 21; 1916, New York, Durand-Ruel, *Exhibition of Paintings and Pastels by Edouard Manet and Edgar Degas*, no. 14; 1933 Northampton; 1946, Worcester, Art Museum, Exchange Exhibition; 1947 Cleveland, no. 20; 1949 New York, no. 27, illus.; 1958 Los Angeles, no. 21; 1962, Seattle, World's Fair, no. 41; 1974 Boston, no. 10; 1984, Miami, Center for Fine Arts, *In Quest of Excellence*, pp. 167, illus.; 1988, New York, IBM Gallery of Science

and Art, *Highlights from the Collection of the Museum of Art, Rhode Island School of Design*

LITERATURE: Grappe 1913, pp. 22, illus.; Lafond 1919, p. 17, illus.; *Bulletin of the Rhode Island School of Design*, 5, 11, no. 2, April 1923, p. 34; Earle L. Rowe, Examples of Degas's Art, *Bulletin of the Rhode Island School of Design*, 5, 11, no. 4, October 1923, pp. 38f., illus.; Ambroise Vollard, *Degas, An Intimate Portrait*, New York 1927, p. 25, illus.; Hausenstein 1931, p. 166; Earle L. Rowe, Pastel Group by Degas, *Bulletin of the Rhode Island School of Design*, 5, 20, no. 2, April 1932, p. 18f.; Dorothy Adlow, A Degas Portrait, *Christian Science Monitor*, 24 April 1934, p. 7; Miriam A. Banks, Mr. Rowe, the Director of the Museum, *Bulletin of the Rhode Island School of Design*, 5, 25, no. 2, April 1937, p. 33, illus.; Mauclair 1937, p. 166, illus.; *Treasures in the Museum of Art*, Rhode Island School of Design, 1956, illus.; S. Lane Faison Jr., *A Guide to the Art Museums of New England*, New York 1958, p. 229, illus.; James Fowle, A Note on Degas, *Bulletin of the Rhode Island School of Design, Museum Notes*, 5, 51, no. 2, December 1964, pp. 6, 9; Minervino 1970, no. 360, illus.; 1979 Edinburgh, under no. 61; Carla Mathes Woodward and Franklin W. Robinson (ed.), *A Handbook of the Museum of Art*, Rhode Island School of Design, Providence 1985, p. 193, illus.; Sutton 1986, p. 134, illus.; Reff 1987, pp. 49f.; Daniel Rosenfeld, *European Painting and Sculpture, ca. 1770–1937*, Providence 1991, pp. 101ff., illus.

53

54

Anne of Cleves

(Copy after the portrait of Anne of Cleves by Hans Holbein the Younger in the Louvre)
ca. 1860
Oil on canvas, 64 × 47 cm
L80
Mr and Mrs David Little
Colour illus. p. 154

PROVENANCE: Fourniol collection, Paris; Durand-Ruel collection; Sotheby's, London, 1 December 1982, no. 7
EXHIBITIONS: 1937, Paris, no. 57; 1960, Paris, no. 3; 1970–71, Hamburg, Kunsthalle, *Französische Impressionisten, Hommage à Durand-Ruel*, no. 9; 1993, Paris, Musée du Louvre, *Copier créer*, no. 221, illus.
LITERATURE: Meier-Graefe 1923, illus.; Jamot 1924, pp. 10, 35; Reff 1964, p. 255; Minervino 1974, no. 51; Elisabeth Foucart-Walter, *La peinture de Hans Holbein le Jeune au Louvre*, Paris 1985, pp. 63, 76

55

Gennaro Bellelli

Study for *The Bellelli family*
ca. 1860
Charcoal, heightened with white bodycolour, on paper
44.7 × 28.4 cm
Atelier stamp lower left
Paris, Musée du Louvre, Département des Arts Graphiques, Fonds du Musée d'Orsay (RF 23414)
Colour illus. p. 192

PROVENANCE: Atelier Degas; René de Gas; Nepveu-Degas family; gift of the Société des Amis du Louvre, 1933
EXHIBITIONS: 1931 Paris, no. 94; 1937 Paris, no. 71; 1976–77, Vienna, Albertina, *Von Ingres bis Cézanne*, no. 47, illus.; 1980 Paris, no. 9, illus.; 1983 Copenhagen, no. 50, illus.; 1984–85 Rome, no. 63, illus.

54

56

Marguerite De Gas

1860–62
Etching and drypoint, 5th state, 4th proof
12.5 × 11 cm
Boston, Museum of Fine Arts
Katherine E. Bullard Fund in Memory of Francis Bullard (1973.2)
Colour illus. p. 178

55

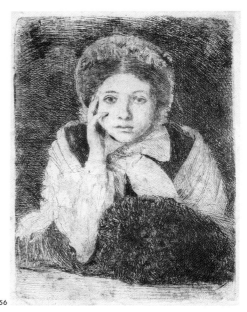

56

PROVENANCE: David Weill
EXHIBITION: 1984 Boston
LITERATURE: Delteil no. 17; Adhémar, no. 23; Reed/Shapiro 14

57
Mlle Natalie Wolkonska
1860–61
Etching, 2nd state
12 × 8.8 cm
Private collection, Berlin
Colour illus. p. 157

PROVENANCE: Burty collection; O. Gerstenberg, Berlin
LITERATURE: Delteil, no. 8; Adhémar, no. 15; Reed/Shapiro 12

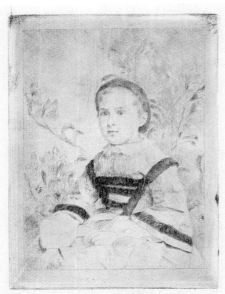

57

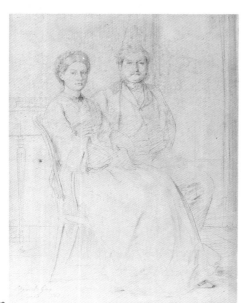

58

58
M. and Mme Paul Valpinçon
1861
Pencil on paper
34.4 × 25.6 cm
Signed lower left: Edgar DeGas/Paris 1861
New York, The Pierpont Morgan Library
Bequest of John S. Thacher (1985.37)
Colour illus. p. 208

PROVENANCE: Mme Jacques Fourchy (née Hortense Valpinçon)
EXHIBITION: 1924 Paris, no. 80
LITERATURE: Boggs 1962, pp. 36, 92; Philip Conisbee, London and Paris, French Artists at Home and Abroad, *Burlington Magazine*, 128, no. 1000, July 1986, pp. 532–34

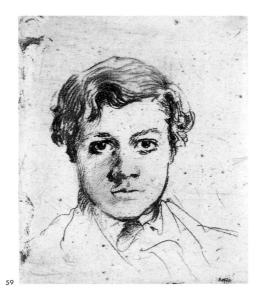

59

60

59
René De Gas
1861–62
Etching
8.7 × 7.2 cm
Private collection
Colour illus. p. 175

LITERATURE: Reed/Shapiro 15

60
M. Ruelle
ca. 1862
Oil on canvas
46 × 38 cm
Signed top left: Degas
L102
Lyons, Musée des Beaux-Arts (B–1726)
Colour illus. p. 210

PROVENANCE: Raymond Koechlin, Paris; bequest to the Museum, 1933
EXHIBITIONS: 1914, Copenhagen, *L'art français*, no. 68; 1924 Paris, no. 6; 1931 Paris, no. 24; 1951–52 Berne; 1952 Amsterdam; 1955 Paris; 1961, Vichy, *D'Ingres à Renoir*, no. 56; 1962, Tokyo/Kyoto, *Art français 1840–1940*, no. 64; 1980, Montauban, *Ingres et sa postérité jusqu'à Matisse*, no. 185; 1989–90, Lausanne/Tokyo/Kitakyushu, *Chefs-d'Œuvre du Musée de Lyon*, no. 59
LITERATURE: Herz 1920, p. 93; Paul Alfassa, Les Collections de M. Raymond Koechlin, *L'Amour de l'Art*, 1925, p. 107, illus.; *Bulletin des Musées de France*, May 1932, p. 82; René Jullina, Les Acquisitions récentes du Musée de Lyon, *Bulletin des Musées de France*, 1935, p. 61; Madeleine Vincent, *La Peinture des XIXe et XXe siècles, Catalogue du Musée de Lyon*, Lyons 1956, no. VII–180; Minervino 1974, no. 148

61
The Infanta Margarita
(Copy after Velázquez)
1862–64
Etching with drypoint, 2nd state
18 × 15 cm
Sammlung E.W.K., Berne
Colour illus. p. 157

PROVENANCE: Atelier Degas
EXHIBITION: 1984 Boston, no. 16/II
LITERATURE: Delteil, no. 12; Adhémar, no. 16; Reed/Shapiro 16

62
Edouard Manet, seated
1864–65
ca. 1870
Pencil on paper
33.1 × 23 cm
New York, The Metropolitan Museum of Art, Rogers Fund, 1919 (19.51.7.)
Colour illus. p. 254

PROVENANCE: Atelier Degas; Vente II, 1918, no. 210 (2); purchased by the Museum
EXHIBITIONS: 1936, New London, *Drawings*, no. 155; 1955 Paris, no. 67, illus.; 1967 Saint Louis, no. 54
LITERATURE: Bryson Burroughs, Drawings by Degas, *Bulletin of The Metropolitan Museum of Art*, vol. 19, no. 5,

1919, pp. 115f.; Hans Tietze, *European Master Drawings in the United States*, New York 1947, pp. 286f.; Rich 1951, p. 18; Huyghe, no. 5; Jacob Bean, *100 European Drawings in the Metropolitan Museum of Art*, New York 1964, no. 74

63

Manet, seated, turned to the left

1864–65
Etching, 1st state
31.4 × 22.5 cm
Copenhagen, Den Kongelige
Kobberstiksamling, Statens Museum for Kunst
Colour illus. p. 255

LITERATURE: Delteil, no. 15; Adhémar, no. 18; Reed/Shapiro 17

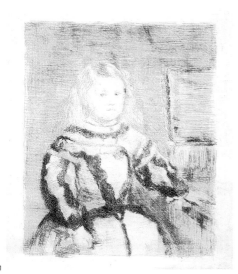

61

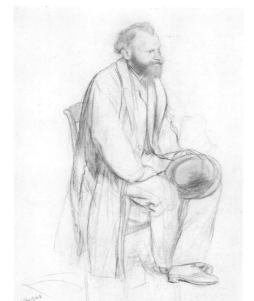

62

64

Manet, seated, turned to the left

1861–64
Etching, 2nd state
36 × 27 cm
Sammlung E.W.K., Berne
Colour illus. p. 255

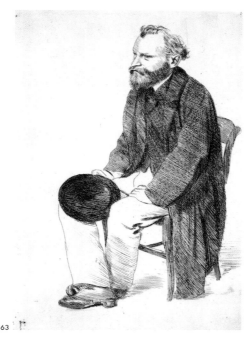

63

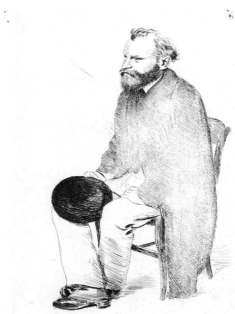

64

EXHIBITIONS: 1985, Winterthur, *Von Goya bis Warhol, Meisterwerke der Graphik des 19. und 20. Jahrhunderts aus einer Schweizer Privatsammlung*, no. 57, illus.

LITERATURE: Delteil, no. 15/II; Adhémar, no. 18/II; Reed/Shapiro 17

65

Manet, seated, turned to the right

1864–65
Etching with drypoint, 1st state
19.5 × 21.8 cm
Vente stamp
Boston, Museum of Fine Arts
Bequest of W.G. Russell Allen (60.257)
Colour illus. p. 256

EXHIBITION: 1984 Boston
LITERATURE: Delteil, no. 16; Adhémar, no. 19; Reed/Shapiro 18

66

Manet, seated, turned to the right

1864–65
Etching, intermediary state between 2nd and 3rd states
31.5 × 22.5 cm
Private collection
Colour illus. p. 257

LITERATURE: Delteil, no. 16; Adhémar, no. 19; Reed/Shapiro 18

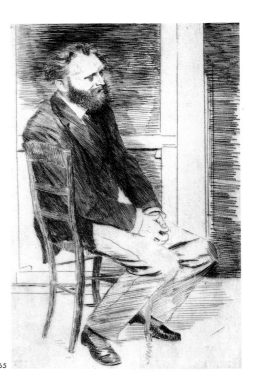

65

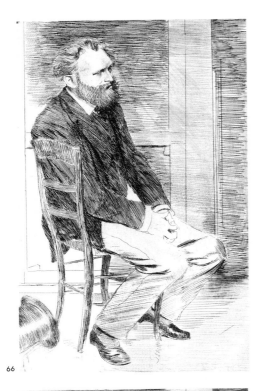

66

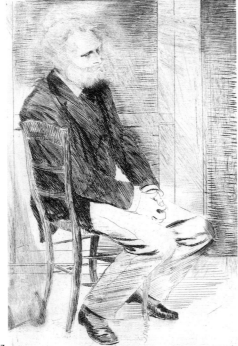

67

67

Manet, seated, turned to the right

1864–65

Etching and drypoint, 4th state, 19.3 × 12.2 cm

Paris, Bibliothèque d'Art et d'Archéologie,
Fondation Jacques Doucet

Colour illus. p. 257

LITERATURE: Delteil, no. 16; Adhémar, no. 19; Reed/
Shapiro 18

68

Edouard Manet (bust-length)

1864–65

Etching with drypoint and aquatint, 1st state

13 × 10.6 cm

Paris, Bibliothèque d'Art et d'Archéologie,
Fondation Jacques Doucet

Colour illus. p. 257

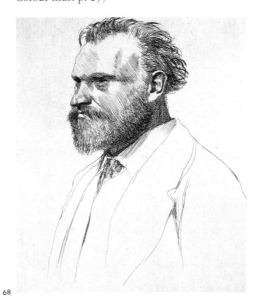

68

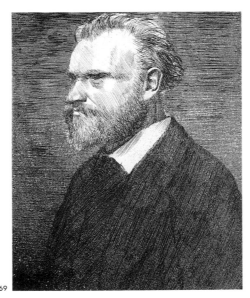

69

LITERATURE: Delteil, no. 14; Adhémar, no. 17; Reed/
Shapiro 19

69

Edouard Manet (bust-length)

1864–65

Etching with drypoint and aquatint
4th state

36 × 27 cm

Boston, Museum of Fine Arts,
Katherine Eliot Bullard Fund in Memory of
Francis Bullard and proceeds from sale of
duplicate prints (1983.308)

Colour illus. p. 257

EXHIBITION: 1984 Boston

LITERATURE: Delteil, no. 14; Adhémar, no. 17; Reed/
Shapiro 19

70

Bellet du Poisat

1865–66

Oil on canvas

41 × 31.8 cm

Signed top right: Degas

L133

Private collection, New York

Colour illus. p. 260

PROVENANCE: E. Chausson, Paris, sale June 1936, no.
27, illus.; Schwenck, Paris; private collection, Paris;
private collection, New York

EXHIBITIONS: 1912, Paris, Galerie des Arts, *Art
Moderne*; 1924 Paris, no. 19; 1931 Paris, no. 30; 1935
Brussels, Palais des Beaux-Arts, *L'Impressionnisme*, no.
14, illus.

LITERATURE: Arsène Alexandre, *Les Arts*, no. 128,
August 1912, illus.; Lafond 1918–19, I, p. 35, illus.;
Lemoisne I, p. 38; 1955 Paris, Degas dans les Collec-
tions Françaises, *Gazette des Beaux-Arts*, no. 27; Miner-
vino 1974, no. 216; Loyrette 1991, p. 483

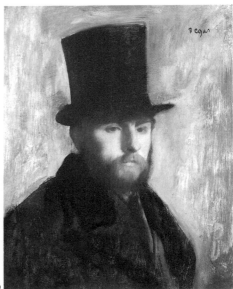

70

71

Portrait of a woman

(Copy after Caroto)

1865–68

Oil on canvas

69 × 53 cm

L133bis

Private collection, Zurich

Colour illus. p. 155

PROVENANCE: Atelier Degas; Vente II, 1918, no. 58; Marcel Nicolle

EXHIBITIONS: 1993, Paris, Musée du Louvre, no. 223, illus.

LITERATURE: Sylvie Béguin, *Andrea Solario en France*, Paris 1985, p. 39f.

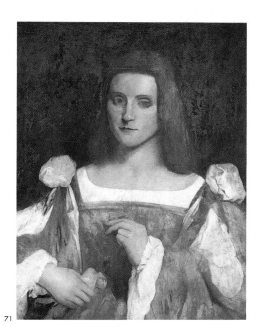

71

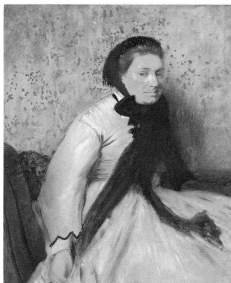

72

72

Woman in grey

('*La femme en gris*')

ca. 1865

Oil on canvas

91.5 × 72.4 cm

Vente stamp lower right

L128

New York, The Metropolitan Museum of Art, Gift of Mr and Mrs Edwin C. Vogel, 1957 (57.171)

Colour illus. p. 226

PROVENANCE: Atelier Degas; Vente I, 1918, no. 75; Dr Georges Viau, Paris; Galerie Charpentier, Paris, sale 22 June 1948, no. 2; Durand-Ruel, Paris and New York 1948; Mr and Mrs Edwin C. Vogel, New York

EXHIBITIONS: 1924 Paris, no. 49, illus.; 1931 Paris, no. 34; 1932, London, Royal Academy of Arts, Burlington House, *Exhibition of French Art 1200–1900*, no. 390; 1939, New York, World's Fair, Pavillon de la France, *Five Centuries of History mirrored in Five Centuries of French Art*, no. 373; 1949 New York, no. 9, illus.; 1960 New York, no. 10; 1974 Boston, no. 3; 1975, St Petersburg, Hermitage/Moscow, Pushkin Museum, *100 Paintings from the Metropolitan Museum*, no. 65; 1977 New York, no. 4; 1986–87, Naples, Museo di Capodimonte/Milan, Pinacoteca di Brera, *Capolavori Impressionisti dei Musei Americani*, no. 18; 1993, Fort Lauderdale, Museum of Art, *Corot to Cézanne, 19th Century French Paintings from the Metropolitan Museum of Art*

LITERATURE: Jamot 1924, pp. 49f., 133; George Waldemar, La Collection Viau, *L'Amour de l'Art*, vol. 6, 1925, p. 362; Bouyer 1925, p. 46; T. Rousseau, *Art News*, 48, April 1949, p. 21, illus.; Theodore Rousseau Jr., Report on Paintings Department, *Bulletin of the Metropolitan Museum of Art*, XVII, October 1958, pp. 55f.; Charles Sterlin and Margaretta Salinger, *Metropolitan Museum of Art, French Paintings*, III, *XIX–XX Centuries*, New York 1967, pp. 6f.; Minervino 1974, no. 213; C.S. Moffett, *Degas' Paintings in the Metropolitan Museum of Art*, New York 1979; C.S. Moffett, *Impressionist and Post-Impressionist Paintings in the Metropolitan Museum of Art*, New York 1985; Roger Hurlburt, Free Spirits, *Sun Sentinel* (Fort Lauderdale), 20 December 1992, p. 4; Helen Kohen, Lasting Impression, *The Miami Herald*, 20 December 1992, p. 61, illus.

73

M. and Mme Edmondo Morbilli

ca. 1865

Oil on canvas

116.5 × 88.3 cm

L164

Boston, Museum of Fine Arts

Gift of Robert Treat Paine II (31.33)

Colour illus. p. 185

PROVENANCE: Atelier Degas; René de Gas, Paris; sale, Drouot, Paris, Succession René de Gas, 10 November 1927, no. 71; F. Wildenstein and Co., New York; Robert Treat Paine II, Brooklyn, Mass.; gift to the Museum 1931

EXHIBITIONS: 1933 Northampton, no. 33; 1936 Philadelphia, no. 10; 1941, Boston, Museum of Fine Arts, *Portraits through Forty-five Centuries*, no. 144; 1970, New York, The Metropolitan Museum of Art, *Paintings from the Boston Museum*, no. 51; 1979, Paris, Grand Palais, *L'art en France sous le Second Empire*, no. 210; 1988–89

Paris/Ottawa/New York, no. 63

LITERATURE: Lemoisne 1927, p. 314; Hendy 1921, p. 43; Catalogue of Oil Paintings, Museum of Fine Arts, Boston, 1932, illus.; *Selected Oil and Tempera Paintings and three Pastels*, Museum of Fine Arts, Boston, 1932, illus.; Boggs 1962, pp. 16, 18–20, 24, 59, 125; Minervino 1974, no. 228; Petra Ten Doesschate Chu, *French Realism and the Dutch Masters*, Utrecht 1974, p. 60, illus.; S.W. Peters, Edgar Degas at the Boston Museum of Fine Arts, *Art in America*, vol. 62, no. 6, November–December 1974; Kirk Varnedoe, The Grand Party that won the Second Empire, *ARTnews*, vol. 77, 10 December 1978, pp. 50–53; Alexandra R. Murphy, *European Paintings in the Museum of Fine Arts, Boston. An Illustrated Summary Catalogue*, Boston 1985, p. 75; 1994, Paris, Grand Palais, *Impressionnisme, Les Origines*, p. 204

74

Edmondo Morbilli

Study for cat. 73

ca. 1865

Pencil

31.7 × 22.8 cm

Atelier stamp lower left

Boston, Museum of Fine Arts

Julia Knight Fox Funds (31.433)

Colour illus. p. 184

PROVENANCE: Atelier Degas; René de Gas, Paris; sale, Drouot, Paris, Succession René de Gas, 10 November 1927, no. 9; Wildenstein and Co., New York; acquired by the Museum 1931

EXHIBITIONS: 1934, Cambridge (Mass.), Fogg Art Museum, *One Hundred Years of French Art 1800–1900*, no. 152; 1936 Philadelphia, no. 72, illus.; 1937 Paris, Orangerie, no. 76; 1947 Cleveland, no. 65, illus.; 1947 Washington, no. 21; 1948 Minneapolis; 1953, Montreal, Museum of Fine Arts, *Five Centuries of Drawings*, no. 208; 1958–59 Rotterdam, no. 162, illus.; 1967 Saint Louis, no. 48, illus.; 1988–89 Paris/Ottawa/New York, no. 64, illus.

LITERATURE: Hendy 1932, p. 45, illus.; Mongan 1932, p. 64, illus.

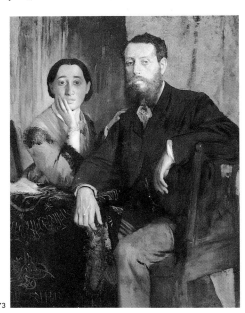

73

75

Mme Edmondo Morbilli

(Thérèse De Gas)

Study for cat. 73

ca. 1865

Pencil on paper

35.2 × 23.3 cm

Atelier stamp lower left

Paris, Musée du Louvre, Département des Arts
Graphiques, Fonds du Musée d'Orsay (RF
42663)

Colour illus. p. 184

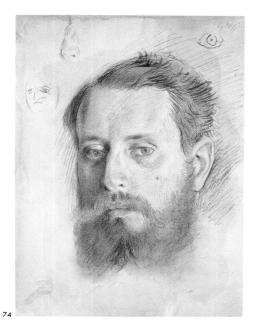

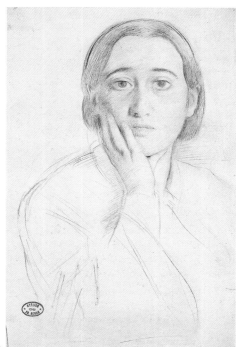

PROVENANCE: Atelier Degas; René de Gas; Nepveu-
Degas family; gift of Madame Arlette Devade (née
Nepveu-Degas), 1990
EXHIBITION: 1990, Paris, Musée d'Orsay, *De Manet à
Matisse*

76

Mme Edmondo Morbilli

(Thérèse De Gas)

ca. 1865–66

Oil on canvas

37 × 29 cm

Signed below right

L132

Private collection

Colour illus. p. 183

PROVENANCE: Henri Fevre, Monte Carlo; Mrs Fred W.
Davies, New York

77

**Elena and Camilla Primicile Carafa di
Montejasi Cicerale**

1865–68

Oil on canvas

58 × 75 cm

L169

Hartford, Connecticut, Wadsworth Atheneum
The Ella Gallup Sumner and Mary Catlin
Sumner Collection Fund (1934.36)

Colour illus. p. 195

PROVENANCE: Mlle Jeanne Fevre, Nice; Reinhardt collection, New York
EXHIBITIONS: 1924 Paris, no. 18; 1934 New York;
1935, Middletown (Conn.), Wesleyan University,
Impressionistic Art; 1935, Kansas City, William Rockhill
Nelson Gallery of Art, *One Hundred Years of French
Painting 1820–1920*, no. 16; 1935, Toronto, The Art Gallery of Ontario, Loan Exhibition celebrating the Opening of the Margaret Eaton Gallery and the East Gallery,
p. 27; 1937, Hartford (Conn.), Wadsworth Atheneum,
43 Portraits; 1940, New York, The New York World's
Fair, *Masterpieces of Art, Catalogue of European and
American Painting 1500–1900*, no. 271; 1947 Cleveland,
no. 7; 1958, New York, Knoedler Galleries, *Masterpieces from the Wadsworth Atheneum*, p. 134, illus.; 1962,
Baltimore, The Baltimore Museum of Art, *Manet,
Degas, Berthe Morisot and Mary Cassatt*, no. 34; 1972,
New York, Wildenstein Gallery, *Faces from the Impressionist and Post-Impressionist Period*, no. 18; 1991–92,
Kanazawa, Japan, Ishikawa Prefectural Museum of
Art/Isetan Museum of Art, Tokyo/Takamatsu City
Museum of Art, Takamatsu/Matsuzakaya Art Gallery,
Nagoya, *Goya to Matisse*
LITERATURE: Boggs 1962, pp. 16f., illus.

78

Giovanna and Giulia Bellelli

('*Les deux sœurs*')

ca. 1865–66

Oil on canvas

92 × 73 cm

Vente stamp lower left

L126

Los Angeles, Los Angeles County Museum of
Art

Mr and Mrs George Gard De Sylva Collection
(M. 46.3.3.)

Colour illus. p. 194

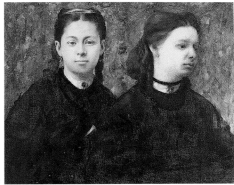

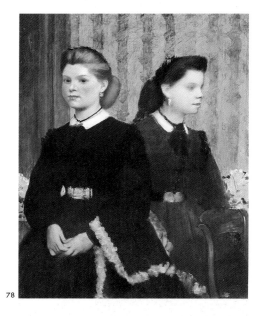

PROVENANCE: Atelier Degas; Vente I, 1918, no. 84; Paul Rosenberg, Paris; Henri-Jean Laroche, Paris, 1928; Jacques Laroche, Paris, 1937; Paul Rosenberg, New York; Mr and Mrs George Gard de Sylva, Holmby Hills, Cal.; gift to the Museum, 1946

EXHIBITIONS: (?) 1867, Paris, Salon, no. 444 or 445 (as *Portrait de famille*); 1928, Paris, Galerie de la Renaissance, *Portraits et figures de femmes de Ingres à Picasso*, no. 52; 1937 Paris, Orangerie, no. 7, illus.; 1947 Cleveland, no. 13, illus.; 1949 New York, no. 8, illus.; 1954, Detroit, The Detroit Institute of Arts, *The Two Sides of the Medal: French Painting from Gérôme to Gauguin*, no. 67, illus.; 1958 Los Angeles, no. 12, illus.; 1960 New York, no. 9, illus.; 1988–89 Paris/Ottawa/New York, no. 65, illus.

LITERATURE: Lemoisne I, p. 54; W.R. Valentiner, *The Mr and Mrs Gard de Sylva Collection of French Impressionists and Modern Paintings and Sculpture*, Los Angeles County Museum, Los Angeles 1950, no. 3, illus.; Boggs 1955, pp. 134ff., illus.; Boggs 1962, pp. 16, 20, illus.; Minervino 1974, no. 215; 1983 Ordrupgaard, p. 94, illus.; Loyrette 1991, p. 195

79
Mme Lisle and Mme Loubens
1865–69
Oil on canvas
84 × 96.6 cm
L265
Chicago, The Art Institute of Chicago
Gift of Annie Laurie Ryerson in memory of
Joseph Turner Ryerson (1953–335)
Colour illus. p. 234

PROVENANCE: Atelier Degas, Vente I, no. 105; Jacques Seligmann, Paris, sale 27 January 1927; The Detroit Institute of Arts; E. and A. Silberman Galleries, New York, 1935; Mr and Mrs Joseph Turner Ryerson, Chicago; Mrs Hugh A. Kirkland, Chicago; gift to the Museum, 1953

EXHIBITIONS: 1954, Fort Worth, Fort Worth Art Center, Inaugural Exhibition, no. 20, illus.; 1960 New York (not numbered); 1984 Chicago, no. 15

LITERATURE: The Detroit Institute of Arts, Purchases for the Collection, *Bulletin of the Detroit Institute of Arts*, January 1922, p. 39; The Detroit Institute of Arts, *The More Important Paintings and Sculptures of the Detroit Institute of the City of Detroit*, Detroit 1927, no. 147; Rich 1954, pp. 22–24, illus.; The Art Institute of Chicago, *Paintings in the Art Institute of Chicago: Catalogue of the Picture Collection*, Chicago 1961, no. 119; Minervino 1974, no. 265

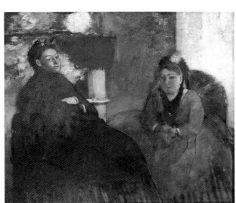
79

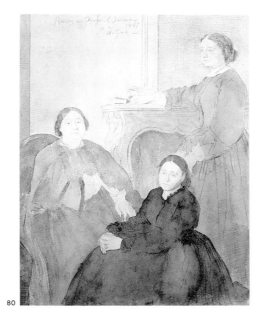
80

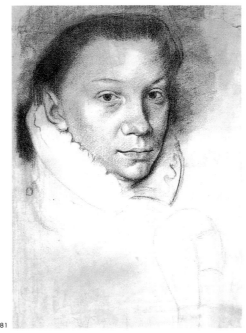
81

80
Mme Michel Musson and her daughters Estelle and Désirée
1865
Pencil and chalk and wash on paper, heightened with white
35 × 26.5 cm
Signed: Bourg en Bresse 6 Janvier 1865/ E Degas
Chicago, The Art Institute of Chicago
Margaret Day Blake Collection (1949–20)
Colour illus. p. 200

PROVENANCE: Atelier Degas; Henri Fevre; Marcel Guérin, Paris; Seligmann and Co., New York; acquired by the Museum in 1949

EXHIBITIONS: 1951 Detroit, no. 190, illus.; 1955, Paris, Musée de l'Orangerie, *De David à Toulouse-Lautrec*, no. 68, illus.; 1963, New York, Wildenstein Gallery, *Master Drawings from the Art Institute of Chicago*, no. 102, illus.; 1965 New Orleans, no. 52, illus.; 1976, Paris, Musée du Louvre, *Dessins français de l'Art Institute de Chicago de Watteau à Picasso*, no. 57, illus.; 1977, Frankfurt, Städtische Galerie, *Französische Zeichnungen aus dem Art Institute of Chicago*, no. 58, illus.; 1984 Chicago, no. 13, illus.

LITERATURE: AIC *Quarterly*, vol. 46, no. 3, September 1952; Lemoisne I, p. 73; Boggs 1956, pp. 6off., illus.; Boggs 1962, p. 21, illus.; The Art Institute of Chicago, *French Drawings and Sketchbooks of the Nineteenth Century*, Chicago 1979; Dunlop 1979, pp. 44–48; Brown 1991, pp. 313f.; Brown 1994, p. 28

81
Elisabeth of Valois
(Copy after Anthonis Mor)
ca. 1865–70
Black chalk and charcoal
40.5 × 27.4 cm
Cambridge, The Fitzwilliam Museum
Gow Bequest (PD.22–1978)
Colour illus. p. 156

PROVENANCE: Mlle Jeanne Fevre; Gimpel Fils, London, 1954; Andrew S.F. Gow; bequest to the Museum, 1978

EXHIBITIONS: 1978, Cambridge, The Collection of Andrew Gow; 1978, Hazlitt, Gooden & Fox, *Selected Works from the Andrew Gow Bequest*, no. 24, illus.; 1987 Manchester, no. 29; 1989, London, Sotheby's, *A Century of British Collecting, Impressionism and After*, no. 41; 1991, London, London South Bank Centre and Arts Council Tour, *The Primacy of Drawing*, no. 31

82
Self-portrait
ca. 1865
Pencil on paper
36.5 × 24.5 cm
Atelier stamp lower left; estate stamp on verso
Paris, Musée du Louvre, Département des Arts Graphiques, Fonds du Musée d'Orsay (RF 24232)
Colour illus. p. 172

PROVENANCE: Atelier Degas; Jeanne Fevre, Nice; sale Collection Jeanne Fevre, Galerie Jean Charpentier, 12 June 1934, no. 34, illus.; acquired by the Société des

Amis du Louvre

EXHIBITIONS: 1969 Paris, no. 113; 1988–89 Paris/Ottawa/New York, no. 59, illus.

LITERATURE: Jean Vergnet-Ruiz, Un portrait au crayon de Degas, *Bulletin des musées de France*, June 1934, no. 6, p. 108

83
Manet at the races
('*Manet aux courses*')
1865–68
Pencil on paper
32 × 24.1 cm
Vente stamp lower left
Verso: *Manet at the races*
1865–68
Pencil
Atelier stamp lower right
Inscribed in an unknown hand at upper left
Rotterdam, Museum Boymans-van Beuningen
(F II 123)
Colour illus. p. 258

PROVENANCE: Vente IV, 1919, no. 78b, illus.; Georges Viau, Paris, Paul Cassirer, Berlin; Franz Koenigs, Haarlem

EXHIBITIONS: 1933–34, Rotterdam, Museum Boymans-van Beuningen, *Teekeningen van Ingres tot Seurat*, no. 50; 1935, Basle, Kunsthalle, *Meisterzeichnungen französischer Künstler von Ingres bis Cézanne*, no. 152; 1946, Amsterdam, Stedelijk Museum, *Tekeningen van Fransche Meesters 1800–1900*, no. 68; 1951–52 Berne, no. 163; 1952 Paris, no. 134; 1964 Paris, Institut Néerlandais/Amsterdam, Rijksmuseum, *Franse Tekeningen uit Nederlandse Verzamelingen*, no. 183, illus.; 1984 Tübingen, no. 58

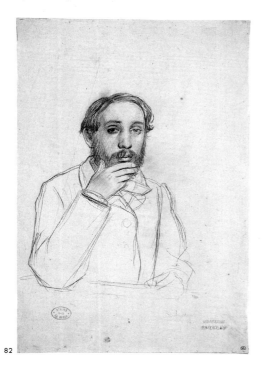

82

LITERATURE: Longstreet 1964, illus.; *Le Vie del Mondo*, XXVI, 1964, p. 755, illus.; G. Picon, *1863 Le Salon des Refusés*, Milan 1966, illus.; H.R. Hoetink, *Franse Tekeningen uit de 19e Eeuw*, Museum Boymans-van Beuningen, Rotterdam 1968, no. 76, illus.; Edinburgh 1979, under no. 4

84
Manet at the races
ca. 1870
Pencil on paper
38 × 24.4 cm
New York, The Metropolitan Museum of Art, Rogers Fund, 1919 (19.51.8)
Colour illus. p. 258

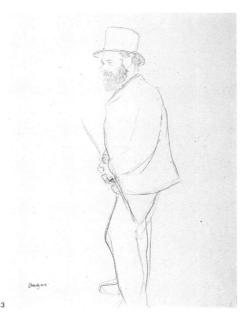

83

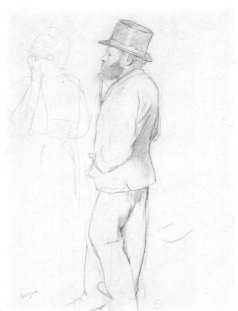

84

PROVENANCE: Atelier Degas; Vente II, 1918, no. 210; purchased by the Museum

EXHIBITIONS: 1948 Minneapolis; 1958, Rotterdam, Museum Boymans-van Beuningen/Paris, Orangerie/New York, Metropolitan Museum of Art, *De Clouet à Matisse, Dessins Français des Collections Américaines*, no. 161; 1967 Saint Louis, no. 55; 1968 New York, no. 31; 1973–74, Paris, Musée du Louvre, *Dessins Français du Metropolitan Museum of Art*, New York, no. 30; 1977 New York, no. 12; 1979 Edinburgh, no. 4

LITERATURE: Bryson Burroughs, Drawings by Degas, *Bulletin of The Metropolitan Museum of Art*, vol. 19, no. 5, 1919, p. 115; *Metropolitan Museum of Art, European Drawings from the Collections*, New York 1943, II, p. 50; John Rewald, *The History of Impressionism*, New York 1946, pp. 93, 98; Boggs 1962, p. 23, illus.; Dunlop 1979, p. 89, illus.

85
Portrait of a man
ca. 1866
Oil on canvas, 85 × 65 cm
Vente stamp lower right
L145
New York, The Brooklyn Museum
Museum Collection Fund (21.112)
Colour illus. p. 250

PROVENANCE: Atelier Degas; Vente I, 1918, no. 36, illus.; Vollard, Bernheim-Jeune, Durand-Ruel, Seligmann; New York, 27 February 1921, no. 35, acquired by the Museum

EXHIBITIONS: 1921, New York, Brooklyn Museum, *Paintings by Modern French Masters*, no. 72; 1922, New York, Brooklyn Museum, *Paintings by Contemporary English and French Painters*, no. 159; 1947 Cleveland, no. 6, illus.; 1953–54 New Orleans, no. 72; 1967, New York, Brooklyn Museum, *The Triumph of Realism*, no. 6, illus.; 1978 New York, no. 5, illus.; 1981, Cleveland, Cleveland Museum of Art, *The Realist Tradition*, no. 149, illus.; 1988–89 Paris/Ottawa/New York, no. 71, illus.

LITERATURE: Minervino 1974, no. 222

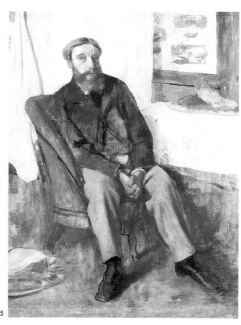

85

86

Joséphine Gaujelin
1867
Oil on panel
35 × 26.5 cm
Signed below right: Degas
L166
Hamburg, Hamburger Kunsthalle (2417)
Colour illus. p. 229

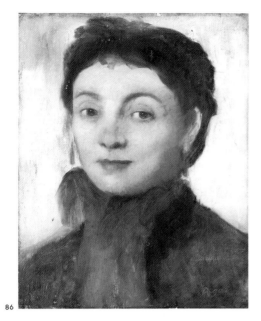

87

87

Joséphine Gaujelin
1867
36 × 23 cm
Charcoal
Inscribed in red chalk, lower right: Mme
Gaujelin; Vente stamp lower left
Frankfurt, Adolf and Luisa Haeuser-Stiftung
Deposited with the Graphische Sammlung des
Städelschen Kunstinstituts
Colour illus. p. 228

PROVENANCE: Vente III, 1919, no. 405/2, illus.;
Durand-Ruel, Paris; Olivier Senn, Paris; Marianne Feil-
chenfeldt, Zurich
EXHIBITIONS: 1924 Paris, no. 95; 1931 Paris, no. 114;
1984 Tübingen, no. 72; 1988, Frankfurt, Städelsches
Kunstinstitut und Städtische Galerie, *Graphische Samm-
lung im Städel – Neuerwerbungen 1983 bis 1988*
LITERATURE: Lemoisne II, under no. 165; Browse
1949, p. 60, no. 17a, illus.; Boggs 1962, p. 118; H.R.
Hoetink, *Franse Tekeningen uit de 19e Eeuw*, Museum
Boymans-van Beuningen, Rotterdam 1968, under no.
88

88

Julie Burtey
ca. 1867
Oil on canvas
73 × 59.7 cm
Atelier stamp below right
L108
Richmond, Virginia, Virginia Museum of Fine
Arts
Collection of Mr and Mrs Paul Mellon (83.17)
Colour illus. p. 231

PROVENANCE: Atelier Degas; Vente I, 1918, no. 85,
illus.; Monteux collection; private collection New
York; Jacques Lindon; Wildenstein & Co., New York,
until 1961
EXHIBITIONS: 1962, Richmond, Virginia Museum of
Fine Arts, *Delacroix to Gauguin: Ten Portraits*; 1966,
Washington, National Gallery of Art, *French Paintings
from the Collections of Mr. and Mrs. Paul Mellon and Mrs.
Mellon Bruce*, no. 51
LITERATURE: Agnes Mongan/Paul Sachs, *Drawings in
the Fogg Museum of Art*, I, Cambridge (Mass.) 1949, p.
357; Boggs 1962, p. 111; Reff 1965, p. 613, note 88;
Fogg Art Museum, *Memorial Exhibition of Works of Art
from the Collection of Paul J. Sachs*, Cambridge (Mass.)
1966–67, under no. 55; Minervino 1974, no. 155; Reff
1976, p. 6, note 2, pp. 110f.; Linda Walters, The West
Wing, A Grand Tradition Continued, *Arts in Virginia*,
vol. 23, no. 12, 1982–83, illus.; Pinkney L. Near, *French
Paintings, The Collection of Mr. and Mrs. Paul Mellon in the
Virginia Museum of Fine Arts*, 1985, no. 12; Wil-
liamstown 1987, under no. 17; 1988–89 Paris/Ottawa/
New York, under no. 76, illus.

PROVENANCE: Bequest of Erdwin and Antonie
Amsinck (née Lattmann), 1921
EXHIBITIONS: 1951–52, Paris, Orangerie, *Impres-
sionnistes et romantiques français dans les musées allemands*,
no. 23
LITERATURE: H. Tietze, *Gazette des Beaux-Arts*, Febru-
ary 1928, p. 114, illus.; Boggs 1962, pp. 31, 118; Miner-
vino 1974, no. 225; Keller 1988, p. 59

89

Julie Burtey
1863–67
Pencil and chalk on paper
30,8 × 21,6 cm
Signed and dated top right: Degas/1963;
inscribed in an unidentified hand, below right:
Mme Jules Bertin
Williamstown, Massachusetts, Sterling and
Francine Clark Art Institute 1406)
Colour illus. p. 230

PROVENANCE: Vente III, 1919, no. 304, illus.; Galerie
Knoedler, Paris; Robert Sterling Clark, Williamstown,
1919; Sterling and Francine Clark Institute, 1955
EXHIBITIONS: 1950, New York, Knoedler Galleries,
A Collector's Exhibition, no. 2; 1959 Williamstown, no.

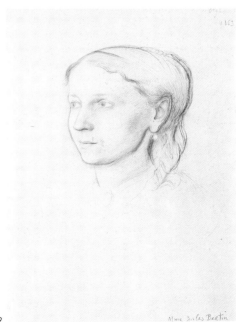

88

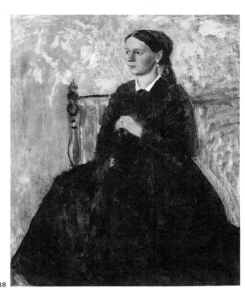

89

17, illus.; 1965, Williamstown, Sterling and Francine Clark Institute, *Exhibit Thirty, A Selection of 19th-Century French Drawings*, no. 156; 1967, New York, Wildenstein & Co., *Treasures from the Clark Art Institute*, no. 60; 1970 Williamstown, no. 16, illus.; 1984 Tübingen, no. 54, illus.

LITERATURE: 1924 Paris, under no. 81; Paris 1937, under no. 69; Lemoisne II, under no. 108; Boggs 1958, p. 243, note 3; Boggs 1962, p. 90, note 97, p. 111; Haverkamp-Begemann *et al*, *Drawings from the Clark Art Institute*, New Haven 1964, p. 156, illus.; 1967 Saint Louis, under no. 47; Reff 1976, p. 110; Pinkney L. Near, *French Paintings, The Collection of Mr. and Mrs. Paul Mellon in the Virginia Museum of Fine Arts*, Richmond 1985, illus. p. 29

90
Julie Burtey
ca. 1867
Pencil, heightened with white
36.1 × 27.2 cm
Inscribed top right: Mme Julie Burtey
Vente stamp lower left
Cambridge, Massachusetts, Harvard University Art Museums, Fogg Art Museum
Bequest of Meta and Paul J. Sachs (1965.254)
Colour illus. p. 230

PROVENANCE: Atelier Degas; Vente II, 1918, no. 347, illus.; Reginald Davis, Paris; Mme Demotte, Paris 1924; Paul J. Sachs, Cambridge (Mass.) 1928–65; bequest to the Fogg Art Museum of Meta and Paul J. Sachs, 1965

EXHIBITIONS: 1924 Paris, no. 81; 1929 Cambridge, no. 32; 1930 New York, no. 17; 1935 Boston, no. 119; 1935, Buffalo, Albright Art Gallery, *Master Drawings*, no. 114; 1936 Philadelphia, no. 64, illus.; 1937 Paris, Orangerie, no. 69, illus.; 1939, New York, Brooklyn Institute of Arts and Sciences Museum, *Great Modern French Drawings*; 1940, Washington, Phillips Memorial Gallery, *Great Modern Drawings*, no. 16; 1941, Detroit, Institute of Arts, *Masterpieces of 19th and 20th Century Drawings*, no. 16; 1945 New York, no. 57; 1946, Wellesley, Farnsworth Art Museum; 1947, San Francisco, Califor-

nia Palace of the Legion of Honor, *19th Century French Drawings*, no. 87; 1947, New York, Century Club, Loan Exhibition; 1948 Minneapolis, not numbered; 1951, Detroit, Institute of Arts, *French Drawings from the Fogg Museum of Art*, no. 33; 1952, Richmond, Virginia Museum of Fine Arts, *French Drawings from the Fogg Art Museum*; 1956, Waterville (Maine), Colby College, not in catalogue; 1958 Los Angeles, no. 13, illus.; 1958–59 Rotterdam, no. 160, illus.; 1961, Cambridge, Fogg Art Museum, *Ingres and Degas – Two Classical Draughtsmen*, no. 4; 1965–67 Cambridge, no. 55, illus.; 1966, South Headley (Mass.), Mt. Holyoke College; 1967 Saint Louis, no. 47, illus.; 1970 Williamstown, no. 17, illus.; 1974 Boston, no. 73; 1979, Tokyo, National Museum of Western Art, *European Master Drawings from the Fogg Art Museum*, no. 89; 1984 Tübingen, no. 55, illus.; 1988–89 Paris/Ottawa/New York, no. 76, illus.

LITERATURE: Rivière 1922–23, fig. 56; Mongan 1932, pp. 64f.; *Drawings in the Fogg Museum of Art*, Cambridge, Massachusetts 1940, I, no. 663, illus.; Lassaigne 1945, p. 6, illus.; Lemoisne II, cf. no. 108; Schwabe 1948, p. 8, illus.; James Watrous, *The Craft of Old-Master Drawings*, Madison 1957, pp. 144f.; Rosenberg 1959, p. 108, illus.; Boggs 1962, pp. 17f.; Reff 1965, p. 613, Gabriel Weisberg, *The Realist Tradition, French Painting and Drawing 1830–1900*, Cleveland 1981, p. 30, illus.

91
Portrait of a woman
(Mme Camus?)
ca. 1867–68
Oil on canvas
57 × 46 cm
BR 49
Isabella Brandt Johansen
Colour illus. p. 236

PROVENANCE: Atelier Degas (not in the Atelier auctions); Adelaide de Groot, New York, from 1936; Metropolitan Museum of Art, New York, on loan from Mrs de Groot; Sotheby Parke Bernet, New York, 25 October 1972, no. 5, illus.

EXHIBITIONS: Metropolitan Museum of Art, New York, on loan in October 1936 and during several months in the years 1944, 1946 and 1948–52

92
'La mélancolie'
ca. 1867–70
Oil on canvas
19 × 24.7 cm
L357
Washington, D.C., The Phillips Collection
(0480)
Colour illus. p. 242

PROVENANCE: Dr Georges Viau, Paris; Wilhelm Hansen, Copenhagen; A.M. Cargill, Glasgow, 1931; D.W.T. Cargill, Lanark, Scotland; Reid and Lefevre, London; Bignou Gallery, New York; purchased by the Phillips Memorial Gallery 1941

EXHIBITIONS: 1900, Paris, Grand Palais, Exposition Internationale Universelle; 1918, Geneva, Musée d'Art et d'Histoire, *Exposition d'Art Français*, no. 55; 1928 Glasgow/London, no. 10; 1931 Paris, no. 57; 1932, London, Royal Academy of Arts, *Exhibition of French Art 1200–1900*, no. 345; 1932, Manchester, City of Manchester Art Gallery, *French Art Exhibition*, no. 35; 1937 Paris, no. 19; 1978 Richmond, no. 7; 1979–80, Tokyo,

Sunshine Museum, *Ukiyo-E Prints and the West*, no. 25; 1983–84, Washington, D.C., The Dimock Gallery, Art Department, The George Washington University, *The Intimate Scale: Paintings from the Phillips Collection*, no. 4; 1986, Washington, D.C., The Phillips Collection, Duncan Phillips Centennial Exhibition; 1986, Washington, D.C., The Phillips Collection, *Emile Zola and the Art of his Time*; 1987, Palm Springs (Cal.), Palm Springs Desert Museum/Miami (Fla.), Center for the Fine Arts, *Selections from the Phillips Collection*; 1987, Canberra, Australian National Gallery, *Old Masters – New Visions: El Greco to Rothko from the Phillips Collection*; 1988, London, The Hayward Gallery/Frankfurt, Schirn Kunsthalle/Madrid, Centro de Arte Reina Sofia, *Master Paintings from the Phillips Collection*, no. 16, illus.

LITERATURE: Lévêque 1978, p. 57; Sutton 1986, no. 69, p. 78, illus.; Keller 1988, no. 41, p. 57, illus.

91

92

90

93

Le docteur Camus

1868

Oil on canvas

40 × 32 cm

L183

Private collection

Colour illus. p. 211

PROVENANCE: Atelier Degas; Vente II, 1918, no. 42, illus.; Poursin, Paris; Sotheby's, London, 7 December 1966

EXHIBITION: 1931 Paris, Orangerie, no. 67

LITERATURE: Minervino 1974, no. 242; Loyrette 1919, pp. 267f.

94

Paul Valpinçon

1868–72

Oil on canvas

32.5 × 24 cm

L197

Private collection, Great Britain

Colour illus. p. 209

PROVENANCE: Atelier Degas; Marcel Guérin, Paris; Lefevre Gallery, London; W.A. Cargill, Bridge of Weir; Sotheby's, London, 11 June 1963, nô. 19; Eugene Thaw, New York

EXHIBITIONS: 1931 Paris, Orangerie, no. 33; 1948, New York, Wildenstein & Co., *French Portraits of the 19th Century*, no. 7; 1949 New York, no. 18; 1954, London, The Lefevre Gallery, *French Paintings XIX and XX Centuries*, no. 5, illus.

LITERATURE: Lemoisne 1931, p. 286, illus.; *Beaux Arts*, 21 August 1936, p. 1, illus.; *Lettres* 1945, illus.; Minervino 1974, no. 260

93

95

Portrait of a man

(Copy after Quentin de la Tour)

1868–70

Oil on canvas

75 × 62.5 cm

BR 48

Lausanne, Musée Cantonal des Beaux-Arts

(334)

Colour illus. p. 150

PROVENANCE: Atelier Degas; Vente II, 1918, no. 37 as "Ecole française XVIIIe siècle"; Hans Leopold Widmer, Valmont-Territet

LITERATURE: Reff 1971, p. 539, illus.

94

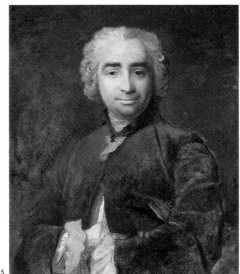

95

96

Marguerite De Gas

ca. 1868

24.5 × 19 cm

L185

Private collection

Colour illus. p. 181

PROVENANCE: Manzi collection, Paris; Dieterle collection, Paris; David-Weill collection, Paris

EXHIBITIONS: 1914 Paris, no. 38; 1924 Paris, no. 29; 1931 Paris, no. 43; 1974 Boston, no. 5; 1978 New York, no. 6

LITERATURE: *Les Arts*, 1914, p. 22, illus.; G. Henriot, *Catalogue de la Collection David-Weill*, p. 225, illus.

97

The Duchess of Montejasi Cicerale

ca. 1868

Oil on canvas

43.8 × 36 cm

BR 52

Private collection, New York

Colour illus. p. 196

PROVENANCE: Degas family, Naples; Mrs Millicent A. Rogers, New York; Mr and Mrs Leigh B. Block, Chicago; Wildenstein & Co., New York; Mr and Mrs Paul Mellon, Upperville (Va.)

EXHIBITIONS: 1960 New York, no. 15, illus.; 1966, Washington, National Gallery of Art, *Paintings from the Collections of Mr. and Mrs. Paul Mellon Bruce*, no. 50, illus.

LITERATURE: Boggs 1962, p. 124; Boggs 1963, p. 276

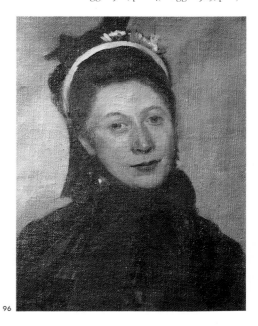

96

98

The Duchess of Montejasi Cicerale

1868

Oil on canvas

49 × 39.5 cm

BR 53

Cleveland, Cleveland Museum of Art

Bequest of Leonard C. Hanna, Jr (1958–28)

Colour illus. p. 196

PROVENANCE: Degas family, Naples; Mrs Millicent A. Rogers, New York; Paul Rosenberg, New York; Leonard C. Hanna, Jr, Cleveland; bequest to the Museum in 1958

EXHIBITIONS: 1956, New Haven, Yale University Art Gallery, *Pictures Collected by Yale Alumni*, no. 77, illus.; 1958, Cleveland, Cleveland Museum of Art, *In Memoriam Leonard C. Hanna, Jr.*, no. 9, illus.; 1963, Cleveland, Cleveland Museum of Art, *Style, Truth and the Portrait*, no. 90, illus.; 1981, Cincinnati, Taft Museum, *Small Paintings from Famous Collections*, illus.

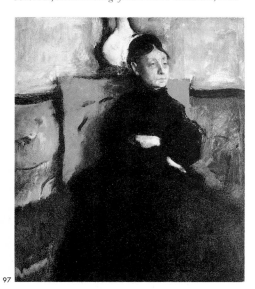

97

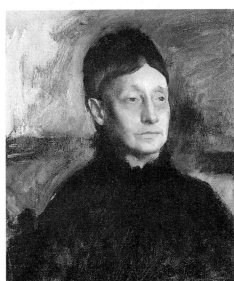

98

LITERATURE: A.M. Frankfurter, Collectors and Million-Dollar Taste, *Art News*, vol. 51, no. 1, March 1953, p. 25, illus.; Great Show of French Masters, *Life Magazine*, vol. 45, no. 8, 25 August 1958, p. 43, illus.; Boggs 1962, p. 124; Boggs 1963, p. 275, illus.; The Artist's View of Man: Portraiture through Four Centuries, *Illustrated London News*, CCXLIII, 1963, p. 521, illus.; M.L. d'Otrange Mastai, The Connoisseur in America: Portraiture from Titian to Degas, *The Connoisseur*, CLIV, October 1963, p. 134f., illus.; S.E. Lee, Style, Truth and the Portrait, *Art in America*, vol. 51, no. 5, p. 28, illus.; *Pictures on Exhibit*, vol. 27, no. 2, November 1963, p. 33, illus.; French Art in the United States, Recent exhibitions, *French News*, no. 22, December 1963, p. 33, illus.; A. Werner, Berichte: Amerika, Cleveland, Ohio, *Pantheon*, vol. 22, no. 1, January–February 1964, pp. 55f., illus.; *Selected Works*, The Cleveland Museum of Art, Cleveland 1966, p. 210, illus.; Cleveland Museum of Art, *Handbook*, Cleveland 1966, p. 172, illus.

99

Study for Interior ('The rape')

1868–69

Pencil on paper

35 × 24.75 cm

Private collection, Zurich

Colour illus. p. 264

PROVENANCE: Marcel Guérin

EXHIBITION: 1989 London, no. 2

LITERATURE: 1988–89 Paris/Ottawa/New York, pp. 143–46

99

100

Emma Dobigny

1869

Oil on panel

30.5 × 16.5 cm

Signed and dated below right: Degas/69

L198

Private collection

Colour illus. p. 233

PROVENANCE: Ludovic Lepic, Paris; sale Lepic, Drouot, Paris, 30 March 1897, no. 51; Durand-Ruel and Manzi, Paris; Mr and Mrs Erdwin Amsinck, Hamburg, 1897; bequeathed to the Hamburg Kunsthalle, 1921; Karl Haberstock, Berlin, 1939; art market, Munich; acquired by the current owner in 1952

EXHIBITIONS: 1937 Paris, Orangerie, no. 10, illus.;

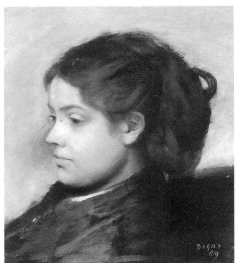

100

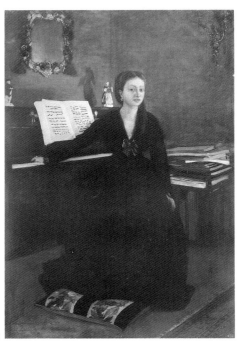

101

1959, Paris, Petit Palais, *De Géricault à Matisse*, no. 41; 1964, Lausanne, Palais Beaulieu, *Chefs d'Œuvres des collections suisses de Manet à Picasso*, no. 4, illus.; 1967, Paris, Orangerie, *Chefs d'Œuvres des collections suisses de Manet à Picasso*, no. 4; 1976–77 Tokyo, no. 10, illus.; 1988–89 Paris/Ottawa/New York, no. 86, illus.; 1994, Paris, Grand Palais/New York, Metropolitan Museum of Art, *Impressionnisme, Les Origines*, no. 64, illus.

LITERATURE: Boggs 1962, p. 64; Minervino 1974, no. 254, illus.

101
Mme Camus at the piano
1869
Oil on canvas
139 × 94 cm
Vente stamp lower right
L207
Zurich, Stiftung Sammlung E.G. Bührle
Colour illus. p. 213

PROVENANCE: Atelier Degas; Vente II, 1918, no. 243, illus.; Alphonse Kann, Saint-Germain-en-Laye; purchased from a French private dealer, 1951

EXHIBITIONS: 1923, Paris, Galeries Les Arts, *Exposition au profit des laboratoires*, no. 181; 1924 Paris, no. 34; 1931, Paris, Galerie Paul Rosenberg, *Exposition d'œuvres importantes de Grands Maîtres du 19e Siècle*, no. 25; 1931 Paris, Orangerie, no. 48; 1937, Paris, Palais National des Arts, *Chefs-d'Œuvre de l'Art Français*; 1951–52 Berne, no. 13; 1958, Zurich, Kunsthaus, *Sammlung Emil G. Bührle*, no. 155; 1958, Berlin, Schloss Charlottenburg, *Französische Malerei von Manet bis Matisse*, no. 5; 1959, Munich, Haus der Kunst, *Hauptwerke der Sammlung Emil G. Bührle*, no. 38; 1959, Paris, Petit Palais, *De Géricault à Matisse, Chefs-d'Œuvre français des collections suisses*, no. 42; 1990–91, Washington, National Gallery of Art/Montreal/Yokohama/London, *Masterpieces from the Bührle Collection*, Zurich, no. 29

LITERATURE: Alexandre 1918, p. 12; Lafond, II, 1919; Jamot 1924, pp. 5of.; Lemoisne 1924, p. 24; Alexandre 1935, p. 150; Lemoisne I, pp. 56, 58, 62; Cabanne 1957, pp. 24, 96; Max Huggler, Die Sammlung Bührle im Zürcher Kunsthaus, *Das Werk*, no. 19, 1958, p. 371; Boggs 1962, pp. 26, 31, 59, illus.; R. Wehrli, Emil G. Bührle: French Nineteenth Century Painting, in: *Great Private Collections*, ed. D. Cooper, New York 1963, p. 220; Minervino 1974, no. 245; Reff 1976, p. 124; Broude 1977, p. 101; De Keyser 1981, pp. 50, 94, 97; Terrasse 1981, no. 146; L. Reidemeister *et al.*, *Stiftung Sammlung Emil G. Bührle*, Zurich/Munich 1986, no. 43; Sutton 1986, pp. 73f., illus.; 1988–89 Paris/Ottawa/New York, p. 155.

102
Mme Camus
Study for cat. 101
1869
Black chalk and pastel on paper
43.5 × 32.5 cm
L211
Vente stamp lower left
Zurich, Stiftung Sammlung E.G. Bührle
Colour illus. p. 212

PROVENANCE: Atelier Degas; Vente II, 1918, no. 243, illus.; Alphonse Kann, Saint-Germain-en-Laye; acquired from a French private dealer, 1951

EXHIBITIONS: 1931 Paris, Orangerie, no. 122; 1951–52 Berne, no. 90; 1958, Zurich, Kunsthaus, *Sammlung Emil G. Bührle*, no. 157; 1959, Munich, Haus der Kunst, *Hauptwerke der Sammlung Emil G. Bührle*, no. 40; 1990–91, Washington, National Gallery of Art/Montreal/Yokohama/London, *Masterpieces of the Bührle Collection*, Zurich, no. 30

LITERATURE: Max Huggler, Die Sammlung Bührle im Zürcher Kunsthaus, *Das Werk*, no. 19, 1958, p. 371; Minervino 1974, no. 245; L. Reidemeister *et al.*, *Stiftung Sammlung Emil G. Bührle*, Zurich/Munich 1986, no. 45

103
Mme Camus
Study for cat. 101
1869
Black chalk and pastel on paper
32 × 43.5 cm
Vente stamp lower right; Atelier stamp verso
BR 50
Zurich, Stiftung Sammlung E.G. Bührle
Colour illus. p. 212

PROVENANCE: Atelier Degas; Vente II, 1918, no. 183, illus.; Alphonse Kann, Saint-Germain-en-Laye; Galerie Nunès et Fiquet, Paris; acquired from a French private dealer, 1951

EXHIBITIONS: 1931 Paris, Orangerie, no. 121; 1951–52 Berne, no. 89; 1958, Zurich, Kunsthaus, *Sammlung Emil G. Bührle*, no. 156; 1959, Munich, Haus der Kunst,

102

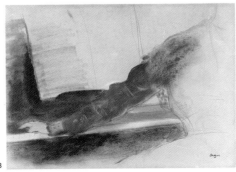

103

Hauptwerke der Sammlung Emil G. Bührle, no. 39; 1990–91, Washington, National Gallery of Art/Montreal/Yokohama/London, *Masterpieces from the Bührle Collection*, Zurich, no. 31

LITERATURE: Max Huggler, Die Sammlung Bührle im Zürcher Kunsthaus, *Das Werk*, no. 19, 1958, p. 371; L. Reidemeister *et al.*, *Stiftung Sammlung Emil G. Bührle*, Zurich/Munich 1986, no. 46, illus.

104
Mme Camus
Study for cat. 101
1869
Pencil on paper
35 × 22 cm
Private collection (courtesy Galerie Schmit, Paris)
Colour illus. p. 212

PROVENANCE: Vente III, 1919, no. 152b

EXHIBITION: 1975 Paris, no. 56

105
Woman seated on a sofa
1868–72
Oil on canvas
45 × 37 cm
L196
Private collection (courtesy Galerie Schmit, Paris)
Colour illus. p. 237

PROVENANCE: Vente II, 1918, no. 14, illus.; Mme Friedmann, Paris

EXHIBITION: 1931 Paris, no. 64

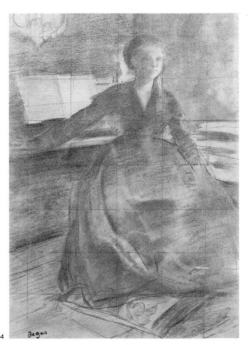

104

106

Henri Valpinçon as a child

1870

Oil on panel

30 × 40 cm

L270

Private collection

Colour illus. p. 207

PROVENANCE: Henri Valpinçon, Paris; Hector Brame, Paris

EXHIBITION: 1937 Paris, no. 13

LITERATURE: Boggs 1962, p. 36

107

Male heads

1870–71

Black chalk on paper

36 × 23 cm

Vente stamp below right; inscribed in an unknown hand on the verso

Rotterdam, Museum Boymans-van Beuningen (F II 130)

Colour illus. p. 218

PROVENANCE: Vente IV, 1919, no. 132e, illus.; Georges Viau, Paris; Paul Cassirer, Berlin; Franz Koenigs, Haarlem

EXHIBITIONS: 1935 Basle, Kunsthalle, *Meisterzeichnungen französischer Künstler von Ingres bis Cézanne*, no. 154; 1946, Amsterdam, Stedelijk Museum, *Teekeningen van Fransche Meesters 1800–1900*, no. 63; Berne 1951–52, no. 165; Saint Louis 1967, no. 67, illus.; Tübingen 1984, no. 79, illus.

LITERATURE: Longstreet 1964, illus.; H.R. Hoetink, *Franse Tekeningen uit de 19e Eeuw*, Museum Boymans-van Beuningen, Rotterdam 1968, no. 83, illus.

108

General Mellinet and Chief Rabbi Astruc

1871

Oil on canvas

22 × 16 cm

Signed below right: Degas

L288

Gérardmer, Ville de Gérardmer

Colour illus. p. 214

PROVENANCE: Charles Ephrussi, Paris; Théodore Reinach, Paris; Mlle Gabrielle Reinach, Paris; bequeathed to the city of Gérardmer, 1970

EXHIBITIONS: 1924 Paris, no. 35; 1936, Paris, Galerie André Seligmann, *Portraits français de 1400 à 1900*, no. 113; 1937 Paris, Orangerie, no. 51; 1987–88, New York, The Jewish Museum, *The Dreyfus Affair: Art, Truth and Justice*, no. 16, illus.; 1988–89 Paris/Ottawa/New York, no. 99, illus.

LITERATURE: Jamot 1924, p. 137, illus.; Gabriel Astruc, *Le pavillon des fantômes: souvenirs*, Paris 1929, p. 98; Boggs 1962, pp. 34f., illus.; Minervino 1974, no. 271; Loyrette 1991, p. 257

109

MM. Jeantaud, Linet and Lainé

1871

Oil on canvas

38 × 46 cm

Signed and dated top right: Degas/mars 1871

L287

Paris, Musée d'Orsay (RF 2825)

Colour illus. p. 215

PROVENANCE: Charles Jeantaud, Paris; Mme Charles Jeantaud, Paris; bequest to the Musée du Louvre, 1929

EXHIBITIONS: 1924 Paris, no. 37; 1931 Paris, Orangerie, no. 53; 1933 Paris, no. 106; 1969 Paris, no. 20; 1973, Turin, Galleria civica d'arte moderna, *Combattimento per un immagine, Fotografi e pittori*, not numbered; 1982, Prague/East Berlin, *De Courbet à Cézanne*, no. 28/no. 30, illus.

LITERATURE: René Huyghe, Le portrait de Jeantaud par Degas, *Bulletin des Musées de France*, December 1929, no. 12; Musée National du Louvre, *Catalogue des peintures, pastels, sculptures impressionnistes exposés au Musée de l'Impressionnisme*, Jeu de Paume des Tuileries, Paris 1958, no. 74; Boggs 1962, pp. 35, 120f., illus.; Minervino 1974, no. 270; Musées du Louvre et d'Orsay, *Catalogue sommaire illustré des peintures du Musée du Louvre et du Musée d'Orsay*, Paris 1986, p. 196, illus.; Anne Distel, Jeantaud, Linet, Lainé, in: *Degas inédit*, Paris 1989, pp. 203ff.

110

Vicomte Lepic and his daughters

ca. 1871

Oil on canvas

66.5 × 81 cm

L272

Zurich, Stiftung Sammlung E.G. Bührle

Colour illus. p. 219

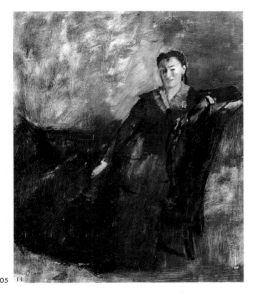

105

106

107

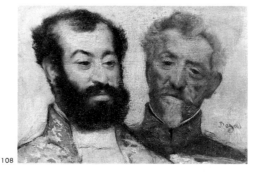

108

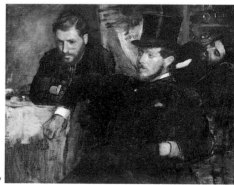

109

PROVENANCE: Vicomte Lepic, Paris; Paul Brame, Paris; Paul Rosenberg, Paris; Emil G. Bührle, 1952

EXHIBITIONS: 1947 Cleveland, no. 16; 1948, New York, Paul Rosenberg & Co., *Loan Exhibition of 21 Masterpieces by 7 Great Masters*, no. 7; 1958, Zurich, Kunsthaus, *Sammlung Emil G. Bührle*, no. 158; 1958, Berlin, Schloss Charlottenburg, *Französische Malerei von Manet bis Matisse*, no. 20; 1959, Munich, Haus der Kunst, *Hauptwerke der Sammlung Emil G. Bührle*, no. 41; 1959, Paris, Petit Palais, *De Géricault à Matisse, Chefs-d'Œuvres français des collections suisses*, no. 43; 1961, Edinburgh, The Royal Scottish Academy/London, The National Gallery, *Masterpieces of French Painting from the Bührle Collection*, no. 22; 1964, Lausanne, Palais de Beaulieu, *Chefs-d'Œuvre des collections suisses*, no. 5; 1990–91, Washington, National Gallery of Art/Montreal/Yokohama/London, *Masterpieces of the Bührle Collection,* Zurich, no. 32

LITERATURE: Cabanne 1957, p. 111; Max Huggler, Die Sammlung Bührle im Zürcher Kunsthaus, *Das Werk*, no. 19, 1958, p. 371; R. Cogniat, *Das Jahrhundert der Impressionisten,* Cologne/Milan 1959, illus.; Boggs 1962, p. 93, nos. 16, 120; R. Wehrli, Emil G. Bührle: French Nineteenth Century Painting, in: *Great Private Collections,* ed. D. Cooper, New York 1963, p. 220; Minervino 1974, no. 259; Terrasse 1980, no. 157, illus.; L. Reidemeister *et al., Stiftung Sammlung Emil G. Bührle,* Zurich/Munich 1986, no. 46, illus.; Sutton 1986, p. 91, illus.

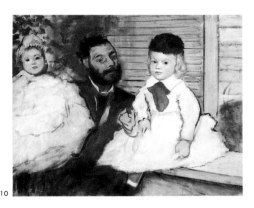

110

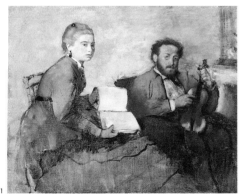

111

111
Violinist and young woman

ca. 1872

Oil on canvas

46.4 × 55.9 cm

Vente stamp lower left

L274

Detroit, The Detroit Institute of Arts

Bequest of Robert H. Tannahill (70.167)

Colour illus. p. 284

PROVENANCE: Atelier Degas, Vente I, 1918, no. 49, illus.; Seligmann, Bernheim-Jeune, Durand-Ruel and Vollard, Paris; Seligmann Sale, American Art Association, New York, 27 January 1921; J.H. Whittemore, Naugatuck; Durand-Ruel, New York, 4 May 1936; Robert H. Tannahill, Detroit, 1 January 1936; bequest to the Museum in 1970

EXHIBITIONS: 1934 New York, no. 10; 1974–75 Detroit, no. 8, illus.; 1988–89 Paris/Ottawa/New York, no. 110, illus.

LITERATURE: Boggs 1962, p. 33, illus.; Frederick J. Cummings and Charles H. Elam, *The Detroit Institute of Arts Illustrated Handbook,* Detroit 1971, p. 157, illus.; Minervino 1974, no. 275; Theodore Reff, Works by Degas in the Detroit Institute of Arts, *Bulletin of the Detroit Institute of Arts,* vol. 53, no. 1, 1974, illus.; Julia P. Hinshaw, *100 Masterpieces from the Detroit Institute of Arts,* New York 1985, p. 118, illus.

112
Mme Olivier Villette

1872

Oil on canvas, 46.3 × 32.7 cm

L303

Cambridge, Massachusetts, Harvard University Art Museums, Fogg Art Museum

Gift of C. Chauncey Stillman, Class of 1898, in memory of his father, James Stillman

Colour illus. p. 238

112

PROVENANCE: Mlle Dihau, Paris; Durand-Ruel, Paris; C. Chauncey Stillman; gift to the Museum, 1925

EXHIBITIONS: 1927, Wellesley College Art Museum; 1929, Cambridge (Mass.), Fogg Art Museum, *French Painting*, no. 31; 1934, Kansas City, Nelson-Atkins Museum; 1942, Glenns Falls, Crandall Library; 1944, Toronto, Toronto Art Gallery; 1944, New York, American British Art Center, *Corot to Picasso*; 1949 New York; 1958 Los Angeles, no. 23; 1964, Saint Louis, Saint Louis County Museum; 1967, Buffalo, Albright-Knox Art Gallery; 1974 Boston, no. 7; 1977, Cambridge (Mass.), Fogg Art Museum, *Master Paintings from the Fogg Collection*; 1985, Cambridge (Mass.), Harvard University Art Museums, *Modern Art at Harvard*; 1990, Tokyo, Isetan Department Store/Yamaguchi, Prefectural Museum, *The Maurice Wertheim Collection*

LITERATURE: *Fogg Art Museum Handbook*, Cambridge 1925, p. 53; *L'Art Moderne du Monde*, vol. 6, *Degas*, Tokyo 1971, p. 27, illus.; Minervino 1974, no. 276; Sutton 1986, p. 131, illus.; Edgar Peters Bowron, *European Paintings Before 1900 in the Fogg Art Museum*, Cambridge 1990, p. 104, illus.; Loyrette 1991, pp. 271, 290

113
Mathilde Musson Bell

1872

Pencil and yellow chalk on paper

31 × 24 cm

Inscribed lower right: Nouvelle Orléans 72/Degas

Richard and Carol Selle, New York

Colour illus. p. 201

PROVENANCE: Jeanne Fevre, Nice; Mme Guillaume-Walter, Paris; John Rewald, New York; Sotheby's, London, 7 July 1960, no. 25, illus.

EXHIBITIONS: 1952, East Hampton, Guild Hall Museum, *Influences in French Painting*, no. 29; 1953, Montreal, Museum of Fine Arts, *Five Centuries of Drawings*, no. 205; 1958 New York, no. 12, illus.; 1960 New York, no. 80; 1961–62, New York, Charles E. Slatkin Galleries, *The Artist as Draughtsman*, no. 48; 1965 New Orleans, p. 47, illus.; 1967 Saint Louis, no. 68, illus.; 1984 Tübingen, no. 87, illus.; 1984 Chicago, no. 18

113

LITERATURE: John Rewald, *The History of Impression-ism*, New York 1961, p. 277, illus.; Boggs 1962, pp. 40, 109; Isaac Delgado, *Edgar Degas: His Family and Friends*, New Orleans Museum of Art, New Orleans 1965, pp. 43f., illus.; James B. Byrnes, Edgar Degas' New Orleans Paintings, *Antiques*, November 1965, no. 668, illus.; Reff 1967, p. 255

114

The cotton office

('*Portraits dans un bureau (Nouvelle-Orléans)*')
1873
Oil on canvas
73 × 92 cm
Signed and dated below right: Degas/Nlle
Orléans/1873
L320
Pau, Musée des Beaux-Arts
Acquis sur le fonds du legs Noulibos en 1878
(878.1.2.)
Colour illus. pp. 202–05

PROVENANCE: Bought direct from the artist by the Société des Amis des Arts de Pau for the Musée des Beaux-Arts, 1878
EXHIBITIONS: 1876, Paris, 11 Rue le Peletier, Société anonyme des artistes, peintres, sculpteurs, graveurs etc., *2e exposition de peinture*; 1878, Pau, Société des Amis des Arts de Pau, no. 87; 1900, Paris, *Centennale de l'Art Français*, no. 209, illus.; 1924 Paris, no. 43, illus.; 1932, London, Royal Academy of Arts, *French Art 1200–1900*, no. 400; 1936 Philadelphia, no. 20, illus.; 1937 Paris, Orangerie, no. 18; 1937 Paris, Palais National, *Chefs-d'Œuvre de l'Art français*, no. 302; 1939 Buenos Aires, Museo Nacional de Bellas Artes, *La pintura frances de David a nuestros dias*, no. 10; 1941, Los Angeles, County Museum, *The Painting of France since the French Revolution*, no. 36; 1947, Brussels, Palais des Beaux-Arts, *De David à Cézanne*, no. 124, illus.; 1951–52 Berne, no. 20, illus.; 1964–65, Munich, Haus der Kunst, *Französische Malerei des 19. Jahrhunderts von David bis Cézanne*, no. 80, illus.; 1974–75, Paris, Grand Palais, *Centenaire de l'Impressionnisme*, no. 16, illus.; 1984–85 Paris, no. 2, illus.; 1986, Washington, *The New Painting, Impressionism 1874–1886*, no. 22, illus.; 1988–89 Paris/Ottawa/New York, no. 115, illus.; 1993 Martigny, no. 3, illus., 1994, Paris, Musée d'Orsay, *La jeunesse des Musées*, no. 163; 1994, Tokyo, Musée National d'Art Occidental, *L'année de l'impressionnisme*
LITERATURE: A. Pothey, Chroniques, *La Presse*, 31 March 1876; Ph. Burty, *La République Française*, 1 April 1876; A. de Lostalot, L'exposition de la rue Le Peletier, *La Chronique des Arts et de la Curiosité*, 1 April 1876; A. Silvestre, Exposition de la rue Le Peletier, *L'Opinion Nationale*, 2 April 1876; Charles Bigot, Causerie artisti-

que: L'exposition des intransigents, *La Revue Politique et Littéraire*, 8 April 1876; M. Chaumelin, *La Gazette des Etrangers*, 8 April 1876; L. Enault, L'exposition des intransigents dans la Galerie Durand-Ruel, *Le Constitutionnel*, 10 April 1876; G. d'Olby, Salon de 1876, *Le Pays*, 10 April 1876; Arthur Baignères, Exposition de peinture par un groupe d'artistes, Rue Le Peletier, *L'Echo universel*, 13 April 1876; Ph. Burty, *The Academy*, London, 15 April 1876; P. Dax, Chronique, *L'artiste*, 1 May 1876; E. Zola, Deux expositions d'art en mai, *Messager de l'Europe*, St Petersburg, June 1876; Ch. Le Cœur, *Musée de la Ville de Pau, notice et catalogue*, Paris 1891, no. 41; L. Bénédite, *Histoire des Beaux-Arts 1800–1900*, Paris 1900, pp. 267f.; Lemoisne 1912, pp. 49f.; Jamot 1918, pp. 124, 127, 133f.; A. Krebs, Degas à la Nouvelle-Orléans, *Rapports France–Etats-Unis*, vol. 64, July 1952, pp. 63f.; Cabanne 1957, pp. 33, 110; Raimondi 1958, pp. 262–65; Boggs 1962, pp. 38–40, 93, illus.; Minervino 1974, no. 356, illus.; Huyghe 1974, pp. 85f., illus.; Ph. Comte, *Ville de Pau, Beaux-Arts, Catalogue raisonné des peintures*, Pau 1978; Brown 1994

115

Eugène Manet
1874
Oil on canvas
65.2 × 81 cm
L339
Private collection
Colour illus. p. 262

PROVENANCE: M. and Mme Eugène Manet, Paris; Mme Ernest Rouart, Paris; Christie's, New York, 19 May 1981, no. 308, illus.
EXHIBITIONS: 1876, Paris, Rue de Peletier, 2ème Exposition des Impressionnistes; 1931 Paris, no. 60; 1936, Venice, *XX Esposizione Biennale Internazionale d'Arte*, no. 12; 1952–53, Toronto, Art Gallery/Montreal, Museum of Fine Arts/New York, Metropolitan Museum of Art/Toledo, Museum of Art/Washington D.C., Phillips Collection/San Francisco, California Palace of the League of Honor/Portland, Art Museum/Minneapolis, Institute of Arts, *Berthe Morisot and her Circle: Paintings from the Rouart Collection*, no. 12; 1960 Paris, no. 185; 1961, Paris, Musée Jacquemart-André, *Berthe Morisot*, no. 1985
LITERATURE: Lafond 1918, p. 32; Meier-Graefe 1920, illus.; Mauclair 1937, p. 166, illus.; Rebatet 1944, no. 28, illus.; Rey 1952, no. 22, illus.; Cabanne 1957, p. 97, 111, illus.; A. Rouart-Valéry, Degas in the Circle of Paul Valéry, *ArtNews*, 59, no. 7, November 1960, pp. 38, 62, illus.; Boggs 1962, p. 93, note 18

116

Léopold Levert
ca. 1874
Oil on canvas
65 × 54 cm
L358
Tokyo, Bridgestone Museum of Art, Ishibashi
Foundation
Colour illus. p. 261

PROVENANCE: Stanislas-Henri Rouart, Paris; Chéramy collection, Paris; Ernest Rouart, Paris; Nate B. and Frances Spingold collection, New York; Wildenstein, New York; acquired by the Museum 1982
EXHIBITIONS: 1931 Paris, no. 58; 1945, Paris, Galerie Charpentier, *Portraits Français*, no. 28; 1951, Pittsburgh, Carnegie Institute, *French Painting 1100–1900*, no. 117; 1960, New York, The Metropolitan Museum of Art, *The Nate and Frances Spingold Collection*; 1962, New York, Wildenstein/Waltham (Mass.), Brandeis University, *Modern French Painting*, no. 13; 1967, New York, The Metropolitan Museum of Art, Summer Loan Exhibition, no. 33; 1969, New York, Wildenstein, *Paintings from the Nate B. and Frances Spingold Collection*, no. 11; 1972, New York, Wildenstein, *Faces from the World of Impressionism and Post-Impressionism*, no. 26; 1981, Fujinomya, *Impressionnisme: Paris et Japon*, no. 20; 1988–89 Tokyo/Okayama, no. 31
LITERATURE: Lafond I, 1918, p. 82, illus.; M. Dormoy, The Ernest Rouart Collection, *Formes*, no. 24, April 1932, pp. 258f.; Reward 1937, illus.; Rebatet 1944, no. 30, illus.; Michel Florisoone, *Portraits français*, Paris 1946, p. 130, illus.; Boggs 1962, p. 121; Minervino 1970, no. 380; Terrasse 1972, p. 28, illus.; *Centenaire de l'Impressionnisme*, exhibition catalogue Paris 1974, p. 241; *The Crisis of Impressionism,* exhibition catalogue Ann Arbor 1979, p. 126, illus.; Sophie Monneret, *L'Impressionnisme*, I, Paris 1978, p. 334; Principales Acquisitions des Musées en 1982, *La Chronique des Arts*, Supplement au Gazette des Beaux-Arts, March 1983, no. 333; Bridgestone Museum of Art, Annual Report no. 37, 1989, p. 35; Bridgestone Museum of Art, Ishibashi Foundation: *Masterpieces from the Collection*, 1991, p. 36

114

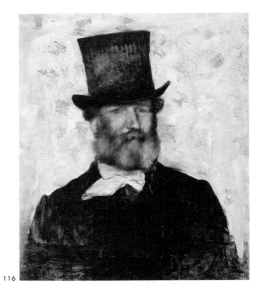

115

116

117

Jules Perrot

1875

Dilute oil-paint on paper

48 × 30 cm

Signed below right: Degas/ 1875

L364

Philadelphia, Philadelphia Museum of Art

The Henry P. McIlhenny Collection in memoriam Frances P. McIlhenny (1986–26–15)

Colour illus. p. 286

PROVENANCE: Eugene W. Glaenzer and Co., New York; Boussod, Valadon et Cie., Paris; J. Mancini, Paris; Maurice Exsteens, Paris; Petitdidier collection, Paris; Fernand Ochsé, Paris; Paul Brame, Paris; César de Hauke, New York; Henry P. McIlhenny, Philadelphia; bequest to the Museum, 1986

EXHIBITIONS: 1914, Copenhagen, Statens Museum for Kunst, *Fransk Malerkunst*, no. 703; 1924 Paris, no. 54; 1933 Northampton, no. 22; 1934, Cambridge (Mass.), Fogg Art Museum, *French Drawings and Prints of the Nineteenth Century*, no. 20; 1935, Buffalo, Albright Knox Gallery, *Master Drawings*, no. 117, illus.; 1936 Philadelphia, no. 78, illus.; 1936, Cambridge (Mass.), Fogg Art Museum, *French Artists of the 18th and 19th Century*; 1938, Boston, Museum of Modern Art, *The Arts of the Ballet*; 1947 Cleveland, no. 67, illus.; 1947, Philadelphia, Philadelphia Museum of Art, *Masterpieces of Philadelphia Private Collections*, no. 123; 1949, Philadelphia, Philadelphia Museum of Art, *The Henry P. McIlhenny Collection*; 1958, Cambridge (Mass.), Fogg Art Museum, Class of 1933 Exhibition; 1962, San Francisco, The California Palace of the Legion of Honor, *Henry P. McIlhenny Collection, Paintings, Drawings and Sculpture*, no. 17, illus.; 1967 Saint Louis, no. 73 illus.; 1984, Atlanta, High Museum of Art, *The Henry P. McIlhenny Collection: Nineteenth Century French and*

English Masterpieces, no. 19, illus.; 1984–85 Washington, no. 13, illus.

LITERATURE: Lemoisne 1912, p. 60; Rivière 1922–23, illus.; Mongan 1938, p. 295; Browse 1949, no. 24; Boggs 1962, pp. 56f., illus.; Minervino 1974, no. 481; 1979 Edinburgh, under no. 16

118

117

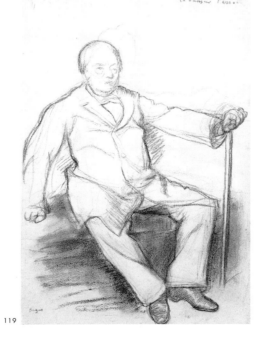

119

118

Jules Perrot

1875–79

Oil on panel

35.5 × 26 cm

Vente stamp lower left

L366

Private collection

Colour illus. p. 287

PROVENANCE: Atelier Degas; Vente I, 1918, no. 54, illus.; Durand-Ruel, Paris; Charles Hovey Pepper, Brookline (Mass.)

LITERATURE: Boggs 1962, illus.; Loyrette 1991, p. 363

119

Jules Perrot

(*'Le danseur Perrot'*)

ca. 1875

Black and brown chalk on paper

49.5 × 33.2 cm

Inscribed by Degas, top right: Le Danseur Perrot

Vente stamp lower left

Private collection

Colour illus. p. 286

PROVENANCE: Atelier Degas; Vente III, no. 157/3; Jon Nicholas Streep, New York; David Daniels, New York

EXHIBITIONS: 1958, New York, Charles E. Slatkin Galleries, *Renoir–Degas*, no. 3; 1960 New York, no. 89; 1960, Minneapolis, Minneapolis Institute of Art, *Three Private Collections*, no. 21; 1961, Palm Beach, Society of Four Arts; 1962, Baltimore, The Baltimore Museum of Art, *Manet, Degas, Berthe Morisot and Mary Cassatt*, no. 61; 1967 Minneapolis; 1968–69, Minneapolis Institute of Arts/Art Nelson Gallery/Institute of Chicago, Fogg Art Museum, Cambridge, Kansas City/Colby College Art Museum, *Selections from the Drawing Collection of David Daniels*, no. 53; 1974 Boston, no. 78; 1987 Manchester/Cambridge, no. 65

LITERATURE: Loyrette 1991, p. 363

120

Elena Primicile Carafa di Montejasi Cicerale

1875

Oil on canvas

69.8 × 54.6 cm

L327

London, The National Gallery (4167)

The Trustees of the National Gallery

Colour illus. p. 198

PROVENANCE: Vincent Imberti, Bordeaux; Paul Rosenberg, Paris; Courtauld Fund, London, 1926; Tate Gallery, London; National Gallery since 1961

EXHIBITIONS: 1926 London, French Gallery, no. 13; 1948 London, Tate Gallery, Courtauld Memorial Exhibition, no. 23; 1952 Edinburgh/London, no. 12; 1955, Paris, Orangerie, *Impressionnistes de la Collection Courtauld de Londres*, no. 20; 1989 Liverpool, no. 5

LITERATURE: Guérin 1928, pp. 373f.; Boggs 1963, p. 275, no. 28; National Gallery Catalogues, French School, Early 19th Century, Impressionists, Post-Impressionists etc. by Martin Davies with additions and some revisions by Cecil Gould, London 1970, no. 4167, p. 53

121
Woman in black
('*La dame en noir*')
1875–78
Oil on canvas
60 × 51 cm
Signed upper right
L386
Stockholm, Nationalmuseum (NM 1759)
Colour illus. p. 241

PROVENANCE: Collection Durand-Ruel, Paris; Collection Wagram; Gift of the Friends of the National Museum, 1913
EXHIBITION: 1967, Bordeaux, no. 43
LITERATURE: Hoppe, 1922, p. 32; S. Strömbom, *Nationalmusei mästerverk*, Stockholm 1947; Minervino 1974, no. 435

122
Woman at a window
('*Femme à la fenêtre*')
1875–78
Oil on paper, printed on linen
61.3 × 45.9 cm
L385
London, Courtauld Institute Galleries
(Courtauld Gift 1932)
Colour illus. p. 239

PROVENANCE: Read collection, Glasgow; sale, Paris, 10 June 1898, no. 26; Durand-Ruel, Paris; Mrs Walter Sickert, London; Mrs Cobden-Sanderson, London; Miss M.-F.C. Knox, London; Miss Stella Cobden-Sanderson, London; Leicester Galleries, London; Samuel Courtauld, 1927; given to the Courtauld Institute Galleries, 1932
EXHIBITIONS: 1908, London, International Society, The New Gallery, no. 86 (erroneously listed as watercolour); 1923, London, Goupil Gallery Salon, no. 72; 1936, London, New Burlington Galleries, *Masters of the French 19th Century Painting*, no. 64; 1937 Paris, Orangerie; 1948, London, Tate Gallery, Samuel Courtauld Memorial Exhibition, no. 22; 1952 Edinburgh/London, no. 13; 1955 Paris, no. 19; 1976, London, Courtauld Institute, *Samuel Courtauld's Collection of French 19th Century Paintings and Drawings*, no. 16; 1984, Takashima/Tokyo/Kyoto/Osaka/Canberra, *The Impressionists and Post-Impressionists from the Courtauld University Collection*; 1994, London, Courtauld Institute Galleries, *Impressionism for England: Samuel Courtauld as Patron and Collector*, no. 16
LITERATURE: *The Burlington Magazine*, November 1917, p. 186; Lafond 1918–19, II, p. 18, illus.; Jamot 1924, pp. 56, 140; Walter Sickert, Degas, *The Burlington Magazine*, vol. 43, December 1923, p. 308; Grappe 1936, illus.; Cooper 1954, no. 22; Denys Sutton, *Walter Sickert, A Biography*, 1976, pp. 111f.; *The Courtauld Institute Galleries*, London 1990, p. 93, illus.; Harbison 1993, pp. 65f., illus.

123
Young woman with her hand across her mouth
ca. 1875
Oil on canvas, 42 × 33 cm
L370
Mr and Mrs Eugene V. Thaw
Colour illus. p. 243

PROVENANCE: E. Fabbri, Paris; A.S. Henraux, Paris
EXHIBITIONS: 1924 Paris, no. 66, illus.; 1931 Paris, no. 76; 1966, New York, M. Knoedler and Co., *Impressionist Treasures*, no. 5, illus.; 1974 Boston; 1976–77 Tokyo/Kyoto/Fukuoka, no. 13; 1988 Tokyo/Mie/Okayama
LITERATURE: Meier-Graefe 1923, illus.; H. Hertz, *L'Amour de l'Art*, March 1924, p. 68, illus.; Mauclair 1937, p. 45, illus.

124
Mme Jeantaud in front of a mirror
ca. 1875
Oil on canvas, 70 × 84 cm
L371
Paris, Musée d'Orsay (1970–38)
Colour illus. p. 217

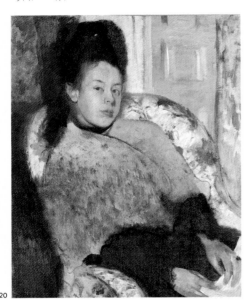
120

122

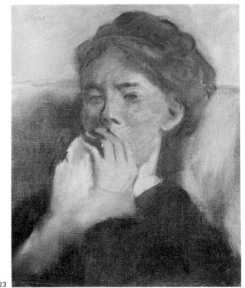
123

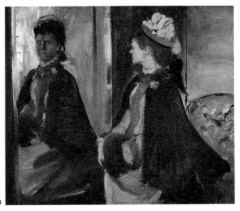
124

121

PROVENANCE: Mme Jeantaud, Paris; Boussod, Valadon et Cie., Paris, 1907; Jacques Doucet, Paris, 1907; Mme Jacques Doucet, Neuilly-sur-Seine; Jean-Edouard Dubrujeaud, Paris; bequest to the Museum 1970

EXHIBITIONS: 1912, St Petersburg, *Centennale de l'art français*, no. 176; 1917, Zurich, Kunsthaus, *Französische Kunst des 19. und 20. Jahrhunderts*, no. 89; 1924 Paris, no. 50, illus.; 1925, Paris, Musée des Arts Décoratifs, *Cinquante ans de peinture française, 1875–1925*, no. 154; 1926, Amsterdam, Stedelijk Museum, *Exposition rétrospective d'art français*, no. 41; 1928, Paris, Galerie de la Renaissance, *Portraits et figures de femmes d'Ingres à Picasso*, no. 56; 1931 Paris, Orangerie, no. 56, illus.; 1932, London, Royal Academy of Arts, *Exhibition of French Art 1200–1900*, no. 344, illus.; 1936, London, New Burlington Galleries, Anglo-French Art and Travel Society, *Masters of French Nineteenth Century Painting*, no. 63; 1937, Paris, Palais National, no. 304; 1949 New York, no. 32; 1955 Rome, Palazzo delle Esposizioni/Florence, Palazzo Strozzi, *Mostra di capolavori della pittura francese dell'Ottocento*, no. 31; 1988–89 Paris/Ottawa/New York, no. 142, illus.

LITERATURE: Lemoisne 1912, pp. 63f., illus.; Lafond 1918–19, II, p. 14; Jamot 1924, pp. 52, 141f., illus.; Lemoisne 1924, p. 98, no. 4; Rivière 1935, illus.; Boggs 1962, p. 120; Minervino 1974, no. 393; Musées du Louvre et d'Orsay, *Catalogue sommaire illustré des peintures du Musée du Louvre et du Musée d'Orsay*, Paris 1986, III, p. 197, illus.; Anne Distel, Jeantaud, Linet, Lainé, in: *Degas inédit*, Paris 1989, pp. 203ff.

125
Eugène Manet
ca. 1875
Oil on paper
30.7 x 22 cm
Vente stamp lower left
L136
Private collection
Colour illus. p. 263

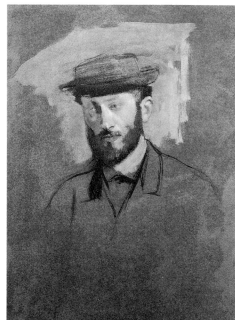

125

PROVENANCE: Atelier Degas; Vente III, 1919, no. 155/2, illus.; Buhler collection, Paris; Otto Gerson, New York; David Daniels, New York

EXHIBITIONS: 1960, Minneapolis, Minneapolis Institute of Art, *Three Private Collections*, no. 22; 1962, Baltimore, Baltimore Museum of Art, *Manet, Degas, Cassatt, Morisot*, no. 35, illus.; 1966, Colby, College Art Museum/Williamstown, Williams College of Art, *Art in the Making*, illus.; 1967 Minneapolis; 1968–69, Minneapolis Institute of Arts/Art Institute of Chicago/Kansas City, Nelson Gallery, Cambridge, Fogg Art Museum/Colby College Art Museum, *Selections from the Drawing Collection of David Daniels*, no. 52

LITERATURE: Minervino 1974, no. 237

126
Mme de Rutté
ca. 1875
Oil on canvas
62.5 × 51.7 cm
L369
Private collection, Zurich
Colour illus. p. 245

PROVENANCE: Mme Friedrich Ludwig de Rutté, Paris; Paul de Rutté, Paris; Mme de Wurstemberger de Rutté, Berne; Wildenstein & Co., London, until 1986

EXHIBITIONS: 1931 Paris, Orangerie, no. 61; 1976 Tokyo/Kyoto/Fukuoka, no. 12; 1982, London, Wildenstein & Co., *French Portraits XVII–XX Century*; 1988–89 Paris/Ottawa/New York, no. 141; 1993 Martigny, no. 5

LITERATURE: Lemoisne I, p. 82; Boggs 1962, pp. 47f., illus.; Minervino 1974, no. 394; Keyser 1981, p. 53; R. Verdi, Current and forthcoming Exhibitions: London Summer Exhibitions, *The Burlington Magazine*, vol. 124, no. 953, August 1982, p. 518

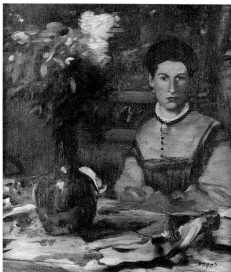

126

127
Henri Degas and his niece Lucie Degas
1876
Oil on canvas
99.8 × 119.9 cm
L394
Chicago, The Art Institute of Chicago
Mr and Mrs Lewis Larned Coburn Memorial Collection (1933.429)
Colour illus. p. 199

PROVENANCE: Degas family, Naples; Mme Lucie Degas, Marquise Edoardo Guerrero de Balde, Naples; Mme Marco Bozzi (née Anna Guerrero de Balde), daughter of Lucie Degas, Naples; Wildenstein & Co., New York, November 1926; Mrs Lewis Larned Collection, Chicago; bequest to the Museum, 1933

EXHIBITIONS: 1926, Venice, Pavillon de France, XVa Esposizione Internazionale d'arte nella città di Venezia, no. 16, illus.; 1929 Cambridge, no. 344, illus.; 1932, Chicago, The Art Institute of Chicago, Antiquarian Society, Exhibition of the Mrs L.L. Coburn Collection: *Modern Paintings and Water Colors*, no. 6, illus.; 1933 Chicago, no. 289, illus.; 1933 Northampton, no. 17; 1934, Chicago, The Art Institute, *A Century of Progress*, no. 204; 1934 New York, no. 1; 1934, Saint Louis, City Art Museum, *Paintings by French Impressionists*; 1936 Philadelphia, no. 24, illus.; 1949 New York, no. 35, illus.; 1951–52 Berne, no. 22, illus.; 1952 Amsterdam, no. 13, illus.; 1984 Chicago, no. 26, illus.; 1988–89 Paris/Ottawa/New York, no. 145, illus.

LITERATURE: *Kunst und Künstler*, XXX, 1926–27, p. 40, illus.; Manson 1927, pp. 1113, 48, illus.; Catton Rich 1929, pp. 125ff.; Hausenstein 1931, p. 162 illus.; Daniel Catton Rich, Bequest of Mrs L.L. Coburn, *Bulletin of the Art Institute of Chicago*, XXVI, November 1932, p. 68; Walker 1933, p. 184, illus.; Mongan 1938, p. 296; Chicago, The Art Institute of Chicago, Masterpiece of the Month, July 1941, pp. 188–93, illus.; Graber 1942, p. 60; Raimondi 1958, p. 264, illus.; The Art Institute of Chicago, *Paintings in the Art Institute of Chicago: A Catalogue of the Picture Collection*, Chicago 1961, p. 1119; Boggs 1962, pp. 45f., illus.; Boggs 1963, p. 273, illus.; The Art Institute of Chicago, *Supplement to Paintings in the Art Institute of Chicago*, Chicago 1971, p. 27; Minervino 1974, no. 402; Koshkin-Youritzin 1976, p. 38; Keyser 1981, p. 55, illus.; Sutton 1986, p. 274, illus.

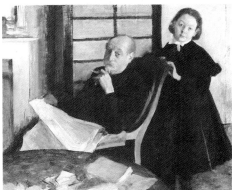

127

128

**The Duchess of Montejasi and her daughters
Elena and Camilla**

1876

Oil on canvas

66 × 98 cm

L637

Private collection

Colour illus. p. 197

[This picture was withdrawn from the
exhibition while the catalogue was in press.]

PROVENANCE: Stefanina Degas (the artist's aunt),
Naples; Vincent Imberti, Bordeaux, 1923; David
David-Weill, Paris, 1923

EXHIBITIONS: 1924 Paris, no. 46, illus.; 1931 Paris,
Orangerie, no. 75, illus.; 1934, Venice, Biennale di
Venezia, *Il ritratto dell'800*, no. 6; 1952, Paris, Musée des
Arts Décoratifs, *Cinquante ans de peinture française dans les
collections particulières de Cézanne à Matisse*, no. 37, illus.;
1988–89 Paris/Ottawa/New York, no. 146, illus.

LITERATURE: Jamot 1924, pp. 21, 58–60, 150, illus.;
Daniel Guérin, L'exposition Degas, *Revue de l'Art*,
April 1924, p. 286; Lemoisne 1924, p. 98, no. 4; H.
Troendle, Die Tradition im Werke Degas', *Kunst und
Künstler*, XXV, 1926–27, illus. 245; Gabriel Henriot,
Catalogue de la Collection David Weill, II, Paris 1927, pp.
229–32, illus.; Guérin 1928, pp. 372f.; Alexandre 1935,
illus.; Grappe 1936, illus.; Raimondi 1958, p. 264;
Boggs 1962, pp. 58f., 95, 124, illus.; Minervino 1974,
no. 583; Loyrette 1991, p. 86

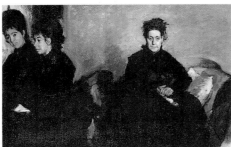

128

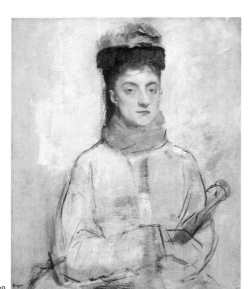

129

129

Woman with an umbrella

ca. 1876

Oil on canvas

61 × 50.4 cm

L463

Vente stamp lower left

Ottawa, National Gallery of Canada (15838)

Colour illus. p. 244

PROVENANCE: Atelier Degas; Vente III, 1919, no. 6;
Baron Denys Cochin, Paris; Hector Brame, Paris; Paul
Cassirer, Berlin; Arthur Sachs, Paris; Marianne Feil-
chenfeldt, Zurich; acquired by the Museum, 1969

EXHIBITIONS: 1931 Paris, (ex-catalogue); 1949 New
York, no. 41, illus.; 1961, Paris, Musée Jacquemart-
André, *Chefs-d'Œuvre des collections françaises*; 1962 Paris,
Galerie Charpentier, *Chefs-d'Œuvre des collections fran-
çaises*, no. 25, illus.; 1964–65, Munich, Haus der Kunst,
*Französische Malerei des 19. Jahrhunderts von David bis
Cézanne*, no. 84; 1975, Ottawa, National Gallery of
Canada, *A la découverte des collections: Degas et le portrait
de la Renaissance*; 1983, Vancouver, Vancouver Art Gal-
lery, *Masterworks from the Collection of the National Gal-
lery of Canada*; 1988–89 Paris/Ottawa/New York, no.
147, illus.

LITERATURE: Clement Greenberg, "Art", *The Nation*,
CLXVII, 18, 30 April 1949, p. 509; Boggs 1962, p. 48,
illus.; Jean Sutherland Boggs, *The National Gallery of
Canada*, Toronto 1971, pp. 61, 141, illus.; Minervino
1974, no. 461

130

At the café

ca. 1876–77

Oil on canvas

64 × 53.3 cm

L467

Cambridge, The Fitzwilliam Museum

Hindley Smith Bequest, 1939 (2387)

Colour illus. p. 301

PROVENANCE: Atelier Degas; Vente I, 1918, no. 71;
P.M. Turner, London; O.F. Brown, London; F. Hind-
ley Smith, 1925; bequest to the Museum, 1939

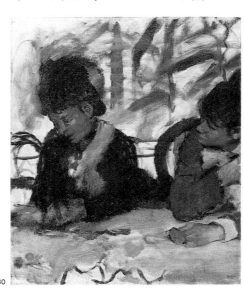

130

EXHIBITIONS: 1922, London, Burlington Fine Arts
Club, *Pictures of the French School of the last 100 years*, no.
35; 1925, Norwich, Castle Museum, Loan Collection,
no. 49; 1926, London, Tate Gallery, Opening Exhibi-
tion, Modern Foreign Gallery, no. 4; 1936, London,
New Burlington Galleries, *Painting of the Nineteenth and
Twentieth Centuries*, no. 67; 1959, London, Goldsmith's
Hall, *Treasures of Cambridge*, no. 48

LITERATURE: Manson 1927, illus.; *Illustrated London
News*, vol. 196, 1940, p. 357; Carl Winter, *The Fitzwill-
iam Museum*, Cambridge 1958, p. 407; *Observer*, 22
March 1959, p. 23

131

Carlo Pellegrini

1876–77

Watercolour and oil and pastel on paper,

63 × 24 cm, inscribed and signed below left: à
lui/Degas

L407, London, The Tate Gallery (3157)

Colour illus. p. 259

PROVENANCE: Carlo Pellegrini, London; Louis Fagan,
London, ca. 1889; Mrs C.F. Fagan, London, 1903;
Christie's, London, 27 May 1907, no. 32; purchased by
the National Art Collections Fund

EXHIBITIONS: 1932 Bristol, Museum and Art Gallery,
French Paintings and Drawings, no. 31; 1932 London,
Whitechapel Art Gallery, *French Art*, no. 122; 1952
Edinburgh/London, no. 14; 1965, London, Arts Coun-
cil Gallery, *Sixty Years of Patronage*, no. 43; 1984–85
Rome, no. 81, illus.; 1987 Manchester/Cambridge, no.
51, illus.

LITERATURE: Minervino 1974, no. 409; Loyrette 1991,
p. 415

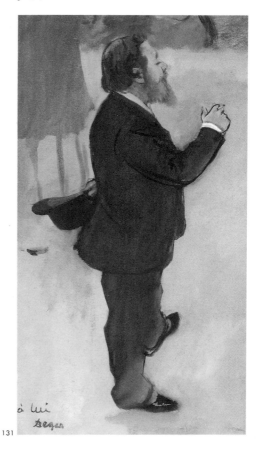

131

132

Ludovic Halévy finding Mme Cardinal in the dressing room

1876–77

Monotype in black ink (1st state, of two), pastel

21.3 × 16 cm

Vente stamp lower right

Stuttgart, Staatsgalerie Stuttgart, Graphische Sammlung (D 1961/145)

Colour illus. p. 222

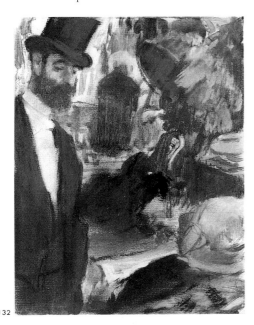

132

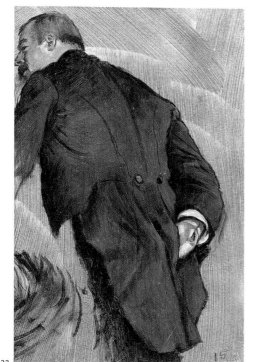

133

PROVENANCE: Atelier Degas; Vente Estampes, 1918, no. 201, not sold; Vente Succession Degas, Paris, Lair-Dubreuil et Petit, 17 March 1928; Maurice Loncle, Paris; acquired by the Museum 1961

EXHIBITIONS: 1984 Tübingen, no. 131, illus.; 1984–85 Paris, no. 128, p. 403, illus.; 1988–89 Paris/Ottawa/New York, no. 167, illus.

LITERATURE: Ludovic Halévy, *La Famille Cardinal*, Paris 1938, illus.; Rouart 1945, illus.; Christel Thiem, *Französische Maler illustrieren Bücher*, Staatsgalerie, Stuttgart 1965, under no. 44; Janis 1968, no. 212; Adhémar/Cachin, under no. 65; Brame/Reff 1984, no. 96a

133

The impresario (Pierre Ducarre)

ca. 1877

Oil on paper

48.9 × 35.6 cm

BR 71

San Francisco, The Fine Arts Museum, Gift of Mr and Mrs Louise Benoist (1956.72)

Colour illus. p. 283

PROVENANCE: Private collection, Paris; Wildenstein & Co., New York

EXHIBITIONS: 1950 Toledo, no. 1; 1958 Los Angeles, no. 27, illus.; 1979, San Francisco, The Fine Arts Museum/Denver Art Museum/New York, Wildenstein & Co./Minneapolis Institute of Arts, *Masterpieces of French Art*, no. 10; 1992 Monterey Peninsula Museum of Art Association/Fresno Metropolitan Museum/University of California Museums at Blackhawk/Santa Barbara Museum of Art/Palm Springs Desert Museum, *The Splendid Centuries: 18th and 19th Century French Paintings from the Fine Arts Museum of San Francisco*, no. 18

LITERATURE: Boggs 1962, pp. 2–3, no. 95; Ralph T. Coe, Degas: The Environmental Portrait, *ARTnews*, 61, no. 9, January 1963, pp. 36, 56–59, illus.; Minervino 1970, no. 414; Varnedoe 1980, p. 97; Shapiro 1980, p. 155

134

Portrait of a woman

(Mlle Malo?)

1877

Oil on canvas

64.8 × 53.3 cm

L274

Detroit, The Detroit Institute of Arts

Gift of Ralph Harman Booth (21.8)

Colour illus. p. 235

PROVENANCE: Atelier Degas; Vente I, 1918, no. 64; Jacques Seligmann, Paris; American Art Association, New York, 27 January 1921, no. 56; Henry Reinhardt and Son, for the Detroit Institute of Arts, 1921

EXHIBITIONS: 1933 Northampton, no. 13; 1947 Cleveland, no. 10, illus.; 1948, Saginaw, Saginaw Museum, *Nineteenth Century French Painting*, no. 7, illus.; 1949 New York, no. 38; 1954, Detroit, Detroit Institute of Arts, *The Two Sides of the Medal: French Painting from Gérôme to Gauguin*, no. 71, illus.; 1965, New York, Wildenstein & Co., *Impressionistic and Post-Impressionistic Masters*, no. 21; 1969, Omaha, Joselyn Art Museum, *Mary Cassatt among the Impressionists*, no. 26; 1976, Midland Center for the Arts, Battle Creek Civic Art Center, *Cassatt–Degas*, no. 25, illus.

LITERATURE: *Bulletin of the Detroit Institute of Arts*, vol. 2, no. 8, Detroit 1921, p. 69, illus.; *Bulletin of the Detroit*

Institute of Arts, vol. 6, no. 8, Detroit 1925, p. 92, illus.; The Detroit Institute of Arts, *Catalogue of Paintings*, Detroit 1930, no. 56, illus.; J. Newberry, The Age of Impressionism and Realism: Detroit's Anniversary Exhibit, *ARTnews*, vol. 38, no. 31, 4 May 1940, pp. 13f.; The Detroit Institute of Arts, *Catalogue of Paintings*, Detroit 1944, p. 37, no. 56; Boggs 1962, pp. 52, 122, illus.

135

Mme Jeantaud

ca. 1877

Oil on canvas

83 × 75.5 cm

Signed top left: Degas

L440

Karlsruhe, Staatliche Kunsthalle (2493)

Colour illus. p. 216

PROVENANCE: Dikran Kélékian, Paris; Paul Rosenberg, Paris; art market, Switzerland; acquired by the Museum in 1963

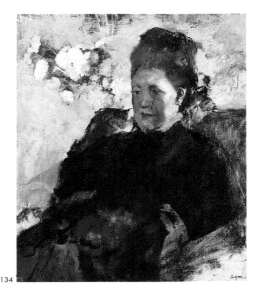

134

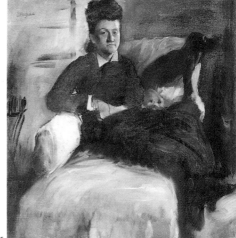

135

EXHIBITIONS: 1924 Paris, no. 51; 1936, Paris, Galerie Paul Rosenberg, *Le Grand Siècle*, no. 19, illus.; 1937 London, Rosenberg and Helft Galleries, no. 5, illus.; 1956, Raleigh, North Carolina Museum of Art, *French Painting in the Last Half of the 19th Century*, illus.
LITERATURE: *Collection Kélekian, Tableaux de l'Ecole Française Moderne*, Paris/New York 1920, illus.; D. Guérin, *Revue de l'Art*, XLV, 1924, illus.; Manson 1927, illus.; Lemoisne I, p. 82; Boggs 1962, p. 120; Minervino 1974, no. 432; Karlsruhe, Staatliche Kunsthalle Karlsruhe, *Katalog Neuere Meister, 19. und 20. Jahrhundert*, no. 2493

136

137

138

136

Mlle Bécat at the Ambassadeurs

1875–77
Lithograph, 1st state
29.1 × 24.3 cm
Sammlung E.W.K., Berne
Colour illus. p. 294

PROVENANCE: Vente IV, Estampes, Paris 1918, nos. 129–31
EXHIBITIONS: 1985, Winterthur, *Von Goya bis Warhol, Meisterwerke der Graphik des 19. und 20. Jahrhunderts aus einer Schweizer Privatsammlung*, no. 61, illus.
LITERATURE: Delteil, no. 50; Adhémar/Cachin, no. 43

137

Mlle Bécat at the Ambassadeurs

1875–77
Lithograph, 1st state
20.5 × 19.3 cm
Sammlung E.W.K., Berne
Colour illus. p. 293

PROVENANCE: G. Viau, Paris
EXHIBITIONS: 1985, Winterthur, *Von Goya bis Warhol, Meisterwerke der Graphik des 19. und 20. Jahrhunderts aus einer Schweizer Privatsammlung*, no. 60, illus.
LITERATURE: Delteil, no. 49; Adhémar/Cachin, no. 42

138

Mlle Bécat at the Ambassadeurs

ca. 1875
Pastel over lithograph
12.8 × 22.3 cm
L372
Private collection (courtesy Galerie Schmit, Paris)
Colour illus. p. 292

PROVENANCE: Zacharie Zacharian, Paris; Marcel Guérin, Paris; Guillaume Guérin, Paris; Galerie Schmit, Paris
EXHIBITIONS: 1924, Paris, no. 212; 1955 Paris, no. 63; 1984 Boston, no. 30; 1985 Philadelphia; 1985 London; 1993 Martigny, no. 120
LITERATURE: Cabanne 1957, p. 112; Minervino 1970, no. 385; Adhémar/Cachin, under no. 43; Reff 1972, I, p. 129

139

Mlle Bécat

ca. 1876
Pencil on paper
Verso: Mlle Bécat
Pencil
16.2 × 12.2 cm
Vente stamp lower centre
Private collection (courtesy Galerie Schmit, Paris)
Colour illus. p. 294

PROVENANCE: Vente IV 1919, 37c
EXHIBITION: 1993 Martigny, no. 123

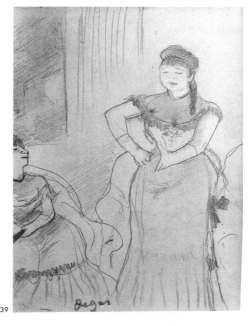

139

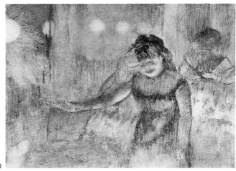

140

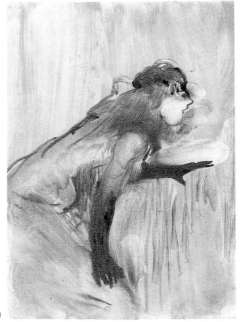

141

140

Singer at a café-concert

ca. 1877

Monotype in black oil paint

12 × 16.2 cm

Atelier stamp on verso

Sammlung E.W.K., Berne

Colour illus. p. 295

PROVENANCE: Atelier Degas; Vente IV, Estampes, Paris 1918, no. 197

EXHIBITIONS: 1964, Berne, Kornfeld und Klipstein, *Ausstellung 1864–1964, 100 Jahre Galerie*, no. 7, illus.; 1968 Cambridge, no. 8, checklist no. 29; 1984 Paris, no. 260, illus.; 1989, Berne, Kunstmuseum, *Von Goya bis Tinguely, Aquarelle und Zeichnungen aus einer Privatsammlung*, no. 11, illus.

LITERATURE: Rouart 1948, illus.; Adhémar/Cachin, no. 6, illus.

141

Singer at a café-concert – 'diseuse'

1877–78

Monotype in black oil paint

18.5 × 13.4 cm

Atelier stamp on verso

Sammlung E.W.K. Berne

Colour illus. p. 296

PROVENANCE: Vente IV, Estampes, Paris 1918, no. 275

EXHIBITIONS: 1964, Berne, Kornfeld und Klipstein, *Ausstellung 1864–1964, 100 Jahre Galerie*, no. 8; 1968 Cambridge, no. 12, checklist no. 47; 1984 Paris, no. 265, illus.; 1985 London, no. 4; 1989, Berne, Kunstmuseum, *Von Goya bis Tinguely, Aquarelle und Zeichnungen aus einer Privatsammlung*, no. 12, illus.

LITERATURE: Adhémar/Cachin, no. 4

142

Café-concert singer

('*Chanteuse de café*')

ca. 1878

Oil on canvas

53.5 × 41.8 cm

L477

Chicago, The Art Institute of Chicago

Gift of Clara Lynch (1955–738)

Colour illus. p. 297

PROVENANCE: Sale, M. de Bonnières, Paris, 2 July 1894; Durand-Ruel, Paris; John A. Lynch, Chicago, 1894; gift to the Museum in 1955

EXHIBITIONS: 1962, Baltimore, Baltimore Museum of Art, *Manet, Degas, Mary Cassatt and Berthe Morisot*, no. 41; 1976 Tokyo, no. 28, illus.; 1979 Edinburgh, no. 43, illus.; 1980 Albi, Musée Toulouse-Lautrec, *Trésors impressionnistes du Musée de Chicago*, no. 6, illus.; 1984 Chicago, no. 38, illus.

LITERATURE: Lafond 1918, p. 40; Grappe 1920, p. 36, illus.; Meier-Graefe 1920, illus.; Jamot 1924, illus.; Bazin 1931, illus.; Mauclair 1937, illus.; Cabanne 1958, no. 74, illus.; The Art Institute of Chicago, *Paintings in the Art Institute of Chicago: Catalogue of the Picture Collection*, Chicago 1961, no. 120; Minervino 1974, no. 449

143

M. Jacquet

ca. 1878

Pastel on paper

26 × 20 cm

Signed centre right: Degas

BR 78

Los Angeles, The Armand Hammer Foundation (90.21)

Colour illus. p. 270

PROVENANCE: Hermann Heilbuth, Copenhagen; Bachstitz Gallery, The Hague, 1921; Mrs Jesse I. Strauss, New York; Parke-Bernet, New York, 21 October 1970, no. 50, illus.

EXHIBITIONS: 1971, Little Rock, Arkansas Art Center; San Francisco, California Palace of the Legion of Honor; Oklahoma City, Oklahoma Art Center; San Diego, Fine Arts Gallery; Los Angeles, County Museum of Art; 1972 London, Royal Academy of Arts;

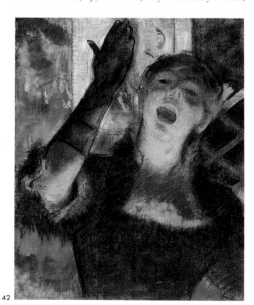

142

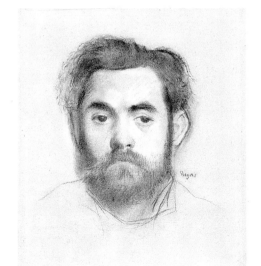

143

Dublin, National Gallery of Ireland; Leningrad, Hermitage; Moscow, Pushkin Museum; Kiev, State Museum of Fine Art of the Ukraine; 1973 Minsk, State Fine Art Museum; Riga, State Museum of Foreign Fine Arts; Odessa, Fine Arts Museum; 1975 Caracas, Fine Arts Museum; Lima, Italian Art Museum; Tokyo, Seibu Museum; Kyoto, Municipal Museum; 1976 Nagoya, Aiche Prefectural Museum; Nashville, Tennessee Fine Art Center at Checkwood; Mexico City, Palace of Fine Arts; 1977, Paris, Musée du Louvre, Cabinet des Dessins; Malibu, J. Paul Getty Museum; Atlanta, High Museum of Art; 1978, Denver, Art Museum; Buffalo, Albright-Knox Art Gallery; Edinburgh, National Gallery of Scotland and Royal Academy; Oslo, National Museum of Norway; 1979, Stockholm, National Museum; Houston, Museum of Fine Arts; 1980, Moultrie, Georgia, Moultrie-Colquett County Library; Los Angeles, County Museum of Art; Washington, Corcoran Gallery of Art, *The Hammer Collection*, no. 98, illus.

LITERATURE: Bachstitz Gallery, The Hague, *Catalogue of Paintings and Tapestries*, Berlin 1921, I, no. 93, illus.; *ARTnews*, vol. 29, no. 23, March 1931, p. 5, illus.; Boggs 1962, p. 120; Christopher White, The Armand Hammer Collection: Drawings, *Apollo*, vol. 95, June 1972, p. 463, illus.

144

Diego Martelli

1879

Oil on canvas

75.5 × 116 cm

Vente stamp lower right

L520

Buenos Aires, Museo Nacional de Bellas Artes (2706)

Colour illus. p. 267

PROVENANCE: Atelier Degas; Vente II, 1918, no. 35; Dr Georges Viau, Paris; Wildenstein et Cie.; Paris, Jacques Seligmann, New York, before 1933; purchased for the Museum by the association Amigos del Museo Nacional de Bellas Artes, December 1939

EXHIBITIONS: 1939 Northampton, no. 11; 1936 Philadelphia, no. 30, illus.; 1937 Paris, Orangerie, no. 31; 1938 New York, no. 8; 1939, Buenos Aires, Museo Nacional de Bellas Artes, *La pintura francesa de David a nuestros dias*, no. 41; 1962, Buenos Aires, Museo Nacional de Bellas Artes, *El impresionismo frances en las colecciones argentinas*, p. 17, illus.; 1975, Munich, Haus der Kunst, *Toskanische Impressionen*, no. 15, illus.; 1984–85 Paris, no. 13, illus.; 1988–89 Paris/Ottawa/New York, no. 202.

LITERATURE: Lafond 1918–19, II, p. 15; Coquiot 1924, p. 218; Fosca 1930, p. 377; Jose M. Lamarca Guerrico (ed.), *Retrato de D. Martelli*, Buenos Aires 1940; Lassaigne 1945, p. 47; Julio Rinaldini, *Edgar Degas*, Posei-

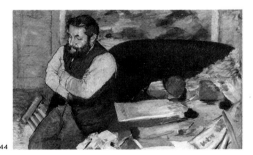

144

don, Buenos Aires 1943, p. 28; Oscar Reutersward, An unintentional Exegete of Impressionism. Some Observations on Edmond Duranty and His "La Nouvelle Peinture", *Konsthistorik Tidskritt*, IV, 1949, p. 113; Boggs 1962, p. 123; Vitali 1963, pp. 269ff.; 1967 Saint Louis, p. 142; Minervino 1974, no. 557; Reff 1976, pp. 132, 317, no. 129; 1979 Edinburgh under nos. 55-58, 60; Loyrette 1991, pp. 318f., 426ff.

145

Diego Martelli

1879
Study for cat. 144
Pencil on paper
11.1 × 16.8 cm
Edinburgh, The National Gallery of Scotland
Colour illus. p. 266

PROVENANCE: Maurice Exsteens, Paris; Agnew, London
EXHIBITION: 1979 Edinburgh, no. 55

146

Diego Martelli

1879
Oil on canvas
110 × 100 cm
Vente stamp lower right
L519
Edinburgh, National Gallery of Scotland (NG 1785)
Colour illus. p. 269

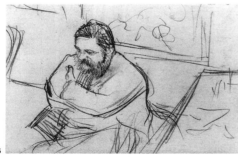
145

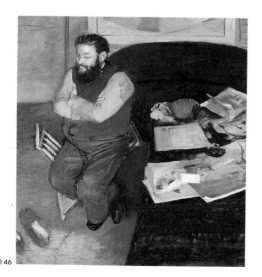
146

PROVENANCE: Atelier Degas; Vente I, 1918, no. 58; Dr Georges Viau, Paris; Paul Rosenberg & Co., Paris; Reid and Lefevre Galleries, London, 1920; Mme R.A. Workman, London; Knoedler & Co., London, before 1930; Reid and Lefevre Galleries, London; acquired by the Museum in 1932
EXHIBITIONS: 1879, Paris, 28, Avenue de l'Opéra, *4me Exposition de Peinture*, no. 57; 1920, Glasgow, Alex Reid and Lefevre Galleries, no. 148; 1922, London, Burlington Fine Arts Club, *French School of the Last Hundred Years*, no. 38; 1923, Manchester, Agnew and Sons Galleries, *Loan Exhibition of Masterpieces of French Art of the 19th Century*, no. 16; 1925, Kirkcaldy, Museum and Art Gallery, *The Kirkcaldy Art Inauguration Loan Exhibition*, no. 39; 1926-27, London, National Gallery, Millbank (Tate); 1930, Paris, Galerie Georges Petit, *Cent ans de peinture française*, no. 14; 1930, New York, Knoedler Galleries, *Masterpieces by 19th Century French Painters*, no. 4, illus.; 1931 Cambridge, no. 8; 1932, London, Royal Academy of Arts, *French Art 1200-1900*, no. 347 (433); 1937 Paris, Palais National, no. 306; 1952 Amsterdam, no. 18; 1952 Edinburgh, no. 17, illus.; 1979 Edinburgh, no. 60, illus.; 1988-89 Paris/Ottawa/New York, no. 201, illus.
LITERATURE: Lemoisne 1912, p. 86; Lafond 1918-19, II, p. 15; Walter Sickert, French Art of the Nineteenth Century, *The Burlington Magazine*, vol. 40, no. 231, June 1922, p. 265; Coquiot 1924, p. 218, illus.; James B. Manson, The Workman Collection, Modern Foreign Art, *Apollo*, III, 1926, p. 142, illus.; Edinburgh, National Gallery of Scotland, *Catalogue of Paintings and Sculpture*, Edinburgh 1957, p. 63; Boggs 1962, pp. 57, 123, illus.; Vitali 1963, pp. 269f.; *The Maitland Gift and Related Pictures*, National Gallery of Scotland, Edinburgh 1963, pp. 22f., illus.; Minervino 1974, no. 556; Reff 1976, pp. 131f.; Pierre Dini, Diego Martelli, *Il Torchio*, Florence 1978, pp. 144f., 155, nos. 64, 66; Reff 31 (BN no. 23, pp. 1, 24, 25, 27, 68); Sutton 1986, pp. 86, 283, illus.

147

Diego Martelli
Study for cat. 146
1879
Black chalk, heightened with white, on buff wove paper
45 × 28.6 cm
Vente stamp lower left
Cambridge (Mass.), Harvard University Art Museums, Fogg Art Museum
Bequest of Meta and Paul J. Sachs (1965.255)
Colour illus. p. 268

PROVENANCE: Atelier Degas; Vente III, 1919, no. 344.1; César M. de Hauke, New York; Paul J. Sachs 1929; bequest to the Museum, 1965
EXHIBITIONS: 1930 New York, no. 9; 1931 Cambridge, no. 17b; 1933 Northampton, no. 27; 1934, Cambridge (Mass.), Fogg Art Museum, *French Drawings and Prints of the Nineteenth Century*, no. 22; 1936 Philadelphia, no. 82; 1940, Washington, Phillips Memorial Gallery, *Great Modern Drawings*, no. 13; 1940, San Francisco, Golden Gate International Exposition, Palace of Fine Arts, *Master Drawings, An Exhibition of Drawings from American Museums and Private Collections*, no. 21, illus.; 1941, Detroit, Detroit Institute of Arts, *Masterpieces of 19th and 20th Century French Drawing*, no. 24; 1943, Santa Barbara, Museum of Art, *Master Drawings Fogg Museum*; 1945 New York, no. 69; 1947 Cleveland, no. 68, illus.; 1947 Washington, no. 16;

1947, New York, Century Club, Loan Exhibition; 1952, Richmond, Virginia Museum of Fine Arts, *French Drawings from the Fogg Art Museum*; 1955 Paris, Orangerie, no. 71, illus.; 1956, Waterville (Maine), Colby College, Miller Library, *An Exhibition of Drawings Presented by the Art Department*, no. 31; 1960 New York, no. 91; 1965-67 Cambridge, no. 60, illus.; 1974 Boston, no. 85; 1979 Edinburgh, no. 59, illus.; 1988-89 Paris/Ottawa/New York, no. 200, illus.; 1990, Tokyo, The Tokyo Shimbun/Yamaguchi, The Yamaguchi Prefectural Museum, *The Maurice Wertheim Collection and Selected Impressionist Paintings and Drawings in the Fogg Art Museum*, no. 47, illus.
LITERATURE: Mongan 1932, p. 68, illus.; *Drawings in the Fogg Museum of Art*, Cambridge, Massachusetts 1940, I, p. 362, no. 673; Francis 1957, p. 216; Jakob Rosenberg, *Great Draughtsmen from Pisanello to Picasso*, Cambridge 1959, pp. 23, 110, illus.; Wick 1959, pp. 87-101; Boggs 1962, p. 123; Vitali 1963, p. 269, illus.; Jean Lemayre, *Dessins de la période impressionniste de Manet à Renoir*, Geneva 1969, p. 43, illus.; Vojtech and Thea Jirat-Wasiutynsky, The Uses of Charcoal in Drawing, *Arts Magazine*, LV, 2 October 1980, p. 131, illus.; Melissa McQuillan, *Impressionist Portraits*, London 1986, illus.

148

Diego Martelli
Study for cat. 146
ca. 1879
Charcoal on paper
45 × 29.7 cm
Cambridge, (Mass.), Harvard University Art Museums, Fogg Art Museum
Bequest of Meta and Paul J. Sachs (1965.256)
Colour illus. p. 268

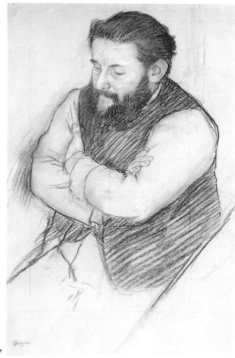
147

PROVENANCE: Atelier Degas; Vente III, 1919, no. 344, illus.; Cesar M. Hauke; Paul J. Sachs

EXHIBITIONS: 1930 New York, no. 12; 1931 Cambridge, no. 17a; 1932 Saint Louis; 1939, New York, Brooklyn Museum of Art; 1941, Detroit, Detroit Institute of Arts, *Masterpieces of 19th and 20th Century French Drawing*, no. 25; 1945 New York, no. 69; 1947, New York, Century Club, Loan Exhibition; 1952, Richmond, Virginia Museum of Fine Arts, *French Drawings from the Fogg Art Museum*; 1960, New York, Wildenstein & Co., Loan Exhibition, no. 91; 1974 Boston, no. 84; 1979 Edinburgh, no. 59, illus.

LITERATURE: L. Goodrich, Degas, *Arts*, XVII, no. 2, 1930, pp. 113f.; Mongan 1932, p. 68; Mauclair 1945, p. 17, illus.; *Drawings in the Fogg Museum of Art*, Cambridge (Mass.) 1940, I, p. 361, no. 672, illus.; James Watrous, *The Craft of Old Master Drawings*, Madison 1957, pp. 134f, illus.; 1967 Saint Louis, p. 140; *Idea to Image: Preparatory Studies from the Renaissance to Impressionism*, Cleveland Museum of Art 1980, p. 60, illus.; Vojtech and Thea Jirat-Wasiutynski, The Uses of Charcoal in Drawing, *Arts Magazine*, October 1980, pp. 129f., illus.

149

Edmond Duranty

1879

Charcoal on blue paper, heightened with white
30.8 × 47.3 cm
Vente stamp lower right; Atelier stamp verso top right
New York, The Metropolitan Museum of Art
Rogers Fund, 1918 (19.51.9a)
Colour illus. p. 265

148

PROVENANCE: Atelier Degas; Vente II, 1918, no. 242/2

EXHIBITIONS: 1919, New York, The Metropolitan Museum of Art, *New Acquisitions*; 1970, New York, The Metropolitan Museum of Art, *Masterpieces of Fifty Centuries*, no. 381, illus.; 1973–74 Paris, no. 31, illus.; 1977 New York, no. 27, illus.; 1979 Edinburgh, no. 52, illus.; 1988–89 Paris/Ottawa/New York, no. 198, illus.

LITERATURE: Burroughs 1919, pp. 115f.; Rivière 1922–23, illus.; 1943 New York, Metropolitan, no. 52, illus.; Rewald 1946, illus.; Rich 1951, illus.; French Drawings, *The Metropolitan Museum of Art Bulletin*, XVII, 6 February 1959, illus.; Boggs 1962, p. 117; Jacob Bean, *100 Drawings in the Metropolitan Museum of Art*, The Metropolitan Museum of Art, New York 1964, no. 75, illus.; Reff 1976, p. 50, illus.; Reff 1977, p. 32, illus.

150

Hermann de Clermont

ca. 1879

Black chalk with white heightening on blue paper, 48 × 31.5 cm
Vente stamp lower left
Copenhagen, Statens Museum for Kunst
Department of Prints and Drawings (tu35.5)
Colour illus. p. 218

149

150

PROVENANCE: Vente III, 1919, no. 162 (2), illus.; Durand-Ruel, Paris; Ambroise Vollard, Paris; Feilchenfeldt, Zurich

EXHIBITIONS: 1931 Paris, no. 132; 1979 Edinburgh, no. 50, illus.; 1984 Tübingen, no. 129, illus.

LITERATURE: Boggs 1962, pp. 113f.; *L'Amérique vue par l'Europe*, Paris 1976, p. 343; Thomson 1979, pp. 50f., no. 50, illus.; Loyrette 1991, p. 359

151

Woman in street clothes

ca. 1879

Pastel on paper, 48 × 43 cm
Signed top right: Degas
BR 104, Walter and Maria Feilchenfeldt, Zurich
Colour illus. p. 272

PROVENANCE: Duc de Cadaval, Pau; Paul Rosenberg, New York

EXHIBITIONS: 1976–77 Tokyo, no. 29, illus.; 1979 Edinburgh, no. 68, illus.; 1984 Tübingen, no. 135, illus.; 1988–89 Paris/Ottawa/New York, no. 205, illus.

152

Mary Cassatt at the Louvre (two studies)

ca. 1879

Charcoal and pastel on paper,
47.8 × 63 cm
Signed top right: Degas
BR 105, Private collection, New York
Colour illus. p. 275

151

152

PROVENANCE: Harris Whittemore, Naugatuck, Conn.; J.H. Whittemore, Naugatuck, Conn., 1926; Parke-Bernet, New York, 19 and 20 May 1948, no. 84; Siegfried Kramarsky, New York; private collection

EXHIBITIONS: 1935 Boston, no. 125; 1939, Boston, Museum of Fine Arts, *Art in New England*, no. 158; 1944–45, Washington D.C., National Gallery of Art, *French Drawings from the French Government, the Myron A. Hofer Collection and the Harris Whittemore Collection*, no. 68; 1947 Washington D.C., no. 17, illus.; 1959, New York, Columbia University, at M. Knoedler & Co., *Great Master Drawings of Seven Centuries,* no. 72, illus.; 1967 Saint Louis, no. 87, illus.; 1978 New York, no. 9, illus.; 1988–89 Paris/Ottawa/New York, no. 204, illus.; 1993 Martigny, no. 126, illus.

153

Ellen Andrée

1879
Etching, 3rd state, 3rd proof
11.3 × 7.9 cm
Josefowitz collection
Colour illus. p. 272

LITERATURE: Delteil, no. 20; Adhémar, no. 52; Reed/Shapiro 40

154

Mary Cassatt at the Louvre

1879–80
Etching, 9th state
34 × 17 cm
Amsterdam, Rijksmuseum, Rijksprentenkabinet (1961–794)
Colour illus. p. 274

PROVENANCE: Atelier Degas; Maurice Exsteens; Kornfeld und Klipstein, Berne 1961
LITERATURE: Reed/Shapiro 52

153

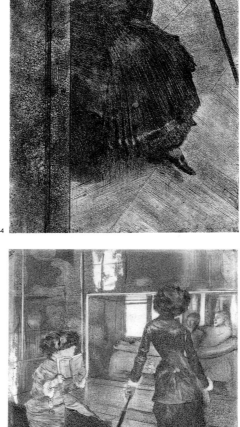

154

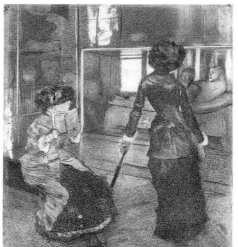

155

155

Mary Cassatt at the Louvre, Musée des Antiques

1879–80
Etching with drypoint and aquatint, 9th state, 3rd proof
26.7 × 23.2 cm
Private collection, Berlin
Colour illus. p. 273

PROVENANCE: O. Gerstenberg, Berlin
LITERATURE: Delteil, no. 30; Adhémar, no. 53; Reed/Shapiro 51

156

Three girls seated

ca. 1879
Pastel over monotype in grey, on beige paper
16 × 21.5 cm
Signed in black chalk, top right: Degas, L550
Amsterdam, Rijksmuseum, Rijksprentenkabinet (1967:88)
Colour illus. p. 299

PROVENANCE: sale Anonyme, Hôtel Drouot, Paris, 10 June 1891, no. 17; Maurice Exsteens, Paris; Paul Brame and César de Hauke, Paris; Gaby Schreiber, London; Kornfeld & Klipstein, Berne

EXHIBITIONS: 1924 Paris, no. 229; 1937 Paris, no. 200; 1948 Copenhagen, no. 96; 1951–52 Berne, no. 29; 1952 Amsterdam, no. 21; 1955 Paris, no. 85; 1958 London, no. 39, illus.; 1964, Berne, Kornfeld & Klipstein, *One Century, 1864–1964*, no. 13; 1968 Cambridge (Mass.), no. 16, illus.; 1979 Edinburgh, no. 94, illus.; 1984 Tübingen, no. 128, illus.

LITERATURE: Meier-Graefe 1920, illus.; Hoppe 1922, p. 82; Troendle 1925, p. 361, illus.; Rivière 1935, p. 171; Graber 1942, illus.; Hausenstein 1948, illus.; Rouart 1948, illus.; Cooper 1952, p. 22, no. 17, illus.; Rich 1959, p. 19, illus.; Minervino 1974, no. 862, illus.; Terrasse 1981, no. 299, illus.

157

'L'Anglaise'

ca. 1880
Oil on paper, mounted on linen, 84.6 × 40 cm
Atelier stamp on verso
BR 98
Collection of Jan and Marie-Anne Krugier-Poniatowski (courtesy Galerie Jan Krugier, Geneva)
Colour illus. p. 298

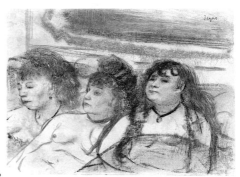

156

PROVENANCE: Atelier Degas, Paris; René de Gas, Paris; Drouot, Paris, sale Succession René de Gas, 10 November 1927, no. 84, illus.; private collection; sale Bangel, Frankfurt, 17 October 1928, no. 54, illus.; Perot; Martin Fabiani, Paris; Alexander M. Lewyt, New York; Los Angeles County Museum of Art, gift of Alexander M. Lewyt, 1953; Sotheby Parke Bernet, New York, 4 November 1982, no. 33a, illus.; Edwin Roth, Cleveland

EXHIBITIONS: 1958 Los Angeles, no. 50, illus.; 1993 Martigny, no. 130

LITERATURE: Accessions of American and Canadian Museums, *Art Quarterly*, XXIII, 1960, pp. 93, 106, illus.

158

The little fourteen-year-old dancer

1880–81

Bronze, part-painted, cotton tutu, satin ribbon

Height 81 cm

Zurich, Sammlung Stiftung E.G. Bührle

Colour illus. p. 288

157

PROVENANCE: Purchased on the English art market, 1954

EXHIBITIONS: 1951, London, Marlborough Fine Art Ltd., *The Complete Collection of Sculpture by Edgar Degas*, no. 20; 1958, Zurich, Kunsthaus, *Sammlung Emil G. Bührle*, no. 319; 1958–59, Munich, Haus der Kunst, *Hauptwerke der Sammlung Emil G. Bührle*, no. 179

LITERATURE: Rewald 1944, no. 20; G. Jedlicka, Degas "Die Tänzerin" (Bronze), *Neue Zürcher Zeitung*, no. 2689, 9 December 1950; Rewald 1957, no. XX; Lemoisne 1954, p. 113; Cabanne 1957, pp. 13, 66, 70, 93, 108, 130, illus.; Vitali 1966; Minervino 1974, no. 73

158

159

159

Nude studies for The little fourteen-year-old dancer

ca. 1878

Charcoal heightened with white chalk on paper

47.7 × 62.3 cm

Vente stamp lower right

Private collection, London

Colour illus. p. 289

PROVENANCE: sale III, 1919, no. 386, illus.; M. Nouf-flard, Paris; Galerie Brame, Paris; Peter Findlay, New York (June 1978)

EXHIBITIONS: 1979 Edinburgh, no. 73, illus.; 1984 Washington D.C., no. 23, illus.; 1987 Manchester/Cambridge, no. 68, illus.; Tokyo 1988, no. 48, illus.; Martigny 1993, no. 32, illus.

LITERATURE: *L'Amour de l'Art*, July 1931, p. 294, illus.; John Rewald, *The History of Impressionism*, New York 1973, p. 451, illus.; Dunlop 1979, p. 178, illus.; 1982 London, p. 8; *Architectural Digest*, Art and Antiques Annual 1984, pp. 50, 55, illus.; 1986 Florence/Verona, p. 212, illus.; Thomson 1988, p. 120, illus.; *The Sao Paulo Collection*, Vincent van Gogh Museum, Amsterdam 1989, p. 70, illus.; *Museu de Arte Sao Paulo*, Japan 1990, p. 150, illus.

160

Young woman in an armchair

ca. 1880

Pencil and pastel on paper

24 × 19.5 cm

Vente stamp lower left

Private collection, Switzerland

Colour illus. p. 243

PROVENANCE: Atelier Degas; Vente IV, 1919, no. 136b, illus.

160

161

Criminal physiognomies

1881

Pastel

48 × 63 cm

Signed top right

L639

Private collection

Colour illus. p. 291

PROVENANCE: Atelier Degas; Vente II, 1918, no. 200, illus.; A. Vollard, Paris; Galerie Schmit, Paris

EXHIBITIONS: 1881, Paris, 35 Boulevard des Capucines, 6e Exposition des Impressionnistes, no. 18

LITERATURE: Henri Havard, *Le Siècle*, 3 April 1881, p. 2; Elie de Monst, *La Civilisation*, 21 April 1881; Joris-Karl Huysmans, *L'art Moderne*, Paris 1883, pp. 225f.; Gustave Geffroy, *La Justice*, 19 April 1881, p. 3; Douglas Druick, in: *Dégas inédit*, pp. 225ff.; Loyrette 1991, pp. 388ff.

161

162

162

The photographer Boussard

1881–85

Watercolour and gouache on paper

30 × 20 cm

L677

Detroit, The Detroit Institute of Arts

Bequest of John S. Newberry (65.144)

Colour illus. p. 271

PROVENANCE: René de Gas; Vente Succession René de Gas, Paris 1927, no. 6, illus.; Lucien Guiraud; Otto Wertheimer, 1927; John S. Newberry, 1952; The Detroit Institute of Arts, 1965

EXHIBITIONS: 1931 Paris, Orangerie; 1958, Cambridge (Mass.), Fogg Art Museum, *Watercolors etc. from Collections of Members of the Class of 1933*; 1960, Cambridge (Mass.), Fogg Art Museum, *Thirty-three French Drawings from the Collection of John S. Newberry*; 1962, Boston (Mass.), *Fifty-One Watercolors and Drawings, John S. Newberry Collection*; 1965, Detroit, Institute of Arts, *The John S. Newberry Collection*; 1978, Midland, Michigan, Midland Center for the Arts/Battle Creek, Michigan, Battle Creek Civic Art Center

LITERATURE: Vente III, no. 366, illus.; Boggs 1962, p. 111

163

Mme Ernest May beside a cradle

1881–82

Pastel on canvas

130 × 80 cm

L656

Private collection, Zurich

Colour illus. p. 220

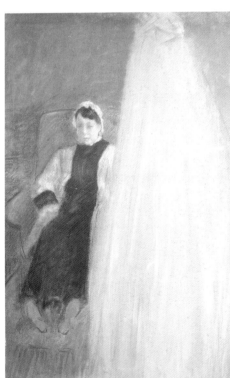

163

LITERATURE: Boggs 1962, p. 123; Reff 1965, p. 615; Minervino 1974, no. 584; Reff 1976, I, pp. 139f.; 1984 Tübingen, under no. 140; Loyrette 1991, p. 418

164

Mme Ernest May

1881–82

Pastel on paper

43.5 × 29.5 cm

Vente stamp lower right; atelier stamp on verso

L656bis

Geneva, Collection Jan and Marie Anne Krugier-Poniatowski (courtesy Galerie Krugier)

Colour illus. p. 221

PROVENANCE: sale IV, 1919, no. 14, illus.; Dr Etienne May, Paris; private collection

LITERATURE: Loyrette 1991, p. 418

165

Mme Ernest May

1881

Black chalk with white heightening on paper

30 × 23.5 cm

Vente stamp lower left

L657

Private collection

Colour illus. p. 221

164

PROVENANCE: sale IV, 1919, no. 262a, illus.; Christian Lazard, Paris; Galerie Arnold-Livie, Munich
EXHIBITIONS: 1931 Paris, no. 140; 1984 Tübingen, no. 139, illus.; 1993 Martigny, no. 128
LITERATURE: Mauclair 1938, p. 51, illus.; cf. Lemoisne II, no. 657, illus., under no. 656; Boggs 1962, p. 123; Hüttinger 1981, p. 7, illus.; Loyrette 1991, p. 418

166
At the milliner's
('*Chez la modiste*')
ca. 1883
Pastel
75.9 × 84.4 cm
Signed below right: Degas
L729
Madrid, Fundación Colección Thyssen-Bornemisza (1978.10)
Colour illus. p. 10

PROVENANCE: Henri Rouart, Paris; Madame Ernest Rouart, Paris; Mrs Robert Lehman, New York; Thomas Gibson Fine Art, London
EXHIBITIONS: 1882, London, 13 King Street, St James's; 1924 Paris, no. 148, illus.; 1937 Paris, Orangerie, no. 110, illus.; 1979 Edinburgh, no. 72, illus.; 1984 Tübingen, no. 141, illus.; 1984–86, Tokyo, The National Museum of Modern Art; Kumamoto, Kumamoto Prefectural Museum; London, Royal Academy of Arts; Nuremberg, Germanisches Nationalmuseum; Düsseldorf, Städtische Kunsthalle; Florence, Palazzo Pitti; Paris, Musée d'Art Moderne de la Ville de Paris; Madrid, Biblioteca Nacional; Barcelona, Palacio de la Vierreina, *Modern Masters from the Thyssen-Bornemisza Collection*, no. 9, illus.; 1988–89 Paris/Ottawa/New York, no. 233, illus.; 1990, Lugano, Villa Favorita, *Impressions and Postimpressions. The Thyssen-Bornemisza Collection*, no. 8
LITERATURE: Bruce Bernard, *The Impressionist Revolution*, London 1986, p. 286; Jacqueline Loumaye/Nadine Massart, *Degas: Le geste peint*, Paris 1992, p. 44

167
Singer at a café-concert (Thérésa)
1883–84
Charcoal on paper, heightened with white
46 × 30 cm
Vente stamp lower left; atelier stamp on verso
Sammlung E.W.K., Berne
Colour illus. p. 296

PROVENANCE: Atelier Degas; Vente III, 1919, no. 393, illus.; Roland Nepveu De Gas, Paris
EXHIBITIONS: 1937 Paris, no. 117; 1943, Paris, Galerie Charpentier, *Scènes et figures parisiennes*; 1989, Berne, Kunstmuseum, *Von Goya bis Tinguely, Aquarelle und Zeichnungen aus einer Privatsammlung*, no. 16, illus.
LITERATURE: Lemoisne 1954, illus. after p. 120; 1988–89 Paris/Ottawa/New York, illus. p. 435

168
Mary Cassatt, seated, holding cards
ca. 1884
Oil on canvas, 71.5 × 58.7 cm
L796
Washington, D.C., The National Portrait Gallery
Gift of the Morris and Gwendolyn Cafritz Foundation and Regents' Major Acquisitions Fund, Smithsonian Institution (NPG 84.34)
Colour illus. p. 276

PROVENANCE: Mary Cassatt, Paris; Ambroise Vollard, 1913; Wilhelm Hansen, Ordrupgaard, 1918; Matsukata collection, Paris, Kobe and Tokyo; Wildenstein & Co., New York, 1951; André Meyer, New York, 1952; New York, Sotheby Parke Bernet, 22 October 1980, no. 24, illus.; Galerie Beyeler, Basle; acquired by the Museum in 1984
EXHIBITIONS: 1913, Berlin, Cassirer, *Degas/Cézanne*, no. 5; 1917, Zurich, Kunsthaus, *Französische Kunst des 19. und 20. Jahrhunderts*, no. 90, illus.; 1920 Copenhagen, no. 7; 1924 Paris, no. 58; 1960 New York, no. 41, illus.; 1962, Washington, National Gallery of Art, *Exhibition of the Collection of Mr. and Mrs. André Meyer*, p. 20, illus.; 1966, New York, Knoedler & Co., *Impressionist Treasures from Private Collections in New York*, no. 6, illus.; 1988–89 Paris/Ottawa/New York, no. 268, illus.
LITERATURE: Jacques Vernay, La Triennale, Exposition d'Art Français, *Les Arts*, 154, April 1916, illus.; Karl Madsen, *Malerisamlingen Ordrupgaard, Wilhelm Hansen's Samling*, Copenhagen 1918, p. 32, no. 70; Lafond 1918–19, II, p. 17; Leo Swane, Degas – Billderne pa Ordrupgaard, *Kunstmuseets Aarsskrift* 1919, Copenhagen 1920, illus. p. 73; Hoppe 1922, p. 33, illus.; Venturi 1939, II, pp. 129ff.; Boggs 1962, pp. 51, 112, illus.; Adelyn D. Breeskin, *Mary Cassatt, A Catalogue Raisonné of the Oils, Pastels, Watercolors and Drawings*, Smithsonian Institution, Washington 1970, p. 13, illus.; Rewald 1973, p. 516, illus.; Minervino 1974, no. 608; Nancy Hale, *Mary Cassatt*, Garden City 1975, illus.; Broude 1977, pp. 102f., 105, illus.; Lucretia H. Giese, A Visit to the Museum, *Boston Museum of Fine Arts Bulletin*, LXXVI, 1978, pp. 45, 49; Dunlop 1979, pp. 168f.; Thomson 1985, pp. 11–13, 16, illus.

166

165

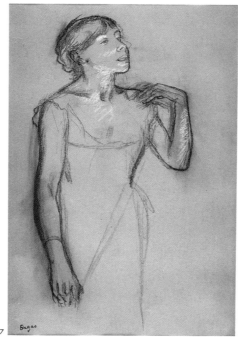

167

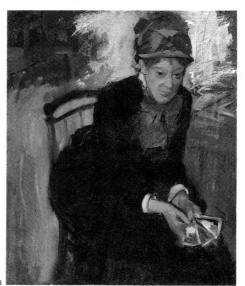

168

169

Mme Henri Rouart

1884

Pencil and pastel

26.6 × 36,3 cm

Signed and dated in black chalk below right:
Degas/84

L766 bis

Karlsruhe, Staatliche Kunsthalle Karlsruhe,
Kupferstichkabinett (1979–6)

Colour illus. p. 223

PROVENANCE: Henri Rouart, Paris; Louis Rouart,
Paris; Edwin C. Vogel, New York; Galerie Arnoldi-
Livie, Munich

EXHIBITIONS: 1968, New York, The Metropolitan
Museum of Art, *Summer Loan Exhibition*; 1973, New
York, Galerie Wildenstein, *Master Drawings*; 1976–77
Tokyo/Kyoto/Fukuoka, no. 37, illus.; 1983, Karlsruhe,
Staatliche Kunsthalle, *Die französischen Zeichnungen
1570–1930*, no. 77, illus.; 1984 Tübingen, no. 154, illus.

LITERATURE: Jean Sutherland Boggs, Mme Henri
Rouart and Hélène by Edgar Degas, *Bulletin of the Art
Division, Los Angeles County Museum*, vol. 7, no. 2,
Spring 1956, pp. 13ff., illus.; Boggs 1962, pp. 67f., 129,

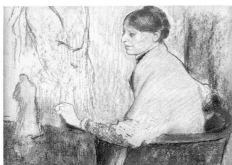

169

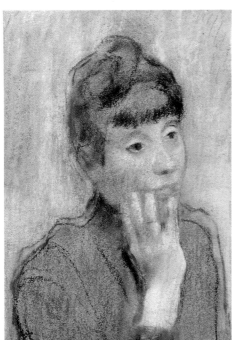

170

illus.; Minervino 1974, no. 607; Millard 1976, p. 58,
illus.; Reff 1976, p. 319; Staatliche Kunsthalle
Karlsruhe, Erwerbungsbericht 1979, *Jahrbuch der Staat-
lichen Kunstsammlungen Baden-Württemberg*, 17, 1980, pp.
224ff., illus.; Terrasse 1981, no. 430, illus.; 1983
London, under no. 27

170

Bust portrait of a woman in a green bodice

ca. 1884

Pastel

49 × 33 cm

Private collection (courtesy Galerie Schmit,
Paris)

Colour illus. p. 247

PROVENANCE: Vente II, 1918, no. 86, illus.; Charles
Comiot, Paris

EXHIBITIONS: 1931 Paris, no. 145; 1975 Paris, no. 27,
illus.; 1976–77 Tokyo/Kyoto/Fukuoka, no. 40, illus.;
1978, Paris, Galerie Schmit, *Aspects de la peinture fran-
çaise XIX–XX siècles*, no. 17, illus.; 1984 Tübingen, no.
153, illus.; 1994 Paris, Galerie Schmit, *Maîtres français,
XIXe–XXe siècles*, no. 19, illus.

LITERATURE: Lemoisne III, no. 801, illus., under nos.
802, 803; Minervino 1974, no. 611

171

Two girls looking at an album

ca. 1885

Pastel

41 × 74 cm

L779

Fondation Rau pour le Tiers-Monde
Zurich (GR 1.674)

Colour illus. p. 279

PROVENANCE: Vente I, 1918, no. 166; Monteux collec-
tion, Paris; Galerie Motte, Paris

LITERATURE: Minervino 1970, no. 622, illus.; Sothe-
by's, London, 28 June 1994, Part I, no. 16, illus.

172

Visiting the museum

ca. 1885

Oil on canvas

81.3 × 75.6 cm

Vente stamp below right

L465

Washington, National Gallery of Art
Mr and Mrs Paul Mellon Collection
(1985.64.11)

Colour illus. p. 277

PROVENANCE: Atelier Degas; Vente II, 1918, no. 20;
M. Tiguel, Paris; Mme Friedmann, Paris; Mme René
Dujarric de la Rivière, Boulogne; Wildenstein & Co,
New York, 1972; Mr and Mrs Paul Mellon, Upperville,
1973; gift to the Museum, 1985

EXHIBITIONS: 1955 Paris, no. 73, p. 20, illus.; 1960
Paris, no. 19, illus.; 1978 Richmond, no. 10; 1986,
Washington, National Gallery of Art, *Gifts to the
Nation: Selected Acquisitions from the Collections of Mr. and
Mrs. Paul Mellon*; 1988–89 Paris/Ottawa/New York,
under no. 76, illus.

LITERATURE: Sickert 1917, p. 186; Rivière 1935, p. 24,
illus.; Lucretia H. Giese, A Visit to the Museum, *Boston
Museum of Fine Arts Bulletin*, LXXVI, 1978, pp. 43f.; 1984
Chicago, p. 118

173

Woman in a red shawl (Hélène Rouart?)

('*Femme au châle rouge*')

1886

Oil on canvas, 75 × 62 cm, L867

Private collection

Colour illus. p. 249

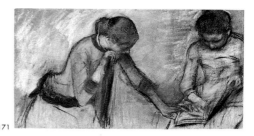

171

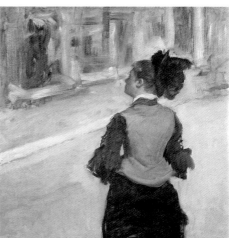

172

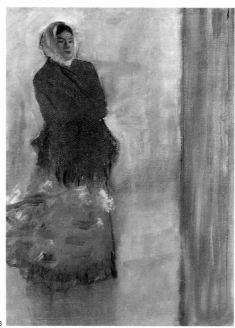

173

PROVENANCE: René de Gas, Paris; Vente 1927, no. 83, illus.; Paul Cassirer, Berlin; Mendelssohn collection, Berlin; Mendelssohn heirs, Berlin; purchased on the art market in Switzerland, 1958

174
Bust portrait of a woman
1887–90
Oil on canvas
55 × 36 cm
L922
Private collection
Colour illus. p. 236

PROVENANCE: Atelier Degas; sale I, 1918, no. 14; Monteux collection, Paris; 1989 Sotheby's New York, The Collection John T. Dorrance, Jr, no. 10
LITERATURE: Minervino 1974, no. 667

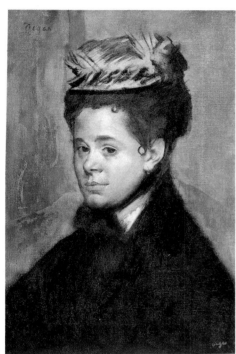

174

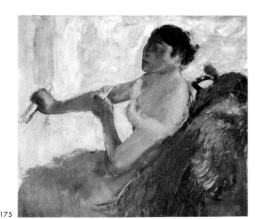

175

175
Rose Caron
(*'Femme assise tirant son gant'*)
ca. 1892
Oil on canvas
76.2 × 86.2 cm
Vente stamp lower left
L862
Buffalo, Albright-Knox Art Gallery
Charles Clifton, Charles W. Goodyear and Elisabeth H. Gates Funds, 1943 (43.1)
Colour illus. p. 285

PROVENANCE: Atelier Degas; Vente III, 1919, no. 17; Dr Georges Viau, Paris 1919–30; André Weil et les Matignon Art Gallery, New York, 1939; acquired by the Museum in 1939
EXHIBITIONS: 1931 Paris, Orangerie, ex-catalogue; 1938, Amsterdam, Stedelijk Museum, *Hondert Jaar Fransche Kunst*, no. 107, illus.; 1947 Cleveland, no. 47a, illus.; 1948 Minneapolis, no. 27; 1949 New York, no. 74, illus.; 1954, Buffalo, Albright Art Gallery, *Painter's Painters*, no. 30, illus.; 1954 Detroit, no. 74, illus.; 1957, Montclair (N.J.), Montclair Art Museum, *Master Painters*, no. 15; 1958, Houston, The Museum of Fine Arts, *The Human Image*, no. 52, illus.; 1958 Los Angeles, no. 54; 1960, Houston, The Museum of Fine Arts, *From Gauguin to Gorky*, no. 17, illus.; 1960 New York, no. 48, illus.; 1961, Pittsburgh, Museum of Art, Carnegie Institute, *Paintings from the Albright Gallery Collection* (no catalogue); 1961, New Haven, Yale University Art Gallery, *Paintings and Sculpture from the Albright Art Gallery*, no. 14; 1962 Baltimore, no. 49, illus.; 1968, Baltimore, Museum of Art, *From El Greco to Pollock: Early and Late Works by European and American Artists*, p. 60, illus.; 1968, Washington, National Gallery of Art, *Paintings from the Albright Knox Art Gallery*, illus.; 1972, New York, Wildenstein & Co., *Faces from the World of Impressionism and Post-Impressionism*, no. 23; 1978 New York, no. 36; 1986, Houston, The Museum of Fine Arts, *The Portrait in France 1700–1900*, no. 40, illus.; 1988–89 Paris/Ottawa/New York, no. 326, illus.

LITERATURE: *Arts et Decoration*, XI, 3 July 1919, p. 114; *Annuaire de la Curiosité et des Beaux-Arts*, 1920, p. 43; Waldemar George, La Collection Viau, I. La Peinture Moderne, *L'Amour de l'Art*, September 1925, p. 364; C. Roger-Marx, Edgar Degas, *La Renaissance*, XXII, 4 August 1939, p. 52; Buffalo, Albright Art Gallery, *Catalogue of the Paintings and Sculpture in the Permanent Collection*, Buffalo 1949, I, pp. 78, 193, no. 36, illus.; Boggs 1962, pp. 64f., 69, 112, illus.; Minervino 1974, no. 670; Millard 1976, pp. 11f., illus.; Stephen A. Nash *et al.*, Albright-Knox Art Gallery, *Painting and Sculpture from Antiquity to 1942*, New York 1979, pp. 216f., illus.; Loyrette 1991, pp. 545ff.

176
'The brown dress'
(*'Femme assise'*)
ca. 1893
Pastel
65 × 49 cm
L1140
Manchester, The Whitworth Art Gallery, University of Manchester (D.1926.3)
Colour illus. p. 246

PROVENANCE: Atelier Degas; Bernheim Jeune, Paris; Independent Gallery, London; acquired by the Museum, 1926
EXHIBITIONS: 1969 Nottingham; 1981, Manchester, The Whitworth Art Gallery, *French 19th Century Drawings in the Whitworth Art Gallery*, no. 21; 1986, Oxford, Ashmolean Museum/Manchester City Art Gallery/Glasgow, The Burrell Collection, *Impressionist Drawings*, no. 22
LITERATURE: Boggs 1962, pp. 64, 95; Pickvance 1964, pp. 162f.; Minervino 1970, no. 1163

177
Henri Rouart and his son Alexis
1895–98
Oil on canvas
92 × 72 cm
Vente stamp lower right
L1176
Munich, Bayerische Staatsgemäldesammlungen, Neue Pinakothek (13681)
Colour illus. p. 225

PROVENANCE: Atelier Degas; sale I, 1918, no. 17; Jacques Seligmann, Paris; American Art Association, sale, 27 January 1921, no. 44; Galerie Justin Tannhauser, Lucerne and New York; acquired by the Museum, 1965
EXHIBITIONS: 1949 New York, no. 83, illus.; 1960 New York, no. 63, illus.; 1988–89 Paris/Ottawa/New York, no. 11 (exhibited only in Paris), illus.

176

178

Alexis Rouart

1895

Charcoal and pastel on paper

58.8 × 40.5 cm

Signed below right: Degas; inscribed top right:
Alexis Rouart/Mars 1895

BR 139

Private collection, New York

Colour illus. p. 224

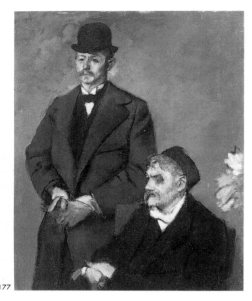

177

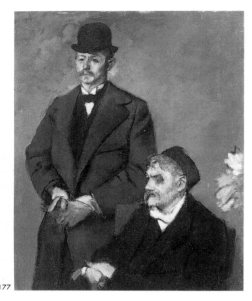

178

PROVENANCE: Louis Heim, Paris; Mme Bloch, Paris;
Wildenstein & Co., New York

EXHIBITIONS: 1951–52 Berne, no. 110; 1972, New
York, Wildenstein & Co., *Faces from the World of Impres-
sionism and Post-Impressionism*, no. 25, illus.; 1975, Phil-
adelphia, Armory of the First Troop, *Centennial Fair in
Celebration of the Philadelphia Museum of Art's 100th
Birthday*; 1976 Tokyo/Kyoto/Fukuoka, no. 50, illus.;
1979, New York, Wildenstein, *French Pastels*, no. 15;
1984 Tübingen, no. 193

LITERATURE: Terrasse 1972, p. 65, illus.; *Pictures on
Exhibit*, XXXVI, November 1972, p. 13, illus.; Miner-
vino 1974, under no. 1176; 1988–89 Paris/Ottawa/New
York, under no. 336, illus.; Boggs/Maheux 1992, p. 183

179

Washerwomen, horses

ca. 1904

Charcoal and pastel on strengthened paper

84 × 107 cm

Vente stamp lower left

L1418

Lausanne, Musée Cantonal des Beaux-Arts
(333)

Colour illus. p. 300

PROVENANCE: Atelier Degas; Vente I, 1918, no. 182;
Galerie Paul Rosenberg, Paris; M. Snayers, Brussels;
sale, Brussels, 4 May 1925, no. 45, illus.; Dr A. Widmer,
Valmont-Territet; bequest to the Museum

EXHIBITIONS: 1907–08 Manchester, Manchester City
Art Gallery, *Modern French Paintings*, no. 173 (?);
1951–52 Berne, no. 69; 1952 Amsterdam, no. 56; 1967
Geneva, Musée de l'Athenée, *De Cézanne à Picasso*;
1984 Tübingen, no. 218, illus.; 1987 Manchester, pp.
103, 105, illus.; 1993 Martigny, no. 26; 1994, Lausanne,
Musée Cantonal des Beaux-Arts, *Une collection dévoilée*

LITERATURE: Browse 1949, no. 235a, p. 411; Cooper
1952, pp. 14, 26, no. 31, illus.; Cabanne 1960, under
nos. 73, 101; Janis 1967, p. 22, note 14; René Berger,
Promenade au Musée Cantonal des Beaux-Arts de Lausanne,
Lausanne 1970, p. 40, illus.; Catalogue du Musée des
Beaux-Arts, Lausanne 1971; Minervino 1974, no. 1192;
Terrasse 1981, no. 669, illus.; Sutton 1986, no. 299,
illus.

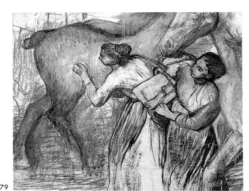

179

180

Mme Alexis Rouart

ca. 1905

Charcoal and pastel

59.7 × 45.7 cm

Vente stamp lower left

Saint Louis, The Saint Louis Art Museum
Museum and Friends Fund and funds given by
Mr and Mrs James E. Rarick, by exchange

Colour illus. p. 224

PROVENANCE: Atelier Degas; Vente III, 1919, no. 303;
Durand-Ruel, Paris; Nierendorf Galleries, New York;
Samuel A. Berger, New York; Sotheby Parke Bernet,
New York, 27 April 1972, no. 55; Greenberg Gallery of
Contemporary Art, Saint Louis; acquired by the
Museum 1979

EXHIBITIONS: 1967 Saint Louis, no. 144, illus.;
1988–89 Paris/Ottawa/New York, no. 390, illus.

LITERATURE: Boggs 1962, illus.

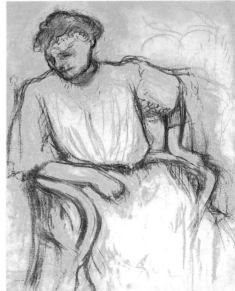

180

Bibliography

Abbreviations

Adhémar/Cachin: Adhémar, Jean/Cachin, Françoise, *Edgar Degas, Gravures et Monotypes,* Paris 1973

BN: Bibliothèque Nationale (see further Reff below)

BR: Brame Philippe/Reff Theodore, *Degas et son Œuvre: A Supplement,* New York 1984

Degas inédit 1989: Musée d'Orsay/Ecole du Louvre, *Degas inédit, Actes du Colloque Degas, Musée d'Orsay, 18–21 April 1988,* Paris 1989

Janis: exhibition catalogue 1968 Cambridge: *Degas Monotypes, Essay, Catalogue and Checklist* by Eugenia Parry Janis, Fogg Art Museum, Cambridge 1968

L: Lemoisne, Paul André, *Degas et son Œuvre,* 4 vols., Paris 1946–49

Lettres 1945: Guérin, Marcel (ed.), *Lettres de Degas,* Paris 1945

Pingeot: Pingeot, Anne, *Degas Sculptures,* Paris 1991

Reed/Shapiro: Welsh Reed, Sue/Stern Shapiro, Barbara, *Edgar Degas: The Painter as Printmaker,* Museum of Fine Arts, Boston 1984/Philadelphia Museum of Arts Arts Council of Great Britain, Hayward Gallery, London 1984 (= 1984–85 Boston/Philadelphia/London in *Exhibition Catalogues*)

Reff: Reff, Theodore, *The Notebooks of Edgar Degas,* 2 vols., Oxford 1976/New York 1985; Reff's numbers, Bibliothèque Nationale numbers (where appropriate) and the notebook page numbers have been given as follows: Reff 23, BN21, p. 44

Vente I-IV: *Catalogue des Tableaux, Pastels et Dessins par Edgar Degas et Provenant de son Atelier,* Galerie Georges Petit, Paris 1918–1919; reprint San Francisco 1989 (= Vente Atelier Edgar Degas in *Auction Catalogues*)

Exhibition Catalogues

1892 Paris: *Paysages de Degas,* Galerie Durand-Ruel, Paris 1892

1913 Berlin: *Degas-Cézanne,* Galerie Paul Cassirer, Berlin 1913

1922 New York: *Degas. Prints, Drawings and Bronzes,* The Grollier Club, New York 1922

1924 Paris: *Degas* (introduction by Daniel Halévy, catalogue by Marcel Guérin), Galerie Georges Petit, Paris 1924

1926 Munich: *Edgar Degas. Pastelle, Zeichnungen, das Plastische Werk,* Galerie Thannhauser, Munich 1926

1928 London: *Works by Degas,* Alex. Reid & Lefevre Gallery, London 1928

1930 New York: *Drawings by Degas,* Jacques Seligmann Gallery, New York 1930

1931 Cambridge (Mass.): *A Loan Exhibition of Paintings and Pastels by Degas,* Fogg Art Museum, Cambridge (Mass.) 1931

1931 Paris: *Degas. Portraitiste, sculpteur* (introduction by Paul Jamot, catalogue by Charles Sterling/Paul Vitry), Musée de l'Orangerie, Paris 1931

1932 Saint Louis: *Drawings by Degas,* City Art Museum, Saint Louis 1932

1933 Northampton: *Edgar Degas,* Smith College Museum of Art, Northampton 1933

1935 Buenos Aires: *Degas,* Buenos Aires 1934

1935 Zurich: *Degas* (introduction by Gotthard Jedlicka), Galerie Aktuaryus, Zurich 1935

1936 Philadelphia: *Degas 1834–1917* (catalogue by Agnes Mongan), The Pennsylvania Museum of Art, Philadelphia 1936

1937 Paris: Degas (catalogue by Jacqueline Bouchot-Saupique, Marie Delaroche-Vernet), Orangerie des Tuileries, Paris 1937

1938 Paris: *Degas,* Galerie Mouradian et Vallotton, Paris 1938

1939 Paris: *Degas. Peintre du mouvement* (introduction by Claude Roger-Marx), Galerie André Weil, Paris 1939

1945 New York: *Edgar Degas,* Buchholz Gallery, New York 1945

1947 Cleveland: *Works by Edgar Degas* (introduction by Henry Sayles Francis), Museum of Art, Cleveland 1947

1947 Washington: *Loan Exhibition of Drawings and Pastels by Edgar Degas,* Phillips Memorial Gallery, Washington 1947

1948 Copenhagen: *Degas,* Ny Carlsberg Glyptothek, Copenhagen 1948

1948 Minneapolis: *Degas. Portraits of his Family and Friends,* Institute of Fine Arts, Minneapolis 1948

1949 New York: *Loan Exhibition of Degas* (catalogue by Daniel Wildenstein), Wildenstein Gallery, New York 1949

1950 London: *Degas,* Lefevre Gallery, London 1950

1950 Toledo: *Degas Exhibition,* Museum of Art, Toledo 1950

1951–52 Bern: *Degas* (catalogue by Fritz Schmalenbach), Kunstmuseum, Bern 1951

1952 Amsterdam: *Edgar Degas,* Stedelijk Museum, Amsterdam 1952

1952 Edinburgh/London: *Degas* (catalogue by Derek Hill), Edinburgh Festival Society and Royal Scottish Academy, Edinburgh/Tate Gallery; London 1952

1955 New York: *Edgar Degas: Original Wax Sculptures* (introduction by John Rewald), M. Knoedler & Company Inc., New York 1955

1955 Paris: *Degas dans les Collections Françaises* (catalogue by Daniel Wildenstein), Gazette des Beaux-Arts, Paris 1955

1955 San Antonio: *Paintings, Drawings, Prints and Sculpture by Edgar Degas,* Marion Koogler McNay Art Institute, San Antonio 1955

1957 Cambridge (Mass.): *Degas Dancers,* Fogg Art Museum, Cambridge (Mass.) 1957

1958 London: *Degas. Monotypes, Drawings, Pastels, Bronzes* (introduction by Douglas Cooper), Lefevre Gallery, London 1958

1958 Los Angeles: *Edgar Hilaire Germain Degas* (catalogue by Jean Sutherland Boggs), County Museum, Los Angeles 1958

1958 New York: *Renoir-Degas,* Charles E. Slatkin Galleries, New York 1958

1959 Beverly Hills: *Twenty-Six Original Copperplates Engraved by Degas,* Frank Perls Gallery, Beverly Hills 1959

1959 Williamstown: *Exhibit Ten, Degas,* Sterling and Francine Clark Institute, Williamstown 1959

1960 New York: *Degas* (introduction by Kermit Lanser), Wildenstein Gallery, New York 1960

1960 Paris: *Edgar Degas 1834–1917* (introduction by Agathe Rouart Valéry), Galerie Durand Ruel, Paris 1960

1964 Paris: *9 Monotypes de Degas*, L'Œil, Galerie de L'Art, Paris 1964

1965 New Orleans: *Edgar Degas. His Family and Friends in New Orleans* (catalogue by James B. Byrnes), Isaac Delgado Museum, New Orleans 1965

1967 Saint Louis/Philadelphia/Minneapolis: *Drawings by Degas* (catalogue by Jean Sutherland Boggs), City Art Museum, Saint Louis/Philadelphia Museum of Arts/The Minneapolis Society of Fine Arts; Saint Louis 1966

1968 New York: *Degas' Racing World* (catalogue by Ronald Pickvance), Wildenstein Gallery, New York 1968

1968 Cambridge (Mass.): *Degas Monotypes* (catalogue by Eugenia Parry Janis), Fogg Art Museum, Cambridge (Mass.) 1968

1968 Richmond: *Degas*, Virginia Museum of Fine Arts, Richmond 1968

1969 Nottingham: *Degas. Pastels and Drawings* (catalogue by Ronald Pickvance), University Art Gallery, Nottingham 1969

1969 Paris: *Degas. Œuvres du Musée du Louvre. Peintures, pastels, dessins, sculptures* (catalogue by Hélène Adhémar), Orangerie des Tuileries, Paris 1969

1970 London: *Edgar Degas 1834–1917* (introduction by Denys Sutton), Lefevre Gallery, London 1970

1970 Williamstown: *An Exhibition of the Works of Edgar Degas at the Sterling and Francine Clarke Art Institute*, Williamstown 1970

1974 Boston: *Edgar Degas. The Reluctant Impressionist* (catalogue by Barbara S. Shapiro), Museum of Fine Arts, Boston 1974

1974 Dallas: *The Degas Bronzes* (catalogue by Charles Millard), Dallas Museum of Fine Arts, Dallas 1974

1974–75 Detroit: *Works by Edgar Degas in the DIA*, Detroit Institute of Arts, Detroit 1974

1975 New York: *Ingres and Delacroix through Degas and Puvis de Chavannes. The Figure in French Art, 1800–1870*

1975 Paris: *Degas 1834–1917* (introduction by Jean Cau), Galerie Schmit, Paris 1975

1976 London: *The Complete Sculptures of Degas*, Lefevre Gallery, London 1976

1976–77 Tokyo/Kyoto/Fukuoka: *Degas* (catalogue by François Daulte), Seibu Museum of Art, Tokyo/Musée de la Ville de Kyoto/Centre Culturel de Fukuoka; Tokyo 1976

1977 New York: *Degas in the Metropolitan* (catalogue by Charles S. Moffett), The Metropolitan Museum of Art, New York 1977

1978 New York: *Edgar Degas* (introduction by Theodore Reff), Acquavella Gallery, New York 1978

1978 Richmond: *Degas*, Virginia Museum of Fine Arts, Richmond 1978

1979 Edinburgh: *Degas 1879* (catalogue by Ronald Pickvance), National Gallery of Scotland, Edinburgh 1979

1979 Northampton: *Degas and the Dance* (catalogue by Linda D. Muehlig), Smith College Museum of Art, Northampton 1979

1980 Paris: *Degas. La famille Bellelli*, Musée Marmottan, Paris 1980

1981 San Jose: *Mary Cassatt and Edgar Degas*, Museum of Art, San Jose 1981

1983 Copenhagen: *Degas og Familien Bellelli* (catalogue by Hanne Finsen), Ordrupgaardsamlingen, Copenhagen 1983

1983 London: *Edgar Degas* (catalogue by Ronald Pickvance), David Carritt Gallery Ltd, London 1983

1984–85 Boston/Philadelphia/London: *Edgar Degas: The Painter as Printmaker* (catalogue by Sue Welsh Reed and Barbara Stern Shapiro), Museum of Fine Arts, Boston/Philadelphia Museum of Art/Arts Council of Great Britain, Hayward Gallery, London; Boston 1984

1984 Chicago: *Degas in the Art Institute of Chicago* (catalogue by Richard R. Brettell and Suzanne Folds), The Art Institute of Chicago 1984

1984–85 Paris: *Degas le modelé et l'espace*, Centre Culturel du Marais, Paris 1984

1984–85 Rome: *Degas e l'Italia* (catalogue by Henri Loyrette), Villa Medici, Rome 1984

1984 Tübingen: *Edgar Degas: Pastelle, Ölskizzen, Zeichnungen* (catalogue by Götz Adriani), Kunsthalle, Tübingen 1984 (English edn. New York 1985)

1984–85 Washington: *Degas: The Dancers* (catalogue by George T. M. Shackelford), National Gallery of Art, Washington 1984

1985 London: *Degas Monotypes* (catalogue by Anthony Griffiths), Arts Council of Great Britain, Hayward Gallery, London 1985

1986 Florence/Verona: *Degas scultore*, Palazzo Strozzi, Florence/Palazzo di Verona, Verona; Florence 1986

1987 Manchester/Cambridge: *The Private Degas* (catalogue by Richard Thomson), Whitworth Art Gallery, Manchester/Fitzwilliam Museum, Cambridge; Manchester 1987

1988–89 Paris/Ottawa/New York: *Degas* (catalogue by Jean Sutherland Boggs, Henri Loyrette, Michel Pantazzi, Gary Tinterow), Galeries Nationales du Grand Palais, Paris/Musée des Beaux-Arts du Canada, Ottawa/The Metropolitan Museum of Art, New York; Paris/New York 1989

1988 Tokyo: *Degas*, Isetan Museum of Art, Tokyo/Prefectural Art Museum, Mie/Daimuru Museum of Art, Osaka/Prefectural Art Museum, Okayama (1989); Tokyo 1988

1989 Liverpool: *Degas, Images of Women* (catalogue by Richard Thomson), Tate Gallery, Liverpool 1989

1989 London: *Edgar Degas 1837–1917* (introduction by Richard Kendall), Browse and Darby, London 1989

1991 London: *Paintings, Pastels and Drawings by Edgar Degas* (catalogue by Richard Kendall), David Bathurst, London 1991

1991–92 Amsterdam: *Degas Sculptor* (catalogue by Ronald Pickvance), Rijksmuseum Vincent van Gogh, Amsterdam 1991

1993 Martigny: *Degas* (catalogue by Ronald Pickvance), Fondation Pierre Gianadda, Martigny 1993

1994 New York/Houston: *Degas Landscapes* (catalogue by Richard Kendall), Metropolitan Museum of Art, New York/Museum of Fine Arts, Houston 1994

Auction Catalogues

Vente I–IV 1918–1919: *Catalogue des Tableaux, Pastels et Dessins par Edgar Degas et Provenant de son Atelier*, Galerie Georges Petit, Paris 6–8 May (Vente I); 11–13 December 1918 (Vente II); 7–9 April 1919 (Vente III); 2–4 July 1919 (Vente IV)

Vente 1927: *Succession de M. René de Gas. Tableaux, Pastels, Dessins par Edgar Degas*, Hôtel Drouot, Paris, 10 November 1927

Vente 1934: *Collection Mlle J. Fèvre. Catalogue des Tableaux, Aquarelles, Pastels, Dessins, Estampes, Monotypes par Edgar Degas*, Galerie Jean Charpentier, Paris, 12 June 1934

Vente 1976: *Important Ensemble de Dessins par Edgar Degas, Provenant de l'Atelier de l'Artiste et d'une Partie de la Collection Nepveu-Degas*, Drouot Rive-Gauche, Paris, 6 May 1976

Vente Atelier Edgar Degas/Degas's Atelier at Auction I + II 1918, Reprint San Francisco 1989
Vente Atelier Edgar Degas/Degas's Atelier at Auction III + IV 1919, Reprint San Francisco 1989

Catalogues raisonnés

Adhémar, Jean/Cachin, Françoise, *Edgar Degas, Gravures et Monotypes,* Paris 1973

Brame, Philippe/Reff Theodore, *Degas et son Œuvre: A Supplement*, New York/London 1984

Delteil, Loys, *Edgar Degas, Le Peintre-Graveur Illustré*, tome IX, Paris, chez l'Auteur 1919

Janis Parry, Eugenia, *Degas Monotypes*, Cambridge (Mass.) 1968 = 1968 Cambridge

Lemoisne, Paul André, *Degas et son Œuvre*, 4 vols., Paris 1946–49

Minervino, Fiorella/Russoli, Franco, *L'opera completa di Degas*, Milan 1970, 1974, 1988

Pingeot, Anne, *Degas Sculptures*, Paris 1991

Reff, Theodore, *The Notebooks of Edgar Degas: A Catalogue of the thirty-eight Notebooks in the Bibliothèque Nationale and Other Collections*, 2 vols., enlarged edn. New York 1985

Rewald, John, *Degas: Works in Sculpture – A Complete Catalogue*, New York 1944

Rewald, John/Von Matt, Leonard, *Degas Sculpture*, New York 1956

Welsh Reed, Sue/Stern Shapiro, Barbara, *Edgar Degas, The Painter as a Printmaker*, Boston 1984 = 1984 Boston

General Bibliography

Adhémar, Hélène, Edgar Degas et la "Scène de guerre au moyen age", *Gazette des Beaux-Arts*, no. 70, November 1967, pp. 295–298

Adhémar, Jean, Before the Degas Bronzes, *ARTnews*, vol. 54, no. 7, November 1955, pp. 34–35, 70

Adler, Kathleen, Angles of Vision, *Art in America*, vol. 78, no. 1, January 1990, pp. 138–143

Alazard, Jean, *Degas*, Lausanne 1949

Alexandre, Arsène, Degas: graveur et lithographe, *Les Arts*, vol. 15, no. 171, 1918, pp. 11–19

Alexandre, Arsène, Essai sur Monsieur Degas, *Les Arts*, no. 166, 1918, pp. 1–24

Alexandre, Arsène, Degas: Nouveaux Aperçus, *L'Art et les Artistes*, vol. 29, no. 154, February 1935, pp. 145–173

André, Albert, Degas, Paris 1934

Armstrong, Carol, Reflections on the Mirror: painting, photography and the self-portraits of Edgar Degas, *Representations*, no. 22, Spring 1988, pp. 108–141

Armstrong, Carol, *Odd Man Out: Readings of the Work and Reputation of Edgar Degas*, Chicago 1991

Aubry, Yves, Degas et la photographie, *Zoom*, no. 98, 1983, pp. 26–33

Baker, Kenneth, Behind the Scenes: Degas's Dancers, *Art in America*, vol. 73, no. 3, March 1985, pp. 138–145

Barazzetti, S., Degas et Ses Amis Valpinçon, *Beaux-Arts*, no. 190, 21 August 1936, pp. 1–3; no. 191, 28 August 1936, pp. 1,4; no. 192, 4 September 1936, pp. 1–2

Bataille, Marie Louise, Zeichnungen aus dem Nachlass von Degas, *Kunst und Künstler* 28, 1930, pp. 399ff.

Bazin, Germain, Degas: sculpteur, *L'Amour de l'Art*, vol. 12, no. 7, July 1931, pp. 292–301

Bell, Quentin, *Degas – Le Viol*, Charlton Lectures on Art, Newcastle 1965

Bergerat, Emile, Edgar Degas (Souvenirs), *Le Figaro*, 11 May 1918, p. 1

Bielmeier, S., Degas, Mallarmé der Malerei, *Pantheon*, vol. 46, 1988, p. 175f; 178

Boggs, Jean Sutherland, Edgar Degas and the Bellellis, *The Art Bulletin*, vol. 37, no. 2, June 1955, pp. 127–136

Boggs, Jean Sutherland, Degas Notebooks at the

Bibliothèque Nationale, *The Burlington Magazine*, vol. 100, I: Group A (1853–58), no. 662, May 1958, pp. 163–171; II: Group B (1858–61), no. 663, June 1958, pp. 196–205; III: Group C (1863–86), no. 664, July 1958, pp. 240–246

Boggs, Jean Sutherland, *Portraits by Degas*, Berkley/Los Angeles 1962

Boggs, Jean Sutherland, Edgar Degas and Naples, *The Burlington Magazine*, vol. 105, no. 723, June 1963, pp. 273–276

Boggs, Jean Sutherland, Danseuses à la barre by Degas, *The National Gallery of Canada Bulletin*, 2/1, 1964, pp. 1–9

Boggs, Jean Sutherland, Edgar Degas in Old Age, *Allen Memorial Art Museum Bulletin*, vol. 35, nos. 1/2, 1977/1978, pp. 57–67

Boggs, Jean Sutherland, Degas at the Museum, Works in the Philadelphia Museum of Art and John G. Johnson Collection, *Philadelphia Museum of Art Bulletin*, vol. 81, no. 346, Spring 1985

Boggs, Jean Sutherland/Maheux, Anne, *Degas Pastels*, New York 1992

Borel, Pierre, *Les Sculptures Inédites de Degas*, Geneva 1949

Bouillon, J.P., Degas, Bracquemont, Cassatt: actualité de l'Ingrisme autour de 1880, *Gazette des Beaux-Arts*, vol. 111, nos. 1428/1429, 1988, pp. 125–127

Bouret, Jean, *Degas*, Paris/Gütersloh/London 1965

Bouyer, Raymond, Degas, "Peintre Classique et Vrai", d'après un Livre Récent, *Gazette des Beaux-Arts*, vol. 11, January 1925, pp. 43–49

Broude, Norma, Degas's Misogyny, *The Art Bulletin*, vol. 59, no. 1, March 1977, pp. 95–107

Broude, Norma, Edgar Degas and French Feminism ca. 1880; "The Young Spartans", the Brothel Monotypes and the Bathers revisited, *The Art Bulletin*, vol. 70, no. 4, 1988, pp. 640–659

Brown, Marilyn R., Degas and A Cotton Office in New Orleans, *The Burlington Magazine*, vol. 130, no. 1020, March 1988, pp. 216–221

Brown, Marilyn R., Degas, *Southeastern College Art Conference Review*, vol. 11, no. 4, 1989, pp. 320f.

Brown, Marilyn R., The De Gas-Musson Papers at Tulane University, *The Art Bulletin*, vol. 72, March 1990, pp. 118–130

Brown, Marilyn R., Two New Degas Letters in New Orleans, *The Art Bulletin*, vol. 73, no. 2, June 1991, pp. 313f.

Brown, Marilyn R., *Degas and the Business of Art,*

A Cotton Office in New Orleans, Pennsylvania State University, 1994

Browse, Lilian, *Degas's Dancers*, London 1949

Browse, Lilian, Degas's Grand Passion, *Apollo*, vol. 85, no. 60, February 1967, pp. 104–114

Buerger, Janet, F., Degas's Solarized and Negative Photographs: A Look at Unorthodox Classicism, *Image*, vol. 21, no. 2, June 1978, pp. 17–23

Buerger, Janet F., Another Note on Degas, *Image*, vol. 23, no. 1, June 1980, p. 6

Buerger, Janet/Stern Shapiro, Barbara, A Note on Degas's Use of Daguerreotype Plates, *The Print Collector's Newsletter*, vol. 12, no. 4, September/October 1981, pp. 103–106

Burnell, Devin, Degas and His "Young Spartans Exercising", *The Art Institute of Chicago Museum Studies* 4, 1969, pp. 49–65

Burollet, Thérèse, Bartholomé et Degas, *L'Information d'Histoire de l'Art*, vol. 12, no. 3, May/June 1967, pp. 119–126

Burroughs, Bryson, Drawings by Degas, *The Metropolitan Museum of Art Bulletin*, vol. 14, no. 5, May 1919, pp. 115–117

Burroughs, Louise, Degas in the Havemeyer Collection, *The Metropolitan Museum of Art Bulletin*, vol. 27, no. 5, May 1932, pp. 141–146

Burroughs, Louise, Degas Paints a Portrait, *The Metropolitan Museum of Art Bulletin*, vol. 21, no. 5, January 1963, pp. 169–172

Cabanne, Pierre, *Edgar Degas*, Paris 1957

Cabanne, Pierre, Degas et "Les Malheurs de la Ville d'Orléans", *Gazette des Beaux-Arts*, 6e Sér., vol. 59, May/June 1962, pp. 363–366

Cabanne, Pierre, Degas chez Picasso, *Connaissance des Arts*, no. 262, December 1973, pp. 146–151

Cahn, Isabelle, Degas's Frames, *The Burlington Magazine*, vol. 131, no. 1033, April 1989, pp. 289–292

Calingaert, Efrem Gisella, More "pictures within pictures": Degas' portraits of Diego Martelli, *Arts Magazine*, vol. 62, no. 10, Summer 1988, pp. 40–44

Camesasca, Ettore, A proposito di Edgar Degas, *Critica d'Arte*, no. 17, vol. 53, June/August 1988, pp. 57–64

Champignuelle, Bernard, *Degas Dessins*, Paris 1952

Charensol, Georges, *Degas*, Paris 1959

Chialiva, J., Comment Degas a changé sa Technique du Dessin, *Bulletin de la Société de l' Histoire de l' Art Français*, 24, 1932

Clarke, Michael, Degas and Corot: the affinity between two artist's artists, *Apollo*, vol. 134,

no. 353, July 1991, pp. 15–20

Cogeval, G., Degas, Perspectives désarticulées, *Beaux-Arts Magazine*, no. 55, 1988, pp. 50–57

Cooper, Douglas, *Pastelle von Edgar Degas*, Basle 1952

Coquiot, Gustave, *Degas*, Paris 1924

Crespelle, Jean Paul, *Degas et son monde*, Paris 1972

Crimp, Douglas, Positive/Negative: A Note on Degas's Photographs, *October*, 5, Summer 1978, pp. 89–100

Dawkins, Heather, Managing Degas, *Vanguard*, vol. 18, no. 1, February/March 1989, pp. 16–21

Dawkins, Heather/Bernheimer Charles, Degas and the Psychogenesis of Modernism, *Art History*, vol. 13, no. 4, December 1990, pp. 580–585

Dayot, Armand, Edgar Degas, *La Revue Rhenane*, no. 9, June 1924, pp. 539–545

Degas, Edgar, *Huit Sonnets d'Edgar Degas*, Paris 1946

Degas, Edgar, *A Degas sketchbook: The Halévy sketchbook 1877–1883*, New York 1988

Dormoy, Marie, Les Monotypes de Degas, *Arts et Métiers Graphiques*, no. 51, February 1936, pp. 33–38

Du Bos, Charles, Remarques sur Degas, *La Revue Critique des Idées et des Livres*, vol. 34, no. 200, May 1922, pp. 262–277

Dufwa, Jacques, *Winds from the East, A Study in the Art of Manet, Degas, Monet and Whistler 1856–86*, Uppsala 1981

Dumas, Ann, *Degas's "Mlle. Fiocre" in Context, A Study of "Portrait de Mlle. E. Fiocre; à propos du ballet La Source"*, The Brooklyn Museum, New York 1988

Dunlop, Ian, *Degas*, New York 1979

Dunstan, Bernard, The Pastel Techniques of Edgar Degas, *American Artist*, vol. 36, no. 362, September 1972, pp. 41ff.

Duranty, Edmond, *La Nouvelle Peinture à Propos du Groupe d'Artistes Qui Expose dans les Galeries Durand-Ruel*, Paris 1876

Failing, Patricia, The Degas Bronzes Degas Never Knew, *ARTnews*, vol. 78, no. 4, April 1979, pp. 38–41

Failing, Patricia, Cast in Bronze: The Degas Dilemma, *ARTnews*, vol. 1, January 1988, pp. 136–141

Fernandez, Raphael/Murphy, Alexandra R., *Degas in the Clark Collection, Williamstown*, Sterling and Francine Clark Art Institute, Williamstown 1987

Fevre, Jeanne, *Mon oncle Degas*, Geneva 1949

Fletcher, Shelley/Desantis, Pia, Degas, The Search for his Technique continues, *The Burlington Magazine*, vol. 131, no. 1033, April 1989, pp. 256-265

Fosca, François, *Degas*, Paris 1921

Fosca, François, *Degas*, Geneva/Paris/New York 1954

Francis, Henry S., Drawings by Degas, *Bulletin of the Cleveland Museum of Art*, 44, December 1957, p. 216

Fries, Gerhard, Degas et les Maîtres, *Art de France*, vol. 4, 1964, pp. 352–359

Gaisford, John, *The Great Artists: Degas*, London 1985

Gauguin, Paul, Degas, *Kunst und Künstler* 10, March 1912, pp. 333ff.

Geffroy, Gustave, Degas, *L'Art dans les Deux Mondes*, no. 5, December 1890, pp. 46–48

Geffroy, Gustave, Degas, *L'Art et les Artistes*, vol. 4, no. 37, April 1908, pp. 15–23

Geist, Sidney, Degas's "Intérieur" in an Unaccustomed Perspective, *ARTnews*, vol. 75, no. 8, October 1976, pp. 80–82

George, Waldemar, Degas et L'Inquiétude Moderne, *L'Art Vivant*, August 1927, pp. 600–602

George, Waldemar, Œuvres de Vieillesse de Degas, *La Renaissance*, vol. 19, nos. 1/2, January/February 1936, pp. 2–4

Gerstein, Marc, Degas's Fans, *The Art Bulletin*, vol. 64, no. 1, March 1982, pp. 105–118

Ghirardi, Giulio, Zandomeneghi e Boldini, due transfugae amici di Degas, *Bruckmanns Pantheon*, vol. 47, 1989, p. 185f, p. 188

Giacomazzi, Giorgio, Versuch über die Visualität der Moderne. Benjamin, Degas und der Impressionismus, *Notizbuch* 7, 1982, pp. 151ff.

Gillet, Louis, A L'Exposition Degas, *Revue des Deux Mondes*, vol. 20, April 1924, pp. 866–880

Gillet, Louis, A L'Exposition Degas, *Revue des Deux Mondes*, vol. 38, April 1937, pp. 686–695

Gordon, R./Forge A., *Degas*, Paris 1988

Goulon Sigwalt, Edouard, Les ancêtres paternels d'Edgar Degas, *Cahiers du centre généalogie protestante*, no. 22, 2e trimestre, 1988, pp. 1188–1191

Graber, Hans, *Edgar Degas. Nach eigenen und fremden Zeugnissen*, Basle 1942

Grappe, Georges, Edgar Degas, *L'Art et le Beau*, vol. 3, no. 1, 1908

Grappe, Georges, *Degas*, Paris 1936

Griffiths, A., Monotypes, *Print Quarterly*, vol. 5, no. 1, 1988, pp. 56–60

Growe, Bernd, *Zur Bildkonzeption Edgar Degas'*, Frankfurt am Main 1981

Gruetzner, Anna, Degas and George Moore: Some Observations about the Last Impressionist Exhibition, in: Richard Kendall (ed.), *Degas 1834–1984*, Manchester 1985, pp. 32–39

Gsell, Paul, Edgar Degas, Statuaire, *La Renaissance de l'Art Français et des Industries de Luxe*, December 1918, pp. 373–378

Guérin, Marcel, Notes sur les Monotypes de Degas, *L'Amour de l'Art*, vol. 5, March 1924, pp. 77–80

Guérin, Marcel, Remarques sur des portraits de famille peints par Degas à propos d'une vente récente, *Gazette des Beaux-Arts*, June 1928, pp. 372ff.

Guérin, Marcel (ed.), *Dix-Neuf Portraits de Degas par Lui-Même*, Paris 1931

Guérin, Marcel (ed.), *Lettres de Degas*, Paris 1945

Guérin, Marcel (ed.), Kay, Marguerite (trans.), *Degas Letters*, Oxford 1947

Halévy, Daniel, *Album de Dessins de Degas*, Paris 1949

Halévy, Daniel, *Degas parle*, Paris/Geneva 1960

Halévy, Daniel, *My Friend Degas*, London 1964

Harbison, Robert, Edgar Degas, The Darkness Within, *ARTnews*, December 1993, pp. 65–66

Hausenstein, Wilhelm, Der Geist des Edgar Degas, *Pantheon*, 7, 4 April 1931, p. 131

Hausenstein, Wilhelm, *Degas*, Berne 1948

Hendy, Philippe, Degas and the De Gas, *Bulletin of the Museum of Fine Arts*, Boston, 29, April 1921, p. 43

Hertz, Henri, Degas et les Formes Modernes. Son Dessin, sa Sculpture, *L'Amour de l'Art*, April 1922, pp. 105ff.

Hertz, Henri, *Degas*, Paris 1924

Hoctin, Luce, Degas Photographe, *L'Œil*, no. 65, May 1960, pp. 36–43

Hofmann, W., Degas et le Drame de la Peinture, *Gazette des Beaux-Arts*, vol. 3, no. 1428, 1988, pp. 119–122

Hofstadter, Dan, Writing about Degas, *New Criterion*, vol. 6, no. 9, May 1988, pp. 60–68

Hoppe, Ragnar, *Degas och hans arbeten: Nordisk ägo*, Stockholm 1922

Hüttinger, Eduard, *Degas*, Munich/New York 1977

Huyghe, René, Degas ou la fiction réaliste, *L'Amour de l'Art*, vol. 12, July 1931, pp. 271–282

Huyghe, René, *Edgar Hilaire Germain Degas*, Paris 1953

Huysmans, Joris-Karl, *Certains: G. Moreau, Degas, Chéret, Whistler, Rops, Le Monstre, Le Fer etc.*, Paris 1889

Imdahl, Max, Die Momentfotografie une "Le Comte Lepic" von Degas, in *Festschrift für Gerd von der Osten*, Cologne 1970

Jamot, Paul, Degas (1834–1917), *Gazette des Beaux-Arts*, vol. 14, April/June 1918, pp. 123–166

Jamot, Paul, *Degas*, Paris 1924

Janis Parry, Eugenia, Degas Drawings, *The Burlington Magazine*, vol. 109, 772, July 1967, pp. 413ff.

Janis Parry, Eugenia, The Role of the Monotype in the Working Method of Degas, *The Burlington Magazine*, vol. 109, 766–767, January/February 1967, pp. 20ff.

Janis Parry, Eugenia, Degas and the "Master of Chiaroscuro", *Museum Studies* 7, 1972, pp. 52–71

Janis Parry, Eugenia, Edgar Degas and the flowering of scholarship, *Drawing*, vol. 10, no. 6, March/April 1989, pp. 126–131

Janis Parry, Eugenia/Thomson, Richard, Degas: The Nudes, *The Burlington Magazine*, vol. 132, no. 1045, April 1990, pp. 279–281

Janneau, Guillaume, Les Sculptures de Degas, *La Renaissance de l'Art Français*, vol. 4, no. 7, July 1921, pp. 352f.

Jeanniot, Georges, Souvenirs sur Degas, *La Revue Universelle*, vol. 55, nos. 14/15, 15 October and 1 November 1933, pp. 152–174; 280–304

Joly, Jeanne, Sur Deux Modèles de Degas, *Gazette des Beaux-Arts*, vol. 69, May/June 1967, pp. 373f.

Keller, Harald, *Edgar Degas: Die Familie Bellelli*, Stuttgart 1962

Keller, Horst, *Edgar Degas*, Munich 1988

Kendall, Richard, Degas and the Contingency of Vision, *The Burlington Magazine*, vol. 130, no. 1020, March 1988, pp. 180–197

Kendall, Richard, The most merciless draughtsman in the world: The drawings of Edgar Degas, *Apollo*, vol. 134, no. 353, July 1991

Kendall, Richard/Pollock Griselda (ed.), *Dealing with Degas*, London 1992, p. 45

Keyser, Eugénie de, *Degas, Réalité et Métaphore*, Louvain-la-Neuve, 1981

Kitaj, Ron, An uneasy participant in the tragicomedy of modern art, mad about drawing, *The Burlington Magazine*, vol. 130, no. 1020, March 1988, p. 179

Kitaj, Ron, Degas and the nude, *Modern Painters*,

vol. 1, no. 2, Summer 1988, p. 93

Koshkin-Youritzin, Victor, The Irony of Degas, *Gazette des Beaux-Arts*, vol. 87, January 1976, pp. 33–40

Kresak, Fedor, *Edgar Degas*, Prague 1979

Kuspit, Donald B., Between solitude and intimacy: Edgar Degas and the realism of illusion, *Arts Magazine*, vol. 63, no. 7, March 1989, pp. 58–62

Lafond, Paul, *Degas*, 2 vols., Paris 1918–19

Landini, Lando, Degas e dintorni: l'ambiente fiorentino e altri amici italiani, *800 Italiano*, vol. 1, no. 3, September 1991, pp. 18–26

Lassaigne, Jacques, *Edgar Degas*, Paris 1945

Lay, Howard G., Degas at Durand-Ruel, 1892: The Landscape Monotypes, *The Print Colletor's Newsletter*, vol. 9, no. 5, November/December 1978, pp. 142–147

Lefébure, Amaury, *Degas*, Paris 1981

Lemoisne, Paul André, *Degas*, Paris 1912

Lemoisne, Paul André, Les Statuettes de Degas, *Art et Décoration*, no. 214, September/October 1919, pp. 109–117

Lemoisne, Paul André, Les Carnets de Degas au Cabinet des Estampes, *Gazette des Beaux-Arts*, vol. 3, April 1921, pp. 219–231

Lemoisne, Paul André, Artistes Contemporains: Edgar Degas à propos d'une exposition récente, *Revue de l'Art Ancien et Moderne*, vol. 46, June 1924, pp. 17–28; July 1924, pp. 95–108

Lemoisne, Paul André, Le Portrait de Degas par lui-même, *Beaux-Arts*, December 1927, pp. 314ff.

Lemoisne, Paul André, A propos des Degas dans la Collection de Marcel Guérin, *L'Amour de l'Art*, 12, July 1931, pp. 284–291

Lemoisne, Paul André, Degas, *Beaux-Arts*, vol. 75, no. 219, 12 March 1937, pp. A-B

Lemoisne, Paul André, *Degas et son Œuvre*, Paris 1954

Lévêque, Jean Jacques, *Edgar Degas*, Paris 1978

Leymaire, Jean, *Les Degas au Louvre*, Paris 1947

Leymarie, Jean, *Les Dessins de Degas*, Paris 1948

Liebermann, Max, Degas, offprint from *Pan*, Berlin 1988

Lipton, Eunice, Degas's Bathers: The Case for Realism, *Arts Magazine*, vol. 54, no. 9, May 1980, pp. 94–97

Lipton, Eunice, The Laundress in Late Nineteenth-Century French Culture: Imagery, Ideology and Edgar Degas, *Art History*, vol. 3, no. 3, September 1980, pp. 295–313

Lipton, Eunice, Deciphering a Friendship: Edgar Degas and Evariste de Valernes, *Arts Magazine*, vol. 55, no. 10, June 1981, pp. 128–132

Lipton, Eunice, *Looking into Degas. Uneasy Images of Women and Modern Life*, Berkley/Los Angeles/London 1986

Lloyd, Christopher, Degas and Sickert in Liverpool, *Apollo*, vol. 130, no. 334, December 1989, p. 415

Lockhart, Anne I., Three Monotypes by Edgar Degas, *The Bulletin of The Cleveland Museum of Art*, vol. 64, November 1977, pp. 299–306

Longstreet, Stephen, *The Drawings of Degas*, Alhambra 1964

Loyrette, Henri, Degas, *Revue du Louvre et des Musées de France*, vol. 38, 1988, no. 1, pp. 61f.

Loyrette, Henri, Degas entre Gustave Moreau et Duranty: Notes sur le Portrait, *Revue de l'Art*, no. 86, 1989, pp. 16–27

Loyrette, Henri, Degas pour son ami Valernes, *Revue de l'Art*, no. 86, 1989, pp. 82f.

Loyrette, Henri, *Degas*, Paris 1991

Loyrette, Henri, Edouard Manet by Edgar Degas, *La Revue du Louvre/La Revue des Musées de France*, vol. 43, no. 1, February 1993, p. 89

Loyrette, Henri, *Degas, The Man and His Art*, New York 1993

Loyrette, Henri/Serullaz, A., Degas et les artistes français en Italie (1856–1860), *Revue du Louvre et des Musées de France*, vol. 38, 1988, no. 1, p. 63

Manson, James Bolivar, *The Life and Work of Edgar Degas*, London 1927

Martelli, Diego, *Les Impressionistes et L'Art Moderne*, Paris 1979

Martensen Larsen, B., Degas' the Little Fourteen-year-old dancer, an Element of Japonisme, *Gazette des Beaux-Arts*, vol. 112, no. 1436, pp. 107–114

Marx, Roger, Cartons d'Artistes: Degas, *L'Image*, 11 October 1897, pp. 321–325

Mauclair, Camille, Artistes Contemporains: Edgar Degas, *La Revue de l'Art Ancien et Moderne*, vol. 14, no. 80, November 1903, pp. 381–398

Mauclair, Camille, *Degas*, Paris 1937

Mayne, Jonathan, Degas's Ballet Scene from "Robert le Diable", *Victoria and Albert Museum Bulletin*, vol. 2, no. 4, October 1966, pp. 148–156

Mazur, Michael, The case for Cassatt, *The Print Collector's Newsletter*, vol. 20, no. 6, January/February 1990, pp. 197–201

McCarty, John, A Sculptor's Thoughts on the Degas Waxes, in: *Essays In Honor of Paul Mellon,*

Collector and Benefactor, Washington, National Gallery of Art, 1986

McMullen, Roy, *Degas: His Life, Times and Work*, Boston 1984

Meier-Graefe, Julius, *Degas*, Munich 1920, 1924

Meier-Graefe, Julius, *Degas*, London 1923

Meller, Mari K., Exercises in and around Degas' classrooms: part 2, *The Burlington Magazine*, vol. 132, no. 1045, April 1990, pp. 253–262

Meyer, L., Degas coloriste, *L'Estampille*, no. 213, 1988, pp. 22–29

Michel, Alice, Degas et son Modèle, *Mercure de France*, vol. 131, 1 February and 16 February 1919, pp. 457–478; 623–639

Millard, Charles W., *The Sculpture of Edgar Degas*, Princeton 1976

Mitchell, Eleanor, "La Fille de Jephté" par Degas: Genèse et Evolution, *Gazette des Beaux-Arts*, vol. 18, October 1937, pp. 175–189

Moffett, Charles S., *Degas: Paintings in the Metropolitan Museum of Art*, New York 1979

Mongan, Agnes, Portrait Studies by Degas in American Collections, *Bulletin of the Fogg Art Museum 1, 4, May 1932, pp. 63ff.*

Mongan, Agnes, Degas as Seen in American Collections, The Burlington Magazine, vol. 72, June 1938, pp. 290ff.

Monnier, Geneviève, Les Dessins de Degas du Musée du Louvre: historique de la collection, *La Revue du Louvre et des Musées de France*, vol. 19, no. 6, 1969, pp. 359–368

Monnier, Geneviève, La Genèse d'une Oeuvre de Degas: "Sémiramis Construisant une Ville", *La Revue du Louvre et des Musées de France*, vol. 28, nos. 5/6, 1978, pp. 407–426

Moore, George, Degas in Bond Street, *The Speaker*, London, 2 January 1892, pp. 19f.

Moore, George, Degas: The Painter of Modern Life, *Magazine of Art*, September 1890, pp. 416–425

Moore, George, Degas, *Kunst und Künstler*, 6, no. 3, 1908, pp. 98ff.; pp. 138ff.

Moore, George, Memories of Degas, *The Burlington Magazine*, vol. 32, no. 178/179, January/February 1918, pp. 22–29; 63–65

Moreau Nélaton, Etienne, Deux Heures avec Degas: Interview Posthume, *L'Amour de l'Art*, no. 7, July 1931, pp. 267–270

Mycho, André, Degas, *Gil Blas*, 18 December 1912, p. 1

N.N, Degas, *La Bibliothèque des Expositions*, Paris 1988

Nathanson, Carol/Olszewski, Edward J., Degas's Angel of the Apocalypse, *The Bulletin*

of the Cleveland Museum of Art, vol. 67, no. 8, October 1980, pp. 243–255

Newhall, Beaumont, Degas: Amateur Photographer, Eight unpublished Letters by the Famous Painter Written on an Photographic Vacation, *Image*, vol. 5, no. 6, June 1956, pp. 124–126

Newhall, Beaumont, Degas, Photographe Amateur, Huit Lettres Inédites, *Gazette des Beaux-Arts*, vol. 61, January 1963, pp. 61–64

Nicolson, Benedict, Editorial: Degas as a Human Being, *The Burlington Magazine*, vol. 105, no. 723, June 1963, pp. 239–241

Nora, Françoise, Degas et les maisons closes, *L'Oeil*, no. 219, October 1973, pp. 26–31

Norton Simon Museum (ed.), *Degas in Motion*, Mount Vernon N.Y. 1982

Pantazzi, M., Lettres de Degas à Therese Morbilli conservées au Musée des Beaux-Arts du Canada, *Racar, Revue d'Art Canadienne*, vol. 15, no. 2, 1988, pp. 122–135

Pecirka, Jaromir, Edgar Degas, *Zeichnungen*, Prague 1963

Pencenat, C., "Miss Lala au cirque Fernando" de Degas, *Beaux-Arts Magazine*, no. 55, 1988, pp. 58f.

Pickvance, Ronald, A Newly Discovered Drawing by Degas of George Moore, *The Burlington Magazine*, vol. 105, no. 723, June 1963, pp. 276–280

Pickvance, Ronald, Degas's Dancers: 1872–6, *The Burlington Magazine*, vol. 105, no. 723, June 1963, pp. 256–266

Pickvance, Ronald, Drawings by Degas in English Public Collections, *The Connoisseur*, vol. 157, nos. 632–633, October/November 1964, pp. 82f. and 162f. and *The Connoisseur*, vol. 159, nos. 641–642, July/August 1965, pp. 158f., pp. 228f.

Pickvance, Ronald, Some Aspects of Degas's Nudes, *Apollo*, vol. 83, no. 47, January 1966, pp. 17–23

Pickvance, Ronald/Pecirka, Jaromir, *Degas Drawings*, London 1969

Pickvance, Ronald, Degas as a Photographer, *Lithopinion*, vol. 5, no. 1, Spring 1970, pp. 72–79

Pool, Phoebe, Degas and Moreau, *The Burlington Magazine*, vol. 105, no. 723, June 1963, pp. 251–256

Pool, Phoebe, Some Early Friends of Edgar Degas, *Apollo*, vol. 79, no. 27, May 1964, pp. 391–394

Pool, Phoebe, The History Pictures of Edgar Degas and their Background, *Apollo*, vol. 80,

no. 32, October 1964, pp. 306–311

Pool, Phoebe, *Degas*, London 1967

Raimondi, Riccardo, *Degas e la sua famiglia in Napoli 1793–1917*, Naples 1958

Raunay, Jeanne, Degas. Souvenirs Anecdotiques, *La Revue de France*, Year 11, vol. 2, no. 6 (15 March 1931), pp. 263–282; no. 7 (1 April 1931), pp. 469–483; no. 8 (15 April 1931), pp. 619–632

Rebatet, Marguerite, *Degas*, Paris 1944

Reed Welsh, Sue, Music in the Air, *ARTnews*, vol. 83, no. 10, December 1984, pp. 108–113

Reff, Theodore, Degas's Copies of Older Art, *The Burlington Magazine*, vol. 105, no. 723, June 1963, pp. 241–251

Reff, Theodore, Copyists in the Louvre, 1850–1870, *The Art Bulletin*, vol. 46, no. 4, December 1964, pp. 552–559

Reff, Theodore, New Light on Degas's Copies, *The Burlington Magazine*, vol. 106, no. 735, June 1964, pp. 250–259

Reff, Theodore, The Chronology of Degas's Notebooks, *The Burlington Magazine*, vol. 107, no. 753, December 1965, pp. 606–616

Reff, Theodore, Addenda on Degas's Copies, *The Burlington Magazine*, vol. 107, no. 747, June 1965, pp. 320–323

Reff, Theodore, An Exhibition of Drawings by Degas, *The Art Quarterly*, vol. 30, nos. 3–4, 1967, pp. 252–263

Reff, Theodore, Some Unpublished Letters of Degas, *The Art Bulletin*, vol. 50, no. 1, March 1968, pp. 87–94

Reff, Theodore, More Unpublished Letters of Degas, *The Art Bulletin*, vol. 51, no. 3, September 1969

Reff, Theodore, Further Thoughts on Degas's Copies, *The Burlington Magazine*, vol. 113, no. 822, September 1971, pp. 534–543

Reff, Theodore, Degas, *The Artist's Mind*, The Metropolitan Museum of Art, New York 1976

Reff, Theodore, The Landscape Painter Degas Might Have Been, *ARTnews*, vol. 75, no. 1, January 1976, pp. 41–43

Reff, Theodore, *The Notebooks of Edgar Degas*, 2 vols., Oxford 1976/New York 1985

Reff, Theodore, Edgar Degas's Little Ballet Dancer of Fourteen Years, *Arts Magazine*, vol. 51, no. 1, September 1976, pp. 66–69

Reff, Theodore, Degas: A Master Among Masters, *The Metropolitan Museum of Art Bulletin*, vol. 34, no. 4, Spring 1977

Reff, Theodore, Edgar Degas and the Dance, *Arts Magazine*, vol. 53, no. 3, November 1978,

pp. 145–149

Reff, Theodore, Degas and de Valernes in 1872, *Arts Magazine*, vol. 56, no. 1, September 1981, pp. 126f.

Reff, Theodore, Au Musée du Louvre by Degas, in: *Art at Auction: The Year at Sotheby's 1983–84*, London 1984

Relin, Lois, La Danseuse de Quatorze Ans de Degas. Son Tutu et Sa Perruque, *Gazette des Beaux-Arts*, vol. 104, November 1984, pp. 173f.

Revilla Uceda, Mateo, Dos autografos de Degas en la Alhambra, *Cuadernos de la Alhambra*, vol. 26, 1990, pp. 265–277

Rewald, John, Degas and his Family in New Orleans, *Gazette des Beaux-Arts*, vol. 30, August 1946, pp. 105–126

Reymond, N., *Degas, "illustre et inconnu"*, Paris 1988

Rich, Daniel Catton, A Family Portrait of Degas, Bulletin of the Art Institute of Chicago, 26, November 1929, pp. 125–127

Rich, Daniel Catton, *Degas*, New York 1951

Rich, Daniel Catton, A Double Portrait by Degas, *The Art Institute of Chicago Quarterly*, no. 48, April 1954, pp. 22–24

Rivière Georges, *Mr. Degas, Bourgeois de Paris*, Paris 1935

Rivière, Henri, *Les Dessins de Degas*, 2 vols., Paris 1922–23; 1973

Roberts, Keith, The Date of Degas's "The Rehearsal" in Glasgow, *The Burlington Magazine*, vol. 105, no. 723, June 1963, pp. 280–281

Roberts, Keith, *Degas*, Oxford 1976

Robins Gruetzner, Anna, Degas and Sickert, Notes on their friendship, *The Burlington Magazine*, vol. 130, no. 1020, March 1989, pp. 225–229

Roger-Marx, Claude, *Degas Danseuses*, Paris 1956

Romanelli, Pietro, Comment j'ai connu Degas: Souvenirs Intimes, *Le Figaro Littéraire*, 13 March 1931, pp. 5f.

Roquebert, Anne, *Degas*, Paris 1988

Roquebert, Anne, *Degas*, Gennevilliers 1990

Rouart, Denis, Degas, *Le Point*, 1 February 1937, pp. 5–36

Rouart, Denis, *Degas: A la Recherche de Sa Technique*, Paris 1945; Geneva/Paris 1988

Rouart, Denis, *Degas Dessins*, Paris 1948

Rouart, Denis, *Edgar Degas, Monotypes*, Paris 1948

Rouart, Denis, *Degas: in search of his technique*, New York/Geneva 1988

Rouart, Denis, *The Unknown Degas and Renoir in the National Museum of Belgrade*, New York 1964

Salmon, André, Degas, der falsche Impressionist, *Das Kunstblatt*, vol. 1, January 1924, pp. 200–209

Salus, Peter H., Unexpected Desolation, *Semiotica*, vol. 75, nos. 3/4 1989, pp. 357–363

Saure, W., Degas, dich bete ich an, *Die Kunst und das schöne Heim*, no. 5, 1988, pp. 362–369

Schwabe, Randolph, *Degas the Draughtsman*, London 1948

Scott, B., The Triumph of Degas, *Apollo*, vol. 127, no. 314, 1988, pp. 282–284

Sérullaz, Maurice, *L'Univers de Degas*, Paris 1979

Sevin, Françoise, Degas à Travers ses Mots, *Gazette des Beaux-Arts*, vol. 86, July/August 1975, pp. 17–46

Shackelford, G.T.M., Les Portraits de Degas, *L'Œil*, no. 392, 1988, pp. 40–45

Shapiro, Michael, Degas and The Siamese Twins of the Café Concert: The Ambassadeurs and the Alcazar d'Eté, *Gazette des Beaux-Arts*, vol. 95, April 1980, pp. 153–164

Shapiro, Michael, Three Late Works by Edgar Degas, *The Bulletin, Museum of Fine Arts, Houston*, Spring 1982, pp. 9–22

Shinoda, Yujiro, Degas. *Der Einzug des Japanischen in die französische Malerei*, Cologne 1957

Sickert, Walter, Degas, *The Burlington Magazine*, vol. 176, no. 31, November 1917, pp. 183ff.

Sidlauskas, Susan, Resisting Narrative: The problem of Edgar Degas' Interior, *The Art Bulletin*, vol. 75, no. 4, December 1993, p. 679

Sizeranne, Robert de la, Degas et l'Impressionisme, *Revue des Deux Mondes*, vol. 42, November 1917, pp. 36–56

Smith, Graham/Weber, Susanna, Edgar Degas and Diego Martelli: "L'oeil Kodak" and the Fratelli Alinari, *History of Photography*, vol. 15, no. 2, Spring 1991, pp. 45f.

Steingräber, Erich, La Repasseuse. Zur frühesten Version des Themas von Edgar Degas, *Pantheon*, 32, January/March 1974, pp. 47ff.

Sutton, Denys, *Edgar Degas: Life and Work*, New York 1986

Sutton, Denys, *Edgar Degas: Vie et Œuvre*, Fribourg 1986

Sutton, Denys, Edgar Degas: Tradition and Innovation, *Gazette des Beaux-Arts*, no. 1431, vol. 111, April 1988, pp. 255–264

Sutton, Denys, Mirrored he a woman, Degas exhibition, *Country Life*, vol. 183, no. 43, 26 October 1989, p. 95

Sutton, Denys, The Degas Sales and England, *The Burlington Magazine*, vol. 131, no. 1033, April 1989, pp. 266–272

Sutton, Denys/Adhémar, Jean, Lettres inédites de Degas à Paul Lafond et autres Documents, *Gazette des Beaux-Arts*, vol. 109, no. 1419, April 1987, pp. 159–180

Sutton, Denys, Degas and America, *Gazette des Beaux-Arts*, no. 1458/1459, vol. 116, July/August 1990, pp. 29–40

Tannenbaum, Libby, Degas, Illustrious and Unknown, *ARTnews*, January 1967, pp. 50ff.

Tatlock, R.R., Degas Sculptures, *The Burlington Magazine*, vol. 42, no. 240, March 1923, pp. 150–153

Terrasse, Antoine, *Edgar Degas*, Milan 1972; Munich 1973; Garden City 1974; Paris 1974

Terrasse, Antoine, Degas et la Danse, *L'Œil*, 257, December 1976

Terrasse, Antoine, *Edgar Degas I-II*, Frankfurt am Main/Berlin/Vienna 1981

Terrasse, Antoine, *Degas et la Photographie*, Paris 1983

Terrasse, Antoine, *Edgar Degas*, London 1988

Thiébault-Sisson, François, La Vie Artistique: Edgar Degas – L'Homme et L'Œuvre, *Le Temps*, 18 May 1918, p. 3

Thiébault-Sisson, François, Degas Sculpteur Raconté par Lui-Même, *Le Temps*, 23 March 1921

Thiébault-Sisson, François, La Vie Artistique: Degas Sculpteur, *Le Temps*, 25 May 1925, p. 3

Thomson, Richard, Degas in Edinburgh, *The Burlington Magazine*, vol. 121, no. 919, October 1979, pp. 674ff.

Thomson, Richard, Degas's Nudes at the 1886 Impressionist Exhibition, *Gazette des Beaux-Arts*, vol. 108, November 1986, pp. 187–190

Thomson, Richard, Degas' only known painting on tile, *The Burlington Magazine*, vol. 130, no. 1020, March 1988, pp. 222–225

Thomson, Richard, *Degas: The Nudes*, London 1988

Thomson, Richard, The Degas Exhibition at the Grand Palais, *The Burlington Magazine*, vol. 130, no. 1021, April 1988, pp. 295–299

Thomson, Richard, The Degas Exhibition in Ottawa and New York, *The Burlington Magazine*, vol. 131, no. 1033, April 1989, pp. 293–296

Tietze-Conrat, Erika, What Degas Learned from Mantegna, *Gazette des Beaux-Arts*, vol. 26, December 1944, pp. 413–420

Tinterow, Gary, Mirbeau on Degas, A little-known article of 1884, *The Burlington Magazine*, vol. 130, no. 1020, March 1988, pp. 229f.

Tobias, T., One of a kind (The wax dance sculptures of Edgar Degas), *Dancemagazine*, vol. 66, no. 3, March 1992, pp. 62f.

Troendle, Hugo, Das Monotype als Untermalung. Zur Betrachtung der Arbeitsweise von Degas, *Kunst und Künstler*, 23, 1925, pp. 357ff.

Tucker, William, Gravity, Rodin, Degas, *Studio International*, vol. 186, no. 957, July/August 1973, pp. 25–29

Valéry, Paul, *degas danse dessin*, Paris 1938

Valéry, Paul, *Erinnerungen an Degas*, Zurich 1940

Van Vorst, Marie/Romanelli, Piero, Degas, *Catholic World*, vol. 134, no. 799, October 1931, pp. 50–59

Varnedoe, Kirk, On Degas' Sculpture, *Arts Magazine*, vol. 52, no. 3, November 1977, pp. 116–119

Varnedoe, Kirk, The Ideology of Time: Degas and Photography, *Art in America*, vol. 68, no. 6, Summer 1980, pp. 96–110

Vitali, Lamberto, Three Italian Friends of Degas, *The Burlington Magazine*, vol. 105, no. 723, June 1963, pp. 266–273

Vollard, Ambroise, *Degas*, Berlin 1925

Vollard, Ambroise, *Degas*, Paris 1936

Vollard, Ambroise, *Souvenirs d'un Marchand de Tableaux*, Paris 1937

Vollard, Ambroise, *En écoutant Cézanne, Degas, Renoir*, Paris 1938

Walker, John, Degas et les Maîtres Anciens, *Gazette des Beaux-Arts*, vol. 10, September 1933, pp. 173–185

Wasserman, Jeanne L., "I Never Seem to Achieve Anything with My Blasted Sculpture", *Harvard Magazine*, vol. 80, no. 2, November/December 1977, pp. 36–43

Wells, William, Who was Degas's Lydia?, *Apollo*, vol. 95, no. 120, February 1972, pp. 129–134

Werner, Alfred, *Degas Pastels*, New York 1977

Wick, Peter A., Degas's Violinist, *Bulletin Museum of Fine Arts Boston*, vol. 57, no. 310, 1959, pp. 87–101

Wilson, Michael, Degas at Artemis, *The Burlington Magazine*, vol. 125, no. 968, November 1983, p. 713

Zillhardt, Madeleine, Monsieur Degas, Mon Ami (1885–1917), *Arts*, 2 September 1949, pp. 4f.; 16 September 1949, pp. 4f.

Photographic Acknowledgements

Rijksmuseum, Amsterdam: pp. 274, 299
Guill Photo, Baltimore: p. 151
Birmingham City Museum and Art Gallery: p. 281
Museum of Fine Arts, Boston: pp. 137, 139, 140–144, 146, 147, 169 (left), 178, 182, 184, 185, 256, 257
The Brooklyn Museum, Brooklyn, N.Y.: p. 250
Museo Nacional de Bellas Artes, Buenos Aires: p. 267
Albright-Knox Art Gallery, Buffalo: p. 285
The Fitzwilliam Museum, Cambridge: pp. 156, 182, 301
Harvard University Art Museums, Fogg Art Museum, Cambridge, MA: pp. 230, 238, 252, 268
The Art Institute of Chicago: pp. 176, 199, 200, 234, 297
Cleveland Museum of Art, Cleveland: p. 196
Ordrupgaardsamlingen, Copenhagen (Ole Woldbye): p. 188
The Royal Museum of Fine Arts, Copenhagen: p. 218
Statens Museum for Kunst, Den Kongelige Kobberstiksamling, Copenhagen (Hans Petersen): p. 255
The Detroit Institute of Arts, Detroit: pp. 142, 235, 271, 284
The National Gallery of Scotland, Edinburgh (Antonia Reeve): pp. 266, 269
Städelsches Kunstinstitut, Frankfurt a.M. (Ursula Edelmann): p. 228
Galerie Jan Krugier, Geneva: pp. 221, 298
Ville de Gérardmer: p. 214
Hamburger Kunsthalle, Hamburg (Elke Walford): p. 229
McMaster Art Gallery, Hamilton, Ontario: p. 153
Wadsworth Atheneum, Hartford, Connecticut: p. 195
Staatliche Kunsthalle, Karlsruhe: pp. 216, 223
Musée Cantonal des Beaux-Arts, Lausanne: pp. 150, 300
The British Museum, London: p. 140
Colnaghi Drawings, London: p. 176
Courtauld Institute, London: p. 239
The National Gallery, London: p. 198
The Royal Collection, London: p. 127
The Tate Gallery, London: pp. 93, 259
The Armand Hammer Museum of Art and Cultural Center, Los Angeles: p. 270
Los Angeles County Museum of Art, Los Angeles: p. 194
Studio Basset, Lyons (Caluire): pp. 164, 210

Fundación Colección Thyssen-Bornemsza, Madrid: p. 10
The Whitworth Art Gallery, Manchester: p. 246
The Minneapolis Institute of Arts: p. 111
Bayerische Staatsgemäldesammlungen, Munich: p. 89
Joachim Blauel/Artothek, Munich: p. 225
Ali Elai, New York: p. 201
The Metropolitan Museum of Art, New York: pp. 88, 167, 168, 226, 254, 258, 265
The Pierpont Morgan Library, New York: pp. 166, 208
Eugene V. Thaw, New York: pp. 172, 186, 243
Malcolm Varon, New York, N.Y.: p. 29
Smith College Museum of Art, Northampton, MA: p. 174
National Gallery of Canada, Ottawa: p. 244
Agence photographique de la Réunion des musées nationaux, Paris: pp. 16, 23, 26, 38, 53, 94, 120, 122, 124, 125, 137, 142, 165, 172 (J.G. Berizzi), 178 (Berizzi), 179, 184 (Berizzi), 187, 189, 190 (Berizzi), 191, 192 (lower left, right), 215, 217
Bibliothèque d'Art et d'Archéologie, Fondation Jacques Doucet, Paris: p. 257
Bibliothèque Nationale de France, Service de la Reproduction, Paris: pp. 139, 140, 145
Jacqueline Hyde, Paris: pp. 161, 197
Lauros-Giraudon, Paris: p. 126
Studio Lourmel 77, Paris: p. 163
Bertrand Prévot, Paris: pp. 182, 192 (upper left)
Galerie Schmit, Paris: pp. 212 (upper left), 237, 247, 292, 294
J.C. Poumeyrol, Pau: p. 203
Philadelphia Museum of Art: pp. 27, 42, 286
Museum of Art, Rhode Island School of Design, Providence: pp. 71, 282 (Cathy Carver)
Virginia Museum of Fine Arts, Richmond, Virginia: p. 231
Museum Boymans-van Beuningen, Rotterdam: pp. 218, 258
The Saint Louis Art Museum: p. 224
Fine Arts Museums of San Francisco: p. 283
Volker Naumann, Schönaich: p. 157
Nationalmuseum, Stockholm: p. 241
Staatsgalerie Stuttgart: pp. 177, 222
Bridgestone Museum of Art, Tokyo: p. 261
National Gallery of Art, Washington D.C.: pp. 23, 56, 90, 103, 162, 186, 277
The National Portrait Gallery, Washington D.C.: p. 276
The Phillips Collection, Washington D.C.: p. 242
Sterling and Francine Clark Art Institute, Williamstown, MA: pp. 146, 171, 230
Walter Dräyer, Zurich: p. 249
Kunsthaus Zurich: pp. 159, 183, 190, 191 (both), 193, 211, 243, 264
Galerie Dr. Peter Nathan, Zurich: p. 152

Fondation Rau pour le Tiers-Monde, Zurich: p. 277
Stiftung Sammlung E.G. Bührle, Zurich: pp. 212 (lower left, right), 213, 219, 288

Index

This is primarily an index of persons portrayed. Works by Degas are listed by subject. Catalogue nos. are given in bold.